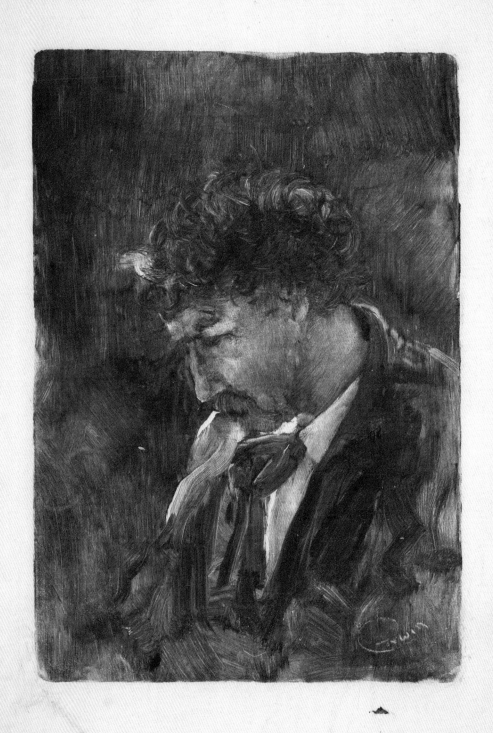

# Whistler

## A LIFE FOR ART'S SAKE

Daniel E. Sutherland

YALE UNIVERSITY PRESS

NEW HAVEN AND LONDON

Copyright © 2014 by Daniel E. Sutherland

Designed by Emily Lees
Printed in China

**Library of Congress Cataloging-in-Publication Data**

Sutherland, Daniel E., 1946–
Whistler : a life for art's sake / Daniel E. Sutherland.
pages cm
Includes bibliographical references and index.
ISBN 978-0-300-20346-2 (cl : alk. paper)
1. Whistler, James McNeill, 1834–1903. 2. Artists – United States – Biography. I. Title.
N6537.W4S88 2014
759.13 – dc23
[B]
2013027646

**A catalogue record for this book is available from the British Library**

*Frontispiece:* Charles Abel Corwin, *Portrait of James McNeill Whistler*, 1880. Monotype.
Metropolitan Museum of Art, Purchase, The Elisha Whittelsey Collection,
The Elisha Whittelsey Fund, 1960 (60.611.134). © 2013. Image copyright The Metropolitan Museum of Art /
Art Resource / Scala, Florence

# Contents

# *Illustrations*

Gallery of Art and Arthur M. Sackler Gallery Archives, Smithsonian Institution, Washington, D.C.: Gift of the Estate of Charles Lang Freer

62 *Nocturne*, 1879–80. F1898.379, etching and drypoint. Freer Gallery of Art, Smithsonian Institution, Washington, D.C.: Gift of Charles Lang Freer

63 *The Doorway*, 1879–80. F1898.385, etching and drypoint. Freer Gallery of Art, Smithsonian Institution, Washington, D.C.: Gift of Charles Lang Freer

64 *The Steps*, 1880. F1917.4a–b, chalk and pastel on brown paper. Freer Gallery of Art, Smithsonian Institution, Washington, D.C.: Gift of Charles Lang Freer

65 *Walter Sickert*, 1895. B2010.12.6, lithograph. Yale Center for British Art: Gift of Patricia Cornwell

66 Oscar Wilde, c. 1882. Courtesy of the Library of Congress, Prints and Photographs Division, [LC–DIG–ppmsca–07756]

67 *The Fish Shop, Busy Chelsea*, 1887. F1903.41, etching and drypoint. Freer Gallery of Art, Smithsonian Institution, Washington, D.C.: Gift of Charles Lang Freer

68 *Chelsea Shops*, c. 1882. F1902.149a–b, oil on wood panel. Freer Gallery of Art, Smithsonian Institution, Washington, D.C.: Gift of Charles Lang Freer

(Between pp. 316 and 317)

69 *Milly Finch*, 1883–84. F1907.170a–d, watercolor on paper. Freer Gallery of Art, Smithsonian Institution, Washington, D.C.: Gift of Charles Lang Freer

70 James McNeill Whistler, 1885. Courtesy of the Library of Congress, Prints and Photographs Division [LC–USZ62–15940]

71 Charles Keene, *Whistler as "Mr Punch" delivering the "Ten O'Clock Lecture"*. *Punch*, July 4, 1885, p. 89, N. 2706 d.10. The Bodleian Library, University of Oxford

72 The Pink Palace, The Vale, 1903–21. Courtesy of the Library of Congress, Prints and Photographs Division [LC–USZ62–113003]

73 *Her Majesty's Fleet: Evening*, 1887. B2002.8.10, etching. Yale Center for British Art: Gift of Robert N. Whittemore, Yale Class of 1943

74 *Archway, Brussels*, 1887. FSG 781813, etching. Freer Gallery, Smithsonian Institution, Washington, D.C. The Bridgeman Art Library

75 Maud Franklin, c. 1900. Courtesy of the Library of Congress, Prints and Photographs Division [LC–USZ62–80089]

76 Beatrice Godwin Whistler, c. 1876. PH1/59. By permission of University of Glasgow Library, Special Collections

77 Whistler with Mortimer Menpes, 1885. Courtesy of the Library of Congress, Prints and Photographs Division [LC–USZ62–66308]

95  *By the Balcony*, 1896. F1905.212, lithograph. Freer Gallery of Art, Smithsonian Institution, Washington, D.C.: Gift of Charles Lang Freer

96  *St. Giles-in-the-Fields*, 1896. 1917.654, transfer lithograph in black, with stumping, on cream laid paper. Art Institute of Chicago, Bequest of Bryan Lathrop

97  *Edward Guthrie Kennedy*, 1893–95. 09.222, oil on wood. Gift of Edward G. Kennedy, 1909. © 2013 Image copyright The Metropolitan Museum of Art, Art Resource, Scala, Florence

98  Rosalind Birnie Philip and Ethel Philip Whibley at St. Jude's Cottage, 1896. PH1/169. By permission of University of Glasgow Library, Special Collections

99  *Study No. 1: Portrait of Mr. Thomas R. Way*, 1896. 1943.3.8764, lithograph. National Gallery of Art, Washington, D.C., Rosenwald Collection

100  Giovanni Boldini, *Whistler Asleep*, 1897. F1906.277, drypoint. Freer Gallery of Art, Smithsonian Institution, Washington, D.C.: Gift of Charles Lang Freer

101  *The Doctor*, 1894. F1906.190, lithograph. Freer Gallery of Art, Smithsonian Institution, Washington, D.C.: Gift of Charles Lang Freer

102  Charles Lang Freer, 1901. A0694. Charles Lang Freer Papers, Freer Gallery of Art and Arthur M. Sackler Gallery Archives, Smithsonian Institution, Washington, D.C.: Gift of the Estate of Charles Lang Freer

103  Whistler's funeral, Cheyne Walk, 1903. Courtesy of the Library of Congress, Prints and Photographs Division [LC–USZ62–61275]

104  Whistler's funeral, St Nicolas churchyard, 1903. Courtesy of the Library of Congress, Prints and Photographs Division [LC–USZ62–61281]

105  Sarah Ann Hanson, date unknown. PH2/6. By permission of University of Glasgow Library, Special Collections

106  Charles James Whistler Hanson, date unknown. PH1/15. By permission of University of Glasgow Library, Special Collections

107  Rosalind Birnie Philip, c. 1903. A1300. Charles Lang Freer Papers, Freer Gallery of Art and Arthur M. Sackler Gallery Archives, Smithsonian Institution, Washington, D.C.: Gift of the Estate of Charles Lang Freer

# Preface

I first met James Whistler when I was twelve and he had been dead for fifty-five years. The occasion was a grammar school trip to the Detroit Institute of Arts. There he was, a self-portrait, right next to his most notorious painting, *Nocturne in Black and Gold: The Falling Rocket.* The memory of that encounter has stayed with me, and now, with the passing of nearly another fifty-five years, it is my reason for telling his story.

First, though, you need to know some things about Whistler. From childhood, he cared passionately about art. Relatives and friends, even the closest and most beloved, came second. Though sensitive and generous, his single-mindedness made him appear selfish, and none can deny that hubris and willfulness defined a large part of his character. Most people found it easier to admire Whistler than to love him. Luckily, we need do neither, but only understand him, although that, in itself, is a challenge. For one thing, the truth was seldom good enough for Whistler. He created his own reality, in both life and art. He had other quirks, but that one most defined him. Insecure and a dreamer, his life became a quest, a constant becoming, in which he frequently reinvented himself. As one of the first "modern" artists, he learned to market himself by fashioning a public image. He intended that people should see him as he wished to be seen. We all do it. As Mark Twain famously said, each of us is a moon, with a dark side we show to no one. Still, it is something else

to conceal one's whole self, and something yet again to seek notoriety with a consciously invented other self. That became Whistler's specialty.

Further complicating matters, he had no easily defined identity. This fact stymied his contemporaries and has frustrated biographers. Ezra Pound, a self-consciously poetic incarnation of Whistler, claimed him as an American, the greatest one since Abraham Lincoln. Others thought him a European, most especially a child of France. He has been called the quintessential "outsider" and the ultimate "insider." He was a maverick and a rebel, but also a much honored Master. He was an untutored genius and a hopeless charlatan. He was inventive and avant-garde; he was eccentric and derivative. He was outrageously egocentric and painfully insecure. Take your pick. Whistler was all those things. Best leave it at that, for to distill or categorize him only diminishes or obscures larger truths.

But make no mistake. James Whistler was a very great artist, arguably the greatest of his generation, and a pivotal figure in the cultural history of the nineteenth century. Critics past and present have judged him the finest etcher since Rembrandt. The painting of his mother may be the second most recognizable portrait – after the *Mona Lisa* – in the Western world. His pastels and lithographs shattered assumptions of what those forms could or ought to be. Most important was his artistic vision. His restless mind, constantly probing and searching for new, more inventive ways to put on paper, canvas, and copper what he saw with his "painter's eye," kept him a step ahead of nearly all his contemporaries. He borrowed from others, to be sure, but he more often inspired. If the power of art is to create images and symbols that change consciousness and alter perceptions, then no one in the nineteenth century did it better. He explained his vision, too, by writing and speaking publicly about what art ought to be.

Without doubt, Whistler led an eventful and controversial life. One might even call it a saga. He seemed to know everyone of any artistic or literary importance in nineteenth-century Britain and France, the two countries where he lived for virtually all his adult life. Today, he is best remembered for suing the eminent art critic John Ruskin, his rivalry with Oscar Wilde, his public battles with both friends and enemies, his not unrelated "autobiography" *The Gentle Art of Making Enemies,* and the iconic painting of his mother. Too little is known of the circumstances that forged those memorable moments and over 2,700 paintings, drawings, etchings, and lithographs.

A popular expression of his day, "art for art's sake," heralded beauty as the ultimate justification for art. To the extent that Whistler devoted himself to the pursuit of

beauty, his was a life for art's sake. One might even call it, given the compulsive nature of his pursuit, art for life's sake. Success did not come easily to Whistler, for he devoted himself not just to art, but to perfection. This, more than anything else, defined the contours and ups and downs of his life. It explains his insecurities, the constant questioning of his own abilities, his sometimes outlandish responses to critics, his failure to be long satisfied with successes, his self-promotion, the longing for recognition, the constant reinvention, the dark side that he showed to no one. Then again, there was the sheer joy of it all. Whistler loved being an artist. That he produced works of genius is his legacy.

# Acknowledgments

Naturally, I have personal debts, probably more than I realize, and certainly more than I can recall, but here are the obvious ones.

I visited thirty libraries and archives in consulting the 200 manuscript collections and 2,000 books, catalogues, dissertations, articles, essays, newspapers, and pamphlets that form the bedrock of my research on Whistler's life. Each institution is identified in the abbreviations used for my endnotes, and while every librarian and archivist with whom I came in contact was helpful and gracious, a few people stood out.

In the United States, thanks to Alice Lotvin Birney at the Library of Congress for guiding me patiently through the intricacies of the Pennell–Whistler Collection. The staff in the library's manuscript reading room, who had served my needs on previous visits, blinked twice when I said I was there to work on Whistler, but they pitched in, as always, to make my weeks with them profitable and agreeable. Elsewhere in Washington, Judy Throm and the efficient staff at the Archives of American Art were immensely helpful, both in the confines of their cramped temporary quarters on D Street, SW, and later, in their spiffy new digs on 9th Street, NW. Colleen Hennessey, Lily Kecskes, and Kenneth Myers (now at the Detroit Institute of Arts) placed all the resources of the Freer Gallery of Art at my disposal. The same was done for me by Susan Augustine at the Ryerson and Burnham Libraries, Art Institute of Chicago. Martha Tedeschi, formerly curator of prints and drawings at the AIC

(now deputy director), not only explained the mysteries of lithography to me, but also, in due course, courageously read portions of a very unfinished manuscript. Thanks as well to Susan Lintleman, Alan Aimone, and Suzanne Christoff in Special Collections at the Cadet Library, U.S. Military Academy.

In the United Kingdom, my research was anchored by the Centre for Whistler Studies, University of Glasgow. This was the Mecca and heartbeat for all things Whistler when I began my research. Sadly, the Centre is no more, a victim of financial retrenchment, but I shall be ever grateful for the intellectual brilliance and personal friendships that I found there. The Centre was almost ready to launch its monumental Whistler Correspondence Project when I first visited in the summer of 2001, and the welcome given to me by the project's director, Nigel Thorp (whom I had met a year earlier in Washington), and Margaret F. MacDonald, the unrivaled authority on Whistler's art, was warmer and more encouraging than I could have dared imagine. Both Nigel and Margaret have continued to tutor me and restrain my most outrageous literary impulses. Other rewarding friendships forged at the Centre include Patricia de Montfort, Georgia Toutziari, Arabella Teniswood, Joanna Meacock, Sarah Lawrence Parkerson Day, and Grischka Petri. Nigel, Margaret, and Patricia also read large portions of my manuscript. Nor dare I forget Susan Macallen, who kept the Centre's administrative machinery humming in such a charming way. Outside the Centre, thanks go to Peter Black and Pamela Robertson of the Hunterian Art Gallery, and to David Weston, former Keeper of Special Collections in the university library.

In London, personal attention was lavished on me by legions of people at the National Art Library, Victoria and Albert Museum, the British Library, and the library at Tate Britain, with special thanks going to Adrian Glew at the Tate. I also owe much to the expertise of Catherine Haill, curator at the Theatre Museum, National Museum of the Performing Arts, Alexia Kirk at the Archives of Art and Design, Nicholas Donaldson at the National Gallery, Mark Pomeroy, Annette Wickham, and Andrew Potter at the Royal Academy, Frances Pattman at King's College London, and my friends at the Courtauld Institute. Emma Floyd, librarian at the Paul Mellon Centre for Studies in British Art, Bedford Square, provided a haven of quiet repose and access to scarce journals.

Elsewhere in Britain, many thanks to Clea Nellist at the Sheffield Archives, Nicholas Robinson at the Fitzwilliam Museum, Cambridge, and Jonathan Smith at Trinity College, University of Cambridge. Special thanks go to Alison Brisby at Castle Howard, the most intimate and charming place in the world to do research, although one must be fond of dogs.

*Acknowledgments*

I am indebted to my many friends at Wolfson College, University of Cambridge, where I spent 2005–06 as a Visiting Fellow. I began writing the manuscript at Wolfson, even as I continued my research in the university's incomparable library and in London. Thanks, especially, to Wolfson's former president Gordon Johnson and his wife, Faith, to Anna Jones, former head of the college library, and to David Luhrs, Wolfson's former head porter, for making life there such a pleasure.

Numerous friends and colleagues have in one way or another contributed research material or ideas that helped to shape my work. They include David Park Curry, Robin Spencer, Ronald Pickvance, Norman MacDonald, David P. Werlich, T. Michael Parrish, Keith Bohannon, Bruce Baker, Derek R. Everett, Richard D. Sonn, and Sarah Simers. Richard and Sarah also read portions of the manuscript to my great benefit. Going above and beyond any reasonable form of assistance, Linda Merrill, of Emory University, provided valuable comments on several chapters of the manuscript, and the exceedingly generous Martin Hopkinson provided copies of his draft articles about Whistler. Lee Glazer, at the Freer Gallery, offered encouragement, helped to improve an early published essay on Whistler, and assisted with the acquisition of illustrations. Jane Dini, now at the Detroit Institute of Arts, taught me much about John Singer Sargent and modern art. I forgive her for trying to assassinate me in Sloane Square. Thanks as well to those uncomplaining graduate research assistants who completed many tedious tasks for me. They include James M. Finck, Amanda Ford, Scot Oldham, Bianca Rowlett, Jeremy Taylor, and Saxton Wyeth. I thank Sonia Toudji and Gregory Buchanan for helping, respectively, with my French and Spanish translations.

Financial assistance that allowed time away from teaching duties and eased the expense of travel came from the Fulbright College of Arts and Sciences, the University of Arkansas, the Department of History's Helen and Hugo Goecke and Adlyn and Harry Kennedy Memorial Travel Award and Ralph V. Turner Travel Fund, and the Nolan Faculty Award, courtesy the William C. & Theodosia M. Nolan Foundation. I also thank Dr. Lynda L. Coon, former chair of the Department of History, Dr. Robin Roberts, former dean of Fulbright College, Dean G. Todd Shields of the Graduate School, and G. David Gearhart, chancellor of the university, for helping to fund the illustration of this book.

My agent Wendy Strothman guided me to a successful partnership with Yale University Press, London, where the ever-patient Gillian Malpass has proved to be a superb editor. I also appreciate the work of Hannah Jenner in collecting the illustrations for the book, the meticulous copyediting of Sandy Chapman, and the editorial guidance of Emily Lees.

*Acknowledgments*

Finally, I am grateful to Helen Spencer and Denis Strauss for allowing me into their homes on Cheyne Walk, places where Whistler once lived. Their cheerful hospitality quite aside, I shall always treasure the experience of sitting in Whistler's gardens.

# I

# *Jamie, My Boy*

1834–1849

James Abbott Whistler was born in the busy mill town of Lowell, Massachusetts, on Friday, July 11, 1834. Not that the place mattered. The bright-eyed boy nearly everyone would call Jemie had fallen into a tribe of nomads. He would live in three countries and nine homes before the age of seventeen, and that was one of the more settled periods of his life. He had also fallen into a distinguished tribe, with high standards of behavior and achievement. Much was given to young Whistler, but much was expected. Even with doting parents – and he came up trumps on that score – the sweet-tempered lad would find his youth a bumpy ride.

His father, George Washington Whistler, was rugged, disciplined, occasionally moody, and at all times a perfectionist (fig. 1). He had been born at the frontier army post of Fort Wayne, Indiana Territory, the son and brother of soldiers. Entering the family trade, he graduated from the U.S. Military Academy in 1819. Life on the frontier made George Whistler self-reliant; West Point made him an engineer. Yet, he was an engineer with a soul. He cherished art and music as much as a sturdy bridge or well-graded road. Standing near the top of his West Point class in mathematics and philosophy, he led it in drawing. A self-taught flutist, he earned the nickname "Pipes." A classmate said Whistler was "too much of an artist to be an engineer," but the classmate was wrong. Whistler, the perfectionist, became one of the nation's finest engineers.[1]

Jemie's mother, Anna Matilda McNeill, was a woman of quiet passions (fig. 2). Born the fourth of six children in a North Carolina family of physicians, soldiers, and planters, she lived from age ten in Brooklyn, New York, where her father had eventually settled. At fifteen, she met and fell in love with the gallant Lieutenant Whistler, only to see him marry her best friend, Mary Roberdeau Swift. However, when Mary died of typhoid nearly seven years later, the heartbroken widower found solace with Anna's family. Her brother William had been a West Point classmate, and Mary had supposedly told George on her deathbed, "If you marry the second time, it must be to Miss McNeill." Of course, a period of mourning was required, and the feelings of Whistler's three small children, George, Joseph, and Deborah, had to be considered. To test her own resolve, Anna left America for England in 1830 to stay with two half-sisters from her twice-wed father's first marriage. Whistler gave her a music box to take on the year-long sojourn. They married a year after her return.[2]

Jemie was the first of Anna's five children, and by the time he was born, Major Whistler had left the army to work for the Boston and Lowell Railroad. Whistler, who had been constructing railroads and making locomotives since 1828, enjoyed a substantial reputation in the new industry. By taking the job in Lowell, he trebled his army pay of $1,000 per annum and received a rent-free, two-story house on what is now Worthen Street. Life was good in Lowell, but whether from restlessness or ambition, Whistler moved his family twice more in the next four years. The nomadic trek had begun. They went first to quiet Stonington, Connecticut. In 1840, they settled in another industrial center, Springfield, Massachusetts, where Whistler became the chief consulting engineer of the Western Railroad. The family, which now numbered six children, lived in a grand house of nearly twenty rooms on Chestnut Street. Several servants attended them, the family favorite being their housekeeper, an Irish immigrant named Mary Brennan.

But hopscotching across New England was nothing compared with the family's next move. Word of Whistler's engineering and administrative skills had reached the Russian tsar. Determined to bind his enormous country together for military mobilization and economic development, Nicholas I hired him to build a railroad from St. Petersburg to Moscow. Whistler received a staggering $12,000 annual salary and a semi-official position at the Russian court, but his task was monumental. The 400-mile railroad, cutting through some of Russia's roughest terrain, would require 200 bridges and nearly 70 viaducts. He would also be responsible for manufacturing the rolling stock, to include 162 locomotives, 2,580 freight cars, and 70 passenger

cars. Eager to begin, he left the United States in June 1842, with Anna, the five youngest children, and Mary Brennan to follow.[3]

That Anna left America at all spoke of her devotion to George and her strength of character. Life in an alien land held no appeal for her. Indeed, she had urged George to decline the Russian post. How would the children be educated? she asked. How might their Christian upbringing be injured, their health endangered? Typhoid fever had already taken a stepson three years earlier, and, as it happened, the third of Anna's own sons, Kirk Booth, aged four, died shortly after his father left for St. Petersburg. Then, just as the family was to join him, in May 1843, Jemie nearly died of rheumatic fever.

The little band finally left Boston in August, bound for Liverpool aboard the British paddle-wheeler *Acadia*. The crossing, full of adventure for nine-year-old Jemie and seven-year-old William McNeill, or Willie, Anna's second child, took twelve days. On arriving in England, they spent a fortnight at Preston with Anna's half-sisters, Eliza Winstanley and the unmarried Alicia McNeill, before catching a steamer from London to Hamburg. A long, uncomfortable coach trip carried them to Travemunde, where they boarded another steamer for the final leg of their journey. Tragically, Anna's youngest son, two-year-old Charles Donald, died from inflammation of the bowels before the family reached St. Petersburg in early October. A distraught Major Whistler blamed himself for the boy's death. He grieved all the more knowing that Charlie's little corpse must be returned to Stonington for interment beside Kirk.[4]

Physically and emotionally drained, the rest of the family surveyed the place they would call home for nearly six years. Russia's imperial capital was a beautiful city, with its gilded spires and domes, grand palaces, broad boulevards, and fragrant gardens, and the Whistlers were fortunate to have Colonel Charles Stewart Todd, the U.S. foreign minister to Russia, help them settle there. Eighteen-year-old Deborah Whistler, with whom Todd flirted, thought the suave, fifty-year-old Kentuckian "a great goose," but Todd leased his own luxurious house on an exclusive street, the Galernaya, to the family. A retinue of servants, including cook, butler, two housemaids, laundress, and yard man, confirmed the aura of luxury. A few of the servants, most importantly the cook, even spoke a little English.[5]

Nor was St. Petersburg as alien as Anna had feared. The city boasted a thriving community of British, American, and English-speaking European businessmen, merchants, and shopkeepers, several of whom befriended the Whistlers. The very pier at which they landed was called the English quay, lined with splendid Neo-Classical

buildings and handsome mansions. An English bookshop stood within walking distance of their new home, and several boarding houses catered to British visitors. An "English Church," established in 1754, sat near the center of the quay. The Anglo-American contingent numbered only about eight hundred in a city of five hundred thousand, but their wealth gave them disproportionate influence. Whistler added to the numbers by hiring a pair of American firms to build the locomotives and cars for his railroad. Their representatives, Joseph Harrison, Andrew Eastwick, and the Winans brothers, Thomas and William, became close confidants.[6]

George and Anna used those connections to keep their home as "American" as possible. George had turned down the tsar's offer of a commission in the Russian army, and he insisted that his children cherish their nationality as much as they did their religion. The family celebrated its first Christmas in the American fashion. They hung stockings and exchanged gifts, and Anna invited four American families to join them in a feast of roast turkey and pumpkin pie. They observed the holiday according to the Gregorian calendar, too, rather than Russia's Julian date, which placed it twelve days later. Not that calendar or country made any difference when Jemie and Willie played out of doors. They ran their sleds on snow-packed streets as they would have done at home, coasted down tall, ice-coated wooden ramps, called "ice hills," erected in the center of town, and skated for hours on ponds and the broad river Neva.[7]

George left the children's religious upbringing to his wife, who, as a devout Episcopalian, insisted on family prayers before breakfast and Scripture readings each evening. Friends marveled at the depth of Anna's piety, and her plain attire and lack of adornment had long been a source of family humor. "Anna is so *unshakable*," a sister-in-law once complained of her, "that sometimes I could shake her. And the way she will stand out even against people whose opinion means the most to her. One can't help admiring it but it seems so – well, so old!" For all that, Anna was quick and smart, well read and articulate. She had a playful streak, too, with a "twinkle" about her. No one less could have captured the affection of "Pipes" Whistler.[8]

Anna's children were divided in their reactions to her piety. The boys occasionally rebelled against both Bible readings and school lessons, but the expectation that they would be good Christians seemed as reasonable to them as that they should behave as young gentlemen. Deborah, called Debo by the family and Dasha by her new Russian friends, was a different matter. Unlike Anna, who regarded court functions as "extravagant" and "dissipated," the vivacious and musically talented young lady chafed when not allowed to attend a soirée, reception, concert, opera, or play. Anna

admired her stepdaughter's "amiability" and unaffected nature but wished she would take more pride in "domestic" accomplishments. Gradually, allowances were made, Debo accepted a degree of "moderation," and a truce prevailed.[9]

In fact, none of the Whistler children was denied the cosmopolitan opportunities available in St. Petersburg. The family eventually accepted invitations to imperial parties and military reviews, and it was impossible to miss the fireworks, booming cannon, and pealing bells that marked public holidays. Jemie was dazzled that first year by a pair of visits to Catherine the Great's palace at Tsarskoye Selo, the "Village of the Tsar," some fifteen miles south of St. Petersburg. Poor health had caused him to miss an earlier tour of the Winter Palace, so he was wide-eyed upon entering Catherine's splendid apartments. Most dazzling was an opulent suite of rooms decorated and furnished in the "Chinese style." A return trip yielded a similar, if contrasting, delight when, prowling the extensive palace grounds, strewn with all variety of novelties and follies, he discovered a miniature Chinese village, complete with pagodas, huts, and bridges.[10]

Both Jemie and Willie looked forward to the tsar's annual military reviews on the Champs de Mars, which they attended three years running. Even without his family's lineage, Jemie loved the pomp of military pageantry, and wanted nothing more than to be a solider. With some sixty thousand Russian troops garrisoned in St. Petersburg, he and Willie encountered soldiers almost daily, but they had never seen anything like this glittering spectacle of banners and uniforms. Not that the foreign display entirely seduced them. They remained, after all, their father's sons. When a Russian staff officer, having noticed what pleasure the boys took in one review, teasingly asked Jemie which regiment he would join, the boy replied proudly, "None here. I must wait to get again to my own country."[11]

Still, the glamour could not disguise the perils of their new world, with persistent rounds of sickness being most notable. Jemie suffered two serious bouts of rheumatic fever and was confined to bed for long stretches of time with coughs and congestion. He also made his first trip to a dentist, the start of a lifetime of problems with his teeth. The delicate Debo fell ill even more often, if not as severely. Russian autumns were chilly and wet, winters more severe even than in New England, with temperatures well below zero for weeks on end. When warm weather returned, much of the land around St. Petersburg reverted to mosquito-infested swamp. Native Russians thrived on drinking water from the Neva, which appeared unpolluted to the eye but had "peculiar effects" on newcomers, who were advised to mix the water with wine or rum.[12]

The poverty of many Russians also reminded the Whistlers that this place was not America. In a land of notable contrasts, none was more stark than the gap between rich and poor. Palaces and ducal homes on the one hand, hovels and crime-filled streets on the other, gave Anna yet another reason to rejoice in her nativity. Crime, as it happened, was something the family experienced personally. They awoke on the morning after their first Christmas to find that "rogues" had stolen a beautiful rosewood writing desk given to Anna by the children. Also missing were a fountain pen given by Anna to George and the major's flute. Whistler offered a "tempting reward & *no questions*" for their return, but the family never recovered its missing treasures. They grieved most over the lost flute, which had "many tender associations" for all.[13]

The family put all such worries behind them come the summer of 1844, when they joined the many affluent Russians and foreigners who escaped St. Petersburg for the countryside. The major rented a villa less than four miles from town, about one hour by carriage, close enough to return for church on Sundays while living in a world of forests, flowers, blue lakes, and "ruby coloured" sunsets. The boys romped through the fields, fished for perch, went boating, staged plays, and made friends with several "little Russian cronies." Willie, who loved flowers, planted daisies in his own small garden. The dacha rang with music, too, when Debo, at the piano, accompanied the major on his new flute. Best of all, Aunt Alicia came to visit them.[14]

Not that paradise came without cost. The boys had been taught by a German tutor in St. Petersburg, and Anna insisted that they continue their lessons, especially in French and Russian, through the summer. She, Debo, and a new Swedish tutor acted as instructors. Each boy also practiced on the piano for thirty minutes a day. Bent as well on self-improvement, Anna read Walter Prescott's *The Conquest of Mexico*, sometimes sharing passages aloud with the family. She also studied French and Russian, although Willie remained her interpreter when dealing with local shopkeepers.

Benevolent and religious duties remained, too. Anna spent much of her time in Russia ministering to the poor and supporting charitable work. Privately, she could be alarmingly dismissive of the lower ranks, but she raised her children to appreciate the family's good fortune and to respect the feelings of less fortunate people. Believing that everyone from the "home of the Pilgrims" had a duty to rescue people who "dwell[ed] in darkness," she had Jemie and Willie distribute religious tracts to local serfs, tenant farmers, "idle young men," and passing soldiers. She never suspected

that the grateful men prized her gifts as rare sources of paper for cigarettes, not as spiritual enlightenment.[15]

Nothing, though, could interfere with Jemie's favorite pastime, drawing. A family story had it that when asked, as a two-year-old, why he had secluded himself beneath a table, the boy replied, "I'se drawrin." Soon after the Whistlers settled in St. Petersburg, his father hired a twenty-seven-year-old Russian army officer and part-time art student named Alexander Koritsky to nurture Jemie's talent one day per week. Koritsky himself studied at the Imperial Academy of Fine Arts under Italian-born Karl Briullov, one of Russia's premier painters. That summer, Jemie drew so compulsively that special trips to the Palette de Raphael, an artist's supply shop in St. Petersburg, were required.[16]

His talent was confirmed that June, when a friend arrived at the villa with a distinguished visitor from Scotland. Sir William Allen had accepted a commission from the tsar to paint what would become *Peter the Great Teaching his Subjects the Art of Shipbuilding.* As he described the project to the Whistlers over tea, Allen noticed how Jemie hung on his every word. Being told of the boy's "love for art," he asked if he might inspect his work. He remained largely non-committal in Jemie's presence, only later telling Anna, "[Y]our little boy has uncommon genius, but do not urge him beyond his inclination." Anna assured him that Jemie's "gift had been only cultivated as an amusement."[17]

Jemie would not have disagreed, for he still dreamed of being a soldier, not an artist. Even his reading that first summer took a martial turn. When his tutor, Hadenscoff, introduced him to the military exploits of Charles XII, the once-formidable Swedish foe of Russia, Jemie devoured a biography of Charles, probably the one written by Voltaire. As his admiration for Charles soared, he thought less highly of Peter the Great, Charles's enemy in the early 1700s. Given an opportunity to view some paintings done by the multi-talented tsar, the boy let his historical judgment influence his artistic appraisal. He was "so saucy as to laugh at them," an embarrassed Anna reported of her son's reaction to Peter's work.

Her elder son fretted Anna in other ways (fig. 3). For one thing, he was an indifferent scholar, applying himself only to subjects that interested him. He was an incessant reader but preferred novels, James Fenimore Cooper being a favorite author. He was unpredictable and spontaneous, too, and audaciously independent. He was moodier than Willie or Debo, more like his father in that respect. All gaiety and high spirits one day, he could be silent or petulant the next. All attentiveness, sensitivity, and generosity one moment, he might turn insolent and heedless of

people's feelings. More content than the other children to be alone, he thought nothing of secluding himself for hours at a time to read or draw. Unlike Debo, who challenged the rules, Jemie quietly made his own. Compared with the "more tractable" and "less excitable" Willie, whom Anna called the "gentlest" of her boys, Jemie, though "noble minded," lacked self-control, ignored physical danger, and seemed bent only on gratifying himself.[18]

The Whistlers returned to St. Petersburg in September but to less expensive quarters. For half of their previous annual rent of $1,800, they obtained a still-impressive third-floor flat of ten rooms. The bathtub had hot running water, a luxury they had not enjoyed on Galernaya. The new house, where they would reside for the remainder of their time in Russia, stood on the fashionable English quay, less than a quarter of a mile from the Winter Palace, and with a sweeping view of the Neva.

So, as the Whistlers began their second year in Russia, life settled into a comfortable pattern. Whistler had a railroad to build, Anna a household to maintain. She would soon be pregnant, too, her new son, John, to be born the following summer. Jemie and Wille resumed their studies with a third tutor, a middle-aged German named Lamartine. Anna could not decide who was the greater talker between Lamartine and Jemie, but she liked the pious Lutheran, who used his salary to support his mother. She also admired his "patience and perseverance" in handling her "wild sons."[19]

Her wildest son somehow persuaded Anna and George to enroll him for thrice-weekly drawing lessons at the Imperial Academy of Fine Arts in the spring of 1845. The century-old academy, located on an island in the Neva directly opposite their new home, formed part of a complex of Neo-Classical buildings that included the financial exchange and the University of St. Petersburg. Admission was by competitive examination, but eleven-year-old Jemie, pitted against some lads twice his age, won a spot in the second of four skill levels. Elated by his placement, he nonetheless despaired of rising any higher. His private drawing teacher, Koritsky, was still a student in the fourth form, and Jemie revered him as a "master." Anna, mindful of William Allen's advice, was pleased to have her son unite "amusement & health" with "improvement."[20]

Evidence of his ability survived in a sixty-eight-page leather-bound sketchbook. Most interesting were drawings (done in pencil, ink, and crayon) of everyday Russian life and of people he encountered in the streets, including peasants, soldiers, policemen, a judge, a "fool," a boy (possibly Willie), and a young woman (possibly Debo). More finished, full-page drawings, some done in watercolor, illustrated biblical

scenes, including Daniel in the lion's den, Queen Esther, the Murder of the Innocents, an infant Jesus, Jesus clearing the temple, Jesus in the Garden of Gethsemane, and the crucified Christ. By way of contrast, the sketchbook also included a drawing of a mermaid with crossed arms covering otherwise exposed breasts. A caption read, "'Oh 'tis pleasant to float on the Sea,'" from Carl Maria von Weber's opera *Oberon*.[21]

Except for Debo, who had returned with Aunt Alicia to England for her health, the whole family attended the Imperial Academy's triennial exhibition of Russian art the following May, in 1846. Briullov's work, including his epic *Last Days of Pompeii*, was prominently displayed. The boys, accompanied by Lamartine, returned nearly every day during one week, and Jemie visited some two dozen times in the following month. His classes at the academy had ended by then, and he had excelled, ranking twenty-eight in a class of more than a hundred students. Surprisingly, then, Koritsky expressed disappointment in his progress that summer, as did the governess of a neighboring family. A favorite of the Whistler boys, she gently lectured Jemie on the need for "better application" in his studies and "greater perseverance in cultivating his talent for drawing."[22]

Jemie's lackadaisical attitude and a want of discipline in both boys invited a drastic remedy. In September, the start of their fourth Russian year, the major placed them in a local boarding school, operated in military fashion by one Monsieur Jourdan. Anna thought it a doubtful experiment, although she admitted that her sons looked handsome in their black uniform jackets, gray trousers, velvet stocks, and black caps. Surprisingly, Jemie adjusted well to the strictly regimented environment. He pronounced everything "first rate," from his new classmates to their spartan meals (brown bread and salt for breakfast, sour beef for dinner). Willie, however, grew homesick and looked "very doleful." Anna thought that, in this, he, unlike Jemie, was "a complete Whistler."[23]

As the school year progressed, none but their father seemed pleased with the arrangement. Debo had returned after a year in England, and she now missed her brothers. The boys came home on weekends, but those precious days passed all too quickly. The young scholars spent much of the time studying, and Jemie, allowed to resume his drawing lessons with Koritsky for two hours on Saturdays afternoons, was lost during that time.

And such wrenching departures come Sunday evening. Willie regularly fought back tears. Even "manly" Jemie, praised so often for his stout heart, gave in occasionally. Urged by Anna to help cheer his sensitive brother, he replied in near agony, "Oh Mother, you think I don't miss being away from my home!" He quickly brushed

away the tears welling in his eyes, but the "elasticity of spirits" everyone expected from this apparently carefree boy could clearly be stretched only so far.

Everyone wept a few weeks later when one-year-old John died in an outbreak of dysentery. Quite unreasonably, Anna blamed herself for the child's death, her guilt compounded by a conviction that excessive grief was sinful. Barely a month later, Jemie wept for himself. As a punishment for talking in class, Jourdan did not allow him to go home that weekend until he had copied his French lesson twenty-five times. He completed the assignment by Saturday night but missed his "Saturday treat" with Koritsky. Debo tried to comfort him, but not even her sympathetic attention could stop the tears, "dashed" away this time "in vexation."[24]

The ordeal ended unexpectedly during the Christmas holidays, thanks to Jemie's worst bout of rheumatic fever since leaving America. He laid painfully abed for six weeks, his breathing labored, his thirst unquenchable, a victim of fevers and sweats. The boy could not possibly return to Jourdan's school, and Anna beseeched Whistler to end the "experiment" altogether. No advantages of education or discipline offered by Jourdan could compensate for the sacrifice of health. Even Willie, healthiest of all the family, had shown signs of fatigue and suffered from "stomach disorder." Anna insisted that she and Debo could tutor the boys while also fostering "habits of virtue." A concerned father could not gainsay those arguments.[25]

Jemie was able to walk by early February 1847, but painful blisters on his chest made it impossible for him to dress. His doctor would not even allow him to draw, though the lad did manage to play chess with his father. It was Debo who found an elixir. To help her brother pass the time, she borrowed a "huge volume" of William Hogarth's engravings. Jemie poured over the drawings for hours at a time. He had been quite unaware of this English artist's wondrous work. "And if I had not been ill, Mother," he marveled to Anna, "perhaps no one would have thought of showing them to me." Jemie's genuine fascination moved his father to purchase a less grand edition of Hogarth.[26]

Life looked much brighter by March. Tsar Nicholas was pleased by the progress of his American mercenaries, and Jemie took pleasure in another "highly extolled" exhibition at the Academy of Fine Arts. Whistler took him and Debo to the opening, and Jemie anticipated resuming his lessons within those hallowed halls. That is, until an influenza epidemic struck the city. The peril felled Whistler first, in April, to be followed by Jemie and Willie. The boys came through thanks to heavy doses of "cough medicine," but when a servant died from the sickness, and rumors of a cholera epidemic spread, Anna said they must escape the poisoned atmosphere.

Whistler was bound to stay at his post, but Debo left to visit friends in Switzerland and Anna and the boys headed for England.[27]

By the time they landed at Hull in mid-June, Jemie was nearly thirteen, and held decided opinions. Pausing during the journey to rest at Travemunde, he and Anna had visited a church that featured an allegorical painting of Death. "[T]he picture itself was more curious than pretty," judged the confident critic in a letter to his father, the oldest surviving letter in his hand. "Some think it was painted by Holbein, but he was born long afterwards." His pampered life in Russia had also made him something of a snob. When Anna tried to economize by purchasing second-class train tickets for the journey from Hull to Preston, she saw that "Jemie's pride was wounded by so doing."[28]

He liked England and its people a "great deale better" than he thought he would do, although he promised his father not to adopt "too many english notions." The refugees spent most of the next four months with the Winstanleys, at Preston. The boys continued with French and German lessons, but their aunts and uncle indulged them shamelessly, and Anna took them on long "gambols" by carriage through the region, from Blackpool to Liverpool. They rented a seaside cottage on the Cheshire coast for part of their stay. An enthralled Jemie asked if he and Willie might remain in England to attend school.[29]

Debo joined them in August, although she wore a "distracted" look. Dr. Francis Seymour Haden, twenty-nine-year-old son of a prominent English family she met in Switzerland, had proposed marriage. Debo had accepted, pending her father's approval. At nearly twenty-two, she felt more than ready to wed. Her closest friend in Russia had married a few months earlier, and her stays in England and Switzerland had instilled a desire to live her own life. As her Aunt Eliza surmised, the family might as well "chop her head off as propose her going back to Russia."

Anna did not oppose the match, and the major, though frantic at the prospect of relinquishing his "greatest treasure," accepted her verdict and headed for England. Accounts of his reaction to the suave, cultured, yet pompous Haden differ, but Jemie heartily approved of his new brother-in-law, who, besides being a physician, also happened to be a talented painter and etcher. Decked out in spiffy white trousers and gaudy polka jacket, a proud Jemie served as groomsman at the October wedding. He and Willie were crushed, though, when told they would soon return to Russia. Having already begun their school year, they begged to remain with the Winstanleys. Their headmaster also wished them to stay, especially Jemie, who, to the astonishment of all, was praised for his mature behavior.[30]

Yet, once returned to St. Petersburg, Anna and the boys did not remain long. With the onset of winter, Jemie's health suffered, and in June 1848, rheumatic fever again downed him. Before he had fully recovered, Russia had its worst cholera epidemic in years. More than twelve thousand people died in St. Petersburg. By early July, one-fifth of the city's half a million people had fled. Anna, Mary Brennan, and the boys returned to England.[31]

Seymour Haden welcomed them to his London townhouse, 62 Sloane Street, in newly fashionable South Kensington, but Anna and the boys were soon away for "health and recreation" to the Isle of Wight. They rented a thatched-roof stone cottage at Shanklin, one of the first "resort" communities in Victorian England. Jemie and Willie found a land of adventure along the tall cliffs that rose above the ocean, the whole region blanketed by lush green foliage, cut by dramatic chines, and honeycombed with dark, mysterious woods that demanded exploration. The endless beaches held treasures, too, rich in seashells and animal fossils, and breached by secret coves once used by smugglers. Anna took the boys on hikes and carriage rides to nearby towns, including Bonchurch, with its "stylish" shops, and Brading, where she judged the new Gothic chapel the "prettiest" church on the island. Friends and relations, including Debo and the Winstanleys, occasionally joined them in the bracing sea air. Debo came laden with birthday gifts for the boys, including a sketch-book and paintbox for Jemie.[32]

It was safe to return to Russia by September, but this time, for the sake of his health and education, Jemie remained in England. He was enrolled at a school recommended by Haden, Eldon Villa, near Bristol. Mr. Phillot, the headmaster, was a kindly man, and the little town of Portishead, where the school was located, a charming place. Still, for a lad accustomed to a loving family and bosom pal like Willie, there were lonely days. He suffered from swollen glands, and his neglected teeth troubled him. He missed his drawing lessons with Koritsky, too, especially when learning that his tutor and the great Briullov had visited his parents. Both artists asked after him, as did the owner of the Palette de Raphael.[33]

His greatest balm came from a maturing bond with his father. The major had always been the family disciplinarian. "Jamie, my boy," he would begin (preferring Jamie to Jemie), and the lad knew he was in for a lecture on obedience, industry, or self-denial. The admonitions seldom had a lasting effect. The precocious and impulsive son wanted to please, and promised to improve, but he rarely managed it. Yet now, his father's advice, sent from afar, meant much to him. His mother may have been the steward of his soul, but his father could be depended on to counsel him

in earthly pursuits. "[Y]ou know Jamie dear that *I should be your best friend,*" Whistler intoned. "I trust you feel that *I am so.*"

The father spoke of character and education. A "spirit of frankness and manliness" should ever guide his actions, the major told him. Be polite to all, he emphasized, as this quality gave evidence of "good feeling and true modesty." As for education, Jamie should pursue a course of study that led to a promising profession. Whistler believed, given his son's "particular talents and likings," that he would make a fine engineer or architect. Toward that end, Harvard or Yale would be a good school to attend. Jamie should prepare himself for university by mastering Latin and mathematics and learning to express himself "clearly and properly" in English. Whistler deemed the latter accomplishment "of the utmost importance" for any "professional man." Jamie must also improve his "habits of study," whatever the subject. "[C]arelessness," his father reiterated, had always been Jamie's "evil genius," apparent even in his drawings: "*finish* your work my boy."[34]

Life then took another dramatic detour. Debo, having invited Jemie to spend the Christmas season with her and Seymour, had also persuaded their parents that his health was suffering at Eldon Villa. Rather than return to school, she said, he should remain to be tutored at 62 Sloane Street. Anna resisted the plan. Fully appreciating her son's natural inclinations, and knowing Debo to be no disciplinarian, she feared that Jemie would become "a butterfly sporting about from one temptation to idleness to another."

Anna knew her children well. Her butterfly was soon on the loose. Debo had entered a glamorous social circle that included members of Parliament and such notable people as William Makepeace Thackeray. She thought nothing of having Jemie attend posh "child parties" and private theatricals, considered by London society to be innocent amusements. George Whistler called it going "among the snobs!" When Jemie spoke enthusiastically about returning to America to seek riches in the California goldfields, his parents fretted over their "worldly minded" son.

Their worst fears were realized when Jemie seemingly took to drink. Debo had no firm evidence, but when young men in his new circle mocked him as a teetotaler, she guessed he had broken an earlier pledge of abstinence. Whistler's military service led him to sympathize with his son, but Anna was more pointed. "Do you ask yourself 'would mother or father approve of my joining in this or that pursuit?'" she asked. "Oh come back to your Mothers embrace," she begged him, "artless as when you left her side, at least preferring what is real to all false glitter, tho you have had a peep at the beau monde."[35]

His family probably overestimated the temptations to flesh and spirit. Not yet fifteen, Jemie remained a relative innocent, and neither fancy parties nor strong drink was as likely to consume him as his ever-deepening passion for art. Not even St. Petersburg, with its Imperial Academy and fine exhibitions, could compete with the education he received in London from the sophisticated, multi-talented Seymour Haden. Acting as the fit "companion" the Whistlers hoped he might be, Haden prowled the city's galleries, museums, and print shops with Jemie. They talked of painting, drawing, and etching; they attended lectures on art. The brothers-in-law even collaborated on a drawing. Debo having given birth to a daughter, Annie, in mid-December, "Uncle Jim" made a sketch of the baby that Haden "finished and made really like her."[36]

Nor was Haden his only tutor. George Whistler, likely with Haden's assistance, had commissioned William Boxall, a forty-eight-year-old English artist who had exhibited at the Royal Academy, to paint a portrait of Jemie. Boxall liked his young sitter so much that he gave him a recently published book about the Italian Renaissance. The author, Anna Jameson, was a friend of Boxall, and her survey of Renaissance painting provided vivid biographical sketches of great artists, explained rival "schools" of painting, and introduced Jemie to artistic theory, as opposed to the techniques of drawing. Here was a whole new world, and having received the book from a famous artist, he devoured it.[37]

Jameson's book complemented a Christmas gift from the major, a copy of Sir Joshua Reynolds's magisterial *Discourses on Art*. It was not easy reading for a fourteen-year-old boy. Like Jameson, Reynolds said that the goal of the artist must be "to discover and to express" beauty in nature, but he also called beauty "an idea that subsists only in the mind." How should Jemie interpret that dichotomy? Haden had stressed the importance of drawing "from nature," but what did Reynolds mean by it? He wrote of "styles," "schools," and "principles" of art, as did Jameson, but also of "real" and "apparent" truths. He stressed as well that artists must be devoted to their work. Only hard "labour" brought "solid fame," Reynolds declared. Even men of genius must have a "passion" for art.

One may imagine the eager young artist nodding and making mental notes. He likely questioned Reynolds's muted praise of Hogarth, but he would have appreciated his estimation of Thomas Gainsborough as a "colourist." Gainsborough had a "painter's eye" for color, Reynolds said, and a "lightness of manner and effect" in finishing his work. Unlike lesser painters, Gainsborough never left an impression of "hardness or dryness." Jemie was learning a new vocabulary, and he quickly put it

to use. "Mr. Boxall is a beautiful Colourist," he informed his father. Going on to describe his completed portrait, he explained, "The background in the picture is very fine, such a warm tone, very like one of Gainsborough's. It has not a *dry* opaque look, but a beautiful creamy surface, and looks so rich!" Jemie had likely seen Gainsborough's work in London, but Reynolds enabled him to express what he saw in the language of art.

Both Reynolds and Jameson praised Raphael, so Raphael joined Jemie's pantheon of heroes. Jameson compared him to Shakespeare. Reynolds, more meaningfully, judged him and Michelangelo the world's two greatest painters, with Raphael having the edge in composition, technique, and ingenuity. Both Reynolds and Jameson mentioned Raphael's famous cartoons for several tapestries at Hampton Court, so when Boxall offered to take his protégé to see them, Jemie could barely contain himself. Contemplating the visit, he enthused to his father, "Fancy being so near the works of the greatest Artist that ever was! I wish you could go with me! And Koritzky too."[38]

His enthusiasm led Jemie to mention again a possible career. He broached the subject cautiously, first thanking his father for the Reynolds lectures and asking his opinion of a newly published book about Russia by John Maxwell, who, as Colonel Todd's secretary in St. Petersburg, had become a family friend. He asked his father to explain the conditions of the recent U.S. peace treaty with Mexico, and said what "a capital thing" it would be to settle in the new territory of California when the family returned to America. Finally, bursting to mention the issue uppermost in his mind, Jemie got down to cases. "I hope, dear Father, you will not object to my choice [of a profession]," he ventured, "viz = a painter, for I wish to be one so *very* much and I don't see why I should not, many others have done so before. I hope you will say '*Yes*' in your next, and that dear Mother will not object to it."[39]

While awaiting his father's reply, Jemie attended a series of lectures by Charles Robert Leslie at the Royal Academy. English art had few more authoritative figures. A close friend of John Constable, Leslie had taught drawing at West Point, and he currently served both as president of the Royal Academy and keeper of the new National Gallery, completed in 1838 in Trafalgar Square. His lectures confirmed what Jemie had read in Reynolds and Jameson. Indeed, Leslie frequently referred to Reynolds's discourses. But he also spoke rapturously of Rembrandt, Peter Paul Rubens, and Diego Rodriguez de Silva Velázquez, and explored the subject of Chinese art, which had so captivated Jemie at the Catherine Palace. Leslie made both old and new lessons more vivid, and Jemie had an opportunity to study the

lectures in detail when they were published in England's foremost cultural magazine, the *Athenaeum*.

Two of Leslie's topics resonated most with Jemie. First, he confirmed Jemie's faith in Hogarth. Unlike Reynolds, who thought Hogarth's subject matter "low and confined," Leslie ranked him with Michelangelo and Raphael. Second, and more profoundly, he clarified Reynolds's somewhat abstract references to artistic "imagination" and the "interpretation" of nature. Never slavishly copy even the greatest artist, not even Hogarth or Raphael, Leslie insisted. An artist must create "a style of his own." Similarly, never try to replicate nature, or depict it as others had done. Rather, use what Reynolds called the "painter's eye" to identify "some genuine quality of Nature for the first time or some new combination of what is already known to Art." This was the supreme challenge, the "great and unceasing difficulty," facing every artist.[40]

The excitement of Leslie's lectures was exceeded midway through the series by a letter from Anna. Jemie's father was too preoccupied with new complications at work to write at present, she said. Responding to political revolutions in France and central Europe, the tsar had stalled construction of the railroad by redirecting funds to strengthen his army. Even so, the major thought of his son "constantly" and sympathized with his desire to be an artist. Both parents still hoped that Jemie would become an engineer or architect, but their "dear boy" had ample time to consider such things. The reply was hopeful enough to relieve an anxious teenage heart.

Then, disaster. The political upheaval in Russia had put an enormous emotional and physical strain on Whistler, as did the lingering effects of cholera, contracted the previous November. He took to bed in February, and remained feeble a month later, barely able to scribble a few lines urging Jemie to honor his temperance pledge. Before the son could read those words, his indomitable father, age forty-eight, died of congestive heart failure. Upon receiving the news, a boy in England, known to dash away tears, wept openly.[41]

# 2

# *Anything for a Quiet Life*

## 1849–1854

Willie scarcely recognized his brother when he, Anna, and Mary Brennan reached England in June. Jemie had grown taller and "much fatter" during their nine months apart. Willie had missed him, too. He had endured hard times at his school in St. Petersburg. The English boys had picked on him, called him "American Monkey" and "Milk Sop." His father had advised him either to ignore the taunters or "knock [them] down." He must "become hardened to rough & tumble," the major said, but the beleaguered Willie had always depended on his elder brother. "[I]f Jim were here it would be all right," he would say.[1]

Jemie coped with his father's death by clinging to art. A friend of Haden, having escorted the lad to several picture galleries, found this young "admirer of painting" to be a "very profound critic – setting down this picture, a dumb, that a mess, and another divine, all in the most innocent and amusing manner." A visit to see his own portrait, by Boxall, at the Royal Academy proved more melancholy. Art critics praised the painting as "fine in expression" and "beautiful in colour," which echoed Jemie's own estimate to his father; but he could take little pleasure in this triumph without sharing it with him.[2]

Aunt Alicia diverted the boys for a time by taking them to meet friends and relatives in Glasgow and Stirling and to visit Edinburgh. Debo had visited Scotland's capital during her first stay in Britain, being present, in fact, for the dedication of

the statue of Sir Walter Scott in the Prince's Street gardens. Anna and the boys did not return to America until August. She had long since shipped their belongings home, all but the piano, which remained with Debo. She now intended to receive her husband's coffin in New York, bury him beside their dead sons at Stonington, and, following his wishes, have Jemie and Willie educated "in their native land."[3]

They settled at Pomfret, Connecticut. The village was some forty miles north of Stonington, but it had an excellent preparatory school, Christ Church Hall, operated by the local rector, Rev. Dr. Roswell Park. Despite his calling, Park had graduated from West Point fifteen years earlier. Anna thought he represented the perfect balance of religious and secular experience. Equally important, Park had a reputation as a disciplinarian, just what her mercurial Jemie needed. In the wake of his father's death, Jemie had become even less disciplined and more prone to "indolence" and "lounging" than in Russia. Only some mention of his father sobered him. "[T]o talk to Jemie of his father's example is a benefit to us both," Anna told friends, "for we weep together & are more closely bound to each other."[4]

Reduced to living on the interest from Whistler's railroad stocks, about $900 per annum, the family moved into half of their landlord's farmhouse. There would be no drawing lessons, no private tutors, no military reviews, none of the comfort or security of St. Petersburg or London. Having been "brought up like little princes," Jemie and Willie now cared for pigs and chickens between school lessons. In winter, their drafty lodgings retained little heat, and snowdrifts kept them housebound for days at a time. The summer heat equaled that of St. Petersburg, but with no suburban dacha for refuge. Anna had enough money to hire a laundress once a week, but the boys bathed in ponds and rivers.[5]

Still, they occasionally visited relatives in Stonington and New York, and family and friends went to Pomfret. A cousin, Emma Palmer, became something of a little sister when she stayed in 1850 to attend school with the boys. Family devotionals, appointed hours for study, long walks together, and evenings spent reading aloud helped anchor them in a stormy world. It seemed, too, that despite the severe winters, they all enjoyed better health than in Russia.[6]

Which is not to say Jemie, or Jim, as Willie and their schoolmates now called him, was not a handful. He had been a beautiful boy, delicate and animated, and as he approached his sixteenth birthday, he showed promise of being a handsome young man. With his shock of curly, dark brown hair, blue eyes, and "pensive, delicate face," he might have been called effeminate were it not for a "somewhat foreign appearance" that lent an air of mystery and, as Emma recalled, "made him very

charming." Fluent in French and German, he was quite sophisticated by local stand-
ards, while his buoyant spirit, love of pranks, and indifference to authority made
him popular at school. "No one could withstand the fascination of his manner,"
Emma maintained, "or resist the contagion of his mirth, inconsequent and thought-
less as he often was."[7]

Precisely, and nothing so fretted or preoccupied his mother as the fate of her elder
son. He was lazy, willfully disobedient, notoriously unreliable, "indifferent" to reli-
gion, and inattentive at school. He delighted in mocking his teacher. Entering the
schoolroom one morning, Anna's prankster sported the same stiff collar and stock
worn by the clergyman. Park tried to ignore the affront, but as the room swelled
with "suppressed laughter," he drew his ruler and approached Jim's seat. Jim leaped
up, and Park gave chase. The lad finally surrendered by throwing himself to the floor
and submitting to the inevitable whacking, though as much in "amusement" as
"discomfort."

Privately, Park found some of Jim's escapades entertaining, but therein lay the
problem with young Whistler. He *was* charming, so perfectly willing to accept
punishment, and so genuinely repentant after each impetuous act, that people always
forgave him. Anna was "full of grief" and "mortified" by his behavior, but, as in
Russia, she imposed no punishment. Because contrition inevitably followed each
misdeed, she stretched her Christian doctrine of forgiveness to a fault. "Jemie sent
home from school in consequence of irreverence at prayers," she lamented. "I ban-
ished him to his room but he was so gentle & obedient and applied himself to study
for the afternoons Latin class, I went to him & he let me cut his hair." Cousin Emma
recalled the same pattern. "[H]e was so funny & bright that you couldnt scold him,"
she said. Still, Emma realized, a "Father's hand" was sorely missed.[8]

He became quite good at drawing caricatures. Going a step beyond his St. Peters-
burg sketches, which, while sprightly, lacked a consistent strain of humor, the new
work included elements of mockery, whimsy, and the grotesque. Blame it on
London, where his fondness for Hogarth, legitimized by Leslie, had been reinforced
by the cartoons of George Cruikshank and Halbot K. Browne (better known as
"Phiz") in *Punch* and the *Illustrated London News*. Asked to contribute some draw-
ings to raise money at a church fair, Jim produced the "most ludicrous" cartoons
Emma had ever seen. The ladies of the church recoiled in "horror," but the sketches
went for a "good price."[9]

As in Russia and England, he drew compulsively. There were religious drawings,
scenes from current novels and plays, and recollections of life in Russia. Besides

Cruikshank and "Phiz," his work showed hints of Paul Gavarni, a French illustrator who romanticized the "bohemian life" of Paris. Jim made some very good water-colors, too, a medium he had first used in Russia. One of those pictures recorded an important event in the life of Pomfret: the burning of the schoolhouse in February 1850. He likely painted it in a celebratory mood, for while the building was not demolished, lessons were suspended for two days to make repairs.[10]

He paid a price for being artist-in-residence, as when called upon to contribute something to the church fair. He would sigh and protest, laughed Emma, but always yielded good-naturedly. "Oh! anything for a quiet life," he would say. The expression came from Charles Dickens, whose works he had begun to read in England. More specifically, it was uttered by one of Jim's favorite Dickens characters, Sam Weller, the clever and amorous cockney servant of Mr. Pickwick. It became Jim's answer to "everything," Emma said.[11]

His choice of heroes worried Anna, who had been consulting brother William McNeill and General Joseph Swift about possible careers for her son. Swift was the first graduate of West Point, a hero of the War of 1812, and, as it happened, a brother of George Whistler's first wife, Mary. Both uncles wanted Jim to follow his father's path to West Point. Anna was less fond of the idea. Recalling the major's last wishes, she thought Jim might "bend his talents to architecture." Nonetheless, in April 1850, she sent him to discuss his future with William in Boston and the general in New York. Swift took Jim to see the military academy, located about forty miles north of the city, in the Hudson River valley. Whatever the lad's inclinations beforehand, he came away smitten with West Point and the "charming & kind old gentleman" who had escorted him.[12]

So it was decided, and a campaign was launched to have him admitted to West Point in 1851. He would not yet be seventeen, a tender age to be shipped off to the academy, but then his father had entered at fourteen and graduated at nineteen. Admittance required an appointment from a U.S. congressman, senator, or, in some cases, the President of the United States. General Swift decided that an "at-large" appointment from President Millard Fillmore was the best option, mainly because it allowed him to use his own enormous prestige as a senior army officer and former commandant of the academy. Influential politicians, including Henry Clay, Daniel Webster, Joseph Trumbull, and Robert Ingersoll, added their weight. They empha-sized that this was the son of George Washington Whistler, one of West Point's most distinguished graduates, and that Jim's mother was "very desirous" that he should follow his father's profession.[13]

Jim received one of twelve appointments given by President Fillmore in 1851, but there seems little doubt that he had been persuaded to become a soldier by the enthusiasm of his family and the memory of his father. It is singular, for instance, that his application, unlike nearly all others, did not include a letter from himself, stating his desire to enter West Point. The idea of a military career was not foreign to him, but he had not mentioned his boyhood fancy since leaving Russia. Yet, here he was, endorsed by the president and bound, apparently, to meet his destiny.

When he arrived at West Point on June 3 with seventy other "Plebes," as first-year cadets were called, Jim found himself part of a regimented and isolated community. The "corps" of cadets consisted of a battalion of approximately 220 men, divided by class into four companies. Their days began at 5 a.m. with roll call. Plebes then cleaned and tidied their spartan barracks rooms (shared by two to three men) before enduring ninety minutes of drill. Breakfast, which consisted of bread, butter, coffee, and some combination of cornbread, hominy, potatoes, and hashed meat, followed drill. Except for Sundays, they attended class or studied in their rooms from 8 a.m. until 1:30 p.m., then marched to dinner. This more substantial meal commonly included roast beef or ham, rice, potatoes, fish, vegetables, and pudding. A second period of classes and study followed from 2 to 4 p.m. After another hour of drill, an evening parade, and a supper of bread, fruit, and tea, cadets returned to barracks to study from 6 p.m. until lights out at 10 p.m.

Discipline was maintained through a system of demerits, and to be reported, or "skinned," for breaking regulations was the bane of a cadet's existence. The "degree of criminality," as it was phrased in army regulations, was graded from one to ten for each offense. Tardiness was punished by a single demerit, while absence from drill drew four. The sharpest punishment (ten demerits) came for "mutinous conduct." The accumulation of two hundred demerits in a single year (from July to June) constituted grounds for dismissal.[14]

Plebes also had to prove their mettle to upperclassmen, who barked, bullied, and hazed them incessantly. Bodies ached from the exaggerated posture, known as "bracing," required of Plebes when standing in formation or being addressed by superiors. Senior cadets also loved to play tricks, or "run it," on Plebes, their object being to test the mental endurance and *esprit de corps* of these would-be soldiers. If they could not stand up to "a little fun," explained an upperclassman, "the die would be irreducibly cast against them."[15]

Jim soon misstepped in this tightly ordered environment. He was now "Mr. Whistler," and his "lounging" ways would not be tolerated. He had drawn forty

demerits by September, the vast majority being either one- or two-demerit crimes. He was late for roll call, late for breakfast, late for dinner, late for guard duty, late for drill, and late for evening parade. He laughed during drill, laughed during inspections, was "inattentive" at drill, and habitually "gazing about." If not unpunctual or inattentive, he was simply irresponsible. He received reprimands for a dirty musket, an untidy tent, improper alignment on parade, and improper execution of the manual of arms.[16]

His behavior alarmed Anna, especially since she learned of it second hand, from the families of other cadets, one of them from Pomfret. Not one to sit by idly, Anna took Willie to visit her first-born on a weekend in mid-August. He promised to reform, but before the month had passed, Anna received fresh reports of his slovenly ways. "You said to me my dear cadet that you would try to have no more [demerits]," she reminded him. "[W]ill it not be a good time . . . to turn over a new leaf? [T]ry for your mother's sake dear Jemie!"[17]

Whistler accepted the rebukes graciously. He knew this was just her way, and he could not be long perturbed with a mother who sent him amusing items from the newspapers, ginger snaps, mince pies, and extra socks and under drawers. He also knew that expectations ran high for the son of "Pipes" Whistler. His father had been famous for his practical jokes and merry ways as a cadet, but he had also recognized the limits of misbehavior. Anna reminded her son regularly of how many loving friends and relatives in America, England, and Russia would be mortified and disgraced if he squandered this opportunity.[18]

Whistler also carried the burden of poor health. While experiencing no serious rheumatic attacks since leaving Russia, he remained fragile. He spent nine days in seven weeks in the cadet hospital for chafed skin (a common ailment with wool uniforms in hot weather), a bacterial infection, and a bout with fever that struck several other cadets. Another potential stumbling block to academic success, nearsightedness, had been diagnosed during the academy's medical examination. His teeth still gave him trouble, too. Anna urged him to clean both his teeth and his musket.[19]

Following a summer encampment that introduced Plebes to life under canvas, the academic grind began in September. First-year classes included mathematics (combining algebra, geometry, and trigonometry) and "English studies" (an unlikely combination of rhetoric, grammar, geography, and ethics), with French added in January. Plebes also received instruction in fencing, the use of artillery, and infantry tactics, although these subjects did not affect their class standing. Assignments to

classes, which averaged about ten students, were alphabetical during the first week. Thereafter, cadets were evaluated and reassigned weekly according to classroom performance, the best students in a subject being assigned to the top "section," and so on down the line. Failure rates were high, especially during the first year. Between a quarter and a third of cadets never graduated.[20]

The increasingly heavy doses of mathematics, science, and engineering that cadets received during their four years had never been Whistler's strong suit, but the curriculum harbored no lethal threats. If emotionally immature, he possessed above average intelligence, even in a Plebe class that contained "more talent" than any other in recent memory. The potential pitfalls for Whistler would be lack of application and self-discipline. His father had regularly warned him against those evils, and his mother now hammered at the same themes. "You *promised* to study regularly & not to suppose *glancing* [at assignments] would suffice," she reminded him. "[T]hink of these things & shew you have moral courage, by resisting idle examples."[21]

Family friends at the academy tried to steer him straight. Most important was William R. Boggs, an upperclassman. Uncle William McNeill knew the Boggs family, and had given Jim a note of introduction to their cadet, who subsequently became a mentor and protector. In addition, several of the staff and faculty had been friends of Whistler's father or knew General Swift, who asked them to take "an interest in James' success." Anna encouraged her son to take Sunday tea with one of those officers, Major William H. C. Bartlett, who extended this "weekly privilege" to cadets who wished to polish their drawing room manners.[22]

None of it could cure Whistler of his rebellious streak. He earned the nickname Curley for his reluctance to visit Joe Simpson, the post's black barber. Once seated in the chair, Whistler joked and cajoled in hopes of getting Joe to "let up" a little on his required monthly haircut. He also instigated one of the year's most memorable incidents. Having caught a bat, Whistler and some friends decided to test the beastie's "biting powers." A sizeable crowd gathered as they tied "a long thread to one of his legs and a piece of paper to the thread" and set fire to the paper. "He shot off like a rocket," marveled a witness, "and made such a show that all Barracks were at their windows to see it."[23]

Somehow, Whistler survived his first year. He passed both the dreaded January examinations and the even more traumatic final exams of June. Failure in a single course on either occasion would have meant dismissal. He ranked ninth in French, forty-first in English Studies, and forty-seventh in Mathematics. He finished a poor

fifty-second in fencing, besides receiving a minor wound and earning a demerit for "not fencing properly." Luckily, cadets could not "fail" fencing, and Whistler was not among the seven members of his class sent packing. One of the failed cadets was James H. Holbrook, who had maliciously informed Pomfret of Whistler's early struggles.[24]

More worryingly, he had accumulated 190 demerits, fourth highest in the class. He would have received even more black marks had not sympathetic classmates, well aware of his perilous position, failed to report some infractions. Anna and General Swift feared that he had fallen into bad company. Swift knew that some cadets, unable to adapt to the army or the academy, defied regulations. They snuck off to nearby taverns, smuggled contraband goods, especially tobacco and liquor, into barracks, and engaged in illicit activities, such as playing cards and cooking in their rooms.[25]

As it happened, his nephew was drawn to just such "idlers." Whistler's closest and most questionable crony, Henry M. Lazelle of Massachusetts, was known for his casual regard for authority and fondness for drink. Whistler received his single highest number of demerits – eleven – after being caught playing cards with Lazelle, and he was lucky at that. Learning of the offense, Whistler's entire class "went on pledge" for him, meaning, they spoke up for his good character and honesty. No one did so for Lazelle, who landed in still more trouble a few months later. A court martial found him guilty of insubordination and confined him to the post for thirty days with extra guard duty.[26]

Miraculously, Whistler escaped punishment for his most common sins, smoking and drinking. Both were forbidden at West Point, so that the favorite spots for cadets to indulge in them were local taverns, even though, to compound the crime, those establishments were officially off-limits. The most notorious tavern belonged to Benny Havens, famous for producing "a certain number of graduates in drinking each year." Whistler stumbled back to barracks more than one evening from Havens's place.[27]

Not that he abandoned legal amusements and refreshments. Whistler patronized the small shop where Joe Simpson's wife sold cakes, ice cream, soda water, strawberries, oysters, and other delicacies unknown in the cadet mess hall. He enjoyed an occasional home-cooked meal at the boarding house of a widowed army officer named "Mammie" Thompson, although Mammie's three daughters were an equal attraction. They may have been, as one cadet called them, a "hard looking set of old maids," but the young men of West Point craved any female society. In winter,

Whistler skated on the frozen Hudson River, as he had done on the Neva. There is no record of him playing "foot ball," which had become a popular sport at the academy by the 1850s, but he enjoyed walking in all weather.[28]

A voracious reader all his life, Whistler frequently visited the cadet library. The breadth of his casual reading that first year was striking. The list included novels by Walter Scott, Charles Dickens, and James Fenimore Cooper, a volume of Thomas Hood's poetry, Jonathan Swift's *Historical Tracts,* Samuel Butler's *Hudibras*, Oliver Goldsmith's *The Vicar of Wakefield,* Elizabeth Southall's romantic novel *The Wide, Wide World,* plus scattered issues of *Chambers's Miscellany* and *Knickerbocker.*[29]

Nor could the army stifle Whistler's impulse to draw. "We talk of you whenever the fine arts come upon the tapis," Debo assured him, even as she sent reports of exhibitions and copies of *Punch* and the *Illustrated London News,* that he might enjoy the drawings and caricatures. He responded by filling textbooks, examination papers, and the "memory" or "souvenir" albums of classmates with sketches of cadet life. Most were crude and hurried, often mere doodles, meant to pass the time in class or in barracks. Others, he dashed off on request, the accumulated results being a rich satirical commentary on his new world. With his "keen sense of the ridiculous," Whistler became the academy's Cruikshank, its Hogarth.[30]

Two centuries of cadets would recognize the scenes. In one early sketch, a hopelessly awkward lad strained to assume the exaggerated position of attention demanded of new cadets. Another one, bearing the caption "Christmas comes but once a year," showed three cadets holding their glasses aloft in a rousing toast. A classmate reported seeing some twenty cadets "almost dead drunk" on the occasion. In the first of another pair of sketches, two cadets bent over their books, reading by lamplight. Whistler titled it, "Boning," the cadet term for studying. Its complement, "Not Boning," showed a single cadet leaning back in his chair and smoking as a disapproving officer spied on him.

More polished early work included four drawings, reminiscent of one of Hogarth's narrative sequences, that marked the half-hours of a sentinel's watch. Alert and on guard at the start, the cadet gradually succumbed to boredom and weariness, first leaning against a tree, then sitting at its base, and finally falling asleep on the ground. Curiously, while the sentinel was highly stylized, Whistler lavished much care on the tree in the first drawing. The delicate shading of its gnarled and knotted trunk showed the influence of Rembrandt, whose work formed a large part of Seymour Haden's collection (fig. 4). Whistler made four other Rembrandt-influenced draw-

ings for Maria "Kitty" Bailey, the lovely and personable fifteen-year-old daughter of a chemistry professor. The most intriguing of those pictures, probably suggestive of Whistler's mood, depicted an old man sitting in a dungeon cell.[31]

So quickly did his reputation as an artist spread through the corps that Whistler received two commissions in the spring of 1852, although neither one paid. Most impressively, he drew the frontispiece for the sheet music of that year's senior class song. It pictured two young men clasping hands on the bluffs above the Hudson River. One of them wore a cadet uniform; the other, bearing a strong resemblance to Plebe Whistler, wore the regular army uniform of a newly graduated second lieutenant. Whistler played no part in producing the lithograph needed to transfer the image, but he was identified as the artist (fig. 5).[32]

Boggs played a hand in the second commission. He thought a scene from the summer encampment drawn by Whistler would make a perfect illustration for dance cards at the gala graduation ball. Lieutenant Richard S. Smith, a professor of drawing, opposed the idea. An engraving would be required to reproduce it, Smith explained, and that would be costly. Told of Smith's decision, Whistler countered that an inexpensive woodcut could be used instead of an engraving, and that he would be happy to make one. This amused Smith, for Whistler had never made a woodcut, but the lieutenant consented and found the finished piece, made only with a penknife, utterly "charming."[33]

Better still, as he began his second year at the academy, Whistler would earn academic credit for his talent. With mapmaking, surveying, and the sketching of field positions being necessary skills for nineteenth-century army officers, cadets received formal instruction in drawing. "Yearlings," as second-year cadets were called, concentrated on topography and the human figure. The third-year course added landscape and painting. Besides Lieutenant Smith, the drawing instructors were Captain Truman Seymour and, more importantly, Robert W. Weir, a civilian. Weir had come to the academy in the mid-1830s to replace Charles Leslie, whose London lectures had fascinated the adolescent Whistler. By the 1850s, Weir was well along with his commission for a mural in the rotunda of the U.S. Capitol. Here was a mentor to equal Briullov.[34]

Having seen some of Whistler's work, Weir was nearly as interested in his new student as Whistler was keen to meet him. He invited the cadet to his studio during the summer of 1852, several weeks before classes began. Whistler excitedly asked Anna to send his drawing and painting materials. She complied, but also voiced her usual concern that drawing not be a "temptation to idleness."[35]

West Point had a single, if "spacious," three-story granite academic building in the 1850s, set at a right angle between the cadet barracks and mess hall. A seventy-two-by-thirty-eight-foot Drawing Academy and two seventy-by-twenty-foot galleries occupied the third floor. One gallery held plaster casts used for drawing models; a picture gallery displayed paintings done by cadets as part of their instruction. It was not the same drawing hall in which Whistler's father had ruled as both student and instructor, but family tradition, nonetheless, had to be maintained.

Tales of Whistler's prowess became legendary. Fellow cadets gawked as he drew a face, then a hand, then a body, "skipping from one part of the picture to another," seemingly "at random." He inserted shadows and background objects in the same way, with no apparent relation to the main figure, until suddenly, it all fit. One classmate recalled an instance when Lieutenant Smith, "jealous of Whistler's talent," took him to task. Whistler had been painting in watercolors when Smith saw him insert a free-floating shadow. The instructor ridiculed the work as "faulty in principle." Without reply, and with but a single sweep of his brush, Whistler inserted the object that cast the shadow. Smith walked quietly away.[36]

Weir, unlike the insecure Smith, indulged his star pupil. Making his rounds of the drawing hall one day as cadets labored over their India-ink drawings, Weir paused to inspect Whistler's progress. Spotting a flaw, he walked to his own desk, loaded a pen with ink, returned to Whistler's side, and bent over to correct the defective line. Whistler, seeing his purpose, raised an arm to "ward off" the intrusion. "Oh, don't, sir, don't!" he pleaded. "You'll spoil it!" The outburst would have drawn a reprimand from Smith. Weir only smiled, withdrew his arm, and returned to his desk. Asked years later if the episode were true, Whistler replied, "Perhaps, and you know he might have!"[37]

One of his finest works under Weir's tutelage was a large (thirty by twenty-two inches) pen and ink drawing called *A Man Dispensing Alms,* copied from an existing work. Having learned from a decade of drawing lessons what effects he wished to achieve, his draftsmanship was remarkably bold and precise. Whistler also made at least five watercolors, again copied from existing prints or paintings, and exhibiting a variety of painting styles. He thought his watercolor of Oliver Cromwell viewing the corpse of Charles I, the original by Paul Delaroche, the "best thing" he did at the academy.[38]

Whistler's freelance work betrayed a fondness for scenes from favorite novels. Walter Scott and Alexandre Dumas inspired some drawings, but Charles Dickens topped the list. Indeed, he went on a Dickens binge in the fall and winter of 1852,

when he read seven Dickens books in as many months. He enjoyed the Englishman's stories partly because they featured areas of London well known to him, but also because he enjoyed Dickens's sense of humor and views on life. Judging from surviving drawings, *Pickwick Papers* was a favorite. He gave two sketches from that novel as a graduation gift to William Boggs.[39]

Anna was more concerned that he master French and mathematics, and he simply had to curb his talent for acquiring demerits. He had received one hundred by the end of September 1852, and while the infractions continued to be minor ones, the large number suggested endemic sloth rather than occasional carelessness. He had also been borrowing money from stepbrother George, Anna learned, and she feared the purpose. "When are all your wild oats to be sown?" she asked pleadingly. Could he not "[c]ast off childish fancies" and "renounce . . . the devices of the flesh"?[40]

Having moved to Scarsdale, midway between New York City and West Point, and just east of the Hudson River, Anna requested that Jemie be given a week-long furlough to visit her. They needed to speak. Colonel Robert E. Lee, the academy's new superintendent, granted a three-day pass. It was a generous concession, given the strict rules against cadets leaving the post until their third year. Lee also knew that Whistler could ill afford to fall behind in his studies. Yet he, like so many army officers, admired Whistler's father and wished to oblige the widow. He allowed her son to depart after classes on Friday, October 1, for three days.[41]

The reunion produced mixed results. An acquaintance recalled a "very subdued" Whistler "sitting very quietly in the dark corner" of Anna's piazza. His mother thought him sulky and petulant, though she had sensed this transformation coming the previous winter. His letters to her had betrayed an abandonment of religion, in both ritual and substance. Anna feared for his salvation. Read your Bible, she urged, if only on Sundays. "If the Cadets discover that you try to devote part at least of the Sabbath to the study for Eternity they will respect you for it," she reasoned. Appalled by his "folly" and "ungraceful" behavior, Anna hoped that her son's "own native sweetness" would reemerge when next they met.[42]

Her words seemed to have some effect. Whistler finished the academic year, in June, with only 168 demerits, an especially notable achievement given the "new administration" ushered in by Colonel Lee. The superintendent had turned things "topsy-turvy," cadets charged, by vigorously enforcing regulations. Cadets who had rarely earned demerits now received them "every week." It is also possible that Lee took Whistler aside for a chat. The colonel had completed his own years as a cadet without a single reprimand, but he appreciated the rigors of cadet life. That his eldest

son and a nephew were also in the corps at that time likely heightened Lee's sympathy for the young men he commanded.[43]

A more likely explanation for Whistler's about-face was ill health. Serious respiratory problems that autumn and early winter spared him many days of duty and many opportunities for earning demerits, as did a case of gonorrhea. Doctors at the cadet hospital diagnosed his embarrassing ailment on October 13, nine days after the visit to Scarsdale. The timing was right for him to have contracted the disease either on a side trip to New York City or on a nocturnal expedition soon after returning to the Point. As it happened, a close friend, Archibald Gracie, reported to hospital with syphilis the day after Whistler. In fact, the academy witnessed a minor epidemic of venereal disease with four more cases reported that winter.[44]

Whistler would have understood from the earliest symptoms of "clap" why the French called it *chaude pisse,* or hot piss. Acute pain when urinating, accompanied by a viscid yellowish-white discharge, announced its arrival. Standard treatment in the 1850s called for bed rest, with the patient "lying on his back." Doctors may also have administered a purgative of castor oil or Epsom salts, or prescribed a compound known as copaiva, taken in capsules the size of "small bird eggs." Possibly, too, if his case was judged severe, he would have received a series of twelve injections of silver nitrate, one every four hours, in his urethra. Whistler did not receive his next demerits until November 11, when he was late for morning formation.[45]

Anna was not told of her son's affliction, but she had to be informed of the far more dangerous rheumatic attacks that struck twice in the new year. The first case, coming in March, kept him in hospital for a fortnight. A more serious bout came two months later. An inflammation, diagnosed as phlegmone, had already confined him to bed for most of the first half of May when, on May 19, he reentered the hospital with endocarditis, an inflammation of the membrane around the heart's valves. Colonel Lee granted him a convalescent leave on May 30 so that the young man might recuperate at Scarsdale. He excused Whistler from taking his final examinations until August.[46]

The summer convalescence coincided with the furlough normally given to new Second Classmen, and if Whistler had not fully earned it, he nonetheless enjoyed this first taste of unfettered freedom in two years. Better still, Willie was home from the St. James Academy, in Maryland, where he had been placed while Anna spent the winter in England. While not as incorrigible as his brother, Willie had become better known at St. James for his pranks than for academic excellence. The brothers commiserated and celebrated, and even Anna, though troubled by their ways,

rejoiced to have them both at home. She told many stories of her trip to England, where she had gone to the British Museum, heard Handel's *Messiah* for the first time, and become acquainted with American arms inventor Samuel Colt, who turned out to be yet another admirer of her late husband.[47]

When the summer idyll ended, Willie entered Columbia College, in New York City, where Anna would move in November to spare him a daily fifty-mile, round-trip commute by train from Scarsdale. Returning to the academy in August, Whistler learned of the deaths of Kitty Bailey and her mother, who had drowned in a steamboat accident on the Hudson River. He passed his examinations, but then entered what most cadets considered the hardest academic year at West Point, with chemistry and philosophy replacing French and mathematics. "Philosophy," the tougher of the two, was, in fact, a course in natural science. It included astronomy, optics, mechanics, acoustics, and magnetism. The textbook, declared one cadet, was "one of those strange things which novelists speak of as 'beggaring description.'" Professor Bartlett taught philosophy, and the now tragic figure of Kitty's father, Jacob W. Bailey, taught chemistry, although, as they generally instructed the top sections of their subjects, Whistler was unlikely to encounter them. In any event, the year would require extra boning.[48]

As for his conduct, Whistler regressed. First came demerits for "long hair." Thereafter, his "light and airy" demeanor, impulsive nature, and disregard for authority regularly landed him in trouble. His circumstances were not improved when Lazelle, who had been suspended the previous December for insubordination, was reinstated and assigned as his roommate. The demerits piled up, and Whistler's academic standing declined. His health suffered; he had "fits of the blues." Interestingly, his worst case of depression, in November and December, coincided with a sharp decline in his demerits, and the realization that he seemed likely to shatter the two-hundred-demerit barrier long before June. Colonel Lee gave the troubled youngster a fighting chance by expunging twenty-two demerits in a traditional mid-year adjustment to the rolls. In return, Whistler served extra tours of guard duty and was confined to his room on Saturdays.[49]

It all went for naught. Whistler had grown to relish his reputation for "recklessness." Most cadets, he told Anna, disapproved of comrades who spent too much time boning, and he, in any case, could only study in "fits & starts." As for the demerits, he liked "to brave the Authorities," and found it impossible to give them full "deference & obedience." By this time, too, a young woman named Emma was involved, which may explain why he was borrowing money from George and fellow

cadets. She seemed to have been a respectable local "belle," not, as one might suspect, the source of Whistler's gonorrhea. Her "large languishing deep black eyes" and "beautiful *really* beautiful rich red lips" captured Whistler's heart, or at least aroused his passion. Anna, hearing rumors of the liaison, begged her wayward son not "to torture the bruised spirit of a disappointed Mother."[50]

Barely two weeks later, on June 16, 1854, Cadet Whistler became Citizen Whistler. He had been one of six students to fail his final examination in chemistry, and he exceeded the maximum number of demerits by eighteen. A distraught Whistler appealed to anyone who might salvage his career. He spent two weeks composing a letter to Secretary of War Jefferson Davis, in which he offered a closely argued and not entirely unreasonable case for reinstatement. Following the advice of Lazelle, whose own troubled history had made him a barrack-room lawyer, Whistler insisted that he had been done an injustice. He had improved his standing in chemistry since January and had finished with a better average in daily recitations than two class-mates who passed the course. Would not Davis allow him to be reexamined? Whis-tler was certain that Professor Bailey, who had been "well pleased" with his improvement, "would agree willingly" to the suggestion. As for the demerits, Whis-tler told Davis that he had committed no "grave offences." In fact, he went on, hinting at further injustice, "I feel convinced that had I passed in Chemistry, my demerits would have been all removed, as was done in the case of a great many others."[51]

Davis left the final judgment to Lee, who had more than once shown his partiality toward Whistler. This time, however, the superintendent could do "nothing more." He had already excused another twenty-five of Whistler's demerits in June, and, contrary to the cadet's own assessment, Whistler had been "retrograding" in chem-istry since March. Lee could only regret that "one so capable of doing well should have neglected himself, and must now suffer the penalty." Whistler continued to seek avenues of reinstatement through the summer, including an appeal to President Franklin Pierce, but Lee had been his best hope. Whistler understood the opportu-nity he had wasted. He may have entered West Point wishing for a quiet life, but he had come to love the place and had no higher ambition than to join his father as an academy graduate. "[A]ll my hopes and aspirations are connected with that Institution and the Army," he had told Jefferson Davis, "and that by not passing, all my future prospects are ruined for life."[52]

Whistler made light of his expulsion in later years by saying he had failed the chemistry exam by misidentifying silicon as a gas. Had silicon been a gas, he recalled

chirpily, he would have been a major general. But the examination had involved "the principles of Chemistry," not a simple identification of elements, and Whistler failed it utterly. A professor at the academy later pointed to "prototypes of other noted graduates" for the "silicon story." He called it a "joke connected with celebrities."[53]

Whistler and his friends knew the truth. Even Henry Lazelle eventually echoed Lee's opinion that Whistler had squandered his talent. "[W]ith his memory and alert mind," Lazelle said, "he could easily have graduated with honor, and well aware of this, he felt keenly the mortification and self-reproach of failure." To his credit, Whistler blamed only himself, not Lee, his professors, or his superior officers. And despite being rejected by West Point, he would always take pride in being a "West Point man."[54]

# 3

# Bohemian Rhapsody

## 1854–1858

A failure at twenty and an embarrassment to his family. What would his father have said? Perhaps Jamie would have paid more attention to his studies and deportment had the major lived. Fathers, after all, can make all the difference. But that was past him now. As Lazelle and other classmates prepared for their final year as cadets and promising careers as soldiers, Whistler floundered.

Anna blamed herself for his ruin. If only she had steered him toward architecture, as the major had wanted. A friend had told her only a year earlier that Jemie, with "his originality & classic taste," might have "gained the top of the tree" as an architect, earning tens of thousands of dollars annually. Deepening Anna's anguish, the reliable Willie was following his brother's desolate path. When severe rheumatic attacks forced him to leave Columbia, her "home-boy" took a job in the Winans's locomotive works, in Baltimore, where he fell in with questionable companions, borrowed money, and declared himself "good for nothing without tobacco!"[1]

All the family urged their ex-cadet to join Willie in Baltimore, where Anna had also settled, that the brothers might redeem each other. The "family" now included the Winans. They had been close to the Whistlers ever since the major arranged their Russian contract. The St. Petersburg operation was still going strong, and their ties to the Whistlers were cemented when George Whistler, his first wife having died

in 1852, married Julia Winans, sister of Thomas de Kay Winans, and became a partner in the business.

Whistler went to Baltimore and hung around the Winans's drafting offices but with no intention of staying. Again using family connections, he inquired about a job in Washington. The U.S. Coast and Geodetic Survey needed draftsmen, and Whistler preferred drawing maps to making blueprints. As it turned out, the chief assistant in the survey's drawing department, Captain H. W. Benham, had been a friend of the major. Benham promised to help the son.[2]

While awaiting word of his future, Whistler came to terms with his recent past by starting a "Journal." He scribbled only three pages, devoted mostly to ruminating about how West Point had been "entirely too small and confined" for someone with his "elastic capacities." He mentioned his rose-lipped Emma, who wrote to him that summer. When Anna urged him to break off "the affair," he used the journal to bid "Em" a light-hearted yet poignant adieu. Indeed, his rambling narrative, while sardonic in tone, was a cathartic effort to "put away" those years on the Hudson. He claimed to be recording events for the "benefit of the next generation," those "disagreeable" tykes who would one day call him "Papa." In fact, the journal read more like an apology to his own papa.[3]

He illustrated the journal, too. A frontispiece depicted a hooded monk (the isolated Whistler) writing in a large ledger (the journal). A caption read, "Nulla dies sine linea" (No day without line), a saying attributed to the ancient Greek artist Apelles, and one of Hogarth's favorite quotations. Another drawing, in the body of the journal, showed Whistler exchanging his cadet uniform for a fashionable civilian suit. Two other sketches formed a set of contrasting views. In the first one, an elderly, sad-looking man sat reading his journal; the second showed the same man, leaning back in his chair, a smile on his face, obviously content with his life and what he had written.[4]

Thus purged, Whistler went to work at the Coast Survey in early November 1854. Located on the northwest corner of New Jersey Avenue and C Street, SE, the "Castle," as the survey's Gothic-style home was called, sat a few blocks east of the U.S. Capitol. The drawing department, where Whistler reported, looked like a West Point classroom, furnished with plain wooden tables and chairs, the walls adorned with scientific instruments. He had been hired on a one-year trial at $1.50 per day, half of what the other dozen or so draftsmen earned.[5]

Each man handled as many as fifteen assignments at a time, mostly drawing maps and topographical views. Whistler completed some jobs in a few days; more complex

projects required several weeks. He also learned a new skill when given an opportunity to etch a view of Boston Harbor. The process required drawing with a hard-tipped needle on a polished copper plate that had been covered with an acid-resistant waxy "ground." The completed plate was immersed in acid to "bite" the exposed lines into the metal. With the remaining ground removed, the plate was next covered with printer's ink to fill the etched lines, its surface wiped clean, then drawn through a press to make the print, or "impression." A genial Irishman named McCoy, the survey's best engraver, taught him the process, and Whistler showed enough skill to be allowed to help with a second etching, a view of Anacapa Island, in California.[6]

But Whistler was unhappy at the survey. Despite drawing "clever, droll, or humorous sketches" in the margins of his work, he displayed none of the spark of his cadet days. One co-worker could not recall him laughing during his entire employment. Its dour decor aside, the survey reminded Whistler of the army, which is not surprising. The superintendent, Alexander Dallas Bache, had graduated first in his class from West Point, and he employed academy graduates, such as Benham, to direct the survey's departments with military precision and discipline. He forbade smoking in the rooms, banned newspapers and books, and expected "punctual attendance and diligent attention" to all duties.[7]

The punctual and diligence bits got Whistler. He was late twice for work in December, failed to appear at all on December 26–27, and missed twenty days in January. He puckishly insisted that he was never late, the office simply opened too early, but the tardiness cost him appropriate deductions in wages. Anna urged him to apologize and promise to be punctual in future. He took her advice, got another chance, but kept his resolution for only a week.[8]

The location of his boarding house was partly to blame. Whistler's "cramped though comfortable" room in northwest Washington, for which he paid ten dollars per month, was one-and-a-half miles from the Castle. The prospect of that long walk on cold winter mornings kept him huddled in bed. Equally though, Washington had too many temptations. If the isolation and regimentation of West Point had failed to instill regularity in Whistler, complete freedom spelled doom. A billiard hall at 13th Street and Pennsylvania Avenue occupied much of his time, and Ford's Theater was barely two blocks from his boarding house. His demeanor changed entirely outside the Castle. He became animated and witty, a charmingly affable companion. His curly locks, no longer threatened by Joe Simpson, grew luxurious. His lustrous blue eyes, fine features, fair complexion, and newly grown mustache

(against regulations at West Point) made him the "handsomest fellow" his friends, men and women, had ever known.[9]

Whether Whistler resigned from the survey or was fired is unclear, but he left without regrets in mid-February. Family and friends did not know what to make of him. A cousin, visiting the capital on business, found him in debt, turned out of his original boarding house, and forced into "miserable lodgings." When fifty-eight-year-old Ross Winans, that family's patriarch, sent a well-intended warning against the perils of indebtedness, Whistler replied so curtly that Julia, his new sister-in-law, decried the lack of respect. Anna did all she could to help from Baltimore. Mince pasties, fresh bread, ginger snaps, candles, and new shirt collars and cuffs flowed to Washington, and she insisted that Jemie send his laundry to her.[10]

They wasted their time. Whistler had decided to be an artist. A legacy from his father's estate was due him in July, when he turned twenty-one. It would amount to only $350 per annum, roughly the wages of a farm hand or semi-skilled urban laborer, but for a lad who had yet to appreciate the value of money, that seemed a fortune. Freed from the need to work for wages, he could go to Paris, the center of the artistic world.

More than simply being enthralled by art, Whistler had become infatuated with the romance of an artist's life. If he had not read Henri Murger's *Scènes de la Vie de Bohème*, he had clearly caught its spirit. Bohemianism was in the air, a stock subject for the illustrated newspapers, and Whistler had read much about the independence, rebelliousness, and nonconformity of artists through the ages. He imagined bohemians to be romantic dreamers, unconventional in dress and appearance, cheerfully existing on crusts of bread and cheap wine, scornful of bourgeois life, and devoted to living by their wits.

Whistler acted and dressed the part in Washington. He sometimes wore a "Scotch cap" with a plaid shawl, the latter thrown across his shoulders "in the fashion of the day." On other occasions, he donned a broad-brimmed slouch hat and loose-fitting coat, generally unbuttoned and thrown back to expose his waistcoat. It was a "lazy – sauntering time," spent carousing with as colorful a cast of confidence men, artful dodgers, aspiring artists, and fetching damsels as Dickens ever invented. Indeed, Whistler gave several of his cronies Dickensian nicknames, including Micawber, Heep, Swiveller, and Esmeralda. All were good-hearted, he insisted, just down on their luck, like himself. He became romantically involved with several young women, one of whom was known as "la fiancée." The father of another young lady, whose sacred "pew" Whistler had entered, was said to be looking for him.[11]

And quite apart from his work at the survey, he had never stopped drawing. "His imagination seemed to be constantly at work, creating pictures," a co-worker marveled. At the Castle, he desecrated hallways with caricatures of his bosses, just as he covered the walls of his rented rooms with pencil and chalk drawings. More substantial work by this "child of the cunning pencil" hinted at the freedom he craved and the bonhomie spirit of his Washington circle. Two nicely detailed pictures, which, in style and substance, echoed Gavarni's depictions of the Parisian Latin Quarter, showed an artist in his studio. He also drew a series of bohemian-looking characters and dashing cavaliers. One of those, a young woman clad in trousers and lifting a glass of wine, was titled "Vive les Débardeures!!" at once a hymn to Bacchus and youthful call to rebellion.[12]

However, difficulties had arisen. The value of his father's railroad stocks had dropped sharply. Payment of his legacy would be delayed, and with Willie returning to college, the family could not afford to support Jemie in Paris. He must demonstrate the same "*industry* and honor," Anna told him, that his father had shown at his age. "[R]ein in your inclinations" and acquire "habits of frugality, industry & order," she urged her impulsive son. "[W]ithout these you can never flourish as an Artist. I do not lecture you, dear Jemie, I only say let us reason together."[13]

Feeling the sting of her gentle rebuke, and knowing that his father would "admonish" him, even from the grave, should he not consider the family's needs, Whistler sought another government job from Montgomery G. Meigs, a West Point graduate in charge of constructing additions to the U.S. Capitol building. The interview did not go well. "He stayed in my office," Meigs reported, "saying that he knew I was busy, but nevertheless staying and talking in the most familiar manner, til I grew heartily tired of him." It was the same casual manner that had always worried his family. Written off by Meigs as "smart and quick but self-conceited and vain," he did not get the post. Besides that, a toothache tormented him day and night.[14]

Then, Thomas Winans intervened (fig. 6). The jovial thirty-four-year-old manufacturer liked young Whistler, and he had treated the family magnanimously since the major's death. He loaned the son money when he left West Point, and paid his travel expenses when he moved to the capital. Winans's personal tastes turned more to sculpture than to painting (the classical nudes in the garden of his palatial home, Alexandroffsky, offended neighbors), but he appreciated Whistler's talent and understood Anna's desire to get him out of Washington. He offered to be his patron if Whistler returned to Baltimore. Sending fifty dollars to settle the young man's debts, he told him to come in three days, on April 26.[15]

Whistler accepted the generous offer, which even his Washington friends urged upon their "naughty Jimmie." Like Winans and Anna, they hated to see him waste such obvious talent. However, Whistler was not good with deadlines. He insisted on finishing a portrait he had begun, his first original oil painting, and "la fiancée" deserved a personal farewell. He did not leave Washington until May 2. Ignoring the delay, Winans installed his protégé at Alexandroffsky, gave him a spare room for a studio, and introduced him to the right people. In return, Winans secured dozens of drawings and sketches, most of them made since Whistler had left West Point. They included a delightful comic depiction of a buoyant Ross Winans, Thomas's father, playing a fiddle.[16]

Whistler also experimented with lithography for the first time when a local artist interested him in that mysterious medium. More elemental than etching, it involved drawing a picture with crayon directly on a piece of polished limestone and running the stone through a special printing press. Whistler made two drawings. One of them, a fine satirical piece, depicted a man singing to his betrothed as she flirted with another suitor. Less finished, though far bolder, was *The Standard Bearer.* Reminiscent of seventeenth-century Dutch drawings, its subject, a confident-looking cavalier, carried a furled banner as he marched toward untold dangers.[17]

The timing of the image was perfect. Whistler completed the print one week after his twenty-first birthday. Two weeks later, around August 1, the young artist, having his own standard to bear and his own future to face, headed for New York City with a newly acquired passport and a visa for France. Winans, seeing there was no stopping him, loaned Whistler $450, to be repaid "with interest for value" from his eventual inheritance. George Whistler, who managed the family's financial affairs and held his stepbrother's power of attorney, would monitor the funds and send him a monthly allowance. George also gave Jemie a copy of Charles Leslie's 1848 Royal Academy lectures, which had been published as *A Hand-Book for Young Painters.*[18]

In New York, Whistler stayed with the Swift family until his ship sailed. Vibrant as the cultural life of the city had become, and as much as his mother still urged him to settle there, he could not be enticed to stay. The number of galleries had increased since his first visit, in 1850. New art journals discussed the latest theories and trends in England and France. Recent debates discussed the definition of "beauty," the Pre-Raphaelite movement, and the "meaning" and role of art in America. Yet, New York's budding art world remained amateurish, without the verve and excitement of London or Paris. Art in America was still percolating, all talk and anticipation, no action, no genuine bohemianism.[19]

On September 3, the sailing vessel *Amazon* (Whistler could not afford passage on a steamship) departed for England. His mother and sister had convinced the adventurer to visit all the family there, especially Debo and Haden, before rushing to Paris. The recently opened Paris Exposition Universelle had pushed living expenses in that city to exorbitant levels in any case, and he should rest and recuperate from the long voyage before plunging into his new life. Whistler complied, later conceding to Anna, "As usual dear Mother you were right!" Dispensing with family obligations as quickly as possible, the Standard Bearer reached Paris on November 2.

He found lodgings for forty francs per month (less than £2 or $10) in the six-story Hotel Corneille. Famous since 1840 as a moderately priced home for students and artists, it stood on the southern edge of the Latin Quarter, across the street from the Royale de l'Odéon and within sight of the Luxembourg Gardens. Although it had been recently "swept and garnished," a fellow art student thought the Corneille "dingy, mean-looking, and dirty." Whistler never noticed. Besides, he had met an Irish medical student named John O'Leary on the Channel crossing with whom to share the room and expenses.[20]

Whistler knew at once he had come to the right place. The France of Louis Napoleon had emerged from the Revolution of 1848 as the most dynamic country in Europe. Georges Haussmann's elaborate system of broad boulevards and spacious public parks was transforming the imperial capital. Thousands of run-down buildings were being razed or refurbished to create an entirely new type of urban landscape. The work had scarcely begun in 1855, but the revitalized city throbbed with the excitement of great expectations. Having endured three political revolutions in barely half a century, Parisians felt that life had begun anew. Progress was the byword. All things seemed possible in this first "modern city."

Artistically, Paris fairly sparkled. Jacques Offenbach and the "can-can" defined a new era in music and theater. French painters, poets, and novelists, long a force in European culture and politics, enjoyed growing opportunities for fame and fortune. That, even more than the romance of bohemia, had brought thousands of aspiring artists to Paris. Other cities, famous as centers for superb artistic training, still beckoned. Rome, Florence, Düsseldorf, Berlin, even London, had their share of students; but no place could match the cosmopolitan energy of Paris. Whatever the new fashion in music, Whistler heard a bohemian rhapsody.[21]

The sprawling Exposition Universelle, designed to eclipse England's Crystal Palace Exhibition of four years earlier, filled three buildings between the Champs-Élysées and the Seine. The two-story Palais des Beaux-Arts announced the Second Empire's

supremacy in art. Jean August Dominique Ingres and Eugène Delacroix, the rival monarchs of French painting, merited their own retrospective exhibits, but wonderful examples of work by Alexandre Decamps, Horace Vernet, and Thomas Couture could also be seen. The Exposition remained open for two weeks after Whistler arrived in Paris, and it is impossible to imagine him not spending at least a day among its wonders. Every other young artist in the city, including Edgar Degas, Gustave Moreau, and Camille Pissarro, attended.[22]

Eager to begin working, Whistler enrolled at the École Impériale et Spéciale de Dessin, which offered courses in drawing, architecture, and ornamental sculpture. From mid-morning until 2 p.m., he drew from plaster casts of classical sculpture. After a break for tea, he returned to draw from live models until evening. Whistler maintained this regimen more or less faithfully until his habit of keeping late hours, followed by increasingly later risings, took its toll. On November 20, he switched to evening classes.

When not attending class, Whistler luxuriated in his new bohemian life, although his allowance from home meant he need not face the hardships of genuine bohemians. He also had affluent friends to whom he could turn. One of Seymour Haden's sisters, who lived in the city, welcomed the ragamuffin Whistler to her home, invited him to the opera, and provided small loans. William Thackeray, a friend of the Hadens, and whose London home Whistler had visited as a boy, asked him to dine at least once. An art-dealer friend of brother George, George A. Lucas, also lent a helping hand after he moved to Paris in 1858, and, in a real pinch, Debo and Haden lived just across the Channel.[23]

Whistler needed a large safety net, for he seemed always in debt. Émile Zola, who had begun his career as a journalist and novelist in the city, estimated that an artist could live on a hundred francs (about $20) per month. The sum fell easily within Whistler's means, but, as he had shown in Washington, budgets and financial planning were alien to him. He spent lavishly on clothes, food, drink, tobacco, and artist supplies until the money ran out. That generally happened before his next allowance came, which forced him to find cheaper lodgings, pawn effects, and run up increasingly larger tabs. He became a master at persuading shop girls and café owners to extend his credit but had less luck with landlords. Whistler lived in nearly a dozen hotels and apartments during his four years in Paris, some of them quite dreary.[24]

Nonetheless, his devil-may-care spirit ensured Whistler's popularity in the Latin Quarter. Day or night in any season, he could be found in one or another café discussing art and life. Fueled by tobacco and cheap wine or strong coffee, the French

expressed their views passionately, and the garrulous, animated, bilingual Whistler fell easily into such a crowd. Everyone called him "Jimmy." His small stature, listed at five foot and three inches on his passport, almost demanded the diminutive form of his Christian name, but so, too, did genuine affection. Generous to a fault, he incurred not a few debts by using his last sous to share a bottle of wine with friends.

The last thing on which he scrimped was his appearance. A holdover, no doubt, from his youthful days at the court of the tsar, Whistler would ever believe that clothes made the man, even for a bohemian. He favored soft-collared shirts, flowing bow neckties, narrow-waisted coats, and flat-crowned, broad-brimmed American-style felt hats. A long black ribbon encircling the crown of the hat flowed several inches over its brim in the rear. In warm weather, he sported an eye-catching suit of white duck, a peculiarly American style, and replaced the felt hat with a straw boater. He paid equal attention to his well-oiled hair, which he carefully coiffed into long ringlets. A small tuft of gray hair in his forelock, a hereditary trait seen in some other family members, including Debo, added to the distinctive appearance. The gray first appeared when Whistler lived in Washington, where friends attributed the oddity to "wickedness." Barely perceptible for many years, as the patch turned white, Whistler groomed it as carefully as he did his ringlets.[25]

He also knew that in order to distinguish himself from the vulgar middle classes the proper bearing was as important as the correct attire. It was the age of the *flâneur*, the apparently idle man-about-town who strolled, even sauntered, along Parisian boulevards for the sole purpose of observing life. Whistler was a natural *flâneur*. His bearing, always confident, had an unmistakable air of casualness, the appearance of "lounging" even as he walked. Yet, as he moved among the throngs in a city made for walking, Whistler's quick eyes and quicker mind absorbed all he saw, the people, the parks, the shops, every detail of the urban landscape.[26]

Glimpses of his new world appeared in Whistler's drawings. *A Scene from Bohemian Life* showed a crowd of young men and women as they smoked and drank in a small garret space. Echoing work done in Washington, it expressed the triumphant realization of his dreams. By contrast, a second drawing, *An Artist in his Studio*, showed a small, miserable figure sitting alone in a disheveled garret (fig. 7). The self-portrait coincided with a spell of sickness Whistler suffered that first winter in Paris, a time when the vulnerable young bohemian perhaps missed his mother. However, the drawings also revealed a maturing artist, with a more convincing use of light and shadow, finer delicacy of touch, bolder lines and contours, greater depth, mood and character conveyed more vividly.[27]

As his confidence grew, Whistler abandoned evening drawing classes to seek a proper atelier, or training studio, run by an established painter. This master–apprentice relationship had been the foundation of artistic training in France for generations, although Whistler knew it was crucial to select a master whose philosophy and teaching methods suited his own temperament. Easier said than done, for politics and clashing artistic philosophies had thrown the French art world into turmoil.

The state-sponsored Académie des Beaux-Arts presided over that world, and it adhered to a strong Classical tradition. Classicists, staunch defenders of monarchy and the Church, controlled the Académie, École des Beaux-Arts, and Salon, France's national exhibition of art. However, the upstart Romanticists, as political and social revolutionaries, had mounted a substantial challenge to their rule. Classicists, whose heroes were Raphael and Jacques Louis David, emphasized drawing as the foundation of artistic training. Ingres was their living exemplar. Romanticists stressed color at the expense of drawing and "finish." They claimed the mantle of Titian and Rubens, and Delacroix, eighteen years younger than Ingres, led them. The two schools also disagreed on the proper subject of a painting. Classicists scorned the contemporary subjects of Romanticism, so different from their own idealized depictions of life.[28]

Further complicating matters, a third, even more "modern" school of painting, Realism, had emerged in the 1840s. Jean-François Millet and Jean-Baptiste Camille Corot defined this crowd with their pictures of contemporary French peasants and rural life. Many Realists also endorsed socialist politics, a subversive challenge by the masses to the bourgeois tastes of both Classicists and Romanticists. By the mid-1850s, Gustave Courbet had become the most famous exponent of Realism. He fought against the label at first, but when the Salon jury rejected three of his paintings in 1855, Courbet erected his own "Pavillon du Réalisme."[29]

By June 1856, Whistler had been in Paris long enough to understand the potential consequences of these debates. No less than West Point or the Castle, the art world had its rules. Demerits, too, for heedless artists. To choose sides could be risky, and Whistler liked parts of all three schools. The influence of Raphael and Seymour Haden, let alone his own talent for drawing, made him a thorough Classicist. At the same time, he admired the combination of color and emotional punch that defined Romanticism. Then again, his love of Hogarth and Gavarni, admiration for Courbet, and instinctive opposition to authority made him a Realist.

He finally cast his lot with Charles Gleyre. The fifty-year-old Swiss-born painter was not a member of the École, and he scoffed at institutional awards and titles, but

he had nurtured hundreds of students since opening his training studio on the rue de Vaugirard in 1843. He was known for two things. Most notably, he charged no tuition. Never forgetting his own poverty-stricken student days, he asked only that pupils pay a nominal fee for using his studio. Second, the brooding, introspective Gleyre encouraged independent, original thinking. His own prejudices tended toward Classicism, but he promoted no school or tradition in painting. Similarly, Gleyre preferred informal teaching methods. He corrected errors and misjudgments discreetly, more through suggestion than direction.

Gleyre did endorse the École's emphasis on drawing as the surest way to learn anatomy, perspective, and composition. Those things, he said, must be mastered before ever touching brush to canvas. Only then did he send students to copy paintings in the Louvre or the Luxembourg galleries, a widespread practice that allowed budding artists to sell work to the rising bourgeois.[30]

But Whistler soon chaffed even with this reasonable program. He already considered himself a fine draftsman, and in truth, few fellow students could claim such a pedigree as the Russian Imperial Academy, West Point, and Geodetic Survey. Few, too, had studied the history of art and its contending schools so closely, or had visited galleries from St. Petersburg to New York. The impatient Whistler had come to Paris not so much to study art as to be an artist. A family friend who visited him in the spring found that he "disdained taking lessons from anybody."[31]

This explains why, within days of enrolling with Gleyre, he moved from the Hotel Corneille, located only a few blocks from the atelier, to 35 rue Jacob, in the heart of the Latin Quarter. The new address was nearly a mile from Gleyre's studio but midway between it and the Louvre. Over the next several months, Whistler virtually abandoned the atelier to copy at least ten paintings in the Louvre, including works by Ingres, Couture, Velázquez, and François Boucher. The copies went for modest sums (about $25 each) to relatives and family friends in America, but the experience instilled in Whistler a reverence for the great masters, as intended by Gleyre.[32]

Whistler spent enough time with Gleyre to absorb other lessons. Most importantly, he learned the value of drawing from memory. Gleyre encouraged students to sketch the models they had seen by day when away from the studio. The practice, he said, encouraged spontaneity and added energy to their work. Whistler also adopted Gleyre's technique for loading a palette. The pigments must be laid out scientifically, Gleyre cautioned, with colors arranged according to the spectrum. He also advocated subdued, sober tints. "Beware that demon colour," Gleyre warned

students, "it will go to your heads." The "queen" of his palette was ivory black, which Whistler ever after regarded as the "universal harmoniser."[33]

Gleyre's studio also bred camaraderie, and Whistler became especially close to a coterie of English students, including George du Maurier, Edward J. Poynter, Thomas Lamont, and Joseph Rowley. Several other budding English artists in Paris, including Thomas Armstrong, Alexander "Aleco" Ionides, and Frederick Leighton, also fell in with them. Already famous for his "droll sayings," Whistler became a raconteur in this "Paris Gang." As they congregated each evening to celebrate life, he mimicked people in the most amusing ways and used extravagant gestures, exaggerated pronunciations, and dramatic dialogues to describe mundane events. In a favorite routine, he sang plantation songs, learned from his mother, in black dialect, all the while strumming an umbrella as though it were a banjo. His act over, he sprawled in the nearest chair to smoke and comment wryly on the next performer.

Still, this flamboyant *flâneur* from America differed from the English crowd. "Whistler was never wholly one of us," Tom Armstrong later mused. He was precocious, cosmopolitan, and seemed older than his years. Hearing Whistler mention his mother, Lamont, feigning incredulity, gasped, "Your mother? Who would have thought of you having a mother, Jimmy." He avoided the physical exertion, including boxing, fencing, and gymnastics, enjoyed by the Englishmen. "Why the devil can't you fellows get your concierge to do that sort of thing for you?" he laughed. He preferred French food and wine to roast beef, mutton, and beer. Indeed, he and the English had, in some ways, come to Paris for different reasons. Whistler intended to live in France. They wished only to earn credentials as "artists" and return home.

Consequently, he had as many French as English friends, including painters Ernest Delannoy and Henri Oulevey and sculptors Charles Drouet and Just Becquet. He also cultivated the unkempt denizens of the Quarter's dingier corners. Whistler called them his "no-shirt" friends, but they were passionate about art, and more eager than the English to argue about the burning issues of the day. With them, he discussed the theories of Charles Baudelaire, Jules Champfleury, Fernand Desnoyers, and Edmond Duranty, all of whom championed the work of Courbet and Gavarni.[34]

Nor did the amorous Jimmy's reputation for escorting "none other" than attractive women suffer in Paris. Even Anna recognized this side of him. He had a "natural fondness for ladies society," she had warned her son's West Point belle, Emma. "[F]lirtation" came easily to him, and his "vanity" would always lead him to "other bright eyes." It was just "his way." In Paris, he found the brightest eyes among

the equally flirtatious *grisettes*, working-class girls, mostly in the millinery or dress-making trades, who took up with aspiring artists and writers. Because those high-spirited young women often shared the beds of their companions, people thought of them as prostitutes, but struggling artists treasured them as models, especially given the two or three francs per day required by professional posers.[35]

Whistler's favorite *grisette* was a dressmaker named Héloïse. Petite, with dark, cascading hair, delicate features, and eyes that radiated intelligence, a student friend of Whistler thought her "remarkable." Héloïse talked incessantly, adored the bohemian poems of Alfred de Musset, and was "madly in love" with Jimmy. She was also possessive and notoriously jealous. Whistler called her Fumette and La Tigresse. Having replaced O'Leary as Whistler's roommate at the Hotel Corneille, she followed him to rue Jacob. Their tempestuous relationship barely survived the next move, to rue St. Sulpice, where Fumette ripped to shreds dozens of Whistler's drawings in a jealous rage. The devastated artist drank through the night.[36]

Hard on the heels of this disaster, Whistler learned that more of his work had been destroyed by his mother. Having come across drawings of the raw, uncensored side of bohemian life sent to Willie, she burned the "impure" things. "[T]hey may have been Artistic, but they disgusted me," she explained. Anna thought only two of the pictures decent enough to show Willie, who was by this time studying in Philadelphia to become a physician. Despite the assurances of a cousin who had visited Paris that Jemie's "dissipation" was "more of the head than heart," Anna asked her son to "keep innocency," "cultivate a *purer* taste," and return home to make a career in his native land.[37]

A series of events in 1857 made that unlikely. First, the Realist movement gained enormous ground at the Salon that summer. With a clear majority of the works depicting scenes of everyday life, a long tradition of historical, religious, and allegorical painting had seemingly been broken. The "human side of art" had replaced the "heroic and divine." Critics wrote of "a new art" and the "vague stirring of new ideas."[38]

Soon after the Salon, Whistler traveled to England, partly to escape Héloïse, partly to visit the Hadens, mostly to attend a grand art exhibition in Manchester. "The Art Treasures of Britain" boasted two thousand paintings and a thousand prints by the Old Masters and every living British artist of note. Additionally, dazzling displays of sculpture, porcelain, china, glass, enamels, medallions, gold plate, jewelry, photography, bookbinding, and medieval armor filled its galleries. It was the largest art show ever seen in Britain. Thousands of people from all social classes attended daily. Whistler joined them in mid-September.

American author Nathaniel Hawthorne, whose principal income came from his customs post at nearby Southport and Liverpool, attended the exhibition. He was struck by the "hopelessness of being able fully to enjoy" the cornucopia. "Nothing is more depressing," he confided to his journal, "than the sight of a great many pictures together; it is like having innumerable books open before you at once, and being able to read a sentence or two in each." Whistler could "read" pictures more quickly than Hawthorne, but he had never seen such variety, not even at the Louvre. Hogarth, Raphael, Reynolds, Rembrandt, Velázquez, Gainsborough, Constable, Botticelli, Titian, Albrecht Dürer, J. M. W. Turner, and on and on. Sadly, he arrived too late for a pair of lectures given in July by John Ruskin, England's leading authority on art.

There is no telling what part of the surfeit most drew Whistler's attention. It was his first extensive exposure to Velázquez, about whom he had heard much in Paris. One reviewer said the six hundred photographs, many of them contributed by Prince Albert, approached "perfection" in their depiction of nature, but Realists like Whistler had their own definitions of "perfection" and "nature." More remarkable to him were the engravings and etchings, which another reviewer called the "most perfect department of its kind in the whole exhibition." What photographer could hope to capture the nuances of shadow and line in the work of someone like Rembrandt? The Dutchman's work, both paintings and etchings, was well represented, but the etchings most impressed Whistler, and set him on a fateful course.[39]

Whistler had been experimenting with etching. A year earlier, in the only group project undertaken by the Paris Gang, he and his friends had thought to publish a set of etchings about life in the Latin Quarter, à la Gavarni. Only three of the plates were completed, but Whistler made one of them. Entitled *Au Sixième* (*On the Sixth*), it showed Fumette making coffee at a stove while Ernest Delannoy, with whom Whistler shared a sixth-floor room at the time, worked at his easel. Given Whistler's modest experience with etching at the Coast Survey, the work showed an impressive ability to animate an otherwise static scene with delicate crosshatching and swirling lines, effects he had earlier mastered with pen and pencil.[40]

Returned to Paris, he devoted himself to etching until falling ill that winter. After a brief stay in hospital, he went to London in mid-January 1858 to recuperate under Debo's care, and to make the Hadens his new etching subjects. He did "realistic" work, too, with no attempt to idealize the bored faces of his nieces and nephews. One effort, drawn more as caricature than portrait, gave nine-year-old Annie a dazed and sorrowful expression as she leaned on a stack of books, their titles clearly visible: *Swedenborg, Mach Belphegor,* and *Directorium Inquisitorium.*[41]

Back in Paris by April, his etching instincts finely honed, Whistler's next subject was Héloïse, an interesting choice. The artist and his *grisette* parted company around this time under uncertain circumstances. Perhaps Whistler had tired of her tempestuous nature; or it may have been she who abandoned him. Héloïse knew the unwritten laws of male-dominated bohemia, and permanent liaisons with *grisettes*, let alone marriage or family life, were anathema to its freedom-loving artists. In the etching, La Tigresse sat in a crouched position, her eyes wary (fig. 8). It was a brilliant portrait, and conveyed Whistler's own understanding that Héloïse no longer trusted him. That would explain one of his periodic bouts of depression that summer. "[N]o one cares for Jemie," he moaned; "no one cares what I do." Strange sentiments for otherwise happy and productive months.[42]

Whatever the case, Whistler soon had another companion, a cancan dancer named Josephine Durwand who performed at the Bal Bullier, on the boulevard Saint-Michel (fig. 9). Some said she was Creole, and one theater manager described her appearance as "gipsy-like." Finette, as she was known, was decidedly less turbulent than Fumette, though spirited in her own way. She once won 1,500 francs by knocking a gentleman's hat from his head with one of her high kicks. She also claimed to have invented the *grand écart,* or splits. Most importantly to Whistler, Finette, with her own professional life to pursue, did not cling to him. She threatened neither his art nor his independence, and she possessed an air of grace and worldliness unknown to her predecessor.[43]

However, the woman Whistler most adored that summer was an eccentric, half-blind flower seller known as Mother Gérard. She claimed to be an educated woman fallen on hard times. She complained of having a tapeworm, too, which forced her to drink only milk. Mother Gérard sold violets and matches in the Quarter, including the main entrance to the Bal Bullier. Flower sellers and rag pickers had become favored subjects for French artists since the previous summer's Salon, but Mother Gérard's alert, knowing face, strangely reminiscent of the young Fumette, would have attracted Whistler in any event.

He made two etchings of her. Rich cross-hatching and deep shadows evoked Mother Gérard's dignified bearing, while the finely detailed rendering of her thin, worn hands, and the folds of her tattered dress told the story of her life and circumstances. Bolder and more detailed than his portrait of Héloïse, the work approached his goal of fusing the craftsmanship of Rembrandt and the spirit of Courbet in a new type of etching. He had found a medium that expressed his brand of Realism, a style that some art critics were calling "Naturalism" (fig. 10).

Whistler "pulled," or printed, these and other of his etchings on a hand press in rue Champagne-Première, a street to which he moved in June. He also sold his first etching that summer, possibly of Mother Gérard. Regardless, he remained fascinated by her face, and being mindful that Rembrandt had achieved greatness as both etcher and painter, he now wanted to paint her portrait. Dressed in her best clothes, she accompanied Whistler and some of his cronies, who liked to "chaff" him about his friendship with her, on a day trip to the country. He began the portrait that afternoon, and although he would not finish it for several months, the picture became his first original painting since leaving America.[44]

Both the etchings and the painting were done *en plein air*, or out of doors, something Gleyre had urged his pupils to do. The experience made Whistler eager to explore the world outside Paris, particularly Holland. He wanted to see the places, observe the light, and absorb the atmosphere that had shaped Rembrandt's work. So, recruiting Ernest Delannoy as companion, he set off on a trip intended to take him through northern France, the German states, and on to Amsterdam.

The trip began promisingly. Traveling by rail, the happy wanderers stopped at several small towns en route to Strasbourg. Whistler made his first etching, a view of a village street, at Liverdun, and his most intricate etching of the trip, *The Unsafe Tenement,* at a nearby farm (fig. 11). From Strasbourg, they crossed into Germany and traveled up the Rhine to the popular spa of Baden-Baden and the picturesque university town of Heidelberg. By then, the etchings, sketches, and watercolors that filled his knapsack confirmed the variety of artistic influences Whistler had absorbed. Holding nearly equal sway with seventeenth-century Dutch painting was the Barbizon school, especially Charles Jacques, its leading etcher. Elements of other contemporary French painters, such as François Bonvin and Jean Baptiste Chardin, had also crept into his work, as had the brooding Gothic presence of Charles Meryon.

Everything went as planned until Cologne, where the gypsy-artists realized they had not a franc left between them. Whistler, who was paying nearly all the costs of the trip, had, as usual, been heedless of expenses. He asked friends in Paris to forward his monthly stipend from America while he and Delannoy lived on credit. Receiving no reply after ten days (friends had sent the money, but it went by error to Rotterdam), they confessed their plight to the innkeeper, Herr Schmidt. A skeptical Schmidt agreed to let the paupers settle accounts when they returned to Paris but insisted on holding their finished plates as collateral. A worried Whistler, who told him that the etchings were the work of a "distinguished artist," begged Schmidt to guard them with "the greatest care."

With that, he and Delannoy started walking the thirty-five miles to Aix-la-Chappelle, where Whistler planned to borrow the train fare to Paris from the American consul. A sympathetic maidservant at Schmidt's inn had given them two grochens (equal to four sous, or two pence) to buy food along the way, but that did not last long. They resorted to drawing portraits of people in exchange for plates of soup, glasses of milk, hunks of bread, and straw beds. The artists fell in with a traveling circus at one point, which gave them a chance to ride in a wagon. Whistler was particularly grateful for that luxury, as his thin-soled shoes had been reduced to shreds.

They reached Aix-la-Chappelle in early October, a week after leaving Cologne. Whistler got fifty francs from the U.S. consul, and the next day, at Liege, Delannoy pried another twenty francs out of the French consul. The day after that, they arrived in Paris, where friends treated them like soldiers returned from the wars. Celebrating with drink and song at the Café Voltaire, Whistler recounted the odyssey in his "inimitable way." That night, still enormously pleased with himself, he informed Debo of his safe return. "[T]he real honest hard miseries of this pilgrimage would have effaced all poetry and romance from any minds but our own," he told her. Having survived agonies and hardships that would have defeated any ordinary man, he had returned "triumphant!"[45]

Waiting for Herr Schmidt to return his priceless plates, Whistler resumed his commissions at the Louvre, where he made a new friend, one of the most important of his life. Henri Fantin-Latour, two years his junior, was the son of a painter. He had been dismissed from the École des Beaux-Arts for lack of progress, and now lived by selling "admirable" copies of famous paintings in the Louvre. He was copying a painting by Paul Veronese when a "strange character wearing a bizarre hat" strolled over to admire his work.

Fantin had noticed the "eccentric" Whistler roaming the galleries on an earlier occasion. Being a shy, undemonstrative fellow, he had not cared for his demeanor, but as they talked on this day, he formed a different opinion. He liked this American who spoke fluent French, and he sensed the honest passion beneath the funny hat. He invited him to meet some friends at the Café Molière. Among the crowd that evening were the painters Alphonse Legros, Guillaume Régamey, and Emile Auguste Carolus-Duran, and a multi-talented sculptor-painter-poet-critic named Zacharie Astruc. Whistler became a regular at their table, where he gradually met other likeminded French artists, including Félix Bracquemond, a brilliant etcher two decades older than the others, and Otto Scholderer, the only German in the circle. All considered themselves Realists.[46]

Whistler's introduction to Legros and Bracquemond paid immediate dividends when the two Frenchmen took him to meet August Delâtre, a master printer of etchings who had worked with Millet and Charles Jacques. With his plates arrived from Cologne, Whistler haunted Delâtre's studio at 171 rue St. Jacques. He learned the nuances and technical details of the printing process, experimented with different types of paper and varying amounts of ink, and came to appreciate why Delâtre described his work as "artistic printing." Together, they selected the best of Whistler's etchings for a marketable portfolio.

Around the first of November, Seymour Haden made a timely appearance. Having come to Paris on business, he sought out Whistler, who took him to see the portfolio being assembled in Delâtre's studio. The quality of his brother-in-law's work startled Haden, but Whistler's poor physical condition, which had deteriorated as a result of the Rhine journey and subsequent labors, alarmed him. He persuaded the young man to recuperate again under Debo's care, while he used his own extensive social connections to help sell the etchings.[47]

Before leaving Paris on November 6, Whistler selected twelve etchings for his portfolio, with Delâtre to make the final "states." There would be seventy sets in all, twenty to be sold in Paris, the others destined for London. Whistler titled it *Douze eaux-fortes d'après Nature* (*Twelve Etchings from Nature*), although he would always refer to it as the "French Set." Fully half the drawings were portraits, including the crouching Fumette, Annie and Arthur Haden, and Mother Gérard. The others came from his trip with Delannoy. Only seven of the etchings had been done literally "from nature," yet Whistler could not have chosen better examples of Naturalism.[48]

A thirteenth etching and a dedication appeared on the title page. The etching, which showed Whistler surrounded by a group of children as he sketched in Cologne, was light-hearted. The dedication to Seymour Haden as *Mon viel Ami* (*My Old Friend*) was heartfelt. It expressed Whistler's appreciation for all that Haden had done for him over the years. It would be going too far to say that Haden had become a father figure, yet their master–student relationship, strengthened by mutual love for Debo, had forged an affectionate bond. More than anyone else, Haden had understood Whistler's desire to be an artist, a goal that Whistler, no longer a student, seemed poised to realize.

# 4

# Portraits and Self-Portraits

### 1858–1861

Staying with the Hadens always signaled a fresh start for Whistler. He had escaped boarding school with them as a boy. Their home had been his last stop before settling in Paris. He began etching in earnest while ensconced in their parlor. He went there now to rest. No rent to pay, no tantrums by unhappy *grisettes*. Only the laughter of a delightful niece and nephews.

Except, he could not rest. With Haden assuming responsibility for selling the French Set in England, and Anna acting as her son's "agent" among friends and relatives in America, Whistler's mind raced ahead. Confident that recognition as an etcher was now assured, he wanted to conquer the world of painting. The Salon jury would soon select works for its 1859 exhibition, and while he could have submitted *Mère Gérard*, he wanted something bigger and bolder. As he sat etching in his sister's parlor, the possibilities of painting a familiar scene, Debo playing the piano, came to him. It would be "realistic," insofar as it depicted contemporary life, but it would also offer the genteel, middle-class story that appealed to Salon jurors.[1]

That did not keep *At the Piano*, as Whistler called the finished painting, from being dramatic and innovative (fig. 12). Most of the foreground, dominated by Debo at the old family piano, was darkly shaded in black, brown, and crimson. Gleyre would have been pleased. For contrast, Whistler seated Debo in front of a cream-

colored wall hung with pictures in gilded frames. Most dramatic of all, and not part of his original design, he placed Annie in the foreground. Dressed in a white frock, the brightest spot on the canvas, she leaned forward, arms resting on the piano, as she listened to Debo play. It was a masterpiece of casual repose, a private moment between mother and child.

With the harmonious color scheme and contrasting light and dark areas lending the picture perfect equilibrium, Whistler anchored the composition by partitioning the entire canvas with strong horizontal lines, provided by the dado and wall moldings. He then daringly cropped the entire scene, a technique borrowed, like the domestic setting itself, from seventeenth-century Dutch painters, though perhaps, too, with a nod to Chardin. Either way, he lopped off parts of nearly every object, including the piano, a nearby table, and the pictures on the wall.[2]

Returning to Paris in January 1859, he found his etchings "very much admired," but a passion for painting had seized him. He completed *At the Piano*, began a portrait of his father (based on an old lithograph and commissioned by brother George), and finished a self-portrait begun two years earlier. Like all self-portraits, it showed the artist as he wished to be seen. Whistler wore his trademark broad-brimmed hat at a rakish angle; thick curls covered part of his face; shadowed eyes, firm jaw, and roguish expression conveyed a jaunty confidence. The picture spoke of his heroes, too. The self-confident air mirrored several of Courbet's self-portraits. The pose, dark coloring, and composition shouted "Rembrandt." It was not a great painting, nothing like Courbet's self-portrait at the same age, but it confirmed Whistler's arrival.[3]

He also formed a new and more select gang in Paris, the Société des Trois, or Society of Three, with Fantin-Latour and Legros. Such romantic-sounding allegiances were a sou a dozen in Paris, a natural product of young bohemians bent on challenging the world. The trio issued no ringing manifesto, proclaimed no "school" of art. Indeed, they continued to pursue different, sometimes contradictory, interests. Fantin, for instance, had never been as keen as Whistler about Courbet; he preferred the work of Millet and Corot, even of Delacroix. Yet, each also learned from the others. It was probably not by chance, then, that Whistler began his self-portrait at the same time that Fantin painted Legros, with both of them using the same Rembrandt painting as a model. In addition, a portrait by Fantin of his two sisters shared similarities with *At the Piano*.[4]

All three men were shocked, though, when, of the several paintings they submitted to the Salon that spring, the jury accepted only one, by Legros. The slight nearly

broke the always fragile Fantin. Whistler, at least, had two etchings, the portrait of Fumette and *La Marchande de moutarde*, accepted from the French Set. In fairness, a good many worthy, if controversial, artists had also been rejected, Millet and Edouard Manet among them. Indeed, the percentage of rejections in 1859 was so high that a minor revolt broke out.

An outraged François Bonvin announced that he would exhibit some of the rejected works in his own studio, in rue St. Jacques. Particular invitations from the twelve-year veteran of Salon politics went to the Society of Three. Long a friend of Fantin, Bonvin was also flattered that Whistler had borrowed some of his own compositional arrangements for the French Set. The Parisian press largely ignored the symbolic rebellion, which opened, like the Salon, on May 1, but artists flocked to Bonvin's studio.

Among the crowd was Courbet, whom Whistler now met for the first time, and how pleased he must have been when his hero, upon entering the gallery, went directly to the *Mère Gérard*. He liked the way Whistler had used a palette knife, rather than a brush, to lay on much of the paint. The technique produced a thick, impasto look, and Courbet had been one of its pioneers. He was even more impressed by *At the Piano*, conceded by most visitors to be the star attraction. Courbet invited the Society of Three to his studio, where he examined and commented incisively on Whistler's drawings. Whistler could not contain himself. "He is a great man! He is a great man!" he exclaimed afterwards to Fantin.[5]

Still, not even the excitement of meeting Courbet kept Whistler from returning to London on May 6, or from reaching a momentous decision. Despite the grand way in which his French friends had rallied around him, his rejection by the Salon stung. Haden and Debo had been urging him to settle in London, and he now thought that might be a wise move, that the prospects for artistic success might be brighter in England (fig. 13).

Haden greeted him warmly, not least because Whistler's lengthy convalescence at 62 Sloane Street the previous winter had inspired the doctor to pick up his own neglected etching needle. They had spent many evenings etching side by side, often the same subject. Haden had bought a small press and turned a vacant room of his house into a studio where they could pull their prints. When the Royal Academy then included one of his etchings in that summer's exhibition, Haden's spirits soared. He persuaded Whistler to venture out of doors with him to etch *en plein air*. On one occasion, they took Annie and young Seymour to Hyde Park and neighboring Kensington Gardens to serve as models. Another time, they traveled down the

Thames as far as Greenwich Park, where an army pensioner, enjoying the summer sun, sat for them.[6]

Haden likely explained, as well, the advantages of a changing patronage system in England. A dramatic expansion of industry, manufacturing, and trade had made England – and specifically London – the financial capital of the world. The aristocracy and landed gentry, conservative in their cultural tastes and, as a group, limited in their economic resources, no longer controlled the art market. Instead, Birmingham industrialists, Liverpool shippers, and London bankers were the new buyers. Whether as cause or effect, this democratization of art also found more newspapers and magazines commenting on the subject and reviewing exhibitions.[7]

Equally important, the new patrons were often more willing than the old ones to invest in "modern" art. Coming themselves from the middle classes, they did not hesitate to associate socially with artists, even bohemians. Some of them found bohemianism chic, and they liked the idea of knowing the artists who had signed their canvases. That lessened the possibility of forgeries, too, always a danger when buying Old Masters. Not that the expanding market ensured success. In London alone, thousands of artists competed for guineas, and the least talented of them overwhelmed the city's three artist benevolent societies with applications for assistance. Luckily, Whistler had both talent and a family to sustain him, and as this middle-class artistic culture blossomed, he was fortunate enough to land squarely in the middle of it.[8]

It also seemed fortuitous that Whistler moved to London in 1859, a remarkable year in the intellectual history of Europe. Moral values and religious beliefs as well as aesthetic tastes and artistic theories were being buffeted on all sides. Charles Darwin's *Origin of Species* and Edward Fitzgerald's *Rubáiyát of Omar Khayyám* were published that year, both of them, in different ways, destined to challenge European (including British) assumptions about science and the social order. Additionally, Samuel Smiles's *Self-Help* and John Stuart Mill's *On Liberty* endorsed individualism and self-sufficiency as the highest social virtues. English artists responded to the changing rhythms of life. Dante Gabriel Rossetti's painting of a courtesan in *Bocca Baciata* defied the widely accepted rule that art should be uplifting, edifying, with a positive moral message. Algernon Swinburne, emerging as the country's most daringly amoral poet, called Rossetti's painting "more stunning than can be decently expressed."[9]

Whistler was so convinced of the wisdom of his move that he urged friends in Paris to join him. Ernest Delannoy came but stayed only briefly. Haden's household

unnerved the affable but unsophisticated Frenchman. The butler terrified him, and he could only marvel at the indoor shower-bath, "like the falls of Niagra." Haden tried unsuccessfully to woo Legros by purchasing his Salon painting, *The Angelus.* He finally induced Fantin to come by sending £5 for travel expenses in exchange for any small sketch the artist chose to give him. "You know that I have always told you that something would change," Whistler reminded Fantin in late June, "well it is England mon cher which welcomes young artists with both hands."[10]

Fantin arrived on July 10 to stay three weeks, long enough to cement his somewhat curious friendship with Whistler (fig. 14). The two friends had little in common beyond art. Modest and retiring, wary of "woman, wine, and beer," and almost fearful of success ("harmful; it makes you relax"), Fantin made a poor bohemian. Whereas Whistler retained a zest for life outside the studio, Fantin found it difficult to balance work and play. In some ways, he better resembled Haden, in whom he found a valued friend. Unlike Delannoy, Fantin enjoyed the luxuries of Sloane Street. He accompanied Haden on carriage rides through Richmond, and the two spent hours inspecting Haden's collection of etchings. Haden taught Fantin the rudiments of etching, purchased several of his paintings, and commissioned him to copy a work in the Louvre.[11]

Meanwhile, Haden and Whistler agreed to publish a series of four portfolios, containing twelve etchings each, of the Thames. Given their different interests, the plan promised variety. Haden, an avid angler and hiker, enjoyed the "picturesque" fields and villages along the river. In drawing the pensioner at Greenwich, for example, while both artists caught him in the identical pose, Whistler drew only the man, and from a few feet away. Haden made the old soldier one of three people in the scene, all of whom became part of a landscape dominated by trees. For their portfolios, Haden would concentrate on the bucolic, upper regions of the river, while Whistler recorded the urban, commercial heart of London. Whistler began his contributions on outings with Fantin by drawing some decrepit Thames warehouses and the equally dilapidated Westminster Bridge.[12]

The project was another example of Whistler's knack for timing. He was returning to etching at a moment when artists and critics in England and France spoke of an "etching revival." Popular in some quarters since the days of Rembrandt, the medium had been treated as a stepchild at major exhibitions for over a century. A small resurgence had begun in France and England during the 1840s, although it had been confined largely to satirical prints and book illustrations in England. Excitement did not spread in either country until the 1850s, and the "revival," which had as much

to do with improved marketing as anything else, was not generally embraced until the 1860s. With Whistler's French Set already enjoying some recognition, he and Haden were positioned to lead the charge in England.[13]

Whistler also seemed poised to meet the latest artistic challenge from France. Charles Baudelaire, the poet-critic once known for advocating Realism, had taken the "modern painter" to task in a series of recent articles. Artists were repeating themselves, he declared, content to produce the same work for years on end. Baudelaire wanted not imitators but "Imaginatives," artists who would look at nature in new ways. He was most agitated by the lack of "imaginative" landscapes. Enough of pastures, peasants, and cottages, he cried. Where were the modern landscapes, the pictures of bustling cities? "[C]hoice of subject" could not be a "matter of indifference," he said: "I hold that *subject-matter* plays a part in the artist's genius."[14]

To Whistler, Baudelaire echoed Joshua Reynolds, Leslie, and Gleyre, who had stressed the need to look beyond literal representations with the painter's eye. Whistler's eye saw wonderful possibilities in the Thames. Instinct also led him to the river. He knew rivers. He had spent his life on or near them, the Merrimac, Neva, Hudson, Potomac, and Seine. The rhythms, smells, and feel of rivers ran through him. For him, as for French art critic Théophile Gautier, the Thames was a "moving panorama," the equivalent of the teeming boulevards of Paris.[15]

Seeking the right spot to work, he took Fantin for a walk downriver. Crossing to the south side of the Thames, they entered a district known as Bermondsey, below Tower Bridge. Fantin grew frightened. It was a part of London so squalid that not even a bohemian would inhabit it. Beyond lay Rotherhithe; north of the river was Wapping. Wharves, warehouses, breweries, and taverns, the "shabbiest, blackest, and ugliest" to be found anywhere, lined both sides of the waterway. Rough longshoremen and boatmen, scores of fishmongers, butchers, and street vendors inhabited the region. Wapping, the more populated district, was a "torpid neighborhood, mean, shabby, and unpicturesque." Perfect, thought Whistler.[16]

Deciding he must live on the river to draw it properly, he moved to a cheap inn in Wapping. The rough environment worried him not a jot. Treating his new companions as familiarly as though they were fellow artists, he laughed and joked with them, described his day's work on the river, and told stories about life in Paris, America, and Russia.

Whistler worked like a laborer, too, bothered only by his nearsightedness, which necessitated much moving between shore and a moored barge when etching. He had even taken to wearing a monocle to compensate for the deficiency. His biggest

artistic challenge, with boats, not to mention men, in constant motion, was how to show movement on the river. Traditionally, artists had been content to freeze an image, so that even when depicting sweeping action, as in a battle scene, they captured only a moment in time. Whistler wanted more. He wanted his boats and men to move, or appear to move. Other artists of his acquaintance were struggling with this same challenge. Whistler's solution was to create sketchy, unfocused, sparsely shaded, "unfinished" images that implied motion.[17]

He made at least seven etchings at Wapping and nearby Limehouse, a district of docks and warehouses to the east. Five of the drawings, *The Limeburner*, *Eagle Wharf*, *Black Lion Wharf* (fig. 15), *The Pool*, and *Thames Police* (fig. 16), showed a pair of new artistic influences on Whistler, Japanese painting and photography.[18]

However lasting his boyhood impression of Chinese art at Catherine's Palace may have been, the popularity of all things Japanese, called *japonisme*, was as difficult as bohemianism to avoid in Whistler's artistic circles by the late 1850s. Western exposure to East Asia had increased steadily since the "opening" of Japan to trade with the West. Japanese watercolors, metal work, and furniture had been exhibited in London as early as 1851. In Paris, Whistler had watched Bracquemond experiment with Japanese techniques in his etchings and inspected both Bracquemond's and Delâtre's collections of woodcuts by Katsushika Hokusai and Ando Hiroshige. At least two Paris shops specialized in Asian prints and porcelain. Whistler would soon have his own collection of prints and *objets d'art*, including porcelain, fans, and screens.[19]

He had already used elements of Eastern composition, most notably a flattened, two-dimensional perspective and compartmentalized space, but also the cropping of a scene, in *At the Piano*. The Thames etchings went farther. Not confining himself to two dimensions, Whistler divided foreground from background by arranging objects asymmetrically in large wedges and placing light and dark areas on the same plane. This challenged the rules of Western art, but it allowed him to carry the viewer's eye deeper into the picture, into a "middle" distance (figs. 15 and 16).[20]

Photography also influenced his sense of perspective. By the time Whistler moved to England, the Photographic Society of London had held its sixth annual exhibition, and it had published a journal since 1853. As seen by the large display at the Art Treasures exhibition and Salon of 1857, photographs were being recognized as legitimate works of art. Closer to home, Haden and his medical partner, James Traer, were amateur photographers. Traer, in fact, had published an article about the problems of focus and perspective in photography. Whistler may even have recalled something about optical theory from his natural philosophy course at West Point.[21]

Quite likely, too, the artistic effects being achieved by French photographers had impressed him. Paris was awash with commercial photographers in 1860, but two men, Philip Henry Delamotte and Hippolyte Auguste Collard, had chosen something other than people and nature as their subjects. Their wonderfully creative photographs had reduced Baron Hausmann's world of iron girders and bridges to abstract patterns of black and white. Collard, in particular, photographed structural elements of the ponts and piers on the Seine in ways that foretold much of Whistler's work on the Thames.[22]

As a result, the Thames etchings were flatter and brighter than the French Set, the light more evenly diffused, the lines crisper and more precise. Equally striking was the way Whistler drew the viewer's eye to a selected part of a composition by obscuring peripheral details. He literally "focused," as one does with a camera, on portions of a scene, so that, as with a camera, areas at unequal depths looked slightly blurred.

The new etchings included few people, but those few served important functions. Among his featured bridges, warehouses, ships, docks, barges, and wharves, Whistler sometimes put a person in the immediate foreground, a device apparently borrowed from John Everett Millais's recent celebrated painting, *The Vale of Rest*. However, unlike Millais, Whistler's people actively welcomed viewers into the picture. They also anchored a scene and guided the viewer's gaze beyond the initial plane. Remove those figures, and the eye leaped immediately to the background, without pausing to enjoy the rich complexity of the waterfront or to feel the movement Whistler worked so hard to instill.[23]

In October, with winter approaching, Whistler returned for ten weeks to Paris. He finally met Baudelaire on the trip, introduced by Legros, but more importantly, he made his first "drypoints." Legros and Haden had tried this variation of etching the previous spring, and Whistler had been impressed by the results. It required drawing with a diamond-tipped needle directly on a copper plate. No coat of wax, no acid bath, thus, no "etching" (from the German *etzen*, meaning to bite). The force of the needle being drawn across bare copper left a ridge, or "burr," on both sides of the score. During printing, this burr, which would have been dissolved by acid in the etching process, trapped the ink to produce a "soft velvety effect," quite distinct from the crisp, precise lines of etching. Whistler loved both the spontaneity of drypoint and the "most painter like and beautiful" results. Its only drawback was that the ridges faded with each printing, so that rarely could more than twenty-five impressions be made.[24]

Whistler made over a dozen drypoints or combination etching and drypoints while in Paris, mostly portraits of friends, including Fumette and Finette. It is a wonder that he persuaded Fumette to pose. Apparently, either he or she (depending on the circumstances of their earlier rupture) had forgiven the other. In any event, two drawings of her showed a more tranquil woman than the crouched tigress of a year earlier. More startling was a drawing of her lying totally nude and asleep. Titled *Venus*, it was Whistler's first known nude since his boyhood mermaid, although there is no telling what earlier work his mother threw out or Fumette ripped apart. Also of interest, he did not intend Fumette's picture to titillate. While unquestionably sensual, it was not at all erotic, unlike the Rembrandt drypoint, done exactly two centuries earlier, that inspired it (fig. 17).[25]

Spring brought the exhilarating news that the Royal Academy had accepted *At the Piano* for its 1860 exhibition, and this in a season when it rejected several hundred more works than in recent years. The painting had drawn praise from several members of the selection committee, further proof that England offered young artists a more sympathetic home than France. Before learning all this, Whistler had considered returning to America. The response to his French Set had been tepid there, with Thomas Winans accounting for most of the sales, but Willie was to be married in November, and Whistler believed his modest but growing reputation might be enough to establish himself in New York. Gleaning hints of his mood, Anna headed for London to escort her son home.[26]

She came too late. The rousing reception given his work convinced Whistler that he would be foolish to leave London. William Winans, brother of his chief patron, agreed. Having visited the Royal Academy exhibition when passing through town, he was impressed by both the published reviews of *At the Piano* and remarks he overheard in the galleries. Some reviews expressed reservations about the painting's unorthodox composition, and many people mentioned the lack of finish, but nearly everyone praised its color. The picture reminded Tom Taylor, respected art critic of *The Times*, "irresistably of Velásquez." Even *Punch*, while having fun with Whistler's name, rendered a joyful judgment. "One would have expected Mr. Whistler's talents to have been developed on the flute rather than *At the Piano*," it submitted. "Nevertheless, the painting of that title shows genius." The reference to a flute likely stirred poignant memories of Major Whistler for all the Whistler family.[27]

Success paid immediate dividends. They began when John Phillips, a fellow of the academy, purchased *At the Piano* for £30, a respectable sum for Whistler's first

public sale. Equally, it had gone to a respected artist. There followed invitations to dinners and receptions where he met influential people. John Millais approached him at one gathering to praise *At the Piano*. "I never flatter," Millais assured him, "but I will say that your picture is the finest piece of colour that has been on the walls of the Royal Academy for years." He also acquired a new patron, Alexander Constantine Ionides, the Greek consul-general and father of Luke and Aleco Ionides, whom Whistler had known in Paris. Ionides looked to George Frederic Watts, a forty-three-year-old painter friend of the Pre-Raphaelites, for advice on art. When the amiable Watts, whose own allegorical and moralistic paintings shared little with Whistler's Realism, praised *At the Piano* as "the most perfect thing he had ever seen," that was good enough for Ionides. He promptly asked Whistler to paint a portrait of Luke and a view of the old Battersea Bridge.[28]

More than that, Whistler became a fixture at the Ionides home in Tulse Hill, south of the river and just west of Dulwich. He loved the genteel bohemia created there by younger members of the family, and he thrived on their favorite amusement, amateur theatricals. A bevy of beautiful and talented young women, including Aleco and Luke's sister Maria and her friends Christine and Marie Spartali, enhanced the ambiance. As gentlemen visitors vied for their attention, Whistler's witty stories and observations seemed to make him "the pet of the set," although he found a worthy rival in George du Maurier, another member of the Paris Gang befriended by the family, who used his lovely tenor voice to counter Whistler's charm. "He talks women over to him," du Maurier laughed, "and I sing them back again to me, and both are delighted at being cut out by the other – ah! This immoral world!" Immoral, too, thought du Maurier, in the way Whistler pursued Ionides's married daughter, the bewitching Aglaia Coronio. On one occasion, du Maurier noted, an "awfully drunk" Jimmy "misbehaved himself in many ways."[29]

Nonetheless, their reunion led to Whistler and du Maurier becoming "immense chums," closer than in Paris. Whistler invited him to share his digs in 70 Newman Street, a narrow, one-room flat he had taken before starting work at Wapping. The neighborhood had an enclave of artists, the closest thing in London to a Latin Quarter. Visitors thought Whistler's sparsely furnished place the "personification of discomfort and disorder," but he had a kindly landlady, and Debo provided sheets and towels. Du Maurier endured it because his share of room and board was a modest ten shillings per week. He grumbled only when an "inconsiderate and exacting" Whistler woke him in the early morning hours to recount that day's "wonderful adventures."[30]

Du Maurier showed his appreciation when, finding freelance work as an illustrator for *Punch* that autumn, he featured Whistler in two cartoons in as many weeks. The first one, which represented a genuine incident, showed du Maurier, Whistler, and Tom Lamont holding cigarettes as they entered a photographer's studio. In a gibe at the artistic pretensions of photographers, du Maurier's caption had the proprietor asking the trio not to smoke in his establishment: "Please to remember, Gentlemen, that this is not a common Hartist's Studio!" The second cartoon showed Whistler seated while drawing in one of the ornate capital letters that were a *Punch* trademark. It was the letter Q, and Whistler's leg, dangling as he sat within the body of the letter, formed its tail (fig. 18).[31]

Crucially, du Maurier's caricatures portrayed two distinctly different Whistlers. The one perched in his Q was a bohemian to the core, with flowing tie, short jacket, and slippers. The Whistler who entered the photographer's studio, dressed in morning coat, cravat, substantial shoes, and top hat, was a gentleman. Of course, having never descended to the sartorial depths of his poorer Parisian friends, his adoption of bourgeois dress and behavior was not so much a transition as a return to the fold. He need not cease being a rebel, but Whistler knew that to attract and keep middle-class patrons he must embrace their ways.

Not by chance, then, he accepted membership around this time in the Junior Etching Club, an honor arranged by Haden. Clubs and societies played important roles in London social life, even for artists. Memberships conferred status and provided the personal contacts necessary to obtain commissions, exhibit work, and receive favorable press coverage. Immediate confirmation of the benefits came at Whistler's first meeting, when he struck up an important and enduring friendship with Charles Keene, a popular illustrator for *Punch* and the *Illustrated London News.*[32]

As it became clear that his friendships with the women of Tulse Hill would remain strictly platonic, Whistler took up with a seventeen-year-old model named Joanna Hiffernan. The daughter of an "impulsive & passionate" Irishman of uncertain occupation, Jo, as everyone called her, had little formal education but was quick and intelligent, with "something rather attaching in her character & manner." Her pale face, "deep blue eyes," and luxurious "copper-coloured" hair made her a popular model in the vicinity of Newman Street, where she began posing for Whistler in the spring of 1860. She became his favorite model, his mistress, and his muse.[33]

Notwithstanding Jo's many charms, Whistler returned to his other model, the Thames, in June. Leaving his flat in the care of du Maurier, he took lodgings at the Angel Inn, on the river and opposite Wapping. He reemerged in town more often

than during his first sojourn on the river. Having achieved a degree of celebrity, he wanted to remain visible. It was just as well, for few friends visited him in Bermondsey. The place made them nervous, as it had done Fantin. Finally, though, Whistler insisted that du Maurier, Luke Ionides, and several others join him for an evening of song, drink, and laughter at the Angel. Du Maurier thought Whistler's fellow boarders "a beastly set of cads," but the environment in which his friend worked, amid "every possible annoyance and misery," increased the illustrator's admiration for him. "He *is* a wonder," du Maurier told his mother; "no difficulty discourages him."[34]

At the same time, the success of *At the Piano* and the Ionides commissions reminded Whistler that painting, not etching, brought the most fame. So, in September, he decided to turn a recent etching and drypoint, *Rotherhithe*, into a large (twenty-eight by forty inches) canvas. He worked in secret, brought Jo down to stay at the Angel, and went to town less often. It was the most complex work he had attempted, and he wanted it to shock everyone. The etching had depicted a pair of sailors smoking their pipes on the balcony of the Angel. He added a woman to the painted version, the trio seated at a table. A forest of ships' masts, spars, and bowsprits rose behind them. Simple enough to conceive but "unbelievably difficult" to execute.

Whistler liked his "splendidly painted" sky, but the middle ground, showing barges, boats, and ships, was a far greater challenge. In an etching, he merely blurred the image to show motion, but in a painting, even the colors had to change. He could not catch the proper shading or make the light, reflected on the water, shimmer. Nor could he get the people right, especially the woman, who was Jo. He portrayed her as a prostitute, copper hair, "as Venetian as a dream!" gleaming in the sunlight, blouse partially opened, as she solicited one of the sailors. Whistler thought she looked "supremely whorelike," and he rejoiced to think that he had given her a "real expression." He fancied her saying with her body, face, and attitude, "That is all very well, my friend! [but] I have seen others!" He slaved over that expression and the coloring of the woman. By November, he had painted and repainted her three times.[35]

Exhausted and exasperated by the effort, he set the canvas aside and retreated with Jo to Newman Street. He also made frequent appearances in Sloane Street that winter without Jo. An Irish-Catholic girl working as an artist's model, however bright and charming, did not suit the drawing room of a respected London physician. She certainly was not there with him on Christmas morning 1860 when Whistler suddenly grabbed his painting kit and went down to the river. The preceding week had

been brutally cold. Snow and ice carpeted the city. Although not frozen solid, the Thames looked like the Neva in December. He could not resist it.

One shivers with cold just looking at the completed twenty-nine-by-twenty-two inch painting, which may explain the speed with which it was done. No agonizing over color or composition, just a spontaneous surge of energy. It took him two more days to finish the picture, but the result was a strikingly atmospheric piece. In the foreground, several ships and barges were stuck fast in ice. The dense, mist-filled and heavily clouded sky combined with the smoke of several factories to obscure the shoreline in the background. One felt the weight of the dull, gray scene in Whistler's thick, impasto application of paint. There was nothing fine or delicate about this canvas, which had little in common with his previous work. It came to be known as *The Thames in Ice*, and he sold it to Debo for a mere £10.[36]

Apparently thinking the Thames painting an unlikely candidate for the upcoming summer exhibition season, Whistler became desperate for another picture, something to prove that *At the Piano* was no fluke. He found inspiration again in Debo's music room, but with a more radical composition. This time, he featured three people instead of two, and they were totally disengaged from one another. He had done something of the sort in an etching of Haden, Debo, and Traer seated at a parlor table (fig. 19). The painting, though, exaggerated the dislocation. An angelic Annie, again clad in white, sat reading a book. Standing in front of her and looking toward the right edge of the picture was a cousin, Ethel Boott, who wore a black riding habit. Her pose may have been inspired by an eighteenth-century Japanese print, although the entire picture also resembled a painting by Velázquez. The third person, Debo, was seen only by her reflection in a mirror.

Instead of stressing the breadth of the scene, as in *At the Piano*, Whistler made the new work, eventually called *The Music Room*, vertical, its visual lines running from top to bottom on a canvas taller than it was wide. He again fixed the viewer's eye with large patches of black and white but, abandoning the muted tones favored by Gleyre, relied on wild bursts of color to balance the picture. To the flat perspective of *At the Piano*, he added another Asian feature by severely, artificially, tilting the floor toward the viewer and joining floor and walls at impossible angles.

The only problem was Annie, who vexed him. One day, she broke into tears, unable to endure the long hours of posing. A remorseful Whistler, realizing that he had expected too much of the twelve-year-old girl, mollified her with a lovely leather writing set. Artistically, though, Annie presented another, non-negotiable problem. Like Jo's head in the Thames painting, he could not get her "right." Almost everyone

adored the painting, including du Maurier and Tom Armstrong, but when Frederick Leighton suggested that Annie's head was "out of harmony," an insecure Whistler rubbed it out. With a headless Annie and the Royal Academy deadline only a week away, he was "in complete despair." Submitting, instead, the portrait of Mother Gérard and three etchings to the committee, he returned to the Thames.[37]

He went upriver this time to begin the painting of Battersea Bridge commissioned by Ionides. Bridges, it happened, were a current topic of discussion in London, which may explain Ionides's choice of subject. Several old wooden bridges, including the ninety-year-old Battersea, were to be replaced. As it turned out, the Battersea would survive until 1890, but several new bridges, including the Victoria (now Chelsea) and the Albert, would be built in the interim to ease the flow of traffic across the Thames. No wonder Whistler found it a timely subject for representing the "modern" city, an even closer match for Collard's Seine ponts than the Rotherhithe etchings. Also like Collard, he recognized the intriguing geometric and spatial possibilities of the bridge, the equivalent of a jumble of ships and wharves on the lower Thames.

He also made etchings of three other bridges, Vauxhall, Westminster, and Hungerford (fig. 20). *Westminster Bridge in Progress* resembled in composition a woodcut by Okada Shuntosai much admired (and eventually owned) by Whistler. Japanese prints and paintings frequently featured bridges. Another East Asian theme defined his *Battersea Dawn*, a combination of etching and drypoint also done about this time (fig. 21). With the old bridge barely discernible on the horizon, the principal subject, as suggested by its title, was not the bridge but the time of day. As with *The Thames in Ice*, Whistler wanted to capture the atmospheric effects of London, something that Hiroshige and Hokusai were known to do in their depictions of misty Japanese dawns.[38]

Whistler's etchings also promised to replenish his purse when, in March 1862, Ralph Thomas, a lawyer and patron of the arts, asked to reissue the French Set (offering £100 for the plates), exhibit the new Thames etchings, and purchase the rights to all new Whistler etchings for seven years. The exhibition would be held at a small gallery owned by Thomas's eldest son, Edmund, at 39 Old Bond Street, the profits to be divided evenly with Whistler. The gallery even had a small printing press on which to test his new plates, with Delâtre to make the final exhibition prints.

Seizing the excellent opportunity, Whistler added two more etchings, *Millbank* and *Little Pool*, to his Thames collection. To flatter his patron, he inserted Thomas and his youngest son in both of them. Arrangements for printing the proofs he found entirely satisfactory. With Thomas being a connoisseur of port wine as well

as of art, Whistler always enjoyed a glass of the best vintages when working at Bond Street. "Excellent! Very good indeed!" he exclaimed every so often as he operated the press. Edmund Thomas never knew if Whistler meant the port or his prints.

Alas, the promising scheme failed to meet expectations. The exhibition attracted little critical notice when it opened in May. What was more, Whistler sold few prints, although that was small wonder. He marketed the Thames etchings at one and two guineas apiece, the upper end being as much as he had charged for the entire French Set. Du Maurier thought the work "magnificent" but, like most potential buyers, found the price "exorbitant."³⁹

Only slightly better news came from other quarters, in what proved to be an up and down year for Whistler. The Royal Academy had exhibited *Mère Gérard* and the etchings, but published reviews were mixed. Most critics pointed to the portrait's dull coloring. "If Mr. Whistler would leave off using mud and clay on his palette and paint cleanly, like a gentleman," declared one newspaper, "we should be happy to bestow any amount of praise on him, for he has all the elements of a great artist in his composition." Meanwhile, he lost any possible sale of *The Music Room* when his mother, having it described to her as a "portrait" of Annie and Debo, asked for the picture.⁴⁰

Whistler needed a holiday. He talked of going to Italy but lacked the money. Instead, he accepted an invitation from a new acquaintance, Edwin Edwards, to visit his country house at Sunbury-on-Thames, three miles from Hampton Court. The visit was restful, productive, and nearly disastrous.

Thirty-eight-year-old Edwards and his wife, Elizabeth Ruth, were interesting people. A lawyer by profession, Edwards had quit the law to devote himself to art and music. Both a collector and talented draftsman, he had become acquainted with Matthew Ridley, an artist friend of Whistler since student days. Ridley introduced Edwards to Legros, Fantin, and Whistler, and Legros turned him into an avid etcher. The Edwardses were also gifted musicians, and with Ruth at the piano and Edwin on flute, their cheerful home must have raised childhood memories for Whistler.

The disaster came on a camping trip with Edwards and Ridley. Though no longer as keen an outdoorsman as in his youth, this rural stretch of the river might still have appealed to Whistler after so many months on the lower Thames had it not been for the heavy rain and high winds that punctuated their excursion. He completed only two drypoints. One of them, *The Storm*, showed Ridley leaning into a gale beneath an ominous sky. More dangerously, the cold and damp downed Whistler with rheumatic fever.⁴¹

He recovered in Sloane Street under the care of Traer, who had become his personal physician. He felt well enough by August to return with Haden to Sunbury, where Fantin had arrived a few weeks earlier. Working this time under sunny skies, he produced four etchings or etching and drypoints, two of them for a publishing venture by the Junior Etching Club. However, Traer, worried about Whistler's still fragile health, prevailed upon him to recuperate in a warmer climate. With that remedy in mind, Whistler and Jo crossed the Channel to France.[42]

# 5

# *Rebellion and Notoriety*

## 1861–1863

Momentarily ignoring Traer's prescription for sea air, Whistler took Jo to Paris. The happy couple spent three weeks visiting friends, the galleries, and the Salon, and Whistler appears finally to have met Manet. The introduction could have come through Legros, Bracquemond, or even Fantin, who had returned from Sunbury by the end of August. It was a timely meeting. Manet's *Le Guitarrero* (*The Guitar Player*) had won honorable mention at the Salon, and many young artists raved about it. The painting fit no prescribed school. Rather, as Fantin observed, it combined the best of Romanticism and Realism. With Whistler already uncomfortable with French Realism, Manet's accomplishment demanded that he push the boundaries of his own work.[1]

Still pondering Manet's innovation, he traveled with Jo to Perros-Guirec, on the Brittany coast. Whistler found plenty of sea air, but he was in no mood to "rest." The golden sand, protruding rocks, churning surf, and brilliant sky enticed him, as they had done French artists like Corot and Bonvin. He painted his first seascape, initially called *Alone with the Tide*, finally titled *The Coast of Brittany*, on his largest canvases yet (thirty-four by forty-six inches), as wide, if only half as tall, as *Le Guitarrero*. However, unlike Manet's dark painting, Whistler employed, as in *The Music Room*, a bright palette. Using the impasto technique to create texture, his blues and browns evoked the feel of sea and sand. The rock-covered beach shone in the sun

as a solid line of cresting waves broke against it. Jo, clad in local peasant garb, reclined, apparently asleep, against the rocks. It would become one of his few great paintings not immediately recognizable as "a Whistler." It was even atypical of his later seascapes, and its "open air freshness" a far cry from the Thames work.[2]

Declaring himself "thoroughly satisfied," he returned to Paris in early November for five months. Attempting to shed his bohemian past, he and Jo lodged on the boulevard des Batignalles, far north of the Left Bank, but they dined frequently in the Latin Quarter, where some restaurants willingly extended credit to the artist and his charming companion. Whistler spent his remaining francs on fashionable clothes for Jo, who loved to shop. He, in turn, enjoyed the sensation caused by "la belle Anglaise" as they strolled about the city.[3]

Whistler also widened his circle of friends in Paris. He seems to have met Degas at this time, although he would not have found the École-trained Frenchman's conservative early work very stimulating. He fell in with Louis Martinet, a gallery owner on the boulevard des Italiens known for exhibiting avant-garde work, including the Thames etchings. He discussed exhibition strategies with George Lucas, who had become his chief agent on the Continent. Ten years Whistler's senior, the dealer was another ex-West Point cadet who had not graduated.[4]

Mostly, though, Whistler struggled with a full-length portrait of Jo. It would be his response to Manet, his own golden mean between Romanticism and Realism. He worked on the giant canvas, seven feet tall and three-and-a-half feet wide, from eight o'clock in the morning until daylight faded. Jo, clad in a white cambric dress, stood on a bearskin rug, long copper hair falling off her shoulders, arms at her sides, a lily in one hand. White draperies, slightly darker than her dress, formed the background. She looked radiant but with an ethereal, other-worldly quality as she stared blankly, nearly hypnotically, into the distance. Whistler called it *The White Girl* (fig. 22).

Scholars still puzzle over Whistler's Rorschach test of conflicting images. Jo is often said to represent a deflowered virgin, some scattered flowers at her feet being the remnants of shattered virtue, the ferocious-looking bear's head the power of male sexuality. The contrast between the once-dangerous beast and passive girl is, indeed, striking, but then it has also been noted that Jo is standing *on* the bearskin, apparently having conquered the animal. Not that there need be hidden meanings or allegorical allusions. Although Whistler had not yet met Dante Gabriel Rossetti, he would have agreed with the painter-poet's views on that issue. Asked by an admirer why he had "introduced some inexplicable object" into one of his pictures, Rossetti replied, "To puzzle fools, boy, to puzzle fools."[5]

*The White Girl* was also Whistler's first tentative step *away* from narrative painting, which was becoming one of the great artistic controversies of the century. Need a painting tell a story, convey a message, or reproduce a recognizable scene? Whistler had come to question that assumption, which is not to say a story could not inspire a picture. A likely source for Jo's portrait was a poem by Baudelaire, "The Red-Haired Beggar Girl," included in his recently published second edition of *Les Fleurs du Mal.* The poem began, "Blanche fille aux cheveux roux" ("White girl with flame-red hair"), and while it did not describe the precise setting of Whistler's painting, some lines were suggestive:

> In place of tatters short
> Let some rich robe of court
> Swirl with its silken wheels
> After your heels.

Stylistically, Whistler drew inspiration for the superbly unconventional painting from several sources, most notably the Pre-Raphaelites. Very little of the Pre-Raphaelite Brotherhood's original program, with its vibrant colors, luminous finish, photographic clarity, and elaborate symbolism, would have appealed to Whistler, but some Pre-Raphaelites had modified or abandoned their allegiance to storytelling, luminosity, and painstaking detail in the mid-1850s. Whistler found in this new direction a likely compromise with French Realism. For *The White Girl*, he borrowed from another painting by John Millais, *Autumn Leaves*, which featured a central figure who resembled Jo. Other painters found *Autumn Leaves*, with its total lack of literary, historical, religious, or dramatic association, "a revelation."[6]

The vacant look in Jo's eyes, as she gazed beyond the frame, came from the Brotherhood's obsession with psychological realism. *The Bridesmaid*, by Millais, who influenced Whistler in numerous ways, could have been a point of reference, or Rossetti's *Bocca Baciata*, one of his several portraits of sensuous-looking women. If Jo was not as overtly sexual as Rossetti's "stunners," her red hair was yet another Pre-Raphaelite trademark. Several of their models, wives, and mistresses had the same auburn tresses.[7]

The "old duffers" of the Royal Academy were not impressed. They accepted *Alone with the Tide, The Thames in Ice,* and the Rotherhithe etching for that summer's exhibition but rejected Jo's unorthodox portrait. The decision was irrational, said Whistler. The Thames painting was a mere "sketch," completed in a few days. He had spent four to five weeks on *Alone* but as many months on Jo's picture. Friends

tried to console him. "Some stupid painters don't understand it at all," Jo told Lucas, "while Millais for instance thinks it splendid, more like Titian and those swells than anything he [h]as seen." Anna, when she heard of her son's distress, wrote to say it was God's will. Years later, Whistler could still recall being "positively sick" over the rejection.[8]

But Whistler seldom remained disheartened for long, and he had larger goals than the success of a single picture. Learning that George du Maurier, a social climber of the highest order, had extended his network from Tulse Hill to Holland Park, he asked for introductions. An influx of affluent Londoners, including, quite soon, the Ionides family, was making Holland Park one of the most desirable residential spots in the city, and intelligent, vivacious women again set the tone. The neighborhood's star attractions were Sarah Prinsep and her sister Virginia, Countess Somers. Though middle-aged, the sisters had been great beauties, and they remained inveterate "lion hunters," known for drawing together the cream of London's artists, writers, and intellectuals. Regular visitors to Sarah's home, Little Holland House, located in Melbury Road, included Alfred Tennyson, Robert Browning, William Holman Hunt, Edward Burne-Jones, G. F. Watts, and another Prinsep sister, Julia Margaret Cameron. Sarah was also the mother of twenty-three-year-old Valentine, a gentle giant of an artist who had fallen in with the Pre-Raphaelites. A "breezy" bohemianism prevailed at Little Holland House. No one "dressed" for dinner. In summer, visitors played croquet and sprawled on Indian rugs strewn across the lawn.[9]

By chance, Whistler found an all-male retreat in the same neighborhood, at Moray Lodge. The impressive new home of Arthur James Lewis, a prosperous silk merchant, amateur artist, and member of the Junior Etching Club, sat atop Campden Hill, surrounded by woods and fields and overlooking Holland Park. The peaceful "bachelor's paradise," with a billiard room unmatched in London, sprang to life one Saturday night each month when Lewis held late night oyster suppers. Some of the better singers present, dubbed the "Moray Minstrels," provided dignified entertainment with a repertoire of part-songs, glees, and madrigals, but when they had finished, the restive crowd often called with "yells and shouts for Whistler." The artist inevitably obliged by seating himself on a high stool in the center of the room, fixing his monocle, and, with an "irresistibly comic look" on his face, singing a Parisian cabaret tune in high-pitched "*argot* French" while acting out the words with affected gestures and the graceful movement of his "small, thin, sensitive hands."[10]

Whistler's new social connections brought no immediate commissions, but they did spur him to lease a two-storied, "old-fashioned" house with "a cosy, homely

character" at 7A Queen's Road (now Royal Hospital Road). His status as a successful artist demanded a house, and Jo deserved it. Being Whistler's muse was no easy job, but Jo loved him, appreciated his genius, and intended to be the woman behind the man. Whistler felt increasingly responsible for her, too, especially since Jo's mother, whom he had called "Mother-in-law," died in March. Their new home stood in Chelsea, which was not as posh as Holland Park, but the borough had benefited, nonetheless, from a shift westward by London's rising middle classes. It had also been known as a haven for artists and writers since the eighteenth century.[11]

Given his still shaky finances, Whistler displayed much self-assurance in leasing a house. With an income that in no way reflected his blossoming reputation, he had been reduced to drawing woodcuts for popular magazines. Then, in June, came a fateful turn of events. As word of his *White Girl* circulated among London artists, Matthew Morgan, ambitious manager of a new gallery at 14 Berners Street, asked to exhibit the painting. Whistler accepted gratefully, especially when Morgan also agreed to show *At the Piano*, some of Fantin's pictures, and a painting by Edwin Edwards.[12]

The fateful part came when Morgan provocatively advertised *The White Girl* as "Whistler's Extraordinary Picture the WOMAN IN WHITE." Quite reasonably, the public associated this title with Wilkie Collins's immensely popular novel of that name, published two years earlier. Certainly, the *Athenaeum*, the only substantial journal to notice the exhibition, understood it that way. Jo's portrait was an "able" effort, their critic wrote, but also "bizarre," one of the "most incomplete paintings" he had ever seen, and it bore no resemblance, as he imagined, to Collins's fictional character.

When no more glowing reviews appeared, Whistler sent a letter to the *Athenaeum*. He was polite, not challenging the reviewer's judgment, only protesting the connection to Collins's heroine. Nevertheless, his reasonable tone masked a confrontational mood, for the artist had rejoiced when Morgan's catalogue mentioned that the painting had been rejected by the Royal Academy "[I]sn't that the way to fight 'em!" he exclaimed to George Lucas, still bitter about the earlier snub. "[I]t is waging an open war with the Academy, eh?"[13]

The ramifications of Whistler's protest were important. He had proclaimed publicly for the first time his radical intentions as an artist, in this instance, to create pictures devoid of narrative. He could tolerate having his work called "bizarre" and "incomplete," but he must protest any suggestion that he had told a story or made a moral statement. Even considering that Baudelaire's poem, not the novel, had

inspired the painting, the composition and color of the work, not Jo's circumstances, had been uppermost in his mind.

A second consequence was potentially more troubling. Respectable artists did not write letters to editors or publicly defend their work as Whistler had done, at least not in England. His private comments had been far more contentious than his letter to the *Athenaeum*, yet this one small act marked a visible change in his public behavior. He had challenged authority since boyhood but never with such purpose. Believing that his genius had not been adequately rewarded, Whistler had become sensitive about his professional and social status. The *Athenaeum's* critic had not respected that status. In presuming to know the artist's intentions, and judging a work of art according to his own expectations, he had been impertinent.

To account for such a change in behavior is a perilous undertaking, but at least part of the explanation lies with the people who had shaped Whistler's ideas about what it meant to be an artist. Courbet topped that list. Although Whistler's personal contact with the "great man" had been limited, he knew, as did the world, that Courbet voiced his opinions loudly and defiantly. The self-styled "savage" of the Parisian art world reveled in notoriety. "[W]hen I am no longer controversial I will no longer be important," he had declared. Whether in boisterous, drunken tirades or defiant "manifestoes," Courbet challenged both fellow artists and, above all, the so-called art "critics." Having engaged in a "war of words" with those "outsiders" since Whistler was a schoolboy, he boasted of being "the first and only artist" of the century and "the most arrogant man in the world."[14]

And Courbet was only the most outrageous Frenchman. Verbal attacks on the Salon, rival schools, and the state of art generally were far more spirited in France than in England. An artist's survival skills had to be finely honed in Paris. Manet missed the nightly clamor of café battles when away from the city, and Degas once praised Manet as someone who stood up well to verbal thrusts. French artists craved respect, praise, and honor above mere remuneration. Henri Murger spoke of the "audacity" of their language, the "extravagant sentences," shaped by the "same mold as the blustering speeches of Cyrano [de Bergerac]."[15]

The nearest thing to public rebellion in England had come from the Pre-Raphaelites. The Brotherhood harbored a defiant conceit that no one knew more than they about art or what constituted the "beautiful." Not by chance, Whistler's personal acquaintance with them began that summer of 1862. He knew Burne-Jones and Val Prinsep from Little Holland House. The "lordly" Frederick Sandys was a regular at Moray Lodge, and Whistler had met George Price Boyce two years earlier

through Edward Poynter. Most importantly, the poet Algernon Swinburne, who had been drawn into the Brotherhood, introduced him to Gabriel Rossetti during a soirée at Swinburne's place in Newman Street. Rossetti would have sympathized with Whistler in the recent *Athenaeum* fiasco, given the negative public reaction a decade earlier to his "old white picture," *Ecce Ancilla Domini*. Whistler won instant acceptance at the gathering by amusing Swinburne's guests with a string of "comic stories." He left in deep conversation with Rossetti and "Ned" Burne-Jones.[16]

Rossetti and Swinburne were soon visiting Whistler in Queen's Road. In turn, Whistler took Swinburne and Rossetti to Tulse Hill and dined at Rossetti's home in Cheyne Walk. Known as Tudor House, Rossetti's digs, very near his own, had been built in the early eighteenth century but stood on the site of a fourteenth-century royal palace once occupied by both Catherine Parr and Queen Elizabeth. In furnishing and decorating the place, Rossetti remained faithful to its Renaissance spirit. Whistler became acquainted with still other members of the Brotherhood at Tudor House, men with whom he would "chaff and row . . . with great spirit and cleverness" into the morning's wee hours. The eclectic conversation, fueled by wine and tobacco, was the most stimulating Whistler had known outside Paris.[17]

The dark, burly, enigmatic Rossetti captivated Whistler. The painter-poet was only then emerging from the despair of losing his wife, Lizzie Siddall, to an overdose of laudanum, but there could be no mistaking his fanatical devotion to art. Like Whistler, he appreciated the genius of Hogarth, Dürer, Gavarini, and Halbot Browne, and while he had no use for the "new" French art of Courbet or Manet, Rossetti did admire Ingres and Delacroix. He also shared Whistler's passion for Asian art. There is conflicting evidence concerning which of the two first appreciated its splendors. Rossetti's brother, William, recalled that Whistler introduced the entire Pre-Raphaelite circle to Japanese woodcuts and Nankin china. Certainly, Whistler had begun to collect the "blue and white" porcelain by that time, and he and Rossetti soon engaged in a spirited contest to amass the finest pieces.[18]

Some younger Pre-Raphaelites encouraged Whistler's combative streak quite literally. Hunt, for instance, loved any vigorous activity, and he most enjoyed boxing. Prinsep, with his "lion head and large stature," liked nothing more than to flex his fourteen-inch biceps in sport. Friends called him Buzz. Whistler had joked about the boxing matches of English students in Paris, but he had engaged in scuffles of his own in his youth and at West Point. Certainly, despite his slight stature, Whistler was no weakling. Friends commented on his "muscular strength," especially in the chest and arms, and no one ever doubted his "pluck." Still, people were both startled

and amused to learn that when last in Paris Whistler had engaged in fisticuffs with a cab driver. He never explained the altercation, but it seems likely the cabby said or did something to injure his dignity as a gentleman. Having entered the Pre-Raphaelite fold, Whistler asked a "well-known 'pug'" for boxing lessons.[19]

None of this, however, did much to solve his immediate problem, which remained a want of "tin." His months in France had been expensive, and by August, the bills were catching up with him. For relief, he turned to his oldest patron, Thomas Winans, in hopes of selling *Alone* and *The Thames in Ice*. With America's civil war well into a second year, Winans's business affairs were anything but stable. Known for their Confederate sympathies, Thomas and brother William could not stay in Union-occupied Baltimore. Instead, they spent the war traveling with their families between England, France, Switzerland, Germany, and Russia. Even so, Thomas, without committing himself to either painting, deposited £50 in Whistler's account.[20]

Interestingly, Whistler did not offer Winans *The Last of Old Westminster*, a gem of a painting done that summer (fig. 23). The painting, like his etching of a year earlier, featured the new bridge, but the "rich colour and delightful confusion" of the scene, conveyed in complex tones of russet, green, mauve, and yellow, was his real subject. While depicting the bustle and grind of the river, with boats puffing up and down, the patterns created by the bridge and construction pilings formed the heart of the picture.[21]

Typically, though, Whistler used the money from Winans not to pay debts, but to return with Jo to the Continent. He had hoped initially to take his long-deferred trip to Venice, but Jo's health had not been good, and the dampness of that city would have worsened her persistent coughing. A doctor had also recommended the mountain air of the Pyrennes to rid Whistler of his own lingering case of "painter's colic" (lead poisoning), contracted by inhaling paint fumes. But health was the least of it. Whistler had wanted to visit Madrid ever since the Manchester exhibition of 1857, when he acquired a deep admiration for Velázquez. The Prado, with its unrivaled collection of the Spaniard's work, required a "holy pilgrimage."[22]

En route, he stopped at the village of Guéthary, a few miles south of Biarritz. Atrocious weather allowed him to complete only one picture, *The Blue Wave: Biarritz*, and it nearly killed him. He had been standing on the beach in early October, studying the crashing of the waves against the rocks, when a series of breakers "engulfed" him. Whistler swallowed "a ton" of salt water as the sea spun and tossed him in a series of "cartwheels" that dragged him from shore. He called for help, but people on the beach could not hear, and they misunderstood his thrashings. "Oh

but see how the monsieur is amusing himself," he later interpreted their reaction, "he must be awfully strong." Finally, two men realized his plight, plunged into the sea, and pulled him to safety. Whistler described the ordeal to friends sardonically, but several other people nearly drowned at Guéthary that autumn.[23]

Unlike his Brittany picture, in which the water was a relative sliver of the composition, the churning sea and darkened sky of Guéthary dominated this canvas. Frustrated by his inability to capture the motion of breaking waves and drifting clouds, he poured out his troubles in letters to Fantin. "I am not working quickly enough!" he complained. "I seem to learn so little!" He wondered if painting directly from nature could yield anything beyond "large sketches." The waves and clouds were there one moment and gone the next, and their colors changed daily. How could he ever catch their "true and pure colour?" he asked; how could he hope to produce the "finish" demanded by the public?[24]

Whistler gave up and headed for Madrid, although he never arrived. He barely managed to slip across the Spanish border, to the village of Fuenterrabia, before postponing the pilgrimage until Fantin-Latour could accompany him. Returning to southwest France, he and Jo stopped briefly at the town of Saint-Jean-de-Luz, but the weather, with rain one day and "stupid sunshine" the next, made painting impossible. "Ah mon cher," he wrote to Fantin, "you are absolutely right – painting from nature! needs to be done at home!" Besides, by that time, mid-November, Whistler missed the excitement of city life. Sending Jo on to London, he paused in Paris to consult with Lucas about frames and with Martinet about exhibiting his Westminster picture. He was due to leave when Thomas Winans passed through town and convinced him to stay a few more days. One thing led to another. Costs mounted. Whistler ran out of money. When he paid his laundress only half of what he owed her, she took him to court. He did not reach London until mid-December, only to suffer a severe attack of rheumatism that confined him to bed for several days.[25]

Once recovered, Whistler spent more time socializing than working. He also became a devoted spiritualist, apparently a result of visits to Tudor House. Spiritualism in all its guises, including séances, spirit rapping, table-turning, telepathy, and mesmerism, was extraordinarily popular in Victorian England. Whistler also fancied Jo a "bit of a medium." She went with him often to Cheyne Walk, and they held their own séances in Queen's Road. Rossetti, who took it all less seriously, thought Whistler a bit daft on the subject, likely to "go mad" if he did not temper his enthusiasm. But having once "talked" to a dead American cousin, Whistler was hooked. He wanted to communicate with long-dead painters in hopes of learning their

secrets. The obsession seemed to run in the family, too. Brother Willie, he would learn, had "curious warnings or presentiments – the Scotch second-sight."[26]

The Thames continued to mesmerize him, too, and every visit to Tudor House made him yearn to live on the river. He spotted a likely place at 7 Lindsey Row (now 101 Cheyne Walk), a western extension of Cheyne Walk. Once part of the eighteenth-century residence of the Earl of Lindsey, the old mansion had since been divided into multi-storied townhouses with large back gardens. The layout resembled a less grand version of Rossetti's home. Only the broad road and an old sea wall separated Whistler from the Thames (fig. 24). Across the water lay Battersea Church, although its picturesque silhouette was marred by neighboring factories, mills, foundries, and towering heaps of coal. Whistler enlisted Rossetti's solicitor, James Anderson Rose, to handle negotiations. After dickering over repairs and fees, Rose acquired a three-year lease for £50 per annum. Whistler and Jo moved in at the end of March 1863 (fig. 25).[27]

That he again leased, rather than bought, the house was typical of the Victorian middle classes. Renting was more cost effective than buying, especially in ever-expanding London. To purchase a multi-story dwelling with hallway, several parlors, dining room, multiple bedrooms, and kitchen, cost £1,000 to £2,000. Renters could get the same house for £20 to £150 per annum, and the convenience of an annual lease made them mobile. That they held these leases on annual terms, with rents paid quarterly, also distinguished them from the working classes, who held weekly or monthly tenancies. As their incomes and prospects rose (or fell), the middle classes could move from house to house, neighborhood to neighborhood as it suited them. To change residences every two or three years was perfectly normal, and a pattern that suited the rhythms of Whistler's nomadic life.[28]

Whistler could not do much to relieve the unprepossessing exterior of his new home, but he created a charming, distinctly oriental, interior. Distempered walls and white paneled doors gave the dining room an airy openness, a perfect place to display his "blue and white" (fig. 26). The darker drawing room became the showcase for his Japanese screens, prints, fans, dolls, and kakemonos, while Persian, Japanese, and Chinese rugs covered the floors of all main rooms (fig. 27). Whistler used the rear of the top (third) floor for his studio. Large windows provided a northern exposure and bathed the gray walls and black oak floor with light diffused by Indian muslin curtains. Otherwise, his "workshop," which contained only the tools of his trade, a table, and a few chairs, contrasted sharply with the elaborate furnishings and decor of many a successful artist's studio.[29]

By then, two circumstances caused Whistler to refocus on art. First, he had heard of a new etching society in Paris, the Société des Aquafortistes. Organized by Delâtre and Alfred Cadart, an art dealer and publisher, its goal, far grander than its counterpart's in London, was to make etching a respected art form. The idea excited Whistler until Fantin assured him that it was a "stupid" organization, ruled by "politics." He might have joined anyway, had he not learned that Cadart was actively recruiting Seymour Haden for membership. Whistler was aware of his brother-in-law's growing reputation as an etcher, the *Gazette des Beaux-Arts*, France's leading art journal, having recently praised him as "one of the most brilliant etchers in England." Call it pique, call it jealousy, call it what you will, but Whistler felt a sudden dislike for his one-time mentor. While he and his friends pushed the boundaries of etching, this amateur, this dilettante, won praise for nothing more than pleasing, pastoral views to adorn drawing-room walls.[30]

Nonetheless, self-doubt seized Whistler, gnawed at him, for the rise of Haden's star made him question the value of his own work. Du Maurier found his mood entirely changed after the *Gazette* review. The confident, boisterous Whistler became "peculiarly modest about his etchings." As if to test himself, he made several fine etching and drypoints of the river and a remarkably tender picture of Jo. The latter, titled *Weary*, showed his Pre-Raphaelite woman collapsed in a chair, quite likely after hours of posing (fig. 28). It could have passed for a recent drawing by Rossetti of his mistress Fanny Cornforth. It may also have owed something to Rossetti's poem *Jenny*. The Jenny of the poem was a prostitute, but Rossetti's description of her "wealth of loosened hair" and "weariness" fit perfectly Whistler's portrait of Jo.[31]

The deadline for the summer exhibitions also drew Whistler back into action. Like all artists at that time of the year, he felt the "tender hooks of anxiety." Yet, despite his angst, Whistler thought himself in an excellent position. He sent *The Last of Old Westminster*, the *Blue Wave*, and six etchings (including *Weary*) to the Royal Academy. It was the largest number of etchings he had ever submitted to a jury, and a direct challenge to "the brother-in-law's" status. He selected three Thames etchings and *The White Girl* for the Salon. Revealing at least a spark of his former combativeness, he told George Lucas, "I have set my heart upon this succeeding, and it would be a crusher for the Royal Academy here, if what they refused were received at the Salon in Paris and thought well of."[32]

That was on March 16, when yet another opportunity to exhibit presented itself. James Rose had arranged for Whistler to show fifteen of his latest etchings and drypoints and one painting at a small, one-day exhibition in King Street. The forty-

three-year-old Rose, it turned out, had many interests. Besides having worked in London as a solicitor for twenty years, he was a member of several gentlemen's clubs, and he would, in time, become a fellow of the Royal Geographical Society and the Anthropological Society. He also invested in art, with a collection that included paintings by Rossetti, Ford Madox Brown, and Burne-Jones. Some of his prints dated to the seventeenth century, although they also included work by Meryon, Cruickshank, Legros, Haden, and Whistler. Whistler thought at first to take advantage of his new friend's offer by exhibiting *Alone with the Tide*, which still wanted a buyer. Instead, and at the last minute, he sent *The White Girl*. It would be a close call, to show it in London on March 26 and still beat the deadline for the Salon, but Whistler tempted fate.[33]

Leaving nothing to chance, he rounded up friends, family, and trusted critics to pack the soirée. He also asked William Rossetti to write a review of the show and make especial mention of *The White Girl*. Rossetti, who reviewed exhibitions for several journals, had not been overly kind in appraising *The Thames in Ice*, but that had been several months before meeting Whistler, and he had been very much impressed by *At the Piano* when exhibited at the Royal Academy.[34]

Given this new opportunity, Rossetti delivered. He praised the etchings lavishly and declared that, as an etcher, Whistler had no "superior since the days of Rembrandt." While not enamored of "The Woman in White," as he called Jo's portrait, Rossetti treated the painting tactfully. "Without being an attractive picture," he said, it was, nonetheless, "remarkable." Moreover, it was "a work of real mark, vivid, strong, and masterly in painting . . . with unmistakeable 'style.'"[35]

The bad news came two weeks later. The Salon accepted Whistler's etchings but rejected *The White Girl*. He found small consolation in the fact that most of his friends had also been either partly or totally rejected. In fact, the jury had refused an unprecedented 4,500 works, three-fifths of the whole. Martinet announced that his Société Nationale des Beaux-Arts, a grand title for an organization run entirely out of his gallery, would exhibit refused works of merit. Whistler submitted his painting to him but remained pessimistic. He was slightly cheered to learn that the Royal Academy had accepted *Old Westminster* and his etchings, even if it had rejected his seascape.[36]

On April 21, Whistler escaped to Holland with Legros, finally completing the journey begun five years earlier with Delannoy; but no sooner had they settled down to etch than events took a dramatic turn in Paris. Protest over the rejected Salon paintings had become so intense that Napoleon III saw fit to intervene. A week

before the Salon opened, he announced a separate exhibition for the rejected works. The Salon des Refusés, as it became known, would open a fortnight after the "official" Salon in adjacent rooms. "[Y]ou can see all the hatred of 30 Years stored up against the Jury," Fantin reported to Whistler. Whistler instructed Fantin to submit Jo's portrait to this second Salon, rather than to Martinet's gallery.[37]

A majority of the rejected artists, not wishing to be labeled rebels, declined the emperor's offer. Consequently, only about 700 of the 4,500 eligible works were exhibited. Critics and cartoonists mocked the spectacle of huge crowds packing galleries to view discarded paintings, and the crowds themselves often laughed at the many novel works on display. For all that, it was a seminal moment for what one scholar has called "the generation of 1863." Fantin, Legros, Bracquemond, Manet, Pissarro, and Claude Monet were among the exhibitors, each one believing, as Courbet had taught them, that publicity was the thing. "Oh do come to Paris," Fantin urged Whistler; "these two Salons, there has never been anything like it."[38]

*The White Girl* and Manet's *Le Déjeuner sur l'herbe* (*Luncheon on the Grass*) stole the show, with perhaps a slight edge going to Whistler. The two paintings could not have been more different in subject. Manet's nude woman, who looked cooly at viewers as she sat with two fully clothed men in a picnic setting, bore no resemblance to the virginal Jo. The paintings did share the same broad brushstrokes and lack of detail, but their "unfinished" look, as well as their subjects, were the very reasons the Salon jury had rejected them. The public and the critics laughed and pondered. Intent on finding a "story" in the paintings, they speculated about their meaning. Manet's woman was assumed almost universally to be a prostitute; Jo received votes as a fallen woman, blushing bride, and ghostly presence, although one visitor dismissed the entire picture as "a piece of bad white-washing." "The hangers must have considered her particularly ugly," influential English critic Philip Hamerton said of Jo, "for they have given her a sort of place of honour, before an opening through which all pass, so that nobody misses her."[39]

Whistler enjoyed the controversy, and not everyone laughed. Returned to London from Amsterdam, he received ecstatic reports from Fantin. "[N]ow you are famous!" his friend exclaimed. "[Y]our picture is very well hung, everyone can see it – you are having the greatest success." The mercurial Baudelaire exclaimed, "charming, charming, exquisite delicacy." A jealous Courbet, among others, called Jo's portrait "an apparition, spiritualistic," but even he acknowledged the picture to be "good." As published reviews appeared over the next few weeks, Whistler's self-doubts faded.[40]

There remained, though, the English response to *Old Westminster*, which had been hung atrociously, virtually scraping the floor. That was nearly as bad as having it "skyed," or hung near the ceiling, and to be exhibited in either way was the nightmare of all artists. All hoped to be placed "on the line," that is, at eye level, but with hundreds of paintings to be crowded into limited space, the choice spots generally went to the best-known artists. Whistler wanted to cut his painting from the frame when he saw its degraded position, but the critics rewarded him. William Rossetti and Frederic G. Stephens, another of the Pre-Raphaelite circle, heaped praise on both *Old Westminster* and the etchings. Stephens even chided the academy for placing such an "artistic and able" picture "where the crinolines [could] scour its surface."[41]

Adding to Whistler's euphoria, George J. Cavafy, a Turkish-born merchant whose English-born son John, a physician, was part of the Tulse Hill crowd, bought the painting for £30. That same month, George Whistler bought *Alone with the Tide* for £84 and ordered a set of Thames etchings. In June, Whistler learned that he had received a gold medal, his first official honor, for an exhibit of twelve etchings at The Hague. The British Museum and the Louvre ordered proofs of all his etchings that same summer. He told Fantin to spread the news of his triumphs "with all the finesse of a scoundrel." Perhaps Baudelaire might write an article about him. Manet, by all means, must hear of his success, and Manet would surely tell his circle at the Café de Bade, a popular gathering place for artists and writers next to Martinet's gallery.[42]

Whistler had to consider himself lucky, too, for the Royal Academy, like the Salon, had rejected an "extraordinary" number of pictures in 1863. A "general storm of indignation" followed, as British artists caught a whiff of the rebellion across the Channel. A parliamentary inquiry into the operation of the academy and its role in the cultural politics of the day was already underway, but British politicians did not intervene in the immediate crisis. Unlike the French Salon, the Royal Academy was not a state-sponsored exhibition, and the National Gallery, which hosted the exhibition, had not nearly as much space as the Salon. However, so widespread did the protest become that an exhibition for the "rejected" academy pictures was arranged privately at the Cosmopolitan Club. Whistler visited as a demonstration of support, and responded to a chance remark by a Royal Academician in attendance. "You know they hang everything that comes in higgledy-piggledy," the academy member said disdainfully. Whistler shot back, "What do you call your present exhibition [at the National Gallery], isn't that higgledy – and *particularly* piggledy?"[43]

Having righted his own ship, Whistler spent much of the remaining summer and autumn helping Legros and Fantin. In June, he finally convinced Legros to

move to London. Insisting that his friend stay in Lindsey Row, Whistler introduced him to the Pre-Raphaelites, the Greeks, the Holland Park crowd, anyone who might advance his career, and as more buyers snatched up his pictures, Legros underwent a remarkable transformation. The hitherto scruffy, moody, and introverted bohemian became a dandy and "society darling," with dozens of ladies sighing over him. "Alphonse has developed social skills that we did not know he possessed," an amused Whistler informed Fantin, "and his ease and confident graciousness surpass all description."[44]

Whistler tried again to convince Fantin to join them, that the Society of Three might make their fortunes together. Earlier in the year, he had persuaded an important London collector, Stavros Dilberoglou, a Greek friend of Ionides, to offer Fantin 150 francs for three of his pictures. Dilberoglou then commissioned three new paintings from Fantin and bought still more of his work in the coming months. The Greek sold many of the pictures for healthy profits, but that hardly mattered to the cash-strapped Fantin.

Whistler thought his friend's success would surely lure him to England. "I think you have only to paint and they will buy every canvas from you!" he told Fantin. "[We] are all selfish, and all a little perverse," he confessed, "but I am faithful to the word of the society, so that there is no door open to me where everyone is not eager also to meet you and to accept your painting. [T]here is gold waiting for us everywhere – we have only to be loyal to each other." Fantin still demurred. "[W]e know we want to fight against the stupid masses," he explained to Whistler, "but each of us separately very free."[45]

In mid-August, Whistler and Legros returned to Holland, this time taking Haden. Whistler wanted to resume his etching expedition, but he also wanted Haden to see his award-winning etchings at The Hague. The trio then went to Amsterdam, where they etched contentedly together and saw many of Rembrandt's paintings. Whistler also shopped for Chinese porcelain, Japanese prints, and "Old Dutch" paper. He had become obsessed with finding the perfect paper for his etchings, and he knew of none with better texture, color, and absorption than seventeenth-century Dutch. As for the china, he returned to London after a fortnight laden with "blue and white."[46]

Few people saw him in the weeks that followed. He had complained even before the trip that a backlog of work kept him in his studio "from dawn to dusk." By autumn, he had completed two new paintings, *Battersea Reach* and *Battersea*. Both pictures measured approximately twenty by thirty inches. Both depicted river traffic on the Thames, though in strikingly different ways. The latter painting, which

played with the atmospheric effects of mist and smoke on the river, was quite experimental (fig. 29). The former one, lively and colorful, showed the bustle of life along Lindsey Row. Whistler painted it "in one go" on a "brilliant autumn evening" from a window of his house. George Cavafy bought it for the same £30 he had paid for *The Last of Old Westminster*.[47]

A delicate family matter also preoccupied Whistler. Brother George now regretted his purchase of *Alone with the Tide* and the Thames etchings, especially the etchings. He had bought them in a "rash moment," he confessed, and the drain on his resources now threatened financial "ruin." Considering the care he had taken in selecting the paper and printing the etchings, Whistler thought his new, higher prices only fair. Knowing, too, that his etchings received nearly universal acclaim, he did not intend to sell himself short.

Of course, he "sympathized at once" with George, and took back both the etchings and the painting, but the episode spoke to Whistler's emerging ideas about the purpose and meaning of art. Rather than catering to the whims of the crowd, he would sell his work only to people who understood it. He knew from his associations in Tulse Hill and Holland Park that such patrons existed. He knew they could afford to pay good prices, and that the more they paid, the greater the public recognition and "value" of his work. People who did not understand or appreciate art should be content with mass-produced engravings. His art *was* "devilish dear," he told George, "expensive objects of luxury, and an extravagance that not every one ought to permit himself."[48]

# 6

# *Homage to Whistler*

## 1864–1866

By the time Whistler made his second trip to Holland, a passion for *japonisme* had swept over London. The most brilliant display of Asian art and culture ever seen in Britain had attracted thousands of visitors to an International Exhibition in Kensington Gardens the previous year. Shopkeepers, already several years behind the Parisians, exploited the occasion by stocking Asian prints, porcelain, fabrics, screens, and furnishings. Farmer and Rogers's Great Shawl and Cloak Emporium, in Regent Street, led the way, and nineteen-year-old Arthur Liberty, a clerk in charge of their new line, soon opened his own shop.[1]

Whistler's interest in Asia went well beyond fans and porcelain by 1863. His favorite Parisian shop still sent word of any particularly nice prints or porcelain it received, but while Rossetti sought out Japanese *objets d'art* with fanatical zeal, and such friends as Degas, Manet, James Tissot, and Alfred Stevens became "obsessed" with *japonisme*, Whistler cashed in on the new craze by *creating* Asian art. Going beyond the Eastern perspectives and motifs used in earlier etchings and paintings, he added Japanese or Chinese characters and settings. The new departure became more subtle over time, more an aesthetic feeling than a visual representation, but the Far East, thereafter, helped to define Whistler's artistic identity.[2]

He made four compelling paintings in 1863–64, all adopted from eighteenth-century Japanese prints. The first picture, *The Lange Lijzen of the Six Marks*, also

bore the stamp of his search for "blue and white" in Holland. *Lange Lijzen* is Dutch for "long Elizas," a style of Chinese vase decorated with female figures. The "six marks" referred to the potter's signature on the base of the vases. For his picture, Jo, dressed in a silken oriental robe, sat painting a "long Eliza," as if working in a Chinese porcelain shop. Whistler made no effort to give her Asian features, and the trappings of the scene, including her robe, the plates and pots that surrounded her, and the carpet (all from Whistler's personal collection), were a promiscuous mix of Chinese and Japanese, *chinoiserie* versus *japonisme*. Despite the eclecticism, no one could deny the painting's East Asian spirit, and no one in England or Europe had done anything like it.[3]

So, too, the second painting, *La Princesse du Pays de la Porcelaine* (fig. 30). Whistler began this Asian version of *The White Girl* in February, almost as soon as he put the finishing touches on *Lange Lijzen*. Rather than have Jo reprise her role, he used twenty-year-old Christine Spartali, one of the Greeks of Tulse Hill, as his model. Hailed as the beauty of her generation, Spartali caused men to go weak at the knees. Swinburne wanted to "sit down and cry" whenever he saw her. She posed for Whistler twice a week for three months before he was satisfied with his effort. "I am so discouraged," he told Fantin-Latour in the early going, "always the same thing – always such painful and uncertain work! I am *so slow*!" He wished he knew as much as his friend about painting. "When shall I know more!" he wailed.[4]

Stylistically, he employed the same sharp angling of the floor as in *The White Girl*, but aside from Spartali's Japanese-influenced pose and posture, everything else about the painting was, again, a Western version of the Far East. It only "looked" Asian, an illusion created by an oriental carpet, screen, and fan, and Spartali's gorgeous kimono. The colors were brilliant, Whistler's brightest palette since *The Music Room*, but he told no story. Spartali was more a decorative object than a living woman, the beauty of the composition counting for everything.[5]

More complex were *The Golden Screen* and *The Balcony*. In composition and color, the first picture was the jewel of the set. Jo, again the model, was still occidental, but this time, sitting in profile on a Japanese rug, swathed in a kimono, and inspecting a collection of Japanese prints, her race was less noticeable. Behind her stood a hand-painted "golden screen" owned by Whistler. *The Balcony*, well underway by mid-February, showed four Japanese women whose clothing and accessories were consistently Japanese. One of the women, seemingly Jo, strummed a Japanese lute. A spray of blossoms in the foreground added to the Asian effect, as did the balcony

scene itself, a common setting in Japanese painting. Yet, there remained a jarring Western element. Having painted the picture on the front balcony of his own house, overlooking the Thames, Whistler used the factories and coal piles of Battersea, across the river, for his background.[6]

Scholars have speculated on the meaning of such intrusive elements in Whistler's work. Some commentators see them as a favorable commentary on the industrialization of Great Britain, and a subtle appeal to the new manufacturers and captains of industry to buy his pictures. More often, in an effort to credit Whistler with a social conscience, these scenes are said to condemn industrialization, with all its unsightly structures, noise, pollution, and general ruination of a quieter life. In this context, his etchings of the lower Thames are said to echo Charles Dickens and Henry Mayhew's brooding descriptions of Babylon's grim underbelly.[7]

Yet, Whistler never, in any way, suggested that his art contained political or social statements. Seeking the vision of urban life demanded by Baudelaire, he simply painted what was in front of him, though admittedly, always with his "painter's eye." Besides, he was a city boy, the proud son of a man whose bridges and railroads had helped to create the urban landscape. Conceivably, Whistler intended the industrial wasteland seen in *The Balcony* to magnify the beauty and serenity of his Japanese women. Then again, during the same months that he painted these otherwise vibrant *japonisme* pictures, he also made several more atmospheric paintings of the Thames. *Chelsea in Ice*, for instance, a title reminiscent of the painting done on Christmas Day of 1860, showcased a single steamer chugging bravely up an ice-encrusted Thames beneath an overcast sky. In the background, along the Battersea shore, loomed a mountainous pile of coal and two industrial smokestacks.[8]

Taken together, the *japonisme* and river pictures also achieved something that Whistler, Fantin, and Legros had been working toward since the 1850s, a genuine tableau, the object of which was to produce, through composition and color, a single, powerful effect. In the case of his *japonisme* paintings, Whistler's exotic, gorgeously costumed women, surrounded by lovely *objets d'art*, radiated pure beauty. As it happened, they also played to the *japonisme* market, for in admiring their porcelain, fans, and prints – pointedly so in *Lange Lijzen* and *The Golden Screen* – the women subtly endorsed the desire of middle-class buyers to surround themselves with similar symbols of cultured refinement.[9]

The idea of a tableau also allowed Whistler to finish the Rotherhithe painting, finally called *Wapping*, after three years of toil. Concerned initially with the "expressions" of a prostitute and her client, he became obsessed with the proper arrangement

of the three people. Along the way, he also made his "whore" far more modest by closing Jo's previously open blouse. This change may have resulted from his mother's arrival in London (discussed momentarily), although Whistler would also have wanted to avoid unnecessary controversy and rejection by either the Salon or Royal Academy. After all, the people in his pictures were only necessary to fix the viewer's eye. The heart of the composition, the tableau, was the arrangement of the ships, sails, rigging, booms, and masts behind them.[10]

Whistler's artist friends admired the ingenuity of his new work, especially the *japonisme*-inspired "English" paintings. Gabriel Rossetti and Ford Madox Brown urged their patrons to buy the pictures before shrewder investors snatched them up. Indeed, Ernest Gambart, London's most successful art dealer, and someone Whistler had been cultivating since the previous spring, bought *Lange Lijzen* for £100. Matching him, Alexander Ionides pledged £100 for one of the uncompleted Thames paintings. *Wapping* went to Thomas Winans, still Whistler's most reliable patron, for £350, which was £100 more than anyone else was willing to pay. The purchase was especially generous given that the U.S. dollar had lost nearly half its value against the pound during the American war.[11]

Whistler's progress was all the more remarkable given the turmoil in his private affairs (fig. 31). First, in November 1863, came an argument between Legros and the "fiery" Jo over Legros's continued residence at 7 Lindsey Row and his failure to repay several loans from Whistler. Most of the loans had been small, given for such things as tobacco, cab fares, and the public baths, but larger sums went for models, Japanese prints, whiskey, and a pistol. Meanwhile, Legros had fallen in arrears with his share of the rent and groceries. William Rossetti thought more than debts was involved, that there had been hard feelings between Jo and the woman Legros "kept" at the time. Naturally, the two artists sided with their respective women. Whistler, who also stood "in mortal fear of Jo," smoothed things over for the moment, but it had been a distraction he did not need.[12]

More tumultuous and far more significant was a rupture with Seymour Haden (fig. 32). Their etching trip to Holland and his own recent successes had momentarily lessened Whistler's pique. However, the friendship crumbled in a series of incidents during the winter of 1863/64. Matters came to a head at a dinner party in Sloane Street shortly after New Year's Day. As art became the topic of conversation, Whistler spoke lightly, though decidedly, about the merits of Realism. He scoffed at all "Academicians," including Haden's other brother-in-law, John C. Horsley, and, by extension, Haden.

Before leaving that night, Whistler invited his host to a dinner at Lindsey Row. Haden accepted only to back out on the appointed day. His "scruples," he said, would not allow him to dine if Jo were present. An angry Whistler, mindful that Haden had dined with Jo in the past, stormed into Sloane Street to denounce the brother-in-law's hypocrisy and mock his new found "virtue." Too stunned to reply, a furious Haden ushered him out and forbade Debo ever again to visit her brother's home.

Whistler described the confrontation to friends as a "glorious war," in which his "vigorous attack . . . of light cavalry," having inflicted "serious wounds," allowed him to retire with "gallantry." His vocabulary, light-hearted and comedic in its way, came from his days at West Point, but it also reflected events in America, where the Civil War, then in its third year, soon altered Whistler's entire life.[13]

He paid little attention to the war in its early stages. He complied in early 1862 with a request from Charles Dickens's magazine, *Once a Week*, for a vignette illustrating the plight of Lancashire mill workers who had lost their jobs as a result of a Confederate embargo on cotton, but that was purely a business transaction. He did not intend the drawing to be a political statement. If anything, Whistler continued to feel a warm attachment to the South. He grew up on Anna's southern cooking and stories about plantation life, learned to think of white southerners as more refined than northerners, and regarded blacks as an inferior race. Consequently, when the abolishment of slavery became an issue in the war, in late 1862, Whistler turned decidedly away from the Union cause.[14]

His family's response to the war settled matters. Upon finishing his medical studies in 1860, Dr. William Whistler had married Ida Bayard King, a second cousin from Georgia. Soon after the war started, he and Ida joined her family in Richmond, Virginia, the capital of the Confederacy, and Willie became a surgeon in the Confederate army (fig. 33). That he also happened to serve under Robert E. Lee delighted Jim, even without his knowing that Lee still thought well of "little Jimmy Whistler." Shortly before the war, having read about the triumph of *At the Piano* at the Royal Academy, Lee confided to his wife, "I wish indeed he may Succeed in his Career. He certainly has talent, if he could acquire application."[15]

Anna Whistler, despite having slaveholding relatives in Georgia and Florida, had tried to honor her late husband by remaining neutral in the war. However, she went to Richmond when Willie asked her to nurse a desperately ill Ida, and by the time Ida died, in March 1863, Anna was a Confederate sympathizer. With Willie away at the front, she was also alone in the war-torn capital, and her eyesight had been

degenerating for years. Consequently, friends of her late husband helped Anna to reenter Union lines and book passage for England.[16]

She reached London in late December 1863, in the midst of the Whistler–Haden war (fig. 34). Whistler was beside himself. The feud had already upset the "quiet peaceful life" of his studio. Now came a "general upheaval." Partly from love, partly as a tactical move, Whistler insisted that his mother stay with him, but, as he exclaimed to Fantin in the exaggerated fashion that had become part of both his speech and writing, "Well! . . . I had a week or so to empty my house and purify it from cellar to attic! – Find a 'buen retiro' for Jo – A place for Alphonse. . . . [S]ome goings-on! goings-on up to the neck!" Jo wound up with a cottage in Walham Grove, Fulham, more than a mile west of Lindsey Row.[17]

How much Anna knew or allowed herself to know about either the family quarrel or Jo is anyone's guess. She gave every sign of being "happier and more comfortable" than she had been in years. She thought Chelsea, "the abode of Artists," charming, her son's "commodious" house, enchanting. She loved its oriental decor, large garden, spacious courtyard, and view of the river. She even accepted the fact that the sitting room, filled with paints, canvases, and easel, was "more than half Studio." Anna visited Debo and the grandchildren on Sundays, but she was content to live with her son. Whistler subscribed to *The Times* for her sake and read to her every evening, as she had done to him as a child. He escorted her on Sundays to Chelsea Old Church (St. Luke's), located only three blocks to the east. If he did not always stay for the sermon, he at least approved of the pastor, and Anna understood that her son now adhered to a "natural religion."[18]

In return, fifty-nine-year-old Anna busied herself in managing her son's household and assisting his career. She welcomed his friends and enjoyed their "visionary & unreal tho so fascinating" conversations about art. The unorthodox Rossetti and often outlandish Swinburne always behaved in her presence, and Anna thought Swinburne a dear, although she clearly had not read his scandalous poetry. She also became fond of the Ionides family and Spartali sisters. When Christine, always accompanied by Marie, came to pose for the still uncompleted *La Princesse*, she served them exotic "American" luncheons of roast pheasant, tomato salads, and canned apricots with cream.[19]

And her son's career was definitely on the rise. That spring, the Royal Academy accepted *Lange Lijzen* and *Wapping*, and William Boxall, a prominent member of the jury, assured him that both pictures would be well hung. Whistler had lost touch with his old friend in recent years, but their reunion was timely.

Once the exhibition opened, critics praised the "colour" and "character" of both paintings.[20]

However, Whistler attracted the most attention that spring at the Salon, where he did not even exhibit. When Eugène Delacroix died the preceding summer, Fantin responded by painting a large (sixty-three by ninety-eight inches) group portrait of ten artists and writers gathered to honor the Romantic colorist. None of the group, which included Whistler, Fantin, Baudelaire, Legros, Manet, Bracquemond, and Duranty, was an advocate of Romanticism, but they were no less Delacroix's successors. As Duranty put it, all were "controversial artists paying homage to the memory of one of the most controversial artists" of their day. Fantin had wanted to include Rossetti and Swinburne, but neither of them could find time to pose. Even so, he created a compelling picture, and a confusing one.[21]

Whistler stood literally at the center of the confusion. Fantin placed him at the forefront of the group, just off center, and occupying his own plane. Dressed in fashionable, tight-fitting morning coat, Whistler wore an expression of supreme confidence. In dress, posture, and manner, he served as a mirror image of Delacroix, whose portrait hung behind him. Equally, he embodied the spirit of the late painter as urban *flâneur* and dandy, someone whose life and work, in Baudelaire's words, conveyed the "gait, glance and gesture," the *feel*, of the modern world. "It is a kind of cult of the self," the poet-critic explained, "the joy of astonishing others, and the profound satisfaction of never oneself being astonished." Fantin's painting expressed his own belief that Whistler was the foremost artist of their generation. Without knowing its title, one would think the assembled group was paying homage to Whistler (fig. 35).[22]

Most critics, and even some friends, wondered why a gaggle of Realists should bow to Delacroix, but Whistler was more concerned about meeting Fantin's high expectations of him. None of his recent work was daring enough to raise eyebrows. He needed another *White Girl*, and so he made one. The canvas was smaller this time, thirty by twenty inches, only a third as tall as the original, but to underscore his intentions, he called the new portrait of Jo *The Little White Girl* (fig. 36).

Wearing a version of her signature white dress, Jo stood before the front parlor fireplace in Lindsey Row. Left arm resting on the mantel, she turned her face in profile so that it was reflected in a mirror behind her. A *lange Lijzen* vase sat on the mantel to her right, and sprays of flowers, as in *The Balcony*, decorated the right foreground. At first glance, the picture might be interpreted as a tribute to female beauty, an ethereal and fragile Pre-Raphaelite beauty. Even having Jo's face reflected

in the mirror was a Pre-Raphaelite device, although the Brotherhood, in turn, had borrowed it from Ingres, Velázquez, and still earlier painters.[23]

Yet, Whistler's picture remained a puzzle. For one thing, the expression on Jo's face differed subtly from the reflection in the mirror, which was sadder, less contented, the corners of the mouth turned down, the eyes vacant and more downcast. A sense of loss, keener even than in *The White Girl*, embodied this new "apparition." Adding to the mystery, Jo wore a wedding ring, although Whistler may have intended that to assure his mistress of her status as "Mrs. Abbott," as she liked to be called.[24]

Worse than not saying what it all meant, Whistler manufactured a drama to shape the inevitable debate over what the picture might mean. He asked Swinburne, who adored the painting, to write a poem about it, to be affixed to the frame. Swinburne was known for composing verses on such occasions. A year earlier, he had dashed off four poems in twenty minutes to accompany a series of paintings by Burne-Jones, and in French. This time, for Whistler, he wrote a sixty-three-line poem in English one morning after breakfast. Among its varied images and metaphors, "Before the Mirror" suggested that Whistler's "languidly contemplative . . . phantom" was thinking of "old loves and faded fears." Gabriel Rossetti, irritated by the continuing French influence on Whistler's work, thought the poem better than the picture.[25]

Whistler selected fourteen of Swinburne's lines to accompany *The Little White Girl* to the Royal Academy, which accepted it and three other paintings for the summer exhibition. *La Princesse* went to the Salon, where Whistler also appeared in another painting by Fantin. Frustrated by the failure of *Homage to Delacroix*, Fantin had made another group portrait, *Le Toast! Homage to Truth*. Its purpose was the same as the first painting, to show the eternal "truths" in art, regardless of "school." He conveyed the message this time with an ensemble of nine artists, six of whom had exhibited at the Salon des Refusés.

Whistler again occupied the most prominent position, and in spectacular fashion. Dressed in a Japanese robe, he led a toast to a nude female model, "glorious in her youthfulness," who symbolized "Truth." His fantastical garb, acquired at La Porte Chinoise, his favorite source of East Asian objects in Paris, was Whistler's idea. In any event, no one, in Fantin's opinion, better deserved the honor of toasting truth in art. "It's he who is making progress," Fantin told Legros. "[H]is paintings . . . make a great impression on me."[26]

Fantin's purpose was again lost on the critics, but Whistler scarcely noticed: Willie had arrived in England. The American Civil War had not yet run its course in January 1865 when an exhausted Dr. Whistler requested a furlough. As a surgeon, he had

dealt unflinchingly with the human carnage of war, but he was worn out, his wife was dead, and fortune had turned against the Confederacy. The government approved his request to recuperate with his family in England and entrusted him with diplomatic dispatches to Confederate agents in the country. It took him a harrowing two months to reach his destination. Unable to break through the Union naval blockade from any rebel port, Willie traveled in disguise to New York. Had he been recognized, he would have been executed as a spy. Instead, he escaped on a ship bound for Liverpool. A week after arriving in London, he learned that the war was over.[27]

One may imagine the warmth of the reunion. Anna had been ill during much of the preceding year, with several months spent recuperating in Germany and on the southern coast of England. Willie's arrival benefited her more than any tonic or change of climate. The two brothers became "almost inseparable." They dined at Tudor House, spent raucous evenings at the sprawling Cremorne "pleasure gardens," a brief walk west of Whistler's house, and enjoyed the Derby at Epsom Downs. Life was good.[28]

Willie's company also made it easier for Whistler to read the mixed response to his exhibition pictures. English critics wrote more favorably than did the French, but few voices on either side of the Channel were enthusiastic. While Lancashire wallpaper manufacturer John G. Potter bought *The Little White Girl* for £50, the French rejected the painting as a pale (so to speak) imitation of the original and dismissed *La Princesse* as a failed exercise in costume. Part of the animus may well have come from Whistler's eccentric presence in Fantin's *Le Toast!* which drew a good deal of "spite."[29]

Whistler was in limbo, deeply insecure about his painting and lacking a sense of purpose. He had enjoyed modest financial success since moving to England. Eleven pictures had sold since 1859 for a total of nearly £1,000, but virtually all of them had gone to family members or acquaintances. His prices had increased but not to the levels enjoyed by established painters. Most reviews had been positive, and fellow artists admired his work, but he had yet to make his name with the public.[30]

So it was that Whistler fell under the influence that summer of Albert Moore (fig. 37). The two artists had first met a year earlier, either at the Arts Club or through painter Simeon Solomon, a mutual friend. An odd duck by any standard, Moore was the "most gentle and affectionate of men," a heavily bearded, sad-looking fellow who, incongruently, loved to laugh. Seven years Whistler's junior, the earnest, methodical Yorkshireman came from a family of artists. Having studied in Paris and Rome as well as the Royal Academy, he had helped to create, along with such painters as Leighton, Poynter, and Millais, a Neo-Classical revival in England. Moore's Classicism, however, was no simple matter. Unlike most adherents to that style, he

had no desire to depict Greek or Roman subjects. His interest, like Whistler's fascination with *japonisme*, was largely aesthetic. The decorative form and arrangement of the female body, clad in ancient dress, marked the extent of Moore's "classicism," which also incorporated Asian and Romantic influences.

Moore became part of the "Whistler clique" at Lindsey Row, and Whistler spent hours at Moore's cluttered studio in Fitzroy Street, near the British Museum. Tom Armstrong and Tom Lamont, already friends of Moore, were also regular visitors, as were Solomon, potter William De Morgan, and illustrator Randolph Caldecott. The office of architect and *japonisme* devotee William E. Nesfield, in nearby Argyle Street, became another popular gathering place. Few of Whistler's Pre-Raphaelite friends approved of Moore's Classical conventions. Rossetti, who thought him "a dull dog," said Moore's work contained "a good deal of silly conceit & woeful shortcoming." Whistler, however, believed the style would appeal to a Royal Academy jury. He recommended to Fantin that Moore replace the "mongrel" Legros in their brotherhood.[31]

The soft, pale coloring and perfect proportion of Moore's work captivated Whistler, and reinvigorated him. "I have really made enormous progress," he told Fantin in August. "I feel I am reaching the goal that I had set myself – I am now fully conscious of everything I am doing!" Focusing on "composition," without being distracted by peripheral details, he began two Moore-inspired paintings. First, in a variation on the "White Girl" theme, he dressed both Jo and a fourteen-year-old model named Milly Jones in whitish gowns. Jo reclined on a divan while Milly, seated on the floor, leaned drowsily against it. A discarded fan and sprays of flowers in the right foreground provided subtle Asian accents, but the feel of the picture, including the languid postures of Jo and Milly, was Classical. So, too, the fit of their costumes, which caressed them. "The body, legs, etc., can be seen perfectly through the dress," Whistler told Fantin excitedly, very nearly in amazement.[32]

Nor could anything be read into *The Sofa*, the picture's initial title, no story, no lesson, no faces in mirrors, no hypnotic gazes. It was the "purest" thing Whistler had ever done. Rather than a mere representation of beauty, he had captured beauty of form, beauty for its own sake, more so even than in *La Princesse* or *The Golden Screen*. Not that he was entirely satisfied with the effort. Rarely happy with anything on the first go, he continued to work on the picture until 1867, when it was first exhibited.

Next came *The Artist in his Studio* (fig. 38). Intended for the Salon, Whistler wanted this brilliantly impish picture to glorify both the new Trois and his own work. It would show Fantin, Moore, himself, and his favorite models, Jo and

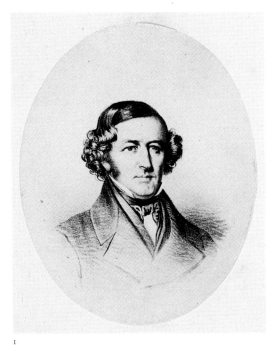

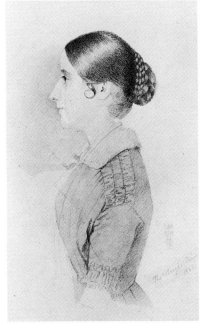

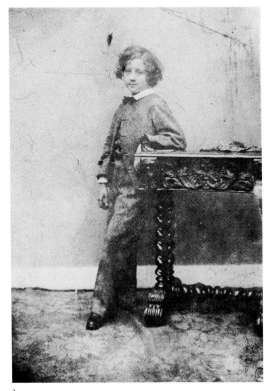

1  George Washington Whistler (c. 1840).

2  Anna Matilda (McNeill) Whistler (c. 1830).

3  James Abbott Whistler, about age ten.

Father and son as they would have looked at the time of their residence in Russia. The painting of Anna was done shortly before her wedding.

4

5

4    *On Post in Camp: First Half Hour.*
The first of a sequence of four
drawings by Whistler that evoked the
tedium of sentry duty.

5    *Song of the Graduates.* Whistler's
first "commission" as an artist became
the sheet music cover for the Class of
1852.

6    Thomas de Kay Winans.
Whistler's earliest patron enabled him
to pursue his dream of being an artist
in Paris.

6

7

7   *An Artist in his Studio.*

8   *Fumette.* A portrait of Héloïse.

9   Josephine Durwand, known as Finette.

Despite Whistler's depiction of himself as a lonely artist, he rarely lacked attractive female company.

8

*Imp.Delatre.Rue S! Jacques.171.*

9

10  *La Mère Gérard.*

11  *The Unsafe Tenement.*

These two etchings became part of
"The French Set" and early examples of
Whistler's brand of Realism.

12   *At the Piano*. This domestic scene of sister Deborah "Debo" Haden and niece Annie was
Whistler's first painting to be exhibited at the Royal Academy, 1860. John Everett Millais called it the
"finest piece of colour" he had seen in years at the Academy.

13  *Self-Portrait* (*Whistler with a Hat*). As he appeared at the time of his move to London.

14  Henri Fantin-Latour. One of Whistler's earliest and closest artist friends, he drew this self-portrait in 1861.

15  *Black Lion Wharf.* This etching, part of the "Thames Set," showed the evolving sophistication of Whistler's work.

16    *Thames Police.* Another etching from the "Thames Set."

17    *Venus.* A portrait of Héloïse. Some scholars believe this female nude, the first by Whistler that has survived, is Josephine Durwand, but the face and hair more closely resemble Fumette.

18

19

20

18  *Whistler as the Letter Q.*
This drawing by George du
Maurier in the October 27, 1860,
issue of *Punch*, was the first
comedic depiction of him in the
press.

19  *The Music Room.* Francis
Seymour Haden, James R. Traer,
and Deborah "Debo" Haden in
1858.

20  *Old Hungerford Bridge.*
One of a series of "bridge pictures"
done by Whistler around 1861, it
became part of the "Thames Set."

21  *Battersea Dawn,* or, *Early
Morning, Battersea.* Also part of
the "Thames Set," this etching and
drypoint shows more concern with
atmosphere than with the distant
bridge.

21

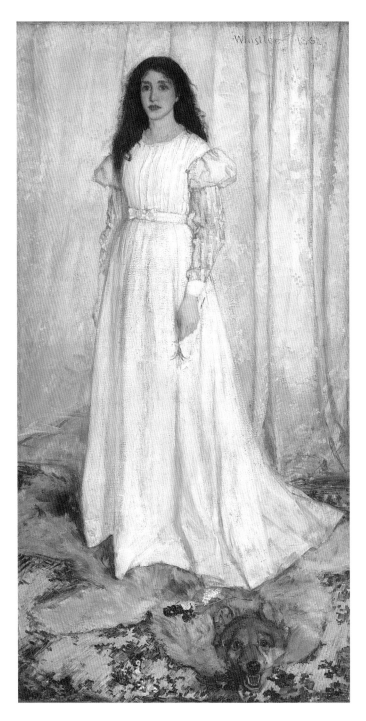

22   *Symphony in White, No. 1: The White Girl*. Rejected by both the Royal Academy and the Salon, Whistler's mystical portrait of Jo Hiffernan was finally exhibited at the controversial Salon des Refusés, 1863.

23 *The Last of Old Westminster*. The only painting done by Whistler to show the replacement of several old Thames bridges in the 1860s and 1870s.

24 *The "Adam and Eve," Old Chelsea*. Drawn in 1878, this etching and drypoint shows that part of the Thames where Whistler lived for the better part of forty years. His house on Lindsey Row was beyond Chelsea Old Church, its square tower visible on the far left.

25   7 Lindsey Row.

26   Dining room.

27   A parlor.

This was the first of four Whistler houses on Lindsey Row and Cheyne Walk. The dining room shows his "blue and white" on display; Jo Hiffernan posed for the *Little White Girl* in front of its fireplace. He decorated other rooms with Asian *objets d'art*.

25

26

27

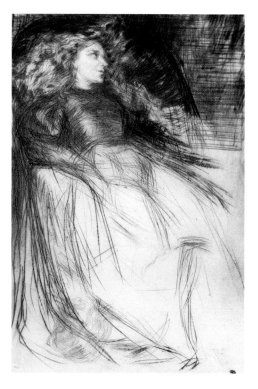

28   *Weary.* This portrait of Jo Hiffernan shows what lovely effects Whistler had begun to achieve with drypoint.

29   *Grey and Silver: Old Battersea Reach.* One of several paintings that depicted river life on his Lindsey Row doorstep, Whistler here experimented with the atmospheric effects of mist and smoke on the Thames.

(*facing page*)  30   *La Princesse du Pays de la Porcelaine.* This gorgeous piece of color, featuring Christine Spartali, was the second of four *japonisme* paintings done by Whistler in 1863–64.

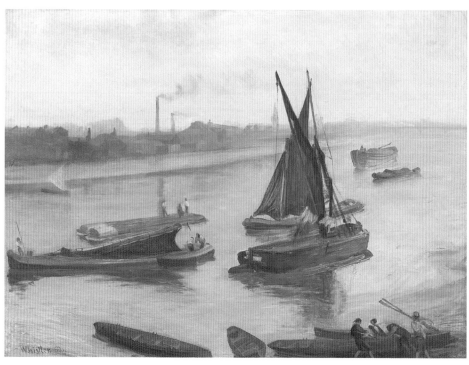

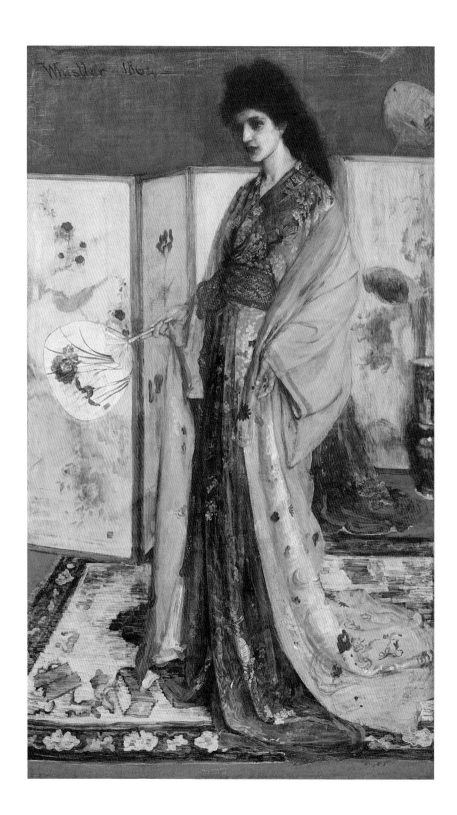

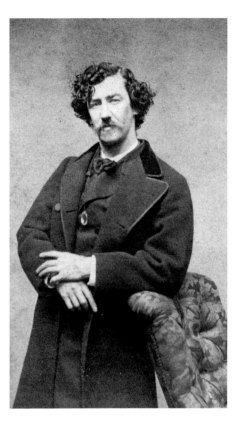

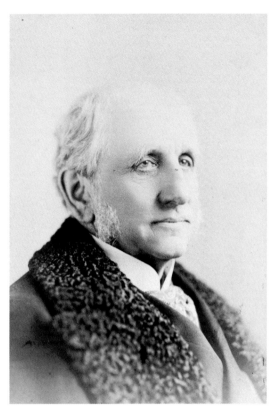

31 Whistler around 1865, the year of his quarrel with Seymour Haden and just prior to his departure for Chile.

32 Francis Seymour Haden in 1878. Once his mentor and "dear friend," Whistler came to despise "the brother-in-law" as a hypocrite and bully.

*Facing page:*

33 William McNeill "Willie" Whistler as a Confederate surgeon.

34 Anna McNeill Whistler in 1865.

35 *Homage to Delacroix.* Painted by Henri Fantin-Latour and exhibited at the Salon in 1864, it was as much a tribute to his friend Whistler as to the recent master of Romanticism.

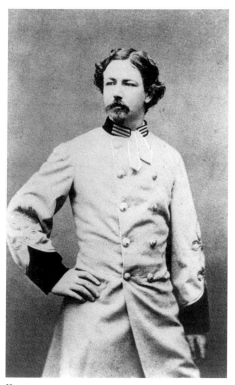

33

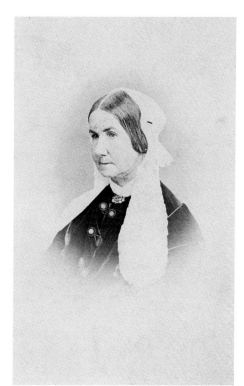

34

35

36 *Symphony in White, No. 2: The Little White Girl.* Algernon Swinburne wrote a poem, affixed to the painting's frame when it was exhibited at the Royal Academy in 1864, that described Jo as a "languidly contemplative . . . phantom."

Christine Spartali, in his studio. He abandoned the simple composition of *The Sofa* in favor of a complex balance of parts, but the color scheme remained pure Moore, with Whistler dressed in light gray, Spartali in a "flesh-coloured" gown, Jo in peach, the studio in gray. He meant to use his broadest, airiest, most liquid brushstrokes, too. People and objects would melt into the background, nearly as apparitions. The scale would be massive, ten feet high and at least six feet wide, "[a]n apotheosis . . . of everything to outrage the Academicians," he told Fantin.[33]

Whistler never finished the picture as intended, only a modest (twenty-five by nineteen inches) version nearly two years later, for in August 1865, life again intruded on art. First, he grew concerned about his mother's failing eyesight, which had grown so poor that Willie took her to an eye doctor, or "occulist," in Germany. Meantime, temporarily stymied by the demands of *The Sofa* and *The Studio*, Whistler decided to do something to settle accumulating debts. He and Jo headed for Trouville, a popular seaside resort on the Normandy coast. If the weather cooperated, a few quick seascapes might answer his financial needs.[34]

He found Trouville to be "a charming place," the "effects of sea and sky" quite fine. What Whistler had not expected to find was Courbet. The great man had come for a few days of sea bathing but, like Whistler, found stunning possibilities in the shifting moods of sea and sky. He also found it profitable to paint portraits of fashionable women at the resort. "My fame has doubled," Courbet boasted, "and I've grown acquainted with everyone who might be of use to me."

The two artists spent several days together, bathing in the "freezing sea," feasting on prawns drenched in fresh butter, and painting. Courbet remembered Whistler from Paris and, more recently, from his work at the Salon, although the Frenchman's ego was such that he described him in a letter to a friend as "my student." A comparison of their work at Trouville gives the lie to that conceit. Whistler completed seven paintings, each one superior to similar efforts by Courbet in conveying the ethereal qualities and translucent colors of nature.[35]

One picture, later titled *Harmony in Blue and Silver: Trouville*, offered a playful contrast to a seascape done a decade earlier by Courbet. The Frenchman had inserted himself in his painting as a trim figure, standing at the ocean's edge and jauntily saluting the sea with a wave of his hand. Whistler's picture showed a chunkier, apparently older man, though clearly meant to be Courbet, standing immobile and well back from the water. There was something ghostly about the figure, too, as though he were fading into the sand. It is not hard to construe the scene as a commentary on Courbet's waning artistic influence.

More importantly, Whistler displayed a strikingly new technique in *Trouville*. He spread his paint so thinly, especially for the sky, that it failed to cover parts of the canvas. And he applied it so smoothly that only words such as "creamy" and "silken" could adequately describe the finished surface. Gone was the thick impasto favored by Courbet. The bands of color that represented sky, sea, and sand were exquisitely modulated, each one shading imperceptibly into the next, sea and sky fashioned from seven or eight different shades of blue, the beach from strips of brown, tan, and beige. Whistler produced the same effects in two other Trouville paintings, later called *Sea and Rain* and *Crepuscule in Opal*.

The innovations had several sources. The finished surfaces showed the influence of Boxall and Gainsborough, perhaps, too, of Manet's recent work. The lighter palette and thinner paints came from Moore. The thinness of the paint also satisfied a long-standing desire to work more quickly. To the viewer's eye, the smoothness conveyed a sense of spontaneity and effortlessness, another of Whistler's objectives. Photography may have influenced its composition, for any photographed seascape would have been reduced to the same parallel bands of sky, sea, and sand.[36]

Whistler's artistic differences with Courbet extended even to how they saw Jo. Effervescent and vivacious, *la belle Irlandaise* "played the clown" for them during their days together, and she captivated Courbet. He insisted on painting her, but unlike the slender, chaste, idealized woman of Whistler's portraits, his Jo was voluptuous and sensual. As she admired her own luxurious hair in a looking glass, Courbet gave Jo a raw sexuality that had no equivalent in Whistler's work.[37]

Returning to London in mid-November, Whistler received a worried letter from his mother in Germany. It concerned Willie. Her younger son had been in England nearly eight months without fixing a new course in life, she said. Some degree of malaise, even melancholy, could be expected in someone recovering from the trauma of war, but his routine of late nights on the town and listless days in Jemie's studio worried her. "[I]f I did not know his artistry," she said, "I'd let him sleep on; but he is gifted in talent as you are." Jemie must shake him from his stupor.[38]

By January 1866, with Willie returned from Germany, rumors said the brothers would go to America. Swinburne, having seen an American journal that praised Whistler's work, told him, "[T]hey worship the ground that you walk on." Apparently, Whistler wanted to see for himself, as well as seek "new subjects for painting," and Willie would make an ideal companion. As it turned out, though, the brothers were bound not for North America, but for South America, and therein lies a tale.[39]

The Whistlers had become involved in a dubious money-making scheme cooked up by some ex-Confederates in London. The city was full of former American rebels who feared political or economic reprisals at home. Thousands of them had fled to every part of the globe, not just England, but also the Continent, Canada, Mexico, and South America. Most refugees sought only peace and security, either for the short term or as permanent expatriates. However, some Confederate soldiers signed on as military advisors or mercenaries with foreign governments.[40]

A shadowy figure named Henry H. Doty brought the Whistlers into this maelstrom. Doty, an inventor of naval weaponry who had helped the Confederate government develop its torpedo program, and Hunter Davidson, a former rebel naval officer experienced at deploying torpedoes, had agreed to assist Chile and Peru in their war against Spain by transporting three steam-powered "torpedo boats" from England and destroying a Spanish naval blockade at Valparaíso. Doty then appears to have recruited Willie, whom he had met during the war, and Willie secured a place for his brother as Doty's "secretary."

Doty promised Jemie a salary of £30 per month, travel and living expenses, and a share of a £60,000 commission should the mission succeed. That would be enough money to pay his debts and establish him in a style befitting a successful artist. Whistler needed a change of scene, too. He was still drifting artistically, freed of Courbet's Realism, and attracted by Moore's Classicism, but uncertain of the next step. His hope of finding new subjects to paint said it all. In later years, he claimed that the arms dealers had been drawn to him by his credentials "as a West Point man," but it seems unlikely that anyone outside Whistler's family knew or cared about his singularly unimpressive military career.

Anna only knew that her sons might be entering "into danger," and that the trip represented a "crisis." Whistler also appreciated the danger, and so made arrangements. He gave up the lease on his house, placed his belongings in the care of friends, and sent Anna to stay with the Hadens. Anna wanted him to leave £100 for his "model," Jo. "[Y]ou promised me to promote a return to virtue in her," she reminded him. "I never forget to pray for her." The son did more than that. He made a will, with Jo his sole beneficiary. He also assigned his power of attorney and entrusted his bank account to her.[41]

Intriguingly, he signed the necessary legal documents as James Abbott *McNeill* Whistler. The reason for this sudden addition to his name is unclear. Perhaps it was done in solidarity with Willie, whose middle name had always been McNeill. Perhaps he wished to honor his mother, whom he had left so conspicuously out of his will.

There was his Celtic pride, too. He later claimed that he "resented" the name Abbott, and thought it his "right," as his mother's eldest son, "to bear her Highland name." He had recently ordered private stationery embossed with the family crest and motto, "Vincere aut Mori" (Conquer or Die), unaware that both crest and motto belonged to the McNeills of Colonsay, not his mother's clan, the McNeills of Gigha.[42]

He sailed for the Isthmus of Panama from Southampton on February 2, although he went without Willie. As a former Confederate army officer who had yet to disavow the rebel cause, Willie was denied a passport by U.S. consular officials. He did sign the requisite oath of allegiance to the United States five months later, in order to visit George Whistler in Russia, but even then, the secretary of the American legation in London commented on Willie's "very surly cast of countenance." Still, Jemie did not travel alone. He escorted Mrs. Doty and her companion on the voyage. Henry Doty, who joined Davidson on the iron-hulled steamer used to transport the promised weapons, thought it best that the ladies not travel with him.

By the time Whistler reached Valparaíso on March 12, having endured a nerve-wracking journey across Panama, the diplomatic situation had become tense, the military situation dangerous. Great Britain, the United States, France, Russia, and Sweden, hoping to defuse tensions and permit legitimate trade to flow in and out of Chilean and Peruvian ports, had sent warships to Valparaíso. The Spaniards were ready to bombard the town should these peacemakers interfere. The Chileans, who had purposefully left Valparaíso unfortified and had no warships there, pinned their hopes on Doty's contraband torpedoes and a pre-emptive strike against the menacing Spanish fleet.

Meanwhile, Whistler passed the time by playing secret agent. In fact, having enlisted with Doty for "special service," that appears to have been his principal assignment. He observed the movements of the several national naval squadrons and kept track of diplomatic negotiations. He listened and observed in the city's cafés and hotels. He recorded the comings and goings of ships and the progress of peace talks. He learned the name of each ship's commanding officer and made friends with the British naval officers, with whom he occasionally dined. He traveled through Chile and Peru by railroad and on horseback and observed the preparation of defenses in the Peruvian port of Callao.[43]

So stood things on the day before Easter, when a fragile ceasefire ended. Amid rumors that torpedoes would soon arrive from the United States and Great Britain, the Spanish had announced their intention four days earlier to bombard Valparaíso and warned all neutral ships to leave the harbor. For three hours, beginning around

9 a.m., Spanish guns pummeled government buildings, warehouses, private dwellings, and commercial property. Few casualties resulted, primarily because the populace, including Whistler, had fled to the hills above the city. Far from playing the "West Point man" when the shooting started, Whistler's "one idea was to get away."[44]

Satisfied with its work, the Spanish fleet sailed north to Peruvian waters on April 14 and did battle with Peru's navy on May 2. Both sides claimed victory, but the Spaniards then headed home. Although a final treaty would not be signed for nearly twenty years, the fighting had ended. Meanwhile, Whistler, still awaiting Doty and Davidson, passed the time by dining with friends and consuming large quantities of wine, ale, cognac, sherry, and absinthe. He borrowed for these "expenses" from Mrs. Doty, who held the purse strings in Valparaíso.

Having brought his pigments and brushes on the expedition, Whistler painted, too. Indeed, on June 12, he commented wistfully that the Royal Academy's annual summer exhibition had been running for more than a month. Whistler began four oil paintings during his weeks at Valparaíso and appears to have made two other pictures on the trip. The Valparaíso paintings, depicting ships in the harbor, are among the few visual records of the Spanish blockade, apparently the only eyewitness views. Whistler may have set up his easel as early as April 1, the day after the bombardment, for he called one picture *The Morning after the Revolution*. He probably did not complete any of the pictures until returning to London, and he worked on at least two of them into the 1870s.[45]

Two paintings, later titled *Crepuscule in Flesh Colour and Green: Valparaiso* and *Symphony in Gray and Green: The Ocean*, displayed the tonal fluidity of Trouville, their colors seamlessly blended by Whistler's long, delicate brushstrokes. He applied the paint using a technique he would later describe as like "breath on the surface of a pane of glass." The mood of the paintings was also striking, with ships, sea, and sky enveloped by mist, fog, and twilight. However, a third painting, to be called *Nocturne in Blue and Gold: Valparaiso Bay*, offered something quite different, the harbor at night. Whistler had painted the Thames shrouded in mist or fog, but this night scene, its effects reminiscent of earlier pictures by his Pre-Raphaelite friends Holman Hunt and George Boyce, presaged the next dramatic step in his art.[46]

He might have done more had not Doty and the armaments ship finally arrived on July 24, more than four months after Whistler had reached Chile. Anything that could have gone wrong on Doty's voyage had done, including mechanical breakdowns, pursuit by a Spanish warship, and a minor mutiny. Of course, with the war ended, the Chileans would not be paying for the torpedoes. The expedition was a

bust. Whistler later said of the moment, "[W]e breakfasted, and that was the end of it." Not quite. The men exchanged words. A frustrated Whistler slapped someone, probably a Doty associate. Doty accused Whistler of seducing his wife. Captain Davidson accused Doty of cheating him out of £100, then signed on with another band of mercenaries to fight for Peru. Doty returned to England. Whistler booked passage home for early September.

The return voyage had its own brand of excitement. Three times in as many days, Whistler engaged in fist fights. First, he assaulted a fellow passenger, likely Haitian, aboard the West Indian steamer *Shannon*, bound from St. Thomas to Southampton. "He offended my prejudices as a Southerner," Whistler declared unabashedly. Blows were exchanged, and Whistler so injured his right hand as to require a sling. When the passenger then tried to revive the battle, the ship's captain asked Whistler to remain in his cabin and posted a guard at his door. Or so Whistler claimed. Another passenger, admittedly unfriendly to Whistler, said the captain had confined him because he had been drinking heavily. All the "Gentlemen" on board, insisted Whistler, said that the "black scoundrel deserved his kicking."

The second incident grew from the first one. The ship's mail agent, Baldwin A. Wake, who was a "strong abolitionist," had hurled sharp words at Whistler following the scuffle. The next day, he entered Whistler's cabin to continue the harangue. Whistler, out of respect for Wake's fifty-three years, kept himself in check. He asked Wake to withdraw, lest they come to blows, at which the impassioned Wake accused Whistler of cowardice. At that, Whistler, his injured hand still in a sling, slapped Wake with his good hand. They grappled; Wake struck Whistler in the eye. Whistler's guard, hearing the ruckus, rushed in to pull Wake away. Whistler's friends urged him to complain to the American authorities in England, which he did upon landing the next day, but the consulate chose not to intervene.[47]

The final altercation came when, upon reaching London, Whistler was met by Henry Doty at Waterloo Station. A row ensued. Each struck the other, and Doty, as he recounted it, denounced his antagonist so that all might hear: "This is Whistler the Artist, a scoundrel, a seducer, a betrayer of his trust, mark him." Whistler then fled, Doty said, to seek refuge in the cloakroom. Whistler recalled only that his former associate had displayed such "astounding impudence," given the farcical end to their arms dealing, that he struck Doty in "a sudden outburst of passion!"[48]

As things turned out, the incident at Waterloo Station would not end the affair. For the moment, though, Whistler wished only to rejoin Jo at her cottage in Walham Grove.

# 7

# Trouble in Paradise

## 1866–1869

Whistler had forgotten how noisy, crowded, and chaotic London could be. The world's first underground railway, opened in 1863, relieved some of the congestion, but thousands of wagons, carts, cabs, and omnibuses rumbled daily through the streets, while the construction of buildings, bridges, railways, and a stone embankment along the Thames kept the city in a state of permanent upheaval. The most welcomed changes came from new sewage, drainage, and water lines. Unfortunately, the improvements had not prevented a cholera epidemic in the summer of 1866. Nearly six thousand Londoners had died, well over four thousand of them in the overcrowded and wretchedly poor East End.[1]

Whistler's financial affairs were no more settled. Jo had tried to pay the most pressing debts by selling his paintings, but a financial panic rocked London at the same time that the cholera struck. An unprecedented expansion of new commercial companies, stimulated by generous limited liability laws, caused the crisis. When bankers, suddenly pressing debtors for payments, demanded £54 1s. 11d. from Jo, she threw up her hands, turned matters over to James Rose and Ernest Gambart, and fled to France.[2]

To meet living expenses, she posed for Courbet, most prominently as one of two lesbian lovers in *Le Sommeil* (*Sleep*). The painting, which showed the women lying together, bodies entwined, was pornographic by the standards of the day. Even more

shocking was *L'Origine du Monde* (*The Origin of the World*), painted that summer or early autumn. The eighteen-by-twenty-two-inch canvas depicted a nude woman lying in bed, her legs spread wide to reveal her vagina and inner thighs. It was impossible to identify the model, whose head was covered by a sheet, but it may well have been Jo. Whether or not she and Courbet frolicked beneath the sheets is equally unclear, although some scholars think it was so.[3]

Jo said nothing of her time in Paris to Whistler, but rumors of his sojourn spread quickly, and he regaled friends with descriptions of his fisticuffs aboard the *Shannon*. Glasses of "wonderful brandy and whiskey milk punch" enlivened the telling, and Gabriel Rossetti penned a limerick to celebrate the episode:

> There's a combative Artist named Whistler
> Who is, like his own hog-hairs, a bristler:
> A tube of white lead
> And a punch on the head
> Offer varied attractions to Whistler.

A less amused William Rossetti rebuked him for his treatment of the "negro gentleman," and thought his "humorous account of the circumstances exhibited the most naive & inveterate prejudice."[4]

More hopefully, Gabriel spoke of a potential buyer for *La Princesse*, and George Whistler agreed to buy *The White Girl* for £250. Whistler was suddenly flush enough to acquire another house, and he found the perfect one at 2 Lindsey Row (now 96 Cheyne Walk). His three-year lease at £80 per annum began on Christmas Day 1866. Somewhat larger than No. 7, with an attic in addition to the three stories, No. 2 would be Whistler's home for the next eleven years, his longest residence anywhere. Anna thought it a "great improvement" on No. 7.[5]

Whistler "got up" the new place in glorious fashion. He tacked purple Japanese fans to the walls and ceiling of his light blue dining room, which had a dark blue dado and doors. His collection of china sat majestically in a large pagoda cabinet in the same room. The parlor was dark red with black wainscoting and woodwork. His studio, on the top floor, was gray with black doors and dado. An array of "delightful Japanesisms," including prints and silks, brightened nearly every room, and he slept in a massive Chinese bed. He later painted the dado of the entrance hall and stairways gold with a sprinkling of rose and white chrysanthemum petals.[6]

However, with the drawing room still unpainted by February 4, and a housewarming announced for the next day, Whistler summoned two neighbors, the Greaves

brothers, to help. He had known the Greaves family since first moving to Lindsey Row. They lived at No. 9, and the father, a boatbuilder and waterman, had often rowed J. M. W. Turner, another former resident of the street, up and down the Thames while the artist sketched. Two daughters, Alice and Eliza, would later pose for Whistler. The boys, Henry and Walter, aged twenty and seventeen, respectively, when Whistler first met them, haunted his studio and ingratiated themselves by cleaning the place, preparing canvases and frames, running errands, doing anything their hero required. They became, after a fashion, his first students, not so much through formal lessons as by watching his every move. They walked like Whistler, talked like him, adopted his gestures and affectations.

Most importantly, the Greaves boys introduced Whistler to the ways of the river. They taught him how to navigate Chelsea Reach, that stretch of the Thames east of Battersea Bridge, by riding its currents and mastering its tides, and how to steer the narrow arches of the bridge. "He taught us to paint," Walter recalled, "and we taught him the Waterman's jerk," a reference to the short, sharp strokes of the oar used by Thames boatmen for centuries. A fair exchange by any measure.[7]

Now, they "worked like mad" to finish the flesh-colored walls and white doors and woodwork of Whistler's drawing room. "It will never dry in time!" the lads worried. "What matter?" Whistler replied, "it will be beautiful!" His guests, "the Fleur de Chelsea," agreed. They loved the entire decor, which contrasted starkly with the eclectic muddle of Tudor House and the heavy Victorian ornamentation of the homes in Holland Park. Gabriel Rossetti found Whistler's "Brazilian hammock-net," a souvenir from South America, "decidedly luxurious."[8]

More significantly, people marveled at the pictures from Valparaíso. They saw at once the transformation in Whistler's technique and ideas about composition. Edwin Edwards thought *Crepuscule in Flesh Colour and Green* "surprisingly novel, impossible to explain" (fig. 39). He wrote to Fantin-Latour, "[I]t's a picture that is very much an ensemble but, even so one could cut it into 3, 4 or 5 pieces and each piece would be a picture . . . it's something very difficult to understand and impossible to describe to someone who hasn't seen it." The implications, he predicted, would be far-reaching. "Whistler is asking a big question about pictures with their rules for chiaroscuro, receding sides, foregrounds and backgrounds." That was more than one question, but Whistler had plenty more, to be asked both of himself and of fellow artists.[9]

In March, he caught up on a year's worth of gossip in Paris. The Café de Bade having fallen out of fashion, Fantin took him to a new gathering place for artists

and writers, the Café Guerbois, located at 11 Grande rue des Batignolles (now avenue de Clichy), across the Seine from their old haunts in the Latin Quarter. Fantin, Frederic Bazille, and Antoine Guillemet were "regulars," but Degas, Pierre-Auguste Renoir, Manet, Astruc, Scholderer, Pissarro, Paul Cézanne, and Monet dropped in from time to time. They generally met on Friday evenings, and from the "artists' corner" where they congregated, "perpetual clashes of opinions" rang through the establishment as sharply as the colliding billiard balls in the café's back room. Fantin would pay tribute to the group in another of his ensemble portraits, this time without Whistler, *An Atelier in the Batignolles*.[10]

Whistler also conferred with Fantin and George Lucas about the upcoming summer exhibitions. Paris would offer two excellent venues, the Salon and another Exposition Universelle. After waiting in vain for an invitation to exhibit in the British section of the Exposition, Whistler submitted *The White Girl, Wapping, Old Battersea Bridge, Twilight at Sea*, and one of the Valparaíso paintings to a grateful American contingent. The Salon accepted *The Thames in Ice* and *At the Piano*. It had rejected the latter painting eight years earlier.

In London, Ernest Gambart hoped to show one of the Valparaíso paintings at his French Gallery, but Whistler sought broader exposure at the Royal Academy. He offered the academy *Sea and Rain*, done at Trouville, *Battersea*, and *The Sofa*, now called *Symphony in White, No. 3*. Fantin, Tissot, Degas, and Alfred Stevens had all seen the *Symphony* by now. Fantin thought it perhaps "too cloud-like[,] . . . like a dream," although he did not mean that as a "serious criticism." Everyone else approved, and Fantin warned that Tissot and Stevens would try to imitate it. Tissot, he said, went "mad over the picture."[11]

Whistler had changed the title partly to attract attention, but also to emphasize that composition and color, not subject, mattered most in painting. Inspiration for the term "symphony" came from several sources. French critic Paul Mantz, for one, had described *The White Girl* in 1863 as a "symphony in white," and a widespread aesthetic theory had long pointed to the musical elements in poetry and painting. Karl Briullov, if Whistler recalled his life in St. Petersburg, had spoken of the artist as a musician, the pencil and brush being the equivalent of "the bow or the voice." Whistler would hereafter rely on musical terms, including "harmony," "arrange-ment," and "variation," to convey the "meaning" of most of his pictures. He renamed older work, too, so that *The White Girl* and *Little White Girl* became *Symphony in White, No. 1* and *No. 2*. He described paintings without musical titles by their domi-nant colors, so that *Battersea* became *Grey and Silver: Old Battersea Reach*.[12]

There was irony in the new titles, in that Whistler's determination to discourage literary "readings" of his pictures coincided with an effort by composers to achieve the opposite end. Ludwig van Beethoven, Hector Berlioz, and Robert Schumann had led audiences to expect "programmed" music, large, instrumental pieces that either bore descriptive titles or were accompanied by program notes to explain the "story" of each movement. By the late 1860s, this trend had only strengthened public expectations that all art, whether music, painting, or poetry, tell a story. Then, too, while Whistler enjoyed symphonic music and would eventually count many musicians and composers among his friends, he preferred the melodies of the music hall to the drama of the concert hall. He loved Offenbach, and he came to favor Gilbert and Sullivan over Richard Wagner.[13]

At the Exposition, American artists had been relegated to the darkest corners and galleries of the exhibition hall, and Whistler's work had been shamefully hung. "For Gods sake what is all this about my pictures in the entry!" he exclaimed to George Lucas. But he was not the only unhappy artist that spring. The French commission had slighted a number of his friends, and the Salon jury had again rejected hundreds of submissions. Angry petitioners, among them Monet, Renoir, Pissarro, Bazille, and Alfred Sisley, demanded another Salon des Refusés. Courbet and Manet staged independent exhibitions, and Manet published a manifesto to protest against the existing jury system. Émile Zola, who had recently come into his own as both novelist and art critic, helped him write it. The critic Jules Castagnary voiced similar sentiments in the avant-garde journal *La Liberté*.[14]

Whistler was still grumbling a week later when he visited Luke Ionides's office. Legros chanced to be there. Whistler had not seen him since before going to Chile. They had bickered again over money on that occasion, and Legros had "bitterly" resented being teased about his upcoming wedding to a "pale" English girl named Frances Hodgson. Now Whistler, in his dark mood, wanted to know when the Frenchman would make good on his debts. Legros insisted that he owed Whistler nothing, but he responded in such a way – "Ce n'est pas vrai" – that Whistler thought he was being called a liar. He struck Legros. A scuffle ensued, and Whistler got the better of it.[15]

Ionides and Gabriel Rossetti wanted Whistler to apologize. "I do not think the affair if it stops here," Rossetti told a friend, "quite amounts to a cause for cutting Whistler, considering his other good points, however. . . . it will introduce a painful limitation into one's intercourse with him." Some important collectors, including George Howard and Luke's eldest brother Constantine, stood solidly by Legros.

Burne-Jones wanted to "call in the police," while Frederic Leighton thought a "round robin of sympathy" for Legros a sufficient response. Most other people, including Rossetti, divided the blame evenly upon learning full details of the encounter, but efforts to reconcile the two men failed.[16]

Still, the Legros affair might have blown over were it not for subsequent events. Whistler went to Paris two days later to judge the situation at the Exposition and visit the Salon. Upon arriving, he learned of the tragic death in that same city of his friend James Traer. Only thirty-three years old, Traer had been attending the Exposition as a member of the British jury when he suffered a violent attack of *delirium tremens*, caused by alcoholism. More to the point, Whistler heard that Seymour Haden, who had come to Paris on behalf of Traer's widow to arrange for a dignified internment, was slandering the dead man. Haden had all but dissolved their medical partnership because of Traer's "intemperance." In Paris, he tried to have his name posthumously struck from the published list of jurors.[17]

Whistler and Willie, who had accompanied his brother, were furious about Haden's behavior, with Whistler's old animosity stoked by the brother-in-law's ever-rising status as an etcher. While Whistler was in Chile, Haden had published an article about etching in the *Fine Arts Quarterly Review*, and Philippe Burty, one of the gatekeepers of French art criticism, had published Haden's Thames etchings. Burty also championed Legros.[18]

When Whistler and Willie then encountered Haden at a Paris café, years of "insufferable insolence and insult" caused the artist to snap. He shoved Haden with enough force to send him crashing through a plate-glass window. A magistrate dismissed all three men, Willie included, with a warning, but later that day, Whistler sent the brother-in-law a scathing letter. He denounced Haden as a "transparent humbug," a "bully of women," a "very Pecksniff," the self-serving, duplicitous hypocrite in Charles Dickens's novel *Martin Chuzzlewit*. "Your whole life is one foolish lie," Whistler ranted. "I have done with you, and only regret that your very cowardice prevented your receiving more punishment at the moment."[19]

Friends and relations responded variously to the news of yet another physical assault by Whistler. People who had been fond of Traer and disliked Haden shed no tears for the brother-in-law, even if they regretted Whistler's lack of restraint. Anna could not but side with her sons, but Deborah was obliged to defend her husband. Having been told, though erroneously, that strong drink had fueled her brother's rage, she pleaded, "For Heaven's sake my dear Jem, stop while there is time or you will die Traer's death." Then, a seemingly final parting. "You cannot live in the world

& do these things," decreed an "utterly miserable" Sis. "For your own sake keep away . . . for wherever you were I could not see you after this."[20]

Yet, even as Debo wrote to him, Whistler found another reason to despise Haden. Traer had been given a "dog's" funeral, without benefit of religious ceremony or a Christian cross to mark his grave. Haden justified the arrangements by claiming, quite falsely, that a legal prohibition prevented a Protestant clergyman from delivering the sacraments in a Catholic cemetery. Jim and Willie had a cross placed on the grave and made plans, through Traer's sister, to return his remains to England. It took more than a year to accomplish the deed, with the Whistler brothers, including George, paying over half of the £62 in expenses. The rest of the money came from friends of Traer, including Rossetti, Swinburne, Sandys, du Maurier, Keene, Alexander Ionides, and George Cavafy.[21]

Desperate to counter the "injurious" and "false" rumors that now circulated about him, Haden published a seventeen-page pamphlet to explain his actions. Unwisely, in the process, he accused Henry Cole, director of the South Kensington Museum (now the Victoria and Albert) and head of the Exposition's British commission, of suppressing evidence about Traer and of being "liable . . . morally" for Traer's death. They were extraordinary charges, not least because Haden had been Cole's personal physician and a close friend for over twenty years. Haden's pamphlet killed the friendship, and his erratic behavior caused more than a little stir. "I think really he must be mad," judged one man.[22]

Nor was Haden, known for his "violent temper," done with Whistler. Both men belonged to the Burlington Fine Arts Club, located at 177 Piccadilly and composed largely of "gentlemen" interested in the arts. Haden had been a founding member. Whistler, sponsored by William Boxall and Louis Huth, had been elected to membership in March. On June 11, as the furor over Traer began to recede, Haden proposed to the club secretary that Whistler's recent behavior was "intolerable to any society of gentlemen." He should be dismissed from the Burlington. That same day, the club's executive committee, on which Haden served, asked Whistler to resign.[23]

So began six months of drama and farce, Whistler versus the Burlington. The artist, dumbstruck that he should be asked to resign without being given an opportunity to tell his side of the story, asked for a "court of inquiry." Ralph N. Wornum, the club secretary and keeper of the National Gallery, acknowledged that the committee had perhaps acted hastily and promised to "investigate . . . the [alleged] cases of assault" more thoroughly. Whistler bristled at the implication that the club had

a right to "investigate" the private lives of members. He replied curtly that he would have nothing to do with such proceedings.[24]

Whistler's friends approved. Brother George warned that resignation would be an admission of guilt. Gabriel and William Rossetti, both Burlington members, said they would resign if Whistler were forced out (fig. 40). On the defensive, Wornum explained to William Rossetti that some members feared that the hot-headed Whistler, if allowed to stay, would attack them as a matter of routine, a veritable Caravaggio. Fantin-Latour laughed when he heard about the *contretemps.* "Whistler is like a woman," he told Edwin Edwards, "like a mistress you love despite all the trouble she gives you."[25]

Whistler relished the commotion, though he was quite sincere in his determination to be treated as a gentleman. "[N]o compromise – no pity!" he told William Rossetti. "I am not to be treated with this insolent discourtesy." Learning that Haden had solicited affidavits concerning his violent behavior from Legros and Baldwin Wake, the postal officer on the *Shannon*, he accused the former of "vile cowardice." Legros's lies and toadying had made him "despicable in the eyes of all noble-hearted men," Whistler told him, and "loathsome to all . . . acquaintances."[26]

The standoff lasted until December, when Henry Doty joined the circus. That Doty knew of the affair suggests how widely it was known in London. In an apparently unsolicited letter to Wornum, the ex-arms dealer presented himself as a former captain in the Chilean navy who knew something of Whistler's low character and wished to see justice done. He accused his former secretary of having "basely and dishonorably betrayed" him, and if he had Whistler's alleged affair with his wife in mind, that might explain his sudden appearance on the scene. The English-speaking community at Valparaíso had doubted that the woman known as "Mrs. Doty" was his wife, but regardless, Doty's real wife asked for a divorce shortly after his return to England. By November 1867, she was seeking passage money to the United States.[27]

With this new testimonial, to which was added evidence that Whistler had recently scuffled with a construction worker in Paris, the executive committee called a club meeting for Friday, December 13, to decide his fate. Whistler attended, but after holding a strategy session on December 12 with Willie, the Rossettis, Pre-Raphaelite architect and furniture designer Thomas Jeckyll, and solicitor and club member Henry V. Tebbs, he again denied the authority of members to judge him. His stubborn conviction earned some sympathy, but an overwhelming majority (nineteen of twenty-six voters) found Whistler "not a fit person" for the club.[28]

The Burlington affair is instructive. Whistler could have remained in the club had he responded to Haden's charges in June and shown the least sign of contrition. He had Wornum's committee at a disadvantage following its heedless initial reaction, but his refusal to compromise sank him. He failed to acknowledge that the committee, too, might be composed of gentlemen acting from "principle." The problem was that Whistler had come to accept combat as a natural state. He relished the sheer gamesmanship in any battle of wits or clash of wills, and he considered violence a perfectly acceptable response to "personal insolence."

It did not help that many friends condoned the behavior of this "little Bantam of Battersea Reach." Edwin Edwards, the former lawyer, thought Haden deserved a thrashing. Boxall and Huth approved of their protégé's stand against the Burlington. The Rossettis, who had counseled Whistler throughout the affair, resigned from the club, as they had vowed to do. Two other members also resigned, and friends with no connection to the Burlington sent letters of support. People all over London toasted Whistler's "martyrdom."[29]

Unseen by the outside world, divisions within his family deepened after Whistler's expulsion. Anna vowed "never again" to enter Haden's home, nor to visit or receive calls from his mother. She insisted that Major Whistler had never liked Haden, and she herself had come to distrust him. The family also learned that Debo, in speaking of recent events to Seymour's friends, emphasized that Jemie and Willie were only her "half brothers." All the Whistlers would eventually reconcile, with Anna and Debo meeting each other at the homes of mutual friends by the end of the following year, but the battle remained a source of ill will in the Haden family for generations.[30]

Only George Whistler, who lectured both Haden and Jim from St. Petersburg, where he still represented the Winans's interests, kept a level head. He spoke most plainly, and most sympathetically, to his reckless brother. Jim could not continue to attack people, either physically or with his pen, and expect not to be a target for revenge. "Nobody can indulge in the style of letter writing you permit yourself without coming to grief," George said bluntly. "It is a very serious thing my dear Jim that you are afflicted with this mania – you will have to correct it to succeed in life."[31]

Jim ignored George's counsel, being far more concerned with his artistic future. The uncertainty he felt before going to Chile remained. If anything, as he read the lukewarm reviews of his recently exhibited paintings, Whistler reached a point of crisis. Even people who had once seen promise in his work curbed their enthusiasm.

For instance, Philip Hamerton, having credited Whistler two years earlier with boldly attacking the "technical problem" of painting white on white in *The White Girl*, declared that *Symphony in White, No. 3*, with its "dainty varieties of tint," could not properly be called "white." Whistler was beside himself, not least because Hamerton was a friend of Haden. When the critic asked a few months later to review some Thames etchings for his new book, *Etching and Etchers*, Whistler did not respond. Hamerton retaliated in the book, which he dedicated to Haden, by calling him a "strikingly imperfect artist."[32]

Nonetheless, the words of at least one critic resonated with the struggling artist. Twenty-one-year-old Sidney Colvin, writing in the *Fortnightly Review*, saw "real strength" in Whistler's "perfect mastery" of tone and color, but he thought no other artist "more completely mystif[ied] the average spectator" with his "neglect of form" and "apparently slurring method." Whistler took note. Having always thought of himself as deliberate and painstaking, he now feared that he had only thrown "everything down pell mell on the canvas." He had depended less on skill and technique than on "instinct and fine colour," and so squandered his natural "gifts" through vanity and "puffed up . . . pride."

Equally, he had followed a false prophet. The influence of Courbet had been "odious!" he exclaimed in near pain to Fantin-Latour that autumn; "the regret I feel and the rage, hate even, I feel for all that now would astonish you." Courbet's brand of Realism, popularized at the precise moment an impressionable young Whistler first arrived in Paris, had caused him to suppress his own, unique view of nature. Thinking of himself as bold and innovative, he had only painted what anyone could have seen, merely "what was there in front of him!"

He wished he had studied with Ingres. The French master, having died earlier that year, was on everyone's mind in the summer of 1867. Art journals paid tribute to him. The École des Beaux-Arts mounted a retrospective of his work. Many English artists, including Albert Moore, still revered him. Whistler would not go that far, but Ingres's reputation as a draftsman did remind him that his own reliance on color to hold the eye had been fatal. He must draw more crisply, with more economy. That Baudelaire, the prophet for many writers and painters of Whistler's generation, had died on the last day of August 1867 seemed another omen. His passing marked a natural turning point for Whistler, a signal to begin a new journey of self-discovery.[33]

Fellow artists would have said Whistler was trying to resolve an essential conflict between English and French painting. French artists generally, not Ingres alone, had

reputations as fine draftsmen, whereas the English claimed to be superior colorists. The difference could be too easily exaggerated, as seen with Courbet, but there was enough truth in it for someone like Whistler, who had been exposed in equal measures to the artistic traditions of both countries, to feel the tension. Together and well balanced, complementing each other, line and color formed a perfect union and yielded "beautiful things." Raphael, one of his earliest heroes, had been known for the restraint and perfect proportions of his paintings, and Whistler was, after all, a Raphaelite, not a Pre-Raphaelite.

He and Fantin had talked of such matters for at least five years, but always in terms of achieving harmony through "opposing colors." Suddenly mindful of Gleyre's dictum that color itself must be restrained, Whistler now sought harmony through a delicate balance of similar tones, shades of a single color. He had first glimpsed that truth at Trouville, with his modulated bands of color for sand, sea, and sky. His association with Moore, which resumed after his return from South America, had pointed him in the same direction.[34]

A final piece of his new theory came from an unlikely source. Edgar Allen Poe, the American poet and short-story writer, had been dead nearly twenty years, but Whistler, as well as Swinburne, Rossetti, and Baudelaire, had long been a Poe enthusiast. Whistler felt a positive kinship with him, in as much as Poe was another of West Point's black sheep, dismissed from the academy for want of discipline three years before Whistler was born. More than that, Poe's poetry, fiction, and ideas about composition spoke to his immediate crisis.

In an 1846 essay, "The Philosophy of Composition," Poe had defined literary harmony precisely as Whistler now defined harmony in painting. Explaining why he had constructed his most famous poem, "The Raven," around a single haunting refrain, "Nevermore," Poe noted that the "pleasure" of this refrain came from its "repetition" and "variation." Applying that idea to painting, Whistler saw how the repetition (a "refrain" in Poe's words) of a single color, "*the* true colour," could hold a composition together. Japanese artists, he recalled, used the same technique. They "*embroidered*" a canvas in just that way, "the same colour reappearing continually here and there like the same thread . . . the whole forming in this way an harmonious *pattern*." It was absurdly clear. Embroidery and repetition, by whatever names, further resolved the problem of subordinating color to line.[35]

So that much, the mechanical side of his dilemma, Whistler understood. However, a conceptual challenge remained. How should a painter look at nature? How see the subject? Reynolds and Leslie had warned not to copy nature slavishly, but to use

"imagination" and find one's own "style." The "simple question," Fantin had called it in ironical voice, knowing full well that the issue defied even complex solutions. It still eluded Whistler, too, which was why he remained closeted in his studio. In this context, his tussles with the Burlington and Haden served as emotional safety valves from the gnawing artistic perplexity that threatened to consume him.[36]

In November 1867, with winter approaching, Whistler thought of continuing his "education" in Paris, perhaps with Fantin. As he told George Lucas, "I have a great deal of very hard work to do – and must be more quiet than I can be here." He was working on an "almost lifesize" version of *The Balcony*, another "Bridge" picture, a painting inspired by Poe's poem "Annabel Lee," and, most importantly, a new commission.[37]

The commission came from Frederick R. Leyland, a thirty-six-year-old shipping magnate and art collector introduced to Whistler by Gabriel Rossetti. Leyland had already requested several pictures from Rossetti to help decorate Speke Hall, a sixteenth-century country house he had rented near Liverpool. Knowing that Leyland liked female nudes, Whistler suggested a group of three thinly clad young women. Following his exciting breakthrough with the third *Symphony in White*, that would give him an opportunity to perfect his mastery of the female form.

Whistler made numerous drawings and pastel studies for the painting. Some of his graceful female figures stood by the seashore, others on balconies or terraces. Most of them wore loose, free-flowing gowns, sometimes Classical in design, sometimes Japanese, quite often a fusion of the two. He copied the poses and garments from Hellenistic figurines in the British Museum, although he was also clearly indebted to the work of Moore and Burne-Jones. This "Greco-Japanese" style had become fashionable in England. Architect and designer Edward W. Godwin, whom Whistler had met through Rossetti, so liked the eclectic combination that he forged an "Anglo-Japanese" style of interior decoration and design. Godwin's companion of several years, actress Ellen Terry, dressed at home alternately in Grecian robes and kimonos. To Whistler, the gowns lent a spontaneous, unencumbered look, neither Realism nor Classicism.[38]

Algernon Swinburne loved the experiments when he saw them in Whistler's studio the following spring. By then, Whistler had turned the studies into six preliminary oils on millboard. In addition to Leyland's commission, most often called *The Three Girls*, they included four similar groupings of young women and a picture of Venus. The brightness of the colors varied from picture to picture, but they all conveyed Whistler's new ideas about harmony, each one being based on variations of one or

two colors, principally white, beige, green, or blue. William Rossetti called them "very promising in point of conception and colour-arrangement."[39]

They would later be called – though not by Whistler – his "Six Projects" or "Six Schemes," and they spoke directly to Swinburne's new aesthetic philosophy. The poet had become one of the first English writers to endorse the French notion of *l'art pour l'art*, art for art's sake. Less restrictive in his thinking than French theorists like Baudelaire and Gautier, he offered a liberating, English version of the idea, similar to the aesthetic ideal voiced by Sidney Colvin. Not only were subject and place irrelevant in a work of art, Swinburne proposed, but beauty of composition alone, the beauty of the "moment," without message or emotion, should be its goal. Equally, he insisted that art should be divorced from the spiritual. Let beauty speak for itself and be its own end, without moral purpose (fig. 41).[40]

Swinburne was so enthralled by Whistler's new work that he mentioned it in a review of the 1868 Royal Academy show, even though Whistler did not exhibit. He lauded the "immediate beauty" of the paintings and compared Whistler to Rossetti, another non-exhibitor the poet found room to praise. Both artists, Swinburne said, shared "one supreme quality of spirit and of work . . .; the love of beauty for the very beauty's sake." He used Whistler's own musical language to describe the "melody of ineffable colour," the "varying chords" of color, and the "interludes" of "tender tones" in his work.[41]

Encouraged by his friend's endorsement, Whistler locked himself in his studio for days on end that summer and fall, barely taking notice of the world. "I am up to my neck in work!" he wailed to Fantin. "[T]he models come and the daylight, and the sun sets far too soon and then someone comes in and stays to dinner – and if I go out for a moment boom! night time! And I'm worn out, dropping with sleep and incapable of doing anything!"

In December, with the sun shifting completely away from his studio windows, he accepted an offer from Frederick Jameson, an architect friend, to share his studio at 62 Great Russell Street, across from the British Museum. The location also allowed him to inspect further the museum's Elgin Marbles and collection of Hellenistic figurines. Equally convenient, as Whistler continued his battle with the female form and Classical design, Moore still lived in nearby Fitzroy Street.[42]

Jameson found his guest "painfully aware of his defects" as a painter and struggling to regain confidence. Whistler cancelled sessions with models, continually scraped down the painting for Leyland, and seemed unable to complete anything. Charles Keene, stopping to visit, thought Whistler oddly indecisive. Life was complicated

further by the necessity of spending at least two evenings a week with his mother, in Lindsey Row. An attack of neuralgia, forcing him to convalesce under his mother's care, also cost valuable time.[43]

By mid-March 1869, Whistler was so embarrassed by his inability to complete Leyland's painting that he offered to return his patron's £400 advance, even though that meant borrowing money from brother George to stay afloat. Drawing the female form had not been easy for him, an especially galling realization for a devotee of Hogarth, whose "line of beauty," the serpentine "S," matched the curvature of a woman's body. His experiments had allowed him to forge a fundamentally new understanding of line, color, and composition, but he had hoped for more.[44]

In a perverse way, the sensation caused by two Moore paintings, *Venus* and *Quartet*, at that summer's Royal Academy show made it easier for Whistler to move on. It took all of G. F. Watts and Frederic Leighton's considerable influence, including a threat to withhold their own work, to have the jury accept Moore's pictures, but the entire exhibition, as it happened, confirmed the popularity of the Classical revival that would define English taste for the next twenty years. Whistler organized an expedition to Burlington House, the academy's new home in Piccadilly, for Anna and Willie's former in-laws, who were visiting London. "[Y]ou'd have fancied he was rejoicing over his own success," Anna marveled, "with so much zest did he enjoy the days holiday." Whistler called Moore's *Venus*, which had been commissioned by Leyland following an introduction to the collector by himself, "the most beautiful work in the Academy. . . . I mean one of the most marvelously perfect things that has been produced."[45]

It was all the reason Whistler needed to bail out on Classicism. He could never master that style, not as Moore had done. Indeed, his desire to imitate or incorporate the styles of others had been a problem all along. He had been so intent on learning what he could from Hogarth, Rembrandt, Courbet, Hokusai, the Pre-Raphaelites, and Moore that he lost all sense of his own identity. It was time to master an exclusive style, to create art that would be undisputedly Whistlerian.

So, with visits to a Turkish bath having rid him of the nagging neuralgia in his back and head, he felt emotionally and physically rejuvenated. He attended a recital by the celebrated opera singer Kristina Nilsson, escorted Anna to a musical "Jubilee" at St. Paul's Cathedral, and took his American guests to a Sunday service at Westminster Abbey. Returning to Lindsey Row from Great Russell Street, he found that Anna had persuaded their landlord to paint the front door, trim the ivy, plant flowers, and generally "put all in neat order for the Season."[46]

Swinburne required care and attention, too. The slightly built, highly emotional, red-haired poet, dubbed "little carrots" by Burne-Jones, could try a person's patience. A hopeless alcoholic who also suffered from a form of epilepsy, Swinburne was fascinated by the dark side of human nature. He idolized Poe and Baudelaire, and had once traveled with Whistler to Paris for the express purpose of meeting the Frenchman. The paganism and sexuality of his published verse scandalized respectable society. *Punch* dubbed him "SWINE BORN," and even some members of Rossetti's circle found him "wanting in human feeling." For all that, the Whistler family adopted him. Anna, whom the poet adored, gave him moral tracts, as she had once done to Russian peasants, in hopes of saving his soul.[47]

Whistler saved Swinburne's skin in an episode at the Arts Club that July. Founded by Arthur Lewis in 1863 as an extension of Moray Lodge, the club, located in Hanover Square, included a mixture of artists, collectors, and dilettantes. Both Whistler and Swinburne joined. Some members had wanted to oust Whistler after the Burlington affair, and they were even less tolerant of Swinburne's obnoxious behavior when he was in his cups. The limit came one night when a drunken Swinburne, oblivious to his actions, "stomped on two members hats & knocked somebody's pipe out of his mouth." It was enough to be blackballed, but Whistler argued his friend's case before the executive committee. "Jemmy stood up for him," an admiring Charles Keene reported of the incident, "& got the poor little wretch out of his mess." Whistler apparently told the committee, "You accuse him of drunkenness – well that's his defense." The artist may also have felt partly responsible for his friend's behavior. It was said that he "alone was able to keep him [Swinburne] from drink."[48]

Whistler's only problem was a familiar one, lack of tin. He knew by the end of summer that a scheme by Alexander Ionides to publish a new set of Thames etchings had collapsed. In a gesture of regret, Ionides bought a self-portrait Whistler had done after returning from South America and displayed it prominently in his dining room for wealthy friends and potential buyers to see. Gabriel Rossetti tried to interest friends in the unsold Trouville and Valparaíso paintings. When none of these kindnesses produced sales, Whistler asked Tom Winans for £500. He had been so "absorbed in study . . . and experiment," Whistler explained, that he had been unable to complete any "saleable" pictures. Now, though, having banished his demons, he was ready to resume work. "I can get high prices for what I do," he assured Winans, "and in the world am looked upon and spoken of as a successful man." He only required, like the captain of a Mississippi River steamboat that had run aground, a little "Greasing" to get back in the water.[49]

Winans sent an unknown amount of money, and not a moment too soon. The coming year would be crucial if Whistler was to regain the public eye, although his prospects were not good if one believed in omens. The family learned on the day before Christmas that George Whistler, who had served on several occasions as his brother's conscience, had died. At forty-seven years of age, George had been two years younger than their father when he passed away. At thirty-five, Jemie's own time might be running short (fig. 42).[50]

# 8

# *Butterfly*

## 1870–1873

Success and satisfaction defined the first half of the 1870s for Whistler as surely as chaos and uncertainty had clouded the preceding four years. In some ways, it was the most productive time of his life, at least in oil painting. Having subdued the demons of color and composition, he began no fewer than seventy pictures between 1870 and 1875, including some of his most revolutionary work. He also reemerged as an etcher by producing some forty new plates. There would be personal conflicts and financial challenges as well, but those had become such a normal part of life as barely to give him pause.

He was not the "great force" at Burlington House he hoped to be in 1870. The best he could do was a reworked *Balcony*, exhibited as *Variations in Flesh Colour and Green*. The picture got mixed reviews, often described as "strange" and "eccentric." For one thing, it did not bear Whistler's signature, at least not in a recognizable form. Instead, he used an odd little symbol that looked like a dragonfly. It was intended to be a butterfly, and while its appearance would change dramatically over time, the device became his trademark. It represented a new, rejuvenated Whistler, an unpredictable free spirit, likely to dart in any direction and never progressing in a straight line. Before long, he was known as The Butterfly.[1]

Anna had called him a "butterfly" in his youth, but it was Gabriel Rossetti who suggested that he identify his paintings with a monogram, rather than sprawling

"Whistler" across the canvas. Rossetti had in mind something like the famous "P.R.B." used by the early Pre-Raphaelites. More recently, Simeon Solomon had signed his work with a distinctive device, and Moore had created a stylized anthemion out of his initials. Whistler's butterfly conformed generally to the "W" of his name. Tom Taylor made sport of these "queer little labels," stuck to the "corners of . . . pictures like a postage stamp," but in combination with his musical titles, Whistler was creating a unique public image.[2]

As for his modest showing at the Royal Academy, Whistler may have been distracted by news that he was to be a father. A twenty-one-year-old parlor maid, Louisa Fanny Hanson, gave birth to Charles James Whistler on June 10, 1870. How Louisa knew Whistler is unclear. Perhaps she had posed for him, although she lived in Clapham, south of London. In any case, he was not inclined to marry her, and she quickly disappeared from his life. He apparently told no one of the boy's arrival except Willie, to whom he always turned when "in difficulties with women." Whistler was not even identified on the birth certificate as the father, and the boy would be known throughout life as Charles James Whistler Hanson. He may have been named after Jo's future brother-in-law. Charles James Singleton, a stockbroker, and Bridget Agnes Hiffernan did not marry until 1901, but they were living together in 1870, and they became Charlie's godparents.[3]

Whistler assumed responsibility for the child, but he could hardly keep him at Lindsey Row. Instead, Charlie was sent to be nursed by a Mrs. Doubleday, who lived downriver in the fishing village of Woolwich. Jo took him to stay with her when he was about two years old. They lived at least part of the time with the Singletons at 5 Thistle Grove, a quiet lane that ran north of the Fulham Road. Whistler's long-time companion had been a shadowy presence since Anna's arrival in England, even more so after the artist returned from South America; but friends still regarded them as a couple, a fact underscored by Whistler's reference to Charlie as his "infidelity to Jo."[4]

Whistler's reluctance to marry either Louisa or Jo, if not admirable, might at least be explained. Despite the best efforts of his own parents, whom Whistler venerated, he had scarcely been reared in a stable domestic setting. Nor did the prospect of a settled life suit the artistic temperament of a Butterfly. About the time Jo claimed Charlie, French poet and novelist Alphonse Daudet published *Les Femmes d'Artiste*, a "realist" fictional argument against marriage for male artists. The institution, ventured the happily married Daudet, was simply not meant for "nervous, exacting, impressionable," creative souls who lived "outside the common life." It took a "special type of woman" to satisfy the emotional needs of the "man-child" most

painters, poets, sculptors, and musicians seemed to be. Man-child was certainly an apt description of Whistler, and he had not yet found that special woman.[5]

Despite his new responsibilities, Whistler was buoyant that summer. Friends found him full of stories, especially about how he had saved Swinburne's neck at the Arts Club. He rejoined the celebrated séances at Tudor House, sometimes with Willie in tow. Frederick Leyland also attended, and the entire Leyland family had embraced Whistler by this time. He accompanied them to the opera and dined several times at their new London house, 23 Queen's Gate. They were fond of Anna, too, who had spent time with her son at Speke Hall the previous autumn. Mother and son received another invitation in August, for despite Leyland's disappointment over the fate of "The Three Girls," he wanted Whistler to paint portraits of the whole family, six pictures in all. They were Whistler's first commissioned portraits since Luke Ionides in 1860.[6]

After three enchanting months at Speke Hall, he had completed only one of the pictures, but it was a striking full-length (seventy-six by thirty-six inches) likeness of the lord of the manor. Whistler's slow progress could be explained partly by his subject's busy schedule. The ambitious, self-made, and sometimes overbearing business magnate sat for him only a few hours each week. Equally, though, Whistler was anxious that the portrait be a success. He regularly rubbed out one day's work to start fresh the next day. Rather than create a portrait in segments, slowly building the composition, he preferred to lay out its essentials in one fell swoop. Only then did he feel confident of catching a sitter's individuality. This notion extended not only to the subject's face and expression, but also to the pose and colors.[7]

In Leyland, Whistler saw, as did many people, a Spanish "grandee." With his dark features, pointed beard, and cool, deliberate gaze, he might have stepped straight out of a Velázquez portrait, which is what Whistler hoped to recreate. To heighten the effect, he painted Leyland in black evening dress against a black background, an "arrangement in black," as he would later title the painting. The only bits of "light" came from Leyland's face, a sliver of ruffed white shirt front, a bare hand placed confidently on one hip, and a single gleaming shoe buckle. One can imagine the difficulties Whistler encountered in painting a black figure against a black background. By comparison, painting white on white was simplicity itself. Yet, in limiting his palette to a single, dominant color, he successfully tested one of his most important new theories.[8]

Upon returning to London, Whistler's thoughts turned to etching, a medium he had almost entirely ignored for the past several years. He arranged with publisher

Frederick S. Ellis, located in Covent Garden, to issue a hundred sets of sixteen etchings, all but one having been made between 1859 and 1861, and all but two intended for the defunct Thames project with Haden. They were also among the etchings that Alexander Ionides had hoped to release. Ellis, who published the poetry of the Rossettis, Swinburne, and William Morris, now revived the plan and, working closely with Whistler, created the precise look the artist wanted to achieve. Whistler was especially concerned about the quality of the paper. Having initially tried to import it from Japan, he finally settled for aged sheets acquired in Holland. Bowing to the demands of the market, Whistler agreed to sell the sets for twelve guineas each.[9]

Most reviews of the portfolio, which became known as the Thames Set, praised Whistler for preserving images of a dwindling past, the wrong reason as far as he was concerned. *Punch*, where Whistler had a number of artist friends, including du Maurier, Keene, and Linley Sambourne, came nearer the set's significance by commenting on its rich tone and texture. They surely saw, as well, that the set documented Whistler's progress in etching, from the starkly "realistic" work of the late 1850s to his more atmospheric sketches years later. In a sprightly review called "A Whistle for Whistler," the magazine also recognized his leadership in the English etching revival. He was clearly the "etching master" of his brother-in-law Haden (a "famous surgeon"), declared *Punch*, and his own work, "beat everything of the kind . . . since Rembrandt."[10]

Not by chance, the *Punch* piece was inserted around the borders of a drawing that dominated the center of the page. The illustration depicted a young woman attired in extraordinary fashion. A large butterfly-shaped hat sat atop her head, while the butterfly wings that formed the bustle of her dress extended around her waist. A tiny butterfly served in place of a buckle on each dainty shoe. The droll and mischievous Sambourne had made the drawing to announce the arrival of The Butterfly. Even its caption commented on Whistler's recent mood. Taken from a popular poem, it read: "At times methinks my soul hath wings."

By then, June 1871, Whistler had returned to painting the Thames, and in ways that pushed the limits of his recent discoveries about color and composition. Using the approach first tried at Valparaíso, he showed the river at night, as many as a dozen times in 1871 and nearly two dozen more by the end of the decade. The series eventually included views of Cremorne Gardens, Trafalgar Square, and the streets of Chelsea, but his paintings of the river became Whistler's principal legacy, his unique response to the challenge of Reynolds and Leslie to see nature anew. As one percep-

tive friend put it, "[His] vision is that of one who has seen something that man has looked at for centuries and never seen before." Anna Whistler believed that Jemie's new pictures were "his own look out on the Thames."[11]

They were radical in two ways. First, they took Whistler a step closer to the Asian ideal of suggesting reality, rather than recreating it. A silhouette could serve as a building; a ghostly shape or swish of the brush might be a boat or person. Nor need scale or "real" distances between objects be a concern, for he was not depicting a particular place at a particular moment. That he chose landscapes, the most popular form of nineteenth-century painting, to achieve his ends made Whistler's break with tradition all the more emphatic. To what extent the spirit world of séances influenced his vision must remain speculative, but the pictures had a distinctive other-worldly quality.[12]

With shadows and allusions to convey the "moods" and poetry of the river, Whistler used lighted windows along the riverbank to fix the eye; an unseen moon, filtered through mist, fog, or clouds, illuminated the scene. Indeed, his first impulse, after speaking of the pictures as a new series of "harmonies," was to call them "moonlights," as Turner had labeled his night views of the river. Yet, Turner had been more interested in color than composition. It was the magic of darkness, the reality of shadows, that attracted Whistler. One wonders if he thought again of Poe, who had written in "Murders in the Rue Morgue," "[I]t was a freak of fancy in my friends . . . to be enamoured of the Night for her own sake" (fig. 43).[13]

To understand the physical effects of darkness, he had the Greaves brothers take him out on the Thames after sunset or before sunrise. "We often used to stay up all night on the river with him, just rowing him about," Walter recalled. Whistler sometimes sketched with white chalk on brown paper to remind himself of the relative position of riverbanks and bridges. "I got it! That's it," he would say after making several strokes, "that reminds me of the whole scene." The final composition grew from those observations, his own familiarity with Battersea and Chelsea Reach, and a soupçon of imagination.[14]

Putting the scene on canvas, Whistler abandoned the bands of color used at Trouville, so that many pictures betrayed scarcely any differences between sky and water. The paint seemed to have been poured on, eliminating nearly all indications of brushstrokes and enhancing the look of effortlessness and spontaneity. Best of all, the genre permitted endless variations, so that while each picture was undeniably Whistlerian, each was also original. Whistler had found a way to satisfy the demands of the marketplace while retaining the uniqueness of his work.[15]

He also made a very different picture that summer. When his model for the day fell ill, the exasperated artist, keen to be doing something, went to Anna and said, "Mother I want you to stand for me! it is what I have long intended & desired to do, to take your Portrait." Just like that, on the spur of the moment, Whistler began one of the most iconic portraits in Western art. He thought to paint his mother standing at first, as she had done for a recent etching; but Anna, now sixty-seven years old, soon knew that would never do. "I stood bravely, two or three days whenever he was in the mood for studying me," she told her sister Catherine, "but realized it to be too great an effort." So Whistler had her sit, "perfectly at my ease," Anna said.[16]

He decided on a mostly black arrangement, partly because Anna, still as much in widowhood as Queen Victoria, always wore black, but also because his largely black and gray studio called for it. The completed portrait would be an *Arrangement in Grey and Black*. He also employed his theory of "threads" by using touches of lighter colors – cream, yellow, pink, ivory, and silver – to hold the composition together. A black curtain or drapery, for instance, used to anchor the left side of the picture, contained an exquisitely delicate silver-gray pattern that matched the color of the wall beside it (fig. 44).

Yet, beyond all the "science," it was impossible to miss the affection that infused the work. He made Anna's face luminous, the brightest part of an otherwise somber-looking picture, and the point to which eyes are immediately drawn. He drew the marks of aging around her eyes and neck tenderly. Friends recognized the positioning of her hands, clutching a handkerchief, as her "very way" of sitting. Years later, responding to praise for his achievement, Whistler mused, "Yes, one does like to make one's mummy just as nice as possible!"[17]

That single, unguarded remark raised suspicions about Whistler's repeated insistence that his art had no emotional content. In truth, as shown in his nocturnes, he was more the romantic than he would dare admit. No artist could be as passionate in his personal life and not betray himself in his work. That he was able to harness his passion and maintain a balance between emotion and formal abstraction was one of the most remarkable things about the painting. People who knew the Whistlers understood. James Rose, who had virtually adopted Anna in place of his own late mother, asked to see the painting four times in as many weeks. Gabriel Rossetti told Whistler, "Such a picture as you have finished of your Mother, must make you happy for life, & ought to do good to the time we are now living in."[18]

Brimming with confidence, Whistler returned to Speke Hall in October to finish the Leyland portraits and with ideas for other pictures (fig. 45). He did several

"evening skies" in pastels while at the hall, and he planned to fill some "small canvases" with "great masses of waves" along the nearby coast. Unfortunately, this first attempt to capture the energy of the English seacoast "fell through." Far from trying to devour him, as the tides had done in France, the English seas were ridiculously docile. "[T]he weather was simply blank!" he cried in disbelief. "The sky – I never saw it so stupid – and as to the sea – it was nowhere at all! – it had simply gone off altogether – really I went to the seaside and I found no sea!"[19]

But life at Speke Hall, where he remained until February 1872, had its compensations. Whistler was quite literally seduced by the place, or at least by its women. He was smitten with Frances Leyland, his patron's lovely and accomplished wife. So, too, with her younger sister, Elizabeth "Baby" Dawson. Whistler began courting the twenty-one-year-old charmer, sixteen years his junior, and by the time he returned to London, they were engaged to be married. The confirmed bachelor had yielded to Lizzie's youth and beauty. Neither was he blind to the social and financial advantages of joining the Leyland clan. As he later admitted, being part of "the set" at Speke Hall had "spoiled" him.[20]

Not that this urban *flâneur* was entirely cut out for the landed gentry. He was part of a shooting party one day when a large bird suddenly flew up from the grass. "Now's your chance!" someone shouted. Whistler cocked his gun, fixed his eyepiece, and blazed away. The bird kept flying, but one of the hunting dogs yelped and fell wounded. "Nothing more was said," reported a member of the group, "and somehow or other we drifted back home." Whistler tried to make light of the situation. "It was a dog without artistic habits," he maintained, "and had placed itself badly in relation to the landscape."[21]

In between hunting, lovemaking, and his trials with open-air painting, Whistler continued with the Leyland portraits, with the bewitching Frances next in line. She had wished to be painted in a black velvet evening gown, to match the picture of her husband, but Whistler thought that all wrong for her. So had Rossetti when, four years earlier, he painted her as a Pre-Raphaelite woman. Whistler wanted to set off her auburn hair, much like Jo's tresses, against more muted colors. And he envisioned her not in restrictive, formal attire, but in a flowing "tea gown," all silk and chiffon, almost intimate in its informality, very Greek, very Japanese, very aesthetic.[22]

Just as her husband's portrait expressed self-assured masculine power, so hers revealed a woman above worldly concern. Whistler painted her full-length, back to the viewer, hands placed behind her, one upon the other. He turned her head and long, graceful neck in profile, but the painting's crowning achievement was the

expression on Frances's face. Her cool, slightly bored look, with eyes half closed, at once demure and aristocratic, was magical. More than mere arrangement or harmony, she became a *Symphony in Flesh Colour and Pink* (fig. 46).

The placement of her hands also bears mention. Of the dozens of portraits Whistler painted during his life, in only one other, also of a woman, did he place the subject's hands behind her, and only with Frances were the hands visible. Whistler arranged them as delicately as he had those of his mother. This, then, must have been a natural pose for Frances, one that meant something to him. Their placement also contained, almost in defiance of her aristocratic bearing, a hint of vulnerability, as though this daughter of an iron-molder was not, after all, entirely certain of her place.[23]

Meantime, good news arrived from London. Before leaving town, Whistler had entrusted two paintings, including a "moonlight," to the Dudley Gallery, in Piccadilly. The Dudley was really just an exhibition hall, but it operated on the same principle as a number of private commercial galleries, including the Berners and French Gallery, that had sprung up since the 1850s and afforded opportunities to exhibit outside the Royal Academy and Salon. Gallery owners also served as dealers, a part of the art trade that had become increasingly necessary as the number of artists and buyers grew. By combining targeted exhibitions with a sales room, private galleries had become, as Tom Taylor noted, the "chief channel between the supply and demand of the industrial picture-market." They also welcomed controversial work and let artists decide which pictures to display.[24]

Both of Whistler's pictures sold before the Dudley exhibition closed. Thomas Sutherland, a lawyer, member of Parliament, and, like Leyland, a shipping tycoon, bought *Variations in Violet and Green* for an unknown price. London banker William C. Alexander paid £210 for its partner, *Harmony in Blue-Green*. Most critics saw the paintings as Japanese-inspired "experiments" or "delicious pieces of indefinite nothing," but artists and friends praised Whistler for having rendered "the poetical side" of the river. He was becoming known as a painter's painter, someone whose refined and deft personal interpretation of nature yielded a "very advanced art."[25]

And no sooner had he returned to London than an astonished Whistler was embraced by the "South Kensington crowd." In March 1872, Henry Cole commissioned him to design a pair of decorative mosaics for the upper level of the museum's south court. Cole had already asked Watts, Leighton, Prinsep, and Poynter for similar work at twenty-five guineas each. Hoping to draw on Whistler's recent experiments with Classical style, he asked him to provide an Egyptian goddess and a Japa-

nese "art worker" for the project. Whistler welcomed this unexpected entrée to the world of academicians, especially when Cole also asked to show *Symphony in White, No. 1* and *La Princesse* at the museum's upcoming International Exhibition.[26]

More than winning a commission, Whistler also gained an important friend in Cole. He had first met the director of the South Kensington Museum when, living with the Hadens in the 1840s, he had attended parties with Cole's children. He became reacquainted with the family in the early 1860s, again through the Hadens. That had already led to friendship with the sixth of Cole's children, Alan Summerly Cole. An expert on textiles who worked for his father at the museum, Alan became one of Whistler's closest confidants. They spent evenings in Lindsey Row smoking cigarettes and drinking "cocktails," and when Whistler could not have *The White Girl* ready in time for the museum's exhibition (damage to the area around Jo's head forced him to show *The Little White Girl* instead), Alan saw him through the crisis. Now the father, his own break with Haden eliminating any possible awkwardness, drew closer.[27]

However, Whistler's biggest test of public and critical approval in several years came when he submitted the portrait of his mother to the Royal Academy. It had nearly been destroyed on the return journey from Speke Hall, where he had added some finishing touches. The railroad car that carried the picture had caught fire, an ill omen it seemed when the academy jury rejected the painting. That would have ended the matter had not William Boxall threatened to resign from the academy's council over the decision. The jury timidly reversed its decision.[28]

Even so, the unconventional portrait failed to impress most people. Benjamin Moran, the U.S. consul in London, liked both Anna and her artist son, despite the "strong dash of the Bohemian" in the latter, but he did not even mention the picture in his notes on the show. Mary Gladstone, the artistically inclined daughter of the prime minister, looked only at the paintings of her friends Millais and Watts when touring the galleries. Paradoxically, Gladstone's lack of appreciation contrasted with Watts's own appraisal. When fellow painter William Richmond told him that Anna's portrait reminded him of Velázquez, he nodded agreement and added, "without the bones." Published reviews praised the "astonishing" effects achieved with such a limited palette, conceded that the picture was "beautifully and delicately" drawn, but also thought it "smacked of caprice."[29]

The reactions failed to deter Whistler, who was by now certain of his new theories, but it helped to have another well-heeled family adopt him that summer. William Alexander, the thirty-two-year-old Lombard Street banker who had bought *Harmony*

*in Blue-Green*, wanted Whistler to paint his three daughters. While preferring Old Masters and eighteenth-century British artists, Alexander had nonetheless become an enthusiast of Japanese and Chinese art, and from the moment he saw his first "moonlight" at the Dudley Gallery, Whistler was his favorite living painter. He and his wife, like the Leylands, also took a shine to Anna, who shared their deep religious convictions. Mother and son had become quite a team.[30]

Whistler began with eight-year-old Cicely Alexander, and he knew exactly how to cast her. His many portraits of women having made Whistler an expert on fabrics and female fashion, he sent detailed instructions to Mrs. Alexander for the "fine Indian muslin" dress Cicely should wear. He recommended that the material be bought either at Farmer & Rogers or at a little shop off Leicester Square. If pure Indian muslin could not be found, the "usual" muslin for women's evening dresses might be substituted. The color, however, must be pure white, Whistler insisted, purged of any corruptive tints. He conceded only that the skirt might "be looped up from time to time with bows of pale yellow ribbon."

Cicely and her mother traveled twice a week to Whistler's studio, eight miles from their home in Hornsey, and stayed the day. Rachel Alexander visited with Anna while Cicely, who was taking ballet lessons at the time, posed like a ballerina, one foot extended. Whistler harmonized the white of her dress with the dominant gray-green wall and floor by adding hints of gold and yellow, the "threads" of his tapestry, to the buckle of Cicely's shoes, a pin in her hair, a feather in her hat, the eyes of some daisies, the wings of the two dancing butterflies, and a discarded garment lying casually in the background.

The finished painting was brilliant but a trial for both artist and sitter. Whistler was by now notorious for the demands he made of his subjects. Leyland had spoken of "martyrdom," but he got off lightly. Whistler required seventy sittings of Cicely, so that the eight-year-old came to think of herself as more "victim" than subject. She learned, as would all his sitters, that Whistler could never "see" them properly until "everything – light, weather, mood – was just right." This impossibly complex combination "might come several days in succession," claimed a painter friend, "or but once in a fortnight."

Cicely returned home in tears on more than one occasion, although that often happened because Whistler had caused her to miss her dancing lessons. "[H]e was quite absorbed and . . . never noticed the tears," she declared, but Whistler did see the tears, and tried to make amends by letting Cicely rummage through his pots of paints whenever clouds or fog disturbed his light. She also found amusement in his

style of painting, the way he would stand "a good way from his canvas, and then dart at it, and then dart back." All was forgiven in time, and looking back, Cicely conceded that she had been a very "disagreeable little girl." Her pouting, petulant look in the portrait told all.[31]

Seventy-seven-year-old historian and philosopher Thomas Carlyle soon sympathized with Cicely. The Sage of Chelsea had been persuaded to sit for Whistler after Emilie Ashurst Venturi, a mutual friend and amateur artist, took him to see Anna's portrait. It is unclear if Carlyle and Whistler had yet met, although they lived only minutes apart. Whistler may have encountered him through the wide circle of English writers and intellectuals, including Venturi, Rossetti, and Swinburne, who supported the movement for Italian independence. Both Whistler and Anna had met Giuseppe Mazzini, who lived for a time in nearby Fulham Road, and Whistler had made small donations to the Italian cause. Carlyle did not commission the portrait, so Whistler would receive no payment until able to sell it, but the prestige of painting the great man could do much for his reputation.[32]

Carlyle claimed not to care for art, and he had not been pleased with an earlier portrait by G. F. Watts. The experience taught him to take charge of these situations, and so it may have been he who asked to pose in virtually the same position and setting as Anna. The artist agreed to put Carlyle in his mother's chair but not in her shoes, for despite the similarities of pose and color, the pictures were of two very different people. Anna's portrait, like the person, bespoke patience, tranquility, piety. Carlyle simply looked bored, liable at any moment to rise and walk away. Whistler also composed the pictures in subtly different ways. To balance Anna's portrait, he inserted a sliver of picture frame in the upper right corner. Remove it, and the entire scheme collapsed. In Carlyle's portrait, he used his butterfly signature to anchor the arrangement.

Like Cicely Alexander's pout, Carlyle's restless look expressed the ordeal of sitting for Whistler. He tried to shorten the interminable hours by talking to the painter, but Whistler rarely conversed when working. Only if Carlyle suddenly shifted his position did he respond with a "For God's sake don't move!" Not appreciating his role as an "arrangement," Carlyle complained that the picture was more a "portrait" of his clothes than of himself. Yet, the atmosphere in the studio was not unfriendly. Though utterly different in nearly every way, the two men liked each other. They strolled together along Cheyne Walk at the end of the early sessions. Carlyle thought Whistler's affectations made him "the most absurd creature on the face of the earth," but he also called the artist "a very remarkable person."[33]

Whistler had another important commission in 1872 from Louis Huth, one of his staunchest defenders in the Burlington Club affair, who asked him to paint a portrait of his wife, Helen; but it was the non-commissioned symphonies and moonlights that Whistler needed to sell, although, by late 1872, he no longer called the new paintings moonlights. Frederick Leyland, an able pianist and devotee of Frederic Chopin, had suggested they be called "nocturnes," and the idea delighted Whistler. It allowed him to be consistent in his use of musical titles while further confounding the critics. "Besides," he told his patron, "it is really so charming and does so poetically say all I want to say and *no more* than I wish!"[34]

In a roundabout way, the Franco-Prussian War provided a pair of venues to exhibit his new work. A rush of French refugee painters and dealers to London in 1870 had infused the art scene with fresh talent and entrepreneurial vigor. Paul Durand-Ruel, a fixture in the French art world, had been the most active dealer. Upon returning to Paris in 1871, he retained his rented gallery at 168 New Bond Street and left English-born Charles William Deschamps in charge. Deschamps, still in his early twenties, was a nephew of Ernest Gambart.[35]

Deschamps exhibited four Whistler paintings that winter, including *Symphony in Grey: Early Morning, Thames*, which had been rejected by the Royal Academy the previous spring. More importantly, Durand-Ruel showed half a dozen pictures at his reopened gallery at 16 rue Lafitte, including the still unsold *Balcony* and *Arrangement in Grey*. The latter was the only one of his many self-portraits to show Whistler as an artist, palette and brushes in hand. He appeared to model it on a self-portrait by Joshua Reynolds, an indication that he still craved acceptance by the Royal Academy. Having not exhibited in Paris for five years, it was a good way to reintroduce himself to the French public.[36]

He asked George Lucas to explain the "system" behind his symphonies and nocturnes to potential buyers and critics. "They are not merely canvases," he reminded the dealer, "but are intended to indicate . . . something of my theory in art. The *science* of color and '*picture pattern*' as I have worked it out for myself during these years."[37]

He also wanted Lucas to stress the importance of his frames. Whistler had first designed his own frames a decade earlier, starting with the *Lange Lijzen*. Its gilded oak frame had two distinct parts. A thin outer border, decorated with Chinese motifs, surrounded a broader surface that immediately encased the picture. The inner part had five rows of spirals cut into the wood, with six large Chinese characters, the "six marks," painted on the corners and at the horizontal midpoints.

Whistler ordered similar frames in the 1860s for *The Little White Girl, The Golden Screen*, and *La Princesse* before introducing three new designs in the 1870s. He first used a checkerboard pattern, another familiar Chinese motif. He then experimented with a more horizontal reed, or basket weave. It, too, was Asian, inspired by Chinese porcelain and Japanese fabrics. Whistler often combined these two designs, the checkerboard filling the frame panel while the reed/weave motif adorned the inner and outer edges. Finally, and most notably, he introduced sets of overlapping curves or waves to the broad flat of some frames, a standard Japanese device. This was especially effective, as one might guess, in framing seascapes. In coming years, he used four additional designs and tried a variety of decorative devices, including rosettes, floral decorations, and Maltese crosses.

His purpose, as he explained to Lucas, was to make his frames part of the composition. This was quite unlike their traditional function, which was to enclose, confine, and separate the canvas from the surrounding space. Other artists, including the Pre-Raphaelites and Degas, had decorated their frames, Whistler conceded, but without "real purpose – or knowledge." He was also undoubtedly original in using frames to flatten his pictures and emphasize their shallow depth. When hung on a neutral-colored wall, the overall effect was a seamless integration of picture, frame, and background, a genuine harmony. Let everyone know these things, Whistler told Lucas. He wanted no "forgers or imitators," no "lot of clever little Frenchmen" stealing his ideas.[38]

However, not everyone was impressed by the new Whistler. At least one friend, Fantin-Latour, was frankly puzzled, a surprising reaction, given how many of his own ideas had influenced Whistler. But Fantin had become disillusioned with other old friends, too, and in the commitment to a bold, visionary art they had shared. Having heard little from Whistler since 1868, he confessed after seeing the paintings in rue Lafitte, "I don't understand any of it. I no longer recognize him. . . . I'd like to see him to hear him explain what he's trying to do." When Whistler finally visited him the following spring, they discussed his new direction "amicably," but Fantin felt a "coolness" between them. "[H]e appeared enchanted with himself, persuaded that he is moving forward while we others stick with the old painting," Fantin decided. Whistler believed that Fantin did not "want" to understand his work.[39]

In London, public and private reaction to Whistler remained just as mixed. Some critics found the fanciful titles, curious signature, and restricted palette too much to absorb. "There is always danger that efforts of this class may degenerate into the

merely tricky and meretricious," one reviewer lamented, "and already a suspicion arises that the artist's eccentricity is somewhat too premeditated and self-conscious." They might admit that Whistler's "slovenliness" was more apparent than real, and that his pictures, in their own way, were "absolutely true to Nature." Yet, the majority dwelled on his "imperfections," and doubted that he took his art seriously.[40]

Otto Scholderer, the German-born follower of Courbet whom Whistler had known since student days in Paris, responded more favorably. Recently settled in London, he had followed Whistler's newest incarnation with interest, and now compared notes with Fantin. "I like Whistler's landscapes more than before," he admitted; "I'm beginning to understand them better now that I've seen several. I'm not yet at the stage [Edwin] Edwards is, who tells me he believes anyone ought to understand it. . . . [Yet] [t]he finesse of his color, above all, his touch charms me; its as fresh as Manet's and finer, more gourmand." Manet had more "God-given talent," the German conceded, but Whistler was "more of an artist."[41]

Whistler cared only that he be regarded as unique, part of no school, assigned to no category. He could do little to staunch the rush of artists who copied his innovations. As *Punch* observed, pictures of girls in white muslin had become a fad. He warned his "pupils," the Greaves boys, not to replicate his work, and even worried that one of Moore's sketches might be mistaken for his own. The word "genius" had been used to describe him. Well, geniuses must stand alone. There could be only one Butterfly.[42]

To promote this independent image, he cultivated dealers and buyers more assiduously by hosting Sunday breakfasts in Lindsey Row, something Frederick Leighton was already doing at his home in Holland Park. A long-standing tradition had artists opening their studios on "Picture Sunday" during the Season in order to test public reaction to their work; "trial heats before the great race," as one observer put it. Whistler's variation on the theme added lively conversation and a meal. The latter often featured American-style buckwheat cakes, prepared by the host, although the extent of the fare depended on Whistler's always uncertain finances. Most importantly, he made his breakfasts exclusive events. Having received personal invitations to attend, guests were among the elect, and "the charm of the host sufficed to cover any deficiency in the feast."[43]

Guests also learned not to expect their host for an hour or two after the invited time of 11 a.m. Whistler had first to bathe, dress, and arrange his hair. Some people thought all the fuss unmanly. At the very least, it seemed extraordinarily vain, but his tardiness was deliberate, meant to ensure a grand entrance. Whistler prepared himself

as an actor applies makeup and dons a costume before appearing on stage, and, of course, there was much of the actor in him, one reason for his love of the theater.

The purpose of all this being sales, Whistler pushed the limits of the market as never before. He charged Louis Huth 600 guineas for the portrait of his wife and another 250 guineas for a recently completed view of Chelsea, *Variations in Pink and Grey*. However, Huth balked when Whistler mentioned a range of 800 to 1,000 guineas for *Symphony in White No. 3*. He also became less amiable when Whistler allowed a model, posing in place of his wife, to wear Helen's expensive velvet gown. In addition, Whistler suffered a loss when Henry Cole withdrew the commission for his badly overdue South Kensington mosaics. No matter. Leyland had bought *La Princesse* for his new London house, and some etchings were going for nearly ten guineas apiece.[44]

Whistler had also begun to crack the U.S. market, thanks to a friend of George Lucas. New York-born Samuel P. Avery, a trained engraver, was among the first American dealers to exploit the appeal of contemporary European art in his country. He had admired Whistler's work since at least 1867, when he served as U.S. art commissioner at the Universelle Exposition. In 1872, he bought thirty-five Whistler etchings, and the artist supplied him with photographs of his paintings as a means of enticing distant buyers. Having given photographs of his work to friends as early as 1865, Whistler realized their value as advertisements.[45]

He hit a rough patch that autumn of 1873. In September, Lizzie Dawson decided not to marry him. No one seemed surprised by her decision. The flirtatious Lizzie had broken the engagement more than once in the previous two years, and Whistler had invested more passion in his work than in the courtship. Being told of her decision, he seemed more perplexed by a recent summons to jury service. Nearly simultaneous attacks of rheumatic fever and bronchitis then laid him low for much of October and November.[46]

Rumblings of a new artistic revolt in France that December revived him. A band of French painters, led by Pissarro, Degas, and Monet, were organizing an exhibition in opposition to the Salon, and Degas wanted Whistler to join them. Whistler had much in common with these "Independents," as they called themselves, many of whom he had known for over a decade. Most notably, he shared their core belief that painters should "render not the landscape, but the sensation of the landscape." He and Degas had come to admire each other's work, and Monet, whom Whistler had probably met by this time, was painting "bridge" pictures strikingly similar to his own. Yet, Whistler's work was more abstract than the Independents', soon to be

known as Impressionists, and his application of paint and darker palette entirely different. Then, too, he saw them as another threat to his uniqueness. An acquaintance recalled him saying, "Oh, I know those fellows; they are a bunch of Johnnies who have seen my earlier work."[47]

Whistler did not reply to Degas's summons, but the Impressionists had given him an idea. That November, the normally conscientious Charles Deschamps had mistakenly identified a Whistler painting as *A Symphony in B Sharp* in an exhibition catalogue. The critics snickered. Whistler, responding in the press for the first time since his *Woman in White* letter of 1862, corrected the error, but he was also determined to eliminate such embarrassments in future.[48]

# 9

# Peacocks and Nocturnes

## 1874–1877

In January 1874, Whistler leased the Flemish Gallery, located at the rear of 48 Pall Mall, for £315, nearly four times what he paid for his house. Deschamps, Durand-Ruel, and other dealers had been very accommodating, but they had many clients, their space was limited, and they had the ultimate say in the appearance of an exhibition. By staging his own show, Whistler could arrange the pictures, select the furnishings, choose the decor, and write the catalogue. Nothing could so completely confirm his identity as an independent artist.

With the help of a "wonderfully clever" frame maker and decorator named Frederick Fox, Whistler turned the pedestrian gallery into a "pleasant 'artist's studio,'" free of "discordant elements." He painted the walls a pinkish-gray, covered the floors with "glaring yellow" matting, installed "rich light maroon" couches, and balanced the rooms with an abundance of plants, flowers, and Chinese vases. Thin blinds hung beneath the skylight created a "subdued and mellowed" effect. Even one of the exhibited works, a folding screen on which he had painted a view of Battersea Bridge, added to the ambiance.

He hung his thirteen oils, thirty-six drawings, and fifty etchings on just two lines, with ample space between works. The larger oils provided occasional breaks in the lines. Degas, who had long recommended this radical departure from the usual ceiling-to-floor exhibition arrangement, did the same for the Impressionist show,

which opened in April. Whistler bound his eight-page catalogue in plain brown paper, an idea borrowed from Deschamps. He signed invitations to the private view, scheduled for June 6, with a butterfly, as he had begun to do with some of his correspondence.[1]

As the big day approached, friends grew excited. Rossetti predicted, perhaps with a touch of envy, that the exhibition would send Whistler's reputation "sky-high." Swinburne could barely contain himself. "I know of others who would give their ears for it," the kinetic poet gushed upon receiving his invitation. "I have seen at least some of the things to be exhibited, and . . . they are second only – *if* second to anything – to the very greatest works of art in any age." Even the reclusive Thomas Carlyle, having declined an invitation to meet the new Russian tsar, Alexander II, would attend in order to see public reaction to his portrait.[2]

When the doors finally opened, visitors applauded Whistler's achievement. Rossetti did not think Frances Leyland's picture a very good "likeness," but he would not dispute its "graceful design," and he conceded that the portraits of Anna, Carlyle, and Cicely were "very fine . . . in their own way." The entire exhibition impressed Otto Scholderer. "What pleases me, and what I haven't felt in his painting," he reported to Fantin-Latour, "is the purpose he has in making each one of them, and a serious and artistic purpose." Whistler wished that Fantin could see it all, that he, too, might understand his "purpose."[3]

Allies in the press called it the "most important event in the Art world." The "official censors" of the Royal Academy should see the show, mused Sidney Colvin, that they might finally appreciate Whistler's unique art. The *Art Journal*, Britain's most influential arts periodical, said his supposedly eccentric musical vocabulary conveyed what too many painters overlooked: "that a picture, whatever its subject, must make its appeal to the eye." After all, the writer concluded, as if taking dictation from Whistler, "A picture should, before all things, be a beautiful scheme and design, both of lines and colour."[4]

Even so, the show produced few sales. James Alfred Chapman, a Liverpool industrialist, possibly introduced to Whistler by Leyland, bought two nocturnes for a hundred guineas apiece, but the artist had hoped for better. What was more, when he refused to restore the rooms to their pre-exhibition appearance upon expiration of his lease, his landlord successfully sued him for £6 11s. 8d.[5]

By then, the summer of 1875, he faced a more perplexing problem. At seventy years of age, Anna Whistler was not faring well in England's dank climate and London's smoke-laden air. Bronchitis had become a nearly annual affliction, and as other

ailments started to plague her, Willie hired a full-time nurse. Debo, the family turmoil of eight years earlier having abated, visited frequently. Even so, Anna remained confined to the house through a damp, cool summer. A fire burned in her grate, even in July. Her breathing remained labored; she coughed heavily.

Persuaded by Willie to leave London, Anna took a suite of rooms at 43 St. Mary's Terrace, high on a hill above the seaside town of Hastings, on England's southern coast. By September, she was strong enough to stroll along the hillside. If feeling fatigued, she sat in her landlady's "pretty flower garden." At night, she could see the lights of the town from the bow window of her sitting room, although she most enjoyed watching, as her artist son would have done, the "moonlight shining on the sea beyond."[6]

Anna's departure liberated Jemie. Acknowledging her indomitable nature, he had taken to calling both Anna and her by then famous portrait "The Mother"; but mothers, no less than wives and children, could cramp a fellow's style, and once freed from her watchful eye, he returned to the unrestrained life of an artist. Emilie Venturi, who had always thought the "propinquity" of mother and son a bit odd, almost rejoiced to see Whistler return to "his evil ways." It was time for the inimitable Butterfly to spread his wings.[7]

Besides Sunday breakfasts and occasional teas, Whistler gave no fewer than fourteen dinners between late August and the end of the year. The dinners ranged from modest affairs of fried cod and cold lamb to feasts that included oyster soup, fried sole, mutton cutlets, oven-braised beef fillets, and pheasant. A variety of cheeses and sweets – usually pastries – accompanied most meals, always followed by coffee. Some dinners were "smokers," with men only in attendance. On those occasions, the menu specified "Café-Cigarettes," rather than "Café" alone. However, Lindsey Row was not Moray Lodge, and all-male gatherings were relatively rare. Whistler believed that all civilized occasions required the presence of ladies.[8]

He staged his entertainments as carefully as he would an exhibition. The dinner menus, created by hand on the morning of the affair, were miniature works of art, written in French, printed on quality paper, and adorned with his butterfly signature. He selected guests with equal care, seeking a mix of patrons, dealers, and artists. He brought together Samuel Avery, Albert Moore, and Cyril Flower one evening. Flower, a barrister known as the handsomest man in London, had been part of the majority that expelled Whistler from the Burlington, but he had since introduced the artist to affluent friends. A few nights later, the guest list included Alan Cole, James Tissot, and Frederick Jameson and his wife. Henry Cole found

himself seated between Frances Leyland and Frances Boehm, wife of the sculptor Joseph, on another occasion.[9]

A friend believed that Whistler entertained so frequently because he disliked solitude, but it was closer to the truth to say he simply enjoyed talking, hearing what other people had to say, and playing to an audience. Conversations in Lindsey Row crackled with talk of art, literature, theater, and music. Whistler was interested and knowledgeable in all manner of things, and had an opinion on everything. The merits of Balzac's novels became the focus of one dinner conversation. Other evenings brought rousing discussions about the "innate desire or ambition . . . to be creators" or the "practical impossibility" of properly performing Shakespeare's plays.[10]

Yet, most people were stymied if pressed to explain why Whistler's conversation was so riveting. As a friend explained, "[S]o much depended upon the man himself, his personality and his manner, and so much upon the exact appropriateness of every word uttered to the mood of the occasion." He was so well read, cosmopolitan, and quick-witted that he could contribute a wealth of stories and informed observations to any conversation. He knew when to be serious, when to be airy, when to inquire, and when to deflate bombast with "barbed arrows." And he expected rebuttals. He relished the company of clever people with whom he could exchange ideas and match epigrams. Friends described him as "alive to the finger tips," filled with "energy," his "agile" mind ever ready for the next contest.[11]

He was also far more tolerant than his combative public image allowed. When discussing art, especially with students or collectors, he betrayed "not the slightest suggestion of patronage, hauteur, or condescension; no show of superiority, wisdom, or greatness." Though an occasional "damn" or "dammit" escaped him, he was rarely profane or vulgar. Though passionate, Whistler was not ill bred, certainly not in the company of women, with whom he was "unfailingly courteous" and "deferential." He respected the intelligence of women, too. In later years, he professed, "[F]or worlds I would not seem to enter upon a tilt with a lady! Men are pigmies, and I am born to collect their scalps, but think you I have not sufficient wit to know that one brilliant woman against me, and I am lost?" Some people recognized a "feminine" element in Whistler's own manner, by which they meant his physical grace, easy charm, and the "deft and agile movements of his hands."[12]

Sometimes, he merely lay in wait, understanding, like all great raconteurs, the importance of timing. For instance, Whistler had known Sir Richard F. Burton, the formidable explorer and linguist, for some years by the 1870s. One evening, at the home of Luke Ionides, a "heated religious discussion" broke out after dinner.

The chief antagonists appear to have been Burton (a "Mahometan"), his wife (a devout Catholic), and Gabriel Rossetti (a "pagan"). All three had marked opinions about religious faith, and before long, a raging debate had "everybody very hot and excited." Everybody, that is, but Whistler, who listened attentively. Finally, Lady Burton, seeking to break the stalemate, asked his religious preference. Whistler, feigning surprise that his opinion should be sought, replied, "I, Madam? Why, I am an amateur," at which everyone dissolved into laughter.[13]

Few people knew how much forethought, as with his seemingly effortless paintings, lay behind Whistler's powers of conversation and repartee. He honed his technique for guiding conversations and "keeping the limelight effectively on himself." He seemed always in motion when speaking, even if seated. He rocked, leaned, pointed, and gestured. He used props, too, such as his monocle, which might be waved in circles, screwed into his eye for emphasis, or let drop to the floor while he fumbled in his waistcoat pocket for a replacement. Rumor had it that he carried four or five eyepieces for that very purpose. He might move a matchbox or salt cellar from place to place on a table, or bring it down with a "triumphant rap" for effect. When standing, he would lean into a person and look them "searchingly" in the eyes. With men, he might place his hand on the listener's arm to emphasize a point, or "buttonhole" a fellow by firmly grasping his lapels.[14]

Just as he had taken to writing with dashes and parenthetical asides, so did he begin to speak in fragments and phrases, frequently repeating a thought, often pausing for effect, sometimes ending in mid-sentence, so that listeners had to imagine his conclusion. "Well, you see, you know – well, you know – you can take it up – you can put it down – and then you – look at it." If a listener, sensing a pause in Whistler's delivery, seemed about to "cut in," he quickly added, "Quite right, my dear," before hurriedly resuming his monologue. Better yet, he would interject a prolonged "AND!" on a "raised note with the assertiveness of a barrister defending a weak case." With conversation thus momentarily suspended, he used the pause to plan "his next move."[15]

He had a repertoire of accents, trills, and laughs. Americans thought he sounded "very English." Britons and Europeans said he retained the flat nasal "twang" of his native country. Some people heard a sharp staccato; others detected the languid syncopations of the American South. One friend described his "strange accent" as "part American, part deliberately French." Most described his voice as high-pitched, loud, harsh, occasionally grating. In truth, Whistler altered his voice to suit an audience and the occasion, often with purposeful affectation. He used an exaggerated,

upper-class English accent when dealing with people he wished either to impress or bewilder. "I'm chawmed to meet you," would be his greeting, followed by, "Deah old Pendleton, how is he? Fine old chap," with the entire conversation punctuated by "Beg pahdon?" and "Reahly!"[16]

He often tossed out a triumphant "Ha! Ha!" or "Ah hah – ah hah!" to confirm the wisdom or wit of his own observations. At other times, his laughter seemed "wild" and unrestrained, "a weird, mocking, almost fiendish laugh, unique of its kind." A variation became the "war-whoop of an Indian who has just scalped his foe." Then there was Whistler's famous "peacock laugh," which could be even more irritating than his high-pitched voice. Some described it as a "caustic, nasal" cackle.[17]

People who did not know him well attributed Whistler's speech and mannerisms to massive conceit. Better say he liked to perform, and little did they suspect his enormous insecurity, the constant worrying and questioning of his abilities. He was forever seeking approval. Had people seen his exhibition? he would write or ask. Had they liked it? Had they seen his recent quip in the press? As his letters to editors appeared more frequently, he would tuck each new "literary composition" in a pocket, to be read aloud on the spur of the moment. Laughing childishly at his own cleverness and chuckling over each "pungent satire and barbed phrase," he asked what friends thought of it. If a response was slow to come, he pressed them. Why did they hesitate? Did they not approve?[18]

Also unsuspected was Whistler's respect for artists he knew equaled or exceeded him in talent. He and Edgar Degas had opposite personalities. The irascible Frenchman cared nothing for fashion, even less for "taste," almost nothing for society. They were the same age, yet Whistler was a bit intimidated by Degas. He accepted rebukes from him that he would have suffered from few other people. They went round and round one day, as Degas tried to convince a doubtful Whistler of the "beauty" of a particular picture. Degas told him to look at this feature and that quality, but Whistler only shook his head. "Non, non, non," he said, as he paced back and forth, looking hard, trying to understand Degas's perspective. Who won the day went unrecorded, but not once did Whistler contradict Degas, or declare him wrong.[19]

Not that Whistler often praised other artists publicly. Indeed, he was more likely to make light of them, even the ones he admired. Being told by a woman that his work rivaled the best of Velázquez, Whistler famously quipped, "Why drag in Velázquez?" Asked sometime later if the remark was to be taken seriously, he responded, "No; of course not. You don't suppose I couple myself with Velázquez do you? I simply wanted to take her down a bit, that's all." Hearing someone gush

over the multi-talented Frederic Leighton's prowess as musician, linguist, and orator, Whistler could not help tossing in, "Paints a little too sometimes, don't he?" Outsiders might think this a snide swipe at the Classicist, but Whistler knew that whatever his other accomplishments, Leighton was first and foremost a fine artist.[20]

People who divined the purpose of his public posturing accepted Whistler's streak of genuine egotism because he carried it to such extremes that they could not help but laugh with him. "Perfectly good humored and satisfied with a conceit that is colossal," decided a fellow artist, "so colossal that it is really delightful, *and – cheek!*" Said another observer, "He was childishly vain, but used his vanity with a cool insolence that either amused or exasperated." Whether goading a critic or a friend, "he was in his sly way laughing at himself." Then again, as du Maurier once observed, "Jimmy's quite as amusing when he doesn't intend to be as when he does."[21]

Friends accepted his immaturity, too. "Mischievous," "elfin," "impish," and "child-like" were all words used to describe him; characterizations inspired only incidentally by Whistler's slight stature. An acquaintance explained his mannered dress and appearance by saying, "[H]e was a *poseur*, and always had to do something different from other men." Someone else thought his "spirit of fun and devilry" akin to that of an adolescent boy. This further explained Whistler's physical and verbal combativeness, which were often precipitous and ill-considered. "Sometimes his remarks were almost startling in their reckless daring," noted a man, likely to cause "consternation" even in friends. But then, as this same fellow recognized, "combat was the delight of his life, and . . . I do not think he was ever quite happy unless one of these pretty little quarrels was on hand."[22]

Yet, where combativeness was concerned, one must never forget the two elements that inspired it. First came questions of honor and gentlemanly behavior. This had been the root of his disagreements with the Burlington Club, Haden, and Legros. Whatever his flaws and affectations, Whistler adhered to an unswerving, if sometimes idiosyncratic, code of conduct. Anyone who breached that code or questioned his sincerity courted trouble. Similarly, he never joked about serious issues of art. He exchanged witticisms and banter gleefully on any subject, but became quite earnest when discussing the science of his profession. Both demands – respect for himself and for art – grew naturally from Whistler's own quest for perfection in his work.

His problem, one might even call it his tragedy, was that not everyone understood or recognized this serious side. They took it to be mere "touchiness" or eccentricity. One old acquaintance eventually gave up on him. Arthur Livermore, who had married a long-time friend of Anna, conceded that Whistler was "perfectly good

natured" and had "very fine notions of art," but he also found the younger man "a very odd person." Livermore spent years apologizing for Whistler's "eccentricities" and wishing he would "behave as he ought to do" before conceding that, for all his "cleverness" and "many personal charms," Whistler was "a vain and selfish person."[23]

Whistler was partly to blame for Livermore's frustration. People could not always tell when he was in earnest, or appreciate the strength of his convictions. "[T]he more deeply serious side of his nature," one critic maintained, "was apt . . . to be ignored or even denied." His "manifest enjoyment in the free play of a ready and relentless wit" obscured the "essential principles of the art he practised," and to which few others could give "finer or more subtle expression." Degas summoned up this paradox when he reprimanded, "Whistler, you behave as though you have no talent."[24]

By the end of 1875, with three exhibitions looming, Whistler had time neither to pose nor do battle. He was especially anxious about the Dudley Gallery's winter exhibition. It would be his fourth appearance there since 1871, but he had never shown anything quite as daring as *Nocturne in Blue and Gold, No. 3* or *Nocturne in Black and Gold: The Falling Rocket*. Nor had anyone else. The former picture, while slightly bolder than his previous nocturnes, could at least be recognized as a view of the Thames. Not so *The Falling Rocket*, which shattered the boundaries of conventional painting. Nothing in the first Impressionist exhibition could touch it. Not even Whistler would again produce such a revolutionary picture.[25]

He painted *The Falling Rocket* at Cremorne Gardens, one of at least eight pictures he made there between 1872 and 1875. Introduced to the place by the Greaves boys, it became a favorite summer haunt. Whistler liked to stroll the grounds and observe the people, often with Alice Greaves, then twenty-five years old, on his arm. Opened in 1832 as a rival to the famous "pleasure gardens" at Vauxhall, Cremorne's twelve acres, stretching northward from the river to the King's Road, held a covered dancing platform, exhibition buildings, theater, refreshment rooms, and banqueting hall. Special events included hot-air balloon ascents, acrobats, mock medieval tournaments, and, most popular of all, fireworks. Several popular dances and songs, including the Cremorne Quadrille and Cremorne Polka, were inspired by its air of gaiety. The gardens attracted middle-class families on Sunday afternoons, but come evening, the brightly illuminated grounds became so notorious for "drink, dance, and deviltry" that complaints by local residents and churchmen led to its closing in 1877.[26]

Not that anyone could identify Cremorne in Whistler's *The Falling Rocket* (fig. 47). He had simplified his subject to almost total abstraction, certainly to the point

where an identifiable setting or story became irrelevant. The inky darkness of this "nightpiece" set it apart from the comparatively brighter blues and greens of earlier nocturnes. He brightened the essentially black canvas not with moon, setting sun, or twinkling lights, but a fireworks display. Even then, except for a blast of light on the lower left side (fireworks being launched), the only illumination came from the sparks of an extinguished rocket, nothing more than gold and yellow flecks. They looked like randomly splattered daubs, belying the fact that the entire composition was as meticulously composed and delicately balanced as *The Mother*. He had used Cremorne's fireworks as a source of light in an earlier picture of Battersea Bridge but far less dramatically.[27]

Few even of his staunchest advocates knew what to make of it, which pleased Whistler more than if he had won universal praise. His "vicious art of butterfly flippancy," he declared, was "doing its poisonous work" among the ignorant critics. He could afford the negative reviews, too, when Percy Wyndham, a jurist and member of Parliament, bought the less audacious *Blue and Gold* for £210.[28]

A positive review of his first (and only) public theatrical performance added to Whistler's high spirits. *Twenty Minutes under the Umbrella*, by Augustus Dubourg, was one of a trio of plays staged by friends at a theater in the Royal Albert Hall to aid local charities. Both Alan Cole and Whistler had leading roles, and Whistler reportedly helped Cole's married sister, Isabella Fowke, adapt the script. Son Charlie, who attended one performance, recalled "great applause."[29]

The applause had scarcely faded when, a few weeks later, Frederick Leyland offered Whistler a fateful commission. The Liverpool magnate had recruited Whistler's friend Tom Jeckyll to remodel his new London house, at 49 Prince's Gate. He only needed Whistler to decorate some "dutch metal" panels in the hallway, a task Whistler appears to have completed by May, when forty-nine-year-old Jeckyll, a manic depressive, suffered a sudden mental collapse. Anxious to finish the nearly completed dining room, Leyland asked Whistler to step in. Jeckyll had already installed the walnut and leather paneling, designed to highlight Leyland's extensive collection of "blue and white." The porcelain was to be displayed on open shelves of carved wood that girdled the room, interrupted only by three large windows that overlooked Leyland's back garden. All Whistler need do was gild the ceiling, doors, shutters, and upper dado. It should have taken no more than a few days, but then Whistler had a better idea.[30]

The gilding completed, he persuaded Leyland that the red flowers on Jeckyll's leather wall panels should be painted yellow and gold, so as to harmonize with his

own *La Princesse*, which was to hang above the room's fireplace. Well, one thing led to another, and by the end of August, Whistler had added a golden wave pattern, meant to be a peacock's plumage, to the cornice and dado, and painted enormous gold and blue peacocks on the window shutters. He had been waiting for just such an opportunity to use the peacock motif, which could be found in numerous London homes by the 1870s. Long a symbol of immortality, peacocks achieved a new vogue in Victorian England as signs of elegance and breeding. Whistler had suggested using them two years earlier to redecorate a pair of rooms at William Alexander's new home, Aubrey House, on Campden Hill. Moore had decorated a Berkeley Square house with the birds two years before that.[31]

Let loose in Leyland's dining room, Whistler lost himself in the sheer joy of creation. He scampered about on ladders and scaffolds to judge the effect of every daub of paint. At Leyland's invitation, he began to spend nights at the house, which the family had vacated during the renovations, and so worked from dawn to dusk. "I am nearly blind with sleep and blue peacocks feathers," he told Frances Leyland. "And how I am working!" he emphasized, "like a nigger."[32]

He was enormously proud of his accomplishment, and come September, as the room neared completion, he invited friends to see it. Artistic London was soon abuzz over Whistler's "Peacock Room." When an arts journal picked up the story, he shared the credit with his "old friend Tom," even though little remained of Jeckyll's original design. Anna, still her son's chief promoter, sent friends in America a copy of the article. An appreciative Whistler told her, "It is a noble work, and one we may be proud of – it is entirely new, and original, as you can well fancy it would be – for at least that quality is recognized in your son."[33]

Leyland responded less enthusiastically. The conservative businessman did not condemn the "elaborate scheme" outright, but Whistler had clearly exceeded his instructions. When the artist then asked two thousand guineas for his work, an incredulous Leyland offered half the sum. An acrimonious correspondence ensued. Whistler insisted that the value of the shutters alone exceeded the proffered payment. Leyland countered that he had not authorized the shutters. More than that, he treated Whistler as a tradesman by paying him in pounds rather than guineas, the usual form of payment for artists and professional people.[34]

Whistler took revenge. Knowing the Leylands would not occupy the house until spring, he obliterated both Jeckyll's beautiful antique leather and his own painstakingly retouched flowers by painting the entire room peacock blue. He added more golden waves and repainted parts of the lower panels in blue and gold. Whistler

insisted that the changes made the room more beautiful, but he resembled "a little evil imp" as he worked. With the shutters closed, and a new blue carpet replacing Jeckyll's patterned rug, the room looked like a lacquered Japanese box.

Whistler added the crowning, if perverse, touch on the south wall, opposite the fireplace and *La Princesse*, by painting a twelve-foot-long mural of two enormous, brilliantly arranged peacocks. Intended as an allegory, the peacocks represented artist and patron. One of them (Leyland) was a "haughty," raging bird; the other one (Whistler), "calm" and dignified, exuded "suppressed strength" as he confronted his rival. The dignified bird had a silver crest feather in imitation of Whistler's white forelock. The "raging cock" sported a silver tuft at its throat, a reference to Leyland's ruffled shirt fronts. Whistler studded its breast feathers with silver coins and scattered more coins at its feet to suggest the bird's avarice (fig. 48).[35]

In February 1877, he held a "private view" at Prince's Gate for his *Harmony in Blue and Gold*. Given that Gustave Courbet, one of his models for self-promotion, had died at the start of the year, the timing seemed appropriate. Emilie Venturi praised the room as "a work of genius in its way, and . . . much too beautiful for the very shoddy couple" for whom it had been created. Henry Cole, who had seen Whistler's initial scheme in June, thought the final version "Dashing." Edward Godwin, Whistler's architect friend, praised it in a published review as a "wonderfully lovely harmony" and "unique work of art." Other people were more amused than impressed. Architect Philip Webb suggested facetiously to George Howard that Whistler should decorate a few rooms at Castle Howard, in Yorkshire. "It wd enliven the Castle that wd," Webb laughed, "and cheer up the gardener, as you could then slaughter the real [peacocks]" and rid the grounds of their irritating "braying."[36]

Whistler knew a reckoning with Leyland must come, but he appeared not to have a care in the world. Venturi, who now lived near him in Lindsey Row, observed in early April that he had been "vexing with mirth the drowsy ear of night very constantly." He attended several séances and engaged Louise Jopling, whom he had recently met, in a memorable debate about the merits of spiritualism. The experience cemented an enduring friendship with the thirty-four-year-old painter from Manchester.[37]

Willie's wedding provided another respite. After years of struggling, both professionally and personally, the doctor had found a happy niche in life. Barred from practicing his specialty of laryngology in England without first passing a pair of examinations, he had established a general medical practice in Old Burlington Street. Unfortunately, he attracted largely deadbeat patients who rarely paid their bills.

James Rose gradually collected the fees and warded off creditors, but Willie suffered "great mental depression" until obtaining a part-time position at Dr. Morell Mackenzie's hospital, 32 Golden Square. Established in 1865, Mackenzie's facility was the first one in the world to specialize in diseases of the throat. By 1872, with that experience to his credit, and having passed his first examination, Willie took a combination house and surgery in Brook Street, off fashionable Grosvenor Square. He became a club man, too, accepting election to the Arundel. That was probably arranged by his brother, who, along with Rose, Gabriel Rossetti, Albert Moore, and Frederick Sandys, was already a member.

Finally, after passing his second qualifying examination, Willie was financially secure enough to marry Helen Ionides, a cousin of Luke and Aleco (fig. 49). The couple exchanged vows on April 17, first at St. George's Church, near Hanover Square, then at a Greek Orthodox church in the City. Anna was too frail to attend the ceremonies, so Willie and "Nellie," as everyone called Helen, stopped at Hastings on their honeymoon.[38]

The only cloud hanging over all their lives was the plight of poor Debo (fig. 50). Sis had taken several hard knocks during the past year. First, sons Seymour and Harry left home to test life's prospects in South Africa and Australia, respectively. Then, Haden moved the family, against Debo's wishes, from Kensington to more fashionable Mayfair, where the "Grand MDs cluster[ed]," said Anna with uncharacteristic sarcasm. Finally, only weeks before Willie's wedding, word came that twenty-two-year-old Harry, who planned to become a sheep farmer in Australia, had died of dysentery.[39]

Whatever the family's fortunes, Whistler was immersed in a revolutionary new exhibition by May. Fifty-two-year-old Sir Coutts Lindsay had built a new art gallery, and no ordinary one. Designed to resemble an ornate private residence, the five-story edifice at 135–37 New Bond Street, very near Willie's Brook Street surgery, included a billiard room, library, private clubroom, and large dining room, where Lindsay's wife Caroline played hostess at sumptuous dinner parties for artists and their patrons. People compared its grand, Renaissance-style facade, green marble vestibule, and elegant furnishings to "some old Venetian palace." Lady Lindsay, a writer, gifted artist, talented violinist, and an heir to the Rothschild fortune, paid for most of the £100,000 Grosvenor Gallery (fig. 51).[40]

While Lindsay, who had studied art in Paris and Rome, denied any desire to compete with Burlington House, he clearly meant to give the Royal Academy's tired old summer show a run for its money. Walter Crane imagined the new gallery would

be "a kind of cave of Adullam for distressed artists" who had "suffered . . . at the hands of the Academy." He and Whistler were among sixty-four artists, including Burne-Jones, Millais, Moore, Poynter, Tissot, Watts, Lawrence Alma-Tadema, and Jopling, invited to participate in the inaugural show. It was a genuine mixture of the avant-garde and public favorites, and Whistler was thrilled by Lindsay's decision to group the work of each artist together, something seldom done in official exhibitions. Then again, with Old and New Bond streets already home to several prominent commercial galleries and becoming a Mecca of cosmopolitan taste, fashion, and commerce, Lindsay's showcase was as much about marketing as about art.[41]

No one who attended the first Grosvenor show ever forgot it. The festivities began a week before the opening with a banquet in the gallery's dining room. The Prince of Wales topped the guest list, but all manner of counts, lords, princesses, and knights attended. Most of them were patrons of the gallery and its artists; many were themselves amateur artists whose work Lindsay had wisely agreed to display. Whistler, besides attending the banquet, was reportedly the first person to arrive for the private view on April 30, 1877.[42]

In conjunction with Whistler's Peacock Room, the Grosvenor helped debut the English Aesthetic Movement, which would dominate the kingdom's cultural life for the next decade. In some ways, Aestheticism was only a refurbished Pre-Raphaelitism, with healthy doses of Neo-Classicism, *japonisme*, and "art for art's sake" tossed in for good measure. None of its ideas would have sounded strange at Tudor House or Little Holland House. Nor was it insignificant that Arthur Liberty, who had by then driven Farmer & Rogers out of business, doubled his stock of East Asian merchandise six months before the Grosvenor show. Lindsay's "Palace of Art" became known equally as the "Palace of the Aesthetics," home to the "Swinburnian School of painters."[43]

Conservative artists, reared on the standards of the Royal Academy, saw varying degrees of danger in the movement, yet a new direction in English painting had taken hold. It was as influential as the first Impressionist exhibition, and with more immediate impact. Despite his continued association with the movement, Algernon Swinburne, its nascent voice, had been replaced by Walter Pater, an Oxford scholar who had preached the "love of art for its own sake" since the late 1860s. Whistler could not have asked for a better endorsement of his own work than Pater's credo: "All art constantly aspires towards the condition of music."[44]

Such was its appeal that Aestheticism became a way of life for some people, a cult of beauty, expressed in fashionable clothing, the decor of the "house beautiful," even

the planning of gardens. Like most cults, it soon parodied itself, and the affected dress, speech, and mannerisms of devotees provided rich satirical material for the popular press. George du Maurier published his first Aesthetic cartoon in *Punch* three months before the Grosvenor show. The magazine followed up a month later by conducting a facetious tour of the studios of artists who were to exhibit at the Grosvenor. "Received with open arms, a war-whoop, and a mint julep," reported the man from *Punch* as he entered Whistler's place. "By Jupiter, what a sketch!" he exclaimed. "Beg ten thousand pardons!" he corrected himself, "what a finished picture! I mean that Fugue in blue-major, with pizzicato background. . . . It is undeniably a Whistler."[45]

All this attention should have worked to Whistler's advantage, especially since half of his four nocturnes and four portraits had already met with critical approval. Not so. Lindsay, who had "expected great things" of him, was disappointed with the work's lack of finish. Henry Cole expressed the same opinion. Julia Cartwright, a young admirer of Burne-Jones, whose paintings were universally praised as the best of the show, was of two minds. "The Whistlers are mad," she confided to her diary. "I like the mist scenes and the midnight scenes too and the bridge and the piers with the lights at sea, but can't stand the portraits or rise to the foolish names – 'Nocturnes in Blue and Silver,' – 'Harmony in Amber and Gold'!"[46]

Public comment was equally divided. Henry James, a then promising American novelist who had been supplementing his income for the past decade as an art critic, dismissed Whistler's "experiments" as entirely disconnected from "life." William Rossetti, while finding more to approve than to disapprove, used the word "experiment" to describe his recent portrait of renowned actor Henry Irving. *Punch*, in its talismanic issue of July 7, 1877, dubbed Whistler "The Genius of Smudge" for the same picture. Twenty-two-year-old Oscar Wilde, recently sent down from Oxford, did not understand the nocturnes at all. Taking a very different view from Cartwright, he called the portrait of Carlyle Whistler's "one really good picture."[47]

Still, the artist appeared to be in "great form" for at least two months after the Grosvenor opening. An American woman who dined with him found the artist "self satisfied" and speaking "very highly of his own works." When he learned that Coutts Lindsay, a fellow spiritualist, had photographed "the vibrations caused by spirit raps," he pressed the gallery owner for details. His good humor continued when replying to a request from a young woman for a list of his "favorites," such as favorite color, flower, and so on. He identified his favorite occupation as "Whittling."[48]

July, however, proved an unsettled month. First, Leyland confronted him over both the Peacock Room and rumors about the artist and Frances Leyland. Despite

the now unbridgeable gap between the two men, Whistler had remained on intimate terms with his patron's wife. How far Frances encouraged his attentions is hard to say, but her recklessness may have been inspired by knowledge of Leyland's several mistresses. Returning to London a week before her husband, in March, she had a strained conversation with Whistler, very likely about their awkward situation. Whatever the tensions, they passed, and Whistler continued to visit 49 Prince's Gate and escort Frances and the girls in public.[49]

Decrying Whistler's willingness to "take advantage of the weakness of a woman [and] to place her in such a false position before the world," Leyland forbade him to enter the London house and ordered Frances to sever all ties with the artist. They ignored the decrees. Rumors spread that Frances intended to run away with Whistler. When Leyland learned that the couple had strolled openly together at Lord's Cricket Ground, he threatened to "publicly horsewhip" his rival. Delighted by the uproar, Whistler threatened to expose Leyland's meanness by publishing their correspondence, and hinted at announcing what he knew of his extramarital dalliances.[50]

Suddenly, though, Frances, calculating her social and financial position, submitted to her husband. Their twenty-year-old son Frederick, who had come to think of Whistler as an elder brother or favorite uncle, intervened with a sobering letter. "[Y]ou will not again approach my mother in any way," he told his friend. The entire family had rallied to his father, Freddie insisted, and hoped that the artist would "not force matters further." Even Whistler, full of righteous indignation against the father, had to feel the sting of that rebuke. He and the senior Leyland would quarrel further over unfinished pictures and promised payments, with some vindictive moments yet to come, but the danger of scandal had passed.[51]

By that time, Whistler had a more formidable adversary in John Ruskin. Coutts Lindsay had invited England's foremost authority on art to the Grosvenor opening because he anticipated a sympathetic appraisal from the man who had championed the Pre-Raphaelites, but the Oxford professor was not impressed by what he saw. His published comments were relatively brief, an afterthought, really, to the July issue of his eclectic series of reformist pamphlets, *Fors Clavigera*. The sober-minded and sexually repressed Ruskin used these manifestoes to combat what he saw as the decay of moral standards in Britain, not least in the arts. So, while praising Lindsay's efforts to "help artists and better the art of his country," he did not think much of the art Lindsay promoted.

Ruskin dismissed most of the exhibition in the bluntest terms. The Aesthetic Movement as championed by Pater, once a disciple, had distorted the meaning of

beauty and the purpose of art, which, Ruskin insisted, must express the highest moral standards and values of a society. He found no moral uplift at the Grosvenor. The only painter of worth had been Burne-Jones, whose work still combined beauty with virtue. Burne-Jones also happened to be an old friend with whom he dined after surveying the show.[52]

Whistler, the very antithesis of Burne-Jones, did not stand a chance with Ruskin. Indeed, he became the critic's prime example of the decay of art and society, and not for the first time. Nearly three years earlier, in one of his Oxford lectures, Ruskin had described a Whistler painting as "a daub professing to be a 'harmony in pink and white' (or some such nonsense)." This "rubbish" had probably not taken more than a quarter hour to "scrawl or daub," he calculated, and yet the artist had asked 250 guineas for it. Such an outrageous inversion of value to product was yet another sign of society's bankrupt standards. When Ruskin then found Whistler asking 200 guineas for his notorious *Falling Rocket* at the Grosvenor, he simply exploded: "I have seen, and heard, much of Cockney impudence before now; but never expected to hear a coxcomb ask two hundred guineas for flinging a pot of paint in the public's face."[53]

Whistler had been smoking quietly at the Arts Club when fellow American painter George H. Boughton showed him newspaper reports of Ruskin's scathing remark. Normally the "life of the place," Whistler grew solemn as he read the caustic words for the first time. After a moment's reflection, he said, "It is the most debased *style* of criticism I have had thrown at me yet." Boughton agreed, and suggested that it might be libelous. Lighting another cigarette, Whistler replied thoughtfully, "I shall try to find out," and left the club.[54]

A few days later, James Rose, who had an enviable reputation for representing artists in financial disputes, filed a suit for libel against Ruskin. Whistler insisted on the action for three reasons. First, as he suggested to Boughton, there was the "debased" and personal nature of the criticism, especially the bits about a "coxcomb" and "Cockney impudence." Ruskin had implied that Whistler was nothing but a self-promoter, brash beyond endurance. The artist doubtless took some pride in the accusation, given that Sam Weller, the clever cockney in *The Pickwick Papers*, had long been one of his heroes. However, *Punch* had recently added a new character to its cavalcade of English archetypes, a "cockney cad" called 'Arry, "loud, slangy and vulgar," with a taste for "smart patter and snide phrases." A generation of readers had warmed to the big-hearted Sam, but Whistler could not afford to be associated with 'Arry.

Second, Ruskin was no ordinary critic. He may have been an aging eccentric, but he remained the font of art criticism in England. He was not the first to accuse Whistler of exhibiting unfinished paintings, or of investing little labor in them, but influential people, namely buyers and patrons, took Ruskin's judgments to heart, and they were already speculating that his Grosvenor review might mean "death for the budding school of symphonies." A quick rejoinder in the press could not reverse the ill effects of Ruskin's words. Whistler needed a bigger stage on which to defend his work and philosophy of art.

Third, Whistler needed money. Besides losing half of the anticipated commission for the Peacock Room, the Grosvenor show had produced no buyers. His debts, created largely by his lavish style of living, had reached danger point. He was borrowing money from friends, even the perpetually broke Swinburne. Bailiffs had already been to his house at the insistence of creditors. Significantly, he was suing Ruskin not only to defend his reputation as an artist, but also for £1,000 in damages, the amount still owed to him by Leyland.[55]

The money would not come easily, or speedily. Ruskin's attorneys did not file a statement of defense until December. Two months later, in February 1878, Ruskin suffered a physical and mental collapse. He appeared to recover in April, when both sides agreed to have the case heard by a "special jury" of property owners, but then Ruskin had a relapse. It would be late November 1878 before the interested parties assembled in Queen Victoria's courts of justice. As a result, Whistler's life would be transformed.

# IO

## Trials

### 1877–1879

Whistler worked like a demon in the autumn of 1877. He had to work. Debts threatened to crush him. In the past, a benefactor like Thomas Winans had bailed him out, or Jo or Anna had managed the situation. More recently, he relied on James Rose to give him breathing space. "Do arrange with the lawyers about this matter of Craft," he told Rose concerning a pesky cheesemonger. "I had forgotten all about it – or rather I had heard no more of it and I am so woefully hard at work." But there were too many Crafts, and some of them had not been paid for two years.[1]

The individual debts were manageable, but they kept mounting. His poulterer wanted £6, his coal supplier demanded £23. The coal merchant had taken him to court at the end of the summer, and in a case that dragged on through the rest of the year, Whistler wound up paying nearly half as much again in legal fees as the original debt. Then came demands from a photographer, an ironmonger, a shoemaker, a wine merchant, a frame maker, two artist supply shops, and a new coal merchant. Craft, the cheesemonger, hired a solicitor and threatened a suit. Whistler retained a second solicitor to relieve an overburdened Rose of some cases.[2]

Other people depended on him, too. Charlie and Jo, for instance, required an occasional £10 note. How much Whistler saw of his son, now seven, is unclear, but the boy looked much like his father at the same age, his dark hair shoulder length (fig. 52). As for Jo, she had been replaced by Maud Franklin (fig. 53). The graceful

twenty-year-old daughter of an English cabinetmaker and upholsterer had been posing for Whistler since she was sixteen. She was not as pretty as Jo, but she had the same red hair and was fourteen years younger than Charlie's "auntie," who had acquired a matronly figure. Maud had also borne Whistler's second child, a daughter named Ione. The infant, like Charlie, lived initially with foster parents outside London. Her exact date of birth is uncertain, but Whistler called a portrait of Maud begun in 1876 "Effie Dean," the unwed mother in Walter Scott's *Heart of Midlothian*.[3]

Not that Whistler made allowances for these complications. He hosted no fewer than twenty-seven dinner parties in the last four months of 1877, besides his regular Sunday breakfasts. What other people would have judged unsustainable extravagances, he treated as necessary investments, both of time and money. Oh, and he decided to build a house. It was to be a purpose-built artist's home, with custom-designed studio, all the rage among affluent members of his guild. E. W. Godwin would be the architect, and he had found the perfect site, a double lot in Tite Street, half a mile east of Whistler's current house and just off the new Chelsea Embankment. The lot cost £1,500, and Godwin estimated the house would cost £1,700, but he promised a work of art, revolutionary in design, and a fit place for Whistler to entertain distinguished friends and patrons.[4]

Typically for Whistler, it would also be an act of rebellion. His decision to remain a denizen of the Thames defied the reputation of Holland Park as the place for successful artists. Once the exclusive domain of their patrons, the neighborhood had become home to a legion of painters and sculptors by the mid-1870s. A few men, like Val Prinsep, had family roots there, but for newcomers, often members of the Royal Academy, it was now chic. Frederic Leighton was among the first to build, and Luke Fildes, G. F. Watts, Marcus Stone, George Boughton, and Hamo Thornycroft soon followed him to the "Leighton Settlement." Melbury Road, in particular, became a solid line of artists' homes. Even Albert Moore, who had grown up nearby, returned.[5]

Godwin was not the architect of choice in Holland Park, and so, for that very reason, was the perfect man for Whistler. Having known him as a fellow artist and clubman since the early 1860s, Godwin had become as close a friend as Fantin or Rossetti. He helped to plan the Flemish Gallery exhibition and did much to publicize the Peacock Room. They had recently collaborated on an Aesthetic "suite" of furniture for the 1878 Paris International Exhibition, with Whistler decorating a Godwin cabinet. Best known as an architect, Godwin also designed furniture, textiles, and wallpaper, produced plays, and published both architectural and theater criticism.

His first wife having died, he rescued the beautiful twenty-year-old actress Ellen Terry from a disastrous marriage to G. F. Watts. She remained Godwin's companion for over six years, bearing two children, until, in 1875, his extravagance and careless handling of money drove her away.[6]

Godwin's original design for Whistler's house called for an eclectic combination of Greek and Japanese elements. Constructed entirely of white brick, its plain front was to be adorned by four plaster panels, the stark whiteness broken only by the gray framing and red stone sills of the windows and peacock blue doors. The front windows themselves varied in size and were positioned asymmetrically. A steeply angled, green-tile mansard roof gave the exterior a Japanese look, and *japonisme* best defined the interior, with its tiled fireplaces, curved lintels, textured lower walls, and spindly balustrades. Construction of what became known as the White House began in November.[7]

Whistler thought to pay for it all by painting the "heads of blokes" and "their pet ballet dancers." When the blokes and ballerinas failed to come, he fell back on full-length portraits and nocturnes. Charles Augustus Howell, a thirty-six-year-old Anglo-Portugese art connoisseur whom Whistler had known since 1864, offered him £100 to paint his twenty-five-year-old mistress, Rosa Corder, herself an artist. Whistler also returned to a portrait of Connie Gilchrist, a celebrated child performer, begun a year earlier. He sold a reworked nocturne to Campden Hill resident and silk merchant William G. Rawlinson for £100 and one of his Cremorne pictures to James Chapman, who had become a reliable customer. What Chapman paid is unknown, but Whistler was so desperate for money that he had offered him two Cremornes for eighty guineas.[8]

The Rosa Corder painting confirmed a pair of trends in Whistler portraiture. First, it was another "black portrait," in the mold of the Frederick Leyland and Henry Irving. Whistler believed that the simplicity of these nearly monochromatic works, of which there would be some twenty, created a pure arrangement. He may even have been reaching for the mystical in the earliest examples of the series, which coincided with an intense period of spiritualism. Equally, his "black portraits" mimicked photographic techniques, even so-called "spirit photographs," in which a ghostly face loomed out of the darkness. Commenting on another, later portrait, he said, "As the light fades and the shadows deepen, all pretty and exacting details vanish, . . . the buttons are lost, but the garment remains; the garment is lost but the sitter remains; the sitter is lost but the shadow remains; the shadow is lost but the picture remains."[9]

*Rosa Corder* was also typical of Whistler's full-length oil portraits of women, which stood in marked contrast to his pictures of men. Beginning in the 1870s, he preferred to show women from the rear or in severe profile, a less confrontational posture than the invariable frontal views of his male subjects. One is tempted to say the difference expressed Whistler's more complex relationships with women, a nod to their remoteness and mystique. While giving his male subjects a dignified bearing, he painted women in a variety of moods and attitudes, as sensual and coquettish, disdainful and alluring, haughty and vulnerable.

Then, too, he almost certainly depicted women from behind in order to exploit the beauty of female fashion. In this, he simply copied the standard pose in contemporary fashion plates. Whether done in the cream colors and chiffon of Frances Leyland or the black and brown of *Rosa Corder*, clothes anchored his arrangement. Similarly, he routinely idealized the figures of female subjects to complement the line of their costumes. Perhaps, too, he had come to think of fashionable clothes, as had many French artists, as yet another expression of "modern life." The Impressionists, for example, believed that a person's clothes, not the face, should be the focus of a painting. As Manet would say, "The latest fashion, you see, is absolutely necessary for a painter. It's what matters most."[10]

Whistler earned at least £2,600 from his oil paintings between 1870 and 1878, but as Charles Howell reminded him, his stockpile of etched plates held even more "gold." The etchings market had increased significantly since the 1860s. Individual prints from Whistler's six-year-old Thames Set now sold for up to two guineas, and he received five times that amount for rarer work. To capitalize on the opportunity, and so reduce Whistler's indebtedness, Howell and Corder helped him prepare a new batch of etchings. They dampened the paper and mixed the ink for him, and Howell took turns with Whistler at the press wheel. Howell also contacted dealers to handle the sales. When Whistler spoke of making his oft-delayed trip to Venice to create a series of etchings similar to the French and Thames sets, Howell made flyers and took subscriptions for the anticipated portfolio.[11]

Which is not to say Howell could always be trusted (fig. 54). The suave and charming "Owl," as friends called him, had worked as John Ruskin's secretary and was part of the Rossetti circle. He had an exceptional eye for assessing *objets d'art*, from medieval furniture and Chinese porcelain to modern etchings and paintings, and a knack for selling them, though often by dubious means. He helped Whistler earn £541 for his etchings in 1877, but Howell also arranged risky loans against some paintings. A safer Howell strategy was to secure £80 for publication rights to a

limited edition of engravings of the Carlyle. He later made similar arrangements for the portraits of Anna and Rosa. Even so, Howell received a commission on those transactions, and he took advantage of Whistler's circumstances to buy paintings and drawings far below market value.[12]

Wisely, Whistler did not rely entirely on Howell to manage things. Thinking to cash in on a demand for "picturesque" views of the Thames, he resumed an earlier series of etchings and drypoints that eventually included Chelsea, Fulham, Wapping, Billingsgate, Greenhithe, and the Battersea and Putney bridges. He also made etched portraits of famous friends, notably Swinburne and Sir Garnet Wolseley, and tried to convince Benjamin Disraeli to sit for a portrait. Whistler eagerly anticipated making a thousand guineas from engravings of Disraeli, but the prime minister claimed to be too ill to pose.[13]

Around May 1878, Whistler also returned to lithography for the first time since his youthful *Standard Bearer*. Artists had enjoyed the versatility of the medium since its invention in the 1790s. Even more than etching, lithography allowed for experimentation with line, tone, and shading, and it yielded subtleties difficult to achieve in etching or painting. Degas, Fantin-Latour, Legros, and Bracquemond had taken it up for those reasons, and a nascent revival in France had spread to Britain. Whistler also knew, considering his debts, that lithography had become a popular form of reproduction in the periodical press. Lithographs were easier to make than woodcuts, simpler to print than etchings, and cheaper to produce than engravings.[14]

Thomas R. Way, a printer who helped lead the lithographic revival in England, and to whom Whistler was introduced by Deschamps and Godwin, became his mentor. Part of Whistler's instruction included "transfer" lithography, a technique that allowed him to draw with crayon on specially treated paper before transferring the image to the usual heavy stones. Besides lightening an artist's load, the process also permitted drawings of the greatest delicacy and nuance. Whistler began by drawing Maud in a variety of poses on both stone and paper. He then took to the river, where he attempted his first "lithotints." This process, which combined crayon with diluted washes of ink applied with brushes, yielded haunting black and white equivalents of his painted nocturnes. Way's son, also named Thomas, thought Whistler's lithotints captured the "exquisite stillness and peace" of the river by night.[15]

Nonetheless, despite brisk sales of a print of Limehouse, bad luck, mismanagement, and public indifference cut short Whistler's return to lithography. First, a promising outlet for his work, a magazine called *Piccadilly: Town and Country Life*, folded just six months after being founded. Whistler then joined Thomas Way in

another doomed publishing scheme. *Art Notes in Black and White* was to have been a monthly series of lithographs offered in limited editions, but it, too, failed to draw public interest.[16]

Whistler's inflated estimate of his work dashed another publishing opportunity, this time for his etchings. The *Gazette des Beaux-Arts* wanted to publish an article about him, but when the editor asked permission to illustrate it with one of his Dutch etchings, Whistler demanded an outrageously high two thousand francs (sixty-three guineas). The magazine had never paid that much to reproduce a work of art, its shocked editor responded, not even for the "masterpieces" of such noted artists as Haden and Legros. That did it. Whistler replied that he would rather "remain unknown until the end of all things" than to think his reputation rested with the *Gazette*.[17]

Despite the setbacks and squandered opportunities, a burst of attention paid to him in the London press made Whistler feel rather self-satisfied that summer. The publicity had begun the previous December, when a three-act "comic drama," *The Grasshopper*, opened at the Gaiety Theatre in the Strand. Starring Nellie Farren and Edward Terry, it had been performed first as *La Cigale* in Paris. Designed to poke fun at the Impressionists, the main character had been an "Intentionist," modeled on Edgar Degas. Rewritten for an English audience, this character became Pygmalion Flippit, a "Harmonist" and disciple of Whistler.

In the play's third act, Whistler appeared on stage, so to speak, when a full-length caricature of him, drawn especially for the play by Carlo Pellegrini, chief illustrator for *Vanity Fair*, was wheeled out. Titled *Creator of Black and White in his Own Manner*, it depicted Whistler in evening dress and monocle. One theater critic thought the "portrait" rather hard on the artist, whose "personal peculiarities" were, "with questionable taste converted into provocatives to laughter." No one, though, laughed harder than Whistler, who had seen rehearsals of the play and approved of Pellegrini's handiwork. He attended no fewer than three performances, always in company with friends, including Lord Archibald Campbell, Alan Cole, and Theodore Watts-Dunton – editor of the ill-fated *Piccadilly*.[18]

Thereafter, the "puffs" came in bunches. In January, an article in *Vanity Fair* named Whistler one of the "Men of the Day." Another caricature accompanied it. This one, by Leslie Ward, Pellegrini's junior at the magazine, was the first of Whistler published outside of *Punch*. Friends like Rossetti thought it "vile," but Ward captured perfectly Whistler's public image in the mid-1870s. He was shown with all of his props, including monocle, cigarette, and mahlstick cane, and dressed in his

signature patent-leather shoes and form-fitting jacket. The self-assured pose and slightly bemused look suggested a man given to neither doubts nor cares.

Most importantly, with the Ruskin trial looming, the *Vanity Fair* article addressed Whistler's controversial theories about art. Speaking directly to the Ruskin case, it defended him against charges that he did not "finish" his pictures. His paintings were "done," the article assured readers, when he was satisfied that he had captured a correct impression of nature, "without any trifling with the facts." It concluded, "Whatever else may be said of him, . . . the truth is in his pictures."[19]

Whistler also fell in with an influential new journalist that spring. Edmund H. Yates, three years his senior, was an Edinburgh-born novelist who shared many of Whistler's interests. As a young man in London, he had enjoyed "Bohemian" amusements, including evenings at Cremorne Gardens and amateur theatricals. He admired Charles Dickens and favored any pub that had Burton Ale on draught. He had lectured in America and worked as a reporter for the *New York Tribune* in Europe before establishing his own weekly newspaper, the *World*, in 1877.

Critics accused Yates and the *World* of introducing the lowest and most vulgar standards of American "personal" journalism to Britain. Yates thought of himself as an iconoclast, his paper "an amusing chronicle of current history" and a "summary of everything worth notice in literature, art, and society." More importantly, and where Whistler would benefit directly, Yates introduced the notion of "celebrity" to England by publishing interviews that revealed the private lives of public people. In the years to follow, a slew of other weeklies, and some dailies, adopted this "light and gossipy" brand of journalism.[20]

Whistler would thrive in the new environment. He called Yates "Atlas," and the *World* became his favorite public platform. Indeed, he now required such allies as Yates. He had naively believed that the excellence of his work would be evident, that it would sell itself. He never considered the need to promote it or to ensure that it was correctly interpreted. It was a lesson well learned.

Interviewed for the paper's popular "Celebrities at Home" series that May, Whistler revealed a side of himself known only to close friends. Dressed for the interview in a blue serge yachtsman's suit and "natty" square-toed shoes, he not only defied his image as an eccentric, but also spoke publicly for the first time about his aesthetic theories. The correspondent was surprised by Whistler's "intense earnestness," his "humorous resentment against the Philistines," and the determination of this "most courteous and vivacious" of men, often plagued by self-doubt, to persevere against close-minded critics and the prejudices of the artistic establishment.[21]

The article, which Whistler later labeled the "Red Rag," elaborated on strongly held beliefs barely mentioned in the *Vanity Fair* piece. Most especially, it questioned the value of narrative painting. "He insists that as music is the poetry of sound, so is painting the poetry of sight," the interviewer explained, "and that the subject-matter has nothing to do with harmony of sound or of colour." More pointedly, Whistler himself continued, "Art should be independent of all claptrap – should stand alone, and appeal to the artistic sense of eye or ear, without confounding this with emotions entirely foreign to it, as devotion, pity, love, patriotism, and the like."

June brought more coverage in the *World* and light-hearted stories about Whistler in *Punch* and the society newspaper *Mayfair*, but also doubts that he would ever occupy his White House. The Metropolitan Board of Works had complained about Godwin's revolutionary design. The board had been created in 1855 to monitor the physical renovation of London, including improvement of streets, construction of drainage and sewage lines, and, as Whistler now discovered, the erection of new buildings. Appalled by the "ugly and unsightly character" of his proposed house, the board insisted that ornamental elements be added to its plain facade.[22]

Whistler and his lawyers used every legal stratagem they could devise, besides bluff and bluster, to stymie the board. In addition to Rose, Whistler also consulted with solicitors George and William Webb, who remained valued advisors thereafter. He asked mutual friends, including a member of Parliament, to intervene with the head of the board. He invoked the name of the Almighty with a force quite alien to him. Nothing sufficed. The board refused to validate his lease. Finally, in June, Whistler agreed to embellish the exterior of the house with two sculptured panels, decorative stone moldings around the doors and windows, and a statue in an alcove between two windows.[23]

Two months later, he at last welcomed guests to the White House (fig. 55). Few people were disappointed by its novelty. Upon entering, they stood in a small vestibule that served as the hub for several stairways. Down one set of stairs, they found a low-ceiling drawing room, the rear windows of which looked out on a "neat little yard." Another set of stairs led up to the dining room, while a third set ascended to Whistler's studio, an immense white room with one wall made entirely of windows. Furniture consisted of a very few tables and chairs. Whether this reflected Whistler's woeful financial straits or his idea of Japanese decor, guests found it an uncomfortable arrangement. Matthew Ridley thought the entire house "very badly built," with doors and windows already warping, but Whistler was thoroughly pleased. Determined to make Tite Street London's new artistic Mecca, he urged friends to build there.[24]

Lillie Langtry would have made an ideal neighbor. Whistler might even have invited her to live at the White House had not Maud again been pregnant and Lillie already married, after a fashion. No one paid much attention to Edward Langtry once Lillie burst on London's social scene in the spring of 1877. Her days of greatest acclaim still lay ahead, but every artist in London, including Poynter and Millais, already clamored to paint her portrait. One admirer thought that an impossible task. Lillie, he insisted, possessed "a beauty beyond reach of the brush."

Whistler thought her "perfect," "exquisite," "the loveliest thing that ever was," with the same Titian hair as Jo, Maud, and Frances Leyland. They became close friends in the summer and autumn of 1878, though how close remains a mystery. Gray-eyed Lillie became a regular at the Sunday breakfasts, less so at formal dinners, but more than a few people commented on their mutual attraction. She was seduced by Whistler's charm, gallantry, "expressive hands," and "oddly arresting" appearance. Initially intimidated by witty and clever men, she found herself perfectly at ease in Whistler's company. He talked about things that interested her, and about which she had something to say. He made her laugh, too. However, the timing for a serious romance was all wrong. Whatever passion there may have been spent itself shortly after Whistler moved to Tite Street, when larger concerns consumed him.[25]

Financial debts remained his principal problem. Alterations to the White House had cost £200, and his builder claimed an additional £900 for labor and materials. More creditors joined the queue. Frederick Leyland, for one, had forwarded nearly £280 in bills for materials used in making the Peacock Room. Whistler also owed back rent on the house in Cheyne Walk, assessments and property taxes on the new house, and he would soon have to make quarterly mortgage payments of £42 7s. 6d. Heavy fines would be imposed, the Webbs warned, if he did not make those payments "punctually."[26]

By mid-October 1878, Whistler was "depressed – very hard up and fearful of getting old." His only chance to clean up the financial mess rested with the looming Ruskin trial. His enthusiasm for the contest was dampened by news that Ruskin, still pleading illness, would not appear in court, but Rose had persuaded the widely respected barrister John H. Parry to plead his case.[27]

Each side would present three expert witnesses, although each side also encountered unanticipated difficulties in securing them. Few artists and critics wanted to be involved in the Whistler–Ruskin feud. Edward Burne-Jones and Tom Taylor finally agreed to testify for Ruskin, but William P. Frith had to be subpoenaed. Burne-Jones later claimed to have "moved earth and hell to get out of it," but con-

sidering his long association with Ruskin, he had little choice but to defend his friend. Besides, Burne-Jones had looked on Whistler as a ruffian ever since the Legros and Haden affairs. He also, like Ruskin, thought the American a "charlatan."[28]

Neither did Whistler's friends, even those who believed him ill-used by Ruskin, wish to enter the box. Of his three witnesses, only Albert Moore appeared readily in court. William Gorman Wills, a failed painter but successful playwright, and William Rossetti would also testify, but Rossetti was "dismayed" by the prospect. He disagreed with Ruskin's reckless review of the Grosvenor show, and he had grown artistically with Whistler, having by 1878 embraced *japonisme*, the new Classicism, and even a conservative type of "aesthetic realism." Yet, as an old Pre-Raphaelite, Rossetti admired Ruskin. "Shd be truly sorry to aid personally in bringing Ruskin in for damages," he confessed in his diary three days before the trial (fig. 56).[29]

Howell would have stood up for Whistler had he not had legal problems of his own. His court date came the same week as the Ruskin trial. Art dealers Oswald Colnaghi and Algernon Graves volunteered to testify, but Whistler's lawyers thought Rossetti a better appraiser of his work. Other friends, including Matthew Elden, Joseph Boehm, Armstrong, Keene, Nesfield, Leighton, Poynter, and Tissot, though supportive, all failed him. Leighton, it must be said, had a good excuse. He was to be knighted by Queen Victoria on the opening day of the trial.

That was Monday, November 25, in the Court of Exchequer, then adjacent to Westminster Hall. The cream of London society packed the dimly lit and excessively warm courtroom. Among the onlookers sat celebrated lyricist William S. Gilbert. A familiar face at the Grosvenor Gallery and Whistler's Sunday breakfasts, Gilbert, who had trained as a barrister, was part of a select group to dine with Whistler that week and, just the day before the trial, to discuss the case in a meeting with him, Moore, and Parry.[30]

Presentation of the plaintiff's case consumed nearly all of the first day's proceedings, and Whistler was first to enter the witness box. He had told Rose and Parry to stress his uniqueness as an artist. This approach, he thought, even though it emphasized the manufactured image of an eccentric he had lately tried to temper, might win over the jury. "In defending me it would be bad policy to try and make me out a different person than the well known Whistler," he instructed his lawyers; "besides I think more is to be gained by sticking to that character."[31]

His choice of words was striking, particularly the references to himself in the third person. He began to speak that way at the time of *The Grasshopper*, when he first saw himself presented as others saw him. The stage caricature had been swiftly

reinforced by Leslie Ward's drawing, so that by the end of the year, even Whistler understood the extent to which his media-created self had eclipsed the serious artist.

However, Parry had no intention of letting Whistler's alter ego dominate the trial. While conceding in his opening remarks that Whistler's "theory of painting" might be considered "eccentric," he emphasized that the artist had followed his own path with "earnestness, industry, and utmost enthusiasm," hardly a man to be "denounced or libeled." His client, falling into line, behaved himself. He was the charming, thoughtful, and witty Whistler of recent newspaper interviews.

When several of his most controversial paintings were shown to the court, he explained his methods and philosophy precisely and matter-of-factly. Asked if a particular "nocturne" gave a "correct representation" of Battersea Bridge, he replied, "I did not intend to paint a portrait of the bridge, but only a painting of a moonlight scene. As to what the picture represents, that depends upon who looks at it." He concluded by saying, "My whole scheme was only to bring about a certain harmony of color."[32]

Whistler proved equally nimble when Ruskin's barrister, the formidable Sir John Holker, attorney-general and chief counsel for the British Crown, raised the central issue of "finish." How long had it taken Whistler, he asked in a patently leading way, to "knock off" *The Falling Rocket*? Whistler pretended at first not to understand the question before replying that it took two days. Believing he had trapped the artist, Holker asked if two hundred guineas was not a steep price for two days of work. Whistler shot back that the number of days he labored on a particular painting had nothing to do with its price: "I ask it for knowledge I have gained in the work of a lifetime." It was a brilliant retort, and altogether true. The courtroom burst into applause. He might have emphasized that it sometimes took him years to achieve a desired effect in a painting, but he finished by saying, "I offer it [*The Falling Rocket*] as a work that I have conscientiously executed and that I think worth the money. I would hold my reputation upon this."

Then, a bombshell. Holker reminded Whistler that Ruskin was not the only person to disparage his work. Did he object to criticism? Whistler replied that he did not expect all the public to understand his work, but he did expect published assessments by supposedly professional critics to be fair and balanced. "It is not only when a criticism is unjust that I object to it," he explained, "but when it is incompetent." And the ideal credentials for a critic? "I hold that none but an artist can be a competent critic," he declared. That remark would have lasting reverberations.[33]

It remained only for Whistler's friends to endorse his positions, but their testimony was uneven. Rossetti's reluctance to testify showed through his statements. He praised Whistler's work and judged two hundred guineas a fair price for the nocturne in question but wavered on other issues. He did not think the painting "exquisite" or "beautiful," for instance. Neither could he say that "much labour" had been invested in it. A good thing Moore and Wills followed Rossetti to the witness box. The Yorkshireman was a brick. He called Whistler's painting "beautiful" and emphasized that the price of any picture must be determined by "the skill of the artist, not always . . . the amount of labour expended." Rather than characterize Whistler's work as eccentric, he praised its "originality." Wills called Whistler "a man of genius and a conscientious artist."[34]

However, none of Whistler's witnesses had explained to a jury of laymen the qualities that made his paintings "art," an issue Holker exploited on the second day of the trial by reminding them of the artist's eccentricities. He pointed to Whistler's habit of drying paintings in his garden. He mentioned *The Grasshopper* twice and linked Whistler to the Grosvenor Gallery and Aesthetic Movement, both of which Holker lampooned as effectively as any *Punch* artist could have done. How many members of this jury of property-owning, middle-class laymen, he asked, would pay two hundred guineas for any of the paintings presented in evidence? Could any of those pictures, whatever "few flashes of genius" they might include, be worth that amount of money?[35]

Luckily for Whistler, Ruskin's friends undermined much of Holker's bold assault. Burne-Jones, billed as the star witness, seemed unnerved by the grandeur and solemnity of the legal proceedings. He insisted that Whistler's nocturnes tended to be "incomplete" and "deficient in form" yet admitted that, in other respects, they were "masterly." He also saw "marks of great labor and artistic skill" in many of his paintings and credited Whistler with an "unrivaled power of representing atmosphere."[36]

The jury retired at 2:40 p.m. to discuss its verdict. A flurry came at 4:15 p.m., when jurymen asked the presiding judge to clarify the meaning of "willful imposture." Fifteen minutes later, they returned their verdict, which found for Whistler but placed the monetary damage to his reputation at somewhat less than £1,000, at one farthing, to be exact. "Well, I suppose a verdict is a verdict," the artist responded placidly, although he prompted a journalist friend to declare the case "a great triumph."[37]

Public and press saw no clear winner. *Punch*, now edited by Tom Taylor, took jabs at both sides, including a cartoon that showed Whistler receiving a giant farthing

from the judge (fig. 57). Drawn by Sambourne, the caption read, "Naughty Critic, To Use Bad Language! Silly Painter, To Go To Law About It!" Reporting events for an American audience, Henry James observed in the *Nation*, "The verdict, of course, satisfies neither party: Mr. Ruskin is formally condemned, but the plaintiff is not compensated." The *Saturday Review* agreed. While condemning the "vulgarity" of Ruskin's language, and noting the futility of twelve laymen judging an issue of aesthetics, it supposed that both Ruskin and Whistler found the verdict "equally unsatisfactory."[38]

Ruskin retreated into martyrdom. The critic was grateful to friends who paid his hefty £400 legal fee, but the verdict and public ridicule wounded his pride. Although he had already decided to resign his Oxford professorship for reasons of health, in announcing his decision after the trial, he gave his legal defeat as the cause. The court's verdict confirmed his belief that the world had run amok. To William Morris, who had been instrumental in raising money for his defense, Ruskin lamented the triumph of "the Clever" over "the Right."[39]

The trial made Whistler much more of a public figure, which, even for someone who sought publicity, was not an entirely good thing. Having gone virtually unnoticed by popular cartoonists for eighteen years, he found himself caricatured everywhere, further magnifying the "other" Whistler as a figure of public fun. He received mingled words of congratulations, sympathy, and support from friends, including West Point classmates, but informed people knew he had suffered a double blow. Not only had he not collected the anticipated £1,000, but the verdict, even more than Ruskin's original review, threatened to reduce the market for his work. As one person put it, "Poor Whistler, who will buy a 'Nocturne' now[?]" Talk of a fund to pay his legal fees brought a tepid response.[40]

Whistler fought back. His clash with Ruskin had shown the power of prejudiced and obtuse critics to distort the meaning and negate the importance of his art. For every reasonable and insightful commentator, there remained the heirs of Ruskin, who expected to find some edifying story or moral message in a painting. Worse still were the writers who thought it their duty to stress the negative qualities of a work of art. Their power had increased, too, as a rising art-buying bourgeoisie sought the advice of men like Ruskin. That must end, decided Whistler. It was one thing for the critics to misunderstand his work; it was quite another for them to scare away patrons and endanger his livelihood.

Of course, complaints about critics were anything but new, and a movement toward better-informed and more responsible art and literary criticism had already

begun. Yet, an obstacle remained. With every conceivable publication, including daily newspapers, weekly "society" papers, and humor magazines, discussing the state of the arts, there were not enough capable critics to go around. William Rossetti, for example, contributed to nearly a dozen journals and newspapers. Consequently, editors often recruited budding novelists and dramatists, such as Henry James, to critique the ever-growing number of exhibitions.[41]

Whistler wanted not gradual reform but revolution. "[T]he first shot at the 'Critic' has at last been fired," he told Arthur Liberty immediately after the trial, and within days he decided that one good shot deserved another. Believing that the press, let alone the jury, had "utterly missed, or perhaps winked at," the principal issue in the trial, he wrote a seventeen-page pamphlet entitled *Whistler v. Ruskin: Art & Art Critics*. Dedicated to Albert Moore, his staunchest ally during the trial, it hit the streets on Christmas Eve. The almost unadorned pamphlet, with the same brown paper covers as his Flemish Gallery catalogue, looked as though Whistler's grocer had produced it, rather than Swinburne's publisher, Chatto & Windus.[42]

"Now the war, of which the opening skirmish was fought the other day in Westminster," he began, "is really one between the Brush and the Pen." His chief argument, voiced privately many times, was that painting, as a "science," could be understood only by its practitioners. Art must not be judged by the casual observer or dilettante. Mr. Ruskin might be a professor of art, and he had doubtless studied his subject in detail, but "a life passed among pictures makes not a painter," Whistler chided. By that standard, "the policeman in the National Gallery" might call himself an expert. "No!" he exclaimed, "let there be no critics! they are not a 'necessary evil,' but an evil quite unnecessary."[43]

Not only did the one-shilling pamphlet sell "like smoke," going through six printings in as many weeks, but subscriptions for engravings of his *Rosa Corder* and *The Mother* shot up. Whistler began to see the possibility of financial salvation in this war. Perhaps he had overestimated the negative consequences of the trial. Excited by that possibility, he distributed the pamphlet to anyone who might publicize it, although he reminded people as well about his financial stake in the campaign. "[Y]ou are not to give them away!" he cautioned one fellow, but to "keep up" the demand. This chap must get his sister and her friends to promote the cause, too. "The ladies you know are the ones to win the world with," he explained; "they must eagerly cry out in full Piccadilly for Whistlers pamphlet!"[44]

Given his concern for the "ladies," Whistler's treatment of Maud during the early weeks of his campaign was extraordinary. Telling her that he must go to Paris for

two weeks, he sent his mistress, now almost eight months pregnant, to stay at a London hotel. That might be interpreted as concern for her well-being while he was away, except that he went nowhere! More than that, he drew George Lucas into the charade. He would send Lucas letters written to Maud, which Lucas would then post to her from Paris. Any replies from Maud were to be forwarded to Tite Street, where Whistler remained. He simply could not be bothered by an expectant mother at this crucial moment. When their second daughter, Maud McNeill Franklin, was born on February 13, she, like Charlie and Ione, was sent to live with foster parents.[45]

Meanwhile, the pamphlet caused a furor in the press. Most men of "the Pen" dismissed it as ludicrous and incomprehensible, and in truth, parts of the pamphlet read like one of Whistler's letters, impulsive, passionate, often clever, but in need of editing. Its truculent tone, intended more to vent his hostility than win an argument, reminded one of Ruskin's review.

But Whistler answered the critics with the same stridency, both privately and in the press, and so made them, rather than Ruskin and the trial, the center of controversy. He spoke of taking their "scalps," and when Tom Taylor protested, quite rightly, that Whistler had quoted him out of context in *Whistler v. Ruskin*, its author shot back, "Bah! you scream unkind threats and die badly."[46]

That same week, four hundred British soldiers defeated nearly ten times their number of Zulu warriors at Rorke's Drift. Whistler could take heart in the odds. He had resisted authority since childhood but never so publicly. Even recent clashes with perceived foes, including Haden, Doty, Legros, and Leyland, had been private affairs. He had responded occasionally to criticism in the press, but those had been civil, often comical retorts. The Ruskin trial changed everything. The verdict and its implications deeply affected Whistler's attitude toward anyone who questioned, let alone denigrated, the purpose of his art or the validity of his "science." The "other" Whistler, he decided, the manufactured Whistler, had been too timid. He had not reacted swiftly or ferociously enough to public slights. The private Whistler vowed that would never again happen.

A pair of photographs taken in the weeks following the Ruskin trial confirmed the transformation. In the first one, posing as the "good" Whistler, he looked slightly bemused but thoroughly dignified, almost contemplative, as though pondering an unexpected question (fig. 58). The second picture, unique among the many photographs of him, showed an entirely different man. Whistler glared at the camera, his eyes narrowed, upper lip very nearly curled in the manner of a stage villain. When

a friend described the image as "detestable," nothing like the "loveable" Whistler, the artist replied, "That is the way Whistler wants his enemies to see him" (fig. 59).[47]

Still, whatever persona he assumed, neither histrionics nor scalps could disguise his serious financial troubles. "I need not dwell upon the strangled state of 'the Show,'" Whistler confided to Luke Ionides in December, the "Show" being his new way of referring to financial and business affairs. By the end of January 1879, more of Whistler's creditors had pursued their claims in the courts. His water bill remained unpaid, and he had missed his first mortgage payment, as the Webbs feared he would do. Whistler insisted, as usual, that he only required a little time to set things right. "It is *all important* that I should not be disturbed in the work that I am *finishing*," he told James Rose. . . . [A]ll the picture dealers are hovering round the place and I have orders and fortune stares me in the face. Another week or two and I shall be out of the wood!"[48]

Rose knew that anyone "hovering" around the White House was more likely a bailiff than a picture dealer, and in March the bailiffs moved in, quite literally. Recent changes in England's bankruptcy laws meant that Whistler, unlike some of his favorite Dickens characters, would not be sent to debtor's prison. However, he could only escape his creditors by declaring himself bankrupt. The court would then seize his estate, sell its assets, and compensate creditors with the proceeds. To prevent debtors from absconding with those assets, county sheriffs placed one bailiff for every creditor in their homes. This "man in possession" also lived at the owner's expense for five shillings per day. The realization that his profligacy had landed him in such a humiliating position threw Whistler into "a great funk."[49]

Crushed by more than £4,600 in personal debts, he signed the bankruptcy papers on May 7, thus postponing the public auction of his property – everything from etching plates to furniture – scheduled for that week. Not all creditors had pressed for payment. The Winans family, for example, to whom he owed the single largest sum, £1,200 for money "lent and advanced," would never have hounded him. Most of his other creditors, however, had run out of patience. Forty-eight of sixty-nine people claimed over £10 apiece, including Leyland, who wanted £350. In addition to the personal debts, Whistler also owed £3,000 on two secured loans for the mortgage on the White House.[50]

With Rose also listed as a major creditor (due £477), Whistler had retained George Henry Lewis as counsel. The well-known "society" lawyer had a goodly list of prominent clients and a reputation for legal wizardry, especially in bankruptcy cases. Whistler had known him and his second wife, Elisabeth, since 1869. The beautiful,

ambitious, and high-spirited Mrs. Lewis enjoyed the company of artists and writers, whom she invited frequently to her soirées, and she had written sympathetically to Whistler after the Ruskin trial.[51]

However, at the public meeting, held on June 4, to determine how to dispose of his possessions, Whistler came unhinged. Seeing Leyland in attendance, he leaped to his feet and denounced the "plutocrats" who ruled society. He railed for so long and with such passion that Lewis and Thomas Sutherland, who agreed to chair the meeting, had to pull him down literally "by his coat tails." Whistler may well have planned the tirade, but there was no mistaking the depth of his animosity. The Ruskin trial may have nudged him in that direction, but it had taken his insolvency, so easily blamed on Leyland, to push him to extremes. In his tortured way of thinking, the trial and bankruptcy became a judgment of his life's work, and so the ultimate insult.[52]

He had already vented his anger in three bitterly satirical paintings, done that spring and intended to humiliate Leyland at the public auction. *The Love of Lobsters*, featuring two crustaceans pitted against each other with raised claws, was a less successful version of his dueling peacocks. The second picture depicted Noah's Ark run aground on Mount Ararat. The animals were dressed "all in frills," clearly meant to represent Leyland's signature shirts. However, neither of those pictures contained an ounce of the vitriol invested in the third.

*The Gold Scab* was absolutely frightening, not the sort of thing one shows to small children. Painted almost entirely in peacock blue, it portrayed Leyland as a hideous hybrid of man and beast. He retained a human face, but one contorted by malevolence. With hands and feet made to look like the claws of a giant peacock, he sat on a miniature White House while playing a piano. Bags of gold sat atop the piano, and the title of the song he played was clearly visible on his sheet music: "The 'Gold Scab.' Eruption in FRiLthy Lucre." Whistler put the picture in the frame intended for F. R. L.'s *Three Girls*. He signed it with his trademark butterfly but gave the otherwise harmless insect a stinger for its tail and drew an arrow from the tail to the back of Leyland's neck.

He now wrote, as a consequence of the liquidation meeting, a jeering letter to Leyland. "[H]ow charmingly characteristic of your own meanness – that for vengeance you should have waited these years," Whistler charged, "and having pocketed the horsewhip like the true Counting house rat should now turn up . . . to work with accounts and punish with your pen [him] who laughs and has always laughed at your pompous rage and impotent spleen." He was slightly mollified upon learn-

ing towards the end of June that Frances Leyland, fed up with her husband's infidelities, had left him and the children, but there is no evidence that Whistler tried to contact her.[53]

Still, the financial settlement invigorated him. Lewis arranged for friendly creditors to claim as much property as possible before the public auction, the idea being to return the things later as "gifts." "You are a great artist!" Whistler exclaimed in thanking his lawyer for limiting the damage. He then destroyed or defaced much that was not claimed and distracted the "sheriff's men" with food and drink while friends smuggled other paintings and furniture out of the house. He also proceeded to accumulate new debts with a final round of entertainments, even cajoling some bailiffs into waiting at table.[54]

That done, Whistler looked for a dramatic way to exit Tite Street. He had already launched a campaign to change its name, which, as he once joked to Gabriel Rossetti, "led to ambiguity and unpleasant reflexions." Whistler lobbied the Chelsea Vestry to dignify its status as an artist's haven by renaming it Holbein Walk or Turner Walk. The campaign failed, but he refused to relinquish his beloved White House without a parting shot, and given the biblical dimensions of his fate, that rated nothing less than a scriptural benediction. Borrowing from the Psalms, he wrote a legend in ink over the front door: "Except the Lord build the House, their labour is lost that build it. E. W. Godwin F.S.A. built this one." Whistler signed it with the same lethal butterfly used in *The Gold Scab*. He could now "vamoose the Ranch."[55]

What remained of his possessions were auctioned at the White House on September 18, 1879. Among the art that sold for a pittance were an unfinished Valparaíso painting, a picture from Cremorne Gardens, and several portraits. Other paintings, drawings, prints, and Whistler's collection of china were reserved for a second auction at Sotheby's in February. The Sotheby sale would be the more profitable of the two, but it yielded only £328. The biggest prize in September was the White House itself, purchased for £2,700 by Harry Quilter, an art critic and unabashed admirer of John Ruskin. Not long before, Whistler had been a rising star. Now, at age forty-four, he was the most famous pauper in the world.[56]

# II

# Death and Transfiguration

## 1879–1880

Two days after Quilter bought the White House, Whistler was in Venice, a city he had longed to see for nearly a quarter of a century. Many friends and associates, including Manet, Leighton, Boyce, and Fildes, had already been there. Ruskin had beaten him by forty-five years, visiting when Whistler was but a year old. Despite his differences with the critic, Whistler could easily have repeated Ruskin's own words upon arriving: "Thank God I am here! It is the Paradise of Cities . . . and I am happier than I have been these five years."[1]

Whistler owed this sudden turn in his fortunes to London's Fine Art Society, located on the same block as the Grosvenor Gallery in New Bond Street. In this, too, he shared something with Ruskin. Founded in 1876, the society specialized in etchings and engravings, which it commissioned, exhibited, and sold. Ruskin, despite his opinion of etching as an "indolent and blundering" art, became an early supporter of the society. The society, in turn, contributed to Ruskin's defense fund after the Whistler trial. In another improbable twist, Seymour Haden, an early patron of the society, had donated two hundred etchings from his private collection and wrote the catalogue notes for an 1878 exhibition of "Great Masters."[2]

The Fine Art Society had been selling Whistler etchings since 1877 but did not think to champion him until Ernest G. Brown, a novice art dealer in his mid-twenties, joined the staff of Marcus B. Huish, managing director of the society, in

1879. As an admirer of Whistler's work, Brown persuaded Huish to publish a new edition of the Thames Set. Huish also paid Whistler nearly £200 for the rights to four other recent etchings of the Thames (fig. 60). So when, in August, the artist proposed making a set of Venice etchings, the society advanced him £150 for travel and living expenses and agreed to pay £700 for twelve plates, to be completed by December 20.[3]

People wondered if Whistler really would go to Italy, or if he had only been desperate to escape England. Gabriel Rossetti thought the "American Velásquez" might return to his native country. So did G. F. Watts, especially after an American magazine called him "the most absolute artist of the time." Burne-Jones was just happy to see him gone. "I hope he will be content," Burne-Jones told a friend, "and let the world rest for a bit."[4]

Leaving Maud with George Lucas until he found lodgings in Venice, Whistler departed Paris by train on the evening of September 18, 1879. His life had been filled with fresh beginnings, but none loomed as large as this one. He felt like a student again, and he would have to live like one. He found a cheap apartment along the Rio di San Barnaba, in the Dorsoduro district, home to students and artists, and very near the Campo Santa Margarita. The people he met in local shops and cafés charmed him, although their language, despite its similarities to French, he liked "not at all." So, too, Italian cuisine, which he pronounced both fowl and foul. Nothing but chicken, he complained. An occasional cup of tea, "bought for gold," was his only solace (fig. 61).[5]

Maud, who arrived in the third week of October, thought Venice "a lovely place." Together, she and Whistler prowled the city's maze of streets and canals. They visited the beaches of the Lido, a popular seaside resort south of the city, and St. Mark's basilica. Whistler conceded that the church was "very swell," even if his Peacock Room was "more beautiful in its effect" than St. Mark's famous dome.[6]

Still, the novelty soon wore thin, and then the weather turned as foul as the food. With snow falling by the second half of November, the city looked picturesque, but the cold and damp chilled Whistler's bones and threatened to scuttle his mission. Venetians said it was the coldest winter in thirty years. When copper plates and etching needles froze in his fingers, he tried drawing in pastels, but that left him with precious few etchings by December 20, the Fine Art Society's deadline. Maud took work as a model "to keep them going."[7]

Whistler felt the weight of exile. "[I] should live in conservatories with flowers and pines and . . . the most charming people to say delightful things," the Butterfly

told sister Deborah in despair. Instead, he sat shivering in "a sort of Opera Comique country when the audience is absent and the Season is over!" He missed the "lovely London fogs" and "felt bored to death . . . away from Piccadilly." He asked friends and relatives to tell him the latest London "gossip" and to send issues of the *World*. "I pine for Pall Mall and I long for a hansom!" he exclaimed.[8]

He was heartened to see that London newspapers still carried occasional notices about him, some even regretting his absence. The Christmas issue of the *World* included a long satire of his Venetian residence that described a failed romance between the artist Fluke Fizzledowne and the beautiful Ididdlia, Countess of Tizvotitis. Fizzledowne, with his "silvery white" forelock, was indisputably Whistler. The identity of Ididdlia was less clear, but the possibilities were tantalizing. The story centered on a lover's spat and the separation of Fizzledowne and Ididdlia. That would make Frances Leyland a likely candidate, but several references in the story could apply either to her or to Lillie Langtry. Concerning Frances, Whistler expressed alarm upon learning that she had moved from Liverpool to an unsuitable part of London.[9]

As much as anything, though, Whistler missed having an audience. He yearned for "the general merriment of the show," in which he had "for such a long time so pleasantly entertained and [been] tolerated." He filled the gap by making himself agreeable to several wealthy English and American couples that lived or wintered in Venice. He mingled with fellow artists, too, in the campo and at cafés. English artist William Graham became a friend, as did Ralph Curtis, a young American artist who had trained in Paris and admired Whistler's work. His parents happened to be part of the wealthy Venetian set. Ralph's father thought Whistler "ordinary of looke & speech" when he first spotted him at the Café Florian, in the Piazza San Marco, but he soon warmed to the artist and welcomed him at his palazzo on the Grand Canal. Another American member of the Venice set, with her own Grand Canal palazzo, was Katharine de Kay Bronson. Soon to form a close friendship with English poet Robert Browning, the charming, cultivated, and sympathetic Bronson was the perfect hostess. She was also a distant relation of Whistler.[10]

Whistler made friends as well with the American consul in Venice, John Harris, and his wife. Their apartment, also on the Grand Canal, may have been the first place in Venice where he displayed his mischievous side. "I said . . . that an artist's only possible virtue is idleness!" Whistler reported gleefully to his sister of one gathering, "and there are so few who are gifted with it." He knew Debo would appreciate the humor of his pose, although, in retrospect, he imagined some people

in Venice thought him "a trial." "Ah well! Nous ne sommes pas ici pour nous amuser," he told her ("We are not here to amuse ourselves"), although, he added in English, "I believe we really are." He knew Debo would understand that contradiction, too, and forgive her "dear generally-misunderstood-though-well-meaning-yet-difficult-to-explain brother Jim!"[11]

As in London, Maud's status as mistress and model barred her from the fashionable salons of people like the Bronsons and Curtises. Some people, in later years, said that "no man ever treated a woman more shabbily" than Whistler did Maud in Venice, but he was quick enough to stand by her when some English artists expressed their disapproval of the couple's relationship.[12]

Still, as usual, Whistler's work came first, and he grew alarmed when Venice failed to inspire him. He had drawn numerous churches, bridges, canals, campos, cafés, markets, sunrises, and sunsets since arriving, all of them good, some of them pleasing, none of them satisfying. Huish began to push him, too. Potential subscribers were "cooling down," he warned Whistler. The ideal time for showing his etchings, before the spring and summer exhibitions, would soon pass. Charles Howell, who continued to work on his behalf in London, reported that the market for his engravings had tightened. Whistler felt trapped, the victim of foolish, not to say ignorant, dealers, collectors, and critics.[13]

Then, towards the end of January, "Providence" intervened. The source of inspiration should have surprised no one, least of all Whistler. He had made his reputation glorifying the unconventional and finding beauty in the ordinary. Now, having sketched all the usual tourist sites and some panoramic views of the city, he suddenly saw "great pictures" staring him in the face, "complete arrangements and harmonies." He had found "a Venice in Venice," Whistler wrote excitedly to Huish, in narrow neighborhood canals and "bits of strange architecture" tucked away in small squares and secluded lanes. The wonder was that, had he promptly executed his commission and rushed home for the sake of his contract, he would have missed this "mine of wealth." "I tell you old chap," he informed Howell, "[t]he work I do is lovely and these other fellows have no idea! no distant idea! of what I see with certainty."[14]

Equally exciting, he discovered new ways to draw the city. While some atmospheric renderings of tranquil lagoons and canals were recognizable "nocturnes" (fig. 62), other etchings and drypoints relied less on tone and texture than on a new staccato style of drawing. Whistler replaced strong, continuous lines with dots and dashes, very nearly calligraphic in form, and structured scenes as geometrical patterns. He saw not doors and windows, pillars and steps, archways and balconies, but

arrangements of squares and rectangles, and all of them drawn to emphasize the abstract over the concrete, nuance over declaration. The new work, he assured Huish, was "far more delicate in execution, more beautiful in subject and more important in interest than any of the old set."[15]

Three striking examples were *The Doorway* (fig. 63), *The Balcony*, and *The Palaces*. The titles, emphasizing, as they did, architectural features, rather than particular places, revealed his purposes. Even when etching identifiable locations, street scenes, or crowds of people, as in *The Rialto*, *The Piazzetta*, and *The Riva*, he paid close attention to architectural details.[16]

And those were just the etchings. He was even more excited about his new technique in pastels. Chalk and crayon had long been used by artists to draw preliminary studies, but pastels were not a highly regarded art form in 1880. Several artists in France, among them Manet and Mary Cassatt, had been experimenting with the medium, but they drew fully realized subjects and covered their paper with color, as they would in painting. Even Degas, widely conceded to be Europe's leading pastelist, used that method.[17]

By contrast, Whistler exploited the impressionistic possibilities of pastels by using color in a radically new way. It began with the paper. Instead of smooth, treated paper, he used plain brown wrapping paper, the type used for his pamphlet, *Whistler v. Ruskin*. He relished its grainy texture, and so liked the earthy tone that he left most of the paper untinted. Instead of drawing a bridge or a building in detail, Whistler, the master of "unfinished" paintings, outlined the subject in black chalk, a "complete picture in itself." He then added touches of white and a "few simple tones," such as blue or orange, to "heighten" the drawing. "[Y]ou can form no idea of their bright beauty – their merry lightness and daintiness," he told artist friend Matthew Elden. "You can't imagine what I have taught myself by all this." It was "a great find," he enthused, and must be kept "dark" as long as possible. As soon as colorists like Tissot saw what he had done, Whistler predicted, pastels would be "quite the fashion."[18]

He attributed his discovery to the Venetian weather. Alternating rain and snow, broken by periods of brilliant sunshine, revealed astonishing colors in the city's polished marble and "rich toned bricks and plaster." "[T]his amazing city of palaces becomes really a fairyland," he told his mother, "created one would think especially for the painter." He was surrounded by "gorgeous" colors and enjoyed a "freshness" alien to fog-and-soot-shrouded London. Having escaped the clutches of color in painting, he found himself seduced once again when it came to chalk and paper.[19]

Some of his pastels became preliminary studies for paintings or etchings, but he conceived most of them as complete works of art. Some, like the etchings, were inspired by architectural details, as in *The Steps* (fig. 64) and *The Staircase*, but most titles either identified specific buildings, such as *The Church at San Giorgio* and *San Giovanni Apostolo et Evangelistae*, or emphasized the colors of the work, such as *Note in Pink and Brown, The Brown Morning: Winter*, and *Blue and Silver: The Islands, Venice*.[20]

He had also stumbled on a new way to compose pastels and etchings, the very "secret of drawing," he later called it. Rather than envisioning a complete scene at the outset, he settled on a single "chief point of interest." From there, his picture grew outward, from the center, stripped to its bare essentials. The effect, he discovered, was easier to achieve with pastels than with etchings, but in either case, he had created "a perfect thing from start to finish."[21]

He could not work fast enough. Rising at 6:30 a.m., Whistler slaved until "hopelessly stupified with sleep and fatigue." He ignored frozen fingers, icicles hanging from his nose, snowdrifts, and drafty archways. "[Y]ou may double your bets all round," he told Huish, "for it is a good thing you have gone in for." He asked Ernest Brown and Thomas Way to rush him more etching ground, varnish, some Japanese paper, and twenty or thirty pieces of "old Dutch paper." Oh, and would Huish please send another £50? He and Maud were "starving."[22]

As winter receded, Whistler received bursts of cheering news from London. His niece Annie would be married in June, and the new Grosvenor exhibition, lacking any of his work, was considered "the worst" yet held at Coutts Lindsay's gallery. He could laugh as well at Disraeli being turned out of office. A fit punishment for refusing Whistler's offer to paint him. He was less pleased that the final auction of his property brought insultingly low prices. The highest bid, made for the portrait of Connie Gilchrist, fetched only £50. *The Gold Scab* went for twelve guineas. Luckily, as planned, friends had bought many of his favorite possessions. He also learned that his inscription above the entrance to the White House remained intact, and that some people, pausing to read it, commented on what a religious man he must be.[23]

Such glad tidings restored his feistiness. When brother Willie landed in a squabble with the head of his hospital, Whistler urged resistance. "There is nothing like a good fight!" he insisted to Nellie. "It clears the air – and the only thing is not to have any half measures – for that gives a chance to the enemy who think you are showing signs of timidity, and so gather courage themselves for a general rush against

you." Whistler regretted that he had not come earlier to this realization. "The mistake I have sometimes made in my battles is that I have left my man alive!" he explained. "He invariably gets better and worries you again, or at any rate remains a regret!"[24]

But if no longer brooding, Whistler could seldom forget the importance of his mission to Venice, not even when writing a letter to his son. He praised Charlie for doing well at school, being an "industrious nice little gentleman," and remaining "obedient and attentive" to his "kind Auntie Jo." He promised to bring him to Venice some day and ride with him in a gondola. Yet, nearly half the letter boasted of his own "perfect gallery" of pastels and "quite new and entirely different" views of Venice. Perhaps he only wanted to impress Charlie with the importance of his "fond papa," which is how he signed himself, but he might well have written the same letter to Huish, Howell, or Way. Addressing both the boy and Jo, whom he knew would read his words, Whistler said, "I [would] have written to you all had I not each day been such a slave to my work."[25]

The arrival in Venice of a group of American art students satisfied his yearning for approval. They had been studying in Munich, a popular training ground for Americans in the nineteenth century, under Frank Duveneck, a thirty-one-year-old American who had himself studied in Munich before opening a school there. The "Duveneck boys," as they came to be known, all in their twenties, knew Whistler by reputation. As one of them, Harper Pennington, would recall, "The rising genera-tion understood him much better [than his own], and looked up to him." He struck them as a "curious, sailorlike" figure when they first spotted him outside the Acca-demia di Belle Arti, "short, thin, and wiry, with a head that seemed large and out of proportion to the lithe figure." John Harris, with whom Whistler had been walking, made the introductions. "Whistler is charmed," the artist said as he shook hands with each of them.[26]

Several of the boys took rooms on the Riva San Biagio, in the Castello district, on the opposite side of town from Whistler. Their view of Venice, which looked west along the broad Riva degli Schiavoni and south across the Bay of San Marco, captivated him. After making several sketches from their windows, he decided to move to an upper-story room in the same building. From there, he could see the Doge's palace and, farther along, across the Grand Canal, the basilica of Santa Maria della Salute. Below, a busy quay, crowded with sailors and workmen, drays and wagons, fairly hummed with activity as ships vied for space in the bay beyond. Whistler had found an Italian Wapping. His new rooms were unadorned, and he

did little to embellish them, save for a photograph of *The Gold Scab* and the "sneering" portrait of himself taken after the Ruskin trial.

The boys were impressed by how Whistler lost himself in work and by how readily he shared his ideas and opinions with them. His ultimate ambition, he confided, was to paint a "grand concerto-like picture" entitled "Full Palette." It would contain the perfect balance of color and line, "a harmony in color corresponding to Beethoven's harmonies in sound." Yet, he espoused no doctrine, proposed no laws, even though he spoke constantly of the science of art. The only "lesson" they learned was the need for "delicacy" in art, especially in etching. "Delicacy seemed to him the keynote of everything," thought Otto Bacher, the most attentive and eager of the boys, "carrying more fully than anything else his use of the suggestion of tenderness, neatness, and nicety."

The vagueness did not bother Pennington, who cared only that he met daily with the "first among living painters." He delighted in hearing himself called "Harrpurrr," the r's being burred with "comic exaggeration." Pennington appreciated how Whistler, by "poking a little kindly fun," taught them, even without formal instruction, to see "the stupidity" of their "garish efforts." As for his rumored sarcasm, the Duveneck boys heard it "rarely," and then only when directed at "those who brought it down upon themselves." Whistler never spoke to offend or discourage, Pennington observed, but rather to instruct "[w]ith unending patience . . . [and] his own sweet reasonableness."[27]

Whistler sometimes played shamelessly on their idolatry. He borrowed money and paints from the boys, and made free use of the high quality printer's ink and portable press Bacher had brought from Germany. An English artist in the city, Henry Woods, from whom Whistler also borrowed money, complained to his brother-in-law Luke Fildes, "[H]e evidently pays for nothing . . . [and] is the cheekiest scoundrel out. . . . There will be a *Grande Festa* if he ever goes away." Seeing how "hard aground" he was financially, reduced on some occasions to selling his watercolors and pastels for a few lire apiece, the boys judged Whistler more charitably. They also saw that, when possessed of the means, he gave as freely as he took. Whistler had believed since his student days in the fraternity of artists, and when he invited the American and English artists in Venice to his much-reduced Sunday breakfasts of fresh fish and cheap wine, they gladly accepted, including Woods.[28]

But his friendship with the Duveneck boys went beyond that of teacher and pupil. He regaled them with stories of the Peacock Room and Ruskin, of Haden and life in London. On the hottest days, a buoyant and youthful Whistler bathed with them

in the canals and had them coach him in his dives. There were pranks and parties, gondola rides and walks across the whole of Venice. Toward the end of their stay, in August, the boys turned a rented coal barge into a "fairy-like floating bower," festooned with flowers and Japanese lanterns and flying an American flag. Whistler was the guest of honor as they plied the Grand Canal and feasted on melons and Chianti.

Café Florian, with a thousand people strolling daily across the Piazza San Marco, was the city's great gathering place. Bacher spotted Richard Wagner one evening, even as a military band played selections from *Lohengrin*. Ralph Curtis, who had also studied with Duveneck in Munich, joined the close-knit group on "hot *sirocco* nights." He chuckled at the sight of Whistler, dressed in white duck and lounging at his ease, "praising France, abusing England, and thoroughly enjoying Italy," but the boys lived for those carefree sessions. They relished Whistler's "brilliant" repartee and powers of debate, and the mock solemnity with which he declared to the impetuous Otto, "Bacher, I am not arguing with you; I am telling you." They absorbed his most superficial habits, and even if not copying his "dainty" way of rolling a cigarette or his "French habit" of taking a glass of absinthe before dinner, these things became indelible memories.

Whistler's complete ease was evident in the way he allowed his young friends to sketch him in unguarded moments, something he had not done since the 1860s, and then only with such trusted comrades as Poynter and Fantin. Ralph Curtis, for instance, caught him enjoying a cigarette on Katharine Bronson's piazza, a pose he later inserted in a large painting. Robert Blum drew him from the rear as Whistler sketched a scene from an open window; but twenty-three-year-old Charles Abel Corwin made the most penetrating portrait. His eight-by-six-inch monotype showed the artist from the chest up, his head bent slightly forward, the face serene yet intent, seemingly sketching or deep in thought. As a study of Whistler's character, stripped of all publicly contrived flamboyance and eccentricities, Corwin's drawing would never be equaled (frontispiece).[29]

Then, who should arrive to disturb Whistler's tranquility but Harry Quilter, new owner of the White House. As Quilter told the story, he was alone one morning, on holiday, sitting in a gondola and drawing a particularly picturesque doorway on the Rio de la Fava when Whistler arrived in his own gondola and frantically waved him away. "Hi! hi! What, what!" Whistler called in a "sort of war-whoop." "Here, I say, you've got *my* doorway." They were at the Palazzo Gussoni, and the prized object would become one of his finest Venice etchings, *The Doorway*. Refusing to acknowledge Whistler's territorial claim, Quilter suggested that they draw together.

Finally recognizing his rival but concealing the fact, Whistler smiled agreeably, stepped into Quilter's gondola, and worked beside him. Only as the morning progressed did he "cleverly" and "with much gusto" turn the conversation toward the "iniquities of the art-critic of the *Times*, one 'Arry Quilter." They parted amicably, but Whistler thereafter would use 'Arry Quilter as a foil for his attacks on conservative or ill-informed critics.[30]

However, come October, Ernest Brown and Marcus Huish told Whistler his Venetian idyll must end. He had exceeded his deadline for the etchings by nearly ten months. If his work was to be shown that winter, he must return to London within a fortnight. They could no longer promise a one-man show, but they hoped at least to include his work in an exhibition of the twelve greatest living etchers. It would be sad, indeed, they prodded, were "the head of the etching revival not represented" in this definitive show. They promised a good crowd, too. The exhibition would be well publicized, with "no end of bunkum to get the people in," but the window of opportunity was small. Every day of delay jeopardized success.[31]

Whistler had all but forgotten the Fine Art Society, even putting aside his etchings and pastels to paint in oils. He did some lovely work, too, including a nocturne of the lagoon and another that showed the facade of St. Mark's. He was ready, though, to return to "the world," and especially to the "great Etching Game" in Bond Street. "It will be great fun – and also a capital rentree for me!" he informed Willie and Helen, although why Huish should bother to include another eleven artists bewildered him.[32]

He sent word that Matthew Ridley, still a reliable friend, should have a printing press "in perfect working order" when he arrived in London. Of course, he would also need another £100 from the Fine Art Society in order to leave on such short notice. The society's executive committee balked at providing yet another outlay. Social acquaintances told them they would be "fools" to send more money. "Jimmy Whistler will never come back," they said, "& you'll never see your money again." The committee sent £50. Whistler protested; he had bills to pay. Huish coaxed the other £50 from his committee.[33]

Following a farewell "tea-dinner," Whistler reached London in mid-November, as cash poor as when he left but transfigured and rejuvenated. Huish found studio space for him, first at the society, later in the Quadrant, at the corner of Air and Regent streets. Young Tom Way, who marveled at the tones and contrasts Whistler drew from his new plates, helped him prepare for the show. Using what Way called the French style of "artistic printing," Whistler achieved the "delicacy" he had

preached to the Duevneck boys by working the ink onto the plates with the palm of his hand and a feather. He used other tricks to alter the tone of each state and different types of paper to vary the texture. He then selected his final dozen plates with an eye toward a variety of sizes and formats, some pictures being horizontal, others vertical.[34]

In the end, Huish found time and space for Whistler to mount a one-man show, his first since 1874. Using the same color scheme as his Flemish Gallery exhibition, he covered the walls with a maroon fabric that contrasted pleasingly with his off-white and gold-tinted etchings. A last-minute crisis occurred when the society's directors worried that a show with only twelve etchings would look ridiculous. They suggested that a printing press be brought into the gallery so that visitors could be "amused" with a practical demonstration of how Whistler made his etchings. The furious artist threatened to withdraw rather than be part of a music hall entertainment. The directors backed down, and the private view for "Mr. Whistler's Etchings of Venice" opened at noon on December 1.[35]

Maud called the show "*a great success,*" but she overstated the case. Despite broad attention in the press, even the most appreciative reviews found it only "interesting." Ruskinian critics leaped on the "slight" workmanship. Expecting to see the crisply drawn lines of the Thames Set and recognizable views of Venice, they were befuddled by Whistler's "soft, more painter-like treatment." A few reviews, as the society's directors had feared, emphasized the small scale of the exhibition. Edward Godwin worried that the show only confirmed his friend's reputation as an eccentric, and that Whistler should have tried to work his way slowly back into public favor before unveiling such radically new art."[36]

The New Bond Street show was duplicated, albeit with different etchings, at the Pennsylvania Academy of the Fine Arts early the next year, but it drew the same response. Huish expressed concern. He had contracted with Whistler for twenty-five sets of the Venice etchings, a total of three hundred prints, to be sold at fifty guineas per set. The society would need every penny of those sales if it was to recoup its investment in him. Equally agonizing for Huish was Whistler's insistence that every print in each set be unique, no two alike. The rarity of a print, as every artist and collector understood, increased its value and distinguished it from mass-produced commercial engravings. Not surprisingly, Whistler never completed the task.[37]

Still, he was pleased with his work, and his sense of redemption was enhanced by the arrival in London of Théodore Duret. It is odd that Whistler had not already met the French collector and critic, four years his junior. Duret had frequented

Madame de Soye's shop in the early 1860s, and by 1880, he was collecting the work of Corot, Courbet, Manet, and leading Impressionists. He had come to London, armed with a letter of introduction from Manet, to write an article about Whistler for the *Gazette des Beaux-Arts*. The delighted artist cooperated fully, even providing a new drawing for the article. When it appeared in April, he regretted that Duret had also seen fit to mention Frederick Leyland, but for the rest of it, Whistler declared, "I have never been so thoroughly understood and explained." He and Duret became friends and allies.[38]

By then, Whistler had also staged a second, more successful, show. Hoping to reduce his losses, Huish had decided to exhibit Whistler's Venice pastels, the plan being to unveil them before the traditional spring and summer exhibitions monopolized attendance and sales. Whistler promised an enormous success. He would show fifty-three of the ninety drawings he had brought back from Italy, and, with more time to prepare, he could stage a much grander production. As with the Flemish show, he wanted the rooms to be an extension of the art. To offset the cost of transforming his gallery, Huish demanded a third of all sales, twice what Whistler anticipated. The artist pleaded his case by insisting that his "perfect" installation would enhance the society's reputation no end. A skeptical Huish reduced his demand to twenty-five percent.[39]

Whistler covered the walls with olive-green fabric to provide a sympathetic, non-reflective background for his brightly gilded frames. A skirting of yellow gold anchored the room, while a molding of green gold encircled the ceiling. He painted most of the frames, which were many times larger than required, in varying shades of yellow gold, although some twelve of them, interspersed "with a view to decoration," had been done in a green gold that matched the ceiling molding. Most of the drawings, which averaged eight by twelve inches, formed a single row, although "here and there," for the sake of variety, Whistler inserted pairs, one above the other. He also prepared a brown paper catalogue for the exhibition.[40]

It is hard to say which caused the greater sensation, the gallery or the pictures. The "crush" of people and carriages for the private view on January 29, 1881, became the talk of the town. There were "Princesses, Painters, Beauties, Actors, everybody," Maud gushed, the rooms so "crammed" that movement became impossible. Over 42,000 people between them paid more than £2,000 to see the exhibition before it closed at the end of March.[41]

John Millais deserved some credit for the numbers. A retrospective exhibition of his work opened at the same time in a room adjacent to Whistler's show, and many

of his customers were drawn to the hubbub next door. It was an interesting juxta-position. Millais, one of the most popular of Victorian painters, had been an early influence on Whistler, but he had been no less affected by the American, as seen in his versions of *The Golden Screen, The White Girl,* and *The Mother.* He had also begun, though never finished, a portrait of Carlyle, and he had painted the picture of Lillie Langtry that Whistler longed to do. Before Whistler's pastel show closed, he would also begin the portrait of Disraeli that had been denied Whistler.[42]

Yet, the contrast between their two exhibitions was stark. "[A]esthetic visitors" found Millais's rooms dreary, the arrangement of his work "crude." Of course, it was hard to compete with the creator of the Peacock Room, but Millais had also failed to follow the new fashion in private exhibition decor, established at least partly by Whistler. Intimate settings, featuring an exclusive ambiance, single-line exhibits, and natural light, had become standard for fashionable shows in both London and Paris. The Grosvenor managed it on a grand scale, but individual artists, like the French Impressionists, incorporated the same elements. Huish, at least, had absorbed that lesson, if not from Whistler, then from Coutts Lindsey and the nearby Grosvenor. Later that year, he asked Edward Godwin to redesign the street entrance to the Fine Art Society, to make it "less of a shop front."[43]

As for Whistler's pastels, visitors were "carried away" by their "jewel-like bril-liancy." They mentioned the "triumph of tone" and "mastery of effect" he had achieved. "Magnificent, fine," Millais decreed in a loud voice, "very cheeky – but fine!" More appreciatively, he told Whistler in a brief note, "They gave me real pleasure." Julia Cartwright, who had been appalled by Whistler's portraits and musical titles at the first Grosvenor show, was transported. She thought the artist a "little black-looking conceited man," but as a lover of all things Italian, she judged that his "Riva sunset with the waters dancing and sky glowing with fire," and his "stormy . . . lagoon with the blue hills standing out against a hot sky," had captured "Venice exactly." Mortimer Menpes, a twenty-year-old Australian artist struggling to make a living in London, did not regret taking the time and money to see the show. "[T]hey are dreams," he said of the pastels, "too fine to write about. I have seen nothing that so impressed me."[44]

Many other artists, a large number of them from abroad, understood the revolu-tionary dimensions of the work in New Bond Street. Almost overnight, Whistler, having contributed mightily to an etching revival, had become the most innovative figure in a "pastels revival." Huish ensured at least one positive review by enlisting Thomas Way to write a piece for the *Art Journal,* a publication edited by Huish. If

the arrangement seemed a bit cosy, it was nonetheless a natural outgrowth of the new symbiotic relationship between dealers and the artists they touted. In any event, most English critics acknowledged Whistler's triumph. *Punch*, delighted to have one of its favorite foils back in circulation, added a spark of jollity to the occasion by dubbing him "Pastelthwaite," a reference to one of du Maurier's stock characters, "Postelthwaite."[45]

Most satisfying to Whistler came concessions from two of his most exacting critics. Harry Quilter quibbled that the drawings were not strictly speaking "pastels" because Whistler had not covered his paper with chalk, but he also called them "perfect works." Thirty-five-year-old Frederick Wedmore had written approvingly of Whistler's earlier work, although, as an admirer of Ruskin, he had bristled over the "trivial" *Whistler v. Ruskin*. "Some men are better than their creeds – some artists better than their theories," he declared at that time. Now, eighteen months on, Wedmore rejoiced to see Whistler turning away from "eccentric error" and "original absurdity."[46]

Maud likely had Quilter and Wedmore in mind when she reported to Otto Bacher that even Whistler's "enemies" acknowledged the "loveliness" of the pastels. Whistler sent Bacher a selection of reviews from both the etching and pastels shows to share with "The Boys" and added a note to Maud's letter: "I manage[d] to thrash them all round, and the poor devil Critics, and not a few of the painter chaps too, are so awfully angry." Better yet, with an asking price of 20 to 60 guineas each, Whistler's share of sales was £687. When a potential customer balked at the "enormous" prices, Whistler, finally able to laugh at the results of the Ruskin trial, responded, "Ha! ha! Enormous! why not at all! I can assure you it took me quite half an hour to draw it!"[47]

How sad, then, that Anna Whistler passed away on January 31, the day her son's pastels show opened to the public. Jemie had written to her about the new work from Venice but failed in his promise to visit when returned to England. He had been busy. There had been no time to visit. Like many sons, he assumed that The Mother would always be there, but it was not that alone. Each grim report of Anna's failing health had caused "tremendous depression." He simply dreaded to see her so near death. He had told her from Venice that he thought of her "continually," and that she need not fret about him. He would rebound from the "years of tribulation and heartbreaking discouragement" to reclaim his "proud reputation." "[Y]ou will rejoice with me," vowed the son, "not because of the worldly glory alone, but because of the joy you will see in me as I produce lovely things."

He and Willie rushed to Hastings when told the end was near, but Anna was gone before they arrived. Willie's medical practice forced him to return to London almost immediately, so Nellie came to help with preparations for the funeral. Whistler tried to divert himself by painting small (nine by five inches) watercolors of the town, the cliffs, the beach, the fishing boats. He walked with Nellie along the windswept cliffs. Decades later, she recalled him being worn down by grief and "remorse," but if he wept, she did not see it. He had cried openly at news of his father's death, a natural reaction for a fourteen-year-old boy. That a forty-six-year-old, world-weary man should be more stoic at the passing of an aged mother was not strange. The funeral over, his mother interred at Hastings, Whistler hastened back to the world he knew best, a world free of sentiment, a world, indeed, where tears betrayed weakness. Yet, a few weeks later, he changed the name on his bank account, and thereafter on all legal documents. Known as James Abbott McNeill Whistler since the Valparaíso adventure, he would now be known simply as James McNeill Whistler. It would not be his last tribute to the resilient little woman who had borne him.[48]

A prescribed period of mourning naturally followed, but Whistler told friends they could find him on most afternoons at the Fine Art Society. The pastels show continued, and given its popularity, he tried to leverage another advance, this one for £300, against profits. Huish refused, so Whistler marched into the gallery on a day "when the crowd was thickest" and shouted, "Well, the Show's over." When Huish and Brown rushed to hush him, he screeched more shrilly, "Ha! ha! they will not give me any money and the Show's over." A humiliated Huish yielded to extortion. Whistler was again riding high.[49]

# 12

# The Butterfly Rampant

## 1881–1883

Whistler had kept a low social profile since returning to England, even before the death of Anna. For a time, he enjoyed parading a white Pomeranian dog around town on a long ribbon, but the poor animal, given to him in Venice and named Ciao, spent most of its time confined to Whistler's studio in the Quadrant. When the artist returned one day to find that Ciao had chewed a pair of trousers to shreds, he scolded and struck the dog. Soon after that, Ciao "disappeared," snatched, Whistler insisted, by some "dog fancier."[1]

He had also lived apart from Maud. While he stayed with Willie and Nellie at their home, 28 Wimpole Street, "Mrs. Whistler," as Maud liked to be called, lodged first on Langham Street, a few blocks to the east, and later, in March, at 76 Alderney, in Pimlico. In April, she disappeared altogether, probably to Paris, amid rumors of another pregnancy.[2]

By the time she resurfaced, nearly three months later and without a child, Whistler had a home for them, or nearly so. He had signed a lease for a flat and studio at No. 13 Tite Street, but one thing after another displeased him about the place. He complained to his landlord about the color of the rooms, the installation of the stoves and grates, the blinds for his studio windows, and the dullness of the floors. The hallway was "an abomination in the sight of God and man," the flat altogether "uninhabitable." The couple did not move in until August.[3]

The location, so near his ill-fated White House, seemed perverse, but Whistler loved Chelsea and the river, and he still hoped to make the stretch of Tite Street between the Embankment and Queen's Road the center of London's artistic world. Another artist, Frank Dicey, resided next door and Frank Miles and Oscar Wilde lived together directly opposite. The street acquired an added cachet in June when Edward, Prince of Wales, attended a séance at Miles and Wilde's place. Whistler may also have attended, in response to Edward's desire to meet him.[4]

His return to Tite Street was also an act of defiance. As he had hinted to Nellie, and as seen when dealing with his landlord, the new Whistler would no longer hesitate to confront perceived enemies. "I pick my prey," he would tell a London art dealer, "and do not indiscriminately pursue 'even unto him that pisseth against the wall!'" However, once aroused, Whistler meant to be a veritable Cyrano, his patch of white hair substituting for the musketeer's plume, his sharpened pen for Bergerac's rapier, as he waged war against chicanery, pretense, hypocrisy, and ignorance.[5]

He found plenty of targets to skewer that spring and summer, starting with Seymour Haden. The brother-in-law had formed a new professional organization, the Society of Painter-Etchers, which he ruled, it was said, "like Ivan the Terrible." In judging submissions for the society's first exhibition, he suspected, quite erroneously, that some etchings attributed to Frank Duveneck had been done by Whistler. Accompanied by Legros, he went to the Fine Art Society to compare "Duveneck's" etchings with Whistler's Venice plates. Whistler threatened to give the pair a "thrashing" when he learned of their surreptitious visit, and when Otto Bacher, ignorant of the tempest, spoke of exhibiting with the society, Whistler scolded him. "Don't dream of it my dear Bacher!" he exclaimed. "[S]end nothing to this Seymour Haden game – for I give you the straight tip – it can't possibly succeed." The "thoroughly rotten scheme," he predicted, would "die the death of the absurd."[6]

Ominous words, as Whistler tried to sabotage the Painter-Etchers. Again comparing Haden to Seth Pecksniff, he informed its members of the indignity done him by their leader. Some of Whistler's friends, including Poynter, urged him to "let the matter rest," but other people egged him on. Watts-Dunton said, quite unwisely, "Your genius for fighting and your love of it are unabated, as I see with pride." The affair culminated in April, when Whistler leaked his correspondence with Haden over the matter to the press. One newspaper called it "A Storm in an Aesthetic Teacup," and chastised Whistler for his childish behavior. Whistler, unfazed, declared victory. This was now his "manner of fighting," he told friends. He would brook neither fools nor knaves, and Haden was both. He had Tom Way print fifty copies

of the correspondence as a pamphlet for friends. *The Piker Papers*, as he titled it, became a collector's item.[7]

By then, the second of Whistler's wars had commenced. Nearly everyone who had dealings with Charles Augustus Howell eventually regretted it. Whistler's friendship with the dulpicitous art connoisseur had endured because he enjoyed the "shock" it caused to be seen strolling down Bond Street with such an "unmitigated . . . rogue." Yet, loans from the Owl during Whistler's financial collapse of the 1870s had been dearly bought at ten percent. Pictures and etchings placed in his care had gone missing, and arrangements for collateral had been mysteriously complex. Whistler feared he would never be able to reclaim some paintings, including *The Falling Rocket* and his portraits of Anna and Carlyle. In the summer of 1881, he devoted himself "with the pertinacity of the redskin to the scalping of Howell."[8]

It began with the discovery of a patented Howell hoax. When relinquishing his Lindsey Row house in 1878, Whistler had sold the new occupant, Sydney Morse, a Chinese cabinet through Howell. The cabinet came in two pieces, but Howell delivered only the bottom half. The top half, he explained to Morse, required repair, and would be sent in due course. Due course never came, not, that is, until June 1881, when Whistler spotted the missing piece in an antique shop, purchased it for £4 10s., and gave it to an astonished Morse.[9]

After telling this story at every dinner table in London, Whistler had the "fiendish pleasure" of learning that Howell denied the entire episode. Even then, the affair might have spent itself had not Whistler and several friends caught Howell falsely claiming to be an intimate friend of Benjamin Disraeli. Whistler refused to let either matter die. When Samuel S. Paddon, a diamond merchant, art collector, and friend of Howell, advised the artist to quit his "petty tirade," Whistler responded that, while not "altogether sportsmanlike," his hounding of the Owl was "completely Howellian." Besides, he added, he "did not care who was right or wrong in an argument," but only "who got the best of it."

At the suggestion of Sydney Morse, Whistler published the correspondence involving Howell in *Correspondence. Paddon Papers. The Owl and the Cabinet*. Alan Cole thought it "too personal for general interest," but an additional printing was necessary when demand outpaced supply. Whistler rejoiced to learn of Howell's "impotent rage!" at having been exposed. "I am becoming quite a gourmet in cruelty it would appear," Whistler confessed blithely. "How bad all this is for us as Christians!" The blasphemous tone would have chilled Anna, but her son, as he told Paddon, saw it all simply as an "amazing game."[10]

The larger game, though, remained his continued artistic resurrection. Returning to portraiture, Whistler wanted to paint "all the fashionables." The carriages of London's upper crust, he boasted lightly to Cole, would soon clog Tite Street, and indeed, the dark days of the Ruskin trial and his bankruptcy seemed ancient history. Hostesses again considered him a prize catch. Everyone wanted to hear his views on art, on Balzac, on spiritualism, whatever the topic of the day, wherever his thoughts might lead. Gallery owners, writers, theatrical producers, actors, lawyers, politicians, and royalty crowded his Sunday breakfasts. "[G]reat success – there were fourteen of us in all!" he reported to Nellie Whistler of one occasion. "You will be pleased to hear that H.R.H. smoked a cigar in the Studio this afternoon – the 'Royal Boy' was of course most charming." Edward required no portrait, but his future paramour, Lillie Langtry, finally sat for Whistler.[11]

Whistler never finished Lillie's portrait, but then he never would have asked her to pay for it. Rather, his first paying customer was Valerie Susan Meux. "Val," as friends called her, was not exactly fashionable, certainly not in the same class as Lillie. As Val Langdon, she had been an actress and music hall performer who knew how to woo men with her pleasing figure and violet eyes. In 1878, she fixed those dazzling eyes on Henry B. Meux, a decade younger than her own thirty-one years and heir to a thriving brewery in Tottenham Court Road. She deserted a corporal in the Life Guards, with whom she had been living, and moved to Park Lane. That was after receiving £10,000 worth of jewelry as a wedding gift and cruising the Nile on her honeymoon. In order to pave his bride's way into London society, Henry commissioned three portraits of her from Whistler for a total of £1,500.[12]

Val Meux said she and Whistler were two of a kind, "a little eccentric and *not* loved by *all* the world," as she put it. Unlike Lillie Langtry, who enjoyed her "numerous sittings" with Whistler, Val, like most other sitters, found it trying to pose for the long hours he required. Nonetheless, her first two portraits (Whistler never completed the third one) captured the lady's sensuous beauty in breathtaking fashion. Whistler cheated a bit, as he did with Maud, by making her more slender than photographs showed her to be. Both paintings were full-length but markedly different in color and composition. The first one was another "black portrait." Standing regally against a black background in a near frontal pose, Val wore a close-fitting, sleeveless velvet evening gown. The only contrast came from her bare arms, face, and bosom, and a long white fur cloak draped over one shoulder. In the second picture, *Harmony in Pink and Grey*, she stood in profile. The pose was more coy than regal, and her pastel-colored dress of silver gray and rose pink more to her own taste.[13]

A visitor to his studio was quite taken with Whistler's method of painting the first Meux portrait, *An Arrangement in Black*. The artist had not attempted such a large-scale project in some time, but he attacked the canvas with zeal. Val stood on a dais some twenty feet from him. Whistler assumed what had become his customary, triangulated position when painting, the canvas to his left front, a mahogany "palette table" slightly more to the left. He found the table, about the size of a large tea tray, less cumbersome than a hand-held palette. "His movements were those of a duellist fencing actively and cautiously with the small sword," the visitor recalled. Clutching a sheaf of brushes with "monstrous long handles," some as long as three feet, he advanced, retreated, crouched, peered, darted forward, and fell back for an hour or two at a time, now and then touching his "weapon" to canvas.[14]

In a curious way, the death of Gabriel Rossetti on Easter Sunday 1882 also shaped Whistler's post-Venice life. At fifty-four years, the painter-poet had been in ill health since before Whistler's exile. Subject to dark moods through much of life, Rossetti had become a recluse, corpulent and addicted to chloral. Whistler did not attend the funeral. Instead, three months later, he wrote a note of "warm sympathy" to William Rossetti. "It would seem that I only *hasten* to write to my *enemies*!!" he explained. But as he approached his own fiftieth birthday, Rossetti's death increased Whistler's desire to bask, like Rossetti, in the adoration of younger artists. He wanted a permanent band of Duveneck Boys to champion his ideas and ensure his legacy. His methods and theories would be their credo, his opinions and prejudices their own. In matters of art, he would become their Master, and in all things the "Amazing One."[15]

Alan Cole noticed that "a sort of claque" had already formed around Whistler. It included some Duveneck Boys who had settled in London, most notably Otto Bacher and Harper Pennington. Young Tom Way also stood ready to do Whistler's bidding, and he brought along a fellow student from the South Kensington schools, Mortimer Menpes, the young Australian who had been dazzled by the pastel show. Walter Sickert abandoned his classes with Legros at the Slade School to follow Whistler, and Waldo Story, an American sculptor who may have met Whistler in Venice, attached himself to the group. They soon numbered about a dozen, "all young, all ardent, all poor."

They hailed Whistler, among all his contemporaries, as the one artist they could enthusiastically emulate. Sickert, who had worshiped Whistler since the first Grosvenor show, declared to a friend, "Such a man! The only painter alive who has first immense genius, then conscientious persistent work striving after his ideal . . . and

[who is] turned aside by no indifference or ridicule" (fig. 65). Menpes recalled unabashedly, "I was almost a slave in his service, ready and only too anxious to help, no matter in how small a way. . . . I simply fagged for Whistler and gloried in the task." Sickert and Pennington, being inclined toward the debonair, also copied Whistler in dress and mannerisms.[16]

The comings and goings of these young men made Whistler's studio something of a royal court. It certainly was not an atelier. Anyone wishing to learn from him had to watch and listen, as had the Greaves brothers and the Duveneck Boys. Even then, Whistler guarded his secrets jealously. "[W]e never got within a certain crust of reserve," Menpes recalled, "in which he kept his real artistic self." He showed his appreciation mainly through playful comments, by telling stories about his days as a West Point cadet and young bohemian, bestowing nicknames, and dining with them at one of his clubs or favorite restaurants. He even put up the more established "Waldino" Story for membership in the Beefsteak Club. They talked of establishing their own "awfully swell" Chelsea Club in Rossetti's old Cheyne Walk house, with "everything most complete in the way of cooking & wine."[17]

Whistler imparted his most important lessons outside the studio. In their walks around Chelsea, he taught his followers how to observe and commit impressions to memory. In trips to the galleries, he marked the differences between good and bad art. "[T]hese so-called masterpieces are not good works," he once told them of some Rembrandt paintings in the National Gallery. "They are pictures that you look at and are interested in merely because of their technical dexterity." Having gazed long and hard at some Turners, his monocle firmly in place, Whistler decided, "No: this is not big work. The colour is not good. It is too prismatic. There is no reserve." As for Constable, "[W]hat an athletic gentleman he must have been!" Whistler speculated, and how weary from painting so many trees.

Though sometimes mawkish, Whistler meant to educate, not entertain. He dispensed praise subtly. He described Velázquez as a "good workman" and Canaletto as an "absolute master of his materials," but then Canaletto's work, he shrugged, was as little understood as his own. On another visit to the National Gallery, he sent Pennington to study Hogarth's *Marriage A-la-Mode* series. The young American had never thought highly of Hogarth, but as he studied these paintings, he grew excited about his obvious technical prowess. Rushing to find Whistler, he grabbed his arm and fairly shouted, "Why! – Hogarth! – He was a great Painter!" An amused Whistler replied conspiratorially, "Sh-sh! Sh-sh-yes! – ·I *know* it! . . . *But don't you tell 'em!*"[18]

Whistler's most famous disciple, if such he may be called, was not an artist at all. Whistler did not at first know what to make of Oscar Wilde. He had known of him since the early Grosvenor days but they did not become friends until his return from Venice. By then, the twenty-seven-year-old poet and critic was a celebrity in his own right, having become, as Swinburne and Pater withdrew from public life, the chief exemplar of the Aesthetic Movement. Unfortunately, Wilde played to the worst parodies of Aestheticism by allowing its fashions, symbols, and mannerisms to overshadow the art in "art for art's sake."

Nothing better defined this new phase of Aestheticism than Wilde's flamboyant attire (fig. 66). Gentleman's clothing was in transition in the 1880s, defined by the grace and elegance of a new type of dandyism. The trend perfectly suited Whistler, but Wilde's gaudy ties, waistcoats, and velvet jackets were purposefully artificial and theatrical. In search of notoriety rather than fame, he took the effeminate aspects of dandified dress to shallow and comic extremes. Critics charged that "aesthetes" like Wilde had no "genuine love of beauty," only a "love of display." Even his later lover, Alfred Douglas, conceded, "I doubt whether I would have 'swallowed' the aesthetic Oscar."[19]

However, and more importantly, Wilde also abandoned an earlier allegiance to Ruskin, whose lectures he had attended at Oxford, to declare that art had no other function than to represent beauty. Art, he insisted, was merely "appearance," and appearance was created through a perfectly balanced visual "effect," the harmony of "light and shade, of masses, of position, and of value." His new heroes were Poe and Swinburne in poetry and Burne-Jones and Whistler in painting, and only Whistler united "all the qualities of the noblest art." He paid homage to this new master of beautiful effects in such poems as "Impressions du Matin":

> The Thames nocture of blue and gold
> Changed to a Harmony in grey.
>
> - - - - - - - - - - - - - - - -
>
> The yellow fog came creeping down
> The bridges, till the houses' walls
> Seemed changed to shadows and St. Paul's
> Loomed like a bubble o'er the town.[20]

Upon first meeting Wilde, Whistler marveled at his ingratiating and affected manner. "Amazing," was all he could say. But what began, from Whistler's perspective, as a master–student relationship soon became a contest of wits and wills

between two evenly matched opponents. It could be argued that Whistler honed Wilde's natural talent for the bon mot and clever repartee, while Wilde taught Whistler the nuances of stagecraft and performance. Physically, they would have made an ideal music hall team, with the tall, large-boned Irishman dwarfing the "gnome-like" American. In any event, their verbal jousting delighted London society. Ellen Terry, who knew something about maintaining a public image, called them the "most remarkable men" she had ever known. "There was something about both of them," Terry explained, "more instantaneously individual and audacious than it is possible to describe."[21]

Cartoonists and satirists were already exploiting their aesthetic ties by the time Whistler returned from Venice. When *Where's the Cat* opened at the Criterion Theatre in November 1880, the lead character was clearly patterned on Wilde, but Whistler hovered behind every reference to aestheticism and art. February 1881 brought *The Colonel*, written by Francis C. Burnand, the new editor of *Punch*, to the Prince of Wales Theatre. Wilde was again the obvious model for the play's "Professor of Aesthetics." Whistler appeared more conspicuously this time as the painter Basil Giorgione and through a painting entitled *Arrangement in Gold*. Ironically, it was an American cavalry officer, the title character in the play, who exposed the shallow pretensions of the English aesthetes and restored "common sense" to the community. Queen Victoria called *The Colonel* a "very clever play." Wilde dismissed it as a "small farce."[22]

But all that paled beside Gilbert and Sullivan's *Patience*. Often described as the duo's finest satire, this Aesthetic parody opened in late April 1881 to instant acclaim. Gilbert's libretto created two rival aesthetes, a "fleshy poet" named Reginald Bunthorne and an "idyllic," or spiritual, poet named Archibald Grosvenor. The story included no painter, and the sentiments and mannerisms of both poets came closer to identifying Wilde than Whistler. Still, the actor who played the role of Bunthorne, George Grossmith, parodied Whistler. His dark curly hair had a white streak in front. He sported a monocle, and, unlike the clean-shaven Wilde, Grossmith's Bunthorne had a mustache and tuft of hair beneath his lower lip. Grossmith also imitated Whistler's characteristic laugh, "Ha ha!"[23]

Ha ha! indeed, for despite the laughter, Whistler was profiting and blossoming as never before. He continued to create Venice proofs for the Fine Art Society, and although he quarreled with Huish and Brown over who should bear the cost, the etchings sold, as did his lithographs. As he roamed the backstreets of London in search of subjects for his etchings (fig. 67), he also hit on a new idea for oil paint-

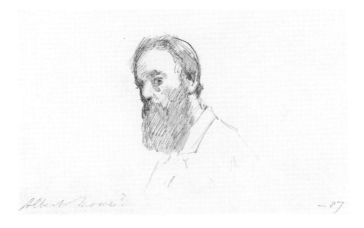

37 Albert Moore in 1887.

38 *The Artist in his Studio.* Never completed as Whistler envisioned it, the painting owed its color scheme to his association with Moore.

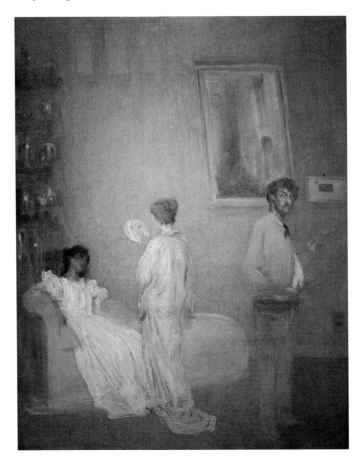

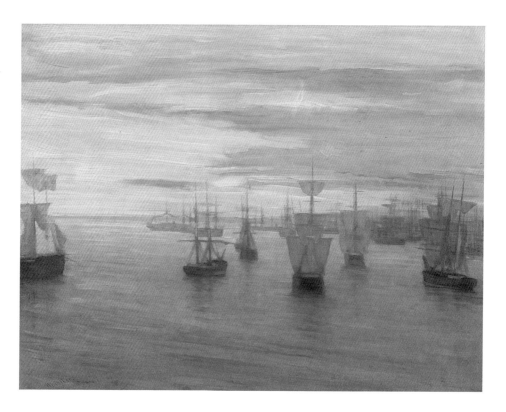

39 *Crepuscule in Flesh Colour and Green: Valparaiso.* Edwin Edwards called this painting "surprisingly novel, impossible to explain" when he saw it in Whistler's studio in 1866.

40 Algernon Swinburne, Dante Gabriel Rossetti, Fanny Cornforth, and William Michael Rossetti in the garden of Tudor House.

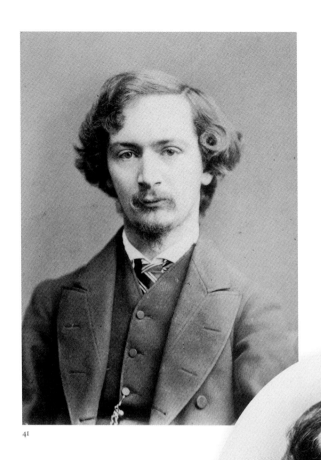

41

41 Algernon Swinburne in 1865. The troubled poet introduced Whistler to the Rossetti crowd and endeared himself to Anna Whistler.

42 George William Whistler. An early patron of his younger step-brother, he tried also to be a voice of reason for the increasingly combative artist.

42

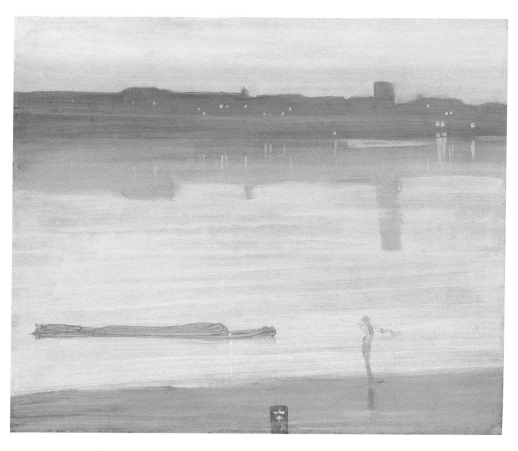

43   *Nocturne: Blue and Silver – Chelsea*. Painted in 1871, this was one of Whistler's earliest and most successful "moonlights."

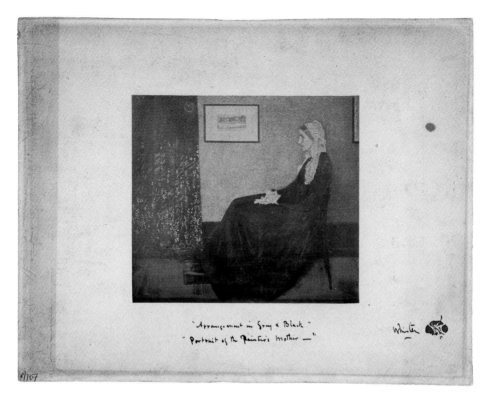

44 *Arrangement in Grey and Black: Portrait of the Painter's Mother*. This is Whistler's own photograph of his iconic painting, inscribed and signed with his butterfly on the mount.

45 *Speke Hall*. Whistler became a frequent visitor at the country home of Frederick R. Leyland, as was Anna Whistler on occasion.

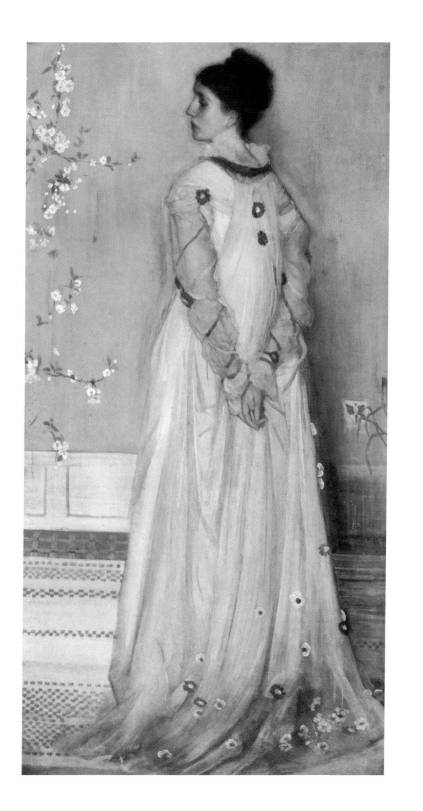

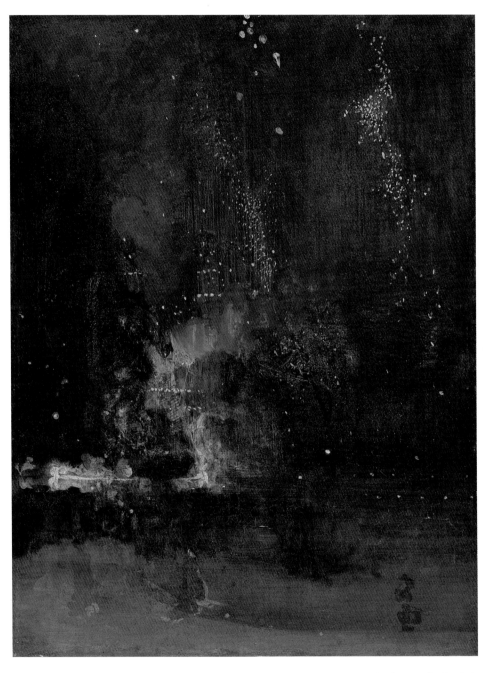

(*facing page*)  46  *Symphony in Flesh Colour and Pink: Portrait of Mrs. Frances Leyland*. One of Whistler's most successful and personal portraits.

47  *Nocturne in Black and Gold: The Falling Rocket*. The painting that sparked Whistler's famous libel suit against John Ruskin and changed the course of his life.

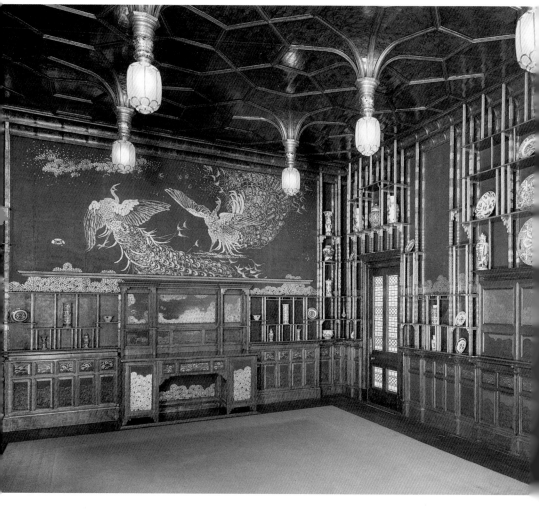

48 *Harmony in Blue and Gold* in the Peacock Room. This photograph of the dining room at 49 Prince's Gate shows Whistler's dueling peacocks.

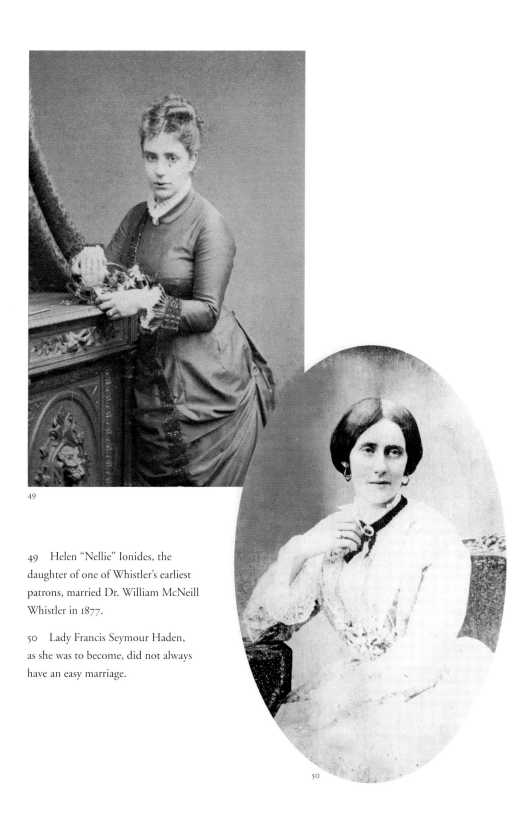

49

49 Helen "Nellie" Ionides, the daughter of one of Whistler's earliest patrons, married Dr. William McNeill Whistler in 1877.

50 Lady Francis Seymour Haden, as she was to become, did not always have an easy marriage.

51

52

51  Entrance to the ornate Grosvenor Gallery, 1877.

52  *The Boy*. Whistler's son, Charles James Whistler Hanson, shown here at approximately age six.

53

54

53   *Maud, Standing.* Maud Franklin, who replaced Jo Hiffernan as Whistler's mistress and favorite model in the mid-1870s.

54   Charles Augustus Howell in the mid-1860s. The notorious "Owl," whose friendship and assistance could be costly.

55

56

57

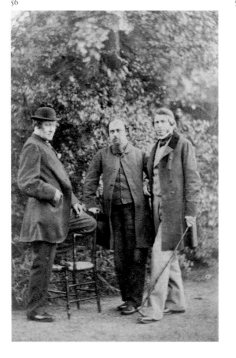

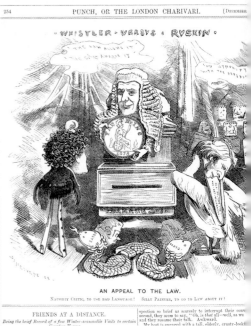

254          PUNCH, OR THE LONDON CHARIVARI.     [December

·WHISTLER·VERSVS·RVSKIN·

AN APPEAL TO THE LAW.

Naughty Critic, to use bad language!     Silly Painter, to go to law about it!

FRIENDS AT A DISTANCE.

*Being the brief Record of a few Winter-seasonable Visits to certain*

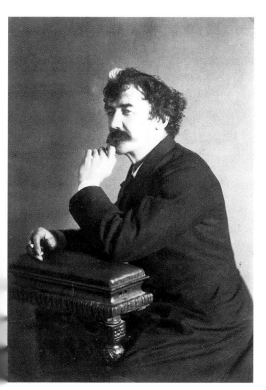

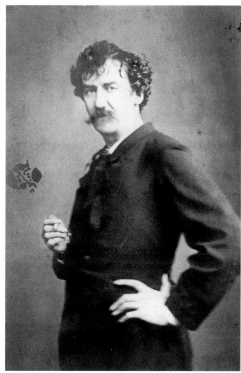

58 The "Good" Whistler, as his friends saw him in 1878.

59 The "Bad" Whistler, as he wished his enemies to see him after 1878.

*Facing page:*

55 The White House, Tite Street. Designed by Edward W. Godwin, it was the only house Whistler ever "owned," if only for thirteen months.

56 William Bell Scott, Dante Gabriel Rossetti, and John Ruskin in 1863. Unlike his protégé Rossetti, Ruskin would have endorsed painter Scott's description of Whistler as a "disreputable man."

57 *An Appeal to the Law*, from the September 7, 1878, issue of *Punch*, suggests that both Whistler and Ruskin suffered in reputation as a result of their legal battle.

60   *Old Battersea Bridge.* This was Whistler's last etching of his favorite bridge before leaving for Venice in 1879.

61   Whistler in an undated photograph, but striking the bohemian pose that perfectly represents his mood and circumstances upon arriving in Venice.

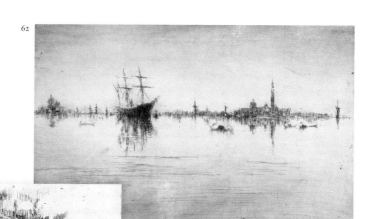

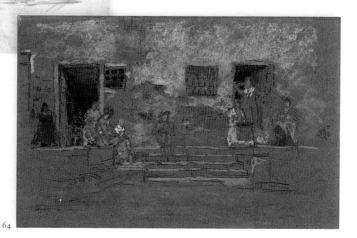

62  *Nocturne.* This haunting etching and drypoint shows the lagoon that stretches out from the Riva degli Schiavoni.

63  *The Doorway.* This small palace on the Riva de la Fava was part of the Venice within a Venice that Whistler so delighted in discovering.

64  *The Steps.* A lovely example of the revolutionary collection of pastels that Whistler created in Venice.

63

64

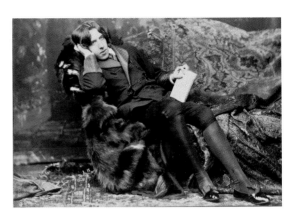

66  Oscar Wilde at his Aesthetic best, seen here during his tour of America in 1882.

65  *Walter Sickert*. Whistler made this lithograph of one of his earliest and most talented disciples in 1895.

67  *The Fish Shop, Busy Chelsea*. One of the many shop fronts that became a Whistler staple in the 1880s and 1890s.

68  *Chelsea Shops*. He painted them as well in oils on small wooden panels.

ings: small, detailed renderings, roughly five by nine inches, of shopfronts, done on wood panels. He loved the daintiness of the format, which he had experimented with in Venice and used for some watercolor seascapes done the previous autumn on a trip to the Channel Islands. While not suitable for large official exhibitions, they could be produced quickly and fit a new trend toward smaller-scaled work for middle-class parlors (fig. 68).[24]

Whistler had enough new work to exhibit at both the Salon and Grosvenor in 1882. Val Meux's black portrait and three Venice etchings went to Paris, where they were generally well received, although another American, John Singer Sargent, drew more attention. The twenty-six-year-old Sargent had exhibited at the Salon every year since 1877. He and Whistler may have been introduced in the autumn of 1880, when both were in Venice. They certainly shared many of the same friends in Venice, London, and Paris, where Sargent lived in 1882. However, they were so different temperamentally that even when Sargent moved to London in 1885, the artists remained more acquaintances than friends. Whistler is said to have admired Sargent's watercolors and drawings. Sargent, for his part, had been influenced by Whistler's use of color, and while seemingly unaware of it, had been attracted to the same nooks and crannies of Whistler's "other Venice."[25]

Seven new Whistler paintings went to the Grosvenor, including Val Meux as a *Harmony in Pink and Grey*, two nocturnes, a portrait of Maud, and two Channel Islands oils. He also sent an unfinished portrait of fifteen-year-old Maud Waller, niece of Pickford Waller, an illustrator and collector of Whistler drawings and pastels. He withdrew this *Scherzo in Blue* after the private view, but not before the critic from the *Pall Mall Gazette* caught a glimpse of it and lambasted Maud as a "scarecrow in a blue dress." Whistler was gratified when one of his followers, the perceptive and articulate Sickert, applied a public cudgel on his behalf. It would not be the last time Sickert defended Whistler in the press.[26]

Positive reviews from the Grosvenor far outweighed the catty comments, but Whistler's personal appearance at the show drew more than a few quizzical comments. Besides wearing a new "faun coloured long skirted frock coat," he carried an extraordinarily long cane, a bamboo shaft nearly half as tall as himself. This "wand," as people soon called it, would become as much a trademark as his white plume. Henry James thought his attire "amusing," but the *Pall Mall Gazette* spoke of "foppish airs," "affectations," and "contempt of public opinion." No one had ever called Whistler foppish. He seemed to be playing into the hands of critics who sought to tie him to the extremes of the Aesthetic Movement. *Punch* did not have

to mention his name for readers to identify "that little man, with an eye-glass, talking and gesticulating very volubly" at the Grosvenor.[27]

Not by chance, Whistler first betrayed his annoyance with Oscar Wilde around this time, and it involved Wilde's own costume. The Irishman had embarked on a year-long lecture tour of America the previous December, his mission being to announce the English Renaissance and civilize the former colonies. Shortly before Wilde left England, Whistler caught sight of him wearing a green overcoat and Polish-style cap. "How dare you!" Whistler challenged in his first published jibe at Wilde. "What means this unseemly carnival in my Chelsea!" He cloaked his irritation in humor, and, in truth, his rebuke was meant partly in fun. Certainly, the good-natured Wilde accepted this and the exchanges to come in that spirit, but there was purpose, as always, in Whistler's remonstrance.

Blithely unaware of the growing suspicions about him, Wilde wrote privately to Whistler shortly after arriving in America. "My dear Jimmy, [t]hey are 'considering me *seriously*.' Isn't it dreadful? What would you do if it happened to you?" Whistler replied with as much honesty as humor: "That you should be considered seriously was inevitable – that you should take yourself seriously is unpardonable." Whistler had Edmund Yates publish a second exchange when he and several other of Wilde's friends, including the poet Rennell Rodd, accused Oscar of dressing like 'Arry Quilter and sounding like Sidney Colvin, who had become a professor at Cambridge. Still not suspecting Whistler's irritation, the roaming Irishman wrote again: "You dear good-for-nothing old Dry-point! Why do you not write to me? Even an insult would be pleasant, and here I am lecturing on you . . . and rousing the rage of all the American artists by doing so."[28]

Whistler had no time to write. He had his hands full with Janey Sevilla Callander Campbell. If his association with Wilde and the Aesthetic Movement made London's more conservative "fashionables" wary of him, Whistler remained a magnet for the likes of thirty-six-year-old Campbell. He had recently designed some trellises for her country estate, and now she wanted a portrait of herself. Beautiful, cultured, and slightly zany, she had become Lady Archibald Campbell upon marrying the second son of the Duke of Argyll in 1869. As Lady Archie, she extolled Aestheticism, advocated female dress reform, staged "pastoral plays" at her country house, practiced spiritualism, and believed in fairies. Oscar Wilde called her the "Moon Lady." She had published an article on "The Psychology of Birds," and in 1886 would issue a pamphlet on Aesthetic interior design entitled *Rainbow-Music*. Asserting that all colors had their equivalent in musical notes, she praised the "natural

music" of the Peacock Room and defined as "Whistleresque" all genius and originality in art.[29]

Nellie Whistler suspected Campbell of being more than a follower of her brother-in-law when Whistler asked if he might meet Janey for tea in Wimpole Street, supposedly to discuss the portrait. Nellie refused to invite the notorious bohemian, but Whistler escorted her there anyway. He also convinced Nellie to address the envelopes for letters he sent to Campbell. He explained that he wished to avoid "compromising" the lady should her husband see their correspondence. When Nellie refused to continue the deception, Sickert performed the task.[30]

Whistler abandoned his original impulse to pose Lady Archie in court dress when she complained that the weight of the costume fatigued her. He next tried a "harmony in silver grey," which he had nearly completed before casting it aside. Interestingly, Whistler invested all of this time and energy without a commission. When Lady Archie reminded him of this fact, he replied, "We are doing this for the pleasure in it." Some pleasure. Despite the intrigue and sparks between them – or perhaps because of them – their mutual physical attraction did not produce a harmonious working relationship. The strong-willed lady peppered Whistler with suggestions for the picture and nearly ended the project. She continued only because Théodore Duret, who was sitting for his portrait at the same time, and Beatrice Godwin, who had taken to visiting Whistler's studio, urged patience.

A good thing, too. The finished painting was a masterpiece that captured Campbell's spirited, impetuous, and independent nature. Whistler called it *Arrangement in Black: La Dame au brodequin jaune – Portrait of Lady Archibald Campbell*. Rather than striking a static pose, Lady Archie stepped away from the viewer and into the background of the picture. It was a daring concept that allowed Whistler to create a series of swirling, seductive curves from the motion of her body and folds of her dress. After all the trouble about her costume, they finally settled on a dress she happened to wear to the studio one day. Whistler liked the textures of the loosely pleated woolen skirt and matching fur cape. Campbell liked the end results, although her family thought the cool, come-hither glance she threw over her shoulder, not to mention a daring glimpse of ankle in a garish yellow-brown shoe, made her look like a prostitute.[31]

Seemingly drained by the experience, Whistler took a brief working holiday in the Low Countries before preparing in December for a second exhibition of Venice etchings at the Fine Art Society. Given that he and Huish were still quibbling over the cost of printing sets from the first show, the contract suggested a remarkable

degree of confidence and perseverance on the part of the society. And if Huish thought the first show had been the height of decorative schemes, he was flabbergasted by Whistler's new installation, an "Arrangement in White and Yellow," which opened on February 17, 1883.[32]

"White walls – of different whites – with yellow *painted* mouldings – not gilded!" Whistler enthused over his creation. "Yellow velvet curtains – pale yellow matting – yellow sofas and little chairs – lovely little table yellow – own design – with yellow pot and *Tiger* lilly!" Daffodils, too, and marguerites and narcissi, with muslin draped from the ceiling and yellow fabric covering a mantelpiece. Whistler had a sudden passion for yellow, that also being the dominant color at his flat in Tite Street. In the gallery, he stenciled yellow butterflies on the white fabric that covered the walls and white butterflies on the yellow curtains. An attendant, borrowed from Bram Stoker at the Lyceum Theatre, donned a cream and yellow livery to greet patrons and sell copies of the exhibition catalogue. Whistler described him as "one of the elements of the Exhibition."[33]

Whistler encouraged people to attend the carnival wearing yellow flowers, kerchiefs, cravats, and boutonnieres. At the private view, where he wore yellow socks, additional attendants, sporting yellow neckties, offered yellow satin and velvet butterflies with silver wire stingers to a "select few" female guests. Among these "women Amazers!!!" was Princess Louise, who attended with her father the Prince of Wales. Edward, a greater connoisseur of women and cigars than of art, did not understand the etchings, but when Louise pinned one of the silken butterflies to her shoulder, Whistler was guaranteed success. "[F]or when once a beautiful woman pins on your colours and wears your badge," he gloated, "she is ready to die for you."[34]

Not everyone understood the humor. A teenage Beatrix Potter avoided the show. "Somewhat behind the times," she decided, "[and] quite disgusting how people go on about these Pre-Raphaelite aesthetic painters." Lucien Pissarro, the twenty-year-old son of French Impressionist Camille, thought Whistler's exhibition had "an air of great joyousness" but accused him of stealing the idea, if not the colors, from a recent Impressionist show. His father commented only that yellow and white made "a charming combination," but he agreed with Potter that the new aestheticism was a "kind of romanticism more or less combined with trickery," an "*eccentricity* to make sensitive people swoon." As for swooning, some visitors said they felt "jaundiced" after prolonged exposure to the gallery.[35]

Nearly lost in this surreal world were fifty-one superb etchings, printed on yellowish paper and encased in narrow white frames scored by a pair of light-brown lines. Forty-

three etchings came from Venice, the others from Whistler's recent work in London. Arranged in groups of three, according to subject, size, and tone, they were hung so high that assistants wondered if people would be able to appreciate the artistry. "[T]hat's all right," Whistler assured everyone. "In an exhibition of etchings, the etchings are the last thing people come to see." Sure enough, a parody of the show had one critic say, "Oh, I was charmed. The Walls, the Programmes, the Furniture – everything was quite *too* lovely. . . . But the Etchings? . . . I don't remember seeing them!" Still, people talked about Whistler's "Mustard-pot Show" for years to come.[36]

Speaking of the catalogue, its twenty pages, with brown paper covers, offered another biting rebuff to art critics. Rather than following the trend in exhibition catalogues of describing the intention of each piece, Whistler inserted excerpts from reviews of his earlier work. "Out of their mouths shall ye judge them," announced the title page, although, in truth, many of the cleverly lifted snippets were taken out of context, with Whistler quoting the only negative portions of otherwise positive appraisals. In one instance, he even allowed a misprinted word, which he had spotted in proofreading, to go uncorrected. The result had Frederick Wedmore say of Whistler's etchings, "They have a merit of their own, and I do not wish to understand it." Wedmore had actually written "under-state," not understand.

Wedmore politely protested this sort of "lively misquotation" and "arrangement of critics" in his review of the exhibition, but the entire affair was so novel that most people found a "delicious insolence" in the catalogue and an "engaging childishness" in the show. *Punch* marveled at Whistler's inventiveness, from the "yallery" flunkey, to the "half done" etchings, to the "Catalogue critical." Bursting into verse, the magazine, which often reflected popular opinion, declared in admiration,

> Vainly the Critics will sit on him,
> Why such a butterfly slay?
> No one can e'er put the bit on him –
> Whistler's the wag of the day.[37]

Indeed, Whistler had come to take almost as much pleasure in writing pamphlets, catalogues, and letters to the press as he did in painting and drawing. He had also moved beyond the pedantic *Whistler v. Ruskin* to adopt a voice that, even when mocking or seemingly ruthless, added to his reputation as an entertaining raconteur. He also understood, though he did not always demonstrate it, the value of a gentle touch. His butterfly signature, which he also affixed to literary efforts, signified this paradoxical style. While darting, fluttering, and hovering in all manner of ways, these

seemingly playful creatures retained their barbed tails, the perfect exclamation point for Whistler's finely honed words.

Nearly giddy with the response to his "perfect" creation, Whistler reigned as the "Butterfly rampant," his "masterpiece of Mischief" having exceeded all expectations. "Never such a Social Hurrah brought about by art means in London before!" he reported to an absent Waldo Story. "The people divided into opposite bodies, for and against – but all violent! – and the Gallery full! – and above all the Catalogue selling like mad!" Having collected the "silly drivel of the wise fools who write," he had "slaughtered" the critics with their own words and left their sour carcasses "lying around in masses!"[38]

And for all his "wild wickedness," he could smile over the financial success of the etchings show. In addition to collecting entrance fees at a shilling a head, the gallery sold two thousand copies of his one-shilling catalogue, for which he received £91. Six printings had been required to satisfy demand, including "Provincial orders" from people who had simply read about it. When the exhibition closed in March, several American galleries restaged the extravagant affair. The roadshow opened in New York that October and went from there to Baltimore, Boston, Philadelphia, Detroit, and Chicago. Whistler's share of the profits for works sold at the London show was only £80, but orders for his Venice etchings rolled in from both Britain and America throughout the rest of the year.[39]

In terms of notoriety, it was Whistler's answer to Wilde's American tour, but he had also begun to consider more seriously the potential for profit in his native land. Lois Cassatt, the thirty-five-year-old sister-in-law of American artist Mary Cassatt, decided while visiting London in April that she must sit for Whistler. When her obliging husband shelled out five hundred guineas for the privilege, Whistler seemingly awoke to the fact that, while his own country could not claim as many "fashionables" as Great Britain, some Americans had lots of money, and they were willing to spend it on modern art.

Mary Cassatt, who had studied art in the United States, Italy, and France before settling in Paris, originally favored Renoir for the commission. She did not know Whistler well, but, perhaps showing the influence of her friend Degas, thought he had gained as much by his fame as a wit as by his talent as an artist. Her opinion seems to have been softened by friendship with an American fan of Whistler. Twenty-six-year-old Louisine Waldron Elder first met her countryman sixteen months earlier, when she visited his studio and bought five Venice pastels. She paid only £30 for them, a genuine bargain. Whistler had needed the cash at the time, but the clever

Miss Elder had also said that was all she could afford after buying works by Degas, Monet, and Pissarro in Paris. Whistler could not possibly let her return to America without something of his own. Besides, he liked the young woman. He personally delivered the framed pastels to her hotel and later sent her an autographed copy of *Whistler v. Ruskin*.[40]

Whistler's attentiveness would pay higher dividends than he could have imagined when Elder married the fabulously wealthy Henry O. Havemeyer in 1883, but for the moment, he devoted himself to courting Lois Cassatt and her husband. He told them about his "remarkable experiences" in the Ruskin trial and with Leyland. He even arranged for them, after making clear "his side of the controversy," to see the Peacock Room. He must have done so through a second party since Leyland received the couple "very cordially." Whistler escorted them to the theater, took husband Alexander to dine at some of his London clubs, and nominated him for membership in the Beefsteak.[41]

The portrait was more of a chore. Mary Cassatt did not think it a very "striking likeness" but praised the picture as a "beautifully drawn" and complete "work of Art." If the face lacked "animation," she said, the cause was Whistler's tendency to "sacrifice the head to the ensemble." Other people recognized this lack of "vitality" in his portraits. Harper Pennington marveled that the master "never painted a smile or a frown," being "too absorbed by questions of values, tone, line and color to leave much for facial expression." Just as his nocturnes could not properly be called landscapes, so Whistler's pictures of people were not traditional portraits. They were "neither 'stunning' nor overwhelming," ventured another friend, but "so quiet, restful, and harmonious as to almost escape notice." Nonetheless, he labored on the portrait of Lois for two years.[42]

In May, he dropped everything to prepare for the Grosvenor, the Salon, and an exhibition at the Paris gallery of George Petit, a showcase as sumptuous as the Grosvenor. He sent a pair of nocturnes to New Bond Street, the portrait of his mother to the Salon, and four nocturnes and four other oils to Petit. His work was well hung and kindly received at the Grosvenor and at Petit's gallery, but it was the Salon that most concerned him. The French Academy would present the Légion d'honneur to a foreign exhibitioner, and Whistler was determined to be the first American of his generation to win that signal honor. "Now here is my chance," he said frankly. "[T]he Amazing one alone should have the bit of red ribbon he requires!"[43]

Despite the "great success" of Anna's portrait, Whistler had to settle for a third-class medal. Mary Cassatt thought the jury balked at giving him the highest honors

because of the ill-disguised lobbying on his behalf by Sickert, whom he had trusted to transport *The Mother* to Paris, Waldo Story, then resident in the city, and Oscar Wilde. Whistler protested the jury's decision and, in company with Wilde, "behaved like a fool" over the perceived slight. He eventually found solace in the fact that the jury had deemed no foreign artist "worthy of the medaille d'honneur" that year.[44]

Another type of foreign recognition further softened the blow when the Société des XX, an association of independent Belgian artists, asked Whistler to exhibit with them early in the new year. As part of the emerging Symbolist movement, its members believed themselves excluded from state-sponsored exhibitions by the "hostility of official artists and public authorities." They hoped to "start a real revolution in aesthetics" by staging their own show in Brussels. Whistler, the notorious rebel, was the first "foreign painter" recruited in their war against the "ignorant."[45]

Meantime, the rebel sorely needed a spot of repose. Sickert had been raving about the beauties of Cornwall, where he had gone to paint at St. Ives in late summer. So, following a final Sunday breakfast in December to celebrate the twin engagements of Oscar Wilde to Constance Lloyd and Lord Garmoyle to actress Emily Fortescue, Whistler, with Mortimer Menpes in tow, boarded a train for the West Country.[46]

# 13

# *Art is upon the Town*

### 1884–1885

J. M. W. Turner had beaten Whistler to St. Ives just as he had to Venice, but Turner made only a few sketches during his brief visit to Cornwall. Whistler spent a month there and did exquisite work in oils and watercolors. St. Ives was not yet the fashionable artist colony it would become, but painters who had discovered the picturesque fishing village fell in love with its natural beauty. Violets, dahlias, and fuchsias grew in abundance. Alternating patterns of showers and sunshine constantly shifted the moods of sea and sky. Rainbows appeared almost daily above the jagged cliffs.[1]

When Whistler arrived in late December 1883, he took "very humble rooms" with Menpes and Sickert at 14 Barnoon Terrace, a lodging house high above St. Ives Bay. He arose each day at dawn, eager to work. "Awake! Rouse yourselves!" he called impatiently to his followers. Had they prepared his panels? Mixed his paints? "Menpes, have you brought any of those note-books with Dutch paper in them? Pshaw! why aren't you all up? Walter you are in a condition of drivel. There you are, sleeping away your very life!" By the time the lads dragged themselves from bed and tumbled into the dining room, they found Whistler calmly awaiting his breakfast of eggs, bacon or fish, and coffee.

He wore mostly country attire, with a straw hat and "short jaunty jacket," but Whistler refused to sacrifice urban proprieties to rural indifference. When his landlady grew lax about arrangements for the evening meal, he informed her in a "very

dignified" if decided manner that "gentlemen" took their coffee after dinner. It must be served, too, he cautioned, in "small, dainty" cups, not "coarse porcelain." It was his way, Menpes realized. He was a "master of detail: nothing escaped him." There was a "fit and proper" way to do everything.[2]

He painted on the same small scale he had used for his Chelsea shops, the oils on five-by-nine-inch wooden panels, the watercolors on similar-sized pieces of woven paper. His subjects were mostly "shops and seas and skies," as he put it, but they also included fishing boats, cottages, cliffs, and headlands. Both format and subject may have been influenced by his recent experiments with a camera obscura. Fascinated by the way its reverse telescoping reduced the size of a scene and flattened perceptions of depth, Whistler had found an entirely new way of viewing nature, as through a "chink in the wall." It simplified color schemes, too, by limiting the range of perceptible tones to five. Sickert and Menpes marveled at the results, with Sickert later insisting that the St. Ives paintings represented the best of Whistler's art.[3]

Whistler was pleased enough with his "little beauties" to join his companions occasionally to fish, tour the countryside, or stroll along the beach. As he sprang "from rock to rock with the agility and lightness of a deer hound," the endurance of this "frail-looking . . . yet withal sinewy, tough, and muscular" forty-nine-year-old man amazed Sickert. Always, too, wearing his square-toed, patent-leather pumps, the one part of his urban attire that Whistler retained.[4]

But a month of the life bucolic was all he could stand. "It is a devil of a way off from here to anywhere!" he exclaimed to Edward Godwin, "and I must get out of this before I fall off!" He was, after all, near Land's End. "[N]othing but Nature about – and nature is but a poor creature," he told Nellie Whistler; "poor company certainly – and, artistically, often offensive." Besides, he was again "on the verge of destitution."[5]

In London by early February, Whistler became consumed by the exhibition season. The Brussels show had already opened, and while his status as the first non-Belgian artist to exhibit with Les XX had been diminished by the addition of French, German, Dutch, English, Scandinavian, and two more American exhibitors (William Merritt Chase and John Singer Sargent), Whistler was clearly the most famous artist to participate. He also decided to send his Carlyle portrait to the Salon, a suitable follow-up, he believed, to the success of *The Mother*. He arranged for Cicely Alexander's portrait, then at the Brussels show, to be sent as well, even though Mr. Alexander complained that its frame had grown "shabby & dirty from her tours." Indeed, both paintings were by then a decade old, high time, Whistler said, to be seen abroad.[6]

He might have had trouble securing the Carlyle had not Charles Howell pawned it and *The Mother* to Henry Graves. The seventy-eight-year-old print dealer and his son Algernon sympathized with Whistler in his financial woes, especially as they saw him dutifully working to pay off his debts and reclaim the items in hock. They had released more than one painting for him to exhibit or try to sell. In 1881, they let him send Anna's portrait all the way to America, the first of his paintings to be seen there.[7]

Whistler was particularly glad to be accepted in Paris when Coutts Lindsay rebuffed him at the Grosvenor. Whistler had submitted the portraits of Lady Archie and Duret, but Lindsay rejected the latter as "incomplete & slightly made out." Not wishing to seem capricious, he explained, "I wish my dear Whistler that you would do yourself and me more justice and not send work that cannot do you or me credit." Whistler seemed to accept the "rebuke" in good spirits. He apologized for the "degraded & begrimed" condition of both pictures and thanked Lindsay for having the "moral courage" to exhibit so many of his "strange things" over the years. Privately, though, he felt "egregiously insulted" and never again exhibited at the Grosvenor.[8]

Still, "*the* Show" that spring would be a one-man exhibition he had arranged at the gallery of Charles William Dowdeswell and sons in New Bond Street. Like the Fine Art Society, and unlike the other dealers through whom Whistler had operated before going to Venice, Dowdeswell commissioned works as well as hosting exhibitions. Such commercial dealers gave artists far more exposure to the market, and they were the ones with whom Whistler preferred to work thereafter. His first Dowdeswell show, with the private view scheduled for May 17, would debut sixty-seven works, mostly oils and watercolors but with a sprinkling of pastels, all done in Cornwall, Holland, or London. It was the largest number of watercolors he had yet exhibited, and a medium the artist had been striving to master since his return from Venice.[9]

Widely regarded as a separate and peculiarly British art form, watercolors were beginning to join the exhibition mainstream in the 1880s, although some controversy remained over the proper method and style of watercolor painting. One camp insisted on a detailed, "complete," and highly finished composition; the opposition promoted an impressionistic, "decoratively effective" style. Whistler, who loved the delicacy, brightness, and atmospheric qualities of watercolors, favored the latter approach, as he did with his pastels. Watercolors also suited the growing popularity for smaller paintings, and the prices they fetched were on the rise.[10]

Accordingly, the soft colors of this "Arrangement in Flesh Color and Gray," as he called the installation, seemed an oasis of calm after the searing yellow of his etchings show. Whistler covered the walls with flesh-colored fabric, a nice complement to his flat wood frames, gilded either "buff silver" or copper. He painted the dado a creamy white, with the moldings varying shades of white, rose, and gray. Gray matting covered the floor and pink-gray gossamer fell in billowing folds from the ceiling. He had installed the same sort of valerium at the Fine Art Society to diffuse the light. It seemed but another affectation to casual observers, but Whistler, who draped muslin curtains over his studio windows for the same reason, insisted that he based the arrangement on "scientific knowledge, and perfect engineering of the light." A gray velvet valance, embroidered with a silver-and-flesh-colored butterfly, covered the fireplace mantel; light gray draperies curtained the windows. An attendant greeted visitors this time in a gray and flesh-colored evening dress.[11]

Whistler's similarly subdued brown paper catalogue for "Notes – Harmonies – Nocturnes" had none of the provocative quotations that had enlivened the etchings show. Instead, he wrote a serious prologue with seven brief aphorisms. Nearly poetic in its rhythms, Whistler intended this "L'Envoie" as an unequivocal statement of his artistic goals. Alternately, it was a rebuttal of Ruskian principles. "A picture is finished when all trace of the means used to bring about the end has disappeared," he declared. Any painting that showed "great and earnest labor" was, in fact, "incomplete and unfit for view." The work of a "master" must show "no effort" and was "finished from its beginning." Lastly, but all embracing, Whistler insisted that a "masterpiece" need not be explained; it had "no mission to fulfil," but stood as "a joy to the artist – a delusion to the philanthropist – a puzzle to the botanist – and accident of sentiment and alliteration to the literary man."[12]

As he had hoped they would do, his watercolors stole the show, especially some remarkable portraits of women. He had made some two dozen non-commissioned drawings and paintings of women since late 1883. About half of them featured Maud Franklin, either in bed during one of her frequent illnesses or quietly reading, sitting in the garden, or playing the piano. However, Whistler cast three other women in the decidedly "modern" mold of Lady Archie. One unidentified model, standing at a slight angle, stared directly at the viewer, lips pursed, chin uplifted, in a striking show of independent sophistication. A popular actress, Kate Munro, stood for a second portrait. Wrapped in a black cloak, she confronted the viewer with a provocative, sultry gaze.[13]

Milly Finch, one of Whistler's favorite professional models in the 1880s, posed twice. In one picture, she coyly raised the hem of her dress to show more than was proper of an out-thrust ankle. Here was a woman who made her own decisions, an impression underscored by Whistler's daring color scheme, with purple-blue background, pink dress, and, best of all, red stockings. Without referring to any of these paintings by title, Frederick Wedmore clearly had Milly in mind when, in his review of the exhibition, he called attention to "the ill-clad grace of some draggled hussy of the slums." Of the paintings generally, he said, "[N]one are conventional and wholly tame."

More than untamed, Milly's other portrait was shocking. Crossing the thin line between independent woman and seductress, she reclined languidly, all but lying, on a red sofa. Dressed much as before, she exhibited her red-stockinged legs almost to the knee, this time a violet dress provocatively outlining the curvature of her lithe body. With eyes half closed and one finger pressed against pouting lips, she seemed to be asking, though far from insisting, if the viewer (or painter) cared to join her. Whistler added a further brilliant touch by having Milly raise a red fan above her head, *à la* Bizet's Carmen. Wedmore wrote of "a leg crossed audaciously, a flash of movement" (fig. 69).[14]

A quiet aura of success enveloped the entire show. "People came there as to a drawing-room," Menpes said of the private view, which, of course, was the precise ambiance Whistler wished his "arrangement" to evoke. He played the perfect host, too, as he moved deftly through the rooms to convey a tone of intimacy. Prince Edward again attended the opening, and Oscar Wilde arrived in a state of bliss. His wedding was twelve days hence, and the only defect in his future bride was that she did "not think Jimmy the only painter that ever really existed." Thereafter, "fashionable" crowds filled the gallery daily. Whistler was too busy even to attend Oscar's wedding. Instead, he sent a telegram on the morning of the ceremony. "Don't wait," it directed.[15]

Nonetheless, revenues from the month-long exhibition were disappointing. Old friends begged off making immediate purchases, and many people who liked the paintings thought them overpriced. In a summer when business was "fearfully bad" at all the galleries, Whistler stooped to negotiating for the sake of sales. He convinced the Earl of Dunraven, a friend of Lady Archie, to purchase one painting, but only after inviting him to a Sunday breakfast and promising to do "something else" for him. He also made "an arrangement in business" with a London solicitor by relinquishing two paintings at half price.[16]

The slow sales and Lindsay's refusal to exhibit the Duret portrait confirmed Whistler's growing belief, demonstrated by his determination to exhibit in Brussels and Paris, that his work was being received more warmly outside of England. Although financially comfortable, with an annual income for the first half of the 1880s that ranged between £800 and £1,500, in comparison to such artists as Millais (£30,000 annually) and Leighton (£10,000), he was a long way from winning top honors. Duret had also told him that he was better appreciated on the Continent. Confirmation seemed to come in reviews of the Brussels and Paris exhibitions, which called his work "enchanting" and "superb." "We speak to the people a language they do not understand," he told Waldo Story, "and those about us who stutter and drivel are listened to with respect, and their common dulnesses accepted as eloquence and wisdom combined."[17]

He turned more decidedly toward America. The nation was booming financially. Unprecedented fortunes were being made by a new generation of manufacturers, industrialists, and financiers, and like the nouveau riche of Liverpool, Manchester, and Birmingham, they craved the trappings of culture. In 1873, Mark Twain mockingly proclaimed that post-Civil War America had entered a "Gilded Age." The warm reception given *The Mother* there, the Cassett commission, and a growing number of Americans buying art in Europe convinced Whistler to pursue that lucrative market.[18]

"[Y]ou should make the wealthy Americans who come to London come to my Exhibition and buy beautiful pictures," Whistler urged George Lucas during the Dowdeswell show, "for now there are plenty most portable – small and dainty." In New York, the Wunderlich Gallery had made a large profit by showing his etchings a year earlier, with lawyer Howard Mansfield becoming their best customer. Edward G. Kennedy, the Wunderlich agent responsible for soliciting modern art from Britain and Europe, assured Whistler of a warm reception should he visit his native land. As things turned out, America would, in fact, be Whistler's richest market by the late 1880s.[19]

Isabella Stewart Gardner, a Boston socialite in her mid-forties, ranked high on Whistler's list of potential buyers. He first met her through Henry James in 1879, when she admired his portrait of Connie Gilchrist at the Grosvenor. Unlike James and two other Boston friends, Mr. and Mrs. Henry Adams, who thought even *The Mother* "affected," Gardner had a catholic definition of "high art." As the wife of John Lowell Gardner, she was known as "Mrs. Jack," and the nickname suggested her lack of pretense. She was not afraid to praise John Sargent's portrait of American

ex-patriot Virginia Amelie Avegno Gautreau at that year's Salon. Sheathed in a nearly strapless black velvet dress, *Madame X*, as Sargent titled it, had caused "Le Scandale." Whistler's own "black velvet" of Valerie Meux, which may well have inspired Sargent's painting, looked demure by comparison. The Gardners were collecting rare books and manuscripts rather than art when they visited London at the time of the Dowdeswell show, but Whistler, hoping to change their habits, invited them to both New Bond Street and Tite Street.[20]

Whistler's pride stood in the way of his biggest potential sale in 1884. When he exhibited his portrait of Carlyle in Edinburgh that autumn, several Scots artists launched a campaign to purchase the painting for their National Gallery. Whistler wanted £400. Unfortunately, his admirers lacked the courage of his convictions. When subscriptions to fund the bid lagged, they suggested that a lower price might attract people who thought the painting "eccentric." The artist was not amused. "I am weary of the discussion and the possible distinctions between what is supposed to be serious and what is known to be excentric in my productions," he told Henry Graves, who still held the picture. Declaring that the Carlyle would "no longer be a cheap and easy acquisition," he raised the price to a thousand guineas.[21]

Graves groaned. Whistler could have redeemed the picture for only £250, which would have served everyone's interests. He tried to reason with him, but the artist's determination not to sell "cheap" had been reinforced by news that England's National Portrait Gallery had recently refused to consider buying the Carlyle at any price. The director of the gallery had "laughed outright at the idea that [it] . . . should pass for painting at all!"[22]

Whistler's hopes rose later that year when the Dublin Etching Club asked to show both *The Mother* and the Carlyle at its winter exhibition. He not only complied, but tossed in the pink and gray Valerie Meux and "a lot of . . . little pictures." It was the largest number of his paintings to be seen in the United Kingdom outside London. The exhibition generated few sales, but Whistler was amused by the controversy his work stirred among the club's members, especially when his friends, defying the uproar, pushed through a resolution to make him an honorary member.[23]

Whistler declined an invitation to lecture in Dublin. He said he could not possibly leave London just then, and for good reasons. First, he had to finish another "black portrait," this one of forty-year-old Spanish violin virtuoso Pablo de Sarasate y Navascues. Whistler had heard him play several times, both on the concert stage and, less formally, at Dieudonne's Hotel, an "untidy inn" with excellent food that had become a gathering place for French artists and French-inspired British artists

in London. His manager, who liked Whistler's nocturnes, convinced Sarasate to sit for the portrait, and the results pleased the artist. "See how he stands!" Whistler proclaimed when finished. "All balanced by the bow, you know."[24]

Of more immediate importance was Whistler's sudden desire to join a professional society. He had long been an avid "club man," with memberships of the Beefsteak, Hogarth, Arts, Arundel, and St. Stephens; but those were largely social organizations. He had not belonged to a society of artists since leaving the Junior Etching Club, and he now seemed to be the only one of his contemporaries without an institutional home. Many friends, including George Boughton, Val Prinsep, Marcus Stone, and George Storey, had even been made associate members of the Royal Academy, as had younger men, such as Luke Fildes and Hubert von Herkomer. Frederic Leighton became a full academician in 1868, Edward Poynter and William Orchardson in the mid-1870s.

Having refused to exhibit in Piccadilly since 1872, it seemed unlikely that Whistler would soon be elected to the Royal Academy, although that is not to say he did not covet membership. Whistler's attitude toward the academy was complex. He rejected its fossilized ideas and exclusionary policies, yet he continued to exhibit at the Salon, which was no less bound by tradition and even more compromised by politics. Whistler, in fact, respected the academy as an institution, and he would have welcomed a chance to reform it. Fildes claimed that Whistler told him an offer of membership "would be most acceptable" if it could be "arranged." Other friends thought he could have been elected had he "behaved himself." When Pennington asked Millais why Whistler had been passed over, the older man, who had been praising Whistler as "a painter for painters," looked embarrassed and dodged the question.[25]

Whistler chose the Society of British Artists as his professional home. It was a perverse choice, given his new disdain for all things British, and the "staid and so truly respectable" society founded in 1823 was no more avant-garde than the Royal Academy. With its meeting rooms and gallery located in Suffolk Street, just west of the National Gallery, the society's two annual exhibitions roused little enthusiasm. Nevertheless, it was regarded as "a kind of nursery to the Academy." Tired of laying siege to the Royal Academy, Whistler saw a way to tunnel beneath its walls. Besides, the Society of British Artists gave him another venue in which to exhibit his work in slow economic times.

He first discussed the merits of the society in St. Ives with Sickert, who then mentioned his interest to a friend and member, Albert Ludovici. The society's officers, including Ludovici's father as treasurer, were skeptical. Although the society

could certainly benefit from the attention Whistler would bring to its exhibitions, some officers feared the potential for public embarrassment should he decide to misbehave. Nonetheless, he was elected to membership in November 1884, just as he was sending his paintings to Dublin.[26]

His election and the invitation to speak in Dublin sparked yet another scheme, one of the most consequential of Whistler's life: he decided to give a public lecture. Believing that he had overestimated the ability of the press and public to see the serious message in his published letters, interviews, and pamphlets, Whistler fancied that a lecture might better convey his ideas. Talks on art had become all the rage. Far lesser artists than he, including Seymour Haden, had spoken in both England and America, and Oscar Wilde had gained an enormous following on his American tour. Wilde's success bewildered Whistler and other artists, who believed the poet "did not really either care for or understand pictures." Worse, they regarded him as an "incurable plagiarist" who parroted the theories of more knowledgeable men. Whistler showed no animosity toward Wilde in public, and in dinners at the Café Royal, where they drank the Butterfly's favorite claret, Wilde's "deference towards Whistler was very marked." But Wilde had appropriated too many of Whistler's own ideas, and the artist meant to reclaim them.[27]

For that, he would need a grand stage, and he found one through theatrical impresario Richard D'Oyly Carte. Best known for producing the Gilbert and Sullivan operettas, Carte also operated profitable lecture circuits in England and the United States. By January 1885, his business manager, Helen Lenoir, had reached an agreement with Whistler for a series of appearances. He would perform first in London, February 20 being the agreed date. A brief tour of England and appearances in New York City and Boston would follow, profits to be divided evenly between Whistler and Carte. The London venue would be Prince's Hall, Piccadilly, site of a Wilde lecture attended by Whistler nearly two years earlier. Here was the "game in full swing!"[28]

Whistler spent hours honing his words and perfecting his gestures. To mesmerize a few dinner guests was easy. To stand on stage and captivate six hundred people was quite another thing. He tried the talk on friends and guests at Tite Street, with Alan Cole, Sickert, Pennington, and Menpes hearing alternate versions. Based on their responses, he tweaked sentences, shifted paragraphs, and reordered pages. A dress rehearsal on February 19 pleased Lenoir and Carte, their only concern being a tendency for Whistler to drop his voice. He must remember to project (fig. 70).[29]

By then, "all the Art people and Private Viewers" in London anticipated what Whistler now called the "Circus." Posters went up all over town, sandwich-board

men paraded the streets, advertisements appeared in a dozen newspapers and journals, personal invitations flew in all directions. Whistler wanted the whole of fashionable society to attend. For that reason, he would deliver his talk at the unorthodox hour of 10 p.m., two hours later than most evening entertainments began. There could be no excuse for not attending. He titled the lecture, quite simply, "The Ten O'Clock," a title as crisp and bland as the cover of a brown paper catalogue.[30]

The enthusiastic crowd of artists, patrons, dealers, friends, and the merely curious who poured into Prince's Hall did not know what to expect, no more than at the opening of a Whistler exhibition. Many of them, including Sir Arthur Sullivan and Lady Randolph Churchill, knew Whistler only slightly. Oscar Wilde came as critic for the *Pall Mall Gazette*, but unlike most journalists, who were seated at the rear of the main floor, Wilde landed in the sixth row, stage right, and just three rows behind Willie Whistler and Edward Poynter. The press received complimentary passes, but everyone else paid for admittance, which started at half a guinea. Whistler apologized to "invited" guests for the inconvenience, but Lenoir, ever the clear-eyed businesswoman, wanted no freeloaders.[31]

Against all odds, Whistler seemed unnerved by the audience. As he walked to the center of a "huge platform," dressed in "faultless evening dress," several people thought he looked "really shy," with "very palpable stage fright." Hoping to steady his nerves, he stalled by leaning his wand against the backdrop, setting his opera hat on a small table beside him, and carefully screwing his monocle in place. Finally, standing poised and erect against a black curtain, he resembled one of his own arrangements. He began timidly, modestly. "It is with great hesitation and much misgiving that I appear before you, in the character of the Preacher," but if his audience would forgive the "effrontery," he wished to "talk about Art."[32]

That said, he seemed to relax, and the familiar, unflappable Whistler of the drawing room took charge. "Art is upon the Town!" he exclaimed, a "common topic for the tea table," extolled and boasted of "as a proof of culture and refinement." Yet, most people, he insisted, could not tell good art from bad. The English public had been hoodwinked by "false prophets" who confused art with virtue or treated it as an aesthetic fad. He did not identify the knaves responsible for this lamentable situation, but the audience knew he referred to Ruskin, Quilter, Colvin, and, yes, Wilde. They saw, too, that he spoke with conviction.[33]

Following this opening salvo, Whistler explained the meaning and purpose of art. Most essentially, he asserted, art must be judged solely by its ability to express the

beautiful. A painting must not be a "symbol" or "anecdote." It need perform no "mission," tell no "story." Neither was modern art to be measured against past standards of beauty. "Listen!" he demanded: "There never was an artistic period. There never was an Art-loving nation." He did not mean that ancient Greek architects or Italian Renaissance painters had not created wondrous things. Only that it was folly for professors and critics to divide or confine art according to dates or geography. The "Sage of the Universities" and the "Gentle priest of the Philistines" must not be allowed to "pigeon-hole" art. Modern artists must neither duplicate the past nor be pitted against it. They might borrow from the past, for art was always evolving, but they must not be its prisoners.[34]

As he delivered his message, Whistler surely glanced at Wilde, and Wilde may well have blanched. Not only had Whistler clearly alluded to the facile preaching of this "Gentle priest," but his reference to an "artistic period" was almost identical to a statement Wilde had made in a lecture to students of the Royal Academy. That was one of the occasions Whistler had in mind when he accused Wilde of stealing his ideas, not that it was original to either of them. William Blake and Walter Pater had said much the same thing in less definitive language. However, in this instance, Wilde had pilfered Whistler's precise words. The phrase might be taken, as well, as a slap at Frederick Wedmore. Attacking Whistler's "theories" five years earlier, Wedmore had referred to "every age of Art."[35]

Introducing another of his most passionate beliefs, Whistler insisted that art, and especially painting, was a science, and that the beauty of nature could be revealed only by applying scientific principles. Left to its own devices, nature was disorganized and indecipherable. It contained the promise of visual beauty, but no more so than a piano contained the beauty of sound. Music required a composer to unlock the magic hidden within the keyboard. Likewise, a painter, by arranging and balancing form and color harmoniously, unveiled a beauty only inherent in nature. "Nature is very rarely right," he explained, "to such an extent even, that . . . Nature is usually wrong: that is to say, the condition of things that shall bring about the perfection of harmony worthy of a picture is rare, and not common at all."[36]

Then came something new, and Whistler's boldest stroke. Going beyond the premise that art should be divested of all literary associations, he spoke of a *"painter's poetry"* that revealed things "quite lost" on the man of letters. Poets might express ideas associated with the night, such as love or solitude, but a painted nocturne conveyed its reality. Here was a revolutionary and wholly visual understanding of art for art's sake, which, as Whistler described it, was really art for beauty's sake. Of

course, the theory justified his personal style of painting, but it was also far more "modern" than anything offered by his contemporaries. And make no mistake, he said, in some of the evening's most memorable lines, to see and express beauty was the painter's special gift:

And when the evening mist clothes the riverside with poetry, as with a veil, and the poor buildings lose themselves in the dim sky, and the tall chimneys become campanili, and the warehouses are palaces in the night, and the whole city hangs in the heavens, and fairy-land is before us – then the wayfarer hastens home; the working man and the cultured one, the wise man and the one of pleasure, cease to understand, as they have ceased to see, and Nature, who, for once, has sung in tune, sings her exquisite song to the artist alone, her son and her master – her son in that he loves her, her master in that he knows her.[37]

He ended with a plea. "[T]he Dilettante stalks abroad," Whistler cautioned the audience. "The amateur is loosed. The voice of the aesthete is heard on the land, and catastrophe is upon us." Worse than catastrophe, "Vulgarity!" prevailed, "and the gentle circle of Art swarms with the intoxicated mob of mediocrity." Most people had no eye for painting, no ear for music, Whistler assured his audience. If they would simply acknowledge this fact, without embarrassment, reject the false prophets of fashion, and listen to the judgments of the artist alone, the "pretenders" to culture would soon be out of business. "[T]he story of the beautiful is already complete," he assured them, "hewn in the marbles of the Parthenon – and broidered, with the birds, upon the fan of Hokusai – at the foot of Fusi-yama."[38]

It may be, as one person believed, that "London went wild" over Whistler's lecture, although that assessment must surely be measured against a recent series of Fenian bombings in the city and the death of Major-General Gordon at Khartoum. Then, too, the premiere of *The Mikado* less than a month later soon became the talk of the town. Even on the night, and despite Helen Lenoir's warning, not everyone at the back of Prince's Hall could hear all that Whistler said. Yet, there is no denying the generally favorable reaction to the "Ten O'Clock." If Art was upon the town, Whistler had become her chief escort. If he had overstated and exaggerated many issues, it was only his way, and to be expected. He had accused much of the audience of having no artistic feeling. Yet, he had been rewarded throughout his hour-long lecture with bursts of laughter and applause (fig. 71).[39]

"It was a triumphant success and I hear on all sides that people were quite surprised at the poetry and eloquence," Ernest Brown told Whistler. A "brilliant

success," said another person, "admirably delivered and was as witty as it was true." A collector and social acquaintance left the hall "hungry [and] wanting more." Albert Ludovici found Whistler's sardonic good sense "still ringing" in his ears two days later. "I know of some who came to smile and be amused," Alan Cole told him, "but who left in a state of meditation & dumbness." The artist had become a philosopher, and a crusading philosopher at that.[40]

Given Whistler's renewed assault on the critics, reviews in the daily press were surprisingly generous, but the most noticed judgment came from Oscar Wilde, who commented twice on the lecture for the *Pall Mall Gazette*. He was polite both times, yet the two pieces contrasted starkly. In the second review, published a week after the lecture, he praised it as a painter's "Bible . . . , the masterpiece of masterpieces, the song of songs." However, those words came as a peace offering after his first, impulsive response, published the day after the performance. People who had observed Wilde's body language and facial expressions as Whistler attacked the high priests of Aestheticism could have guessed what was coming.[41]

"[H]e stood there, a miniature Mephistopheles mocking the majority!" Wilde wrote initially, the majority being the "Philistines" they both deplored. Yet, Wilde went on, despite "his brilliant paradoxes, and, at times, his real eloquence," the artist's "pathetic appeal to the audience not to be lured by the aesthetic movement" had failed. Whistler had been foolish, Wilde maintained, to insist that only a painter could judge the merits of a painting. Wilde agreed that "only an artist" could judge art, but poetry, paintings, sculpture, even architecture, were all of a kind, he insisted, and "he who knows one, knows all." And if there must be a "supreme artist," someone who understood the "mysteries" of all the arts, then surely, Wilde smiled, that must be the poet.[42]

While willfully misinterpreting some of what Whistler said, Wilde also raised issues the artist failed to resolve. Most notably, by insisting that painting be stripped of all emotional associations, Whistler had left open the question of how public and critics could respond to a painting if not through their intellect or emotions. Similarly, it was one thing to insist on the genius and superiority of the artist, but how were the dilettantes and amateurs, stripped of their professors and high priests, to tell the genuine artists from the hucksters? Nonetheless, in venturing where few had dared tread, Whistler initiated a debate that would resonate for a century and more beyond Prince's Hall.[43]

First, though, his response to Wilde, published in the *World* and *Pall Mall Gazette*. "Nothing is more delicate, in the flattery of 'the Poet' to 'the Painter,' than the *naiveté*

of 'the Poet," Whistler said in exchanging paradoxes with Wilde. "You have pointed out that 'the Painter's' mission is to find '*le beau dans l'horrible*,' and have left to 'the Poet' the discovery of '*l'horrible dans le beau*'!" Wilde's published response borrowed boldly from Whistler's fellow New Englander Ralph Waldo Emerson. "[R]emain, as I do, incomprehensible," he advised Whistler: "to be great is to be misunderstood." The exchange died when the newspapers chose not to publish Whistler's rejoinder, but the "Ten O'Clock" had laid bare aesthetic and personal differences that continued to erode the Whistler–Wilde friendship.[44]

Whistler earned £110 for the lecture, but his career as a public speaker was short-lived. He reprised his performance in the coming weeks for favored hostesses and at selected public venues. None of the public appearances, which included the Society of British Artists, Royal Academy Student's Club, and universities of Oxford and Cambridge, was done on the scale of Prince's Hall, nor, apparently, with the same zeal. In addition, the American tour, with its complex logistics, had to be postponed. As things turned out, Whistler never returned to his native land.[45]

For the moment, that scarcely mattered, for he had distractions enough. First of all, he had barely settled into his new house and studio. He had rented the studio, located at 454A Fulham Road, in October 1884 for £70 per annum. A cavernous barn of a place, with two stoves, it was one of six new artist studios known collectively as the Fulham Studios. They had been built, as London's artist district stretched ever farther to the west, amid a collection of warehouses that backed onto the Walham Green (now Fulham Broadway) rail station. It was so far off the beaten track that Whistler had to give directions to visitors.[46]

His new house was equally hard to find. It sat midway on a two-hundred-yard-long "private road" (no more than a country lane) called The Vale. Running north of the King's Road and just east of Beaufort Street, this cul-de-sac had only four houses, all shaded by mature elm and chestnut trees. Whistler's three-story late Georgian house (now No. 2) was commodious and comfortable. An iron veranda ran across the front, while two sets of French doors opened onto a narrow second-story balcony. Indoors, he painted the walls daffodil yellow and most of the paneled dado of the rooms and stairway apple-green. Transforming the shabby exterior with a shade of primrose he had admired on many a Venetian palazzo, Whistler called his new domain the "Pink Palace" (fig. 72).[47]

He had wearied of his landlord and the imperfections of 13 Tite Street, and the new house and studio together cost less than his rent there. Then, too, The Vale provided a quiet haven in the sprawling hubbub of Victorian London. Lower Chelsea

and the river front had been transformed since his days on Lindsey Row. Construction of the Embankment, which had by then reached Chelsea, and the new bridges that spanned the Thames drastically altered its character. The "queer old" Battersea Bridge that he had immortalized was gone. A row of new red brick houses stood on the site of the venerable Swan House, and clones of those "sterile agglomerations" were "rapidly creeping" along the entire northern bank of the Thames. A "hideous aqueduct," courtesy of the Chelsea Water Company, also disfigured the neighborhood. The increased traffic that followed completion of the bridges and roadway carried a creeping urban cacophony into peaceful Chelsea. Whistler never made another painting or etching of this blighted stretch of river. As for his once-fancied artistic Mecca, "I am no longer in Tite Street," he declared. "Tite Street has consequently ceased to exist."[48]

No sooner had he settled in The Vale than the exhibition season "engulfed" him, and no show was more important to Whistler than that of the Society of British Artists, his first with the organization. Oscar Wilde tried to make amends by attending the private view, and having heard one of the artist's recent bon mots, immediately gushed, "Heavens, I wish I had said that Jimmy." Whistler replied with a "strident" laugh, "But you will, Oscar." The exhibition did not receive broad press coverage, but Whistler was featured in a review by an important new admirer. William Ernest Henley, a thirty-six-year-old journalist, poet, and playwright, best known for his stirring poem "Invictus," devoted nearly two pages of his article in the *Magazine of Art* to Whistler. Challenging the lingering image of his man as a "charlatan," Henley declared, "Mr. Whistler . . . may make a jest of many things, [but he has] a sane and serious faith in art itself."[49]

By the time the show closed in May, Whistler had been appointed to the society's executive committee, a position he used to shape the society in his own image. He began by recommending two or three Sunday receptions during the Season to elevate the society's profile and provide more opportunities for members to show their work. To repair the society's dismal financial condition, he suggested replacing the lavish Press Day luncheons that had traditionally preceded exhibitions with modest breakfasts. Most importantly, he had friends and acolytes elected to membership. Menpes was the only one inducted that spring, but other followers, including Sickert, Pennington, Sidney Starr, and William Stott, a French-trained painter from Lancashire, met outside the society to discuss the master's principles and await their turns. Two women, Canadian-born artist Elizabeth Armstrong and Sickert's new bride Ellen, also attended these gatherings of the "school" of Whistler.[50]

With all the distractions, his own work lacked focus that summer. Maud posed when able, but she was frequently ill, which may account for Whistler's "rather worn" look at times. He also began an experimental portrait "by gaslight" of Edward God-win's wife Beatrice, painted or drew an unusually large number of children, and did a series of female nudes, mostly in chalk and pastel. Out of doors, he made water-colors of shopfronts.[51]

The most memorable work done in his studio that summer was a painting by William Chase. The American artist, fifteen years younger than Whistler, had trained at the Royal Academy of Munich and often exhibited in Europe. An admirer of Whistler's work, he paid him a visit one day and wound up, at Whistler's insistence, staying several weeks. Whistler dubbed the dapper American "the Colonel," although he thought of Chase as another disciple, someone to carry his philosophy back to America. The two men quarreled within a fortnight, with Chase periodically threat-ening to leave. Whistler, who enjoyed his company, always convinced him to stay.

They painted portraits of each other, and while Whistler never completed his assignment, Chase produced an iconic image of his host. Fascinated by the duality of the "two Whistlers," he captured the "public" man in a way that rivaled the "private" Whistler drawn in Venice by Charles Corwin. Dressed immaculately in black, his white tuft of hair resplendent, monocle in place, Whistler struck an amus-ingly affected pose. Left hand on hip, right hand extended to grasp the crown of his wand, one eyebrow slightly arched, he seemed to ask, as interpreted by Chase, "You've never taken me seriously; why should I be serious with you?" Chase thought it "the best thing" he had ever done.[52]

By then, Chase was determined to escape his gilded cage. He suggested a trip to Belgium or Holland, the latter being one of Whistler's favorite haunts. Whistler agreed to Holland if Menpes went with them, but he behaved peevishly from the start. He carped about accommodations aboard ship, about some Germans they encountered on the train, and about the quality of an art exhibition they saw in Amsterdam. He apologized for his fits of "intolerance and disputatiousness" by letter soon after Chase returned to America, but the reconciliation did not last. When Chase exhibited his portrait a year later, expressly against Whistler's wishes, the "monstrous lampoon" was ridiculed mercilessly by critics. Whistler fumed all the more fifteen years later when Chase, passing himself off as a confidant, gave public lectures about him. In the end, Whistler denied knowing Chase.[53]

Meantime, with Chase's departure for America, Whistler went to Dieppe, and with a definite purpose. The Dowdeswells, the Fine Art Society, and Wunderlich

had seen a surge in sales of his work that summer, attributable, most likely, to the success of the "Ten O'Clock." Hoping to cash in on "the 'Boom,'" the Dowdeswells offered him another one-man show, to be held the following May. Whistler decided that Dieppe would make an ideal spot to create fresh harmonies and nocturnes.[54]

He and Menpes, who still accompanied him, were far from being the only painters at the popular French resort. Sickert, Degas, Jacques-Emile Blanche, Daniel Halévy, and Irish writer and critic George Moore were already there. When Whistler treated them to an abridged version of his "Ten O'Clock," Degas looked more amused than impressed. He appreciated the "irony" of a lecturer who derided his audience, but he snorted at Whistler's bald attempt to have people "talk about him" on his own terms. Then again, Degas, who considered himself a literary stylist, may have envied the "Ten O'Clock's" success. Sickert recalled him saying, "The role of the butterfly must be pretty tiring. Me, I prefer to be the old ox."[55]

Nonetheless, Dieppe inspired Whistler. He completed a dozen small oils, mostly of the seashore, and twice as many watercolors, including picturesque views of the marketplace and the streets of town. There was also a portrait. His sitter was the beautiful Olga Alberta Caracciolo, a summer resident who also happened to be the daughter of a duchess and goddaughter of the Prince of Wales. Every artist in Dieppe vied to sketch or paint the often moody Olga, but none captured her so perfectly as Whistler in *Scherzo: Arrangement in Pink, Red and Purple.*[56]

In London by early October, Whistler resumed his campaign to reform the Society of British Artists. In preparation for its winter exhibition, he had the galleries freshly painted and decorated with floral arrangements. A new friend on the hanging committee, George Jacomb-Hood, made sure that members of his "school," including "Clifton Lin" and "Rix Birnie," were well represented. Lin and Birnie were Maud and Beatrice Godwin. When some council members objected to having Whistler's followers identified as his "pupils" in the body of the catalogue, he settled for listing them as such in the index.

And he drew attention to the show. "Mr. Whistler is present in force," said one critic of his nine oils and pastels, "and it is amusing to find him figuring in the character of a leader instead of a rebel." Others complimented him on transforming the "dingy" Suffolk Street galleries. His portrait of Lois Cassatt attracted the most attention, being compared favorably with the previous spring's *Sarasate*. People also liked the female nudes he had done that summer. Though "very slight in themselves," the figures seemed "dignified and graceful in line and charmingly chaste." The crowds so thronged around his pictures that Joseph Boehm had "to wait long to get near them."[57]

One of his small nudes, *Note in Green and Violet*, caused a stir. Prior to the private view, Whistler fastened a caption to it: "Horsley soit qui mal y pense" (Shame on Horsley who thinks this evil). Horsley was John C. Horsley, Seymour Haden's other brother-in-law, who, in a recent public lecture, had denounced the painting of female nudes as exploitive and immoral. His comments formed part of a national debate about the public exhibition of nudes, although they may also be linked to a series of riveting articles about child prostitution in the *Pall Mall Gazette* that summer. In any case, Horsley had coupled prostitution with modeling by speaking of the latter as a "shameful calling." The "whole system of study 'from the nude,'" he added, was a decadent "importation from France." Whistler had adapted the motto of the Order of the Garter (Honi soit qui mal y pense), Britain's oldest chivalric order, to ridicule Horsley's pretentious standard of morality.[58]

The society's hanging committee made him remove the superfluous caption, but not before it had been reported in the press. Many artists and critics praised him for challenging Horsley. "Whistler is indeed a necessity of life," concluded one review of the exhibition. The "ever-delightful little 'Master' and his catalogued caterpillars," who hoped "in the fulness of time [to] become butterflies," had stolen the show from the "ancients" of the society. However, this reviewer continued, Whistler should take care, lest his "joyous method of blending laughter and genius" ruin his mystique. "Artists, explained, like gods understood," the critic cautioned, "are no artists at all." But Whistler had a mission to perform, a crusade to conduct. He had only begun to explain the meaning of art.[59]

# 14

# Explanations and Expectations

## 1886–1888

It was more than Whistler could stand: 'Arry Quilter a Cambridge don?! His nemesis had applied for the Slade professorship of art, once held by John Ruskin and recently vacated by Sidney Colvin. A perfect trio of sage preachers. It was like baiting a bear. Whistler insisted in the *World* that he had long since killed 'Arry, and had his scalp to prove it; but if Cambridge still wanted him, by all means, Whistler chortled, pull Quilter from the grave and prop him up in Colvin's vacant seat. The difference between "the quick and the dead" would be slight.[1]

That Quilter did not get the professorship probably had nothing to do with Whistler's jab, but the incident spoke to the artist's light-hearted mood in early 1886. With a second one-man show at the Dowdeswell Gallery, the Salon, another Les XX show, and an international exhibition in Berlin all in the offing, he waxed confident. He had also reached another potentially lucrative deal with the Dowdeswells for a set of twenty-six Venice etchings, more than twice the number he had promised the Fine Art Society. Thirty portfolios would be printed to start, priced at fifty guineas each. Another dozen prints of fifteen subjects plus an additional 123 proofs would be added later.

He promised to print the portfolios by April 1, a month before his exhibition opened. Well aware of their man's meticulous work habits, the Dowdeswells pressed him from the start, and emphasized that the project would "*come to naught*" if he

did not finish on time. The exhibition would again feature mostly watercolors and pastels, but it would be an opportune moment to introduce the etchings. Unfortunately, Whistler could not resist experimenting, so that, despite keeping "woefully busy," he completed only two dozen proofs of fourteen etchings by April. The task would drag on for another year, and he would realize only a fraction (£238) of the anticipated profits.

His pace was further slowed by his insistence that a list of eleven "propositions," similar to the ones included in his 1884 exhibition catalogue, accompany the set, and he deemed them to be as important as the etchings. Thus far, he had spoken and written about his artistic principles largely in terms of painting. This was his chance to address other important issues. Identifying each proposition with a large Roman numeral for the sake of gravitas, he stressed the proper proportions of a picture or etching, the ideal surface "space," and the desired width of a picture's borders. Most importantly, he took aim at the "unscientific" methods of "amateur" artists and the "unreasoning connoisseurship" of collectors who failed to appreciate the harmony of picture, border, and frame.[2]

As for the exhibition, Whistler called it, as he had the previous Dowdeswell show, "Notes – Harmonies – Nocturnes," although he spoke of it artistically as an "Arrangement in Brown and Gold." Eschewing the textured fabrics used to cover the walls of his previous installations, Whistler relied on plain brown paper to set off his gilded frames, varnished in shades of yellow, red-gold, and copper. "[I]t will be *the* Artistic event of the season," he predicted, "*complete perfection of finish,*" the "great characteristic of the Whistler shows."[3]

It certainly was one of his best if judged by the lavish praise heaped on the exhibition's seventy-five pictures, two-thirds of them watercolors, but also including small oils and pastels. Whistler had seemingly outlasted his critics. "[H]e has refused to change," observed one commentator, "laughing with those who took him as a jest, but ever serious with himself." The show also precipitated private reassessments. Poet Richard Watson Dixon, a friend of the old Pre-Raphaelites, decided that Ruskin had been "wrong" about Whistler and had done the artist a "great injustice." His "execution" could still be impossibly "negligent," Dixon told a friend, but Whistler had an innate "feeling for . . . the very soul of art."[4]

Yet, the positive notices again failed to produce guineas, one reason being Whistler's refusal to recognize the traditional hierarchy of media, in which pastels and watercolors were priced lower than oils. He considered all three art forms equally valid means of expression, and priced them according to his estimate of their indi-

vidual values. Consequently, the two most expensive works on display were a pair of pastels, priced at 120 guineas each. Told by Charles Dowdeswell that the show was "an absolute loss" for the gallery, Whistler replied stiffly, "If you know of others with whom you could have brought about more brilliant results and have done better, I must not stand in their way – or in yours any more." The tension passed, but Whistler did no more shows for Dowdeswell.[5]

Whatever his pricing scheme, Dowdeswell knew that Whistler was no Jonah. Given the hard financial times and unsettled political climate in England that spring and summer, the dealer had taken a calculated risk in staging the show. "There is no business about & no money anywhere," he had told Whistler three months before the opening. The English economy had hit a rough patch, and things looked set to get worse. With wages stagnant, if not in actual decline, London's laboring classes were in near revolt. Unemployment had reached ten percent, the highest rate in Victoria's reign. A virulent brand of "physical-force Socialism" had spread among the disaffected.[6]

One of the most disturbing outbreaks of unrest had occurred on February 8, "Black Monday," as it became known. Thousands of unemployed workers smashed windows and looted shops along Piccadilly and Oxford Street. Twenty-year-old Beatrix Potter and her mother, shopping in the Haymarket, "narrowly missed" being swept up in the mob. Whistler's friend Elisabeth Lewis and her children had been insulted and jostled as the "rabble" passed through Hyde Park. An outraged Whistler accused William Morris, a follower of Ruskin known for his socialist politics, of being one of the "ring leaders." Morris, in fact, disapproved of violence and played no part in Black Monday, but Whistler assumed the worst of this "dabbler in decoration." Morris should be hanged, Whistler told Elisabeth Lewis, not only for the day's upheaval, but also for "his foolish interference in Art." He was a mindless agitator, no better than Wilde, "with his babble on about the beautiful."[7]

Whistler himself was deep into politics of another kind. When the president of the Society of British Artists, a "stout and jolly" Scot named John Burr, announced that he would relinquish his office, some older members touted Wyke Bayliss as his successor, but Whistler's friends shuddered at the prospect. The pious Bayliss, well known for his opposition to "art for art's sake," and devoted to expressing "higher" values in art, had already opposed Sunday afternoon teas in the gallery. Consequently, Whistler and Albert Ludovici, his "trusty Aide de camp," worked to pack the society with more followers, elect him president, elevate the "Whistlerite faction" to governing positions, and establish a "Whistler regime" in Suffolk Street.[8]

The claque basked in the "glory" of Whistler's election on June 1, and the London press milked it for weeks. Malcolm C. Salaman, art critic for the recently established (and ultimately short-lived) *Court and Society Review*, generated much of the excitement. Following a "long talk" with Whistler at the Dowdeswell Gallery, Salaman had become a true believer. Commenting on the election, he declared that none but the "supremely ridiculous" could doubt its significance for the future of British art. Hinting that the new president deserved even higher honors, he urged all British artists to "flock to the standard of Mr. – why not Sir James? – Whistler."[9]

Whistler encouraged Salaman and other friends to keep the pot stirred, but he also knew that nothing could do that better than a controversial painting. Gertrude Elizabeth, Lady Colin Campbell, was not as enamored of the spirit world and fairies as Lady Archie, her sister-in-law, but she was every bit as beautiful and accomplished, and far more scandalous. In the summer of 1886, having been granted a "judicial separation" from her husband, she asked for an outright divorce. The original separation had been based on the "cruelty" of Lord Campbell, who had infected her with syphilis. She now charged "misconduct." He did not deny the allegation but accused her, in turn, of several adulterous affairs. A trial had been set for late November, with George Lewis handling Gertrude's case. Meanwhile, Lady Campbell wanted Whistler to paint her portrait. Smitten by her beauty and sensitive to her plight, Whistler turned his "lovely leopard" into a harmony in virginal white and ivory.[10]

They began in August and were still at it in October when Isabella Gardner came to town. Though not yet collecting paintings, it had become her habit to visit Whistler whenever in London, and this time she wanted a portrait of herself. The excited artist anticipated 500 to 600 guineas for a full-length pose until Gardner said she had only two weeks to spare before returning to America. She settled for a dainty (eleven by six inches) likeness in pastel. Whistler settled for 100 guineas, although Mrs. Jack also bought another pastel and a small oil for 160 guineas. In the end, it would be Sargent who painted the grand portrait.[11]

More tragically that October, Edward Godwin died after battling kidney stones for several agonizing months. Whistler and Lady Archie, who were with him at the end, broke the news to Godwin's closest friends, including Ellen Terry. Later, they raised funds for the widowed Beatrice, whom Whistler thought a talented painter, to study art in Paris. They solicited funds, as well, to educate the Godwins's eleven-year-old son Teddie.[12]

If legend is to be believed, Whistler bid farewell to his friend in Godwin's own bohemian style. Supposedly, in escorting the corpse from London to rural Oxford-

shire for burial, Whistler, Lady Archie, and Beatrice enjoyed a picnic lunch on the coffin as they rumbled along country roads. That went a bit beyond the Victorian pastime of picnicking in cemeteries, but given the theatrical nature and occasional daffiness of the principal players, the story is entirely plausible. Lady Archie and Godwin had been drawn together by her open-air "pastoral" plays, some of which he produced and designed. Beatrice, whose feelings toward her husband were more complex, may have been celebrating his demise. "He had been an unsatisfactory partner in all respects," observed a friend, "condemning her to a life little short of poverty while he sympathized with discontented but otherwise charming ladies in softly lighted boudoirs."[13]

Returned to London from the funeral, Whistler continued to see Beatrice, or "Mrs. Trixie," as he called her. As they worked to finish the gaslit portrait begun two years earlier, he grew increasingly fond of her. No hint of impropriety tainted their relationship, but Lady Colin Campbell, still posing for her own portrait, suspected something was up. Trixie arrived so regularly to "carry him off" each afternoon that the Leopard, anticipating her arrival, teased Whistler by saying, "Isn't it time for the Little Widdie?"[14]

But neither Trixie nor the Leopard could compete with the Society of British Artists, which consumed far more of Whistler's time than he had anticipated. With the first exhibition under his leadership scheduled to open in the last week of November, Whistler repainted four more gallery rooms, hung billowing yellow velariums in all the galleries, and doubled the price of tickets to the annual "Smoking Conversazione." That event, held a fortnight after the show opened, allowed the public to meet socially with artists while giving artists opportunities to court buyers. Admission to the Royal Academy's conversazione was free but by invitation. Whistler, who intended to "take London by storm!" charged two guineas for the privilege of mingling with his members.[15]

However, the cosmetic changes paled beside his determination to exclude all "mediocre work" from the exhibition. The days of covering gallery walls from ceiling to floor were over, he said. Henceforth, society exhibitions would resemble his own shows, with a single line of pictures and ample space between them. The society under his leadership would "cease to be a shop" for the sale of shoddy goods. Only work of high merit would grace the walls of Suffolk Street. His hand-picked Hanging Committee rejected hundreds of paintings. Aggrieved members talked of resigning.[16]

When the Prince of Wales asked Whistler to tell him something of the history of his society at the private view, the president replied brightly, "It has none, Sir; its

history begins to-day." Some observers agreed, again praising Whistler for breathing fresh life into Suffolk Street. Even *Punch*, while referring to him as "Brevet Sir James," said the society owed "much, very much, to the genius of its President." However, with his reforms raising expectations that could not possibly be satisfied, the exhibition also received a fair amount of abuse. What was one to think, for instance, when, having rejected the work of experienced artists, Whistler found room for a painting by Lady Colin Campbell? Most critics also thought Whistler's portrait of that same lady, which he unveiled at the exhibition, was so "unfinished" as to have "no business in the gallery." Whistler apparently intended either to arouse sympathy for the lady, whose divorce trial began that same week, or to cash in on her notoriety.[17]

The most contentious issue to emerge from both the show and Whistler's "possession" of the society was the divide between "French" and "English" art. It was not a new contest. It had been part of the mix at the Ruskin trial, where Whistler's French training was used to explain his poor workmanship. People had commented at the society's previous winter exhibition on the "foreign" work of Whistler and his followers. By the spring of 1886, some older society members and conservative art critics complained that the society was "less British than ever," with some of the "most striking contributions" being "entirely French, in conception and treatment." Similarly, the New English Art Club, which had staged its first exhibition in April and was filled with admirers of Whistler, had considered calling itself the Society of Anglo-French Painters. It would become known, in any event, as the home of English Impressionism.[18]

Dismissing the entire debate as nonsense, Whistler silenced grumblers within the society by paying off its £500 debt. He possessed nothing like that sum in ready cash, but having learned at least one trick from Charles Howell, he borrowed the money from Richard D'Oyly Carte by using three paintings as security. Some members of the executive council were suspicious. What interest would he want on his loan? they asked. A genuinely indignant Whistler replied, "[T]his is a simple transaction among gentlemen, and not a question of my lending money at interest!" George Lewis, who handled the legal end of the deal, was not so blasé. He insisted on holding the mortgage of the Suffolk Street gallery and having five society members named as guarantors of the loan. The society accepted his terms and Whistler's "generous offer."[19]

Even so, the president's financial investment was nothing compared with his professional stake in the society, a situation that consumed him for much of the next twelve months. As president of a respected organization, the art world no longer

considered him "as one crying in the wilderness." He had become "a prophet," and he meant to lead his people to the Promised Land. Eager to enact further reforms, but too busy to attend council meetings, he depended on his chief lieutenants, Scottish-born William A. Ingram, French-trained Thomas A. Gotch, and Horace H. Cauty, the society's secretary, to "put down" any opposition. "[A]ll that is delightful must be maintained," he instructed them, "and all that is tiresome must be trodden underfoot." Most reliable was Ingram, an "extremely energetic" young man who thought of himself as Whistler's "prime minister" in Suffolk Street.[20]

Then, Whistler's grandest scheme. In recognition of Queen Victoria's fiftieth year on the throne, he composed a tribute that not only pledged the society's fealty, but also asked Victoria to recognize it as the Imperial Society of British Artists. His audacious proposal, which, in name at least, would raise his society above the merely "Royal" Academy, looked as grand as it sounded. Using aged Dutch paper, Whistler paid an expert in heraldry five guineas to hand-letter the twelve-page document in Gothic script. He then illuminated it personally with the royal coat of arms, the queen's monogram, and additional illustrations. Princess Louise advised him on the protocol for submitting the document, bound at last in an album of yellow morocco.

Whistler was momentarily perplexed when the government's home secretary, upon receiving the memorial, informed him that a society operating wholly within the United Kingdom could attain no higher status than "Royal." Should he wish to amend his request along those lines, the queen would consider it. Determined to comply, Whistler found an unexpected advisor in fellow American William Henry Hurlbert. The sixty-year-old former editor of the *New York World*, then resident in England, had friends in the government and knew how to proceed. Another letter to the Home Office, a revised memorial, and all was well. By August 10, Whistler, the American, was president of the Royal Society of British Artists.[21]

The society's members were astonished. Perhaps their mad-hatter president really could topple that effete crowd in Piccadilly. They were also delighted when Whistler unveiled a new emblem for them. The society had for years been identified by a circular crest with a lion on a shield superimposed on a rose. Again consulting his expert on heraldry, Whistler simplified the design by replacing the crest with a rectangular box, dispensing with the shield and rose, and placing an imperial crown on the lion's head.[22]

Whistler also made a remarkable set of twelve etchings during the Jubilee celebration, a result of an invitation as president of the society to attend a royal naval review

at Spithead. The exceedingly spare images gave only glimpses, mere whispers, of the mighty fleet. Yet, they conveyed brilliantly the feel of the occasion, the bright skies, the salt air, pennants snapping smartly in the breeze. They were as evocative in their way as Whistler's earliest, elaborately detailed Thames etchings (fig. 73). He later prepared a special set for presentation to Victoria, scented, it was said, with the queen's favorite perfume.[23]

Looking to his own affairs, he made a shrewd business decision that summer. Resenting the pressure to churn out two Venice sets on demand, and knowing that he could make very much more money by selling individual proofs, Whistler decided to market his own etchings. He would still rely on dealers to connect him with buyers and act as distributors. In fact, his network expanded. In addition to the Fine Art Society, the Dowdeswells, and Deschamps in London and the Wunderlich Gallery in New York, he established dependable working relationships with W. Craibe Angus in Glasgow (with whom he had dealt occasionally since 1882), Thomas McLean and Roland F. Knoedler in London, and Frederick Keppel in New York.[24]

Nor did he ignore his French agents. The Paris-based dealers Boussod, Valadon et Cie and their London branch in New Bond Street, the Goupil Gallery, became especially important to him. Whistler had known the thirty-year-old Scots manager of the Goupil, David Croal Thomson, since returning from Venice. At that time, Thomson was an assistant editor for the *Art Journal,* a post he conveniently retained after taking charge of the gallery. It so happened that the Goupil was equally interested in Whistler's lithographs, a medium to which he returned in the autumn of 1887. With the help of young Tom Way, Whistler resurrected the ill-fated *Notes in Black and White* of 1878 to produce a set of six lithographs, entitled *Notes,* that Boussod, Valadon et Cie issued with modest success.[25]

The difference now was that Whistler laid down strict rules for conducting business. He would send etchings on approval to dealers or individual clients but limit the time allowed to consider a purchase. Should someone bid on work already out for approval, the person with ready cash took precedent. He gave a twenty percent discount on new etchings, a practice adopted from the Dowdeswells, but set his prices artificially high to compensate for the loss. He allowed no discount on older, rarer etchings, and he planned to make all future prints rarities by limiting their numbers. He would rather produce a hundred new plates than a hundred proofs from one plate. As he began to reap the financial benefits of the new arrangement, measured in hundreds of pounds, he extended it to the sale of his pastels and lithographs.

He tested the new system in America by sending sixty etchings on approval to the Wunderlich Gallery. The lot included his best work from the naval review, a variety of London shopfronts and street scenes, and three etchings of Buffalo Bill's Wild West Show. Whistler had taken son Charlie and Teddie Godwin to see the celebrated performance at Earls Court, where it enjoyed a six-month run as part of an American Exhibition. Seemingly all of London, from Queen Victoria down, attended the spectacle. Ultimately, Wunderlich passed on the Wild West etchings, but bought thirty-four others for £323.[26]

Frederick Wedmore unexpectedly aided his new business plan. By the mid-1880s, Whistler had made more than 250 etchings in numerous states, and Wedmore, who hailed him as the "representative etcher of his own generation," thought they should be catalogued. Ralph Thomas, James Rose's law partner and son of the Ralph Thomas who had failed to publish Whistler's Thames etchings in 1861, issued a cursory listing in 1874. Wedmore undertook his version in the summer of 1886. Whistler objected to the project, mostly because the critic continued to praise Haden's work. Yet, he also made use of the list, understanding, as he did, the value of a comprehensive catalogue for buyers and dealers.[27]

While refusing numerous offers to promote his work over the next few months, Whistler did take time to oblige D'Oyly Carte. The impresario and Helen Lenoir were to be married in April 1888, and they wanted him to devise a color scheme for their new home in Adelphi Terrace, a short walk from the Savoy Theatre and overlooking the Thames. Selecting the "exact shades" to brighten the old rooms, built in the 1770s, Whistler painted the staircase walls light pink, the dining room deep pink, and the library primrose yellow, similar to the color of his own drawing room in The Vale. "[I]t seemed as if the sun was shining however dark the day," a much satisfied Helen said of the library. Carte also wanted Whistler to decorate his luxurious new Savoy Hotel, then being constructed adjacent to the theater. London had seen nothing like it, with a bathroom in every suite, telephones, speaking tubes, electric bells, and the city's first mechanical lift. One wonders what the creator of the Peacock Room would have done with such an opportunity had not Carte's board of directors decided to hire "a large firm" for the job.[28]

Early that autumn, Whistler traveled through the Low Countries. It was a family holiday this time, in company with Willie and Nellie, but that did not keep him from making nineteen exquisite etchings, most of them in Brussels. "The place is simply lovely," he told a friend, "and I only wonder how it is that I should never have discovered it before." While drawing some of the well-known tourist spots,

including the Guild House, Hotel des Duce de Brabant, and Place des Palais, he rejoiced in his ability to find an unknown Brussels. His favorite subjects, as they had been for several years in London, were the shopfronts of neglected alleys and byways. He also continued, as he had done since Venice, to focus on architectural details and ornamentation, combined with an even more marked, and seemingly contradictory, move toward abstraction (fig. 74).[29]

He exhibited for the last time with Les XX a few months after visiting Brussels. While still well received in the Belgian press, his work no longer fit the movement's increasingly Neo-Impressionist direction. He may also have felt slighted because the society had rejected his nomination for membership two years earlier on the grounds that he was not only foreign, but also lived abroad. By contrast, an international exhibition in Munich that summer was keen to have him. One of the jury even went to London to discuss the number of works Whistler might exhibit. They settled on a staggering thirteen oils, twenty watercolors, seven pastels, and thirty etchings.[30]

Meantime, Edward Kennedy, the American dealer most actively promoting his work, sparked a series of momentous events by pressing Whistler to publish the "Ten O'Clock." Twenty-five copies of the lecture had been printed for close friends in 1885, but Helen D'Oyly Carte advised against general distribution when an American tour seemed likely. With the tour now suspended indefinitely, Whistler looked for a publisher. He rejected an offer by Harper and Brothers, whose proposed fifteen percent royalty was ten percent less than he demanded, in favor of Chatto & Windus, who had issued the earlier limited edition. He later tapped Houghton, Mifflin and Company as his American publisher.[31]

Equally important, Whistler found a way to market the lecture in France, thanks, in a roundabout way, to Monet. The forty-seven-year-old Impressionist shared many friends with Whistler, and their art had been shaped by many of the same influences, including Japanese painting and an apprenticeship under Gleyre. Yet, they had only become close when both exhibited at George Petit's gallery in 1887. Whistler subsequently invited Monet to visit him in London, proposed him for membership in the Beefsteak Club, and persuaded him to exhibit with the Royal Society of British Artists.[32]

Then, on a trip to Paris in December 1887, Whistler attended a luncheon in Monet's studio. Also attending was Stéphane Mallarmé. Whistler had met the forty-five-year-old French poet a few years earlier through Duret, but on this afternoon, acquaintanceship blossomed into friendship. Mallarmé thought Whistler a "master enchanter . . . , able to be both precious and worldly," and the American's sense of

the ridiculous amused him. Learning that Whistler, like himself, revered Poe, Mallarmé gave him a copy of his French translation of Poe's verse. When the artist said he planned to publish the "Ten O'Clock," the poet begged to issue a French translation. A friend, he said, could have it printed in the Symbolist newspaper *La Revue Independante* before issuing it as a pamphlet.[33]

The London and Paris editions of the *Ten O'Clock* appeared in the first week of May 1888. By July, 309 of 510 copies of the English pamphlet had been sold, and people clamored for Whistler to deliver the lecture again publicly. The reception in France was more muted, but Whistler thought that just as well. Although grateful to Mallarmé for his help, the translation in *La Revue* had not entirely pleased him. It seems that Mallarmé had been uncertain enough of his English to ask American-born Symbolist poet Francis Viele-Griffin to assist him. Rushing to Paris before the pamphlet edition was printed, Whistler worked with Mallarmé to correct "one or two passages where the subtlety of ideas and perhaps the precision of expression" had not been fully conveyed.[34]

However, genuine tragedy marred publication of the English *Ten O'Clock*. Whistler had seen little of Algernon Swinburne since 1879, when the physically deteriorating poet moved to Putney. Living under the care of Theodore Watts-Dunton, Swinburne had continued to decline, both physically and emotionally. His "wonderful green eyes" remained as bright as ever, and he retained his "courteous high bred voice" and "depricatory smile," but mere remnants of his old carrot top still clung to the "domeshaped bald head," and he was almost deaf. Still, Whistler was so confident that Swinburne would deliver a brilliant puff for the *Ten O'Clock* that he urged him to review it for the *Fortnightly Review*.[35]

Sounding much like Wilde three years earlier, Swinburne called the lecture a confused jumble of "truths and semi-truths, admirable propositions and questionable inferences." The *Ten O'Clock* contained many brilliant passages and phrases, he acknowledged, but it lacked "any continuity of reasoning or coherence of argument." That Whistler should place Asian art on a par with the ancient Greeks surpassed all reason. Never an artistic period? What on earth could Whistler mean? Did he even know the definition of an "aesthete?" The entire lecture must surely be a joke, Swinburne concluded, the greatest one ever by this "jester of genius." Like Wilde, he advised Whistler to stick to painting.[36]

Watts-Dunton boasted that he had persuaded Swinburne to write the "really brilliant" piece, and Whistler suspected him of pushing Swinburne to say things the poet had "not understood." If true, the episode bore witness to Watts-Dunton's

mixed influence on Swinburne's life. He had nourished the poet's fragile psyche, established regular work habits in him, and tempered his self-destructive behavior, but he had also encouraged him to cut nearly all ties to the past. This included old literary influences, such as American poet Walt Whitman, whose writings Swinburne now labeled indecent. Watts-Dunton had always professed to admire Whistler. Certainly Whistler regarded him as a confidant. Yet, the Ruskin trial and Whistler's open war on art critics caused the overly dignified editor of the *Athenaeum* to think Whistler "a bit of a charlatan."[37]

Shock, anger, sadness, disbelief. It is hard to know which emotion struck Whistler first or hardest, although each had its turn. He would have known how to reply to such a "*furious* article" from Wilde, but how to respond to the fragile Swinburne, a man Whistler's mother had treated as one of her own children, and whom he had repeatedly saved from ruin? "Why, O brother!" Whistler wrote to him. "Do we not speak the same language? Are we strangers, then, or, in our father's house are there so many mansions that you lose your way?" Had Swinburne sided after all with the High Priests? "Oh Brother! where is thy sting! O Poet! where is thy victory!" Still unable to reconcile himself to Swinburne's betrayal, Whistler sent a public protest to the always obliging *World*: "Thank you my dear! I have lost a confrere; but then I have gained an acquaintance – one Algernon Swinburne – 'outsider' – Putney."[38]

Swinburne went "pale with rage" when he read the retort. The two men never met or corresponded again, but given the circumstances, tragedy seemed inescapable. As the poet had written years earlier:

> There is no help, for all these things are so,
> And all the world is bitter as a tear.

And these words:

> For thee, O now a silent soul, my brother,
> Take at my hands this garland, and farewell.

Swinburne's emotional instability worsened over the next two decades. He excoriated other old friends in public and private, although none had been closer to him than Whistler, and he attacked none so violently as the artist. "Whistler, yes, very clever, certainly very clever," he would say, "but a little viper!" Somewhat more gently, in an undated and unpublished poem apparently written after their break, he intoned:

Fly away, butterfly, back to Japan,
Tempt not a punch at the hand of man,
And strive not to sting ere you die away.
So pert & so painted, so proud & so pretty,
To brush the bright down from your wings were a pity.
Fly away, butterfly, fly away![39]

If the Butterfly were to fly anywhere, it would be to France, where the reception he received during the visit to Mallarmé deepened his displeasure with England. Among existing friends, Duret had published another admiring article about him in February. He exhibited later that summer at Paul Durand-Ruel's gallery with Renoir, Berthe Morisot, Sisley, Pissarro, Gustave Caillebotte, and other members of the old Impressionist "gang." Morisot thought Whistler and Renoir the stars of the show. Furthermore, he narrowly missed an opportunity to exhibit with Auguste Rodin. While it is unclear where and when Whistler first met him, the sculptor had visited the Fulham Road studio soon after Whistler leased it, and they had corresponded as early as 1885. They may have been introduced by William Henley, who was Rodin's biggest promoter in Britain. In any event, Rodin loved the English as much as Whistler loved the French, and they had become friends by 1888.[40]

It is unclear how many Symbolist painters Whistler met on the trip, although he eventually became acquainted with the likes of Gustave Moreau, Odilon Redon, and Pierre Puvis de Chavannes. Their emphasis on deliberate ambiguity, the "suggestion" of objects, the reality of shadows and dreams, had much in common with Whistler's nocturnes and post-Venice pastels, etchings, and lithographs. Far from thinking of his work as "Impressionism," about which they remained ambivalent, Symbolists saw Whistler as a kindred spirit. They did not even take him for a Pre-Raphaelite, although a British equivalent of their work had its roots in that movement.[41]

Whistler fell in more quickly with Mallarmé's Symbolist literary cronies, who challenged the starkly graphic depictions of modern life by such Nauralists as Zola. Nor did they insist on the superiority of literature over art. While defending their craft as the preferred means of expression, they also judged novels and poems by their ability to produce, "as in the case of a picture, a unique and comprehensive impression." In fact, many young French poets, including Paul Verlaine, had been influenced by the "transparent shadows" and "ephemeral apparitions" in Whistler's work. Whistler grew especially fond of Viele-Griffin, Mallarmé's co-translator. Although born in Virginia as Francis Viele, the twenty-five-year-old poet had lived

in Paris from age seven. Mallarmé also introduced Whistler to Octave Mirbeau, a novelist, journalist, and critic who had praised his work as early as 1885.[42]

Joris-Karl Huysmans, whose novel *À Rebours* launched the Symbolist movement, had also written admiringly about the "spiritual" tone of Whistler's painting. Whistler had apparently read *À Rebours* by this time, and while he probably had reservations about the self-destructive decadence of its author, he approved of Huysmans's ideas. Indeed, the book's indictment of bourgeois consumerism may have shaped parts of the "Ten O'Clock." Whistler would also approve of Huysmans's 1891 novel *La Bas*, although for the sake of its supernatural and occult, rather than its notorious satanic, elements.[43]

Oddly enough, while he had not yet met Huysmans, Whistler's new French connections did allow him to cement a friendship with thirty-three-year-old Count Robert de Montesquiou, said to be the model for Jean des Esseintes, the decadent anti-hero of *À Rebours*. Henry James had introduced them three years earlier, when Whistler arranged through James for Montesquiou to view the Peacock Room. Painter and poet had communicated occasionally since then, and Montesquiou had followed Whistler's career with interest. A year before Whistler's visit to Mallarmé, the count wrote a poem in his honor:

> Portraits brilliant – and yet sombre,
> Like a light in the depths of night;
> Glowing rays – full of shadows,
> Like pleasures – full of perplexities.
> - - - - - - - - - - - - - - - - - -
> All the clarity – all the mystery
> Beside all the obscurity – and all the clearness:
> That is the law of the Sky and the earth,
> Of the Creations of the God Whistler.

Deeply touched by the tribute, Whistler had sent Montesquiou an etching. Now, meeting him again in Paris, he became ever more attracted by the poet's "strange but winning personality." They lunched together and went to the Durand-Ruel exhibition. When Montesquiou visited London in June, the French dandy attended his first Sunday breakfast.[44]

It was at one of Montesquiou's soirées that Whistler also met Marcel Proust. The encounter meant little to Whistler but everything to the aspiring twenty-three-year-old writer. The *Ten O'Clock* had profoundly shaped his ideas about art, and he greatly

admired the portrait of Carlyle. The young dandy was so smitten that he "appropriated" one of Whistler's "handsome grey gloves," which he treasured for years. In writing his series of novels known collectively as *In Search of Lost Time*, Proust based important parts of his fictional painter Elstir on the American, and several incidents in the series mentioned Whistler by name.[45]

Whistler's new French friends gave him the confidence he needed that summer for a showdown with the Royal Society of British Artists. Overestimating his support among the rank and file, he had pushed too forcibly for reform and with regrettably little tact. He had brought more followers and such staunch friends as Belgian-born, French-trained Alfred Stevens into the fold, decorated the galleries according to his own tastes, and insisted on controlling invitations to private views. Grumbling about his high-handedness, opponents pushed back. They forced him to remove recent decorative touches from the galleries and replaced his single line of pictures at exhibitions with three rows. Whistler apologized for having acted with "more zeal than consideration," but even some friends acknowledged that the master made a disastrous leader. Council meetings became duels between Whistler and his "chief antagonist," Bayliss. William Ingram left one council meeting "completely exhausted" by the "combat."[46]

The old guard had first confronted Whistler before his visit to Paris. At the general meeting of May 7, 1888, the same day their spring exhibition opened and the same week the *Ten O'Clock* appeared in print, Vice President William Holyoke and eight other members asked Whistler to resign from the society. He responded with a lengthy defense of his record as president. As he spoke, he watched the reaction of his audience, as though calculating his chances for survival. The situation did not look good. A number of allies were absent. The speech became a filibuster, until finally, the "subject was dropped," to be revisited at a special meeting five days later.[47]

On May 12, Whistler and his followers narrowly defeated the resolution to banish him, nineteen to eighteen, but another peril loomed. Members were to elect a new council and officers at the June meeting, and the old guard, determined not to be outvoted this time, turned out in force. "[T]hey brought up the maimed, the halt, the lame, and the blind – literally," Whistler marveled, "like in Hogarth's 'Election.'" The fireworks started early, with accusations that he had "impaired the dignity of the Society." When his turn came, Whistler rose to "cast a slow, comprehensive, meditative stare" on the assembly. "You know, you people are not well," he said sweetly. "You elected me because I was much talked about and because you imagined I would bring notoriety to your gallery. Did you then also imagine that

when I entered your building I should leave my individuality on the doorstep?" After a pause: "No, British Artists: I am still the same eccentric Whistler whom you invited into your midst."[48]

When Wyke Bayliss won election as president, Whistler, with a grand flourish, resigned and left the gallery. Seven ardent supporters followed him, the first of twenty-three members to join their leader. William Ingram, his "valiant lieutenant" and "prime minister," did not resign, and in later years, would say only of Whistler's role in those "troubled times," "I am afraid . . . that much occurred then which would be unfair & injurious to his memory."[49]

The press, which had gleefully followed the melodrama in Suffolk Street, reported the final scenes in lavish detail. The *Pall Mall Gazette*, seeking to tell both sides of the story, published lengthy interviews with Whistler and Bayliss. Naively (or perhaps not), the editor asked Marion Spielmann to do the honors. Whistler might well have refused to sit down with Spielmann, who had recently replaced William Henley as editor of the *Magazine of Art*. A vocal opponent of French "modernism," Spielmann had written an unflattering review of the *Ten O'Clock* and once described some Whistler lithographs as "marvellous facsimile[s]," but Whistler was eager to put his case before the public.[50]

"Why am *I* – who, of course as you know, am charming, why am I the pariah of my parish?" he asked innocently. "Why should these people . . . perish rather than forgive the one who had thrust upon them, honour and success!" Without making reply, Spielmann asked Whistler if he saw any "moral" in these events. Pausing before answering, Whistler became "impressive – almost imposing – as he stroked his moustaches and tried to hide a smile behind his hand." The "final convulsion," he said, had been inevitable, the society consisting, as it did, of two divergent groups. "[A]nd so you see," the ex-president concluded, "the 'Artists' have come out, and the 'British' remain – and peace and sweet obscurity are restored to Suffolk-street! – Eh? eh? Ha! ha!" That same week, Whistler cancelled his £500 loan to the society.[51]

# 15

# Games and Honors, Various

## 1888–1890

Time for a fresh start, and for Whistler, that generally included a new house. It was another Godwin creation in Tite Street, completed just before the architect's death. Whistler had agreed six years earlier to lease one of four proposed studio flats in what became Tower House (now No. 46). Lillie Langtry and Bram Stoker pulled out of the venture, but Whistler decided that Tite Street must once more be made fashionable. He returned from The Vale in early May. By June, he was hosting Sunday breakfasts and dinner parties.[1]

He had a new hostess, too. Maud was out; Beatrice Godwin was in. Maud saw it coming. Whistler had become disenchanted with her (fig. 75), and for much the same reason he had broken with Jo. She had not modeled exclusively for him since their return from Venice, which was well enough until she posed nude for Whistler's friend William Stott. Critics savaged Stott's *Birth of Venus* when it debuted at the Royal Society for British Artists' 1887 winter exhibition. Whistler was shocked not so much by the image of Maud without a stitch of clothing as by the unspoken assumption that she had been intimate with the handsome Stott, who was also her own age. Even the critics sensed "a heated ardour" that "raise[d] the temperature of the picture."[2]

The incident worsened an already deteriorating situation. Maud ignored the fact that Trixie spent ever more time at Whistler's studio, but when the Little Widdie then turned up at The Vale, the women quarreled. The volume of one contest grew

so loud that Whistler turned both of them out of the house. After the fateful winter exhibition, he and Maud lived increasingly apart. Maud accepted invitations to stay with Stott's parents, who kept a house outside Paris. She was visiting them when word came of Whistler's engagement to Trixie.[3]

Rumors that Whistler and Trixie would wed had been flying since June (fig. 76). When planning his first Sunday breakfast at Tower House, he instructed his new cook to consult "Mrs. Godwin," not Maud, about the menu. Although some of his family and friends disapproved of the way Whistler discarded Maud, his relationship with Trixie had grown over several years out of similar tastes and inclinations and an abiding fondness for each other. He expressed his feelings by borrowing from Ben Jonson: "It is a flame, an ardour of the mind. . . . It is the likeness of affection."[4]

James Whistler and Beatrice Godwin exchanged vows at 11 a.m., August 11, 1888, in fashionable St. Mary Abbotts Episcopal Church, Kensington. The couple had apparently settled on a date only that week, and not definitely until two days before the ceremony. The *Pall Mall Gazette* got wind of it and hurriedly assigned Marion Spielmann to cover the story. He was already at the church when Whistler arrived forty minutes before the appointed hour. Seeing his purpose, Whistler decried, "Disturber of the peace! Who gave you the news which I had fondly thought was enveloped in Whistlerian mists?" It is unclear who attended. Some people recalled Willie, Nellie, and Trixie's sister Ethel, but Spielmann mentioned only the members of the wedding party. Debo and Haden, who had left London to live in an old Hampshire manor house, Woodcote, did not attend, but Sis later sent an affectionate letter of congratulations.[5]

Whistler wore a tight-fitting blue frock coat, shiny new top hat, canary-yellow gloves, and square-toed boots. Beatrice, dressed in blue, arrived twenty minutes after him. Henry Labouchere, a Liberal M.P., editor of the reform journal *Truth*, and seemingly one of the friends who had nudged the couple into setting a date, gave away the bride. Louise Jopling, Labouchere's wife, and a third woman, possibly Ethel, formed the rest of the party. Whistler had no best man, and he looked to be a "bundle of nerves," glancing repeatedly from side to side while waiting for the ceremony to begin. Jopling thought he feared that Maud might appear. In fact, Maud was with George Lucas, who lived near the Stotts, in the market town of Melun, southeast of Paris. Soon afterward, with his assistance, she settled permanently in France.[6]

Words of congratulation rolled in, as did invitations to dine, even though friends had been "fêteing" the couple for a week. There were jokes, of course, about the fifty-four-year-old "gossamer Bachelor" becoming a "Butterfly Chained." The couple

received no avalanche of gifts, such as younger people would have welcomed, but nearly all who made an offering gave silver dinnerware, probably at Whistler's suggestion. He had begun to collect silver in March of that year. His first purchases were modest enough, a cigarette case and three Sheffield dishes. Beginning in May, however, with his engagement to Trixie, the couple collected with a will, much as he had done years earlier with Chinese porcelain. By the day of the wedding, they could have set "the most distinguished table in London."[7]

Whistler left instructions that none should know the details of their three-month wedding tour in France, although son Charlie, who had served as his father's private secretary for the past year, kept him informed of events in London. They spent the first few days in Paris, at the Hotel Hedler, but do not appear to have visited friends, not even Montesquiou, who had sent Trixie a delicate gold and glass butterfly pendant as a wedding gift. Moving on to Boulogne, they chanced upon Alan Cole and his wife, and so lingered for a day. They stopped next at Chartres before navigating the Loire Valley and heading back toward Loches and Bourges. "Here we are in the sun from one end of the day to the other," Whistler told Willie and Nellie from Tours, "eating grapes at dinner and melon at breakfast." He was having a genuine "holiday!" Whistler marveled. At Loches, they added a saucepan to their silver collection for thirty-seven francs. Trixie likely kept an eye open for antique jewelry, her other passion, especially necklaces and bracelets encrusted with garnets, pearls, rubies, or diamonds. Whistler denied her nothing. "I suppose we shall go on drifting," he said in late September, "and following the warm weather."[8]

Holiday or not, Whistler could not refrain from working. He painted some watercolors in Boulogne and made more than forty etchings at Loches, Tours, Bourges, and Amboise. He called the etchings his "Renaissance" set, a continuation, really, of the work in Brussels, but now absorbed in the details of Renaissance architecture. He rarely drew an entire building, but focused, instead, on the intricate patterns in doors, windows, towers, and moldings of picturesque chateaux. He had Charlie place an anonymous notice, written by himself, in the *Pall Mall Gazette*, to announce his achievement. "Those who have seen them in Paris," it read, "say that the elegancies of French Renaissance have never been so exquisitely rendered as in these fairy-like plates."[9]

He returned to London in November with a "most knowing and wicked" magpie named Coco, which sat on his shoulder and encouraged "mischievous thoughts" in French. It may have been Coco, then, that inspired his most mischievous thought in years. His absence from London, Whistler reasoned, may have allowed old divi-

sions to resurface within the Royal Society of British Artists. If so, and if he and his friends withdrew their resignations, they might have enough votes to restore him to the presidency. When only a few of his "merry men" supported the scheme, Whistler contented himself with a visit to the society's winter exhibition. Overhearing someone praise a small painting by Frederic Leighton as "a gem," Whistler, with a "dangerous smile of appreciation," commented, "Yes, like a diamond in the sty!" There would be a final brush with Wyke Bayliss the following spring, but truly, Whistler no longer needed the society, if he ever had done.[10]

Evidence of that was already mounting. While still in France, he learned that the Munich International Exhibition had awarded him a second-class medal for *The Mother*. Annoyed not to have received a first-class decoration, he had Rennie Rodd, then serving in a British consular post in Germany, suggest through diplomatic channels that Whistler was "deeply wounded" by the "second-class compliment." Influential German politicians and artists responded by securing the Cross of St. Michael of Bavaria for him and honorary membership in the Royal Academy of Munich.[11]

Recognition also came in the form of sales and invitations to exhibit at other international shows. In London, the Fine Art Society and the Dowdeswells did a brisk business in Whistler etchings, and Walter Dowdeswell could not wait to get his hands on the Renaissance Set. From Glasgow, where *The Mother* went on display that spring, word came of a different sort of compliment, the first forgery of a Whistler painting. Demanding that the "sham Whistler" be removed and its owner identified, he told George Lewis to prepare for battle. "Kill him my dear George!" he shrieked, "and if he blows his brains out, see that he does it in Piccadilly, that the fear of the Lord & Lewis come upon those who offend." It did not come to that, as both the innocent owner of the painting and the unwitting dealer from whom he had purchased it were equally keen to expose the fraud.[12]

The excitement of the chase, the euphoria of his honors, and the surge in sales were sullied, though, by a pair of personal clashes in the winter of 1888–89. It is a wonder Whistler had not broken sooner with Mortimer Menpes. Few people could resist the handsome Australian's "strange, whimsical, and mysterious air," but he had a talent for testing the master's patience. Three years earlier, Menpes had used some of his frames without permission in an exhibition. "How dare you!" Whistler had reprimanded. "Do you realise that I lifted you more or less out of the gutter, artistically?" he asked. "Saved you; cleansed you; allowed you the intimacy of my studio. . . . More than that, I made a friend of you." Menpes, who knew the truth of all this, could only wait for the storm to pass (fig. 77).[13]

However, the Australian soon committed a more serious series of sins when, like Oscar Wilde, he passed off Whistler's ideas as his own. Several of Whistler's followers wished by the late 1880s to assert their artistic independence, a quite natural evolution in the eyes of most observers. Sickert, for instance, had told Whistler, with sincere gratitude, that having taught him to walk, the master need not continue to carry him. He had matured, found value in the work of other artists, especially Degas, and wanted to forge his own style. Even so, Sickert continued to seek Whistler's counsel and, as a leader of the New English Art Club, to endorse many of his ideas. Menpes, by contrast, and despite having named his new daughter Dorothy Whistler Menpes, failed to acknowledge the master's influence.[14]

The end came when Menpes appropriated his ideas about interior decoration for an article in the *Pall Mall Gazette*. Sickert, who had pacified Whistler more than once on the subject, told him not to be "drawn by Menpes's rot." It was what he wanted, Sickert observed shrewdly, for the publicity it would generate. The warning tempered Whistler's response in the *World*, where he complained about kangaroos who put everything in their own pockets; but a few months later, he dispensed with the Australian once for all in a terse private note: "You will blow your brains out, of course. . . . Goodbye!"[15]

He gladly would have pulled the trigger on his second foe that winter. Most people blamed William Stott, known as a loud man of "rather savage mood," for what happened at the Hogarth Club on the evening of January 3, 1889. Whistler was feeling jovial and self-satisfied when he entered his second-favorite London club, having just presented a set of etchings to his favorite, the Beefsteak. So when Stott, also a member of the Hogarth, approached him and called Whistler "a liar and a coward," tempers flared. Whistler slapped the solidly built Stott before somehow gaining position to kick him squarely in the buttocks. The next morning, Whistler demanded that the club's governing committee "take steps to prevent a recurrence of such an unbearable provocation and monstrous insult" as given him.

With Whistler's encouragement, newspapers in France, Great Britain, and the United States reported the episode. Stott's version, which had him besting Whistler in the "fracus," was lost in a tide of laughter over Whistler's more colorful description. Even John Sargent, who disapproved of taking scalps, was amused. The Hogarth Club asked Stott to apologize. He resigned instead.[16]

Whistler was especially glad to see the encounter publicized in America because his next exhibition there was scheduled to open in March. Having enjoyed some success by restaging Whistler's 1883 Venice show, the Wunderlich Gallery wanted to

reprise the 1884 and 1886 shows done for the Dowdeswells, which had highlighted his watercolors and small oils. As the first major exhibition of his painted work in America, it had to be done smartly, and Whistler was lucky to have a pair of expert advisors in New York, Edward Kennedy and Harper Pennington. Kennedy, still serving as the gallery's chief agent in Britain and Europe, had seen at least one of the "Notes – Harmonies – Nocturnes" shows in London, and Pennington, having returned to the United States under mysterious circumstances, gladly helped to "arrange" the gallery, this time in pale pink and peach.

The show was moderately successful. The drawings, pastels, and watercolors, priced between $110 and $750, sold well enough, but Whistler failed to send very many oils. Those on hand went for $900 to $2,600, the principal buyers being Howard Mansfield, Henry O. Havemeyer, and Charles L. Freer. Havemeyer, a New York businessman, drew his interest in art from his new wife, the formerly frugal Louisine Elder. Freer, a Detroit industrialist, became interested in Whistler's work after seeing Mansfield's collection of etchings. He built a similar collection through Wunderlich, and at this latest show, bought his first Whistler watercolor, *Grey and Silver – Liverpool*, for $265. Whistler's share of the show's profits was nearly $400, about £80.[17]

Still, while American sales now represented the bulk of his income, Whistler could not ignore Britain and the Continent. Evidence of that came with the enormously satisfying celebration of his recent German honors, used more generally by friends to emphasize Whistler's "influence upon art, at home and abroad."

There had been a modest testimonial dinner in Paris on April 28, but a much grander affair was held three days later in London at the Criterion restaurant. Between 100 and 150 people, mostly artists and dealers but with a sprinkling of journalists and critics, paid a guinea each to offer homage to Whistler and feast on salmon, chicken, and duck. Six of his friends, including Coutts Lindsey and Edmund Yates, delivered spirited tributes.[18]

Whistler maximized the publicity by writing an anonymous account of the festivities for the *Sunday Times*. "It is rare that an artist is accorded, in his lifetime, such an ovation as that tendered to Mr. Whistler," the self-aggrandizing article began. "It was the heartfelt tribute of true English artists to a master whose work and worth are justly rated by all whose opinion is authority." He replied to this "enthusiastic demonstration," which had obviously "touched the deeper chords of his always sympathetic nature, . . . with some of those glittering paradoxes" the audience had come to expect from him, and which were greeted, in turn, by "rounds of applause and laughter."

Yet, the article also showed a self-deprecating, even vulnerable, Whistler. "We are all even too conscious that mine has, hitherto I fear, been the gentle answer that sometimes turneth not away wrath!" he told the audience. A witty observation, but also an admission that his jests were sometimes misplaced. Once, too, Whistler let slip his public facade entirely. "[In] surroundings of antagonism," he explained in his own voice, "I may have wrapped myself, for protection, in a species of misunderstanding." Only on occasions like this banquet, among friends who knew him and appreciated his art, could he toss aside "all former disguise," reveal his "true feeling," and humbly accept such "unwonted testimony of affection and faith."[19]

Whistler was moved further several weeks later by events in Paris, where all eyes were fixed on another Exposition Universelle. He had planned to exhibit with the Americans until their jury, its members concerned largely with securing space for their own work, rejected most of his submissions, including twenty of twenty-six etchings. The stunned artist received no explanation, although one juror said privately that he "did not like Whistler, and would not vote for anything by him." A more fair-minded man said of Whistler's treatment, "I was so ashamed of my country!"[20]

Defecting reluctantly to the British, Whistler was rewarded with a first-class medal for his portrait of Lady Archie and was finally made a chevalier in the Légion d'honneur. The French "knighthood" did not make him "Sir James," as the English equivalent would have done, but he basked in the congratulations of Duret, Montesquiou, Mallarmé, and Monet. Indeed, Duret, who had lobbied strenuously on his behalf, deserved some credit for both prizes. Sargent was also inducted into the Légion, but Whistler could claim a trophy denied his fellow American when the Comtesse Greffulhe, Montesquiou's ravishing, billiard-playing cousin, sent him a red ribbon, emblem of the Légion, embroidered by her own hand.[21]

That same summer, Whistler received a gold medal for ten etchings and three paintings at an exhibition in Amsterdam. Appropriately, he was in Amsterdam at the time. Invited to participate in an etching exhibition at The Hague, he and Beatrice spent two months in the land of Rembrandt. He was "lionized" everywhere, introduced to Dutch artists and writers, and asked to expound on his artistic theories. Whistler also visited Elbert Jan van Wisselingh, a Dutch-born art dealer who had learned his trade in Paris before establishing his own firm in Holland and England. By the autumn of 1889, Wisselingh, who was also married to a sister of Whistler's Glasgow dealer Craibe Angus, provided another profitable outlet for his work.

To top it off, Whistler left Amsterdam with a dozen terrific etchings. At first glance, they looked very much like his work in Venice. Dodging the contents of

chamber pots emptied from the windows and balconies above him, he had navigated the city's canals to capture the hidden beauties of its architecture. He knew he had found something unique, a new Amsterdam, just as he had found a new Venice, new London, and new Brussels, but he had also discovered a new technique. By combining the more abstract look of his etchings from the 1880s with the detail of his French and Thames sets, Whistler created extraordinarily complex images, unlike anything he or anyone else had done. He again emphasized structural and geometrical patterns in such etchings and drypoints as *The Steps* (fig. 78) and *The Square House*, but the masterpiece was *The Embroidered Curtain* (fig. 79). The title came from the picture's centerpiece, curtains hanging in the windows of an otherwise plain dwelling, but the rich texture and exquisite detail of the curtain gave the scene a luminous quality.[22]

He revealed his discovery to Marcus Huish midway through the sojourn. "[W]hat I have already begun," he assured the director of the Fine Art Society, "is of far finer quality than all that has gone before – combining a minuteness of detail . . . with greater freedom and more beauty than even the Venice Set, or the last Renaissance lot." Almost unaccountably, given his struggle to complete his Venice commissions for Huish, Whistler offered him thirty proofs for two thousand guineas. He also proposed a "unique and choice little exhibition" for that winter. On the wall opposite his framed etchings, he would hang the destroyed plates, "with the pictures still looking like enamels upon them." He likely got that idea from Sickert, who a few months earlier had mentioned some collectors – "asses," Sickert called them – who framed etching plates. Whistler, however, thought it a good way to assure collectors of the rarity of his work.[23]

The show never came off, and in any case, after a year of pondering, Whistler had finally decided to move to Paris. American and British dealers were sending regular payments by this time, and his average annual income had risen by £400 since 1886, but Whistler had become dissatisfied with the reception given his work in England. He still had admirers there, as seen by the Criterion banquet, but that occasion, being inspired by foreign recognition, had only underscored the rush of honors from Europe. Whistler had left Paris in 1860 because he thought the opportunities for success greater in England. Nearly thirty years on, the situation had changed.[24]

Marriage had also altered Whistler's view of the world. Far from chaining the Butterfly, Beatrice had given him a richer domestic life than he had known in many years. Although they shared the same restless and rebellious bohemian disposition, Trixie came from a large family, being the second of ten children. Two sisters, Ethel

and Rosalind, were particularly close to her. She also had her son Teddie, twelve years old at the time of the marriage, and although the boy did not live with the couple, he remained an important part of Trixie's world. Whistler had also become fond of the lad.[25]

As for the woman herself, Trixie was better educated, more artistic, and more sophisticated than any other woman Whistler had known, at least any unmarried woman. She was physically larger than her husband, being an inch or two taller, and grew plump in middle age. Yet, she remained "quite beautiful," with "dark liquid eyes and tea-rose complexion." One of Whistler's models recalled, "She had the prettiest little nose and mouth I've ever seen, and a perfectly charming speaking voice."[26]

Some people, thinking her imperious and "as eloquent an egotist as her husband," distrusted Trixie. Lady Colin Campbell thought her scheming and manipulative. Walter Greaves believed that she persuaded Whistler to see less of old friends. "[O]ne day he got married and vanished," said Greaves. Perhaps so, but Trixie had the perfect temperament for managing her Jimmy. Far less excitable than he, she carefully gauged when to scold, when to show patience, and when to inspire. If Whistler misbehaved in company, she simply "rolled her eyes expressively." Trixie took life as it came, an acquaintance said of her, and "refused to be bothered about anything." And a good thing, this woman decided. "Living with Whistler," she explained, "would either discipline a woman into fortitude or drive her to the divorce court."[27]

Yet, Whistler depended on her implicitly. He had half a dozen pet names for her. If no longer the "Widdie," she remained, depending on the occasion and circumstances, his "Luck," "Chinkie," or "Wam." They behaved like two children when together, a friend thought, and the artist admitted that Trixie "mellowed his irascible nature." Whistler believed that her powerful "Obi" [Obeah], a prayer or invocation in African voodoo rituals, made him invincible. He could not fail with such a kindred spirit. "We must never stop," he would tell her, "for we have much farther to go."[28]

Charlie also appreciated his stepmother, who expressed her tenderness and respect for him in ways seemingly beyond Whistler. The father–son relationship had become quite formal, more even than was usual in middle-class Victorian families. Whistler nearly always addressed Charlie as Mr. Hanson. Charlie called his father Mr. Whistler. Interaction had been particularly tense since the wedding, when, as Whistler saw it, Charlie had been "rude and ill-mannered" in helping Maud collect her belongings from The Vale. "It should have been your desire as well as your duty to see in what way you could have cared for Madam," he had scolded. "[A]ll this would

have been the natural instinct of a gentleman." A strange reaction, considering Whistler's own treatment of her.[29]

Whistler could soften on occasion, as when expressing sympathy for an earache that plagued Charlie or complimenting his work as secretary, but the son lived on tenterhooks. He had an active social life, belonging to several clubs and regularly attending concerts, lectures, and art exhibitions as well as sometimes dining at Whistler's home and attending the Criterion banquet. It seems he had little contact with his half-sisters Ione and Maud, but with Beatrice's encouragement, he did become acquainted with Ethel and Teddie. Nonetheless, thinking himself over-worked and underappreciated, Charlie started to call his father "Boss."[30]

Having turned nineteen in 1889, Charlie, like many of his father's acolytes, tried to assert himself, but with disastrous results. In December, the Boss twice sent him away when Charlie reported for work, presumably for something he had said. Charlie protested that Whistler had "misunderstood" him. "I would not have hurt your feelings for anything," the son declared. "I am more than wounded by your harsh treatment." Seemingly aggrieved by more than the events of that week, he declared, "I never thought that you could have treated me – your own son – so badly by ordering me out of the house, and shutting the door against me. . . . without a penny in my pocket to do the best I could." He exaggerated his poverty, for Whistler paid Charlie £10–15 per month, but for the moment, he was banished.[31]

However, Whistler had more than an unhappy son to distract him by the end of 1889, enough to postpone the move to Paris. A final public clash with Oscar Wilde set things off. The Jimmy and Oscar show had flagged since the days of the "Ten O'Clock." Whistler had spoken derisively of him as "the Bourgeois" Oscar after Wilde married and briefly edited the *Women's World* magazine, but he still invited him to his exhibitions. Wilde, for his part, had begun to establish his name as a writer of fiction, something more substantial than the poetry, criticism, and lectures that had first defined him, although he continued to honor Whistler in such poems as "Symphony in Yellow."[32]

Two things disrupted the relative peace. First, Wilde published "The Decay of Lying." The essay was primarily a criticism of Realist fiction, as epitomized by Henry James, but Whistler heard in it the echo of his own words. Referring to the modern "realist" novelist, Wilde complained, "He has not even the courage of other people's ideas," the same words, in essence, that Whistler had once hurled at Wilde. The artist agreed entirely with Wilde's general premise, that "lying, the telling of beautiful untrue things," was the "proper aim of Art," but the poet's plagiarism could not go

unchallenged. Feigning flattery at this "latest proof of open admiration," Whistler insisted in *Truth* that Wilde, nonetheless, owed the world penance or an apology for his transgressions.[33]

Whistler considered his letter a fine example of "noble generosity in sweet reproof," but Wilde showed no such sunny disposition. Enough of these "shrill shrieks of 'Plagiarism,'" he responded in *Truth*. Not only had Whistler's "insolent letter" been filled with "impertinence," "venom and vulgarity," but it was "deliberately untrue" and "deliberately offensive," penned by an "ill-bred and ignorant . . . person." The only original ideas about art ever expressed by Whistler, Wilde insisted, were references to "his own superiority over painters greater than himself."[34]

The good old days of witty parry and riposte had ended, and Wilde, having entered the actively homosexual phase of his life, was especially sensitive to charges of deception. This may also explain Wilde's increasing tendency to describe perceived foes as "vulgar," a word that Whistler had applied to Wilde and his followers in the "Ten O'Clock." Victorians understood it to mean the common herd, people who lacked the refined sensibilities of the artist. For Wilde, this now included small-minded people who turned in disgust from homoerotic love.[35]

Henry James thought Whistler should have avoided the "idiotic . . . squabble." A female acquaintance asked why he could not "let sleeping Oscars lie." A clever line, but the exasperated artist replied, "Ah, he won't sleep & he *will* lie!" Other people, then and later, accused Whistler of having always bullied Wilde. The Irishman, they said, found no enjoyment in public "rancour and bitterness." Yet, that assessment saddled Whistler with too much malice. While the artist was clearly more comfortable than the poet with Marquis of Queensbury rules, the game was always the thing for Whistler. He once said that he loved the Old Testament for its "wide range of invective," but to wound his opponent was not as important as being admired for the cleverness of his word play, the aptness of his allegories and metaphors. Then, too, like the Old Testament prophets, Whistler spoke only in rightful wrath against perceived sinners.[36]

Wilde took no more of the baiting, but neither had he finished with Whistler. Later that year, he published another essay, "The Critic as Artist," to reassert the superiority of poets over painters as critics. He then symbolically murdered Whistler in his novel *The Picture of Dorian Gray*. Initial drafts of the manuscript had Basil Hallward, the painter-friend chillingly stabbed to death by Gray, as a thinly disguised version of Whistler. Wilde changed the descriptive personal details for fear of a libel suit, but the satisfaction of knocking off the artist remained a secret pleasure. At a

deeper level, the novel, which was Wilde's bid to join the ranks of Symbolist writers like Husymans, also reaffirmed the superiority of the writer-critic over the artist. Finally, a year later, in a revised edition of "The Decay of Lying," Wilde purposely added unacknowledged themes from the "Ten O'Clock."[37]

By that time, Whistler confronted far more dangerous foes than Wilde and played for higher stakes than a pilfered phrase. He had known thirty-one-year-old Mary Bacon Martin for three years by 1890. Born in New York, Martin had arrived in Europe as an agent for an American wallpaper manufacturer in search of patterns and designs. Possessing a keen eye for avant-garde art, she became enamored of Whistler's work and that of a budding school of young Glasgow-based Scottish Impressionists. Also recognizing the importance of the French art market and its growing ties to America, she convinced her employer to form a syndicate with Boussod, Valadon et Cie in order to "run Whistler, the Glasgow School, and certain French pictures."[38]

Whistler described Martin as a "cross between a Jeanne d'Arc of painting and the Becky Sharp of old," but he treated her cordially, even inviting her to Royal Society exhibitions. When nothing came of her hopes to market Whistler's work and organize an American tour for him, she returned home and married a freelance journalist and art critic named Sheridan Ford. Her new husband, who had just published a shrill pamphlet, *Art: A Commodity*, to denounce the "enslavement of art to mammon," also admired Whistler. Indeed, Whistler was one of twenty-four American painters to whom Ford had dedicated it.[39]

The ambitious couple popped up in London only days before Whistler's wedding with a new proposal for an American tour. George Lewis reviewed their offer, but it was no better than Bacon's initial one. "[T]he Fords would have me sign away my future altogether," Whistler wrote in astonishment to Charlie from France. "[I]t is most amazing coolness to suggest that I should be 'farmed' by them." That appeared to end matters. The Fords went home without a contract, and Whistler finished his honeymoon in peace. Nor did the couple bear Whistler any ill will, as Sheridan Ford wrote several complimentary newspaper articles about him over the next several months.[40]

But the Fords were nothing if not persistent, and in 1889 they returned to England with an offer to collect and edit Whistler's published newspaper correspondence as a book. That plan took Whistler's fancy. With his recent Munich honors, Criterion banquet, and a "comprehensive" exhibition of his work soon to open in Bloomsbury, it seemed an opportune time for a retrospective of his "literary" career. He would

even allow Ford, as a friend recalled, to "publish the book for his own profit." Whistler wanted to call the collection *Scalps!* It became, instead, *The Gentle Art of Making Enemies.* The title was Ford's idea, though it may have been inspired by the reference in Whistler's Criterion speech to "the gentle answer that turneth not away wrath." No one mentioned it, but the title's acronym, GAME, doubtless delighted Whistler.[41]

Ford trolled the volumes of newspaper clippings Whistler had collected since the 1860s, and Charlie helped him consult newspaper files at the British Museum. By mid-August 1889, he had plenty of material, and Whistler had arranged with Chatto & Windus to distribute the book. Then, Whistler abruptly ended the project. His reason was unclear. He may have learned of a shady financial "speculation" in Ford's past. More likely, he had begun to feel "hurried," and so thought it best to "postpone" publication. Seeking to end on a positive note, he sent Ford ten guineas and thanked him for his labors.[42]

Ford was not pleased. Returning the money, he railed, "[S]hall I have a brutal philanthropy thrust upon me and be buried by the vulgar cheque of commerce?" Whistler should also remember, Ford said, that as a journalist, he, Ford, was "endowed in perpetuity by an all-wise Providence, that Truth may triumph and the foolish in high places be put to shame." And Ford did more than rant. Having retained page proofs of the book, he made plans to publish it in England and America. The news vexed Whistler. The summer exhibitions, his move to France, everything was put on hold. Still hoping to leave England sooner than later, he gave up his lease at Tower House, temporarily rented a house at 21 Cheyne Walk, and devoted himself to quashing a species of theft beyond even Wilde's imagination.[43]

The American edition of Ford's "piratical scheme" never materialized, and the formidable George Lewis had the English edition confiscated before it could be distributed. Still not satisfied, Whistler urged his lawyer to have an injunction issued against Ford in America. He wanted him arrested, too. When Ford suddenly went missing, Whistler told Lewis to hire a "detective of the lower order" to track him down. He thought the fugitive had taken sanctuary with the artist to whom he had dedicated the book, American-born John McClure Hamilton. Whistler confronted Hamilton at the Grosvenor, and after a heated exchange, stomped out with a warning: "[D]on't have anything to do with that fellow Sheridan Ford, he'll, well, you know, take your spoons!"[44]

If not the spoons, Ford had taken the printer's plates, and hired a publisher in Antwerp. The indomitable Lewis called in a Belgian attorney to confiscate the books

and charge Ford with infringement of copyright, a crime, ironically, that could not have been supported under English law. Whistler compensated the Antwerp publisher for the cost of two thousand books and pumped the family for information. How did the "desperate little Yankee adventurer" react when he found that his plot had been foiled? Whistler wanted to know. "[F]orget no detail in . . . [your] description of the scene," he begged them. Upon reading their reply, Whistler showered thanks on the family. "The description of the dreadful little woman," referring to Mary Ford, "trotting after her man is simply delicious!" he told them. He reveled in the whole story of the "discomforture of the shaby little couple . . . and their flight into Egypt!"⁴⁵

But the Fords had fled only as far as Ghent, where they printed yet another edition. Aware by now of Whistler's relentless pursuit, they became more underhand. The new books, four thousand copies this time, bore the imprint of New York and Paris publishers, neither of whom had given Ford permission to use their names. This time, too, Ford was able to ship copies to England and America before the posse arrived. Within days, Whistler discovered the book at stalls in Chelsea. George Lewis issued another round of warnings through the British and American press against selling the "pirated" book. Whistler personally grabbed every copy he found in London and told friends as far away as Edinburgh to raid local bookshops. He enlisted Mallarmé to suppress the book in Paris.⁴⁶

Ford dedicated the new edition to "All Good Comrades Who Like a Fair Field and No Quarter." The Introduction declared, "I commend the book to Mr. Whistler's enemies, with the soothing assurance that should each of them purchase a copy the edition will be exhausted in a week." Whistler professed to be unperturbed by the jibe, and one can almost believe him. He had enjoyed the chase, the matching of wits, the game. And even as he called Ford an "impotent little vermin," his biggest grievance, in typically Whistlerian fashion, was the slapdash, unaesthetic look of Ford's handiwork. Printed on cheap paper, with numerous typographical errors, it was a mere "journalistic" production, not an "artistic" one. Whistler later said that he had anticipated this "garbled form," and that this was one of the reasons he had taken the project out of Ford's hands.⁴⁷

Insisting that a book, no less than a painting, exhibition catalogue, or gallery, must be a harmonious arrangement, Whistler said he would "squelch" Ford by publishing his own edition of the *Gentle Art*. Given all the publicity created by Ford's activities, he told Lewis, it should also prove "a most *paying business!*" Whistler's volume differed from the banned book in every possible way. He used quality paper,

wide margins, and his trademark brown cover. Where Ford had randomly adorned a few pages with one-of-a-kind, insipid-looking butterflies, Whistler positioned individually crafted butterflies, each with a distinct personality to convey a precise meaning. So closely was he linked to the gossamer insect by this time, that it alone identified him as author. His name appeared nowhere on the cover or title page.[48]

Whistler's book also differed in intent. Ford had only compiled an anthology of the artist's literary jousts with critics and other "enemies." Whistler prepared a statement of his artistic beliefs, a vindication of his life's work. He included not only the public battles, but also testimony from the Ruskin trial and the whole of *Whistler v. Ruskin*, the "Red Rag," and the "Ten O'Clock." He used marginal comments, too, as he had done in his 1883 exhibition catalogue, to deflate old foes. He did this most effectively with the trial testimony, where he quoted from Ruskin's own writings to ridicule the case for the defense. He also omitted some of the battles mentioned in Ford's book.

In some important ways, Whistler's *Gentle Art* was an autobiography. He had been taking stock of his life and career that spring and summer. In his waning days at Tower House, he described himself to a journalist as an old ship that needed the "barnacles" scraped from its sides. By barnacles, he meant the clinging critics and philistines, and he pronounced the word with such a "fierce rolling of the 'r'" that the journalist shivered. Adopting "his most serious and sensible mood," Whistler described the three periods of his artistic life. "First, you see me at work on the Thames," he told the reporter, "the crude and hard detail of the beginner." Next, the experiments of the post-Valparaíso years, and now his current period, defined by the Dutch etchings and Renaissance Set. In later years, Whistler referred to the *Gentle Art* as his "Bible," the same word Oscar Wilde had used to describe the "Ten O'Clock." He may have thought of it, too, as his *Pilgrim's Progress*, dedicated to "The rare Few, who, early in Life, have rid themselves of the Friendship of the Many." It was a clever play on Ford's second dedication.[49]

Whistler selected twenty-seven-year-old William Heinemann, a cosmopolitan Francophile, to publish the book (fig. 80). Whistler probably met him through Walcott Balestier, an ambitious literary agent who also arranged for the *Gentle Art* to be issued in New York. Whistler was attracted not only by Heinemann's desire to produce quality literature, but also by his interest in artistic, tastefully designed books. The result would be one of the closest friendships of Whistler's life.[50]

They worked jointly on every detail of the eclectic manuscript. At Heinemann's office in Bedford Street, near Covent Garden, and during long breakfasts on the

balcony of the Savoy restaurant, they discussed the number of copies to be produced, the size and format of the pages, the placement of commas, the purpose of each butterfly, the design of the cover. The result, as a reviewer of the book would observe, was a volume "dainty in all externals" and "absolutely unlike anything that ever before . . . proceeded from a printing press." In addition to a "regular" edition, which reached bookstalls in mid-June 1890, Heinemann published an oversized, autographed "deluxe" edition in August. The former volume sold for a half guinea ($2.50 in America), the latter for a guinea and a half ($7.50). Thousands of the regular edition sold within a month.[51]

Friends and admirers chuckled anew over Whistler's feuds and battles, and most reviewers liked the unique publication. A few journals, mostly in America, noted that Whistler had omitted "certain things" of which he had become "a little ashamed," although one of those American publications, the *Nation*, conceded that his talent for "putting an antagonist in the wrong" made for "amusing reading." While finding fault with some of his theories, the *Pall Mall Gazette* admitted, "If one were once to begin criticising the collected writings of Mr. Whistler, one would destroy all the charm." Equally heartening, some critics mentioned the serious purpose behind seemingly mindless personal attacks. While apparently "unscrupulous, ready at any moment to thrust his dagger under the fifth rib of a friend," Whistler operated with "the profound conviction of the artist."[52]

At least one friend hoped the *Gentle Art* marked the end of Whistler's public battles and "clowning." William Henley, with his burly frame, sonorous voice, and decided opinions on literature and art, was not one to mince words. This, after all, was the man who, having lost a leg to gangrene, wrote "Invictus," and whose friend Robert Louis Stevenson had turned him into Long John Silver for the novel *Treasure Island*. Now editor of the *Scots Observer* after five years at the *Magazine of Art*, Henley thought it time for the painter of the *Sarasate*, the etcher of London, Venice, and Amsterdam, and the author of the "Ten O'Clock" to be quit of critics and philistines. "All that part of the battle is fought and won," he proclaimed. Whistler should return to the studio, "take himself with decent seriousness," and "leave the rest to time and art."[53]

Sensible advise, no doubt, but asking too much of Whistler, who saw no difference between the creation and promotion of art. And miraculously, given the turmoil of the past six months, he had been working. He met with prospective patrons, finished commissions, and submitted work to exhibitions in Brussels and Paris. He pulled proofs of Holland and Renaissance etchings and placed them with several

galleries. He lobbied on behalf of Les XX for an exhibition at the Grosvenor. His most important buyer that season, Charles Freer, spent the better part of a day with him talking about art. Freer found Whistler, "in spite of his eccentricities," to be a "cordial, big-hearted, jolly man, with a keen sense of humor" and "a profound knowledge of art and literature." The collector returned to Detroit with a dozen etchings and pastels worth £180.[54]

Whistler also became involved briefly with a new weekly newspaper. Advertised as "lively and eccentric," and designed to compete with such topical papers as the *Pall Mall Gazette,* the *Whirlwind* devoted much space to the arts. Walter Sickert served as the paper's first art critic, to be succeeded by Sidney Starr. Whistler declined several offers by the paper's twenty-four-year-old editor, Herbert Vivian, to write for it, but he produced a new series of lithographs, "Songs on Stone," to be inserted as supplements in selected issues. He asked Octave Mirbeau to mention the paper in the Parisian press and solicited a poem for it from Mallarmé. The "Prince of Decadents," as Vivian proudly crowned Mallarmé, obliged with a sonnet entitled "Billet a Whistler" ("Letter to Whistler").[55]

Whistler completed only three lithographs before the *Whirlwind* went bankrupt, but its demise scarcely mattered to his work. Heinemann and Harper Brothers were both eager to publish a full portfolio of "Songs on Stone." He had also sold a painting for a hundred guineas at the Brussels exhibition, and the buyer, an American, had commissioned a portrait of his daughter for two hundred guineas. And while he did not profit from it, Whistler was pleased by the sale of two older paintings. Twenty-two-year-old artist Walford Graham Robertson had chanced upon them at the auction of Charles Howell's estate, the Owl having died the previous spring. Inevitably, given his colorful life, rumors abounded about the cause of death. Old enemies said he had been murdered, his body found lying outside a public house, a half sovereign "tightly jammed between his teeth." In truth, the fifty-year-old "rascal" had died in bed of pneumonia.[56]

Before the *Whirlwind* died, Vivian served Whistler by telling his side of a violent encounter with Augustus Moore, brother of George. The episode echoed Whistler's confrontation with William Stott, only this time, Whistler was the aggressor. Moore, as editor of a rumor-mongering weekly newspaper called the *Hawk,* had made disparaging remarks about the deceased Edward Godwin. Learning that Moore would attend the Drury Lane Theatre on a particular evening, Whistler attacked him in the foyer. Screeching, "Hawk! Hawk!" he strode up to the miscreant, struck him with his cane, and admonished in biblical tones, "Thus I chastise you!" Moore, his

face cut by the stinging blow, lunged at his attacker. Astonished bystanders pulled the two apart as they wrestled on the floor.

Newspapers in London and Paris took sides, although disinterested witnesses tended to support Whistler. Moore had a reputation as a hothead who made libelous statements. He had even fallen out with his brother, who, while not commenting publicly on the incident, sympathized with Whistler. Among Whistler's friends, only author James Runciman took the fifty-six-year-old artist to task. "What the devil are you thinking about?" he exploded, underscoring Henley's concern after publication of the *Gentle Art*. "[Y]ou have given every dirty whipper-snapper a chance of having his joke about you, . . . a man of genius who has made a damned fool of himself. . . . You are enough to rile the twelve apostles."[57]

The admonishment was not enough to dissuade Whistler from ending the year with another small, not to say petty, victory over one of his oldest foes, Frederick Leyland. Hearing that American journalist and friend Theodore Child wished to write an article about Leyland's art collection and the Prince's Gate mansion, Whistler urged him to include a photograph of the Peacock Room, that all the world might see his masterpiece. The problem, both men knew, was that Leyland would never permit it. Whistler suggested bribing the butler to admit a "burglarious photographer" to the house. Whether or not Child resorted to bribery, he got his photograph and published it with his article in the December issue of *Harper's Monthly*.[58]

# 16

# Scotland is Brave, but Vive la France!

## 1891–1892

In mid-January 1891, Edward A. Walton, a thirty-year-old Scottish painter whose atmospheric landscapes and style of portraiture were unmistakably Whistlerian, informed his hero that a group of Glasgow artists had petitioned their city to purchase the Carlyle. Would Whistler sell it? Still irked by the reluctance of the Scottish National Gallery to pay four hundred guineas for the picture in 1884, Whistler said yes, but again demanded a thousand guineas. Glasgow's city commissioners, hoping to knock off a few hundred pounds, sent a delegation to meet Whistler in London, but after drinking "Vienna tea" (laced with lemon and rum) and smoking cigarettes at 21 Cheyne Walk, it was smiles all around. Whistler got his price.[1]

That Glasgow, the "Second City" of the British Empire, should buy the portrait was not wholly coincidental. Carlyle, of course, was a son of Scotland, but Glasgow had also established a reputation as the artistic heart of the Scottish nation. The French- and Dutch-influenced "Glasgow Boys," led by Walton, James Guthrie, and John Lavery, represented the "strongest community" of modern British painters outside London. At one time associated with the Impressionists of the New English Art Club, they had forged their own identity, even though, like many in the club, they still looked to Whistler as their master.[2]

Besides selling the picture, Whistler had it cleaned, varnished, and reframed. "He is a favourite of mine," the artist told Elisabeth Lewis, wistfully personalizing the

portrait in a way that contradicted his scientific theories about art. "I like the gentle sadness about him – perhaps he was even sensitive – and misunderstood – who knows! such things have been I am told." Far from sad, the Graves were delighted to unload the picture after a dozen years. With much of his own share of the sale going to other "thirsty creditors," Whistler realized more prestige than profit. "Dear me!" he wailed to Aglaia Coronio, "if people really do begin to buy my work, I shall be ruined beyond all hope!!"[3]

That seemed unlikely, not with dealers in New York and London reporting brisk sales of his prints all spring and summer. In addition, Mallarmé, Freer, Mansfield, Frank J. Hecker (a business associate of Freer), and William S. Carter (a New York lawyer) bought prints directly from Whistler. The London market for his paintings remained sluggish, but that allowed him to buy back older works and resell them at higher prices. He also received several new commissions. Robert Crawford, one of the visiting Glasgow officials, wanted a small painting to commemorate his encounter with Whistler. John C. Bancroft, a retired American diplomat in London, purchased an oil and a watercolor and spoke of having Whistler paint his daughter. He also wanted any new "sea-piece" Whistler might do that summer.[4]

Most importantly, and much to Whistler's delight, Robert Montesquiou wanted his portrait painted, and he trusted only Whistler to get it right. Montesquiou had become so enamored of the artist that he had trimmed his mustache, stood more erect, changed his speech pattern, and altered the pitch of his voice in imitation of Whistler. The sittings began in March, when Montesquiou agreed to two pictures. One would be a "black portrait," with The Bat, as he was known, in evening dress; his attire for the other would feature a gray evening cloak (fig. 81).

Montesquiou counted seventeen "draining" sessions that month. He also learned why sittings with Whistler were so long and numerous. Having completed a preliminary sketch in an hour of "feverish frenzy," Whistler became extraordinarily particular and cautious. Raising his brush toward the canvas, he would pause, look intently at the spot he thought needed a daub, toss the brush aside without using it, grab another one, perhaps use it, and so on. The result, Montesquiou told a friend, was that Whistler might apply fifty "touches" to the canvas in three hours, with each stroke, in Whistler's words, removing "one veil" more from his subject.[5]

That Whistler made any progress was a testament to his enthusiasm and soaring ambition. He was preparing for three exhibitions that spring, the most important one being a show in Paris. After a generation of sporadic reform, the Salon had split in half the previous year. The original exhibition continued in the Champs-Elysées,

but a new Société Nationale des Beaux-Arts now held a separate show at the Palais des Beaux-Arts, built for the 1889 Universelle, in the Champs des Mars. With its livelier, more youthful work, Whistler was a perfect fit for this "l'Ecole nouvelle." Of 3,400 applicants in 1891, only 350 artists, including Whistler, were accepted. He sent *Rosa Corder* and the *Crepuscule in Flesh Colour and Green*.[6]

Visiting the show in June, he was shocked by what he saw. "Oh Chinks!!!!" he exclaimed to Beatrice. "[Y]ou cannot imagine it – Bad – so jolly bad!" The poor quality would not be noticed in London, he said, but one expected better of Paris. The paint was merely slapped on, with colors running in all directions, the drawing "marvelous in its blatant badness!" Where the beauty? The private galleries were no better. He saw a room full of frightful Renoirs at Durand-Ruel's. "I *dont* know what has happened to the eyes of every body," he continued to Trixie. "The things are simply *childish*." He even spotted an "absolutely shameful!!" Degas, although he probably did not mention that to the painter when they breakfasted together the next day.[7]

The horrors of the exhibitions aside, Whistler had a "lovely" time in Paris. He spent a day with Mallarmé at Fountainbleau, enjoyed an evening with Montesquiou and Comtesse Greffulhe, and visited Alfred Stevens and Fantin-Latour. Fantin, having become a chevalier of the Légion d'honneur a decade before his friend, had made his peace with the French artistic establishment. He served on Salon juries and refused to associate with the upstart Société Nationale. Not that his painting was unadventurous. He was well acquainted with the Symbolist crowd in Paris, and had produced a number of "imaginative" pictures based on the operas of Richard Wagner. On the day Whistler visited, Fantin introduced him to a "most wonderful *transparent*" paper for transfer lithography. "[It is] such as old Way never dreamed of!" Whistler wrote excitedly to Trixie, "and such as I suppose I should never have seen in London." He bought £300 worth of the magical sheets.[8]

His visit with "dear old Stevens," Whistler's senior by a decade, opened still other possibilities. The Belgian had remained very much in the Realist, genre-painting tradition of Corot, but he shared Whistler's love of *japonisme*, cigarettes, and women's fashions. Parts of a book he had written in the 1880s to explain his "artistic creed" sounded like the "Ten O'Clock." He now suggested a joint exhibition with Whistler, an idea that Whistler immediately embraced. "[F]ancy from my point of view what a shock!" he informed Trixie. "The accepted and orthodox Stevens and the Black Pirate together!" Whistler discussed arrangements for the "alliance" with Georges Petit, and envisioned the show going on to London, Brussels, Munich, and Berlin, although, in the end, it never materialized.[9]

More fun awaited him in London, where an invitation had come to serve on the hanging committee of an exhibition at the Walker Gallery, in Liverpool. It would require another week away from Trixie, but it was a distinct honor. Besides, Trixie was occupied with a commission for a stained-glass window, illustrations for a book of fairy tales (published by Heinemann), and additional illustrations for William Henley's *National Observer* (formerly the *Scots Observer*, but now based in London). So, like a boy on holiday, and with Trixie's Obi to protect him, Whistler was off to Liverpool for the first time since his days at Speke Hall.[10]

Once arrived, he complained incessantly. He suffered from a cold, claimed to be bored, despaired at the quality of the paintings, and carped about his colleagues on the committee. His only joy came from the fact that he stayed with a family that had entertained John Ruskin during the great trial. He even slept in the same room Ruskin had occupied. "I understand that he was in a most beautiful state of exasperation," Trixie learned, "tearing up much paper and tossing pens about all over the place! delightful!"

He also found a way to make "mischief." Whistler made sure that the work of friends, including Jacomb-Hood, Philip Wilson Steer, and Luke Fildes was well hung, but Fildes's painting, *The Doctor*, served his own purposes. Whistler did not care for the sentimental scene of a physician nursing a sick child, for which Fildes had received a commission of £3,000 (more than Whistler would ever make on a painting) and high praise at the Royal Academy. So having hung it in "the place of honour," he surrounded Fildes's otherwise fine work with a pathetic lot of "baby pictures" (babies with puppies, babies and jam jars, babies in Heaven) in hopes of exposing the "ignorance, pretension and incapacity" of the public's shallow taste.[11]

Whistler was himself honored in Liverpool when the organizers added one of his paintings, the *Fur Jacket*, to the exhibition and asked him to speak at a closing banquet, but greater recognition soon followed. The purchase of the Carlyle inspired several of Whistler's friends to launch a quiet campaign to put *The Mother* in the Musée du Luxembourg. First, David Thomson had the painting exhibited at Boussod, Valadon et Cie, where Maurice Joyant, the gallery's director, made sure it attracted admiring crowds along boulevard Montmarte. Meanwhile, that "artful fox" Mallarmé urged a friend in the Ministre des Beaux-Arts to have the government buy it, and Duret convinced the director of museums, Roger Marx, to endorse the proposal. Gustave Geoffrey, an influential art critic and champion of "art nouveau," publicly demanded a place for *The Mother* in the national collection.[12]

In November, the Ministre des Beaux-Arts asked Whistler if it might buy it. Marx had played a crucial role in the end, as did George Clemenceau, a radical journalist and deputy in the Chamber of Deputies (and future prime minister) who supported the arts. Whistler would be paid only four thousand francs (less than £200), but among living French painters, only Monet had been welcomed into the Luxembourg, and few of his paintings had sold for four thousand francs. Of the three living Americans already exhibited there, none had received that large an "honorarium." Not that Whistler was inclined to haggle. "[O]ne cannot sell one's Mother," he said plainly.[13]

The celebration began before the final papers were signed. In England, the newly formed Chelsea Arts Club held a banquet to recognize its most distinguished member. Montesquiou marked the occasion with a soirée and added a "grand encore" to a poem he had been writing about Whistler. He dedicated the poem, titled "The Moth," to Beatrice, and when he read it to Whistler a few days later, the Bat was gratified to see the undisguised emotional response of "this terribly sensitive but pent-up man." Duret told Whistler that influential friends would have him promoted from Chevalier to "Officier" in the Légion d'honneur. It was an appropriate move, given that the German government had recently elevated his rank in the Order of St. Michael. An American journalist wondered slyly what John Ruskin might be thinking of all the hoopla.[14]

Whistler could barely keep track of the soirées and dinners that followed. Staying at a hotel in the rue de Tournon, which led directly to the Luxembourg, he had no sooner settled into his red chintz room than Mallarmé arrived with news that an "*immense* banquet" had been planned in anticipation of his promotion in the Légion. A doting Montesquiou followed Mallarmé with a bouquet for Trixie and the offer of an opera box to see *Lohengrin*. Crestfallen to learn that Beatrice would not arrive for another fortnight, the Bat rebounded when told she would also bring Ethel. He promised to deliver more flowers then and reserve the opera box for another night. Meantime, he escorted Whistler to a vaudeville show in company with Comtesse Greffulhe, composer Prince Edmond de Polignac, chief minister of Beaux-Arts Henri Roujon, and an Italian prince who was "always in debt" but "always charming." Whistler sat between prominent society hostess Madame Marie de Montebello and a Russian princess who spoke excellent English. Afterwards, in what Whistler thought the "final triumph" of the day, Montesquiou herded everyone to the Boussod, Valadon et Cie gallery to see an exhibit of the artist's work.

It became too much for Whistler, who escaped the public attention by breakfasting and dining quietly over the next few days with one or two friends. A visit from

Ross Winans Jr. and his wife, who were wintering in Paris, also occasioned relief. Best of all, if more melancholic, was an evening spent with Charles Drouet in the Latin Quarter. "Well we went off and dined," he reported to Trixie, "and afterwards back to the students ball – the 'Closerie de Lilas' – to see what it would all look like. . . . Well Chinkie – it was probably not much changed in character . . . but any impression of the picturesque that I might have remembered had gone." The students looked like "common mashers or clerks." The "Gavarni kind of wonderful people in great hats and amazing trousers" had vanished. Feeling tired, "rather bored," and older even than his nearly fifty-eight years, the former bohemian returned to his hotel and went to bed.[15]

Appropriately, Drouet capped off the fortnight of fêtes with a dinner at his atelier. The occasion acquired added significance when, as Whistler dressed for the evening, a breathless Mallarmé banged on his hotel door. Word had come, Mallarmé said as he burst into the room: Whistler had been made an Officier in the Légion d'honneur. When the artist arrived at Drouet's atelier, his host embraced him and broke the news to the applauding guests, themselves Chevaliers in the Légion. "[H]e drew himself up . . . and made them a speech like a puffed out little Napoleon before his army at the Pyramids!!" Whistler reported to Trixie of the emotional scene. "Amazing!" Drouet had good reason to be excited. "[Y]ou cannot exaggerate the high esteem in which in France this honour conferred upon you is held," he emphasized to Whistler. "[I]t means guarantie – money – it means la fortune!"[16]

It meant more than that to Whistler. This latest proof of French esteem made it the perfect moment for his long-delayed move to Paris. "[They] are pleased that I am with them," he told Trixie, "and take joy in my joy and pride in my pride." That thought meant more to him than the medals and awards. "[A]fter all those black and foolish years in London among the Pecksniffs and Podsnaps with whom it is peopled," he explained to Willie, "you can fancy the joyous change! . . . To go and look at one's *own* picture hanging on the walls of the Luxembourg! remembering how it was treated in England – to be met everywhere with deference and treated with respect and vast consideration." Just as he and other genuine artists had left the Royal Society to the British, so would he leave the entire people and their "foolish mediocrities." He wondered at his "obstinacy" in remaining so long "amidst a people so absolutely unfitted for [art]." His defection to France would be "a tremendous slap in the face to the Academy and the rest!" he rejoiced to his brother. "Really it is like a dream! – a sort of fairy tale."[17]

Yet, the move was motivated by more than simple spite or revenge. To resettle in Paris represented a genuine homecoming. Whistler had never ceased to love the place and its people, who, unlike the earnest British, understood "the joke of life." The city also suited the "feminine" element in Whistler's character and sensibilities. He seemed to agree with a fellow American artist who, in comparing the British and French capitals, declared, "London is a male, a great, gloomy being, sitting up on his island, rough, unshaven, besmeared with cinders and smut, and glowering across at the courtesan Paris, as she graciously smiles back at him with every wile. For Paris is a woman."[18]

Then there were Whistler's own nomadic inclinations. It was as difficult for him to remain in one place as to form lasting personal attachments. If not positively fearing permanence, he had come, as an artist, to associate it with stagnation. When first contemplating the move to Paris two years earlier, he had told Gérard Harry, a Belgian journalist friend, "I do not care for definitely settling down anywhere. Where there is no more space for improvement, or dreaming about improvement, where mystery is in perfect shape, it is *finis* – the end – death. There is no hope, nor outlook left." He had not, for example, been living at 21 Cheyne Walk, but rather occupying it, biding his time. Many of his belongings had remained in packing cases, stacked in the hallway. The only room that he and Trixie even pretended to decorate was an upstairs sitting room.[19]

However, before resettling again, Whistler would give the "B.P.," as he now called the British people, a final parting shot: a retrospective exhibition at the Goupil Gallery. The idea originated with David Thomson. Given recent events in Paris, a retrospective would create "a very big splash," Thomson predicted, besides allowing Whistler to "rub in" the purchase of *The Mother*. The gallery director knew it was a calculated risk, insofar as any immediate financial return was concerned. The London art market had been in another trough of late, and one-man shows had fared poorly. On the brighter side, Whistler's work had been selling well, and the excitement over *The Mother* promised to make him an even hotter commodity. Indeed, John Bancroft, the retired diplomat, worried that Whistler would immediately raise his prices. "It is all right my dear Bancroft," Whistler assured him. "I fear I am not the brilliant man of business you suggest. If I were, I ought to be rich like the rest of 'em!"[20]

He decided on a restrained show. No canopy, no color coordinated "arrangement." The invitations would be unadorned, without the customary butterflies. The only bit of "harmony" would come from the picture frames. Having tried a variety of

frames since the 1860s, Whistler wanted, on this occasion, to use a single noble yet subdued style. He would personally hang each picture, all of them to be cleaned. Some paintings in private hands he knew to be in an "abominable state," which he attributed to the "climate and smoke of England." Luckily, Whistler had discovered an expert picture restorer in Berners Street, Stephen Richards, to rescue them. Unluckily, he depended on the owners to pay for this restoration and reframing, and eight people refused. Whistler dismissed the cheapskates as "typically British" but "beseech[ed]" all of his patrons to start keeping their pictures "*under glass.*"[21]

He eventually collected forty-three of his favorite paintings, including *The Little White Girl, The Balcony, Lange Lijzen, Crepuscule in Flesh Colour and Green,* the portraits of Carlyle, Rosa Corder, Valerie Meux, Cicely Alexander, and Lady Archie, and a fistful of nocturnes. Julia de Kay Revillon, his niece through George Whistler, sent *The Music Room* from St. Petersburg. Paintings he failed to acquire were held by people who rejected Whistler's contention that he had only "entrusted" his work to them. "I do not acknowledge that a picture once bought merely belongs to the man who pays the money," he had declared more than a decade earlier, "but that it is the property of the whole world." The title page of the exhibition catalogue announced that the exhibited paintings had been "KINDLY LENT THEIR OWNERS."[22]

Indeed, Whistler indulged himself most fully in the catalogue by again annotating each entry with derisive comments from past reviews. The parody was his farewell salute to both the critics and the BP. The introductory page read, "The Voice of a People," the implication being that he held the entire nation accountable for the foolish judgments of its art critics. And for anyone steeped as deeply as Whistler in the Old Testament, those five words carried an even deeper rebuke. He had lifted them from 1 Samuel (8:7), in which God declared, "Hearken unto the voice of the people in all that they say unto thee: for they have not yet rejected thee, but they have rejected me, that I should not reign over them."[23]

He was disappointed that the show would open in March 1892, before the London "Season," but Thomson pointed out the benefits of this. The public would not yet be bored by exhibitions, and with Parliament and the law courts still in session, people would be looking for amusement. Thomson also promised to invite the entire House of Commons as a way of raising interest in "a Whistler" for the National Gallery. Both men agreed that the exhibition should be brief, only three weeks, which would make it "much more smart and select – and rare." So with three thousand invitations printed, posters in the railway stations, "sandwich men" ready to parade the streets, and advertisements placed in the leading newspapers, all was ready.[24]

Thomson could not have been more pleased by the hundreds of people who daily filled his gallery to see "Nocturnes, Marines, & Chevalet Pieces," the exhibition's title. Some ten thousand people attended before the show closed on April 9. Whistler received all monies from catalogue sales (one shilling apiece), with Thomson keeping the "gate money." Another printing of the catalogue was required only a week into the exhibition, and two more printings followed, each one, on Whistler's orders, being identified as a new edition.

Regular admittance was a shilling, but known friends of Whistler could attend for nothing, as could artists and students who entered before 11 a.m. Thomson grew skeptical when large numbers claimed the latter concession. *Punch* ran a cartoon showing the worried manager as he queried a shabby-looking fellow at the gallery's elegantly draped entrance. "Come to see Jimmy's show," the stranger declared. "I'm a Artist – corner o' Baker Street – chalks" (fig. 82). Thomson compensated by reserving Fridays for "serious people" who wished to examine the pictures "in quietness" at two shillings and sixpence. Edward Burne-Jones, who might have entered free, paid his shilling, spent an hour examining the pictures, and had a "long talk" about them with Walter Sickert. Mortimer Menpes slipped in free as a "friend," and having surveyed the galleries, declared for all to hear, "What a Master. What a Master!" A youthful disciple of Ruskin thought some of the nocturnes "outrageous in their impudence" but judged *The Little White Girl* "very beautiful," the portrait of Carlyle "full of dignity & character," and Lady Meux "striking and masterly."[25]

Some critics still refused to join Whistler's "raucous *claque* of . . . adorers," but *Punch*, besides its cartoon of Thomson, gave the show two notices and made sport of "Britons" still unable to "get beyond a timid tolerance" of Whistler. Sickert, in an article Thomson managed to have published in the *Fortnightly Review*, discussed Whistler's long battle against a "conspiracy" by English critics to thwart him. "Truly we owe him some amends," the former acolyte urged, "and they should be made honourably and ungrudgingly, with a sense of gratitude." George Moore, while admitting that Whistler's "character" had for several years seemed "incomprehensible" to him, acknowledged the "genius" of his work in a series of articles. Thomson informed Beatrice, "Mr. Whistler is becoming the fashion, at least it is becoming the correct thing to pretend to admire him. What a dreadful thing it is that people *cannot* learn more quickly."[26]

Another notable review came from a new ally and kindred spirit, thirty-seven-year-old American author, journalist, and art critic Elizabeth Robins Pennell. She and husband Joseph, an etcher and illustrator, had moved to London from Phila-

delphia in 1884, shortly after their marriage. They met Whistler almost at once but became better acquainted with other artists, writers, and journalists. Joseph was especially good friends with Walter Sickert, with whom he shared an interest in the new fad of cycling. Then again, the Pennells thought Oscar Wilde and Seymour Haden "very pleasant and friendly," and as avid socialists, they attended William Morris's political meetings at Kelmscott and discussed politics long into the night with George Bernard Shaw (fig. 83).[27]

They did not know Whistler well until the early 1890s. Joseph first caught his attention by skirmishing publicly with both Philip Hamerton and Hubert von Herkomer, who had become the Slade Professor of Fine Art at Oxford. It began when Hamerton publicly dismissed the difference between an etching and a photogravure as unimportant and Herkomer described his own photogravure reproductions as "etchings." Pennell, the etcher, took exception, and his plea for the superiority of an original etching over a reproduction spoke forcefully to one of Whistler's concerns.[28]

But it was Elizabeth Pennell who most often praised Whistler's work in print. Sympathizing fully with his disdain for moralism in painting and the baleful influence of ill-informed art critics, she singled him out in a review of the previous year's Champs de Mars Salon. Whistler, she decided, had, in concert with Manet, Degas, and Monet, "revolutionized the art of painting." In describing the "intensely modern character" of the Goupil show, she hailed him as a man ahead of his time, "an Impressionist almost before the name impressionism in art had been heard," and whose "far-reaching influence over modern painting" was "only beginning to be felt."[29]

Whistler claimed "absolute" victory over the BP with the Goupil exhibition, his pleasure further enhanced by the praise heaped on his work at that spring's Champs des Mars Salon. He urged Thomson to reprint the Salon reviews in the London papers under the heading, "The voice of *another* People!" On May 4, finally content to leave England on his own terms, he signed the lease (£44 per year) for a well-lighted studio at 86 rue Notre Dame des Champs, just south of the Luxembourg Gardens. Shortly thereafter, Beatrice spotted a delightful, if slightly run-down, seventeenth-century house on the rue du Bac, only a short walk from the studio.[30]

As usual, he paid little attention to cost, even though house and studio would stretch his financial resources to the limit. A depressed economy in both the United States and Great Britain had caused the market for his etchings to take a sudden dip, and only a few collectors considered the new paintings a safe investment. The small oils, which were now the norm for "a Whistler," lacked the dramatic appeal

of his older pictures. Not even all artists understood this shift in his work. Camille Pissarro wondered if Whistler had lost his creative touch or grown complacent, content to glide on his reputation.[31]

Thomson suggested that he raise money by compiling a "souvenir" album with two to three dozen photographs of his finest paintings. The idea intrigued Whistler. However, they must be genuine photographs, not photogravures, he warned, the Herkomer episode still in mind. The text, he decided, could come from his exhibition catalogue. "Don't you see?" he asked Thomson excitedly. "Opposite each painting the extracts that I have already collected! Perfect! That is the real Whistler Album if you like! and moreover the only text I could tolerate – for I will not have myself *presented* by any one – or excused – or explained."[32]

He told Thomson to photograph the paintings at the Goupil before returning them to their "owners." No need to get permission, he said. The paintings and the copyrights belonged to him. Thomson urged caution. They dared not photograph the pictures, let alone publish the images, he said, without consulting the owners. Courtesy alone dictated that course, and Thomson was not as confident as Whistler about copyright, which had become a complex issue for artists and dealers in an era of cheap mechanical reproductions. Then there was Whistler's proposed text. The parodies from the exhibition catalogue were "hardly serious enough for such splendid pictures," he advised. A "simple portfolio" of titles and photographs would be best.[33]

Thomson forgot with whom he worked. Whistler may not have been up to speed on copyright laws, but he knew something about photography, and everything about how to present his own pictures. Unlike some painters, he had never feared the challenge of the camera, and had long since applied photographic principles of perspective and depth to his own work. He had also exploited photography for his own purposes by giving autographed photos of paintings as gifts and, as president of the Royal Society of British Artists, selling photographs of exhibition pictures to raise money for the society. He had even "exhibited" his mother's portrait at the Goupil as a photograph, and he had long sold prints of the portrait, much to the chagrin of Thomas Way, who complained that this practice cut into his market for lithographs of the painting.[34]

It hardly mattered in the end. The impossibility of photographing some paintings to Whistler's satisfaction caused the project to drag. He also found fault with the mounting of the photographs, the order of their arrangement, the size of the margins, the butterfly signature, the placement of the text, even the design of the promotional circular. Everything had to be "exact." As other events and opportuni-

ties overtook the album, it was not finished until the following summer, when it produced only modest sales.[35]

Whistler would have to depend on his reputation as a portraitist to stay afloat, but that, too, remained a hit-and-miss prospect. Sir William Eden offered five hundred guineas for a portrait of his wife, and John Lavery introduced Whistler to Edinburgh manufacturer John J. Cowan, who was willing to pay up to six hundred guineas for his own portrait. Valerie Meux nearly commissioned another picture. She wanted "something *dreamy*" this time, perhaps pure white. "I look best in soft colours," she purred. The project fell through when Val learned that Whistler was leaving England. "[W]hen in Paris," she explained, regarding possible sittings, "I spend all my time at the dressmakers."[36]

Most promisingly, the Duke of Marlborough asked Whistler to paint full-length state portraits of him and the duchess. The duke, who had long admired Whistler's work, probably broached the subject when Whistler gave him a tour of the Goupil exhibition. He initially balked when told the two paintings would cost three thousand guineas, but Thomson, who negotiated the deal, told him that was a bargain. Arrangements were made for Whistler and Trixie to visit Blenheim Palace that autumn for the sittings. Tragically, the duke suddenly died, aged forty-eight, in early November.[37]

Whistler could no more have anticipated the passing of Marlborough than he could have done the sudden "traffic" in his older work. The first shocking instance came only a few days into the Goupil exhibition, when a visitor offered Julia Revillon, through Thomson, £450 for *The Music Room*. She turned him down, but an aroused Whistler wanted the name of the potential buyer. Was it Seymour Haden? he asked Thomson suspiciously. It would be like the brother-in-law to filch a masterpiece at such an absurdly low price. Never mind that the painting had passed through the family from Anna to Julia's mother and so to Julia. It would be "ruinous" to the value of all his work if she relinquished it for anything less than a thousand guineas. Moreover, he told Thomson, in stressing his principal objection, "The great point is not the changing of ownership of these pictures, which is scarcely interesting to me – but to *confirm*, by every transaction, my large prices."[38]

As it turned out, the bid had come from a Glasgow dealer, not Haden, but the episode depressed Whistler. He knew his patrons had a right to make a profit on their investments, yet it pained and irked him that people to whom he had entrusted his creations should discard them so cavalierly. He complained of people who, in their "indecent haste" to make "dirty gains," rushed to "hawk about and sell" his

paintings while they were "hot on the market." Some people proved their mettle, such as Val Meux, who refused a thousand guineas for one of her portraits, but the general trend gave Whistler yet another reason to despise the English, if not the entire BP. He resolved that no more of his paintings would fall into English hands. Those already sold, he would try to spirit out of England to America, France, or Scotland (no longer scorned), even if it meant buying them back himself.[39]

No sooner had Whistler decided on this new strategy than two of his most treasured creations became available. Frederick Leyland had died in January 1892, and his family decided to auction off the Prince's Gate house, its furnishings, and its art work, including *La Princesse* and the Peacock Room. Whistler urged no fewer than three dealers – Thomson, Edward Kennedy, and Alexander Reid – to attend the auction at Christie's and "fight" for the painting and, if circumstances permitted, the room. "[E]ven if you do not buy," Whistler told Thomson, "you surely ought to see that the picture is properly competed for."[40]

The auction proved bittersweet. The Peacock Room remained part of the house, and while Reid outbid Thomson for the painting (neither man knowing they acted under the same instructions!), it sold for only £450. Whistler thought it should have gone for 2,000 guineas, especially since two paintings by Burne-Jones at the same auction fetched £3,500 each. Thomson explained that instructions from Paris had limited his bid. Still, the portrait of Christine Spartali held its own against paintings by Rossetti and Albert Moore, and Whistler had already thought of an alternative way to profit from the Peacock Room. Reminding Thomson that Leyland had "never properly paid" him for his work, he proposed a second photographic album, this one to celebrate his masterpiece of decoration. Resurrecting the scheme proposed to Theodore Child two years earlier, he urged, "Why not get a man to go down and with a Kodak photograph the four walls and the *ceiling*?" At least a dozen images could be fashioned from those plates, he said, perhaps even "reproduced in colour – gold and blue!"[41]

Whistler got his photographs but lost interest in crafting a second album. Instead, he threw his energy into finding suitable buyers for *La Princesse* and several other paintings that had come on the market. He was particularly keen on wooing more of the American nouveau riche. Having sold a pastel to Berthe Palmer, wife of a wealthy Chicagoan, he told Thomson to track down the lady and interest her in some of his oils. Two weeks later, Palmer bought Aglaia Coronio's *Grey and Silver: Old Battersea Reach* for £450. Whistler was disappointed when an Englishman beat her to Alexander Ionides's painting of Valparaíso Bay, and for only £400; but toward

the end of the year, Isabella Gardner paid £600 for the Trouville seascape with its ghostly Courbet.[42]

Gardner's purchase also exposed how far Whistler would go to get his paintings out of England. The Trouville had been one of four pictures owned by John Cavafy. The Greek had been prepared to sell them all to John Bancroft for £600, despite the Trouville having been a gift to his father from Whistler. Appalled by Cavafy's disloyalty, the artist convinced him to give Edward Kennedy the lot for £650, not mentioning that the dealer, in turn, had promised to return the Trouville to him after the sale. Kennedy felt some "anxiety" about the deal, but Whistler spurred him on, the results being a handsome profit. A livid Bancroft threatened legal action when he learned of the maneuver, but Whistler was so set on diddling greedy traffickers in his work that he could not see (or would not acknowledge) the shabbiness of his action.[43]

Alexander Reid was equally important to Whistler's larger plan. The thirty-eight-year-old Scot had worked briefly for Boussod, Valadon et Cie in Paris, where he shared lodgings with Theo Van Gogh, another Boussod employee. He had also been "right overhead in love" with Mary Martin before she married Sheridan Ford. Reid returned to Glasgow to open his own gallery in 1889. Still infatuated with French painting, if not Mary, he named his gallery La Société des Beaux-Arts and promoted Impressionism, the French-influenced Glasgow Boys, and Whistler. Already holding *La Princesse*, he secured the *Fur Jacket* and the "black" portrait of Lady Archie for £800 plus half the profits when he resold them. Whistler agreed to the arrangement mostly because he had been unable to sell the *Fur Jacket* for the £1,600 he wanted. However, the painting had recently won a gold medal in Munich, and Reid, given this new pedigree, felt confident that he could unload it for a tidy sum.[44]

Unforeseen events then landed a sale to eclipse all others. Whistler had been trying to sell the notorious *Falling Rocket*, still held by the Graves. Berthe Palmer liked it "immensely" but offered no more than six hundred guineas, just three-quarters of what Whistler wanted. His stubbornness seemed to have sunk his chances until Sidney Starr, who had fled to America following an affair with another man's wife, located a buyer in New York. Samuel Untermyer, an attorney and investor, would pay Whistler's asking price without ever seeing the original painting. He relied entirely on Starr's estimate of the picture's "artistic qualities" and "commercial value."[45]

Of all his recent successes, selling *The Falling Rocket* most pleased Whistler, and to an American no less. "[T]he Ruskin lot will be furious about the Falling Rocket!" he rejoiced to Starr. The "high priest" of the philistines had lived to see Whistler

reap four times the price Ruskin had ridiculed in 1877. That sort of "commercial slap in the face," Whistler told friends, was the "only rebuff understood or appreciated" in England. Best of all, with no dealer involved, Whistler received the entire benefit of the sale. He was giddy. "As to the fifteen pounds I once lent [you]," he told Starr generously, "well my dear Sidney – we will say no more about that."[46]

To so rejoice in a victory fourteen years delayed suggested further depths to Whistler's mood. He had often said his work belonged to the world and future generations, not chance purchasers, but, as he approached sixty, his vision of the future took a more personal cast. He had told Cavafy nearly four years earlier, "[T]his is history we are writing, and in this case history concerns me." When the wavering Kennedy seemed ready to abandon the Cavafy–Bancroft scheme, he repeated for the dealer's benefit, "[R]emember that we are writing history."[47]

He and William Heinemann had already agreed to a new edition of the *Gentle Art*, and in light of Whistler's concern about his legacy, the added material would be telling. Whether or not he had been conscious of the autobiographical nature of the first edition, the purpose of the revised work was clear. A new section, to be called "Auto-Biographical," would include his recent letters to the *Pall Mall Gazette* and the catalogue from the Goupil exhibition. The catalogue revealed the "real Whistler," presented, excused, and explained, as he had put it to David Thomson, by none but himself. Like David Copperfield, he would be the hero of his own story.[48]

# 17

# A New Life, New Markets, New Friends

## 1893–1894

The Whistlers had settled comfortably in Paris by the end of 1892. Jemie loved his spacious new studio, the topmost of several studios in a six-story building. It contained only a sofa, some chairs, two tables, full-length mirror, and stove, but it was bathed in light, a place to create "every effect dreamed of – from Rembrandt through to the daintiest of pastels!" he told Trixie, and the "only *painting* place" he had enjoyed for years (fig. 84). Its location on the rue Notre Dame des Champs reminded him of his old joke about "Tite" Street. "Only the French have any taste in the naming of streets," he laughed.[1]

Their house at 110 rue du Bac stood a half mile south of the studio, midway to the Seine (fig. 85). Workmen did not finish necessary renovations until September, but it was worth the wait. Passing through an "imposing" archway from the street, one approached the house along a covered tunnel that opened into a paved courtyard. A blue door with a brass knocker gave way to a small room devoid of furniture, save for a settee to collect the coats and hats of visitors. Straight ahead was the drawing room, furnished with a few chairs, a couch, grand piano, and table. Blue matting covered the floor. To the right, a dining room boasted only a large table and Empire chairs but also retained the home's "quaint" seventeenth-century cupboards.

The windows of the drawing room looked out on a walled garden at the rear of the house, accessible through a door in that same room. A large Japanese reed basket, yellow Japanese embossed wallpaper, and porcelain lacquered panels evidenced the continuing pull of East Asia on Whistler.[2]

Not that he abandoned his old world entirely. "I do not promise that I shall not from time to time run over to London," he chided friends, "in order that too great a sense of security may not come upon the people!" He maintained memberships in several London clubs and accepted an invitation to join the Society of Portrait Painters, which displayed *La Princesse* at its 1892 summer exhibition. The society immediately put him on its executive committee. In addition, friends, including the Pennells, Walter Sickert, and George Moore, visited him; and he attracted a new generation of American and English artists and art students living in Paris.[3]

He also kept an eye on son Charlie. While the young man had no flair for art, he did show a talent for technical drawing, and Charles Ambrose McEvoy, an electrical engineer, had accepted him as an apprentice. Both Whistler and Willie knew the Irish-born McEvoy, Whistler from the Chilean affair, Willie from their days in the Confederate army. Whistler then paid for tuition and books when Charlie enrolled in a pair of evening chemistry courses at King's College London, although he was not pleased by Charlie's mediocre grades. Another "chance *thrown away*," he chastised. Ignoring his own misadventures with chemistry at West Point, Whistler told him, "You *couldn't* stand lower than at the bottom of the class, and so there you stood. You probably never went near the place – and again my good will was abused."[4]

Charlie did not help matters by asking his father to pay for a more fashionable hat shortly before his academic shortcomings were exposed. "I have no means to help an 'Idle Apprentice' with 'tall hats,' " Whistler shot back. He softened, though, when Charlie, after all, received a certificate of merit in one class. McEvoy also sent positive reports of his progress and hoped soon to give him a salaried position. Charlie cleverly used the changed circumstances to ask his father for £5 to buy a suit. He had been working "awfully hard," he assured him, and literally worn out his clothes. "I am ragged!" he exclaimed. "I feel a disgrace to the Capt[ain], myself and every one else." Whistler, who already provided an "allowance" of fifty guineas per year, sent £8.[5]

In return for his largesse, Whistler expected Charlie to run errands for him in London and send clippings from the newspapers, but a rapprochement had been achieved. Charlie congratulated his father on the sale of *The Falling Rocket* and his success in reclaiming other pictures. "I don't believe in the middleman in art," he told him sagely. Even a stern father might have smiled at such a remark, and Whistler

must surely have been touched when Charlie sent consolations over the death of the Duke of Marlborough. Commenting on more than just his father's lost commission, the son proclaimed, "If he could only have stayed a little longer he would have lived through the ages."[6]

Yet, Whistler's approval would never be unstinting, largely because he never felt entirely comfortable in a father–son relationship. Thinking for some reason that Charlie might be drawn into a recent outbreak of violent labor protests in London, he asked Willie to counsel him. "[H]e is such a serious Ass that he might be led by his love of mystery and general monkeyism to disport himself at some of these accursed 'clubs,'" he explained to his brother. "[L]et him understand the loathing we have for that lot." His words conveyed concern, even affection, but Whistler lacked the temperament to deal with his son directly.[7]

He was far more solicitous of his dealers. They, in turn, were keen to keep his business, although the ties that bound them varied in degree. Alexander Reid ensured Whistler's patronage by naming his first-born son Alexander James McNeill Reid. At the other extreme, Whistler felt his relationship with the Fine Art Society, for which he was still pulling proofs for the first Venice set, to be a type of bondage. Of all his British dealers, he most trusted David Thomson, who by spring 1893 had moved the Goupil from New Bond Street to more fashionable Regent Street and opened a second gallery on Charles Street, in ultra-smart St. James. Thomson had also recently sold the *Lange Lijzen* for £600 to an American, having acquired it from its English owner, James Leathart.[8]

Thomson's value had increased in November 1892 when he replaced Huish as editor of the *Art Journal*. The dealer-editor mentioned Whistler's work frequently in articles and notices over the next few years, and he would have included a Whistler lithograph in every issue of the *Journal* had the artist furnished one. Whistler did provide one for Thomson's inaugural issue, and although he grumbled about the small payment of £10, he was too much a master of marketing by the early 1890s – be it through galleries, exhibitions, direct sales, or the press – not to appreciate Thomson's many uses.[9]

One of Thomson's first moves was to recruit Dugald S. MacColl to write a long, illustrated article about Whistler. Himself a painter and etcher, the thirty-three-year-old Scot's artistic roots were in the New English Art Club and Glasgow school. He had already praised Whistler in the *Spectator*, but his article for Thomson, published in March 1893, anointed the Butterfly as the master of modern painting. Two months later, while in Paris for the Salon, MacColl chanced to meet Whistler in the galleries. Never one to lack confidence, the critic introduced himself and proceeded to lecture

Whistler on the beauties of a certain Burne-Jones painting. Whistler listened politely before responding in all sincerity, "But I understand Botticelli much better than he does." That settled, the two men proceeded "arm in arm" through the rooms before finishing the day with glasses of absinthe. Whistler considered MacColl "a good fellow" ever after.[10]

Whistler also maintained his journalistic connection with William Henley. While still in London, Whistler had attended several of Henley's famous weekly luncheons at Solferino's restaurant, in Rupert Street. The editor used these freewheeling sessions, jocularly known as the "Henley Regatta," to stimulate the thinking of his staff and contributors to the *Observer*, especially about literature and art. As a result, Whistler fell in with a new generation of journalists, critics, and writers, including Robert A. M. ("Ram") Stevenson, Rudyard Kipling, and James M. Barrie. Stevenson, a forty-four-year-old critic and professor of art who had studied painting with Carolus-Duran, was already an admirer.[11]

In early 1893, another journalism friend, Gleeson White, left the *Observer* to become editor of a new arts journal, the *Studio*. Like Thomson, he asked Whistler to provide a lithograph as a "supplement" for the first issue. Whistler protested, only half jokingly, about helping to establish another *English* journal, but White flattered and cajoled until the artist gave him *Gants de Suède* (fig. 86). Thereafter, Whistler lithographs became a staple of the *Studio*, with his work frequently mentioned in the magazine.[12]

Whistler needed all the exposure he could get in 1893. Dealers in both Great Britain and America had been complaining about sluggish sales for at least three years. Whistler's paintings had grown in value, but they did not fetch anywhere near the prices they might have done a few years earlier. His income that year was the lowest since the 1860s. "The weather is depressing, the Art Barometer is at its lowest," a fellow painter lamented to Whistler in January. The situation in Britain resulted from yet another downturn in the "Great Depression" of 1873–96, this one connected to the near failure of the banking and investment firm Baring Brothers. The American economy was even more volatile, having endured a series of sharp peaks and declines since the mid-1870s. The year 1893 would be one of the worst of the decade. Hundreds of American banks failed amidst a raging debate over whether the nation should use gold or silver as its monetary standard. "The times are out of joint," E. G. Kennedy reported from New York.[13]

This may, in fact, have been another reason so many people were relinquishing their Whistlers. They simply needed cash. Even Willie asked his brother to help sell

*The Artist in his Studio*, painted in 1865. Jemie insisted he must not part with it for less than £500, but it would take three years to find a buyer willing to pay £400. Another factor in Britain, the economy quite aside, was a "glut" of painters. With several thousand artists already seeking buyers, and hundreds more joining the throng annually, it was no wonder prices remained depressed and sales slow.[14]

The French art market was equally affected, but Whistler was too enthralled by his new life to be overly concerned about economic trends. He held Sunday "teas," rather than breakfasts, in the rue du Bac. In the evening, he listened to the chanting of the Capuchin friars who lived on the other side of his garden wall. The garden was a tranquil place. Trixie often used the serene setting to bring him out of a dark mood. "Jimmy, I want you to come out and see what is the matter with the rose-bush," she would say, "it looks droopy." After protesting mildly, he would follow her, "child-like," into the garden, where they would "walk back and forth, arm in arm," until his spirits brightened (fig. 87).[15]

An incident in Whistler's garden became the "starting point" for a pivotal scene in Henry James's final novel, *The Ambassadors*. James had become well enough acquainted with Whistler to base several fictional characters on the "queer little Londonized Southerner," most notably in *Roderick Hudson* and *The Tragic Muse*. In *The Ambassadors*, he exploited a conversation overheard at a Whistler tea between William Dean Howells, the American author and editor, and Jonathan Sturgis, a thirty-year-old expatriate American writer of whom Whistler had grown fond. The fictional encounter took place in the Paris garden of an Italian sculptor, Gloriani. James's description of the garden was a composite of several in the Faubourg-St. Germain district, but its finer details came from the rue du Bac. Gloriani, despite his nationality and occupation, was based partly on an aging Whistler (fig. 88).[16]

Within the house and away from his garden, Whistler liked to play cards, especially whist. He was good at whist, and the game gave him an opportunity to tell stories and pontificate, which is what he liked best of all. He enjoyed music if it was light-hearted. When Trixie played Grieg, Schumann, or Chopin for guests on their grand piano, Whistler would sit "peacefully dozing" before calling out, "Haven't you good people had your fill of doleful dumps? Let us have a funeral march, Trixie, to liven us up a bit." If feeling out of sorts, or if his guests became "too much" for him, he sought refuge in a butler's pantry, to smoke or read.[17]

One composer of "serious" music that Whistler appreciated was Claude Debussy. Their friendship grew when, having met at a Tuesday afternoon Mallarmé salon, Whistler learned that the leading exponent of Symbolism in French music admired

his pictures and the *Ten O'Clock*. Artist and composer also shared an admiration for the poetry of Edgar Allen Poe and the woodcuts of Hokusai. While Chopin had been the first composer to apply the word "nocturne" to his music, Debussy's own version of the form came closer to Whistler's misty visions of the Thames. Whistler seemed to acknowledge the similarity by attending the premiere of *Prélude à l'après-midi d'un faune*, inspired by Mallarmé's poem, in December 1894.[18]

Mallarmé himself remained Whistler's closest friend in Paris. Their two families had also become close, with Mallarmé's daughter Genevieve becoming very fond of the flamboyant American. Indebted to Mallarmé for his translation of the "Ten O'Clock" and the campaigns for *The Mother* and Légion d'honneur, Whistler tried to create an English market for his poetry. He was especially hopeful about some devilishly clever quatrains that Mallarmé had devised from the postal addresses of friends. The poet had even used the verses to send letters. They would be all the rage in Mayfair, Whistler tried to persuade Heinemann, just the sort of thing that Oscar Wilde would steal and make fashionable. "Don't you see all the envelopes covered with Oscar's doggerel going through the Post?" he marveled.[19]

Despite Whistler's spirited sales pitch, Heinemann, who, to Whistler's horror, thought the verses should be translated for an English audience, eventually passed on the project. Whistler then tried to interest Harper and Brothers, but they, too, turned him down. Nonetheless, Mallarmé, to show his appreciation for Whistler's efforts, added his address to *Les Récréations postales*:

> Leur rire avec la même gamme
> Sonnera si tu te rendis
> Chez Monsieur Whistler et Madame,
> Rue antique du Bac 110.[20]

Whistler repaid him in early 1893 by making a lithographic portrait for Mallarmé's next volume of poetry, *Vers et prose*. Mallarmé thought it the best likeness ever done of him, superior even to a painting by Manet. Naturally, like all of Whistler's sitters, he suffered in the process, though not in the usual way. He had been standing too near a stove when Whistler began to draw, and when he tried to escape the heat, the artist, oblivious to his plight, pleaded with him to be still. As a result, the stoic Mallarmé, who wrote a poem to commemorate the occasion, scorched the calves of his legs (fig. 89).[21]

Although Whistler had resumed lithography in 1887, he had really only dabbled in it until seeing how pleased Mallarmé and Beatrice were with his efforts, and how

eager such editors as Thomson and White were to have the results. Resolving to master the medium, he drew on both stones and transfer paper, compared the effects of crayon and chalk with lithotint washes, experimented with color lithography, and made prints on various grades of paper. He found that drawing on transfer paper worked best. Of the approximately 180 lithographs he eventually made, only 20 were drawn on stone, and he made half of those during his initial flirtation with the process, in the late 1870s.[22]

He also made etchings, pastels, and lithographs of similar subjects in order to judge which process yielded the best results. Parisian streets and shopfronts became favorites, and he made dozens of etchings and lithographs in and around the Luxembourg Gardens. The etchings, which would be his last significant set in the medium, resembled the Renaissance group in the delicacy of their lines and shading. He used his own press in Paris to print them, although, being somewhat rusty at that end of the business, he called on several people for assistance, including Joseph Pennell, Delâtre, and Frank Short, an admiring thirty-five-year old English artist and printer (fig. 90).[23]

As he considered how best to profit from the lucrative lithographic market, Whistler made a surprising decision. Rather than make his prints as dear as possible, as he had always done his etchings, he told dealers to sell them at a full guinea below market price, two guineas for his black and white lithographs, three guineas for color prints. Thomson and Kennedy both advised against the policy, as well as protesting his low fifteen percent discount to dealers, which reduced their profits; but Whistler, wishing for once to reach the broadest possible audience, and more or less acknowledging the commercial nature of lithography, held firm.[24]

André Marty, editor of *Journal des artistes* and a collaborator with Roger Marx on the quarterly subscription album *L'Estampe originale*, helped Whistler tap into the French market by soliciting a lithograph for the latter publication. There was little profit in it for Whistler, but Marty promised to bear all expenses, including the cost of quality Japanese paper. Whistler's advantage came from occupying "the same box" as noted French lithographers Bracquemond and Chavannes, who also contributed to the volume. Deciding "to be amiable," he submitted one of the semi-nude young women, lightly draped in transparent robes, he had been working on.[25]

Female nudes became one of Whistler's favorite subjects for both lithography and pastels in the late 1880s and early '90s. He may have failed, as he saw it, to master the female form in painting, but he had always been more sure of himself with pen, pencil, crayon, and chalk.

Before leaving England, he had used the Pettigrew sisters, Hetty, Lily, and Rose, for much of this work. They had first posed for him in the mid-1880s, when they ranged in age from ten to fourteen. All three girls, even then, were beautiful to a fault, and they had matured well beyond puberty by the early 1890s. Rose, the youngest, looked eighteen, though still in her middle teens. She was smitten with Philip Wilson Steer, fourteen years her senior, and posed for him most of each week. The situation annoyed Whistler, not least because Steer had never been an abject follower, even though, as a painter, he had learned much from Whistler. None of the girls was shy. Rose appears to have pretty much thrown herself at Steer, and Lily, the middle sister, had posed completely nude for photographers. Hetty posed nude for French-born and largely self-taught Théodore Roussel, whom Walter Sickert called the "most thorough going & orthodox Whistlerite of them all." She became the forty-six-year-old painter's mistress and bore him a child.[26]

Whistler's nude models assumed a variety of poses. Some of them reclined; others were seated. Several held small children, suggesting, perhaps, the influence of Mary Cassatt, who was noted for such pictures. Others pranced, skipped, and danced, arms uplifted, the lightness of each movement accentuated by gossamer robes or shifts. The action poses were inspired by a sensational series of nearly eight hundred photographs, *Animal Locomotion*, published by Eadweard Muybridge in 1888. Whistler subscribed to the series, which documented in frame-by-frame sequences the precise movements of people and animals. Equally, he had seen Loie Fuller's famous "butterfly dance," in which the American singer and dancer swirled thin draperies around herself to simulate the wings of a butterfly. She performed in both London and Paris in the early 1890s, and was a favorite of Mallarmé.[27]

Whistler was self-conscious about using pre-pubescent girls for this work, although not from personal scruples. With few exceptions, his nudes, even the grown women, retained a touching innocence, their bodies graceful and lovely without arousing passion. Rather, it was a question of the American and English markets. While the French thought nothing of nudity, the American middle classes demanded even that "the legs of the piano . . . be draped," he complained to Edward Kennedy. "To them," he said of his countrymen, "a nude figure suggests . . . general impropriety, only!" The English were no better, although their objections, like those of John Horsley, grew from the belief that nudes represented the degeneracy of French art. Such prejudices caused Whistler to delay exhibiting one of his most exquisite lithographs, *Little Nude Model, Reading*. "[A]fter all," he explained to David Thomson, "is it not entirely too delicate for the *public*? – I think so" (fig. 91).[28]

He entrusted the lithographs to the Ways, who remained his principal printers, not to say valued friends. As he expressed the professional relationship to Thomson, "Mr. Way . . . brings to this work of mine the appreciation and complete understanding of the connoisseur and artist that he is." Father and son understood Whistler's mania for perfection, could be relied on to carry out his written instructions to the letter, and, seeing his fevered desire to master a medium they revered, did all in their power to please and assist him. That was not always easy. A year earlier, Whistler had attempted color lithography, which was to have been a major attraction of the never completed "Songs on Stone" portfolio. The Ways tried to convince him that quality color prints could only be achieved by working directly on stone. When Whistler insisted on using transfer paper, the younger Way tried dutifully yet ultimately futilely to get satisfactory prints. Whistler would complete only seven color lithographs, six of them on stone.[29]

Far more successful were his experiments with "stump," a technique that smudged drawn lines and created atmospheric effects by using a piece of rag or rolled paper. Once Tom Way had explained its uses and possibilities, stump became Whistler's favorite lithographic trick, one used successfully, as well, with his pastels. "The stump skies I think charming," he told Way after seeing the printed results of an early trial. "There is a delightful velvety quality about them," he explained, "quite as fascinating as anything in etchings." He cautioned the Ways, as was his habit when discovering a new technique, to tell no one about it. "This is *mine* you know," he declared, "and the chic that I shall get out of it just now when no one dreams of it ought not to be a manner intruded upon by those tiresome people who unscrupulously vulgarize everything before it has been properly thought out!"[30]

Whistler also depended on the Ways to publicize his work. To accompany his first lithograph in the *Studio*, the younger Way and William Rothenstein, a twenty-two-year-old English art student in Paris, wrote an article on "artistic lithography." Way would continue to praise the " 'painter-like' quality" of Whistler's lithographs for another decade, and under the tutelage of father and son, the artist's confidence in the medium soared. "I have always been so beastly poor," he confided to the son in exaggerated fashion, "only now I fancy I see fortune looming on the *horizon!* – and I might really be rich – who knows! It would be amazing fun – and what wonderful things we would do then! . . . for I am sure to make lithography a roaring fashion!"[31]

But not even a roaring fashion could pay all the bills, and so Whistler made time for commissioned paintings, especially two portraits. John Cowan and William Eden were very different men. Cowan became a devoted friend who bought several pic-

tures over the years, although, even after sixty sittings spread over a decade, Whistler never completed his portrait. The earliest and most intense of the Scot's "fatiguing" sessions came in May and June of 1893, when Cowan and his wife traveled to Paris from their home in Edinburgh. Cowan recalled "lots of rubbing out and despair" by Whistler. "What an ass I am," the artist would occasionally say. "It just wants two touches, but how the devil to do them. I don't know. We have got into trouble." Whistler later blamed his miscues on Mrs. Cowan, who, in trying to pass the time for her husband by reading aloud from *Treasure Island*, distracted him.[32]

William Eden presented quite a different problem, not least in his determination to get value for money. "He is troublesome in his dealings," Thomson warned Whistler, "& you must be *very careful* & precise in business details & settle the matter before hand." Eden had agreed to pay 600 guineas for a "*small* full length" of himself but bristled at the 525 guineas Whistler asked for only a head of Lady Eden. Following personal negotiations with the artist, and having George Moore intercede on Whistler's behalf, Eden finally agreed, in early 1894, to a small "sketch" (eight by thirteen inches) of his wife for 100 guineas. He left the medium up to Whistler. An oil, watercolor, pastel, it was all the same to Eden.[33]

Whistler invested little effort in his best opportunity to exhibit that summer, at Chicago's Columbian Exposition. With a former Duveneck Boy, Oliver Grover, chairing the selection committee for the American section, talk circulated that he would paint a commemorative picture for the exhibition and address a special audience of painters, but Whistler had lost all desire to visit America. Instead, he relied on Beatrice and Thomson to assemble his work, and asked friends in America to see it properly hung. In collecting the three paintings and fifty-nine etchings eventually shown, Beatrice and friends encountered owners who would not lend, owners who promised to lend but reneged, works sent too late, and works sent in the wrong frames. It was a dreadful muddle, and it took many months to get things right.[34]

The job done, the Whistlers escaped Paris to spend six weeks on the coast of Brittany. The city was hot that summer, and Trixie was unwell. Besides that, political violence had seized parts of Paris, including the Latin Quarter, in the most revolutionary rumblings of public discontent since the failed Commune of 1871. Anarchism was on the rise, as in England, and in Paris, anarchists were determined not only to bring down the government, but also to wrest control of the French labor movement from fellow socialists.[35]

Equally alarming to Whistler was the cultural decadence that accompanied the political radicalism. Not only had the center of Parisian entertainment shifted to

Montmartre by the 1890s, but the nightclubs and cabarets that replaced the more intellectually stimulating cafés were bold and brassy. The garish windmill atop the "noisy and rowdy" Moulin Rouge typified the change. Rather than a world of ideas, Paris had become a realm of fantasy and sensual pleasure for the bourgeoisie. Even students, whose changed dress Whistler had already observed, succumbed to the trend by moving their annual Bal des Quat'z' Arts to Montmartre.[36]

Whistler diverted himself in Brittany by painting some new "Marines" around Perros-Guirec and Paimpol. Naturally, the sky and sea remained frustratingly placid until near the end of his stay, but he returned to Paris in early September with at least five oil paintings, seven watercolors, and seven lithographs. Most of the paintings were either four by five inches or six by nine inches, the smaller oils being on wood panels. However, two oils, *Violet and Silver: A Deep Sea* and *Dark Blue and Silver*, both measuring twenty by twenty-nine inches, were his largest seascapes in a quarter of a century. Nor had he limited himself to the sea. He and Trixie explored inland to the villages of Vitre and Lannion, where he painted shopfronts and made most of his lithographs, one of them capturing the bustling marketplace at Vitre.

He also made a brilliant pair of color lithographs, *Red House, Paimpol* and *Yellow House, Lannion*. The original drawings were in black and white, but back in Paris, he added color washes under the careful eye of Henri Belfond, one of the few Parisian printers he trusted. In the *Red House*, he used color only to lend contrast and emphasis, whereas the yellow and green of the *Yellow House* became structural components of the composition. Adding the colors was a tedious process, the applications of each tint requiring a separate stone and printing. The *Yellow House* may have taken as much as a month to complete. As in all his work, Whistler strove for "simplicity," and his use of color certainly contrasted with the gaudy, fully tinted lithographs of French artists like Henri Toulouse-Lautrec.[37]

In Paris, Whistler also learned that Albert Moore had died in late September. His friend had abandoned London's old bohemian district, most recently around Red Lion Square, in the mid-1870s to take a house and studio in Holland Park, although the new place, located on an unmarked lane off Melbury Road, was so concealed as to be nearly invisible. When his "wife" of many years, whom he had never legally married, did not follow him to Holland Park, his "constant companion" became a dachshund named Fritz, who lived on sardines and oranges. An untold number of cats also roamed the grounds and invaded Moore's house. His valiant housekeeper tried to keep the place clean, but she worked for a man who, rather than repair a leaking roof, set out pots to catch the drips.

Moore's new abode could be taken as a metaphor for his "unconventional" life. Like Whistler, he had remained outside Britain's artistic establishment. He was never invited to membership in the Royal Academy, a slight to his friend that angered Whistler far more than it did Moore. Whistler now urged a memorial exhibition of his work at the Grafton Gallery, which several of Moore's former students, including Graham Robertson, arranged. "Whistler – the real Whistler, not the fantastic cynic known to the public," Robertson later observed, "liked many men – perhaps a little capriciously and fitfully – but Moore was one of the few men whom he respected."[38]

Whistler failed to sell his own Brittany pictures through the Grafton that fall, and the news concerning his other work remained mixed moving into the new year of 1894. The outlook brightened when his portrait of Lady Archie won a gold medal at the Pennsylvania Academy of Fine Arts, and efforts were being made to purchase the painting for the academy, the first Whistler to be owned by an American public gallery. Equally exhilarating, Arthur Studd, a thirty-year-old English art student of independent means, bought two of Whistler's favorite older paintings, *Little White Girl* and *Nocturne: Blue and Silver – Cremorne Lights*, from John G. Potter for £1,400. Whistler had liked "Peter" Studd, as everyone knew him, since their first meeting the previous year. He now embraced him as a "confrere." Besides having rescued the paintings from the "further uncertainties & rudenesses of the 'market,'" Studd understood Whistler's personal attachment to his work. "I hope you will always regard them as your own property as far as exhibitions are concerned," Studd assured the creator, "& I shall be glad to send them whenever & wherever you may desire." When Whistler almost immediately asked to exhibit *The Little White Girl* in Antwerp, Studd proved as good as his word.[39]

But these successes could not entirely temper Whistler's annoyance at several incidents of disloyalty during the same few months. John Potter's grasping sapped some of the joy from the sales to Studd, and a few months later, Aleco Ionides sold *Old Battersea Bridge* to Thomson for four hundred guineas. It mattered little to Whistler that Ionides was so hard up that he spoke of selling his house. The point was that his father had purchased the painting from Whistler for £30 in 1859. Most disappointing of all, Julia Revillon sold *The Music Room* through Christie's, and for a measly £200. Somewhat mollified that it went to a Glasgow dealer (who later sold it to a Frenchman), Whistler nonetheless wrote a biting letter to his niece. "[T]he picture, over which you bargained, and haggled, and . . . finally sent to the public auction," he reminded her, "was a *gift from my Mother to your own!*"[40]

These irritations, however, were nothing compared with trials soon to come.

# 18

# Litigation and the Lamp

## 1894–1895

Whistler seemed happy enough in April 1894. If he occasionally grumbled, it was mostly from habit, and as long as he did not engage in public "rows," Trixie was content. Then, the "relapse." An exchange of letters in the *National Observer* with Marion Spielmann was a relatively tame affair, involving the status of the nude in painting. However, a second episode, which had begun three weeks earlier, rivaled the Ruskin trial and the Peacock Room for drama.[1]

In January, George du Maurier had published the first of eight installments of his new novel, *Trilby*, in *Harper's Magazine*. The melodramatic story about a Parisian *grisette* transformed through hypnotism into a diva took Britain and America by storm. Subsequently issued as a book, *Trilby* became an international best-seller, a wildly successful stage play, and the inspiration for numerous parodies. With much of the action set in the Parisian ateliers and cafés of the 1850s, du Maurier drew freely from his days with the Paris Gang. Many characters were but thinly disguised versions of Joseph Rowley, Tom Armstrong, Tom Lamont, Aleco Ionides, Edward Poynter, and Whistler.[2]

Whistler, who had seen little of his friend since the 1860s, scarcely noticed the first two installments of *Trilby*, but then came Joe Sibley. Du Maurier described this character as "the idle apprentice, the king of bohemia," and no one could have mistaken the author's model. "[A]lways in debt, . . . vain, witty, and a most exquisite

276

and original artist," Sibley was "eccentric in his attire" and "adored" being the center of attention. An illustration showed him in patent-leather shoes, broad-brimmed hat with flying ribbons, a cigarette in one hand, a long wand in the other. Sibley had "pretty manners (and an unimpeachable moral tone)." He was "genial, caressing, sympathetic, charming; the most irresistible friend in the world," as long as, du Maurier cautioned, one acknowledged his supremacy. "The moment his friendship left off," the author warned, "his enmity began at once" (fig. 92).[3]

This last bit had nothing to do with the Whistler of the 1850s, no more than the wand, but du Maurier made Sibley's defects all the more glaring by comparing him with the "industrious apprentice" in his story, a chap named Lorrimer. Clearly meant to be Edward Poynter, Lorrimer was "no bohemian," and while he and Sibley were good friends, neither one quite approved of the other fellow. Yet, Lorrimer was the "most delightful companion – the most affectionate, helpful, and sympathetic of friends." A bit of a stick, to be sure, but, unlike Sibley, no coward. Sibley was "better with his tongue than with his fists," du Maurier said. He was a plagiarist, too, who stole the best lines of other people. "Let us hope that he sometimes laughed at himself in his sleeve," du Maurier said hopefully, "or winked at himself in the looking-glass, with his tongue in his cheek!"

Whistler had been caricatured often in print and on stage but never in this way. He felt betrayed, and told du Maurier so in a private letter. "[W]hat now in the name of all that is traitorous, should I do with 'friendship' such as yours!" he bellowed. He accused du Maurier of "envy, malice," and "furtive intent." As though in shock, or perhaps only restrained by Beatrice, he waited several weeks more before protesting publicly in the *Pall Mall Gazette.* "[H]e has been harbouring, for nearly half a life," Whistler then said of du Maurier, "every villainy of good fellowship that could be perfected." The artist preferred an "open enemy" to such a "foul 'friend.'"

When du Maurier failed to reply, the *Gazette* sent someone to interview him. The seemingly embarrassed author tried to dismiss the controversy. Yes, he admitted, Joe Sibley had been created to some extent with Whistler in mind, but only to stir "pleasurable recollections" of student days. He regretted that Whistler had "taken the matter so terribly seriously." Du Maurier admitted that a "bit of drollery" about himself in Sheridan Ford's edition of the *Gentle Art* may have fostered a playful desire for revenge, but he could only think that Whistler's violent protest resulted from lifelong bitterness at not being counted a "genius . . . by the wide public."[4]

It was a weak explanation. Perhaps du Maurier, while not a mean-spirited man, still envied Whistler's sudden rise as an artist, or his "thick as thieves" relationship

with the "Rossetti lot." Du Maurier had, after all, sided with Seymour Haden and Alphonse Legros in their clashes with Whistler, and being something of a prude, he had felt uncomfortable around Jo. Even in their chummiest days, du Maurier had said of Whistler, "[N]othing is more fatiguing than an egotistical wit." It had all been a long time ago, and in his eagerness to tell a good story, explained friends, he simply "lost his head."[5]

Some acquaintances advised Whistler to drop the matter, but he insisted that du Maurier's "lie" could distort "history" by poisoning the way a "future biographer" perceived him. Then, too, Whistler may have been as guilty as du Maurier of envy. Du Maurier owned a handsome, nearly palatial, home in the rarified air of Hampstead and seemed to be financially secure. Whistler, of course, was not poor, and any financial woes that weighed on him grew from his own reckless spending. Yet, at that very moment, he found Beatrice scrimping to save money for some fabric to cover their sofa and chairs.[6]

And so, a showdown. Whistler tried to have du Maurier either reprimanded or expelled from a pair of clubs to which they belonged, the Beefsteak and the Arts. The majority of members in both clubs sympathized with Whistler, but du Maurier had already resigned from the Beefsteak, and the Arts Club decided against public action for legal reasons. Dissatisfied with the response, Whistler asked George Lewis to take legal action. As one of du Maurier's oldest friends, Lewis demurred, and added his voice to those advising against litigation. However, William Webb told Whistler he had a strong libel case.[7]

That was all the encouragement Whistler needed. His litigious juices had already begun to flow upon learning that a new catalogue of his etchings was about to be issued by Frederick Wedmore. Whistler threatened legal action if Wedmore included in his "foolish book" any of the nonsense the critic had recently spouted in an article about British etching. The only question in du Maurier's case was the point of attack. Whistler and Webb agreed that Harper and Brothers, which held "the law of libel in horror," would make a better target than du Maurier. Eschewing financial damages, Webb sought only to halt future sales of the offensive March issue of their magazine, a public apology for the barbed portrayal of Whistler, and removal of the libelous passages from the inevitable book edition. By midsummer, Harper and Brothers had agreed to all terms and begged Whistler to believe that they had been "quite unaware" that du Maurier had written anything to cause "annoyance."[8]

That ought to have ended matters. Instead, the saga dragged on through the summer. First, the form and placement of the public apology became an issue. Then,

Whistler wanted to inspect du Maurier's revisions for the book edition, in which Joe Sibley became Bald Anthony. The deal nearly collapsed when the Harpers failed to halt circulation of the March issue in Britain, and when Joe Sibley continued to breathe life in the final August installment. Nor did the Harpers send Whistler their letter of apology until several weeks after publication of the book edition of *Trilby.*

Finally, though, Whistler felt vindicated. "Well Hurrah! at last hurrah!" he told Webb. He regarded the episode as one of his "most brilliant and *complete* triumphs," comparable to any battle recorded in the *Gentle Art.* Indeed, he asked William Heinemann if the "du Maurier campaign" did not warrant a third edition of that book. Here, after all, was a splendid example of the "scientific and West Point kind of fighting." He urged journalist friends to trumpet his success in London and the "provincial papers."[9]

He felt all the more elated because his art was selling well again that summer and fall. Orders for etchings and lithographs rolled in from galleries in London and New York. Paintings shown at the Champs de Mars went at or very near Whistler's asking price of 250 to 400 guineas. His "black" portrait of Montesquiou drew some laughter, but the Bat adored it, and David Thomson asked to reproduce it in the *Art Journal.* He also received more commissions for portraits than he had done in several years, with Americans topping the list. Arthur J. Eddy, a Chicago attorney who had been dazzled by Whistler's work at the Columbian Exposition, offered seven hundred guineas and traveled to Paris for his sittings. The Kinsella family, also from Chicago, commissioned a portrait of their daughter Louise, who was attending school in Paris. Whistler's American dentist in Paris, Isaac B. Davenport, wanted a portrait, too.[10]

What was more, his new patrons showed promise of eternal devotion. The thirty-five-year-old Eddy confessed to being "homesick" for Whistler's company when he and his wife returned to Chicago. "[Y]ou were the only man I ever met and associated with daily whom I found companionable and ever more enjoyable each succeeding day," the lawyer declared. He spoke to his friends at the Art Institute of Chicago about organizing a Whistler exhibition. Another American, Alfred Pope, who had bought two Brittany seascapes, also admired the artist as much as his work. The fifty-two-year-old manufacturer from Cleveland and his family purchased several pictures in France that summer, including a Degas and a Manet, but Pope seemed most pleased with having met Whistler. He vowed to buy more Whistler paintings as they became available, and spoke of having his portrait made when next in Paris.[11]

Whistler's only disappointment was that his lithographs still had not reached a wider market. Even at two and three guineas, the masses found his "luxurious" prints

(done on old Dutch and Japanese paper) too costly, especially considering their "unfinished" look. Nothing like the value for money one got, for instance, with a print by Currier and Ives. "Bosh! I am happy to say Bosh!" Whistler told Edward Kennedy. "I have fallen no nearer popularity than before – and . . . only the same small circle of collectors who buy etchings, ask for my lithographs." Discovering, too, that some dealers sold his prints for a guinea more than they paid for them on discount, Whistler raised his prices to five guineas. He even threatened to stop using the art periodicals to promote his work. "We are altogether too choice for *that*!" he told Tom Way. "Only now and again will we give them something – just to make them eager."[12]

But as the du Maurier affair wound down, many people just shook their heads over Whistler's crusade against his old friend. John Bancroft, still irked by Whistler's treatment of him two years earlier, said the artist's protest had done him more injury than the novel's characterization of him. "The truth is, with all his talent, Jimmy is getting old & shriveled & into his second childhood," Bancroft told du Maurier, a friend of long standing. "He is a great painter beyond question & can say & write a good thing on occasion. But in daily life he is about as responsible and intelligent as a spoiled child of five & I fancy Mrs. W. feels just that kind of responsibility about him."[13]

In fact, it was Mrs. W. who required care. She had fallen ill again, and in November, Whistler asked Willie to diagnose her malady. As things turned out, she had cervical cancer, but Willie, who was no gynecologist, thought she only required rest. Whistler decided to spend the winter in London, where Trixie would have "the advantage of English nursing and care." Their departure from Paris was delayed by the arrival of Charles Freer, accompanied by forty-three-year-old American artist Thomas Dewing. Whistler liked Dewing. He also liked it when Freer, who had recently bought £200 worth of lithographs, spent another 1,300 guineas on three drawings and an unfinished nude. With this timely nest egg in hand, he, Trixie, and Ethel were in London by December.[14]

The ongoing political upheaval in France also made it a good time to leave. In December 1893, anarchists had thrown a dynamite bomb into the Chamber of Deputies. No deaths resulted, as they did soon after in an explosion at a café near the busy Gare Saint-Lazare, but the violence escalated through the spring and summer. In April 1894, another bomb damaged the Foyot restaurant, where Whistler often dined. Beatrice heard rumors that anarchists intended to blow up Bon Marche, the fashionable department store around the corner from the rue du Bac, although,

she also observed that the threat did not deter ladies from flocking there to buy new spring hats. The nadir came two months later with the assassination of President Sadi Carnot, in Lyon. Whistler watched the funeral procession for Carnot in Paris, even making two lithographs of the scene, but the random violence appalled him. "For my part a little healthy American lynching would be the proper thing for these scoundrels," he declared.[15]

If not as physically violent as Paris, London had also changed in the two years Whistler had been away. Indeed, it seemed as though everything in Britain had been dubbed "new." The "new" art criticism was well enough. That had begun before Whistler's departure, and it tended, if anything, to reflect his own thinking. Less familiar were the budding feminism of the "new woman," the loose morality of the "new fiction," and a more risqué "new music hall." In imitation of the Moulin Rouge, female chorus lines at the Alhambra, Empire, and Palace displayed more leg, their tableaux more nudity. The legitimate theater had taken a turn toward the "new drama," and Oscar Wilde led the way. He had already produced *Lady Wind-ermere's Fan* and *A Woman of No Importance*, and his latest efforts, *An Ideal Husband* and *The Importance of Being Earnest*, were to open in January and February, respectively. The verve and wit of those plays made them hugely successful. Not so Wilde's dark, Symbolist-inspired drama *Salomé*, which the lord chamberlain had banned in England.[16]

Whistler did not disapprove of all the changes. He felt some kinship, for example, with Britain's Symbolist-inspired poets. Thirty-year-old Arthur Symons had emerged as the archetype of those "Decadents." The Welshman had fallen under the sway of French Symbolism in Paris during the late 1880s. Returning to England, he discovered Whistler's "exquisite art," learned of the critical abuse he had endured, and proceeded to write poetry that echoed the nocturnes. He was enthralled when, upon meeting his hero, the artist took him and his work seriously. "[H]e talked of art," Symons recalled, "certainly for art's sake, with the passionate reverence of the lover, and with the joyous certainty of one who knows himself loved."[17]

In fact, the number of British, as well as French, poets and writers who had been influenced by Whistler was rather striking by the mid-1890s. There had been Swin-burne, Wilde, and Henley in earlier days, but now a new generation appreciated the poetic qualities of his art. They could recite favorite passages from the "Ten O'Clock" and saw the Thames not as a Dickensian netherworld of choking fog, ugly ware-houses, "dingy and gritty" steamers, and "damp looking, dirty blackness," but as a fairyland of evening mists. As Henley wrote two years earlier:

What miracle is happening in the air,
Charging the very texture of the gray
With something luminous and rare?[18]

However, the "new art" perplexed Whistler. Again, he approved of some innovations, many of them rooted in French art and touted by the "new" critics. He also approved of some rising younger artists, such as Charles Ricketts and Charles H. Shannon, to whom he had ceded his house in The Vale. Those two he regarded as gentlemen. He found it harder to warm to people like Aubrey Beardsley and the "new" style of English drawing.[19]

Twenty-one-year-old Beardsley had been a fan of Whistler. While still working as a clerk for an insurance company, he spent a week's salary on a "gem" from the Thames Set. He called Whistler's portrait of Cicely Alexander "truly glorious, indescribable, mysterious and evasive." His own drawing style showed the influence of the Peacock Room, which he had visited. He also adopted Whistler's ideas about harmony, including the notion that a frame was but an extension of a picture. Beyond art, Beardsley applauded the genius of both Whistler and Wilde as self-promoters. He cultivated the image of a dandy and boasted of his ability to shock, or "put one over," on the philistines. He once wore a duplicate of Whistler's straw "boater," complete with fluttering ribbons, to the Salon.[20]

He also contributed to an explosion of new literary periodicals that showed Whistler's influence. Relying on a synergy of the new art, new journalism, and Symbolism, these avant-garde publications challenged the reigning orthodoxies in fiction, poetry, and painting by showing how art and literature complemented each other. That should have pleased Whistler. So, too, the physical layout of the journals, including *The Yellow Book*, which Beardsley helped to launch in 1894. The clean, crisp, nearly square pages, asymmetrically placed titles and headings, and large margins deliberately copied the *Gentle Art*. Whistler even contributed lithographs to three of the new magazines, the *Albemarle, Pageant,* and *Savoy*. In fact, while none of the upstart publications could be mistaken for the *Art Journal*, they were not as radical as their reputations. Even *The Yellow Book* published work by Sickert, Pennell, and Leighton. *Punch* did not take the Decadents as seriously as it had the Aesthetic Movement, mostly because they were not as much fun. "Aubrey Weirdsley" and the rest of his "Sect," *Punch* predicted, would soon pass from the scene.[21]

Whistler's aversion to Beardsley and his style of drawing was more personal. At first, he simply found this aesthetic-looking "young thing" an odd duck. "Look at

him!" he exclaimed to Pennell, who first introduced them in Paris, "he's just like his drawings – he's all hair and peacock plumes." Then there were Beardsley's gross depictions of sexuality and eroticism. His women became menacing creatures, his drawings of male genitalia a form of phallic worship. Most shocking were his hermaphroditic and androgynous creatures, endowed with female breasts and male genitals. All of it, too, had a satanic element alien to Whistler's sensibilities. Beardsley's decadence bordered on degeneracy. Had Whistler known he preferred hashish to absinthe, it would only have confirmed his judgment that the younger man had no place in his world.[22]

Worst of all was Beardsley's lack of decorum and restraint. He drew wicked caricatures, even of people he professed to admire, and Whistler soon joined that list. Hurt by Whistler's cool reception of him and his work, Beardsley made buffoonish renderings of the artist and a drawing of the ailing Trixie that was nothing less than cruel. Published in May 1894, it depicted a very stout woman enjoying a glass of wine. Burne-Jones, ignorant of the woman's identity, was appalled in strictly human terms. "[S]he looked like a mere lustful animal," he winced. Later that year, Beardsley took aim at Whistler in the often lewd and certainly bizarre illustrations he provided for the published edition of Wilde's *Salomé* by incorporating the Butterfly's signature in the femme fatale's gown. Not satisfied with that, he drew Whistler as a malevolent-looking satyr for the title page of another book.[23]

Whistler, thinking only to keep his mind off Trixie's suffering, lost himself in work. He began as many as eleven portraits that winter, thanks in no small part to Sickert, who opened his studio to the master. The working arrangements were less than ideal. Located in Robert Street, just west of Euston Station and on the edge of Camden Town, Sickert's studio was cold and damp, reached "through the dingy passage of a tenement house reeking of cats and cabbage." The place also served as Sickert's lodgings while his wife, seeking to escape their strained marriage, wintered on the Continent.[24]

Unfortunately, after three months in London, Trixie's health had not improved. Friends commented on her "good spirits," but she remained physically weak. Following a stay at Long's Hotel, in New Bond Street, the Whistlers moved to Willie's new house, 17 Wimpole Street, in February. "I have been unable to think of anything," Whistler confessed, as the "long weeks of cruel weather" wore more on him than on his wife. They agreed to forsake "dirty and foggy London" for the "Sunshine and gaiety" of 110 rue du Bac, only to learn that a blanket of snow covered Paris. Instead, Whistler took Trixie and Ethel to Devonshire, in the south of England, where his wife might benefit from the warm sea air.[25]

Leaving the sisters momentarily, Whistler returned to France for an impending legal action. He had decided that his completed portrait of William Eden's wife was worth more than the baronet's one hundred guineas commission. He returned the money, but Eden wanted the painting. He sued the artist for ten thousand francs, or about £400. Whistler had taken too lightly David Thomson's warning that precise terms were required when dealing with the baronet. Whistler's friends thought it a "ridiculous action," the result of "pride" and stubbornness on both sides, but Whistler took the case even more seriously than he had done the slight by du Maurier. It had been necessary to protect his image in the *Trilby* affair, but Eden challenged Whistler's right to control his own work. Who, after all, had the stronger claim to a painting, the artist or the buyer? The issue "stirred the very depths" of his being.[26]

He had secured a first-rate French advocate through Mallarmé and seemed to be on firm legal ground. Ethically, though, his case was shaky. Not only had Eden refused to take back the money, but Whistler had then rubbed Lady Eden's face out of the painting and replaced it with the likeness of another woman. "The picture has been *entirely* repainted," he declared innocently, "and the Portrait . . . doesn't exist!" Too his regret, Whistler would have no opportunity to make such pithy appeals at the trial. With neither plaintiff nor defendant to testify in court, he would have to make his case in the press.[27]

Consequently, the drama outside the courtroom surpassed the legal proceedings. When Eden publicly touted George Moore as an "expert" on art who could verify his version of events, Whistler ridiculed his erstwhile friend's credentials in the press. Moore countered publicly and privately. He was reading a wonderful book by Huysmans, Moore informed the "elderly excentric," and so had no time for his "senile little squalls" in the papers. Whistler might have let the insulting language and sensitive subject of his age pass had not Moore also questioned his "code of honour." That "gross insult" was too much. Whistler challenged him to a duel. Moore dismissed the challenge as absurd. Besides, he added, sticking to his original game, Whistler was "too old and near-sighted" for such sport.[28]

The court rendered its judgment on March 13, 1895. Whistler was to refund the price of the painting plus five percent interest, restore and surrender the original portrait to Eden, and pay a thousand francs in damages and court costs. The artist barely blinked. He had lost on "*Technical* grounds" only and would appeal the verdict. He had also, Whistler boasted, bested George Moore, whom he denounced as a coward for refusing to duel. "[W]e have . . . brought him down, first shot for ever!" he exalted to friends. "He can never again show his face in France. No club

would allow him to enter its doors – and no gentleman here will ever be seen in his company."[29]

There is no telling what mischief might have followed had not Trixie joined him at the end of March. She returned to Paris "better though not yet strong." They retreated into a relatively quiet life, even declining an invitation to visit Isabella Gardner in Venice. Whistler exhibited lithographs at the Champs de Mars Salon that summer and paintings at shows in Antwerp and Venice, where *The Little White Girl* captured a prize of 2,500 lire.[30]

But prizes counted for little with Trixie so ill. Whistler remained unsettled, out of sorts, irritable. Learning that a pair of librarians in Albany, New York, had issued a "guide" to his work, he complained about being "shelved in the Library as an element of education." His hackles rose a bit higher when Lawrence Alma-Tadema mentioned him in a lecture at the South Kensington schools as an artist who sometimes struggled to achieve a harmony of color. Alma-Tadema had intended to warn students that even the greatest painters sometimes got it wrong. Whistler, however, decided that such "gratuitous impertinence – not to say insolence" required a letter to the *Pall Mall Gazette*.[31]

Adding to his petulance, he learned in May that a $15,000 commission from the Boston Public Library had been withdrawn. Nearly four years earlier, John Sargent and Edwin Abbey had arranged for him to design a decorative mural for the library. However, as had happened in the 1870s with his commission from the South Kensington Museum, Whistler procrastinated so long that his benefactors lost patience. He apologized for the delay but to no avail. Sargent and Isabella Gardner tried to salvage the situation by suggesting that some portion of the Peacock Room, in danger of being demolished by its new owners, be incorporated in the library. The thought of seeing his room "sampled round in scraps" horrified Whistler. He preferred that it be destroyed, which, he judged, "would be so perfectly English."[32]

Long before the museum issue was resolved, Whistler and the rest of the world were mesmerized by the fate of Oscar Wilde. The Irishman's woes began when he sued the Marquis of Queensbury, who had accused him of posing as a sodomite, for criminal libel. The trial began on April 3, 1895, in the Old Bailey, just as excitement over *Eden v. Whistler* and the Whistler–Moore duel drew to a close. Wilde lost the case, and his own testimony led to him being arraigned on charges of gross indecency and sodomy. A jury voted for conviction on May 25, Queen Victoria's birthday. Wilde received two years at hard labor.

When some newspapers mentioned his former ties to Wilde, Whistler complained bitterly of being "treated together" with the "large indecent poet." Nonetheless, he followed the course of the legal battle. "What of Oscar?" he asked Heinemann as the first trial began. "Did you go to court? What does he look like now?" He thought the harsh verdict unwarranted, but Whistler relished the discomfiture and hypocrisy of Wilde's friends, who, fearful of guilt by association, fled London for Paris. "Piccadilly in its desertion might have been a street in one of the cities of the Plains after Jehovah had wiped up the place!" he chortled to Lady Archie Campbell. Nor did he see Parisians expressing much sympathy. "Their sense of the ridiculous is too great for any thing but contempt for either his criminal practices, his surroundings or his punishment," Whistler mused.[33]

Of more interest to him was the fate of Wilde's personal property. In order to pay £600 in court costs, Wilde had to auction the books, china, furniture, and artwork from his Tite Street home, as Whistler had done sixteen years earlier. The collection of art included several Whistler drawings, one of which, a chalk sketch of Maud Franklin, Wilde had bought for five guineas at Whistler's bankruptcy sale. Whistler asked Thomson to retrieve it for Trixie, although why a wife should want a portrait of her husband's former lover seems curious at best. More likely, Whistler saw the purchase as a matter of justice, an opportunity to benefit from Wilde's predicament, as Wilde had done from his own. Thomson got the drawing for fifteen guineas, the unusually high price attributable to the fact that it was mistakenly identified as a sketch of Sarah Bernhardt. Joseph Pennell walked away with another Whistler drawing for only a shilling, snatched, he said, from "a lot of stuff" that had been dumped in a fireplace. As for the drawing of Maud, far from presenting it to Beatrice, Whistler tried to sell it for thirty guineas.[34]

However, of all the distractions that summer, none was more worrisome than Trixie's health. She seemed to be improving by July, and rallied wonderfully for the biggest family event of the year, the wedding of Ethel to Whistler's journalist friend Charles Whibley. A photograph of the wedding party showed a smiling Beatrice enjoying her sister's big day (fig. 93). Whistler worried at first that Trixie would miss the companionship of Ethel – called Bunnie by the family – but twenty-one-year-old Rosalind, the youngest of the Philip siblings, promptly filled the void. That settled, Whistler determined to take his wife on another holiday. Italy, he thought, would be ideal, followed by a return to London and more consultations with the doctors.[35]

They got only as far as Normandy, and stayed only a month. The "waters and baths" of Bagnoles-de-l'Orne were well enough, and Whistler subsequently recom-

mended them to Willie for his rheumatism, but the town was "quite too dull." In September, they crossed the Channel to Lyme Regis, on the Dorset coast. Whistler thought the "change of air" and pleasant autumn weather would benefit Trixie. He was embarrassed to find himself again in England, but Lyme Regis was a picturesque spot that might yield "some lovely little pictures."[36]

On Willie's advice, Trixie left for London after only three weeks, to be joined by Rosalind at Garlants Hotel, in Suffolk Street. Trixie had insisted, though, that Jimmy continue his work in Dorset, and work he did, or, as he put it, "Work I must, . . . wherever I find myself stranded." He produced eighteen lithographs and eight oil paintings in a little over two months, although he also found time to inquire almost daily about Trixie's health. "Don't be 'morbid' dear Love!" he encouraged, making use of a favorite word among the artistic Decadents. "Cheer up my own Chinkie luck. You *are* stronger, & this dismal weather depresses us all!" When her maid Louise began to sulk, he urged Trixie to call in Ethel. Despite her grace, beauty, and cuddly nickname, Bunnie knew how to handle servants. Edward Kennedy called her Queen Boadicea. Her new husband, by contrast, was known as "Wobbles."[37]

Other worries weighed on Whistler as well, most notably the financial difficulties of his brother and son. He directed Thomson to purchase one of his older pictures from Willie. In Charlie's case, he sent £30 directly, the money being needed to secure a patent for an invention. "All this is difficult for me," he reminded his son. "You have had what seems to you a very hard time – but your trials are really nothing – they only concern *yourself*." The lesson imparted, he tried to end on a sympathetic note. "I don't complain of your conduct," he assured Charlie. "Frankly I believe you behave well – and are persevering in your work – & I doubt not it will all come out right." Still, the exasperated father closed with his usual reminder: "I cannot be *always* prepared to help you!"[38]

He then learned that his first "students," Henry and Walter Greaves, had completed a commission to decorate the interior walls of the Streatham Town Hall, located five miles south of Chelsea. Whistler had no immediate reason to doubt the quality of their murals, but he wanted reports. "It is a dangerous thing to be a pupil of Whistler," he explained to Thomson, "and before now I have found that the 'influence' of that curious master was of the most ephemeral kind!" The murals, as it happened, were a hodgepodge of every image Whistler had ever used, including Battersea Bridge, Henry Irving as Philip of Spain, Carlyle, Japanese ladies, girls holding *lange Lijzens*, peacocks, the firewheel at Cremorne, a rendering of *Chelsea in Ice*, even patterns from Whistler's picture frames.

Trixie was horrified. "You have no idea how dreadful it all is!! terrible!" she reported dutifully. The Greaves had created "a sort of hideous Whistlerian chaos," a "screaming farce." Admittedly, she had never warmed to the boys, but "My, God," she reflected, "I could kill them – conceited ignorant – miserable gutter born wretches." Striving mightily to compose herself, she urged Whistler to say nothing publicly about the murals. Heeding her advice, he went so far as to write a "charming" letter to the brothers to thank them for the tribute. Explaining his reaction, he told Trixie, "[T]hey were very intelligent & nice boys – and . . . I feel kindly about them after all."[39]

Then again, Whistler was immersed in his own work. Most of the paintings done at Lyme Regis were small (five by eight and six by nine inches) wood panels, but he also put two portraits on canvas (twenty by twelve inches). *The Master Smith of Lyme Regis* echoed Whistler's earliest days as an artist, when he liked to draw the rugged features of blacksmiths, longshoremen, and other laborers. His subject this time was forty-year-old Samuel Govier. With strong arms folded across his chest, Govier looked directly and fixedly at the viewer, his whole countenance bespeaking impatience with the foolishness of posing. In stark contrast, though no less masterful, was Whistler's portrait of eight-year-old Rosie Randall, daughter of the town's mayor. *The Little Rose of Lyme Regis* faced the viewer as boldly as Govier, but where the blacksmith expressed impatience and world weariness, the lovely little Rose, while betraying a hint of a pout, personified the vulnerability of childhood (fig. 94).[40]

The "grinder," as he began to call himself, thanked his Chink for making him stay. "[I]f I had gone without carrying these works on," he told her in early November, "I should have remained in the bitter fog – of indecision and want of pluck." His "exile" also inspired Whistler's deepest period of self-analysis since the 1860s. "I have gone into my shell again and pondered upon the great problem of the work to myself – and by myself," he told Beatrice. He concluded that, despite constant second guessing and ceaseless doubts, he had been correct about his "gospel" of painting. His "great Jury Lady" would also recognize in this new work the "innermost of the agonies" they had shared, the "Scars! – deep scars" both wore. Thanks to his "dear Luck," his art had a new maturity, was "less boyish," he fancied, and "perhaps also less irresponsible!" Had he at last fulfilled "what Burne Jones called long ago 'much promise'?"[41]

He wrote to her like a man possessed, page after page, day after day, sometimes twice a day, to explain his epiphany. Unlike the 1860s, when he had written to Fantin of technique and composition, Whistler's new inspiration bordered on the spiritual.

He spoke reverently of "the Lamp," of "something stupendous," as powerful as Chinkie's Obies. And it was real, very real, not a "hysterical illusion" born of loneliness or isolation. "No – the Lamp is . . . the real light of *untiring love*," he assured her, "and purity, which finally means knowledge!" He was dismayed that it had taken him so long to understand this, though perhaps those lost years were to be embraced as his purgatory. "[T]he jealous Goddess holds it back and guards it, and only trusts it to the care of the one who, I believe, has suffered," he explained of the Lamp, "and proved by his years of suffering that he is worthy . . . and is not content with premature success, and the peoples praise!"[42]

This new power might also allow him to finish earlier, imperfect work. The portraits of Duret, Sarasate, and who knew how many others might yet be "saved" and "made really to live!" He recalled stories of how Velázquez had done just that, "*put those touches* in" to redeem an old failure. "[Y]ou know how you used to grieve when you would see me sitting dazed before the unhappy little picture begging hard to become a masterpiece," he reminded her. "Well Chinks all those badly treated pretty things remain on his mind – and make him sit up in the dark knight – for the Goddess forgives nothing."[43]

By Christmas, he was ready to leave Lyme Regis, if for no other reason than because newspaper reports that he was grievously ill had alarmed family and friends. The weather had turned miserable, too, damp and cold, and he was lonely. Visitors had tried to cheer him. David Thomson and Ernest Brown arrived on separate occasions to discuss possible exhibitions. Peter Studd joined him to work side by side for a few weeks.[44]

He also left because one of the most important exhibitions of his career had already opened in London. With everyone "much agog about lithography," and Alma-Tadema, Leighton, and "other great and chosen ones of Burlington House" planning their own print shows, Huish and Brown had convinced him to exhibit his revolutionary lithographic work at the Fine Art Society. That had been the reason for Brown's visit to Lyme Regis. "It does seem a pity to me that you having been the originator of the revival here should not have the credit," Huish flattered the artist. Thomson had also lobbied for the exhibition, but Huish promised "any [business] arrangement" to get his first Whistler show since 1883.[45]

"Mr. Whistler's Lithographs," with seventy of his best, opened on December 7 for six weeks. Huish knew from experience to adhere faithfully to his instructions regarding invitations, advertisements, installation, prices, discounts, and the rest. Time did not permit more than a pedestrian catalogue, but Joseph Pennell wrote a glowing

preface. Way senior agreed to write an article about the exhibition for Thomson's *Art Journal.* Nonetheless, while still in Dorset, Whistler had worried about every detail of the approaching show. "I *knew* it would be so," he admitted to Huish. "[H]ere I am up to the neck in the whole business. I can't help it." He wrote to Huish almost daily in the fortnight before the private view, and returned to London for two days to approve the hanging of the works selected for exhibition.[46]

By nearly every measure, the show was a success. After printing costs, advances, and discounts, Whistler received only £105, but some most unlikely people, including du Maurier, Eden, and Haden, had attended. The brother-in-law spent "a long time" in the gallery. "They are generally considered the very best things you have done," Brown reported. "There is *no* doubt of your popularity now. I shouldn't be surprised if you [rivaled] 'Trilby' in that very soon." Of course, Brown conceded, a few philistines remained, people who whispered, "[T]hey are very good as far as they go," or, "It's a pity he didn't put more work into them." Wiser heads knew better. R. A. M. Stevenson described the lithographs as works of "genius," and the Fine Art Society received orders long after the exhibition closed.[47]

A spate of articles published during and soon after the exhibition made Whistler's name synonymous with lithography. An amused Thomson, who might well have grumbled over his lost bid for the event, chuckled, "Mr. Whistler's greatest fault is that he lives, artistically, about thirty years before other people." The artist had also consoled Thomson by promising to exhibit his new paintings at the Goupil. When the dealer saw what prizes he had acquired, the power of the Lamp bewitched him. "I cannot too warmly speak of their gorgeous colour, their exquisite style and harmony," he gushed. The forthcoming show, he predicted, would "make an epoch in Art." Now, if only Clever Dick could cure his Chinkie.[48]

# 19

# *I Journey by Myself*

## 1896–1897

The sales and publicity from the lithographic show meant little to Whistler compared to Trixie's health. He spoke of going to New York in search of "a great Medicine Man" until stumbling across one in London. He was a Scot, Whistler emphasized to friends, not an Englishman. In February 1896, the couple abandoned rooms at De Vere's Hotel for a comfortable suite on the top floor of the Savoy Hotel. At the same time, Whistler installed Rosalind and her seventy-year-old mother, Frances Philip, at 36 Tite Street, called Dhu House.[1]

Trixie insisted that her husband also take a studio. He had been using Sargent's spare quarters at 76 Fulham Road, but in late March, he found his own place at 6 London Mews. The "huge" second-floor space, as bright as his Paris studio, stood behind 8 Fitzroy Street, which he always gave as the address, near Fitzroy Square. Whistler still thought of that part of town as London's "classical neighbourhood of Art," and if "classical" meant down at the heels, besides swarming with foreign anarchists and political exiles, it was an apt description. Albert Ludovici, with a studio nearby, introduced Whistler to his new neighbors, showed him the best places to eat, and told him about a shop that sold French newspapers and had a reliable barber. The studio cost £50 per year, a heavy expense in addition to doctors and hotels, but the timely sale of his twenty-year-old *Fire Wheel*, a match for *The Falling Rocket*, to Peter Studd for a thousand guineas relieved much of the financial pressure.[2]

Despite the new studio, Whistler made some of his finest lithographs while tending Trixie in their nest atop the Savoy. Two of the eight were poignant images of his Wam. In *The Siesta*, she looked at him "pathetically" while convalescing on a chaise, the once-matronly body severely wasted. In *By the Balcony*, she sat, well bundled against the chilly March air, gazing over the Thames at the city beyond (fig. 95). The remaining drawings, all made on the balcony, offered six different views of the river, its bridges, and the Embankment. One drawing looked east to St. Paul's Cathedral. Another one, from the opposite direction, showed the Houses of Parliament, just visible on the horizon. A lithotint of the factories and warehouses on the south bank, drawn directly on stone, was as evocative as any painted nocturne.[3]

Besides his work at the Savoy, Whistler made twenty-two other lithographs between January and late April. Three of them were buildings that caught his eye: a barber shop near the Fine Art Society, the Gaiety Theatre (opposite Tom Way's office in Wellington Street), and a butcher's shop in Cleveland Street, near his new studio. While still at the De Vere, he drew a view of Kensington Gardens from his hotel window. He also did sixteen portraits, including the Pennells, old Tom Way, Henley, Rosalind, and her mother. Finally, he drew a pair of Soho churches, St. Giles-in-the-Fields and St. Anne's. Excepting the lithographs done at the Savoy, those two were much the best of his work. That he should have been visiting churches at this juncture is not without interest. Both of them also rested in secluded streets, cut off from the noise and bustle of the city, respites for a weary artist and worried husband (fig. 96).[4]

By contrast, Whistler's painting, which required the largest investment of time and confined him to his studio, received little attention. He cancelled the scheduled March exhibition at Thomson's gallery, unable to prepare for it adequately. He found it impossible to arrange portrait sittings for financier Cecil Rhodes, then at the height of his power and influence. He fared only slightly better with the Scottish novelist and poet Samuel R. Crockett. Whistler managed a few sittings for him but never completed the portrait. He agreed to draw a cover design for a book by Charles Whibley but only because Wobbles was his brother-in-law and William Heinemann was to publish it.

True to form, Whistler released much of the tension on innocent bystanders, his principal target being Edward Kennedy (fig. 97). Whistler had taken to calling him "O.K.," a playful enhancement of the dealer's Celtic heritage as an "O'Kennedy," but the nickname also showed approval. He had become a valuable and entirely reliable agent for Whistler in America, and he shared most of Whistler's artistic

opinions. "I'm a bit combative myself," he told the artist, "& if there are Philistines left, I like to hammer them."

However, Kennedy's outspokenness had become a problem. "Now Mr. Whistler, you listen to me," he would say before launching into some criticism of the artist's work or marketing schemes. When Whistler raised the price of his lithographs, Kennedy protested that it would hurt sales. He had also heard customers "growl" about Whistler's use of transfer paper. Personally, he agreed with the artist that the "effect" was more important than the means of obtaining it, but he felt obliged to speak plainly. "I presume I am making myself unpopular over there," he speculated from New York, "but I think you ought to know how people feel about these things." Beatrice had long since grown weary of Kennedy, not only because of his presumptuous manner with Jimmy, but also because she knew he referred to Bunnie as Queen Boadicea and to herself, in overly formal tones, as "madame."[5]

Most recently, Whistler had sent a portrait of one of his favorite Paris models, Carmen Rossi, to Kennedy in hopes of a quick sale. Kennedy considered it a good painting but agreed with his most likely buyer, Albert Pope, who called it "a disagreeable subject." Kennedy confessed, "I'd hate to meet her on a dark night. . . . She is the most cut-throat looking person I've seen for many a day." Whistler did not tell him that he had first drawn Carmen when she was a "half-starved, half-civilized" street urchin of eight, and that even as she grew into a sensuous young woman, he still referred to her as "my child." However, he did snap back by saying that her portrait had been praised in Paris as "a rare piece of work!" well worth the 300 guineas he asked for it. Pope eventually bought it for £270.[6]

Luckily, both Whistler and Kennedy apologized as quickly as they offended. "Never mind my dear OK!" Whistler would say. "You are a dear good OK – and we like you – and will forgive you many things. And you have been very nice to me just now in my anxieties – and so prompt and charming!" It is hard to say if by "we" Whistler was writing in the third person or suggesting some rapprochement between O.K. and Trixie, but Kennedy was certainly aware of "madame's" condition and tried to make amends for his sometimes thoughtless comments. He sent Trixie a pain-relieving solution of pepsin difficult to obtain in Britain, and to Whistler, a bottle of the new "elixir of America," Martini cocktails. So, that was all right.[7]

The same could not be said of the ailing Trixie. The Scots doctor now attended her twice daily. "[W]e are doing better!" Whistler wrote hopefully to Kennedy in late March. This time, the "we" did mean him and his wife, and people noticed how

frequently he used that plural pronoun when speaking of Trixie's condition, as though he shared her physical suffering. "You know there is but one thought for me – one hope!" he exclaimed to Kennedy on another occasion, "and we are ill – so ill!" Kennedy thought to himself, "Poor soul."[8]

After more than a month at the "madly expensive" Savoy, Whistler rented a rambling, two-story house called St. Jude's Cottage on Hampstead Heath. He found a "fund of drollery" in the location, which he compared with living in an English landscape painting. "Well, well," he told Kennedy. "Look at the trouble I took to get rid of this infernal country! and here I am again – up to my knees in [the] place!" However, the benefit to Trixie was clear. The center of London, standing only four miles to the south, was barely visible through the clouds of coal smoke that hovered above it. At Hampstead, famous as a spa since the seventeenth century, she could breathe easier (fig. 98).[9]

It did no good. Whistler watched helplessly as she slipped away. "I shall never forget the misery and pathos of his sitting beside his wife's sofa, holding her hand, while she bravely tried to cheer him with banter and gossip," a friend said of those last days. Finally, though, the pain made it impossible to pretend. "Oh! Chink. I do suffer," she had confessed to him a few months earlier, employing a mutual term of endearment. "I never thought I should be like this. But – you know – I was too happy, so I am given some aches to remind me, that this world is not quite Paradise." With a poignancy that had pulled at him then and haunted him now, she added, "Sweet, I think I've loved you always even from the Peacock room days!"[10]

Trixie succumbed to the cancer on May 10. The shaky scrawls Whistler sent to tell friends of the end were barely legible. "[T]he sun has gone out of my sky forever," he told them. Nor was this merely a spasm of grief. His anguish ran deep, and it was abiding, tinged to some degree by bitterness. He blamed the "ignorance and *cant*" of the doctors for failing to catch the cancer in time to treat it. Debo and Willie felt his loss. To Debo, he grieved, "I am a poor sad fellow Sis. What is to become of me!" Nearly a year later, approaching the anniversary of his wife's death, he would ask her the same question. Condolences arrived from all quarters, but, as a friend confirmed, "He was a changed man when she was no more."[11]

He buried Trixie in the quiet riverside cemetery of St. Nicholas parish church, in Chiswick, some five miles upriver from Chelsea. He intended to join her in time. They had chosen the spot together, largely because of the river, but also because William Hogarth was buried in the same cemetery and had once lived nearby. Later that year, Whistler erected a trellis so that flowers might brighten the spot. More

substantially, he left a legacy to her elegance, taste, and artistry by bequeathing Trixie's collection of "rare and beautiful" garnets to the Louvre. His only conditions were that they be displayed as the Beatrix Whistler Collection and be accompanied by proofs of her "exquisite etchings."[12]

He coped with her passing as he had done with her illness, by immersing himself in work. Excusing himself from large social gatherings for several months after the funeral, he relied for companionship on sister-in-law Rosalind, whom he made his legal ward. The work also became another way to memorialize Trixie, as he returned, guided by the Lamp, to unfinished pictures he knew had "particularly interested" her. "It would grieve her that they should not be finished," he confided to Elisabeth Lewis, "and I suppose that I am now to carry out what she knew was begun."[13]

He turned first to the portrait of twenty-four-year-old Marion Peck, daughter of a Chicago businessman. Begun a year earlier, the painting had acquired special meaning for Whistler. He explained to the Pecks, then conveniently back in England, "[T]his particular picture was always one in which my wife took great pleasure, and it would have greatly grieved her if I were to lose the occasion of your visit for making it as perfect as she knew it must become with very little more work." He may have tried too hard. The painting remained unfinished when the Pecks returned to America. Perfection eluded him as well in his portrait of Louise Kinsella. Sargent thought the picture quite marvelous, a judgment that momentarily inspired Whistler to think of it as the "most important" one he had ever attempted. Nonetheless, it, too, remained uncompleted.[14]

Other paintings acquired similar importance, if not urgency. Charles Freer had already paid 1,300 guineas for one of them, a nude study begun some three years earlier, and three drawings, but Whistler insisted that the painting needed more work. Freer, who had come to understand Whistler's mania for perfection, told him not to hurry, and to deliver it only when each "deeply loving" stroke had met Trixie's expectations. The artist rubbed it down and reworked it countless times, but he either failed to achieve what he sought or simply could not bear to part with this "Blue and Gold Girl."[15]

Completely flummoxed, he leaned that summer on Edward Kennedy, who had recently bought a portrait of Ethel and the two Lyme Regis paintings, *Master Smith* and *Little Rose*, for £1,500. Kennedy also promised to buy two other pictures of Ethel when Whistler completed them. With that, artist and dealer escaped London for the Normandy coast. The week-long excursion improved Whistler's health, but he painted only two small panels. He was annoyed, as well, by a "flock of Britons" who

tried "boisterously" to draw him into their circle. Whistler made it known by his cold formality that he had not come to France to play at "croquet and skittles."

Worse, though, was the flood of memories that overwhelmed him on the trip. The "smallest & most trivial" incidents reminded him of her "dear companionship." When a stewardess on the Channel boat from Southampton to Le Havre recognized him and asked after Trixie, Whistler became miserable, and remained so the entire week. Stopping to paint at one church, he thought of lighting a candle for her. "I wish I were a Catholic," he wrote to Ethel. He mentioned the same inclination to Kennedy, and seemingly to others, for the word soon spread through London that Whistler was "turning toward Rome." Alone with his sketchbook, he scribbled to himself, "And so I still put out my hand to take the other – that I may never again hold, and again I know that I journey by myself."[16]

The return to London brought no joy, so, after two listless months, he joined Rosalind and her mother, who had gone to check on the condition of 110 rue du Bac. Expecting to be crushed by a sense of "forlorn destruction," he found, instead, relief. Being in her house, among her things, proved more peaceful in some ways than sitting beside Trixie's grave. He was cheered, too, by an exotic songbird, the last of a pair that Charles Freer had sent her from India. "[W]hen she went – alone, because I was unfit to go too," he told Freer, "the strange wild dainty creature stood uplifted on the topmost perch and sang and sang – as it had never sung before! . . . And suddenly it was made known to me that in the mysterious magpie waif from beyond the temples of India, the spirit of my beautiful Lady had lingered on its way – and the song was *her* song of love – and courage – and . . . so was her farewell!"[17]

But the healing took time. Back in London, he stayed at Heinemann's flat, 4 Whitehall Court, while spending most days at his studio. Two self-portraits received some attention. One of them, *Brown and Gold*, he had started a year earlier, but a new portrait, *Gold and Brown*, was more intriguing. Unlike its full-length precursor, which showed a clearly aging Whistler, the new picture, a half-length, was of a distinctly younger man. Perhaps the news that another of his generation, George du Maurier, had died, inspired the Dorian Gray portrayal. Perhaps he only wanted a younger companion in the studio.[18]

In fact, his studio fairly brimmed with youth, and probably not by chance. Whistler drew and painted portraits of young girls that winter. Unlike such painters as Sargent, Cassett, Renoir, and Millais, he had never been known for portraits of children, although Joseph Pennell insisted that Whistler had a knack for capturing

the "tender beauty, the dainty grace of childhood." That certainly was true in his lithographic portrait of David Thomson's four-year-old daughter Evelyne, and Ernest Brown's daughter, Nellie, sat for him several times between October and December 1896. He also chanced upon a more humble model, red-headed Lillie Pamington, on one of the impoverished side streets around Fitzroy Square. Though only in her early teens, Lillie's melancholy face fascinated him.[19]

Despite his own melancholy, he also cared for family and friends in need. Most urgently, Willie, in poor health that winter, required money. Luckily, Whistler was relatively flush at the moment, a result of Kennedy having sold the portrait of Sarasate for £900 to the Carnegie Institute in Pittsburgh. In addition, John Cowan, by now a reliable customer, bought a watercolor portrait of Ethel for 100 guineas. But when Whistler tried to give his brother £30, Willie refused the "generous and open handed" offer. "Many is the time that I have known him to give to a friend or even acquaintance in trouble what he had not got strictly as balance in the bank," Willie told Debo, "trusting to his work and luck to supply the deficiency and his own needs." Jim still found a way to help by convincing Thomson to buy *The Artist in his Studio* from Willie for £400.[20]

He took financial responsibility for his in-laws and stepson, too. With Rosalind and her mother secure in Paris, two other Philip sisters moved into Dhu House, where Whistler often dined. Mindful that Rosalind was now his ward, he sent her money to buy a new hat and urged her to buy a good winter dress. Teddie, now twenty years old, and blessed with the artistic gene Charlie lacked, had been placed under the tutelage of sculptor Albert Gilbert. The forty-two-year-old Gilbert, who had studied with Joseph Boehm and been much influenced by Whistler's brand of aestheticism, saw promise in Teddie. "I am very fond of him," he reported to Whistler, "he is a boy with a personality, and excellently good withal." Pleased by the reports, Whistler revised his will to give Teddie one-fifth of the interest from his estate until age twenty-three. He made Rosalind his executrix and sole heir. There was no mention of Charlie.[21]

When English watercolorist Charles E. Holloway fell ill in early 1897, Whistler ordered a doctor to attend him and helped pay for food and medicine. Holloway had achieved only modest financial success, but Whistler liked his work and was fond of the man, four years his junior. He had, in fact, been painting a small (nine by five inches) portrait of the gentle-looking, full-bearded artist. He acted with others to put Holloway in hospital near the end and attended the funeral with Pennell and Ludovici, even though he complained unconvincingly about the necessity of taking

a brougham all the way to Finchley. When the Goupil Gallery staged a memorial exhibition of Holloway's work, Whistler contributed his portrait of the man he called *The Philosopher.*[22]

Judging by this streak of benevolence, one might suppose Trixie's death had sapped Whistler of his zest for life, but even as he engaged in good works, a series of controversies and contretemps engulfed the artist. It never occurred to him to resist, that at his age brawling might be unseemly. Edward Kennedy dared not, given their recent pact, express his own belief that the once-dashing champion was in danger of becoming a "tiresome & boresome" curmudgeon. Yet, given the important roles that controversy and strife had played in his life, it may all have been for the best. It can be dangerous for an alcoholic to go cold turkey, and Whistler relished his wars as a drunkard required his bottle. Indeed, he now embraced conflict as another means of coping with Trixie's death. He imagined that she would have enjoyed some of the tempests, or rather, that she did enjoy them, for she was always with him.[23]

The first encounter, coming only a month after her passing, was little more than an outburst, with Frederick Keppel the target. Whistler had never warmed to the American dealer, so when he learned that Keppel had presented the Pennells and Ernest Brown with copies of the "libelous" Albany "guide" to his life and work, the artist upbraided him in an angry letter. Keppel was stunned. Having arrived in England shortly after Trixie's death, he had immediately sent Whistler a tender letter of condolence. In like manner, he had distributed the pamphlet to Whistler's friends because he thought it would please him. Kennedy told Whistler he was overreacting, not only in his response to Keppel, but also in the importance he attached to the pamphlet. "No," Whistler replied, "this stuff is official and I must protest."[24]

A month later, in early July, Whistler fell out with old Tom Way (fig. 99). Their break started with a disagreement over the frontispiece for a catalogue of Whistler lithographs the printer had been compiling. That, in turn, led to a disagreement over a monstrously high printing bill. It culminated with Whistler trying to retrieve some paintings that Way had acquired during his bankruptcy. It was another year before lawyers negotiated a settlement for both paintings and printing costs, and that only after Whistler had written a final, intemperate letter to Way. "[A]nd this to a man," recalled the son sadly, "to whom he had over and over again addressed letters in the most affectionate terms, and spoken of as one of his oldest and staunchest friends." True enough, and given the circumstances, a rupture as tragic as the one with Swinburne. Then again, Way, even as a "willing slave" to Whistler, could also be a "cross-grained old man, with an uncertain temper."[25]

Whistler's feistiness was fueled at least in part by a sudden rush of nostalgia for his days at West Point. The year 1895 had been the fortieth anniversary of what would have been his graduation from the academy. He had received letters over the years from former classmates who reminisced about "ancient times" on the Hudson, but the missives now came more frequently, as did an official request for a sample of his art. It would be displayed beside some of his cadet work in the school's new Drawing Academy, he was told, as a handsome reminder of the early signs of "genius" that had made Whistler "famous on two continents." He obliged by sending a photographic portfolio from his 1892 Goupil exhibition. More to the point, he began to speak and write of his artistic clashes not just as wars, as he had done for years past, but also in terms of the lessons to be learned from the martial past. He had already begun to address Rosalind as the "Major." He was "General" Whistler.[26]

Yet, it was a minor skirmish that most likely would have won Trixie's approval. Whistler had not seen Seymour Haden for several years, certainly not since the Hadens had moved from Mayfair to Hampshire. He had no more use for the brother-in-law than he did for Ruskin, Leyland, or any number of enemies, but Haden's attitude toward him was more complex. "The longer I live, the more I admire Whistler as an artist," he had told Frederick Wedmore. He could recall, too, how "*lovable*" Whistler had been in his youth. "Something turned him," he ruminated to Wedmore, "something warped him – I don't know what."

Wedmore thought the brothers-in-law simply had incompatible temperaments, the "heat" of Haden's nature clashing with Whistler's "cussedness." And so it seemed when, quite unexpectedly, they attended the same banquet that autumn. As Whistler, with his usual loud laughter and boisterous talk, made himself the center of attention, Haden abruptly left the hall. Soon after, he sold two of Whistler's early masterpieces, *At the Piano* and *The Thames in Ice*. Debo surely objected to the sales, but Whistler's "quiet and subdued" sister was no match for her "tyrant" husband. Whistler might have flown into a rage at the news, had he not learned that both paintings had gone, through a dealer, to John Cowan.[27]

He did, however, allow William Eden, with the resumption of their legal tilt near at hand, twice to get his goat, if only indirectly. First came news that the jury of the New English Art Club had accepted a watercolor by Eden for its upcoming exhibition. Having always thought of the artists of the club as kindred spirits, Whistler expressed his displeasure in an exchange of published letters with William Rothenstein, the member of the jury Whistler most blamed for the outrage. In the end,

and to their credit, both men drew back and acknowledged they had overreacted. Though less trusting than in the past, they remained friends.[28]

A falling out with Walter Sickert was more meaningful. It was not their first disagreement, but always, in the past, the younger man, like Rothenstein, had thought better of challenging the master. Whistler, for his part, had come to accept Sickert's displays of independence because he liked his work. He was also fond of Ellen Sickert, and Trixie had liked Walter. Now, though, with Trixie gone, and the adulterous Walter behaving badly toward Ellen, Whistler was less charitable.

The last residue of charity vanished when Whistler spotted Sickert "parading" down Bond Street with William Eden and George Moore. It was an innocent enough excursion for Sickert. Having encountered his two companions at a luncheon earlier that day, he had set off with them to visit a gallery or two. Whistler saw only a supposed friend cavorting with known enemies. Nor did it help that Sickert had declined to support Whistler publicly in the Eden trial. The next day, well aware that Whistler had seen him, Sickert left his calling card and an explanation at the London Mews studio. Whistler returned the card, having scribbled on it, "Judas Iscariot." A few weeks later, Sickert tried once more to apologize, but by then, Whistler had also learned that Walter had been a member of the infamous New English Art Club jury. Sickert received the dreaded note of "Adieu," though not without Whistler acknowledging, "[D]oubtless I shall miss you."[29]

He may also have said something of the kind to his French valet, T. C. Constant, to whom he bid adieu a few weeks later. Whistler had been lucky with some of his servants, not so lucky with others. Constant, after serving him well for nearly a decade, had become "hopelessly entangled . . . in a disgraceful intrigue." A maid servant in Ethel's household with whom he had been romantically involved was caught stealing articles of clothing from Ethel's wardrobe. Constant had nothing to do with the thefts, but then came word that Rosalind was having trouble with Louise, the housekeeper at 110 rue du Bac, and that Louise had also been intimate with Constant. His ties to both girls sealed the valet's fate. Whistler released him for his "assish intimacy." Further complicating matters, the episode with Louise had turned Rosalind and her mother decidedly against all "Frenchies." They wanted to return to England. He promised to find them a "pretty little place" in Mayfair or near the Thames.[30]

Were that not irksome enough, he faced another domestic problem in London. Mrs. Willis, his landlady and housekeeper in London Mews, had a weakness for gin, and it had affected her work. Whistler arrived at his studio several days running in

"bitterly cold" weather to find it unheated and buried in "British squallour and filth." He learned the reason for this neglect from the landlady's eight-year-old daughter, Lizzie, who had become another of his child models. Her mother's problem this time was not gin but a New Year's present of whiskey. More shockingly, Lizzie announced that she had enjoyed her own ration of holiday cheer. "Did you indeed," Whistler mused, "and how much?" A full glass, the girl replied, and "t'was good!" Her parents also gave her gin and rum, she went on, although she liked whiskey best. "But," marveled Whistler, "doesn't it make you tipsy!" Lizzie giggled, "Oh . . . I was drunk once!!"[31]

While not inclined to intervene in the life of the Willis family, Whistler had to remedy the condition of his studio, where he spent much time and ate some meals. He hired a maid named Marie, wife of the sommelier at the Café Royal, and she turned out to be a "perfect little treasure." Either because he could not afford or could not find a new valet, he also asked Marie to perform some of Constant's old duties, which she did cheerfully. "[S]he is far better than *any* man possibly *could* be," he rejoiced to Rosalind. "And the cooking goes on again all right – to say nothing of a continued cleaning!!"[32]

And so, as suffocating as the months since Trixie's death had been for him, Whistler finally emerged from his stupor. Buoyed as well by a pair of laudatory articles by David Thomson and Elizabeth Pennell, he resolved to exhibit again at international exhibitions, something he had not done in three years. He was invigorated as well by reading Henry James's new novel, *The Spoils of Poynton*, which James had sent in return for an etching given him by Whistler. The story revolved around the efforts of a genuine lover of beauty to keep her *objets d'art* (the "spoils") from falling into the hands of an unappreciative philistine.[33]

By the end of February 1897, Whistler even felt confident enough to reestablish a professional presence in London. Paris would remain his principal residence, but he fancied that his time away had caused the British heart to grow fonder of him, and for all his grumbling about its weather and wretched inhabitants, he still thought of London as the Great Metropolis. The sprawling city, with its crowded streets, teeming docks, and bustling railroad terminals, had a population of nearly six million souls drawn from every settled continent. "[T]he reproach that you can see nothing in London, that you can learn nothing in London, is but an artless tradition, now completely out of date," he would tell Elizabeth Pennell. "I have no doubt for a minute that Paris as the great art centre is waning . . ., and though there still are enormous attractions in Paris, those of London are bound to surpass them in the future."[34]

Besides, he had a new business scheme in mind. Weary of seeing dealers profit even marginally from his work, Whistler decided to open his own gallery. Charles Ricketts and Charles Shannon had opened a shop a year earlier off Regent Street for their publishing venture, the Vale Press, and used it to sell their prints and those of friends. Whistler had enquired about displaying his work there, but a nervous Ricketts, never as close as Shannon to Whistler, and doubting the wisdom of doing business with the unpredictable artist, put him off.

In April, Whistler created his own Company of the Butterfly. He rented a vacant shop at 2 Hinde Street, off Manchester Square, and hired Christine Anderson, who lived next to his studio, to manage the place and keep the books. Whistler assured Edward Kennedy that his new "syndicate" would not interfere with their business relationship in New York, but a bemused Kennedy seemed unconcerned. He predicted, not unkindly, that the Company of the Butterfly would fold within a month.[35]

That seemed a safe bet to anyone who knew Whistler, especially when he became distracted by another legal contest. The trouble started when Sickert criticized Joseph Pennell in the *Saturday Review* for publishing a set of transfer lithographs as "pure" lithographs. Not only was this misleading, Sickert declared, but Pennell was cheapening an exquisite art form. Having broken with Sickert just days earlier, Whistler sided with Pennell. Equally, he and Pennell shared a cause. The vast majority of Whistler's own lithographs were drawn on paper, and he was keen that they be recognized as the genuine article, not cheap commercial reproductions.

The case went to trial on April 5, with Sickert and Frank Harris, editor of the *Saturday Review*, named as co-defendants. Sickert had tried to settle the matter privately, but Harris, like Whistler, relished a public battle. Whistler, young Tom Way, Sidney Colvin, and Alfred Gilbert testified against the Sickert–Harris lineup of George Moore, William Rothenstein, and Charles Shannon. Thrilled to be on the "warpath" again, Whistler was at his dramatic best in the courtroom. His "keen and merry eyes . . . twinkled and sparkled beneath bushy eyebrows," the famous white forelock rose "gracefully on the rebellious head of hair."

Two days of testimony and thirty-five minutes of jury deliberation brought Pennell £50 in damages. Whistler, treating the verdict as a personal victory, dispatched a telegram to Rosalind: "Headquarters April 6 Enemy met and destroyed. Guns and Quartermaster Department ours. Sickert in ambulance." Signed, "General" Whistler. A few days later, he reported his triumph to Debo. "Naturally I have swept over the place like a Cyclone," he boasted, "leaving ruin and disaster behind me!"

He also wanted Debo to appreciate the trial's artistic importance. "Really, do you know, the whole thing would seem to amount to a sort of involuntary public recognition of the position of your brother!" When, later that year, the Fine Art Society exhibited the Pennell lithographs that had caused the furor, Whistler wrote a glowing endorsement for the catalogue.[36]

Remarkably, he had performed his star turn while quite ill. The doctors diagnosed influenza and ordered him to recuperate in a warm climate. He traveled to Paris in April to be nursed by Rosalind in rue du Bac. Though admittedly "a bad one for 'resting,'" he kept to his bed for at least two weeks and remained in the city for another fortnight.[37]

To pass the time, he sat for a portrait by Giovanni Boldini. Whistler had known the fifty-five-year-old expatriate Italian for only a few years, but he liked his painting style, reminiscent, he thought, of such masters as Hals, Velázquez, and Goya. Futhermore, Boldini's portrait of Robert de Montesquiou, done earlier that year, had been well received at the Champs du Mars Salon, and he had made a striking portrait of Lady Colin Campbell in 1894. Far bolder than Whistler's own chaste representation of Campbell, the Italian's picture captured her sexual allure and self-assurance. Boldini's talent aside, Whistler was also grateful to the Italian for intervening on his behalf with the organizers of an international exhibition in Venice. When he missed the deadline for submitting work, Boldini managed to have nine of Whistler's Venice etchings accepted for the show.

Nearly everyone but Whistler liked the portrait. He wore formal dress but sat quite informally, sideways in a chair, his head leaning on an upturned hand. It was an elegant pose, reminiscent of Boldini's portrait of Montesquiou. Whistler thought he looked "*raw*," too much as he did in one of his gruff moments. The Pennells liked it for that very reason, as did Kennedy, who had accompanied him to the sessions in Boldini's studio. Whistler may also have disapproved because Boldini made him look his age, approaching sixty-three years. His face was thin and drawn, and while that condition could be attributed to his illness, there was no disguising the almost totally gray mustache and abundant gray in his hair. Among his friends, only Freer shared Whistler's reservations. He called the picture "unpleasantly realistic," with "not enough [of] the finer side of his character." There appeared to be more agreement about a drypoint Boldini made of him as Whistler napped on the studio sofa. Kennedy thought it "absolutely like Whistler" (fig. 100).[38]

By the time Whistler arrived back in London, around June 6, preparations had begun for Queen Victoria's Diamond Jubilee. Seeing the city festooned with wreaths

and banners, he became obsessed with the tawdriness of the celebration. "[E]very where," he exclaimed, "ugliness stares me in the face!" That evening, at dinner with Kennedy, the Pennells, and two American ladies, he fell into his "old tirade" against the English. Only Kennedy, of the assembled company, lamented his astonishing lack of "discrimination & justice." Whistler, in turn, grumbled that Kennedy, to the shame of his Celtic roots, was "becoming more English every day . . . more & more like Haden," a comparison he knew would raise Kennedy's hackles.[39]

A week later, with the weather feeling more like November than June, and nothing but "rain, rain, rain!" the town looked even uglier. The banners and decorations had multiplied, and a gallery of bleachers lined the processional route Victoria would take from Buckingham Palace to St. Paul's Cathedral for a thanksgiving service. "All they think of is how each one shall find a plank to squat on!" Whistler marveled, "and literally, all public buildings – *churches* – clubs and the rest of it are up to their roofs in rows upon rows of scaffold benches! tacked over with the cheapest red calico!" Even Trafalgar Square, a stone's throw from the Suffolk Hotel, where he had taken rooms, was ensconced in boards. "[R]eally I am not exaggerating!" he told Rosalind, "*and* . . . common – so common & cheap – and at the same time stupendous in its smug belief that it is all right!" Whistler made several satirical sketches of the preparations, one of which was published in the *Daily Chronicle*.[40]

Nonetheless, he attended another naval review at Spithead on June 26, perhaps by invitation, as he had done in a more amicable spirit for the queen's Golden Jubilee. Kennedy and Ethel, who had come over for the festivities, accompanied him. He managed to paint a small watercolor of the pageant, which Kennedy later sold for £100, enough, Whistler rejoiced, to pay his expenses on the trip. He delighted equally in a royal proclamation that allowed the nation's pubs to remain open until 3 a.m. on June 23. "[T]he Queen knows her people!" he exalted, "and by that hour, I suppose, there wasn't one of her subjects who wasn't superbly drunk in the land! men, women & children – and doubtless little Lizzie among them – in the midst of the Willis family!"[41]

Whistler watched a portion of the review aboard the yacht of American millionaire George W. Vanderbilt, who, a month earlier, had asked him to paint his portrait. Nothing was said about price, but Whistler hoped for at least two thousand guineas. It was one reason he left Paris when he did, for Vanderbilt planned to return to America at the end of June. The sittings began before the Jubilee and would continue whenever Vanderbilt was in England. He happily paid the two thousand guineas, not only for his "beau" portrait, but also for the "delightful days" spent in Whistler's

company. The sum was twice what Whistler had made on any other painting, and Vanderbilt added to it by commissioning a portrait of his new wife Edith the following year.[42]

Even without Vanderbilt, sales went well that summer. Freer purchased a twenty-year-old nocturne for six hundred guineas, just his second Whistler oil. The profits from lithographs and etchings, including sales through a new Paris dealer, Siegfried Bing, amounted to £650 between May and September. He could have sold a painting to "Mrs. Jack" Gardner, who descended upon him in July, "full of plans and devoted proposals." Unfortunately, she wanted one of Whistler's favorite portraits of Ethel, "the Red Bunnie," as he called it, which was not for sale. The only somber note came as a warning from Kennedy that a change in American customs laws had made the duties on works of art entering the country very much higher.[43]

More important than financial gain were the results of Whistler's long-delayed rematch with Eden in the French courts. The trial opened on November 17, and Whistler's advocate performed brilliantly. The artist had to refund the £105 advanced by Eden and pay £40 in damages, but he could keep his painting. More importantly, the judge endorsed Whistler's long-standing position that a work of art belonged to the artist. "[I]t *is* a precedent," he rejoiced to Heinemann, "a *new law* has been made that separates forever the 'Artist' and the 'Cobler.'" He reported even more grandly to Debo, "And it was commanded that a record of these things be kept in the Chronicles of the Court, and it was graven upon the tablets of the 'Causes Celebres' – and the new law was added to the Code Napoleon – and the name thereof is famous for ever! 'Whistlère'!"

They would capitalize on the trial with a "little brown" pamphlet, he told Heinemann, to include his correspondence with Eden, the testimony and verdicts in both trials, and his usual bits of "devilry" in marginal comments. It should be published in both English and French editions, he instructed, but the work was especially needed in Britain, where the BP, despite a parody of the baronet in *Punch*, had not grasped "*at all*" the significance of the case.[44]

For the moment, though, he was distracted by Max Beerbohm, a twenty-five-year-old journalist, caricaturist, and younger half-brother of Whistler's actor friend Beerbohm Tree. Like Aubrey Beardlsey, Max Beerbohm found in Whistler a model of the "dandy" he wished to become, but he also worshiped Oscar Wilde, had contributed to *The Yellow Book*, and was friendly with Will Rothenstein, Sickert, George Moore, and Beardsley. If a dandy, he was a superficially flamboyant Beardsleyan dandy. He also had a reputation, like Beardsley, for making mercilessly satirical

observations about famous people. The *Daily Mail* employed him to cause controversy, and Frank Harris gave him carte blanche to write on any topic he chose for the *Saturday Review*.

When Beerbohm commented mawkishly on Whistler's life, work, and the hero worship he inspired, the artist took exception. He might have laughed at Beerbohm's suggestion that he had been spoiled by success and was past his prime as artist and provocateur had he not glimpsed in the younger man a pale shadow of the ill-informed type of critic he had always detested. Beerbohm's superficial judgment may have resulted from the nearsightedness of youth, but he had also demonstrated the caricaturist's weakness for observing surface qualities at the expense of his subject's character. "I doubt whether Mr. Whistler has ever suffered greatly in the pursuit of his art," Beerbohm brayed. "While other great painters have, for good or ill, been tearing their hair, he has been arranging his before a mirror." Whistler, speculated Beerbohm, had never confronted the "'fearful horned beast'" of life.[45]

Whistler's reply, which Harris published the following week, was a model of restraint. Rather than rage against this "simple youth, of German extraction," he aimed his response at Harris. "I congratulate you, Sir," he told the editor, "upon your latest acquisition in all his freshness, and I would say to him, as Marshal MacMahon said to the negro, 'Continuez!'" It was the sort of non-response, as Whistler well knew, that did not permit a riposte. Beerbohm tried to "score off Whistler" with a reply in the *Review*'s next issue, but it was a tepid thing, and that ended matters.[46]

# 20

# Presidentand Master, Redux

## 1898–1900

It was all great fun, the business schemes, the court cases, the public duels, but Whistler had not produced any really good art since Trixie died. Oh, he was full of ideas. "I am doing work that is far beyond anything I have done before," he told William Heinemann at the end of January 1898. "I sit in the studio and could almost laugh at the extraordinary progress I am making and the lovely things I am inventing!" But he had done nothing new, and he ignored long-standing commissions. Marion Peck had waited so long for her portrait that she had become engaged and married since the first sitting.[1]

The lure of exhibition politics revived him. Following the example of the Impressionists, Les XX, and rebellious movements in Germany and Austria, a group of British artists, thinking of themselves as "outsiders," had decided to mount their own exhibition of "international" art in London. The idea originated with Francis Howard, a twenty-four-year-old journalist, critic, and painter, but the Glasgow Boys, including John Lavery, Edward A. Walton, and James Guthrie, excitedly endorsed the plan. Whistler, still in Paris following the Eden trial, pledged support.

Within weeks, he was running the show. People who recalled his fractious leadership of the Royal Society of British Artists may have chuckled, but when his friend Albert Gilbert resigned as chairman of the organizing council in February, he was asked to replace him. Coyly demurring at first, Whistler finally accepted on condi-

tion that Lavery serve as vice chairman, to direct affairs in London until he returned to the city of black smog and chilly rain.

Controversy erupted almost at once, although, in truth, it had been brewing for a while. Gilbert resigned after finding himself at odds with several council members and when, as an associate of the Royal Academy, he became "frightened" that the International, as it had been christened, was being viewed as a "new and better Academy." Next, Charles Ricketts, Charles Shannon, and Will Rothenstein withdrew from the council. Shannon and Ricketts said they left over a procedural issue, but it may also have been a response to Whistler's elevation. Ricketts did not care for Whistler's "French" tendencies and anti-British rhetoric. Neither did he like to be snarled in public controversy, even though, like Whistler, he regarded as "enemies" those who did not share his opinions. In any case, he and Shannon spoke of staging their own spring exhibition at the moribund Grosvenor Gallery.[2]

Frederick Augustus Maxse, a retired British admiral turned political writer, offered his Prince's Skating Club, on Pont Street, just south of Hyde Park, to house the International Exhibition. The challenge would be to recruit enough exhibitors to fill the three sixty-by-sixty-foot galleries into which the enormous rink would be divided. Sickert was out, said Whistler. Neither did William Stott stand a chance. Someone suggested Legros, but that notion died quietly. Maxse recommended Mortimer Menpes, but the council, packed by now with Whistler's friends, including Joseph Pennell and George Sauter, found a diplomatic way to put off their benefactor.

Over 140 invitations went out to potential contributors, and members of the council hit the road to persuade key people to participate. Guthrie and Walton went to Scotland, Sauter to Germany. Lavery and Pennell canvassed London, and Pennell contacted American dealers. When Whistler again fell ill with influenza at this critical juncture, Ludovici traveled to Paris to solicit work from Degas, Rodin, Blanche, and Chavannes. Despite competition from the twin Salons and an exhibition being mounted in Vienna, Ludovici won commitments from nearly all but the Anglophobic Degas. He also persuaded Whistler to accept Paul Cézanne, whose work the chairman found childish.[3]

"[W]rapped in flannel, inhaling eucalyptus from a steaming jug," Whistler despaired of things being done properly. He insisted that his instructions from Paris be read aloud at council meetings, and that he be told the name of every artist invited to exhibit. Some work, it turned out, had been accepted because Howard, as secretary, thought the artist a likely financial contributor to the exhibition. Whistler, wanting no such "mediocrities," quietly axed them. "[K]now that those people

belong to Piccadilly," he warned, "& their presence would be intolerable." He even-tually set aside doubts about the quality of some work, a dramatic shift from his stance as head of the Royal Society. He even demonstrated some diplomacy. When Ludovici reported that Rodin's only contribution was so sensuous as to offend English sensibilities, Whistler paid the sculptor a personal visit. He got five different works and the prestige of Rodin's name in the catalogue.[4]

And, as with all his ventures, Whistler promoted the exhibition to the hilt. "The British public is kept completely in the dark as to the real nature of the Art move-ment throughout the world," he told a journalist from the *Pall Mall Gazette*. "It will be the task of the International Art Exhibition to enlighten that ignorance." With no hint of false modesty, he took credit for arranging an exclusive and unprecedented show. Expanding on his notion of exclusivity, he added, "[W]e do not express our-selves so much to the general public . . . as to that section of the public that is seriously interested in Art." The exhibition would be "an artistic congress," meant to demonstrate the "progress" of European art.[5]

He used the word "congress" purposefully, for he did not intend that the Inter-national should die after the exhibition. He wanted to make it a professional orga-nization, and the finest one in Britain. In early May, with the hanging of the galleries to begin in three days, the council created the International Society of Sculptors, Painters and Gravers. It postponed until a later date the writing of a constitution but named Whistler president.[6]

Some people may have thought that premature, given the tepid response to the exhibition. Whistler was pleased with its quality, but only 250 works went on display, far short of the 400 he wanted. Whistler contributed *At the Piano, The Thames in Ice* (both shipped by John Cowan from Edinburgh), *Rosa Corder, La Princesse, The Philosopher,* a Valparaíso nocturne, and "one or two heads" of his Fitzroy sprites. He also insisted that three etchings done by Beatrice be shown. He and Maxse, the latter having absorbed the show's £300 loss, blamed the mediocre attendance on Howard's feeble efforts to publicize the exhibition. Dismissing the critical notices and reviews as the "poor little squalid puffery of the penny-a-liner" press, Whistler had George Sauter write a proper review for the *Studio*. The article not only extolled the exhibi-tion, but also announced the birth of the International Society. Naturally, Whistler reviewed and improved Sauter's handiwork before it went to press.[7]

Whistler spent the next few months traveling, thanks to the five hundred guineas William Heinemann gave him for a painting "fresh from the easel." It was one of several heads of women and girls, most of them unidentified, that he had recently

attempted on oval canvases. His travels took him frequently to England, mostly London, where he stayed either at Garlant's Hotel or with Heinemann. His business varied, sometimes involving the International, sometimes the Company of the Butterfly, most often the Eden pamphlet. In July, he went with Teddie Godwin, now twenty-two years old, to paint in Somerset. He thought this coastal county "the prettiest part of England," even if the contrast between its red earthen roads and green hills was a "shocking business," artistically speaking. He was equally appalled by how the people "spoiled their cottages by daubing them all over a sort of dull drab red . . . after their own savage instinct."[8]

While in London, several new models caught his eye, including two daughters of his new landlady in London Mews, Mrs. Burkitt. The elder girl, sixteen-year-old Sophie, sat for him that summer. He would not use twelve-year-old Edith for another two years, but she became a regular in the studio. Absolutely devoted to Whistler, she waited at the studio door until his carriage arrived, generally around 10 a.m., and stayed through the day. He allowed her to clean his brushes, "tidy" stacks of pastels and drawings, and replenish the paints on his palette. When she began to sit for him, he rewarded her patience with a gold bracelet, set with a moonstone, from Liberty's.[9]

He found another pair of sisters in the "alleys" of Fitzroy Street. Eva and Gladys Carrington, in their early and mid-teens, posed for a series of nude or semi-nude charcoal drawings and pastels. When clothed, they wore the same wispy robes as his dancing girls. They were more worldly than the Burkitt sisters, with Eva, the elder, being "quite brazen" in her budding sexuality. She never posed when Edith was in the studio.[10]

He was in Paris, though, when, on September 9, Genevieve Mallarmé notified him that her father had died that morning. The news hit Whistler hard. The poet, besides being instrumental in reviving Whistler's reputation and career in France, had been eight years his junior, another reminder of his own mortality. The artist had last seen him a few weeks earlier, when he made a pen and ink drawing of Mallarmé's demon cat, Lillith. "I love him so much!" he confessed to Genevieve of her father. "Forgive me, . . . that I intrude upon your great pain – but you know I live in sadness! – and he – better than any other understood." Returning to London, that same week, he became an "invalid" himself at Whitehall Court, "depressed," listless, and taking "no more pleasure in work."[11]

Yet, work again helped him to rebound, beginning with the Eden pamphlet. He had, over the course of the preceding year, assembled most of the desired documents

and clippings, although friends advised against publishing them. His legal counsel-ors, the Webbs and George Lewis (now, *Sir* George) warned him absolutely not to publish in England. Whistler resisted the pressure. "I have a *right* to keep my reputa-tion clean, as shall be that of a Southern Gentleman – even in England!" he protested to Heinemann, "and that if vermin are destroyed in ones path, it is because they are intolerable." He appealed to Elisabeth Lewis, his truest "advocate" as he called her, "beside whom the fair Portia lady was merely a dull person – old fashioned – and quite out of it!" Could not she convince the Great George that a pamphlet was absolutely "*necessary*"? Whatever influence Lady Lewis brought to bear, *The Baronet and the Butterfly* was published only in America and France the following May, and to unappreciative reviews.[12]

Meantime, a second and ultimately more important project occupied Whistler: an opportunity to teach. It seemed an odd vocation for him to pursue, yet many of his contemporaries, including Legros, Poynter, Chase, and Fred Brown, had taught at prestigious schools of art. Some of his own students, including Sickert, had opened ateliers. As it was, Whistler fell into his new career when his "cut throat" model Carmen Rossi opened a life-study studio. She asked him to help pay the lease on a place at 6 passage Stanislas, a small street between boulevard Raspail and rue Notre Dame des Champs, very near his studio. He soon found himself, as well, agreeing to instruct classes.

A bit unnerved by the prospect, he persuaded Fred MacMonnies, who had trained in America with Augustus Saint-Gaudens and in Paris, to assist him. When some early notices referred to the atelier as the Académie Whistler, an "Anglo-American" school directed by "professors" Whistler and MacMonnies, Whistler corrected the impression with notices in several London newspapers and the Paris edition of the *New York Herald*. The school, he insisted, was the Académie Carmen. With or without his name attached, a rush of British and American students bid for admit-tance. After little more than a month, sixty "*élèves*" had enrolled. They paid thirty-five francs per half day for instruction in painting, twenty francs in sculpture, or twenty francs for night classes, which ran from 7 to 10 p.m.[13]

Carmen announced his arrival in grand style. Stepping aside as he entered the studio for the first time, her "great Italian chest flung back, her still beautiful head high in the air, in her deep voice the roll of drums," she declared, "Monsieur Whis-tlaire!" Students, who had awaited him in a "dazed state of expectancy," were startled by the slight stature of their near-mythical teacher, but, as one of the Americans reported, "There is no one, over here [in Paris], I would rather have as an instructor

than Mr. Whistler." Employing the method used by his own master, Gleyre, he circulated slowly and deliberately through the awestruck ranks, monocle firmly fixed, to inspect their work. He spoke kindly, patiently to each student, asked where they had studied previously and told them, "I really come to learn – feeling you are all much cleverer than I."[14]

Congenial as he seemed, Whistler had definite ideas about teaching art and the management of an atelier. First, he separated the men and women, standard practice of the day, especially if nude models of either sex were to be used. The women occupied the ground floor, men the floor above them. West Point discipline was the watchword in both studios. He forbade singing, smoking, and the usual "studio cackle." He wanted none of the rowdy behavior that defined the ateliers of his youth. He lost students as a consequence, but those who remained, some forty in all, adopted his serious attitude toward art.

Having gotten their attention, Whistler proceeded to dictate laws of art his students would never forget. These élèves, after all, no less than his earliest followers in Venice and London, were to be disciples, and as the reality of mortality gripped him more firmly every day, a note of urgency crept into Whistler's desire to impart his "system." He had decided years earlier that the training given to young painters, even at such celebrated Parisian ateliers as the Académie Julian, was "radically wrong." Chance had handed him an opportunity to set a proper example.

In painting, Whistler insisted that students first learn "complete mastery of the palette," the arrangement of colors, the significance of tone. "My idea is to give them three or four colours – let them learn to model and paint the form and line first until they are strong enough to use others," he explained to MacMonnies. "If they become so, well and good, if not, let them sink out of sight." To his students, he said, "I do not teach Art; with that I cannot interfere; but I teach the scientific application of paint and brushes." Most importantly, he taught them to see with a painter's eye, and to understand that "the real, quiet, subtle note of Nature required long and patient study." Having "floundered" for many years trying to learn those same lessons, he wished to spare them his agony.[15]

Whistler seldom visited the studio more than one morning per week, usually on Friday. He never offered detailed critiques of a student's progress. Rather, as he wandered from easel to easel, he made general observations, sometimes dispensing compliments, occasionally betraying frustration, nearly always offering encouragement, in his familiar "broken, rather hazy sentences." Students came to understand that his "manner" said as much as his words, and that his goal was not simply to

correct errors, but also to instill self-criticism. Before leaving, he made a few general remarks to the assembled class. This "Parisian 'ten-o'clock,'" as one student recalled, was the "real lesson" of the day.[16]

At least three women understood what Whistler was about. Inez Eleanor Bate, Irish by birth, had been disappointed in the instruction she received at schools in Belgium. She "rushed" to enroll in Whistler's atelier, and was soon "absorbed" in her new teacher. "She can see nothing outside Whistler," Elizabeth Pennell observed after discussing the new academy with Bate. "Even the Old Masters do not count for much. . . . He taught her to see – he taught her that to create something beautiful was the end and object of art. It was a revelation [to her]."[17]

Equally taken, if not as smitten, was Gwendolyn John. Like Bate, the twenty-two-year-old Welsh woman had also studied elsewhere, at London's Slade School in her case, under Fred Brown and Philip Steer. She and two other women moved to Paris in 1898 to cut loose and paint on their own, but they enrolled in Whistler's atelier upon learning that he, unlike the Slade, stressed painting over drawing. Lack of money forced them to leave Paris after one term, but John carried with her Whistler's lessons of the palette.

Before she returned home, Gwen's elder brother Augustus, also a Slade student, visited her in Paris. Being acquainted with Michael Rossetti and Walter Sickert, and a good friend of Will Rothenstein and Max Beerbohm, Augustus knew something of Whistler's human failings, but he had always admired him as an artistic rebel. He recalled years later the "electric shock" that passed through Fred Brown's classes when the "jaunty little man in black" chanced to visit them. Spotting him at the Louvre on his visit to Gwen, John asked how his sister progressed, and suggested that he thought her painting showed "a feeling for character." Whistler replied, "Character? Character? What's that? It's *tone* that matters. Your sister has a fine sense of *tone.*"[18]

Then there was Alice Pike Barney. A mature woman of forty-one years with two daughters in their early twenties, Barney was married to a wealthy American manufacturer less spirited, less artistic, and less bohemian than she. Ten years earlier, with her daughters attending school in Paris, she had enrolled in Carolus-Duran's atelier, where she studied sporadically for the next three years. Barney had already exhibited at the Salon when she enrolled in the Académie Carmen. Some scholars have suggested a romance between her and Whistler. Be that as it may, Barney acknowledged Whistler's enduring influence on her painting. In the 1930s, she wrote and produced a stage play about him.[19]

Alice's elder daughter was more impressed with Carmen. Natalie Barney discovered early in life that she preferred girls to boys, and Carmen became her first lover. The women first met when Carmen was posing as a model in Carolus-Duran's atelier. Although married, the sensual Italian was infatuated with Natalie. Their affair was interrupted by the Barney family's travels between Europe and America, but the two women pledged undying devotion when apart. "You are the one I love most in the world, next to God; I wait for you," Carmen told Natalie. Nevertheless, their passion spent itself soon after Alice enrolled in Carmen's atelier. Natalie moved on to become the favorite of Liane de Pougy, the most celebrated courtesan in belle époque Paris. She eventually settled in the city, enjoyed numerous lesbian love affairs, and wrote Sapphic poetry.[20]

Entering the new year of 1899, Whistler's students had to compete for his attention. There was, for instance, the matter of William Heinemann's wedding, which took place that February in Italy, birthplace of his bride, Magda Stuart Sindici. Whistler served as best man. It was his first trip to Italy since the Venice days, and this time he visited Florence and Rome, although Venice was also on his mind. He planned to exhibit there at an international exhibition in the spring, as well as in St. Petersburg. With no new work to offer, he persuaded John Cowan, William Alexander, Graham Robertson, and his newest Scots enthusiast, Glasgow shipowner William Burrell, to loan paintings.

Spring also brought the second International exhibition, and with it, a host of problems. First, an insurance agent and personal friend of Ludovici absconded with the society's insurance fund. Then, Admiral Maxse, having lost hundreds of pounds on the first show, insisted on a guarantee of £1,500 for the use of his rink. The money was secured by selling sixty "shares" in the exhibition at £25 apiece. Pressing his advantage, Maxse insisted that Menpes be included in the show. Whistler, weakened by another case of influenza, and still absent in Paris, let his executive council handle the matter. When it rejected the Kangaroo's work, Maxse retaliated by refusing to pay for alterations Whistler had made to the galleries. He also withdrew an invitation for Whistler to review the show in the *National Review*, edited by his son.[21]

At the same time, Whistler became tangled in the case of James J. Shannon. Whistler had reluctantly agreed to the American painter's appointment to the council a year earlier. He liked Shannon, a friend since Royal Society days, and one of those who had resigned with him. Shannon was also devoted to the International. However, like Albert Gilbert, he was an associate of the Royal Academy, and so Whistler, determined to stress the superiority of his own organization, used Shannon's irregular

attendance at council meetings to justify his removal. When Sargent learned of Whistler's capriciousness, he withdrew from the society. "I have no animosity whatever to it [the International] or to its President," he informed Lavery, but neither did he "wish to be subject to a censorship."[22]

The exhibition, which opened with a private view on May 9, attracted only slightly more attention than the inaugural show. Against his better judgment, but hoping to bolster the "international" credentials of his organization, Whistler had invited some French exhibitors, including Vuillard, Bonnard, and Toulouse-Lautrec, who were even quirkier than Cézanne. Arthur Symons called their work "poster" art, "art meant for the street, for people who are walking fast." It was an interesting characterization. The art of the *flâneur*, the carefully considered painting of Whistler's youth, had seen its day. Poster art did not seek "pure beauty," Symons explained. Neither did it represent art "for its sake." It was merely "art of the day and hour," meant to grab attention, "a fanciful, ingenious, elaborate, sometimes tricky way of seeing things" that attracted the *badaud*, or gawker. Similarly, another critic dubbed the work exhibited by two Austrians, Franz von Stuck and Gustav Klimt, part of a "weird school" of art.[23]

Again blaming the International's woes on Francis Howard's " 'don't care a damn' manner" in managing it, Whistler relied more than ever on Lavery, Guthrie, and Walton to enhance the society's profile. They finally had a constitution and by-laws written and approved. The society then endorsed a campaign, begun by students at the Slade School of Art, to halt proposed alterations to St. Paul's Cathedral. To balance the financial loss from its first exhibition, the International joined with the Art Workers' Guild to stage a costume ball in the Guildhall, and Whistler approved a concert in the society's own galleries. He also proposed that William Webb oversee the society's "financial and business management" as honorary solicitor.[24]

But just as he seemed to be making headway, ill health again felled Whistler. While attending a July meeting of the council in London, he contracted his third case of influenza in less than a year, the second in three months. He blamed the English weather; doctors ordered him to a warmer climate. With Rosalind and her mother already on holiday at Pourville-sur-Mer, near Dieppe, he joined them. Impossibly "fidgetty" at first, Whistler settled down to paint nine seascapes (all oils on wood panels) and perhaps as many as five watercolors of shopfronts. "September & October are clearly the months for the sea," he reported to Ludovici. "I am just beginning to understand the principle of these things. You know how I always reduce things to principles!"[25]

His health improved, too, until a last-minute calamity. With Rosalind and her mother already gone to London, Whistler developed a painful case of shingles from sitting in the "wild draughts" of some old churches at Dieppe. What started as a stiff neck spread through his nervous system to affect his scalp. He compounded the problem by rubbing the affected areas "violently" with a patent medicine. Seeking relief in Paris, he stayed at the Hotel Chatham, 19 rue Dannou, rather than opening 110 rue du Bac, but summoned his new housemaid, Euphrasie, to apply ointment and pomades to his scalp. The treatments worked, even lending his hair "an extra touch of curl and picturesqueness." Duret told him he looked forty years younger. "[T]he longer locks have taken to themselves an extraordinary gloss," he marveled to Rosalind, "and go waving and curling about until I begin to look like poor dear Boxall's portrait." When Euphrasie then presented him with a dashing black foulard to protect his throat, confidence in his appearance was fully restored. He looked "*Amazing*!!"[26]

Rosalind mocked his vanity, but Whistler was again upon the town. He saw much of Duret and Viele-Griffin, and dined with Henrietta Reubell (his and Henry James's favorite Parisian hostess) and Isabella Gardner, who also toured the Académie Carmen. He enjoyed cocktails with the Heinemanns when they visited and met with his "financier," Heinemann's brother Edmund, to discuss "stocks & scrips & things in the City." He spent a whole day in his studio with Rodin listening to a gramophone someone had given him. They played mostly American music, or "chanson nègre," as Rodin described it, which may have been either old minstrel tunes or the budding rhythms of ragtime.[27]

Whistler's spirits were lifted further when Georges Petit included five of his unsold paintings in a December exhibition. He could not attend the opening, even though the new president of France, Emile Loubet, would be there, but Whistler decided that was a good thing. With everyone expecting him to attend, his absence would be "beautiful." More beautiful still was the reaction to his paintings, which attracted several interested buyers. To Rosalind, he reported, "Well, you know Ma'me, I like this sort of appreciation, and respectful attitude after all those years of dull execration in the Island." Trixie, he said, "would be delighted."[28]

Meantime, changes had been made at the Académie Carmen. With few students interested in sculpture, MacMonnies had left. Carmen was absent, too, having fallen ill. Whistler compensated by shifting responsibility for operating the school to Inez Bate. Indeed, he had become so impressed by Bate's work that he took the extraordinary step of legally making her his "apprentice." William Webb drew up the five-year indenture in language employed for such arrangements since at least the

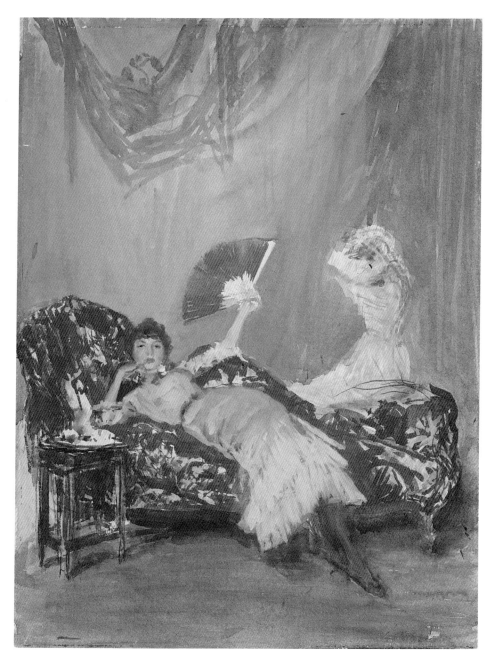

69　*Milly Finch*. One of Whistler's most successful – and erotic – watercolors, and one of his several depictions of "modern" women in the 1880s.

70   Whistler in the year of "The Ten O'Clock," 1885.

71   So heralded did Whistler's lecture become that *Punch* borrowed his performance for the masthead of its next volume, published in July 1885.

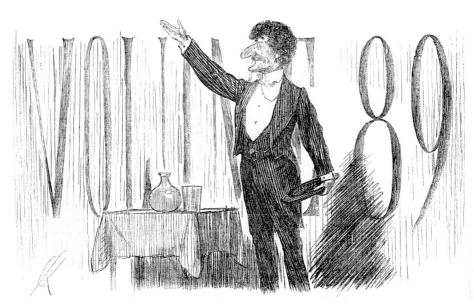

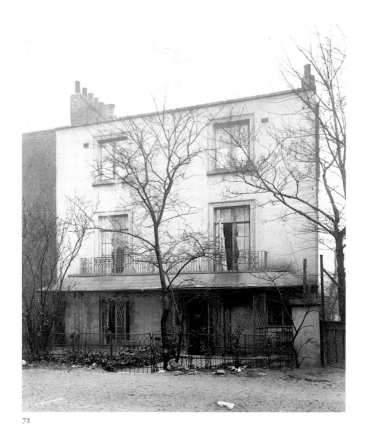

72

72 The Pink Palace, Whistler's new house in The Vale.

73 *Her Majesty's Fleet: Evening.* A scene from the naval review at Spithead and part of the "Jubilee Set" Whistler presented to Queen Victoria.

74 *Archway, Brussels.* This part of Whistler's "unknown" Brussels shows the entrance to the Impasse des Liserons.

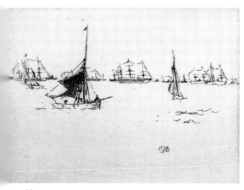

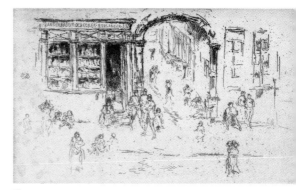

73                                  74

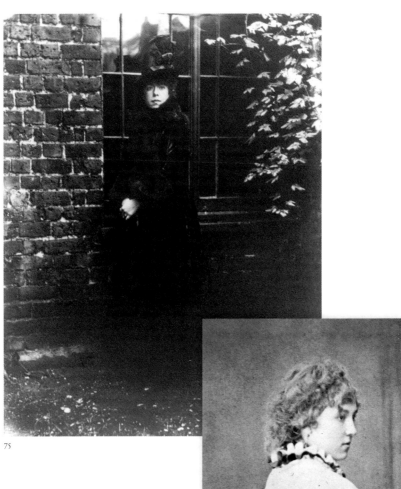

75

76

75    Maud Franklin. Whistler's partner in joy and sorrow for more than a decade was on her way out by 1888.

76    Beatrice (Philip) Godwin Whistler. Trixie, though the same age as Maud, was more glamorous and accomplished.

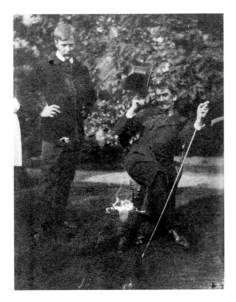

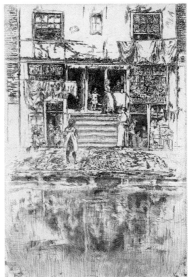

77 Whistler, holding his "wand," with Mortimer Menpes in 1885.

78 *The Steps, Amsterdam.* A shop front in the unknown Amsterdam.

79 *The Embroidered Curtain.* The height of Whistler's etched work.

80 William Heinemann. The debonair publisher understood Whistler's mania for perfection.

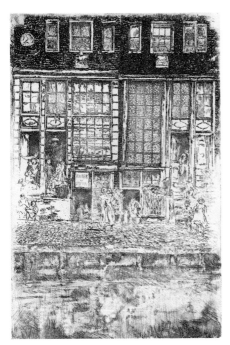

A BROTHER PASTELLIST.

[Messrs. GOUPIL admit Artists and Students free to Mr. WHISTLER's Exhibition.]

*Gatekeeper (stopping squalid Stranger).* "NOW THEN, WHAT DO YOU WANT?"
*S. S.* "COME TO SEE JIMMY'S SHOW." *Gatekeeper.* "ONE SHILLING, PLEASE!"
*S. S.* "NOT ME! I'M A ARTIST—CORNER O' BAKER STREET—CHALKS. LE'MME THROUGH!"
[*Chucked!*

81               82

81   *Count Robert de Montesquiou.* The "Bat" was among the first of Whistler's new connections in Paris.

82   David Croal Thomson screening Whistler's "fellow artists" at the Goupil exhibition. *Punch*, April 9, 1892.

83   Joseph and Elizabeth Robins Pennell in their London home.

83

84    Whistler in his Paris studio on the rue Notre Dame des Champs, 1899.

85    The busy rue du Bac, although No. 110 was cushioned from its noise
by the home's imposing wall and gate.

86

87

88

86 *Gants de Suède*. Whistler's sister-in-law Ethel, called "Bunnie," posed for many paintings, etchings, and lithographs.

87 *La Belle Jardinière*. Trixie in the garden at 110 rue du Bac.

88 Whistler by his garden wall.

91

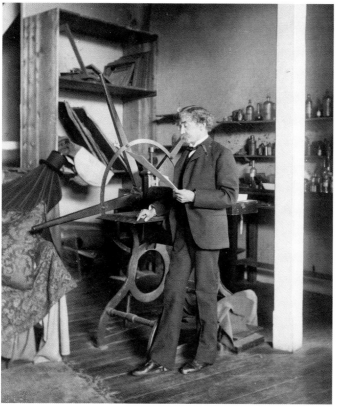

89 *Stéphane Mallarmé.*
The 1892 lithograph that
scorched his legs.

90 Whistler at the press
in his Paris studio, 1899.

91 *The Little Nude
Model, Reading.* Far
"too delicate" for public
viewing, Whistler told
D. C. Thomson.

92    Joe Sibley, "the idle apprentice," from *Trilby*, by George du Maurier.

93    Ethel's wedding party in the garden at 110 rue du Bac, July 1894. The bride sits on the far right. The ailing Trixie is third from the left.

(*facing page*)  94    *The Little Rose of Lyme Regis*. Eight-year-old Rosie Randall posed for Whistler's finest portrait of a child.

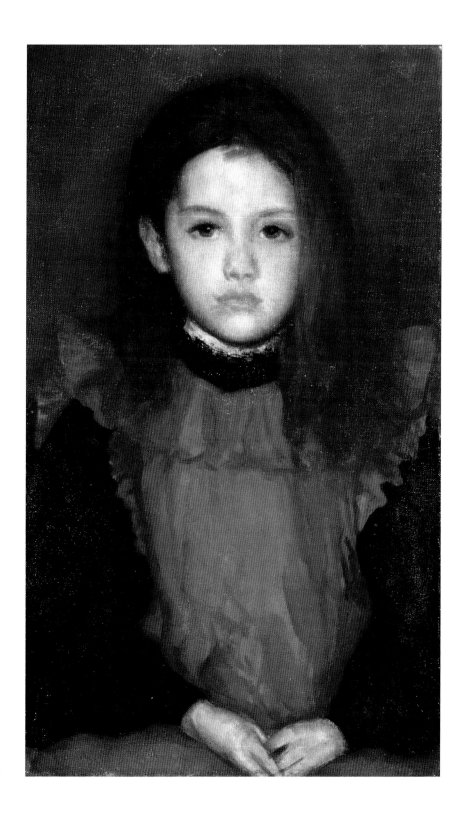

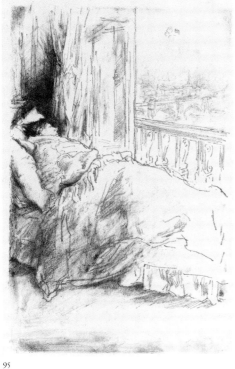

95  *By the Balcony*. One of Whistler's last, poignant drawings of the dying Trixie.

96  *St. Giles-in-the-Fields*. One of the churchyards where Whistler sought solace.

97  *Edward Guthrie Kennedy*. Whistler's dependable New York agent.

95

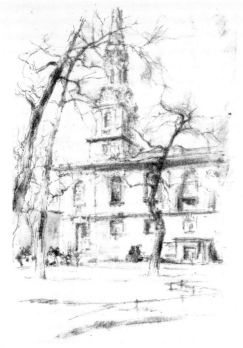

96

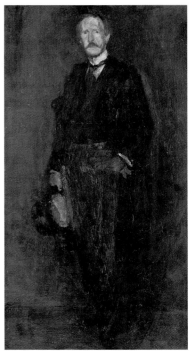

97

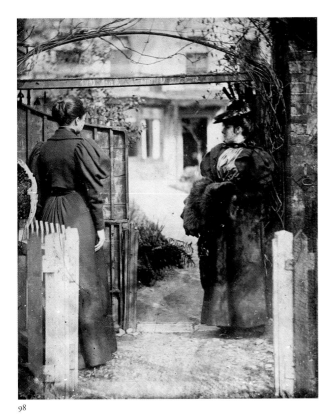

98

98   Rosalind Birnie Philip
and Ethel (Philip) Whibley at
St. Jude's Cottage, 1896.

99   *Study No. 1: Portrait of
Mr. Thomas R. Way*. Whistler's
lithographic mentor.

100   *Whistler Asleep.*
E. G. Kennedy thought Giovanni
Boldini's 1897 etching "absolutely
like Whistler."

100

99

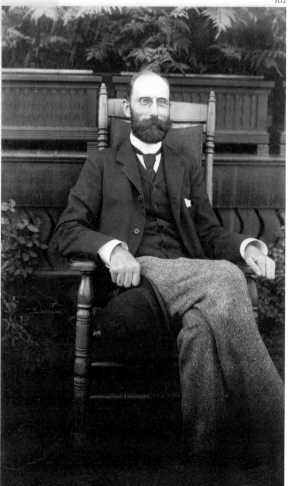

101 *The Doctor*. An 1894 lithograph portrait of William McNeill Whistler.

102 Charles Lang Freer in 1901. Whistler's most generous and loyal patron.

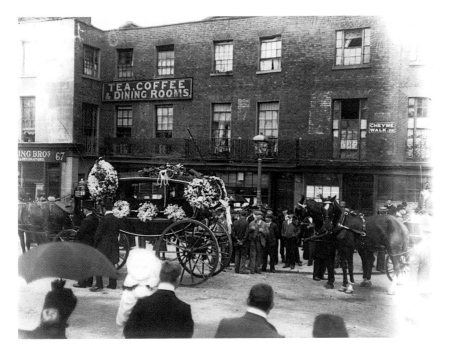

103   The funeral of Whistler, showing the hearse near his house on Cheyne Walk.

104   The graveside scene at St. Nicholas churchyard, Chiswick.

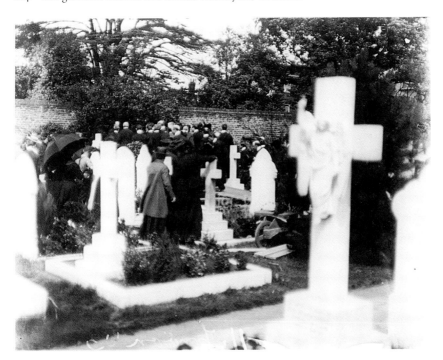

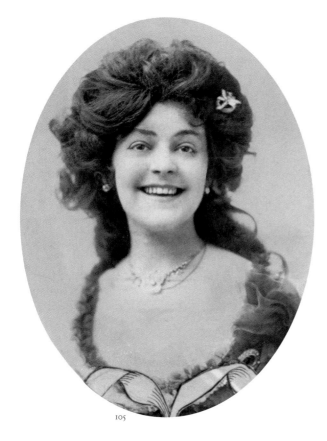

105    Sarah Ann (Murray) Hanson, undated.

106    Charles James Whistler Hanson, undated.

107    Rosalind Birnie Philip around 1903.

105

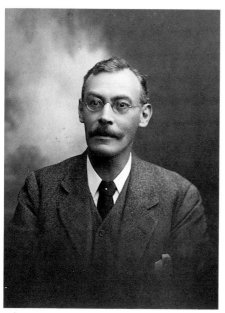

106

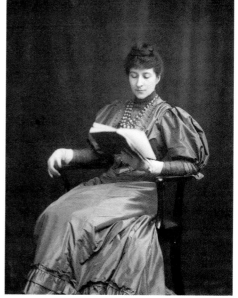

107

seventeenth century. Depending on Bate to begin the new term, Whistler reminded her, "You will remember all that has been said about the standard necessary for admission." She should judge candidates "more on their personal attitude than anything else." Above all, they must demonstrate *"perfect loyalty"* to his principles. He wanted no advanced students whose ideas about art had been shaped elsewhere. Whistler also trusted her to select someone to direct the men's studio.[29]

Whistler's confidence in Bate was revealing. He had long believed women students represented the "future of art," and he had refused to let Carmen follow the usual custom of charging them more for tuition than she did the men. He could be severely critical of his female students, but he also believed their minority status in the art world made them more teachable than men. They appreciated the need for training and were eager to be instructed by an acclaimed master. Unlike some male students, they did not see him as a potential rival, whom they might one day challenge for supremacy. Besides, Whistler said, men lacked "personality" and were "less interesting" than women.[30]

However, the demands of teaching disrupted his own work, and as he failed to find the talented new followers he hoped to groom, Whistler grew tired of the atelier. The lack of "loyalty" among students who complained about his infrequent visits shocked him. Their parents grumbled, too, especially the American parents. Even Bate's parents complained, and blamed him when she became engaged to marry a fellow student, Clifford Addams. Whistler threw up his hands and told William Webb to handle the problems. He had no time for "complications of this amazing kind!"[31]

A far greater jolt came on February 27, 1900, when Willie died of influenza, aged sixty-three (fig. 101). Upon receiving the news, Whistler asked Duret to "come around" and keep him company. He did not attend the funeral for fear of injuring his own health. "Willie himself would know how mad the risk would be!" he explained lamely to Helen. He also knew that Willie was to be buried beside their mother, at Hastings, another reason to avoid the scene. He sent Helen money "for immediate matters," wrote an obituary for the Paris edition of the *New York Herald*, and arranged to have one of his lithographs of Willie, done six years earlier, published with a biographical sketch in the *British Medical Journal*. It gladdened him to see that his brother's former comrades in the Confederate army also marked his passing. "I think Willie would have been pleased," he told Helen.[32]

The death of the International nearly followed. Having found it "impossible" to work with Admiral Maxse, who, in any event, would himself die in June, the society severed connections with the Prince's rink. The executive council talked of joining

forces with other "outsiders," such as the New English Art Club. All might "*pull together*" in a single, spectacular show, they reasoned, but by then, the Season was nearly upon them. There would be no exhibition in 1900.[33]

It was just as well, for Whistler had already turned his attention to the Exposition Universelle, to open in Paris on April 14. He decided to exhibit as an American, as he would have done at the 1889 Exposition had the jury allotted him more space. Besides, despite his sarcastic remarks about American art critics, Whistler had never rejected his native land. Interviewed by a countryman in May 1899, he confessed, "I am really a d__d bluffer when I pretend that I am not proud of being an American." His parents had instilled that sense of pride at an early age, and while he had become, over the years, the most cosmopolitan of men, there remained about him something unmistakably American.[34]

Crucially, though, Whistler's national identity was tied closely to West Point, a not insignificant factor in 1899. The United States had just crushed Spain in a war to liberate Cuba. Whistler cared little about the larger issue of imperialistic expansion that grew from the conflict. The "base-born" and "half-nigger" Cubans were of no account to him. However, he took inordinate pride in the valor and "chivalrous conduct" of the West Point graduates who had led the victorious army. The U.S. secretary of state called the Spanish conflict a "splendid little war." Whistler called it "the most wonderful and beautiful war that had been fought since the days of Louis XIV." He had instructed the American interviewer that May, "Tell the American people that I would not exchange my two years at West Point for all the honours that foreign countries have given me." Complying with a request to be listed in the first edition of *Who's Who in America* that same year, Whistler wrote proudly that he had been educated at West Point.[35]

By contrast, the Boer War, which erupted just as America's clash with Spain wound down, piqued his desire to compete against British artists at the Exposition. He became something of a "bore" himself on the subject of South Africa, losing no opportunity to praise the plucky Dutchmen and pillory the bumbling British. He laughed at the "gross stupidity of the British Generals" and teased Rosalind to the point of "insubordination" when the Major snapped back in defense of the empire's armies. In like manner, he became interested in the reopened Alfred Dreyfus case because – despite referring to it as the "Jew question" – it involved the army and French national pride.[36]

As for the Exposition, the Americans needed Whistler in 1900. U.S. officials, envisioning the start of an "American century," with a new role for the United States

as a world leader, wanted to make a grand statement in Paris. The military victory against Spain had shown the nation's martial might. The Exposition could showcase American industry, manufacturing, science, agriculture, commerce, and art. The art was important for demonstrating American refinement and expressing the character and individuality of the young giant. The very best painters and sculptors would be needed to establish the credibility of an "American school" of art.

Whistler and Sargent were the stars of the American fine arts exhibit. Their work may have been more representative of French tastes and foreign training than of an American school, but they were indisputably the most famous American artists at home or abroad. Whistler contributed half a dozen etchings and three paintings, *The Little White Girl*, the self-portrait *Brown and Gold*, and *L'Andalousienne*, a portrait of Bunnie. He thought Bunnie's picture "very swagger," the personification of a refined yet self-confident modern woman, and none could deny the elegance of all three paintings. As though to underscore that point, Boldini's very swagger portrait of Whistler hung in the Italian galleries.[37]

The larger Exposition, which ran through November, was phenomenal. More than fifty million people visited its sprawling grounds and grand pavilions. Anchored again by the Eiffel Tower, and stretching along both sides of the Seine, it covered a far larger area than the 1889 affair. It was the most architecturally elegant international show ever staged, and its impressive demonstration of industrial power and energy announced the start of a "modern" age, if not an American century. Edward Kennedy was fascinated by a clock that told the time "by a phonographic voice." Nearly 6,000 incandescent bulbs illuminated the Palais de l'Électricité, the city's first underground rail line carried visitors beneath the crowds, and a new overground rail station, the Gare d'Orsay, welcomed them to the City of Light.[38]

The variety of artistic styles displayed in the two fine arts buildings, perched on the northern side of the river, was startling. Realism and Impressionism, the daring innovations of Whistler's younger years, looked tame beside Post-Impressionism. The older styles still dominated, but people like Pissarro, who found the "vogue" for such modernist painters as Cézanne "extraordinary," wondered for how much longer. He complained that Whistler was too tame, simply "repainting the old masters," and lacking the "inspiration" of Manet and Renoir. Yet, perhaps because the work of an old rebel like Whistler seemed soothing amid the "odious bazaar," the American won Grands Prix for both painting and etching. Sargent also won a Grand Prix for painting, and the American contingent of painters as a whole, many of them clearly influenced by Whistler's work, received 114 medals,

second only to the French. MacMonnies took one of three American Grands Prix for sculpture.[39]

American historian Henry Adams, who "haunted" the Exposition for much of its seven-month run, would not have given Whistler any prizes, no more than Pissarro, but considering all the talk of an American century, his perspective holds interest. Adams had spent his adult life trying to understand the American character. "American society," he told a friend shortly before the Exposition opened, was "a kind of Whistler that never had any atmosphere to scrape, but shows the paint crude." It was not a compliment, his opinion of Whistler's painting having been fashioned by his wife, who disliked both the work and the man.[40]

However, like many people, Henry Adams gradually came to understand Whistler. About a year after the Exposition, he encountered the artist raging against the Boer War at a public banquet. "For two hours he declaimed against England," Adams recalled, "witty, declamatory, extravagant, bitter, amusing, and noisy." However, what most struck Adams, as it did others who bothered to look beyond Whistler's public facade, was the contrast between artist and showman. Whistler's art was full of "*nuance* and tone," Adams decided; it "never betrayed" the same "vehemence" as his tirade against the English. How curious, thought the notoriously cautious and reticent Adams, a man much like his friends Henry James and John Sargent, that Whistler should wish "to be seen eccentric where no real eccentricity, unless perhaps of temper, existed." He concluded that Whistler must have been "brutalized . . . by the brutalities of his world."[41]

Whistler did not stay for the Exposition. Having ensured that his pictures were properly hung, he spent most of the summer in Britain. In London, while lodged first with the Heinemanns and then at Garlant's Hotel, he worked on some long-standing commissions but considered it futile to continue with others. He returned an advance of two hundred guineas for a picture begun two years earlier. When the former Marion Peck asked him, after five years, either to complete her portrait or return that £200 advance, he seemed almost relieved to relinquish the money. He could afford both sums. A portrait of Nellie Brown brought him £600, and David Thomson, now managing the gallery of Thomas Agnew and Sons, paid three hundred guineas for two of the recent Pourville panels. That was in addition to a thousand guineas from Wunderlich's for *L'Andalousienne*, which Whistler pocketed before leaving Paris. In August, he retreated with Rosalind and her mother to a seaside house they rented outside Dublin. Except for a brief trip to Holland, he remained there for two months.[42]

But he was not well. By mid-October, the artist felt strong enough to travel to Paris for the start of the new term at Académie Carmen, but the trip, and more particularly the Channel crossing back to London, worsened his condition. At the end of November, he confessed to Helen Whistler that his illness, now marked by a persistent cough, both "wearied" and "worried" him.[43]

His doctor recommended sea air, and so on December 15, Whistler left with Ronald Murray Philip, his twenty-nine-year-old brother-in-law, for Algiers, on the Mediterranean coast. Before leaving, he probably heard of Oscar Wilde's death in Paris, which came on the same day he wrote his worrying letter to Helen. Wilde had been bedridden since September with an undiagnosed syphilitic disease. Whistler had not seen him for well over two years. On that occasion, they had come "face to face" at a Paris restaurant. Oscar thought Jimmy looked "old and weird," but neither man spoke. The scene was eerily reminiscent of a stanza in Wilde's cathartic and poignant *Ballad of Reading Gaol*:

> Like two doomed ships that pass in storm
> We had crossed each other's way:
> But we made no sign, we said no word,
> We had no word to say;
> For we did not meet in the holy night,
> But in the shameful day.[44]

# 21

# *Off the Treadmill*

## 1901–1902

It was a wonder Whistler ever traveled. He always claimed to be miserable, and complaints about the trip to Algiers came early and often. He could scarcely fault the voyage out. Shipping magnate and friend Thomas Sutherland, reliable and steadfast since the days of the bankruptcy, told the captain of the vessel to pay particular attention to Whistler's comfort, and the artist had not enjoyed such a congenial traveling companion as Ronnie Philip since Trixie. Nearly all else, however, displeased him for the next six months.

Entering the Straits of Gibraltar, he took an instant dislike to the landmark British possession that guarded it. The "stupid" hotel in Tangier, where he spent Christmas, served "bad" dinners, and he dismissed the picturesque city as "*entirely too* 'Eastern.'" Working his way along the North Africa coast to Algiers, he spent the first day of the twentieth century at a wretched hotel with appalling food. Whistler thought the town "cheap" and tawdry. So much for Algiers. On to Marseilles, France, which was marginally better. "[W]hat beautiful things one could do here!" he enthused to Rosalind, "but it is *not* warm – not warm *enough* for me!" In fact, three feet of snow greeted him at Marseilles. He and Ronnie spent a fortnight huddled in front of a fire planning their next move.[1]

He made a few sketches on the passage to Tangier, mostly of Ronnie Philip: Ronnie seated, Ronnie reading, Ronnie in repose. Despite his contempt for Algiers,

he made some two dozen sketches and drawings of that town's streets, shops, cafés, markets, and people. The output contrasted starkly with the single wood panel painting of the beach at Marseilles, where he claimed to see such charming possibilities.[2]

A fine remedy for influenza. He should have gone to the Caribbean, Whistler declared, a genuine "Southern" clime. Instead, he landed at Corsica in late January, with the Mediterranean "kicking up its heels" and the temperature at 8 degrees centigrade. "[The] wind flew down the mountains – and whirled in from the sea! and then the rain was simply emptied out of the sky!" he reported. The sun shone the next day, but the temperature remained "too risky" to paint or draw. He spoke of returning home.[3]

The weather gradually improved on Corsica, where he stayed in the capital city of Ajaccio at the Hotel Schweizerhof, but Whistler was slow to work. "[W]hen it is warm enough to stand still, it is vile to look at!" he reported to John Lavery of the Mediterranean, "and when you are relieved from the glare and linger to look with a paint brush in your fingers, you are blown indoors by Mistral or 'tra montana.'" He suffered a relapse in late January, the result of playing "reckless tricks" with his health. He had stood, like an "idiot," he admitted to Rosalind, "gawking at wonderful 'shops' – in damp slums until after sun set!"[4]

More than gawk, he finally did paint the shopfronts, as well as the market, the streets, the houses, and the people of Ajaccio. A favorite subject was people seated or standing in doorways and archways. He used the same motif in several etchings, the last etchings he ever made. One of them, *Marchande de Vin*, showing an old woman in peasant dress, bore a striking resemblance to *La Mère Gérard*, done some forty years earlier. He also made a watercolor (ten by six inches) of the harbor at Ajaccio and a half-finished portrait (oil on canvas) of a Corsican boy. It had not been easy to find a suitable subject among the "little ragamuffins" of Ajaccio, plentiful in number but "entirely too wild to sit." Still, the results rivaled his best recent pictures of children.[5]

Ronnie Philip returned home in mid-February, but reports of blizzards and snow in Paris and London convinced Whistler that his health stood a better chance on Corsica. He thought of renting a villa on the island. Summer, he told Rosalind, should be lovely by the sea. He celebrated the gradually warmer days of March and April by devouring cakes like a greedy schoolboy in the hotel garden. Still, with Ronnie gone, he felt as "nervous as a cat!!" What was happening in London? he wondered. What were his fellow artists doing while he stagnated?[6]

Rosalind was his lifeline to London. She reported to him on Charles Shannon's exhibition at the Van Wisselingh Gallery, a Menpes exhibition at the Fine Art Society, and a show at the Goupil. At his insistence, she looked in on the Carrington sisters to see how they fared. "Give some little present to Eva," Whistler suggested, "any thing – Chocolates if you like – to both – & say I wanted some account of them – as indeed I do." Rosalind might spend an afternoon with their mother, too. "We must not lose the run of the Carringtons," he explained. He asked her, as well, to inventory the work in his studio. Search every shelf, drawer, and cabinet, he said. The engraved etchings plates needed special attention, and he sent detailed instructions for treating them. If the work became tedious, he said, perhaps Bunnie or little "Edie" Burkett might lend a hand.[7]

More dramatically, the General, from his headquarters on "Bonaparte's Island," instructed William Webb to sell his lease on the shop in Hinde Street. "I rather hate giving it up," he admitted to William Heinemann, "but I never had time to attend to it." Edward Kennedy had predicted as much. Indeed, the Company of the Butterfly had floundered nearly from the first. Christine Anderson had long since departed, to be followed by a series of interim managers. He asked his publisher, Rosalind, and Mrs. Burkitt to remove the stock and furnishings to London Mews. When an ungainly table proved too large for the studio, he had Rosalind sell it. It was at such moments that he missed the Owl. "Howell was the one who could have managed that sort of transaction beautifully," he laughed, "pleased every body – and put twenty pounds in his pocket as well!"[8]

Ridding himself of the £90 annual lease was a relief, but the Académie Carmen and his house in Paris, where he had not lived for over a year, burdened him still. Rosalind urged him to close the atelier. Carmen, it seemed, had opened a wine shop. Taking the Major's advice, he ordered the school's doors shut at the end of term, on April 6. A women's life class was all that remained, and though well attended, it could neither justify continuation of the academy nor maintain Whistler's enthusiasm for the project. There must, of course, be a dignified and solemn ceremony to mark the closing, he said, and he wanted Carmen to participate. "[S]he should in no way be left out – either of ceremony or consultation," Whistler thoughtfully instructed Inez Addams, "so that she may have the satisfaction of feeling that, to the last, she was 'in it' with all of us – that she was Madame la Patronne – and not merely the landlady."[9]

Addams did his bidding, to the "sad stupefaction" of the remaining students. When Carmen proved too ill to attend the ceremony, Whistler wrote to assure "la

belle Patronne" that the brilliant success of the Académie would not have been possible without her. "So chin up my dear Carmen," he chuckled, "for we all love you." He assured Inez Addams, "Remember always that the end was perfect! and the time of it what it should have been – and the breaking up of it, with official dismissal issued from Napoleon's Island, of such rare completeness and fine finish that one would seem to have travelled the world over to bring it about." He showed his pleasure by ordering articles of apprenticeship drawn up for Clifford Addams as had been done for Inez.[10]

So passed the long days of his recovery, during which he also completed his biographical sketch for a new edition of *Who's Who in America*. This time, determined, as he once told Debo, to remove "the taint of Lowell" from his life, he claimed to have been born in Baltimore. "I don't choose to be born at Lowell," he said on another occasion. "I refuse to be born at Lowell, and I shall be born where I want to – Ah ha!" He stated also that his mother's family came from aristocratic South Carolina, rather than the more plebeian North Carolina. He eliminated any mention of having lived in England and deleted his year of birth.[11]

Naturally, he managed to fall into at least one legal tussle. In the rue du Bac, Euphrasie had commandeered the rug of an inconsiderate neighbor who for years had beaten the dust from her carpets into Whistler's garden. The woman sued to have the rug returned and won the case by stating falsely that she had seen nude models in Whistler's garden. The claim so "shocked" the judge that he all but forgot the issue of the rug. Damages were purely nominal, a mere twenty-five francs (one guinea), but an outraged Whistler spoke of suing for defamation of character. He settled for writing a "dandy" letter to his antagonist, a little something to "take the cream off her cup of satisfaction."[12]

William Heinemann buoyed him when he and a friend visited in March. Unfortunately, another spell of miserable weather hit at the same time. Whistler and his guests managed a pilgrimage to Napoleon's birthplace, but the rain kept them indoors playing dominoes on most days. Whistler generally won, even though he was just learning the game. Heinemann suspected him of cheating but laughed it off. The publisher had also brought a camera, which he used to take a telling photograph of Whistler. It showed him seated on a box and sketching. Dressed against the cold in a heavy, mid-calf-length coat, a broad-brimmed, low-crowned hat pulled tightly over his head, he looked old.[13]

Feeling much like the man in the photograph, Whistler came to a painful realization. "[F]or *years* I have had *no play*!" he lamented to Rosalind, "and have been the

dull dog – the sad dull dog you have all known – moping in his kennel in Fitzroy Street." He exaggerated wildly but went on. "Years! think of it! – for years I have made myself my own treadmill and turned upon it in mad earnestness until I dared not stop." He wailed in the same pitiable manner to Charles Freer. "I have *never* rested!" he marveled. "[N]ever taken a 'holliday'! Never permitted a Saturday afternoon! . . . And in this wild pursuit of work the machine, this beautiful & sensitive machine – 'not made in Germany' – was cruelly overwrought."[14]

It was an extraordinary outburst. Whistler a "dull dog?" Never enjoyed himself, never taken a holiday? That may have been true at some moments in his life, but to imply that this had been his general plight, and that he had broken down under the burden of relentless, unbidden labors, was downright silly. Some projects had wearied him, no doubt, especially the commissioned portraits and endless etchings for the Fine Art Society, but art had been his life, not a mere profession or avocation. His nervousness and physical weakness came not from overwork, but from old age, something he was loath to admit. The "overwrought" machine was simply wearing out. In referring to a "treadmill," Whistler may also have been thinking of Oscar Wilde's plight in prison, where the poet had seriously damaged his health on such a contraption.

Rosalind and Bunnie made light of his self-pitying lamentations, but that only brought another wave of despair. He laid blame for his condition on a reckless, maniacal, evil twin, a device he had not used in ages. "Whistler has for years and years! so leaned on Jimmie that he wore him out!" he exclaimed in the third person, "and bore him down to the dust – and took all his joy out of him – and without Jimmie, what is Whistler! – and there you have it!" There, indeed. The "bright and delightful Jimmie" had stopped the "restless – blind – relentless Whistler" in the nick of time, before the youthful, exuberant Jimmie had been "wearied and done to death" by that old man.[15]

Whistler ventured home in early May. He had a tolerable voyage aboard the SS *Egypt*, a "great 'big ship,'" with a "good cabin & obsequious Steward." The only discordant note was a gaggle of British passengers. The women, designated the "Britonnesses" by Whistler, were bad enough, but the men! "[T]heir pipes are *every where!*" he exclaimed, "the whole length of the deck reeks of them. There is really *nothing* like this people!"[16]

In London, he took rooms at Garlant's Hotel, although to say Whistler lived anywhere the remainder of the year suggests a permanence of place and habit that did not exist. Having finally given up the lease on 110 rue du Bac, he roamed, to

stay with friends or relations at the seaside, in the country, at Dieppe, and at The Hague. In London, he left Garlant's for Tallant's Hotel, in North Audley Street, but the "landlady & the cooking" soon drove him in "a state of frenzy" to seek refuge at Dhu House.[17]

Queen Victoria had died while he was on Corsica. His friend Edward was now king, but London had not visibly changed. He toured the art galleries to see what those "other chaps" had been doing, but the only painting that impressed him was Botticelli's masterpiece *Madonna and Child*, on display at the Colnaghi Gallery after being bought by Isabella Gardner for £12,000. He sent his own work to exhibitions in Dresden, Munich, Edinburgh, Glasgow, Paris, London, Philadelphia, and the Pan-American Exposition, held in Buffalo, New York. He attended none of those events but received gold medals at both American shows. The Italian government bestowed the Order of Commander of the Crown of Italy, and friends in Glasgow nominated him for honorary membership in the Royal Scottish Academy. The Museé du Luxembourg wanted to mount an exhibition of his etchings.[18]

The International Society seemed to function equally well with or without him. John Lavery had managed things while he was on Corsica. Upon his return, Whistler threw himself into preparations for the next exhibition, due to open in October. He made sure the work of Clifford and Inez Addams was included. Lavery was puzzled by his attachment to the couple, especially Mrs. Addams. Whistler explained that few students had so perfectly understood his principles, and that he meant to pass his "torch" to Inez in due time. When Lavery responded that "no woman was worthy of such an inheritance," Whistler replied patiently, "My dear Lavery, have you never heard of Sappho, or do you know the work of my wife?" For his own part, Whistler contributed seven pastels to the exhibition.[19]

The show, held at the Royal Institute of Painters in Watercolours, in Piccadilly, was a modest success. It lost only £125, the smallest deficit thus far, but the press paid little attention. Oswald Sickert, one of Walter's younger brothers, made the most perceptive comments. It was not a bad show, he said, but the quality of the International's exhibitions had declined each year. The society, like the Royal Academy and New English Art Club, had come to depend on a few "pictures of the year" to attract crowds. Equally apparent had been the declining number of foreign exhibitors, thus exposing the conceit that this was an "international" organization.[20]

Whistler was not pleased, but he was more distressed by evidence that someone had been stealing and selling his pictures. John Cowan had first alerted him to the problem months earlier, although the Scotsman suspected forgery rather than theft.

Questioning the authenticity of the signatures on two "Whistlers" purchased from Alexander Reid, he sent the paintings to Whistler, who recognized them as his own work but noticed, too, that parts had been cleaned and repainted. More importantly, he had not seen the pictures since leaving them in his Paris studio. He immediately suspected Reid, "an awfully slippery customer," of engaging in "an *organized conspiracy*."[21]

However, when several purloined lithographs then turned up in a Paris gallery, suspicion fell on Carmen. She steadfastly denied knowledge of the thefts, but Whistler asked the Addamses, then living in the city, to investigate. In a "tête-à-tête" with Carmen, Inez persuaded her to travel to London and speak directly with Whistler, who, even though convinced of her guilt, believed she regretted her behavior and would be looking for a "*way out*." She was not the innocent he supposed. Before leaving Paris, Carmen confided to Addams that she was anxious not to jeopardize her position with Whistler as a model but wanted her terms of employment "clearly defined once for all." Carefully watching the effect of this declaration on Addams, she insisted on twenty francs per day, although, "if Monsieur had no further use for her, she might accept 30,000 francs compensation." When Addams reminded Carmen of Whistler's many kindnesses to her, she dismissed them all as "nothing."[22]

Clifford Addams thought Whistler would have been less angry about the thefts had Carmen sold the pictures to private collectors, rather than dealers, who then sold his work for "big prices to their own profit." Still suspicious of Reid's role in all this, Whistler asked Cowan to dig deeper into the Glasgow connection, but the Scotsman, on advice of his lawyers, demurred. Whistler, who had recently arranged for Charles Freer to buy two of Cowan's paintings, including *The Thames in Ice*, for £2,400, accused him of betraying "the McNeill."[23]

That was in mid-November, when, with his health still in decline, Whistler's doctor again ordered him out of London. With the International exhibition still on, and hopes of a legal breakthrough in the Carmen case, Whistler traveled no farther than the ancient health spa of Bath, where he, Rosalind, and Mrs. Birnie Philip spent the best part of December and January 1902. In his absence, David Thomson sold four of his drawings for £1,000. Whistler's share was £900, enough to compensate for an unfortunate speculation he had made in a gold mine, done, he now regretted, without having consulted Edmund Heinemann, "the Financier."[24]

He left Bath determined to find a house of his own. Edward Walton told him about a place at 74 Cheyne Walk, next door to him. It belonged to thirty-eight-year-old Charles R. Ashbee, a noted architect and devotee of both the Arts and Crafts

Movement and socialist politics. He and his wife were temporarily abandoning their home to join a "back to the land" communal experiment in the Cotswolds. Ashbee had built the house himself, as well as several other residences on Cheyne Walk, including Walton's own, between Oakley and Church streets.

Known for his eccentric designs, which combined the Arts and Crafts style with Queen Anne, none of Ashbee's houses was queerer than this one. Its unadorned front facade looked like the rear of a respectable dwelling, its narrow copper door like a tradesman's entrance. The kitchen was on the ground floor, next to the study and dining room, rather than in the basement, but Whistler liked its "odd decorative touches." The house also had a well-lighted studio with a northern exposure. That meant he could abandon his London Mews studio, which would save money and spare him from traipsing to and fro in London's unpredictable weather. The house was not for sale, only for rent, but William Webb negotiated a two-year deal at £135 per annum.[25]

Whistler would not have gotten the place had the decision been left to Ashbee's wife. Neither Ashbee cared for the "Whistler school" of painting, but when the artist arrived to inspect the premises, Janet Ashbee had a strong "physical" reaction to the "little, horrid, cantankerous, curled, perfumed creature" who would occupy her home. "He gave me the impression of an old, old man trying to be young and sprightly and aping the oddities of youth," she confided to her diary, "or rather of an old monkey copying the affectations of a young man." Whistler did little to be agreeable. Bundled in a brown ulster, he complained about the drafts and unfiltered light pouring through the north windows. Aware of his famous parting inscription above the entrance to the White House, Janet Ashbee prayed, "Let us hope he will refrain from painting on the walls sarcastic comments on the builder of the house."[26]

With his health seemingly restored, and a settled domestic life in the offing, Whistler concluded his years in London Mews by finishing Edith Vanderbilt's portrait in time for the Champs de Mars Salon. He also sold the Vanderbilts a portrait of Lizzie Willis that had been promised to Kennedy. Whistler called it *The Little London Sparrow*, although George Vanderbilt, knowing the history of the Willis family, jocularly referred to it as *L'Enfant du Gin*. The artist received no medals that year at the Salon but basked in nearly universal popular and critical praise for his paintings. Only one of the five pictures he sent remained unsold by the end of the summer, and that one, a portrait of Lillie Pamington, some people thought badly hung.[27]

The melodrama surrounding his missing paintings also ended that summer. Carmen and George Petit had recovered one of the portraits for 7,000 francs (£280).

They returned it to Whistler for 8,500 francs. The additional 1,500 francs, Carmen explained, would allow her to leave Paris for Italy. Whistler yelped at the price but was glad to recover the picture. The thieves were never conclusively identified, but the thefts stopped, and Whistler did not wish to press Carmen further.[28]

By then, he had a new reason to be irritated. No sooner had he moved into 74 Cheyne Walk than the "abominable noise" of a new Ashbee house being constructed next door frayed his nerves. How typically "English," Whistler claimed, for Ashbee to leave knowing full well the new house would be built.[29]

Ordered by his doctor to find quietude abroad, Whistler, Rosalind, Charles Freer, and a new maid named Marie traveled to Holland in the latter part of June. The cure nearly killed him when he suffered sharp chest pains, seemingly a mild heart attack, in crossing the North Sea. The experience so terrified him that, after taking rooms at The Hague, he altered his will, or rather, the signature on it. Having signed the previous one as James McNeill Whistler, it occurred to him that some relative, "however distantly connected," might dispute a document that did not also bear his baptismal name of Abbott.[30]

Ethel Whibley arrived to share nursing duties with Rosalind when Freer returned to America in late July. Both women revered Freer for his steadfastness during the crisis. "A more unselfish man I have never known," Rosalind reported to her mother. Yet, she attributed Freer's loyalty equally to Whistler. "He is extraordinary – the power he has of calling out devotion," she marveled of her brother-in-law. The two men had grown close that spring, when Whistler began a portrait of Freer and they celebrated a Boer victory by downing gin slings together at the Carleton Hotel. Having bought only three Whistler oils over the previous decade, Freer began snatching up every available painting in Britain, often at Whistler's urging, always with his blessing. Mary Cassatt said of Freer, "The poor man knows absolutely nothing about pictures," but he knew what he liked, and he became the premier collector of Whistler's work.[31]

Whistler's fitful recovery exhausted his entourage. "I am not as good at nursing as I used to be," confessed Rosalind, "or perhaps," she added pointedly in a letter to her mother, "some people are more exacting." Even so, as Freer had learned, one could scarcely deny the man. No sooner had Whistler petulantly downed his meager supper of bread and milk than he cheerfully entertained Rosalind and Ethel with "lively little stories."[32]

When London journalists tracked him down in hopes of a good story, Whistler eluded them and reduced expenses by taking rooms in an adjacent building. Even

so, the "newspaper spies" revived his spirits by reporting that the "gay butterfly" might not have long to live. A few years earlier, Mark Twain had responded to erroneous newspaper reports of his passing by announcing that the stories had been greatly exaggerated. No such brief rejoinder could satisfy Whistler. Writing to the *Morning Post*, he corrected several errors in the newspaper's "quick biography." He was especially grieved, the artist said playfully, that the paper's "premature" eulogy said little about how he had "offended" people during his lifetime. He begged the editor to "contradict" this notion, lest it ruin his reputation.[33]

Among the biographical errors he corrected was an assertion that *The Little White Girl* had been inspired by a Swinburne poem. On the contrary, Whistler insisted. The painting had inspired Swinburne's delicate lines, a "noble recognition of work by the production of a nobler one!" For anyone who thought that Whistler had broken lightly with the poet fourteen years earlier, here was evidence of how dear remained Whistler's memory of Swinburne. "You may roar at me as much as ever you please," Harper Pennington wrote to him, "but I *was* touched by your letter to the Post, especially what you said of Swinburne. That was charming, *charming*, & it pleased me the more because I thought I saw forgiveness in it."[34]

Whistler was not appreciably stronger when he left Holland in early September, but the prolonged convalescence had become intolerable. Also to be considered was the flagging stamina of Rosalind and Bunnie. He had hired a "professional" nurse to help them, but the "fatigue & strain" still showed. When Elizabeth Pennell, in Holland to review some gallery exhibitions for a London newspaper, stopped to say hello, she found their rooms "rather comfortless" and Whistler in "one of his most irritable moods." Sorting through accumulated bills, he had become convinced that their "low highwayman" of a landlord had overcharged them. Equally irritating, his doctor had told him that he "could keep well only by the greatest care and constant watchfulness," with no "excitement!" A bemused Pennell thought to herself, "[H]ow was that to be prevented?"[35]

How, indeed, when, arriving back at Cheyne Walk, he found the noise unabated. He protested by refusing to pay his rent and asking friends to have Ashbee expelled from the Arts Workers' Guild, to which nearly all of London's "distinguished" artists, save himself, belonged. A furious Ashbee swore he would have evicted Whistler had the artist not been ill.[36]

Despite the upheaval, Whistler's spirits improved as his strength returned. His doctor initially confined him to an upper-story bedroom, where Whistler guarded against the chill by wearing a heavy black coat over his nightshirt. Allowed, after a

week, to sit downstairs, he replaced the coat with a knitted shawl, drawn tightly around his shoulders. When tired, he reclined on an Empire bed, a kitten curled beside him for company. Harper Pennington unknowingly helped by sending a copy of an article he had written about their days in Venice. The magazine's editor had waited two years before publishing it, Pennington laughed, for fear Whistler might sue him.[37]

By October, Whistler felt strong enough to work in his studio, where there was less noise. He declined several commissions but had a red-haired model named Dorothy Seton sit for a pair of portraits. A new portrait of Rosalind also showed promise, and he resumed work on the portraits of Magda Heinemann and his dentist, Isaac Davenport, when sittings could be arranged. Davenport found him determined to paint even when weary, despite doctor's orders that he work no more than ninety minutes per day. "I worked too long yesterday," Whistler confessed to Davenport at one sitting. Yet, no sooner had the artist conceded the need for moderation than he resumed painting, completely absorbed in the project. "[He would] finally say," Davenport recalled, "'I must stop this time – really.'"[38]

His most enthusiastic effort went into a winter exhibition that included none of his work. The Fine Art Society asked to borrow pieces from his collection of old silver for an exhibition of table plate. Whistler agreed to the loan, but being forbidden to leave the house, he relied on Rosalind and Ethel to mount the display. It included everything from salt cellars to a coffee pot, over eighty pieces valued at £560. Whistler contented himself with preparing a small card for the display. On it, he wrote a verse from Proverbs 10:20: "The tongue of the just is as choice silver." He later regretted not asking to review proofs of the catalogue entries, which he thought entirely too brief. His name was also misspelled as MacNeil.[39]

He then became agitated when Montesquiou sold his portrait for 60,000 francs (£2,000). It had been understood that Montesquiou would bequeath the picture to the Louvre. That he had, instead, tried to profit from it gnawed at Whistler for two months. He wrote drafts of several public letters, never published, before finally sending a brief, scathing note to the count. "[A]nd the portrait acquired as a poet, for a song," he concluded, "is resold, as a Jew on the rue Lafitte, for ten times the melody!" A stunned Montesquiou replied, rather feebly, that he had sold the painting to "guarantee worthily the future of a very noble work of art." They never communicated again.[40]

The tilt with Montesquiou also came as Whistler's recent string of illnesses led him to ponder his legacy yet again. When John Lavery caught him that winter de-

stroying paintings and prints that Whistler thought inferior, their creator explained, as he had done in the past, "To destroy is to exist." The integrity of the work was everything. Ten years earlier, as he prepared his "autobiographical" section for the *Gentle Art*, Whistler brooded over what "foolish truths" people of only "slight intimacy" would one day write about him. The recent *Morning Post* obituary had confirmed those fears. He agreed with brother-in-law Wobbles Whibley, who had declared in an article about the "limits" of biography, "No sooner is genius laid upon its bier than the vultures are ready to swoop."[41]

William Heinemann had thought of writing a "life of Whistler," something an American editor urged the Pennells to do in the late 1890s. Elizabeth Pennell, worried about Whistler's response, had declined, and warned the editor that no one should attempt it without "his sanction." In 1900, Whistler agreed to cooperate with the Pennells in writing a book limited to a discussion of his art, but that was reason enough for Elizabeth to begin keeping a detailed record of their meetings and conversations.[42]

In 1901, an unauthorized biography was published, filled with the sort of inane drivel he most feared. That same year, Sheridan Ford resurfaced. Whistler thought he had rid himself of this "most impudent of scoundrel tramps" when a court in Antwerp found him guilty *in absentia* of "Piracy." An unrepentant Ford ignored the £120 indemnity, but when he tried to find work as a journalist in Paris and London, Whistler so hounded him that he returned to New York, abandoning his wife and daughter in the process. However, in 1901, Ford published *The Art of Folly*, a collection of poems about the art world written six years earlier for a Paris newspaper. Curiously, Charles Freer paid the printing costs of the book, seemingly in hopes of persuading Ford to temper some unflattering references to Whistler. He wasted his money.[43]

Now, upon his return from The Hague, Whistler learned that a London publisher, George Bell and Sons, wanted to include him in a series of brief artist biographies. The Bells had asked Bernhard Sickert, another of Walter's brothers, to write the book, but Sickert, not wishing his "scalp" added to the artist's collection, asked Whistler's permission to proceed. When Whistler failed to reply, Sickert declined the offer. The Bells then recruited Nancy Bell, no relation, but a popular writer on art and the wife of painter and illustrator Arthur Bell. Whistler said he would allow publication only if given the right to edit final proofs of the book, a concession he was also seeking for his biographical entry in the *Encyclopædia Britannica*. Bell and Sons refused him. The book was not published during his lifetime.[44]

And if biographers were a relatively new foe, Whistler had not let up on his original enemy, the critics. That winter, he took on one of his oldest opponents, Frederick Wedmore. In a November 1902 review, Wedmore insinuated that a portrait of Lillie Pamington shown at the Society of Portrait Painters was a well-known work that did not merit close description. As a matter of fact, Whistler had shown it only once before, at the Champs de Mars Salon the previous spring. A brief public skirmish between artist and critic followed when Whistler accused Wedmore of incompetence. He then recruited William Heinemann to help him expose Wedmore's lifetime of folly in a pamphlet that would include all of his correspondence with Wedmore and the choicest passages from the critic's published reviews. "An Interrupted Correspondence," Whistler's last literary effort, never went beyond page proofs.[45]

Whistler said the duel with Wedmore made him well again, but by the year's end, his health remained fragile. Complete bed rest might have proved a cure, but he had to be doing something, anything, if only to cause mischief. The Pennells thought the surest measure of this once-dapper man's decline was how he neglected his appearance. One day, he wore different colored shoes, and the staple of his "extraordinary costume" had become an old, floor-length, fur-lined brown coat, kept "well buttoned up." "That he should . . . be willing to be seen in it," ventured the Pennells, "seemed one of the worst signs of all." More troubling, though, was Whistler's reaction to a canceled portrait sitting by Magda Heinemann. He thought it a "pity" she could not come, but he also felt some relief. "[T]he hand is stayed – and the work ceases," he remarked, "for the joy of it has gone!"[46]

He seemed merry enough on Christmas Eve of 1902. He cheated at dominoes with Clifford and Inez Addams, the real fun being that everyone knew he was cheating and he knew everyone knew it. When a dealer arrived with a check for £410, payment from a sale of etchings and lithographs, Rosalind snatched it, tucked it in a pocket, and joyfully "slapped" at it. Whistler remonstrated, "Major, Major!" but he knew she needed the money to maintain their household.[47]

# 22

# *The Evening Mist*

## 1903–1908

The cheering prospects of Christmas carried into the new year of 1903. Dominoes became a mania, and even on bad days, with fits of coughing, low spirits, or waning energy, Whistler's mind remained sharp. He retained a possessive interest in the International and spoke of finding a permanent gallery for the society. He even approved of a new biography of himself. Its American author, Elbert Hubbard, made no pompous or ill-informed judgments about his art, and the book had so many factual errors that Whistler could only laugh. He could scarcely object to the way Hubbard quoted from the *Gentle Art* and *Ten O'Clock* as though citing Holy Scripture. Whistler called it "extraordinary," much better, he imagined, than anything Nancy Bell might have done.[1]

As for work, the portraits of Rosalind, Magda Heinemann, George Vanderbilt, and Dorothy Seton still wanted little somethings. Even a picture that sold for four hundred guineas at the previous year's Salon, *The Neighbours*, required "a few more touches." At Whistler's request, Isaac Davenport returned to sit, only to have the tired artist drop his hand and let the brush slip from his fingers. Pausing to rest, he fell asleep. There was time to sleep. Vanderbilt, at least, would not come until the summer.[2]

He most relished a picture begun a year earlier. Richard A. Canfield, a notorious American gambler, had persuaded him to paint his portrait. An advance of £500 for

two other pictures helped Canfield's cause, but having seen photographs of Canfield's baronial New York home, Whistler also thought him a man of taste. Its "refined feeling," the "perfect relation" between furnishings and *objets d'art*, Whistler said, bespoke someone "born to live with delight in what he gathers about him," not a " 'Collector' " who "stock[ed] his place with bric-a-brac!"[3]

Having sat for Whistler the previous spring, Canfield suddenly reappeared in London the second week of February. His illegal gambling house (-cum-brothel) had been raided in December. Rather than face trial, Canfield skipped the country, although everyone knew where he went. New York newspapers carried cartoons that showed him in London posing for Whistler. Some of Whistler's friends, most notably the Pennells and William Webb, worried about a "scandal."[4]

But Whistler had a weakness for bounders like Canfield. He called him "His Reverence" because of his smooth, dignified bearing. Canfield, in turn, was impressed by Whistler's stature as a "West Point man" and his "infectious" enthusiasm whenever reminiscing about the academy. However, the gambler's friendship proved costly. When Edward Kennedy cautioned Whistler about taking up with "a man of that kind," the artist rebuked him sharply, and in a way that Kennedy "could not forgive." William Chase had warned the dealer years earlier, "He will turn on you some day Kennedy, mark my words." Kennedy had replied cavalierly at the time, "Let him turn, . . . others can do a formidable turning act too!" True to his word, Kennedy had not communicated with him since Whistler's return from The Hague.[5]

Like him or not, the corpulent gambler had become nearly as great a connoisseur as Freer of Whistler's art. By May, when he returned to New York to face his legal woes, Canfield had spent £1,360 on sixty-nine lithographs, nine watercolors, two pastels, and several ink and pencil sketches. His biggest prize, the portrait of Rosa Corder, cost another £2,000. He acquired the picture only after a relentless assault on its owner, Graham Robertson, and with Whistler's encouragement. "Damn fool!" Canfield later said of Robertson. "I would have offered 5,000 pounds and jumped at the chance of getting it for that."[6]

Canfield's guineas came on top of more recognition from Scotland. In February, Whistler learned that he had been elected an honorary member of the Royal Glasgow Institute of the Fine Arts and that the University of Glasgow wished to confer a Doctor of Laws degree. He might have scoffed at a title from Cambridge or Oxford, but purchase of the Carlyle had long since cemented his allegiance to Glasgow. He would receive the degree *in absentia*, for his doctor forbade him to travel north for the ordination, but Whistler basked in the "flattering compliment."[7]

News from America compensated for missing the pomp and circumstance of Scotland. First, he learned that Robert Montesquiou, like Oscar Wilde, was borrowing freely from his ideas for a series of lectures in New York. Whistler thought of tweaking this "weak descendent of the crusades" in the press until Harper Pennington assured him that New Yorkers were more amused than impressed by the Frenchman's "baragouin," or gibberish. However, Whistler did respond to the "inferior" hanging of his work at exhibitions in Philadelphia and New York. Told of the debacles by Charles Freer, he sent a satirical letter to the organizer of the New York show that found its way to the city's newspapers. Whistler had again "caused a chuckle of satisfaction to run through the art world."[8]

It seemed like old times. Letters from old friends burnished his memories, and visitors found him eager, almost desperate, to reminisce. Pennington wrote to him about Venice, the nocturnes, Chelsea, and his first impressions of *The White Girl* and *Alone with the Tide* in 1875. Someone had recently offered $25,000 for *The White Girl*, he told him. One can imagine the ailing artist looking bemused at that news, much as he looked in the Boldini portrait, then part of an exhibit at the New Gallery. "A speaking likeness," *Punch* said of the picture. "And what good things he is saying to you! What a light in his laughing eyes!"[9]

Sadly, that light appeared less often by summer. Graham Robertson was not surprised. Whistler had declined steadily since the death of Trixie. Having read aloud a letter intended for the newspapers, perhaps the Wedmore letter, he asked for Robertson's opinion. "Well? Eh? Well?" he prodded in his usual way. "How's that, d'you think?" Robertson faltered. He could not tell him that it lacked his customary sparkle and spontaneity. Rosalind, witnessing the scene and guessing Robertson's thoughts, passed close to him and whispered, "Don't tell him now if you don't like it. He has been over it all the morning and he's so tired." Robertson understood. One of the two most "vital people" he had ever known, the other being Sarah Bernhardt, was fading. A man for whom life had been "an art and a cult," who had "lived each moment consciously, passionately," was worn out.[10]

By July, Whistler had taken a turn for the worse. Another Philip sister, Constance Lawson, joined Rosalind and Ethel to nurse him. Friends saw a "curious vague look in his eyes, all the life gone out of him." When Duret visited, he found him in a "stupor." Hearing that Whistler had been uninterested in examining some prints shown him by a London art dealer, Kennedy thought it "a sign of the end." The artist displayed occasional spunk, as when refusing to eat any more "damned" chicken soup, but that only made Rosalind, her nerves already frayed, more anxious.

Whistler's sixty-ninth birthday came and went with little comment and no celebration, and the artist turned somber indeed when told that William Henley had died on the same day.[11]

Charles Freer, among all Whistler's circle, seemed least willing to concede the seriousness of his condition (fig. 102). Having arrived in London, he sent flowers to brighten the house and spoke eagerly of sitting for his unfinished portrait. With the doctor's permission, he took Whistler on brief carriage rides "to town" and across the river to Battersea Park. On July 16, they drove through St. James's and Hyde parks. Whistler seemed refreshed. He played dominoes with the Major and Bunnie before dinner. He slept well that night.[12]

Freer reported to 74 Cheyne Walk the next day, a Friday, at 3:40 p.m., ready for another carriage ride. Whistler had died five minutes earlier. It was a fine day, warmer than the previous one, which had been cloudy with periods of rain. Whistler, in good spirits that morning, suddenly collapsed after lunch. Rosalind sent for the doctor, but he came too late to save Whistler from a blood clot in his brain. Freer spent the next five days with the Philip sisters. A calm and experienced voice, as he had been at The Hague, he helped them cope with the trying details of a funeral. To his business partner and fellow art collector in Detroit, Frank Heckler, Freer wrote, "Need I say that in all things of perfect refinement of beauty the greatest masters are now all gone."[13]

After embalming, Whistler lay in his studio for three days so that friends could pay their respects. Both Jo and Maud visited. Jo wore a heavy veil, but when she raised it to gaze on Whistler's face, Freer recognized her instantly, despite the streaks of gray in her thick auburn hair. She stood by the coffin for nearly an hour. Maud, having married a wealthy American, John A. Little, and moved to Paris, probably learned of Whistler's death while spending summer on the French coast. Duret kept both her and George Lucas informed of Whistler's condition. Maud told Duret and Lucas that the past no longer concerned her, but she was "very much affected" when she saw his face, and some people claimed to see her later at the funeral, even that her unexpected appearance caused "some disturbance." A few months after Whistler's death, she assisted Duret and Menpes with published appreciations of the artist.[14]

Shortly after 11 a.m. on July 22, a brief funeral service was held at St. Luke's, Chelsea Old Church, where Anna Whistler had worshiped. Wreaths and flowers, sent by artists' societies in England and Scotland, adorned the sanctuary. James Guthrie, John Lavery, Edwin Abbey, Duret, and George Vanderbilt, who had just arrived from America, bore the polished oak casket, draped with a purple pall and

topped by a small chaplet of gold bay leaves. Devoted Peter Studd, who would rather have sold his house than part with his Whistlers, was to have been a pall-bearer. He kindly gave way to a distraught Duret, who kept lamenting that Whistler had been the last of his old friends.

At least a hundred friends and relatives filled the pews, and a large crowd gathered outside. Attendees included members of the Royal Academy, but only the International and Royal Scottish Society, of the many organizations to which Whistler belonged, sent official representatives. Then again, arrangements for the funeral had not been published until the preceding day. There would be no memorial service at Westminster, as there had been for Burne-Jones, nor at St. Paul's, as there would be for G. F. Watts. No one proposed burial at St. Paul's, as had befitted Lord Frederic Leighton and Sir John Millais, even though some admirers thought Whistler more deserving of such honors than any of those men.

From St. Luke's, a cortège of seven carriages followed the hearse and an open landau filled with more floral wreaths to Chiswick, where Whistler would rest beside Trixie (fig. 103). As he passed beside the Thames one last time, the river seemed to change mile by mile, one moment being a "grey reflection of the sky, overdone with a curious green light," the next, seemingly crystal clear, the green light "shining from within." They reached Chiswick's St. Nicholas churchyard shortly past noon. Late arrivals found it impossible to get near the graveside (fig. 104).[15]

Published tributes appeared for months in the art journals of Britain, America, and France. A few commentators refused to concede too much influence to Whistler's art, usually because they confused the art with his public image. "One cannot be both king and court jester," as one critic put it. Whistler's friends bristled at such damnable "rubbish," and, in fact, most commentators recognized his genius. They fondly recounted notable events in his public life, including letters to the press, the Peacock Room, the Ruskin trial, the "Ten O'Clock," the *Gentle Art*, the Jimmy and Oscar show. They noted that, despite his vanity and sometimes outrageous behavior, Whistler had never lacked courage or wavered in his beliefs. "He followed his own path," summarized an American newspaper, "and the place he occupied was his by right." Poems – mostly bad ones – celebrated the "immortal elfin," this "Puck," this merry "sprite."[16]

Thoughtful obituaries mentioned the same three features of Whistler's life. First, his youthfulness. Everyone knew he had been ill, but the end still came as a shock. "He was in his seventieth year," Arthur Symons marveled, "and until quite lately seemed the youngest man in London." "[I]t was impossible to conceive of Mr.

Whistler as an elderly man," submitted thirty-seven-year-old English painter and critic Roger Fry. "He seemed to be always inaugurating a revolution, leading intransigent youth against the strongholds of tradition and academic complacence." More than simply lying about his age, he had refused to think of himself as old. Even people who knew the truth could be fooled. Ethel Whibley, in completing the death certificate, listed his age as sixty-seven.[17]

Second, and most consistently, Whistler was hailed for devoting his life to the creation of beautiful things. His single-mindedness and absolute conviction in "certain principles of art" sometimes went too far, but no one who knew anything of the private Whistler could doubt the sacrifices he had made for art's sake. "For all the artists of our time," insisted Fry, who was not uncritical of Whistler's theories, "he has stood out most emphatically for artistic probity." If often a "protagonist," he was also an "Artistic Evangelist," declared a Manchester newspaper. The *Academy* concluded, "Whistler the flâneur, the epigrammist, the scalp hunter, sprightful and spiteful, was swept away, and what was left was Whistler the consummate artist responsive to the chords of beauty." A professor of Japanese art insisted that Whistler came nearer than such past masters as Giorgione, Velázquez, or Michelangelo in "blending all the characteristic excellences into a single broader art, that must lead out as pioneer into the future."[18]

Third, commentators laughed at the depiction of Whistler as Mephistopheles. This may have displeased the artist, who reveled in that reputation, but friends had known the truth for some time. "[Y]ou represent to me all that is delightful, fine and great in life," Pennington had chided him in March. What was more, he continued, others thought the same thing. "George Vanderbilt has found you out, too," he said. "He knows that you have a great big heart which you have been at some pains to hide from most persons." Now, the public was being let in on the secret. "[T]here was a more genial side to him than this gentle art of making enemies," noted a commentator who was particularly struck by Whistler's efforts to promote women artists. "[There was] the gentler art of making friends, which he understood even better."[19]

Many of Whistler's supposed enemies privately endorsed this last assessment. Edward Kennedy was heartbroken by his failure to reconcile with Whistler. Having been in London for several weeks, and learning the seriousness of his friend's condition, he finally went to Cheyne Walk just hours before Whistler died. Rosalind, for whatever reason, turned him away. The full weight of the loss struck him several months later, while reading Whistler's old letters. He still blamed Whistler for their

rupture, but that could not ease the "painful feeling" that they had been estranged at the end.[20]

The Thomas Ways, father and son, also would have welcomed reconciliation. "I trust he may soon be himself again," the younger Way had told Freer during the illness at The Hague. "I would like to offer him my father's and my sincerest sympathy, only I fear he would not take it kindly." Way attended the funeral and was one of the people who thought the service should have been held at St. Paul's. He later published his "memories" of Whistler, although, not wishing to dredge up old grievances, he subtly stressed that he wrote of Whistler "the artist."[21]

The list went on. Will Rothenstein attended the funeral and wrote fondly of Whistler in his memoirs, as did Mortimer Menpes, perhaps the most mercilessly abused of the disciples. Indeed, like young Way, Menpes wrote an entire book about his association with Whistler. William Chase was a bit harder. "[H]e will be very much missed as an Artist," he told his wife upon learning of Whistler's death, "but I question if many will grieve his absence in any other way. I certainly am *not* over come with grief." Yet, when fifty students at his atelier in Holland sent a funeral wreath to St. Luke's, Chase thought it a "nice" gesture. Writing years later about his experiences with "the two Whistlers," he concluded, "[T]here was only one genuine . . . Whistler the tireless, slavish worker, ceaselessly puttering, endlessly striving to add to art. . . . Whistler the great artist . . . was his *real self.*"[22]

Walter Sickert, who was living at Dieppe, did not comment on Whistler's passing. He would write critically of some of Whistler's theories and actions in the years to come, and he remained sensitive about his own image as a "traitor," but he never denied his fondness and admiration for the "fascinating and impish master." Ellen Sickert, his former wife, mindful of Whistler's many kindnesses to her and Walter, attended the funeral.[23]

Marion Spielmann and Max Beerbohm penned appreciative essays. "Prodigiously affected by trifles, irritated by the unimportant," Spielmann observed, "he fought and attacked where it would have been to his greater dignity to have ignored." However, the editor continued, Whistler never "sacrifice[d] a principle or prostitute[d] a thought . . . in order to better his position." Spielmann could separate the man and the artist, much as Whistler himself had done. "He is 'Jimmy' in life," Spielmann declared, "but 'Mr. Whistler' in art." Beerbohm also understood Whistler's "unfaltering devotion to his own ideals." Having ridiculed the *Gentle Art* six years earlier, he now revealed, "It happens to be also a book which I have read again and again."[24]

Not everyone was so magnanimous. Algernon Swinburne, just three months before Whistler's death, said he wanted neither to discuss the artist nor to see him. Equally uncompromising, though in a purely intellectual way, was E. Wake Cook. The Australian-born artist shuddered to read the gushing tributes to Whistler. An academician to the core, Cook wondered if people had forgotten how this "stormy petrel" had promoted "anarchism" in art. There could be no disputing Whistler's "dominating and fascinating personality," or the skill with which he "so daintily, so delightfully," presented his "gospel" to the world, Cook conceded, but therein lay the danger. Whistler had persuaded many artists, critics, and average people of the truth of his "false doctrines." He had been the "evil genius of British Art and Art Criticism."[25]

If anyone had a right to be critical it was Charlie Hanson. Now thirty-three-years old and working as an electrical and mechanical engineer, he attended the funeral with his wife, Sarah. The relationship between father and son had remained cordial since the early 1890s, although Whistler had not attended Charlie's wedding in 1896. He had been offended because Charlie told him of the nuptials only days before the event and had sought "neither advice nor counsel" from him about marriage. Nonetheless, Whistler sent a wedding gift of money "to the lady," and when Sarah replied in the kindest way, he regretted his earlier "tone" and wished the couple "every happiness" (fig. 105).[26]

Contact between father and son was occasional thereafter, although Whistler kept track of Charlie's fortunes through Willie and Agnes and Charles Singleton. He sent Christmas and New Year greetings, and expressed concern about the slightly built Charlie's medical problems. Still, he could not resist an occasional lecture. In 1900, he wished Charlie and Sarah "health & success" in the new year but added, "& what is called Luck – which comes to those who don't wait for it!" He never added Charlie to his will, although that circumstance might have changed had he lived to see the daughter born to Charlie and Sarah in 1905. Charlie died in 1935, having returned to live in Clapham, where his mother resided and he had been born (fig. 106).[27]

As for his other children, Whistler had remained close to Edward Godwin. His stepson showed his respect by designing and sculpting the bronze tomb that guards the remains of Whistler and Trixie to this day. Begun in 1909, he completed the work in 1912. Whistler does not appear to have seen his surviving daughter by Maud, Ione, beyond her childhood. He likely did not know that by the time of his final illness she had married, moved to America, and borne three children.[28]

Then came what Whistler had dreaded more than death: the rush by friends and admirers to memorialize him. He had wished to be remembered in a single retrospective exhibition in Paris, for, as Max Beerbohm pointed out, "no one would have been more annoyed than he by canonization." Yet, the very afternoon of his funeral, the council of the International voted to erect a memorial to their leader in a garden along Cheyne Walk that already included a statue of Carlyle and a bas-relief bust of Rossetti. Rodin, who replaced Whistler as president of the International, volunteered to sculpt it for the cost of the materials, but disagreement arose over what form it should take. The council envisioned a large, symbolic "Winged Victory" to represent "Whistler's triumph – the triumph of Art over the enemies." Rodin chose instead a Venus-like "muse" of art. His model was Whistler's former student Gwen John, by then Rodin's lover. He liked the Welsh girl's "fine legs," although it was her striking face that became the focus of the sculpture. In the end, it did not matter. The statue remained unfinished at the time of Rodin's death in 1917.[29]

More divisive was the bitter feud among Whistler's family and friends over who should shape his legacy. Most people were probably not surprised to learn that, after payment of taxes, funeral expenses, and outstanding debts, together totaling £112 3s. 7d., Whistler's estate amounted to only £11,020, a modest sum for someone of his stature. He had ended with greater wealth than Rossetti, Ruskin, or Albert Moore, but far less than Leighton, Millais, or Burne-Jones. More surprising, and alarming to some people, was the control Rosalind assumed, as his "personal representative," over the copyrights to his art and private correspondence. This is what caused the feud. "Whistler made plenty of trouble in his life," a bemused Frederick Keppel observed as the controversy grew, "and he seems to still turn and *bite* his best friends from his grave."[30]

The pro-Rosalind camp was relatively small. Besides her family, it included Freer, the Vanderbilts, Canfield, Graham Robertson, Peter Studd, and "the Scots," led by Lavery and Guthrie. Mrs. Vanderbilt showed support by naming a new chrysanthemum the "Miss Birnie-Philip." Understandably, though, Freer topped the list. He had no sooner returned to Detroit than Rosalind wrote to him. "I wish America were not so far off and that instead of writing we could talk!" she worried. "There are so many things to . . . ask your advice upon that I do not know where to begin." Part of her concern involved financial investments, which Freer agreed to manage for her. More important was the Major's need to plan campaign strategy and battle tactics.[31]

At twenty-nine, Rosalind was considerably younger than her leading adversaries, but no less committed to managing her brother-in-law's affairs as she believed he

would have done (fig. 107). "Poor Linda," a friend considered, "such a strange life for a young girl as hers has been. Mr. Whistler will always be a great memory to us all but above all to her." More than a memory, Rosalind often claimed to feel his presence, "as if he were still watching over his own affairs." Her stubborn conviction worried opponents, who accused Rosalind of having "inherited all Whistler's most unreasonable prejudices," and of exceeding her legal authority over copyright issues for exhibitions and publications.[32]

The Pennells provided the heart of the opposition. They had resented Rosalind's influence over Whistler even before he died. Indeed, they believed the entire Philip family had sucked the life out of him. Joseph Pennell described the Philip sisters as "five vampires in black" at the funeral, and where others might have admired Rosalind's stoic, "expressionless face" at the graveside, Pennell thought her either "mad or a fool" for displaying so little emotion. When she was forced to vacate 74 Cheyne Walk and take lodgings across the river, at 103 Albert Bridge Road, Pennell dismissed her as the "Lady at Battersea."[33]

Necessarily, the Pennells distrusted Freer, too. Joseph, at least, appeared to be jealous of the collector's personal relationship with Whistler. That prejudice deepened when, after attending the initial planning sessions for the Rodin monument, Freer withdrew and subsequently commissioned a memorial plaque for West Point from American sculptor Augustus Saint-Gaudens. More substantially, both Pennells accused Freer of buying Whistler's remaining pictures from Rosalind at bargain prices. In fact, while he did purchase a number of paintings from the estate, they were nearly all works that he had already claimed, including his own unfinished portrait. Freer made his grandest purchase from the dealer who had acquired the Peacock Room, and only after Rosalind had begged him to save it. Following some inspired bargaining, he paid £8,400 for the room in 1904. More importantly, he eventually donated it and his entire art collection, of which Whistler's work was only one part, to the American nation.[34]

Rallying to the Pennells were people who, if not so dismissive of Freer, shared the couple's resentment of the entire Philip clan. This included the three surviving women of the Whistler family, Debo, Annie, and Nellie. Frail at age seventy-eight, Lady Haden, as Debo had become, disapproved of Rosalind's status as Whistler's ward and heir. Annie, now approaching fifty-five years of age and married to a solicitor, sided with her mother. This was out of loyalty at first, but she became increasingly "indignant" toward the Philips after what she considered their cool treatment of her and Lady Haden at Whistler's funeral. Nellie, for her part, was one of several

people who dated Whistler's declining health and happiness from his marriage to Trixie, rather than from her death.[35]

An impressive array of Whistler's friends also sided with the Pennells. Thomas Armstrong, Alan Cole, and William Rossetti befriended them, as did Luke Ionides and Théodore Duret, two more people who claimed to have disapproved of Whistler's marriage. From a younger generation, Inez Addams had felt sorry for Rosalind immediately after Whistler's death but subsequently became so annoyed by "her airs" that she dropped all pretense of neutrality. Whistler's closest business associates and legal advisors, including David Thomson, William Heinemann, Tom Way, Frederick Keppel, and William Webb also became important Pennell advocates.[36]

Most of those people resented Rosalind's severe restrictions on exhibitions and photographic reproductions of Whistler's art, but the Pennells feared her determination to deny publication of Whistler's private correspondence and her insistence that his "dying wish" had been "that no life should be written." The Pennells' book about his art had become precisely that, a biography. They had been interviewing people, soliciting letters, and asking dozens of Whistler's friends to share their recollections of him ever since the funeral. By the autumn of 1907, they had finished writing the manuscript, but Heinemann, who was to publish it, dared not move without first clarifying their legal rights, which Rosalind seemed poised to quash.[37]

The market had been flooded in the four years since Whistler's death by purported "biographies" and reminiscences and memoirs that featured him. "Everybody is having a fling at poor Whistler," American art critic and professor John C. Van Dyke told the Pennells. "Why I'm even writing about him myself and in the 'Ladies Home Journal' at that! – Heaven help us." It would not be long, he feared, before the "poor chap" was " 'explained' out of existence." A. L. Baldry and George Boughton thought the "gushers" had displayed an "amazing absence of logic in the Whistler discussions," although both men, like Van Dyke, knew the Pennells would be the main event. Boughton, who liked neither the Pennells nor Heinemann, thought it an evil day when that trio set upon Whistler, and he was pleased to see Rosalind "shutting down on Joe and his schemes." Just look at them, he scoffed to Baldry, "tumbling over each other to write his *Life*! Great Scott!! The grim irony of it all!!" Boughton did not expect to find even "a *few* grains of truth" in the Pennell book.[38]

Another painter friend of Whistler thought the bickering "a tragedy of human cross-purposes that was probably quite unnecessary," but, as befitted Whistler's legacy, the suspicions and resentments finally led to litigation. The case of *Philip v. Pennell* went to trial in the Chancery division of the High Court of Justice in July

1907. Both sides won something in the three-day battle, although, in strict legal terms, Rosalind lost her suit. The case featured two main issues. On the first one, the judge ruled that Whistler had clearly "assented to Mr. and Mrs. Pennell writing a book on himself." There remained some question, he acknowledged, about the type of book intended, whether biography or catalogue, but even a catalogue, he maintained, must necessarily contain biographical information. On the trickier issue of copyright, the judge split the difference. The Pennells were not allowed to publish Whistler's correspondence verbatim, but they could use information about his "character, habits and opinions" derived from it.[39]

The court's decision gave the Pennells enough leeway to launch their monumental *Life of James McNeill Whistler* late the following year. In advertising it, Heinemann made much of the court decision. The "biography," as he pointedly called it, had been "authorised" by Whistler and was "based on material furnished by himself and by his family." Freer predicted that the book would be quickly forgotten. In fact, there would be six revised editions over the next seventeen years, with a French edition published in 1913.[40]

But the Pennells should have counted themselves lucky. The judge had passed over a crucial issue in the trial, or rather, found too little evidence to rule on it. Many fine points in the case depended on whether Whistler intended the book to be published during his lifetime, and had the judge understood Whistler's obsession with controlling his legacy, his desire to be the author of his own biography, he may well have ruled differently. The Pennells knew, as well, of a provision in their commission that could have sunk them. They insisted repeatedly that the letter written to them by Heinemann in May 1900, saying that Whistler had consented to a book about his art, had also invited them "during his lifetime, to do the life." However, the Pennells failed to produce this letter in court, largely because they, Heinemann, and George Lewis, who advised them, thought it might be "misconstrued" and do their case "a great deal of harm." The letter subsequently disappeared. In later years, when the Pennells published portions of Elizabeth's diaries as *The Whistler Journal*, they altered or deleted passages concerning their commission and the missing letter.[41]

Whether or not the Pennells got Whistler's story right is another matter altogether, and still much debated. People who had known Whistler far longer accused the American couple of "exploiting" the dead artist. Marie Spartali, the model for *La Princesse*, refused to cooperate with them until Nellie Whistler asked her to talk about "those early days." Even so, Spartali held "back things not desirable & unnecessary." Other people, including Alan Cole, made lists or marginal notes of the errors

they found in the *Life*. It would have been interesting to know Edward Kennedy's reaction. O.K. preserved his extensive correspondence with Whistler and had begun to write memoranda and brief notes about Whistler's work and activities, but the American knew all too well the difficulties of explaining Whistler's complex life and personality. When a French art dealer asked why he had not joined the tribe of eager scribes, Kennedy snorted, "I could write about Whistler, but I leave that to fools."[42]

Rosalind, who lived until 1958, spent the remainder of her life acquiring as much as possible of Whistler's private correspondence. Freer, who continued to be a staunch friend until his death in 1919, provided cash to purchase letters that came on the market. Not that Rosalind's guardianship was faultless. She met "reluctantly" with Whistler's next biographer, James Laver, and only after he had published his 1930 volume. While cordial, she appalled the author by saying she intended to destroy some of her brother-in-law's letters. Laver could guess their content when Rosalind casually mentioned that Jo and Maud had been "primarily models." She "[w]ould obviously have liked to think that they were never anything else," he mused.[43]

What Whistler would have made of it all is hard to say, although that thought worried Elizabeth Pennell. A year after publishing the biography, she dreamed of Whistler. "He suddenly made his appearance in a room where we were with a number of other people," she confided to her diary. "The only comment was, 'Why he is not dead, after all.'" All went well until Rosalind walked in to show Whistler some documents. "[M]y thought was," Pennell wrote, "I wonder what he will say to the way she has behaved to us, will he side with her? But he turned and spoke to me in the old friendly way with his usual smile and gestures." Then, however, still dreaming, a "little qualm" struck her: "[H]e will hardly like the way we treated the Leyland affair!"[44]

People who do not dream of Whistler may at least commune with him. While Rodin never completed his memorial, in 2003, the centenary of Whistler's death, a life-size statue of the artist was erected in a tiny public garden at the northern foot of Battersea Bridge. The bronze likeness faces upriver and across Battersea Reach, a sight Whistler gazed on countless times. Appropriately, it shows him at work, sketchbook in hand, doing what he most loved to do. Stand near him at dusk, follow his gaze across the Thames, and one may easily imagine him saying, "When the evening mist clothes the riverside with poetry, . . . Nature . . . sings her exquisite song to the artist alone, her son and her master – her son in that he loves her, her master in that he knows her." And there remains the art, for its own sake.

# *Abbreviations*

JW identifies James Whistler throughout. In addition, the following abbreviations are used:

Manuscript Depositories and Selected Collections

| | |
|---|---|
| AAA | Archives of American Art, Washington, D.C. |
| AAD | Archives of Art and Design, London |
| AIC | Ryerson and Burnham Libraries, Art Institute of Chicago |
| BL | British Library, London |
| BMA | Baltimore Museum of Art |
| CH | Castle Howard, England |
| FGA | Freer Gallery of Art, Washington, D.C. |
| FM | Fitzwilliam Museum, University of Cambridge |
| GUL | University of Glasgow Library |
| HM | Hunterian Museum and Art Gallery, University of Glasgow |
| KCA | King's College London Archives and Corporate Records |
| LC | Manuscript Department, Library of Congress, Washington, D.C. |
| MHS | Maryland Historical Society, Annapolis |
| MMA | Metropolitan Museum of Art, New York |

NA      National Archives, Washington, D.C.

NAL     National Art Library, Victoria and Albert Museum, London

NGA     National Gallery, London

NYPL    New York Public Library

PWC     Pennell–Whistler Collection, Manuscript Department, Library of
        Congress, Washington, D.C.

RA      Royal Academy of Art, London

RB      Rare Book Room, Library of Congress, Washington, D.C.

RHC     Ransom Humanities Research Center, University of Texas, Austin

TC      Trinity College, University of Cambridge

TGA     Tate Britain Gallery of Art, London

SA      Sheffield Archives, England

UM      John Rylands Library, University of Manchester

UO      Bodelian Library, University of Oxford

USMA    Cadet Library, U.S. Military Academy, West Point, N.Y.

WC      Whistler Collection, University of Glasgow Library

Periodicals and Published Works

*AB*      *Art Bulletin*

*AH*      *Art History*

*AJ*      *Art Journal*

*AM*      *Atlantic Monthly*

*AQ*      *Art Quarterly*

*BM*      *Burlington Magazine*

*FAQ*     *Fine Arts Quarterly Review*

*FR*      *Fortnightly Review*

*G*       *James McNeill Whistler: The Etchings. A Catalogue Raisonné*, ed. Margaret
          F. MacDonald. Online edition, University of Glasgow, 2008.
          http://etchings.arts.gla.ac.uk, the G followed by catalogue number.

*GAME*    *The Gentle Art of Making Enemies*, by James McNeill Whistler (London,
          1890).

*GBA*     *Gazette des Beaux-Arts*

*GUW*     *The Correspondence of James McNeill Whistler, 1855–1903*, ed. Margaret F.
          MacDonald, Patricia de Montfort, and Nigel Thorp; including
          *The Correspondence of Anna McNeill Whistler, 1855–1880*, ed. Georgia

Toutziari. Online edition, University of Glasgow, 2003. http://www.whistler.arts.gla.ac.uk/correspondence, the *GUW* followed by document number.

| | |
|---|---|
| *ILN* | *Illustrated London News* |
| *IS* | *International Studio* |
| *JPRS* | *Journal of Pre-Raphaelite Studies* |
| *LJW* | *The Lithographs of James McNeill Whistler*, 2 vols., by Harriet K. Stratis, Martha Tedeschi, Nesta R. Spink, Katharine Lochnan, and Nicholas Smale (Chicago, 1998). |
| *LW* | *The Life of James McNeill Whistler*, 2 vols., by Elizabeth R. and Joseph Pennell (London, 1908). |
| M | *James McNeill Whistler: Drawings, Pastels and Watercolours: A Catalogue Raisonné*, by Margaret F. MacDonald (New Haven, 1995), the M followed by catalogue number. |
| *MA* | *Magazine of Art* |
| *MM* | *Metropolitan Magazine* |
| *NC* | *Nineteenth Century* |
| *OAJ* | *Oxford Art Journal* |
| *PCQ* | *Print Collector's Quarterly* |
| *PMG* | *Pall Mall Gazette* |
| *PQ* | *Print Quarterly* |
| *SR* | *Saturday Review* |
| *TLS* | *The Times Literary Supplement* |
| *VCB* | *Visual Culture in Britain* |
| *VPR* | *Victorian Periodicals Review* |
| *VS* | *Victorian Studies* |
| *WJ* | *The Whistler Journal*, by Elizabeth R. and Joseph Pennell (Philadelphia, 1921). |
| *WR* | *Whistler Review* |
| YMSM | *Paintings of James McNeill Whistler*, 2 vols., by Andrew McLaren Young, Margaret F. MacDonald, and Robin Spencer (New Haven and London, 1980), the YMSM followed by catalogue number. |

# Notes

I: JAMIE, MY BOY

1   Albert Parry, *Whistler's Father* (Indianapolis, 1939), although marred by an unreasonable bias against Anna Whistler, is the only modern biography of George Washington Whistler.

2   Elizabeth Mumford, *Whistler's Mother: The Life of Anna McNeill Whistler* (London, 1940), is the only narrative biography of Anna, although it should be supplemented by the excellent essays in Georgia Toutziari, "Anna Matilda Whistler's Correspondence – An Annotated Edition" (PhD thesis, Univ. of Glasgow, 2002).

3   Richard Mombray Haywood, *Russia Enters the Railway Age, 1842–1855* (Boulder, Col., 1998), 30–32, 35–36, 38, 58–59, 74–75, 100–01. Useful for background is Haywood, *The Beginnings of Railway Development in Russia in the Reign of Nicholas I, 1835–1842* (Durham, N.C., 1969).

4   Toutziari, "Anna Whistler's Correspondence," 102–10; Anna M. Whistler Diary, 1843–48, November 28, 1843, NYPL, with microfilm copy in AAA.

5   Whistler Diary, November 28, 1843; Katherine Prince Journal, December 12, 1845, Katherine Prince Collection, AAA.

6   J. G. Kohl, *Russia and the Russians in 1842,* 2 vols. (London, 1842), and John S. Maxwell, *The Czar, His Court and People* (London, 1848), describe Russia and St. Petersburg; Alexander Lee Levin, "Inventive, Imaginative, and Incorrigible: The Winans Family and the Building of the First Russian Railroad," *Maryland Historical Magazine*, 84 (Spring 1989), 50–56.

7   Frederick Prince to Katherine Prince, January 8 [1843], Prince Collection; Whistler Diary, November 28, 1843; G. W. Whistler to JW, February 15, 1843, *GUW* 6659.

8   Mumford, *Whistler's Mother,* 22–23, 30.

9   Whistler Diary, February 14 and 26, and March 29, 1844.

10   George Heard Hamilton, *Art and Architecture of Russia* (3rd edn.; New York, 1983), 283–86, 292–93, 335; Maxwell, *The Czar,* 70–71;

Whistler Diary, May 29, July 9, and August 28, 1844.

11 Maxwell, *The Czar*, 60, 96; Kohl, *Russia and Russians*, I:69–70; Whistler Diary, May 31, June 5, and July 1 and 5, 1844, April 5 and 17, 19, and June 18, 1845, July 7, 1846; Anna Whistler to J. G. Swift, September 24, 1846, Joseph Gardner Swift Letters, AAA.

12 G. W. Whistler to J. G. Swift, September 28, 1837, Deborah Whistler to Swift, September 28, 1843, Swift Letters; Kohl, *Russia and Russians*, I:56.

13 Phyllis Penn Kohler, ed. and trans., *Journey for Our Time: The Journals of the Marquis de Custine* (New York, 1951), 68–73; Maxwell, *The Czar*, 206–07; Whistler Diary, November 28, 1843.

14 Whistler Diary, April 10, 22–24, and 28, May 29, and July 1, 1844.

15. Ibid., January, February 11 and 26, March 12, June 2 and 17, July 1, 5, and 22, and August 18, 1844; Haywood, *Russia Enters Railway Age*, 256–61.

16 Galina Andreeva and Margaret F. MacDonald, eds., *Whistler and Russia* (Moscow, 2006), 58–60, 83–84. For Briullov, see Galina Leontyeva, *Karl Briullov: Artist of Russian Romanticism* (Bournemouth, 1996).

17 Whistler Diary, July 1, 1844.

18 Ibid., November 23, 1843, May 3, 6, and 29–30, June 5 and 10, July 1, 5, 8, 10, and 12, and August 20, 1844, April 5 and 17, 1845.

19 Ibid., June 28, 1845.

20 Hamilton, *Art and Architecture*, 290–92, Kohl, *Russia and Russians*, I:11–12; Andreeva and MacDonald, *Whistler and Russia*, 20, 60–61; Whistler Diary, April 5 and 17 and May 5, 1845.

21 St. Petersburg Sketchbook, c. 1844–48, No.46004, HM, with detailed descriptions of the drawings in M.7.

22 Whistler Diary, May 2 and 30, and July 7 and 14, 1846; Andreeva and MacDonald, *Whistler and Russia*, 63–67, 69–73.

23 Whistler Diary, September 12, 1846; Anna Whistler to J. G. Swift, September 24, 1846, Swift Letters.

24 Prince Journal, November 10, and December 10, 12–13, 16, 19, and 23, 1845, August 28–29, and September 2, 1846; Whistler Diary, November 29, 1845, March 9, September 12, October 6, 15–16, and 29, and December 5, 1846.

25 Whistler Diary, December 25 and 29, 1846, and January 23 and 30, 1847.

26 Ibid., February 6, 8–9, and 27, 1847; JW to Anna Whistler, March 17, 19 and 20, 1849, *GUW* 6390. Debo probably acquired James Heath and John Nichols, *The Works of William Hogarth* (London, 1835). George Whistler may have purchased Rev. John Trusler's *Hogarth Moralized*, 2 vols. (London, 1831), an edition that would have pleased Anna.

27 Whistler Diary, February 6, March 23, April 15, May 10, and June 26, 1847.

28 Ibid., June 26, 1847; Anna Whistler to G. W. Whistler, June 8 and 10, 1847, JW to G. W., June 21 and 23 and July 3, 1847, *GUW* 6357, 6660.

29 Whistler Diary, June 26, July 28, and September 10, 1847; JW to G. W. Whistler, June 21 and 23 and July 3, 1847, *GUW* 6660.

30 Whistler Diary, December 9, 1846, September 10, 1847, and subsequent undated entry; G. W. Whistler to Anna Whistler, July 16, 18, and 19, 1847, *GUW* 6661; G. W. to Anna, September 17, 1847, Swift Letters.

31 W. Bruce Lincoln, *Nicholas I: Emperor and Autocrat of All the Russias* (Bloomington, Ind., 1978), 273–74; Anna Whistler to G. W. Whistler, June 20–21 [1848], *GUW* 6358.

32 Whistler Diary, undated entry following September 10, 1847 and July 22, August 1–2, 6, 8–9, and 11, and September 1848.

33 E. I. Winstanley to JW, September 28 [1848], [Autumn 1848], December 22, 1848, John Winstanley to JW, December 23, 1848,

Deborah Haden to JW [September 1848], [November 1848], WC; several letters from Anna Whistler to JW, September–December 1848, *GUW* 6359–61, 6366, 6368, 6374–76.

34   Whistler Diary, June 2 and 17, and July 1, 5, 8, and 13, 1844; Anna Whistler to G. W. Whistler, June 8 and 10, 1847, G. W. to JW, August 9, 1848, Anna to JW, September 12 [1848], *GUW* 6357, 6662, 6361; G. W. to JW, September 17 and 29, 1848, October 27 and November 8, 1848, WC.

35   Deborah Haden to JW [November 1848], December 1848, WC; Anna Whistler to JW, February 19, 20, 22, and 24 [1849], *GUW* 6387, plus *GUW* 6374–75, 6377, 6382–83, 6386, 6388; Rosa (Haden) Horsley Diaries, March 8, 1849, Horsley Family Papers, UO; "Child Parties," *Punch*, 16 (January–June 1849), 35–36.

36   JW to Anna Whistler, March 17 and 19–20, 1849, WC. The drawing of Annie was *Ma Nièce*, M.21.

37   Claire Richter Sherman, ed., *Women as Interpreters of the Visual Arts, 1820–1979* (Westport, Conn., 1981), 93–121; Judith Johnson, *Anna Jameson: Victorian, Feminist, Woman of Letters* (Aldershot, 1997), 156–71; Anna B. Jameson, *Memoirs of the Early Italian Painters* (London, 1845).

38   G. W. Whistler to JW, September 17 and 29, 1848, WC; Sir Joshua Reynolds, *Discourses on Art*, ed. Robert R. Wark (New Haven and London, 1975), 18, 95–98, 171, 259–60; JW to G. W., January 26–27, 1849, *GUW* 6667.

39   JW to G. W. Whistler, January 26–27, 1849, *GUW* 6667.

40   C. R. Leslie to Henry Angelo, February 4 [1849], Artists' Papers, AIC; *Athenaeum*, No. 1112 (February 17, 1849), 172–76, No. 1113 (February 24, 1849), 198–202, No. 1114 (March 3, 1849), 230–33, No. 1115 (March 10, 1849), 254–58; JW to G. W. Whistler, January 26–27, 1849, JW to Anna Whistler, February March 17, 19 and 20, 1849, *GUW* 6667, 6390.

41   G. W. Whistler to JW, January 18, 1849, WC; Anna Whistler to JW, February 15, 1849, March 9 and 10, 1849, March 16, 1849, G. W. and Anna to JW, February 28, and March 12 and 22, 1849 *GUW* 6386, 6388, 6389, 6383.

## 2: ANYTHING FOR A QUIET LIFE

1   William Whistler to JW, September 26 [1848], September 29, 1848, October 2 [1848], October 6, [1848], December 8 [1848], February 19, 23 and 24 [1849], May 10 and 12, 1849, WC; Anna Whistler to JW, December 13, 1848, December 22, 1848, *GUW* 6377–78.

2   William Whistler to Joseph Harrison, June 16, 1849, WC; Anna Whistler to Harrison, June 11, 1849, June 25, 1849, July 7, 1849, *GUW* 7627, 7633–34; Anna to G. E. Palmer, June 1, 1849, June 8, 1849, v.296, PWC; J. B. Francis to Sarah Francis, May 9, 1849, James Laver Papers, GUL.

3   Anna Whistler to Joseph Harrison, June 19, 1849, July 7, 1849, July 15, 1849, Anna to Sarah Harrison, June 20 [1849], Anna to JW, September 29, 1848, *GUW* 7629, 7634–35, 7632, 6366.

4   Deborah Haden to JW, July 28, 1849, WC; Anna Whistler to JW, May 10, 1849, August 23, 1849, Anna to Joseph Harrison, June 11, 1849, June 19, 1849, June 25, 1849, July 7, 1849, August 8, 1849, Anna to Sarah Harrison, June 20, 1849, *GUW* 6392–93, 7627, 7629, 7632–34, 7636.

5   Anna M. Whistler Diary, January 11, 15, 19, 22, and 29, April 10 and 16, and June 11 and 20, 1850, Box 33, PWC; Anna Whistler to M. G. Hill, October 8, 1851, *GUW* 7638; E. W. Palmer to E. R. Pennell, September 25, [1906] and January 17, 1907, v.296, PWC.

6   Whistler Diary, January 15, February 11, April 17, May 4, 13, and 20, June 1 and 27, and July 4, 1850.

7   A. J. Bloor, "Whistler's Boyhood," *Critic*, 43 (September 1903), 249–50.

8   Whistler Diary, January 17, 22, 29, February 22 and 27, March 23, April 4 and 6, May 2, 22, 25, and 29, June 1, 3, and 14, and September 13, 1850; Anna Whistler to JW, April 9, 1850, April 11, 1850, *GUW* 6394–95; L. C. Moulton to E. R. Pennell, December 27, 1905, v.294, E. W. Palmer to Pennell, September 25 [1906], v.296, PWC; Bloor, "Whistler's Boyhood," 250.

9   Whistler Diary, July 19 and 26, 1850; Anna Whistler to JW, August 6, 1851, *GUW* 6398; Deborah Haden to JW, November 9, 1851, WC; Bloor, "Whistler's Boyhood," 250.

10   M.23–72, 74–78; Nancy Dorfman Pressly, "Whistler in America: An Album of Early Drawings," *Metropolitan Museum Journal*, 5 (1972), 128–30, 139, 150–51.

11   Bloor, "Whistler's Boyhood," 250.

12   Whistler Diary, January 19 and April 3, 4, 18, and 23, 1850; Anna Whistler to JW, April 9, 1850, *GUW* 6394; Anna to M. G. Hill, [September] 20 and 21 [1850], *GUW* 7631.

13   James A. Whistler, file No.335 for 1850, United States Military Academy Applications, 1805–1866, Adjutant General Records, RG 94 (M688, reel 183), NA.

14   Joseph B. James, "Life at West Point One Hundred Years Ago," *Mississippi Valley Historical Review*, 31 (June 1944), 21–40; *Official Register of the Officers and Cadets of the U.S. Military Academy, West Point, New York, June 1852* (New York, 1852), 13–14, 16.

15   E. L. Hartz to father, June 24, 1851, Edward L. Hartz Papers, LC; Merlin E. Sumner, ed., *The Diary of Cyrus B. Comstock* (Dayton, Ohio, 1987), 10, 13–14.

16   Register of Delinquencies, 1851–53, 296–97, Records of United States Military Academy, USMA.

17   Anna Whistler to JW, June 10, 1851, August 6, 1851, August 27, 1851, September 16 [1851], *GUW* 6396, 6398–6400.

18   William Whistler to JW, June 19 [1851], July 10, 1851, December 8, 1851, WC; Anna Whistler to JW, July 10 and 11, 1851, September 16, 1851, October 15, 1851, November 13, 1851, November 25, 1851, December 17 and 19, 1851, January 15 and 16, 1852, February 10 and 11, 1852, May 3 and 4, 1852, *GUW* 6397, 6404, 6406–10, 6414.

19   Post (Cadet) Hospital, U.S. Military Academy, New York, Field Hospitals, New York, v.607, 76, 80, Adjutant General Records, RG 94, NA; Anna Whistler to JW, August 6, 1851, August 27, 1851, *GUW* 6398, 6399.

20   James L. Morrison, Jr., "Educating the Civil War Generals: West Point, 1833–1861," *Military Affairs*, 38 (October 1974), 108–109.

21   E. L. Hartz to father, July 13, 1851, Hartz to Jenny, October 24, 1851, Hartz Papers; Anna Whistler to JW, August 27, 1851, *GUW* 6399.

22   A. M. Butt to Joseph and E. R. Pennell, February 27, 1912, v.279, PWC; H. M. Lazelle, "Whistler at West Point," *Century*, 90 (September 1915), 710; Joseph G. Swift, *The Memoirs of Gen. Joseph Gardner Swift* (New York, 1890), 267–68; Anna Whistler to JW, June 10, 1851, July 10 and 11, 1851, August 27, 1851, Anna to M. G. Hill, October 8, 1851, *GUW* 6396–97, 6399, 7638.

23   Sumner, *Diary of Comstock*, 10–12; L. L. Langdon to E. R. Pennell, September 23, 1906, v.301, PWC; R. R. Ross Diary, May 25, 1852, Reuben R. Ross Papers, Tennessee State Library and Archives, Nashville. An incomplete copy of the Ross Diary is also at USMA.

24   Anna Whistler to JW, November 13, 1851, January 15, 1852; Deborah Haden to JW, April 9 [1852], WC; *Official Register, 1852*, 14; Post Order Book No. 2, June 1846 to November 1852, 593–94, 601, 620, 643, USMA; Register of Merit, 1836–53, entries for January 1852, June 1852, USMA.

25   *Official Register, 1852*, 19; Sumner, *Diary of Comstock*, 11–13, 63; James, "Life at West

Point," 35–37; Anna Whistler to JW, July 10 and 11, 1851, September 16, 1851, October 15, 1851, *GUW* 6397, 6400, 6404.

26  Ross Diary, June 8, 1852; C. B. Comstock to Joseph Pennell, October 3, 1906, v.301, PWC; Register of Delinquencies, 296–97; Register of Punishments, entries for February 9 and May 1, 1852, USMA; Sumner, *Diary of Comstock*, 61, 102, 138. Lazelle romanticized the card-playing incident in "Whistler at West Point," 710.

27  Samuel J. Bayard, *The Life of George Dashiell Bayard* (New York, 1874), 54; Ross Diary, October 26, 1852; C. B. Comstock to Joseph Pennell, September 13, 1906, October 13, 1906, v.301, PWC; A. M. Butt to E. R. and Joseph Pennell, February 27, 1912, v.279, PWC.

28  C. B. Comstock to Joseph Pennell, October 3, 1906, Thomas Childs to L. L. Langston, October 22, 1906, v.301, O. O. Howard to Pennell, September 13, 1906, v.303, PWC; Thomas Wilson, "Whistler at West Point," *Book Buyer* 17 n.s. (September 1898), 114–15.

29  Entry of Books Issued to Cadets by Special Permission of the Superintendent, May 1850–August 1852, USMA; Entry of Books Issued to Cadets on Saturday Afternoons, 1851–53, USMA; *Official Register, 1852*, 22.

30  Anna Whistler to JW, November 25, 1851, Deborah Haden to JW, November 9 [1851], April 9 [1852], WC; Lazelle, "Whistler at West Point," 710. JW's known West Point drawings are M.73, 79–172, but see also John Sandberg, "Whistler's Early Work in America, 1834–1855," *AQ*, 29 (1966), 48–52, and Pressly, "Whistler in America," 130–33.

31  Gustav Kobbé, "Whistler at West Point," *The Chap Book*, 8 (April 1898), 440–41; Wilson, "Whistler at West Point," 113; Sumner, *Diary of Comstock*, 50–51, 102; Susan Clayton, "Kitty's Whistler in the Beaverbrook Collection," *Atlantic Advocate*, 50 (September 1959), 40–45; M. 84–86, 98, 103, 114, 128–31.

32  M.108; J. L. Black to JW, April 2, 1888, *GUW* 304; Anna Whistler to JW, May 3 and 4, 1852, *GUW* 6414.

33  A. M. Butt to Joseph and E. R. Pennell, February 27, 1912, v.279, PWC.

34  Theodore Sizer, ed., "The Recollections of John Ferguson Weir: Memories of West Point," *New York Historical Society Quarterly*, 41 (April 1957), 110, 139. See, generally, Irene Weir, *Robert W. Weir, Artist* (New York, 1947).

35  Anna Whistler to JW, July 29 and 31 [1852], September 3, 1852, October 6 [1852], *GUW* 6416, 6418, 6421.

36  Wilson, "Whistler at West Point," 113–14.

37  Kobbé, "Whistler at West Point," 440; E. R. Pennell Diaries, July 23, 1906, Joseph and Elizabeth R. Pennell Papers, RHC.

38  M.139, 143, 145, 173–74, 176; *LW*, I:32.

39  Cadet Circulation Records, August 1852–July 1855, entries for September 1852–April 1853, and Entry of Books Issued to Cadets on Saturday Afternoons, 1853–1855, entries for February–May 1853, both in USMA; M.88, 135–37, 144–47, 168; A. M. Butt to Joseph and E. R. Pennell, February 27, 1912, v.279, PWC.

40  Register of Delinquencies, 1851–53, 297; Anna Whistler to JW, July 7 [1852], September 3, 1852, September 12, 1852, [September] 20 [1852], *GUW* 6417–20.

41  Anna Whistler to R. E. Lee, September 24 [1852], *GUW* 7549; Lee to Anna, September 28, 1852, Superintendent's Letter Book, No.2, July 1849–February 1853, 288–89, USMA.

42  H. A. Davis to E. R. Pennell, December 24 [1906], v.282, PWC; Anna Whistler to JW, February 10 and 11, 1852, March 3, 1852, October 6 [1852], *GUW* 6410, 6412, 6421.

43  Bayard, *Life of Bayard*, 37–38, E. L. Hartz to Jenny, February 17, 1853, Hartz Papers; Anna Whistler to JW, October 6 [1852], *GUW* 6421; Douglas S. Freeman, *R. E. Lee: A Biography*, 4 vols. (New York, 1934–35), I:339–46.

44  Post (Cadet) Hospital Records, v.608, 24, 27–29, 31–33, 35, 42.

45  Frederick Hollick, *A Popular Treatise on Venereal Diseases, in All Their Forms* (New York, 1852), 45, 59–70.

46  Anna Whistler to JW, April 7, 1853, R. E. Lee to Anna, May 26, 1853, *GUW* 6426, 12608; Post (Cadet) Hospital Records, v.608, 46, 51, 56, 58–59; G. P. Cammon to W. H. Church, June 3, 1853, Whistler File; Special Orders No.56, May 30, 1853, Post Order Book No.3, 60.

47  Family correspondence in *GUW* 6418, 6422, 6425, 6427, 6442, 7639–40.

48  Anna Whistler to JW, [September] 13 [1853], November 16, 1853, December 1, 1853, *GUW* 6415, 6430, 6432; Clayton, "Kitty's Whistler," 41–42; E. L. Hartz to Jenny, September 21, 1853, April 23, 1854, Hartz to father, October 7, 1853, March 18, 1854, June 8, 1854, Hartz Papers.

49  Anna Whistler to JW, September 29 [1853], November 16, 1853, December 1 [1853], [December 26, 1853], February 10, 1854, March 17, 1854, *GUW,* 6429, 6430, 6432, 6434–35, 6442; Post (Cadet) Hospital Records, v.608, 73, 81–83, 85, v.609, 2–4, 6, 8, 11, 17, 19; Staff Records, v.5 (1851–54), 363, 367, USMA; Register of Delinquencies, 1849–54, 204–05; Register of Punishments, September 1847–October 1857, entries for September 9 and 16, 1853, January 13 and 27, February 10 and 24, and March 24, 1854.

50  Anna Whistler to JW, March 17, 1854, May 29 and 30, 1854, *GUW* 6439, 6442; James McNeill Whistler "Journal," n.d., Winans Papers, MHS; James McNeill Whistler "Journal" [1854], MMA.

51  *Official Register of Officers and Cadets of the U.S. Military Academy, West Point, New York, June 1854* (New York, 1854), 19; JW to Ralph Ingersoll, June 14, 1854, Ralph Ingersoll Collection, Howard Gotlieb Archival Research Center, Boston University; H. M. Lazelle to JW, August 16, 1854, WC; JW to Jefferson Davis, July 1, 1854, *GUW* 806.

52  Freeman, *R. E. Lee,* I:335–37; H. M. Lazelle to JW, August 16, 1854, [August 16, 1854], WC.

53  *LW,* I:33; Sumner, *Diary of Comstock,* 150; E. L. Hartz to father, June 18, 1854, Hartz Papers; C. W. Larned to Joseph Pennell, October 4, 1906, v.303, PWC.

54  Lazelle, "Whistler at West Point," 710; *LW,* I:36–38.

### 3 : BOHEMIAN RHAPSODY

1  Anna Whistler to JW, September 29 [1853], February 10, 1854, May 29 and 30, 1854, Anna to J. H. Gamble, April 3, 1854, *GUW* 6415, 6435, 6437, 6439.

2  Anna Whistler to JW, November 16, 1853, March 17, 1854, *GUW* 6430, 6442; *LW,* I:39–42.

3  Anna to Fair Stranger, September 2 [1854], *GUW* 6443; James McNeill Whistler "Journal" [1854], MMA.

4  M.193.

5  H. W. Benham to A. D. Bache, October 14, 1854, November 15, 1854, Correspondence of A. D. Bache, Superintendent of the Coast and Geodetic Survey, 1843–65, v.2, Coast and Geodetic Survey Papers, RG 23 (M642, reel 101) NA; A. A. Gibson to Benham, November 30, 1854, Reports of Office Work, v.14, Survey Papers (reel 115). For JW's career at the Coast Survey, see Marlene A. Palmer, "Whistler and the U. S. Coast and Geodetic Survey: An Influential Period in a Flamboyant Life," *Journal of the West,* 8 (October 1969), 559–77.

6  John Ross Key, "Recollections of Whistler While in the Office of the United States Coast Survey," *Century,* 75 (April 1908), 931; G.1–2; Daily Reports of Occupation, December 1854, January and February 1855, and J. C. Clark to H. W. Benham, January 31, 1855, Survey Papers.

7   Key, "Recollections," 929, 931; Reports of Projected Work, January–April, 1855, v.22, Survey Papers (reel 133); Hugh Richard Slotten, *Patronage, Practice, and the Culture of American Science: Alexander Dallas Bache and the U.S. Coast Survey* (Cambridge, Eng., 1994), 8–10, 148–51, 154–55.

8   Daily Report of Occupation of Draughtsmen, November–December 1854 and January–March 1855, v.23, Survey Papers (reel 134); Anna Whistler to JW, January 8, 1855, February 1, 1855, February 13, 1855, *GUW* 6449, 6451–52; Gustav Kobbé, "Whistler in the U. S. Coast Survey," *The Chap Book*, 8 (May 1898), 479–80.

9   Key, "Recollections," 928–30; F. L. Hunt to JW, December 1882, *GUW* 2200; Kobbé, "Whistler in Coast Survey," 480.

10   Anna Whistler to JW, [November 1854], December 7, 1854, January 8, 1855, January 15, 1855, [January 15/February, 1855], *GUW* 6445, 6447, 6449–50, 6452, 6462.

11   *LW*, I:44, 47; Key, "Recollections," 928; F. L. Hunt to JW, May 3, 1855, May 18, 1855, June 15, 1855, *GUW* 2197–99.

12   Kobbé, "Whistler in Coast Survey," 480; Key "Recollections," 929, M. B. McReynolds to E. R. Pennell, v.293, January 8, 1921, PWC; M.133 185–86. For JW's drawings in the year after leaving West Point, see M.177–209.

13   Anna Whistler to JW, January 8, 1855, February 1, 1855, February 13, 1855, *GUW* 6449, 6451–52.

14   Wendy Wolff, ed., *Capital Builder: The Shorthand Journals of Montgomery C. Meigs, 1853–1859, 1861* (Washington, D.C., 2001), 244.

15   Thomas Winans Account Books, 1851–56, entries for November 6, 1854, April 21, 1855, Box 22, Winans Papers, MHS; Thomas Winans to JW [April 23, 1855], Anna Whistler to JW, April 24 [1855], *GUW* 7077, 6459.

16   Anna Whistler to JW, March 15, 1855, [March 20–21, 1855], March 28, 1855, April 24 [1855], F. L. Hunt to JW, May 3, 1855, December 1882, JW to E. G. Perine [two letters dated to May–July 1855], *GUW* 2197, 2200, 6453–55, 6459, 9367–68; Winans Account Books, May 11, 15, and 17, June 25, July 20 and 26, 1855; M.194, 212.

17   *LJW*, I:30–37.

18   Winans Account Books, July 30, 1855; Anna Whistler to JW, July 25, 1855, JW to Thomas Winans, August 1, 1855, JW's passport (issued July 28, 1855), *GUW* 6464, 7078, 4325. JW's copy of *A Hand-Book for Young Painters* (London, 1855) survives in Special Collections, GUL.

19   Catherine H. Voorsanger and John K. Howat, eds., *Art and the Empire City: New York, 1825–1861* (New York, 2000), 36, 41–42; Roger B. Stein, *John Ruskin and Aesthetic Thought in America, 1840–1900* (Cambridge, Mass., 1967), 1–2, 32–42, 78–85, 101–19.

20   JW to Anna Whistler, October 10, 1855; Anna to JW, October 12–15, 1855, *GUW* 6466, 6468; Jacques Lethève, *Daily Life of French Artists in the Nineteenth Century*, trans. Hilary E. Paddon (New York, 1972), 49–56, 148; Thomas Armstrong, *Thomas Armstrong, C.B.: A Memoir, 1832–1911*, ed. L. M. Lamont (London, 1912), 116–17, 171, 173.

21   James H. Rubin, *Impressionism and the Modern Landscape: Productivity, Technology, and Urbanization from Manet to Van Gogh* (Berkeley, Calif., 2008), 17–27; Lois Marie Fink, *American Art at the Nineteenth-Century Paris Salons* (Cambridge, Eng., 1990), 59–63.

22   Frank A. Trapp, "The Universal Exhibition of 1855," *BM*, 107 (June 1965), 300–05; Patricia Mainardi, *Art and Politics of the Second Empire: The Universal Expositions of 1855 and 1867* (New Haven and London, 1987), 39–47.

23   Anna Whistler to J. H. Gamble, February 4, 1856, October 17 [1858], JW accounts, November 25, 1855–August 8, 1856, *GUW* 6471, 6499, 6672–73; Emma Bergeron to Emma Haden, June 6, 1856, June 15, 1856, Haden to J. C. Horsely, April 15 [1857], Charles Bergeron to

mother, February 5, 1859, Horsley Family Papers, UO; Lillian M. C. Randall, ed., *The Diary of George A. Lucas: An American Art Agent in Paris, 1857–1909* (Princeton, N.J., 1979), I:9–10, II:73; Armstrong, *Memoir*, 121, 175, 181–83.

24  Lethève, *Daily Life*, 147–50; Armstrong, *Memoir*, 175, 177–78.

25  *LW*, I:48–56; Armstrong, *Memoir*, 137–38; F. L. Hunt to JW, May 18, 1855, *GUW* 2198.

26  Suzanne M. Singletary, "Whistler and France" (PhD diss., Temple Univ., 2007), 5–18; Nancy Forgione, "Everyday Life in Motion: The Art of Walking in Late-Nineteenth-Century Paris," *AB*, 87 (December 2005), 664–87; Aruna D'Souza and Tom McDonough, eds., *The Invisible Flâneuse?: Gender, Public Space, and Visual Culture in Nineteenth-Century Paris* (Manchester, 2006), 3–14.

27  M.211, 213; Anna Whistler to JW, February 1, 1855, April 30 and May 4 [1857], *GUW* 6472.

28  Albert Boime, *The Academy and French Painting in the Nineteenth Century* (London, 1971), 1–21; Carl Goldstein, *Teaching Art: Academies and Schools from Vasari to Albers* (Cambridge, Eng., 1996), 58–61; Elizabeth Prettejohn, *Beauty and Art, 1750–2000* (Oxford, 2005), 65–89.

29  Prettejohn, *Beauty and Art*, 89–102; Dominique de Font-Reaulx, *Gustave Courbet* (New York, 2008), 19–28, 31–35, 220; James H. Rubin, *Courbet* (London, 1997), 156–74.

30  William Hauptman, *Charles Gleyre, 1806–1874*, 2 vols. (Zurich, 1996), I:328–39; R. Lenora Moffa, "The Paintings of James McNeill Whistler, 1859–1877: A Technique of Mutability" (PhD diss., Emory Univ., 1991), 90–118.

31  F. B. Miles to Joseph Pennell, February 1, 1907, v.294, PWC.

32  *LW*, I:54, 59–61, 67, 72–74, YMSM 11–20.

33  Petra ten-Doesschate Chu, "Lecoq de Boisbaudran and Memory Drawing: A Teaching Course between Idealism and Naturalism," in Gabriel P. Weisberg, ed., *The European Realist Tradition* (Bloomington, Ind., 1982), 242–89; David Bomford et al., *Art in the Making: Impressionism* (London, 1990), 11–17.

34  Armstrong, *Memoirs*, 113, 133–37, 140–42, 146–47, 172–74, 176–77, 180–81, 183–85, 190, 193–94; *LW*, I:52–54.

35  H. M. Lazelle to JW, December 15, 1878, Anna Whistler to Fair Stranger, September 2 [1854], *GUW* 2497, 6443; Susan S. Waller, *The Invention of the Model: Artists and Models in Paris, 1830–1870* (Aldershot, 2006), 47–61.

36  *WJ*, 86–87; Armstrong, *Memoir*, 191–93. Drawings of Fumette are G.3, 12; M.288–89r.

37  Anna Whistler to JW, April 30 and May 4 [1857], August 17 & September 16, 1857, *GUW* 6472, 6487.

38  Mainardi, *Art and Politics*, 33, 69–70, 114–20, 125; Albert Boime, "The Second Empire's Official Realism," in Weisberg, *European Realist Tradition*, 31–123.

39  Ulrich Finke, "The Art Treasures Exhibition," in John H. G. Archer, ed., *Art and Architecture in Victorian Manchester* (Manchester, 1985), 102–26; Jonah Siegel, *Desire and Excess: The Nineteenth-Century Culture of Art* (Princeton, N.J., 2000), 157–60, 181–86; Armstrong, *Memoir*, 102–6, 187–89; Nathaniel Hawthorne, *The English Notebooks*, ed. Randall Stewart (New York, 1941), 545–63; *AJ*, 3 (June 1857), 187, (August 1857), 233–35.

40  Anna Whistler to JW, September 23, 1856, *GUW* 6476; Armstrong, *Memoir*, 146–47; Katharine Lochnan, *The Etchings of James McNeill Whistler* (New Haven and London, 1984), 21–25; G.3.

41  Lochnan, *Etchings*, 25–27; G.4–10.

42  Anna Whistler to JW, August 1, 1858, November 18, 1858, *GUW* 6498, 6501; G.12.

43  Margaret F. MacDonald, "East and West: Sources and Influences," in MacDonald et al., *Whistler, Women, and Fashion* (New Haven and London, 2003), 55–58.

44  *LW*, I:57; G.24–25; Randall, *Diary of Lucas*, II:77; YMSM 26–27; Armstrong, *Memoir*, 186.

45  Lochnan, *Etchings*, 33–48; G.13–23, 26–27, 29; JW to Deborah Haden [October 1858], *GUW* 1912; Armstrong, *Memoir*, 189–90; *LW*, I:61–64. For the dozens of sketches and drawings and a few watercolors JW made on the trip, see M.228–86.

46  Armstrong, *Memoir*, 185–86; Timothy John Wilcox, "Alphonse Legros: Aspects of His Life and Work" (MPhil. thesis, Courtauld Institute, 1981), 13–17; Douglas Druick and Michael Hoog, *Fantin-Latour* (Ottawa, 1983), 65–67, 70–73.

47  Lochnan, *Etchings*, 48–56; G.28; Anna Whistler to J. H. Gamble, December 5 [1858], *GUW* 6502.

48  Ernest Delannoy to JW, November 9, 1858, *GUW* 820; Lochnan, *Etchings*, 57–58; G.7–8, 11–14, 16, 18, 20, 22–24, 26–27.

4: PORTRAITS AND SELF-PORTRAITS

1  Anna Whistler to J. H. Gamble, December 5 [1858], *GUW* 6502.

2  YMSM 24. Some scholars speculate that the picture was meant to commemorate the death of Major Whistler. See Richard Dorment and Margaret F. MacDonald, *James McNeill Whistler* (New York, 1995), 71–73; Suzanne F. Cooper, "Music, Memory and Loss in Victorian Painting," *Nineteenth-Century Music Review*, 2 (2005), 34–36.

3  JW to Deborah Haden [January 12/30, 1859], *GUW* 1913; YMSM 23, 25–31.

4  Jane Munro and Paul Stirton, *The Society of Three: Alphonse Legros, Henri Fantin-Latour, James McNeill Whistler* (Cambridge, Eng., 1998), 1–5; Douglas Druick and Michael Hoog, *Fantin-Latour* (Ottawa, 1983), 66–67, 72–85, 92–96.

5  Mathilde Arnoux et al., eds., *Correspondance entre Henri Fantin-Latour et Otto Scholderer: 1858–1902* (Paris, 2011), 75–77; JW to Deborah Haden [January 12/30, 1859], *GUW* 1913; Thomas Armstrong, *Thomas Armstrong, C.B.: A Memoir, 1832–1911*, ed. L. M. Lamont (London, 1912), 179, 186; *WJ*, 89–90.

6  Katharine Lochnan, *The Etchings of James McNeill Whistler* (New Haven and London, 1984), 68–70; G.30–32, 37, 39–43.

7  Dianne Sachko Macleod, *Art and the Victorian Middle Class: Money and the Making of Cultural Identity* (Cambridge, Eng., 1996), 1–10, 209–12; George P. Landow, "There Began to Be a Great Talking about Fine Arts," in Joseph L. Altholz, ed., *The Mind and Art of Victorian England* (Minneapolis, Minn., 1976), 125–45.

8  Grischka Petri, *Arrangement in Business: The Art Markets and the Career of James McNeill Whistler* (Hildesheim, 2011), 38–42; Christopher A. Kent, "'Short of Tin' in a Golden Age: Assisting the Unsuccessful Artist in Victorian England," *VS*, 32 (Summer 1989), 487–506.

9  Macleod, *Art and Victorian Middle Class*, 267–74.

10  Mary Glen Perine to _____, June 21, 1859, Henri Fantin-Latour to JW, June 26, 1859, JW to Fantin-Latour [June 29, 1859], F. S. Haden to Fantin-Latour, June 29 [1859], *GUW* 12491, 1073, 8050, 8049.

11  Druick and Hoog, *Fantin-Latour*, 71–72, 77–78, 137, 147.

12  Katharine Lochnan, "'The Thames from Its Source to the Sea': An Unpublished Portfolio by Whistler and Haden," in Ruth Fine, ed., *James McNeill Whistler: A Reexamination* (Washington, D.C., 1981), 38, although the project was planned earlier than suggested by Lochnan.

13  Emma Chambers, *An Indolent and Blundering Art?: The Etching Revival and the Redefinition of Etching in England, 1838–1892* (Aldershot, 1999), 2–4; Elizabeth K. Helsinger et al., *The "Writing" of Modern Life: The Etching Revival in*

*France, Great Britain, and the United States, 1850–1940* (Chicago, 2008), essays by Helsinger (1–8) and Martha Tedeschi (25–37).

14   Jonathan Mayne, ed. and trans., *Art in Paris, 1845–1862: Salons and Other Exhibitions Reviewed by Charles Baudelaire* (Oxford, 1965), 144, 148–49, 152, 156–57, 159, 162–65, 194–203; David Scott, "Writing the Arts: Aesthetics, Art Criticism and Literary Practice," in Peter Collier and Robert Lethbridge, eds., *Artistic Relations: Literature and the Visual Arts in Nineteenth Century France* (New Haven and London, 1994), 61–75.

15   Christopher Wood et al., *Artist as Narrator: Nineteenth Century Narrative Art in England and France* (Oklahoma City, 2005), 92–113.

16   Nathaniel Hawthorne, "Up the Thames," *AM*, 11 (May 1863), 599, 602.

17   Lochnan, *Etchings*, 86–89, 98, 100; JW to Henri Fantin-Latour [January/June 1861], *GUW* 8042; Michael Fried, *Manet's Modernism, or, The Face of Painting in the 1860s* (Chicago, 1996), 319–21, 379–80.

18   G.48–55.

19   Gabriel P. Weisberg et al., *Japonisme: Japanese Influence on French Art, 1854–1910* (Cleveland, 1975), 3–5, 116–17; Toshio Watanabe, *High Victorian Japonisme* (Bern, 1991), 211–16; Ayako Ono, *Japonisme in Britain: Whistler, Menpes, Henry Hornel and Nineteenth-Century Japan* (London, 2003), 5–6, 14–15, 41–44.

20   Lochnan, *Etchings*, 87, 92–95; Ono, *Japonisme in Britain*, 43–46.

21   Lochnan, *Etchings*, 98–100; Nigel Thorp, "Studies in Black and White: Whistler's Photographs in Glasgow University Library," in Fine, *James McNeill Whistler*, 87–98; Sarah Elizabeth Kelly, "Camera's Lens and Mind's Eye: Whistler and the Science of Art" (PhD diss., Columbia Univ., 2010), 1–15, 25–26, 36–41.

22   Elizabeth Anne McCauley, *Industrial Madness: Commercial Photography in Paris,* *1848–1871* (New Haven and London, 1994), 47–56, 196–212.

23   Lochnan, *Etchings*, 87–96.

24   Druick and Hoog, *Fantin-Latour*, 77–78; Lochnan, *Etchings*, 101–02; JW to W. E. Henley [April 24, 1891], *GUW* 10562.

25   G.33–36, 58–63, 66–69, 72–73; Gary Schwartz, ed., *The Complete Etchings of Rembrandt* (London, 1977), B203.

26   Anna Whistler to J. H. Gamble, March 27, 1860, Anna to Deborah Haden, May 4, 1860, *GUW* 6508–09.

27   Catherine Carter Goebel, "Arrangement in Black and White: The Making of a Whistler Legend" (PhD diss., Northwestern Univ., 1988), 156–58, 691–94; *The Times*, May 17, 1860, p. 11; *Punch*, 39 (July 14, 1860), 17.

28   John Philips to JW, July 30, 1860, *GUW* 4978; Daphne du Maurier, ed., *The Young du Maurier: A Selection of His Letters, 1860–1867* (Garden City, N.Y., 1952), 4; Caroline Dakers, *The Holland Park Circle: Artists and Victorian Society* (New Haven, 1999), 7–10, 106–09.

29   Julia Ionides, "The Greek Connection – The Ionides Family and Their Connections with Pre-Raphaelite and Victorian Art Circles," in Susan Casteras and Alicia Craig Faxon, eds., *Pre-Raphaelite Art in its European Context* (Cranbury, N.J., 1995), 160–74; David B. Elliott, *A Pre-Raphaelite Marriage: The Lives and Works of Marie Spartali and William James Stillman* (London, 2006), 11–14, 16–20; Du Maurier, *Young du Maurier*, 4–16, 28–29, 33, 66–67.

30   JW to Mario Proth [June/August 1859], JW to M. W. Ridley [July/September 1859], Henri Fantin-Latour to JW, August 5, 1859, *GUW* 11559, 5190, 1074; Du Maurier, *Young du Maurier*, 3–7, 10–11, 13–15, 33–34; Armstrong, *Memoirs*, 150–51.

31   Du Maurier, *Young du Maurier*, 14, 17–18; *Punch*, 39 (October 6, 1860), 140, (October 27, 1860), 163.

32  Minutes of the Junior Etching Club, 1859–64, entries for July 6, 1859, 53, November 2, 1859, 56, May 2, 1860, 74, NAL.

33  Du Maurier, *Young du Maurier*, 118; *LW*, I:88–89, 94–95; W. M. Rossetti to Joseph Pennell, November 6, 1906, v.298, PWC; Sarah Agnes Wallace and Frances Elma Gillespie, eds., *Journal of Benjamin Moran, 1857–65*, 2 vols. (Chicago, 1948–49), II:1149.

34  *LW*, I:84–85; Du Maurier, *Young du Maurier*, 10–11, 16, 27–28.

35  G.70; YMSM 35; Robin Spencer, "Whistler's Subject Matter: 'Wapping,' 1860–1864," *GBA*, 100 (October 1982), 131–42; Du Maurier, *Young du Maurier*, 16, 26, 27; JW to Henri Fantin-Latour [January/June 1861], *GUW* 8042.

36  YMSM 36.

37  YMSM 34; *LW*, I:89–91; Toshio Watanabe, "Eishi Prints in Whistler's Studio? Eighteenth-Century Japanese prints in the West Before 1870," *BM*, 128 (December 1986), 874–75; H. Barbara Weinberg, "American Artists' Taste for Spanish Painting," in Gary Tinterow et al., *Manet/Velázquez: The French Taste for Spanish Painting* (New Haven and London 2003), 263–64; Du Maurier, *Young du Maurier*, 26–27. The du Maurier letter is mistakenly dated November 1860 by the editor.

38  Peter Matthews, *London's Bridges* (Oxford, 2008), 65–70, 80–83, 90–108; G.75–77, 95.

39  *LW*, I:85–86; G.78–79; Martin Hopkinson, "Whistler's First Print Exhibition, 1861" *PQ*, 27 (September 2009), 257–67; Du Maurier, *Young du Maurier*, 38.

40  Goebel, "Arrangement in Black and White," 158–60, 693–96; Anna Whistler to JW and Deborah Haden [July 15/31, 1861], *GUW* 6512.

41  Druick and Hoog, *Fantin-Latour*, 105; Valerie Gatty, "Artists' Fruitful Friendships," *Country Life*, 155 (March 7, 1974), 507–08; G.80–81.

42  Anna Whistler to JW, August 3, 1861, August 19, 1861, JW to A. J. Lewis [November 1861], *GUW* 6516–17, 2138; G.82–85; Junior Etching Club, *Passages from Modern Poets* (London, 1862), Nos. 7, 45.

## 5: REBELLION AND NOTORIETY

1  Douglas Druick and Michael Hoog, *Fantin-Latour* (Ottawa, 1983), 13–14; Michael Fried, *Manet's Modernism, or, The Face of Painting in the 1860s* (Chicago, 1996), 7, 186–87, 239, 457 n.20, 473 n.65. For the mutual influences on and between JW and Manet, see Suzanne M. Singletary, "Manet and Whistler: Baudelairean *Voyage*," in Therese Dolan, ed., *Perspectives on Manet* (Farnham, 2012), 49–72.

2  YMSM 37.

3  Daphne du Maurier, ed., *The Young George du Maurier: A Selection of His Letters, 1860–67* (Garden City, N.Y., 1952), 103–04, 105, 118; receipt for rent, March 24, 1862, L. M. Lalouette to JW, May 6, 1862, *GUW* 2641, 2476.

4  Lillian M. C. Randall, ed., *The Diary of George A. Lucas: An American Art Agent in Paris, 1857–1909*, 2 vols. (Princeton, N.J., 1979), I:5–6, II:130–32.

5  Quote from Walford Graham Robertson, *Life Was Worth Living: The Reminiscences of W. Graham Robertson* (New York, 1931), 88. Among the many interpretations are Robin Spencer, "Whistler's 'The White Girl': Painting, Poetry, and Meaning," *BM*, 140 (May 1998), 300–11; Aileen Tsui, "The Phantasm of Aesthetic Autonomy in Whistler's Work: Titling *The White Girl*," *AH*, 29 (June 2006), 444–75; Nicholas Daly, "The Woman in White: Whistler, Hiffernan, Courbet, Du Maurier," *Modernism/Modernity*, 12 (January 2005), 1–11; David Park Curry, *James McNeill Whistler: Uneasy Pieces* (New York, 2004), 68–84.

6  Alastair Grieve, "Whistler and the Pre-Raphaelites," *AQ*, 34 (Summer 1971), 219–20; Henry Holiday, *Reminiscences of My Life* (London, 1914), 41–42.

7  Elizabeth Prettejohn, *The Art of the Pre-Raphaelites* (London, 2000), 108–09, 149; Marcia Werner, *Pre-Raphaelite Painting and Nineteenth-Century Realism* (Cambridge, Eng., 2005), 14–15, 143–51.

8  Joanna Hiffernan to G. A. Lucas, April 9, 1862, JW to Lucas, June 26 [1862], JW to Edwin Edwards, [April 7, 1862], Anna Whistler to JW, May 12, 1862, *GUW* 9186, 11977, 13733, 6519; Druick and Hoog, *Fantin-Latour*, 105–06, 113, 119–20; *LW*, I:96.

9  Du Maurier, *Young du Maurier*, 112, 118–19; Caroline Dakers, *The Holland Park Circle: Artists and Victorian Society* (New Haven and London, 1999), 18–40; Anna M. W. Stirling, *A Painter of Dreams and Other Biographical Studies* (London, 1916), 298–300.

10  Dakers, *Holland Park Circle*, 72–76; Felix Moscheles, *In Bohemia with Du Maurier* (London, 1896), 128–33; *LW*, I:79–80.

11  *LW*, I:98–99; Du Maurier, *Young du Maurier*, 118.

12  Anna Whistler to JW [July 15/31, 1861], August 3, 1861, February 19, 1862, May 12, 1862, JW to Edwin Edwards [June 10/12, 1862], *GUW* 6512, 6516, 6518–19, 9079.

13  Catherine Carter Goebel, "Arrangement in Black and White: The Making of a Whistler Legend" (PhD diss., Northwestern Univ., 1988), 161–63, 696; Rachel Teukolsky, "White Girls: Avant-Gardism and Advertising after 1860," *VS* (Spring 2009), 422–37; JW to G. A. Lucas, June 26 [1862], *GUW* 1197.

14  E. R. Pennell Diaries, July 18, 1903, Joseph and Elizabeth R. Pennell Papers, HRC; James H. Rubin, *Courbet* (London, 1997), 97–98, 107–108; Petra ten-Doesschate Chu, *The Most Arrogant Man in France: Gustave Courbet and the Nineteenth-Century Media Culture* (Princeton, N.J., 2007), 1–2, 10–13, 17–18, 37–43.

15  Nancy M. Mathews, ed., *Cassatt and Her Circle: Selected Letters* (New York, 1984), 46; Roy McMullen, *Degas: His Life, Times, and Work* (Boston, 1984), 155; George Moore, *Impressions and Opinions* (New York, 1891), 309; Chu, *Most Arrogant Man in the World*, 77, 90–91, 113.

16  Robertson, *Life Was Worth Living*, 91–92; Virginia Surtees, ed., *The Diaries of George Price Boyce* (Norwich, 1980), 29, 34–35.

17  Surtees, *Diaries of Boyce*, 12, 26–27, 35–37; Pamela Todd, *Pre-Raphaelites at Home* (New York, 2001), 107–21; W. H. Hunt to G. L. Craik, April 4, 1897, No. 1381, William Holman Hunt Papers, UM.

18  Jan Marsh, *Dante Gabriel Rossetti: Painter and Poet* (London, 1999), 266–67, 282–88; William M. Rossetti, *Dante Gabriel Rossetti: His Family Letters, with a Memoir* (London, 1895), I:263–64, II:179–80. For the relationship between JW and Rossetti, see Joanna Meacock, "Apostle of the New Gospel: Whistler and Rossetti," in Lee Glazer et al., eds., *James McNeill Whistler in Context* (Washington, D.C., 2008), 31–44.

19  Surtees, *Diaries of Boyce*, 24–25; Stirling, *Painter of Dreams*, 337; Armstrong, *Memoir*, 193–94.

20  T. D. Winans to JW, August 25, 1862, *GUW* 7080; Jean Jepson Page, "James McNeill Whistler, Baltimorean, and the *White Girl*: A Speculative Essay," *Maryland Historical Magazine*, 84 (Spring 1989), 25–28.

21  *LW*, I:100–101; YMSM 39.

22  *LW*, I:95; JW to Henri Fantin-Latour [October 24/31, 1862], *GUW* 8029; H. Barbara Weinberg, "American Artists' Taste for Spanish Painting," in Gary Tinterow et al., *Manet/Velázquez: The French Taste for Spanish Painting* (New Haven and London, 2003), 260–71.

23  YMSM 40–44; JW to Henri Fantin-Latour [October 1/5, 1862], [October 14/21, 1862], *GUW* 7951, 8028.

24  JW to Henri Fantin-Latour [October 14/21, 1862], *GUW* 8028.

25  JW to G. A. Lucas, October 18 [1862], [December 19, 1862], JW to Henri Fantin-Latour [October 21/28, 1862], [October 24/31, 1862], [November 12/19, 1862], *GUW* 9187, 9189, 8030, 8029, 7952; Randall, *Diary of Lucas*, II:138, 143, 145.

26  William E. Fredeman, ed., *The Correspondence of Dante Gabriel Rossetti*, 9 vols. (Cambridge, Eng., 2002–11), II:520, III:27, 37–38; Luke Ionides, *Memories* (Paris, 1925), 12, 49–50; Marsh, *Rossetti*, 301–02, 337, 340; *WJ*, 156–58.

27  C. W. Downes to JW, January 9, 1863, I. H. Keene to JW, February 21, 1863, March 27, 1863, Keene to J. A. Rose, [February] 24, 1863, March 20, 1863, JW to Rose [March 4/11, 1863], [March 16/23, 1863], [March 20, 1863], Rose to JW, March 18, 1863, *GUW* 11857–58, 12160, 11848, 11856, 8986, 8984–85, 11847.

28  John Burnett, *A Social History of Housing, 1815–1970* (London, 1978), 194–96; F. M. L. Thompson, *The Rise of Respectable Society: A Social History of Victorian Britain, 1830–1900* (Cambridge, Mass., 1988), 169–74.

29  Deanna Marohn Bendix, *Diabolical Designs: Paintings, Interiors, and Exhibitions by James McNeill Whistler* (Washington, D.C., 1995), 63–73, 92.

30  Emma Chambers, *An Indolent and Blundering Art? The Etching Revival and the Redefinition of Etching in England, 1838–1892* (Aldershot, 1999), 21–23; Gabriel P. Weisberg, *The Etching Renaissance in France, 1850–1880* (Salt Lake City, 1971), 8–24; JW to Fantin-Latour, [October 1/5 1862], Fantin-Latour to JW, October [7/14], 1862, *GUW* 7951, 1075.

31  Du Maurier, *Young du Maurier*, 197; Surtees, *Diaries of Boyce*, 37; G.93–97.

32  "Art-Gossip," *Reader*, 1 (April 18, 1863), 390; JW to G. A. Lucas, March 16 [1863], *GUW* 10693.

33  JW to J. A. Rose, [March 20, 1863], [March 24, 1863], [March 25, 1863], *GUW* 8985, 8987, 8983; Martin Hopkinson, "James Anderson Rose," *PQ*, (forthcoming).

34  Peattie, *Letters of William Rossetti*, 111–12, 131; Roger W. Peattie, "William Michael Rossetti's Art Notices in the Periodicals, 1850–1878," *VPN*, 8 (June 1975), 79–82; Julie L'Enfant, "Reconstructing Pre-Raphaelitism: The Evolution of William Rossetti's Critical Position," in Michaela Giebelhausen and Tim Barringer, eds., *Writing the Pre-Raphaelites: Text, Context, Subtext* (Farnham, 2009), 106–108.

35  W. M. R., "Mr. Whistler's Etchings," *Reader*, 1 (April 4, 1863), 342.

36  JW to Henri Fantin-Latour [April 22, 1863], JW to Louis Martinet [April 23, 1863], *GUW* 8034, 8033.

37  J. F. Heijbroek and Margaret F. MacDonald, *Whistler and Holland* (Amsterdam, 2000), 49; Ross King, *The Judgment of Paris: The Revolutionary Decade That Gave the World Impressionism* (New York, 2006), 56–62; JW to Henri Fantin-Latour, [April 22, 1863], [May 3, 1863], Fantin-Latour to JW, April 26, 1863, May 1, 1863, *GUW* 8034–35, 1080, 1079.

38  Fried, *Manet's Modernism*, 7; Henri Fantin-Latour to JW, May 1, 1863, *GUW* 1079.

39  King, *Judgement of Paris*, 70–79; Juliet Wilson-Bareau, "The Salon des Refusés of 1863: A New View," *BM*, 149 (May 2007), 309–19; Goebel, "Arrangement in Black and White," 164–71, 679–707; Pamela Gerrish Nunn, "Critically Speaking," in Clerissa Campbell Orr, ed., *Women in the Victorian Art World* (Manchester, 1995), 111; Philip G. Hamerton, "The Salon of 1863," *FAQ*, 1 (October 1863), 259–60.

40  Henri Fantin-Latour to JW [May 15, 1863], *GUW* 1081.

41  Goebel, "Arrangement in Black and White," 171–75, 708–10; [Frederic G. Stephens], "Royal Academy," *Athenaeum*, No. 1855

(May 16, 1863), 655, No. 1856 (May 23, 1863), 687–88; "Royal Academy (Fifth Notice–Landscapes)," *Reader*, 1 (June 13, 1863), 582. For Stephens's generally favorable response to JW's work, see Martin Hopkinson, "F. G. Stephens and Whistler," in *British Art Journal*, forthcoming.

42  George Whistler to JW, May 2, 1863, JW to Henri Fantin-Latour, [July 6/10, 1863], *GUW* 6676, 8043.

43  Hamerton, "Salon of 1863," 231, 262; Gordon Fyfe, "Auditing the RA: Official Discourse and the Nineteenth-Century Royal Academy," in Rafael Cardoso Denis and Colin Trodd, eds., *Art and the Academy in the Nineteenth Century* (New Brunswick, N.J., 2000), 120–28; Philip McEvansoneya, "The Cosmopolitan Club Exhibition of 1863: The British Salon des Refusés," in Ellen Harding, ed., *Re-Framing the Pre-Raphaelites: Historical and Theoretical Essays* (Aldershot, 1996), 27–42; Holiday, *Reminiscences*, 95–96.

44  JW to Henri Fantin-Latour, [May 25/ June 10, 1863], [July 6/10, 1863], *GUW* 8044, 8043.

45  JW to Henri Fantin-Latour, [May 25/ June 10, 1863], [July 6/10, 1863], [July 12/17, 1863], [August 16, 1863], Fantin-Latour to JW and Alphonse Legros [July 11, 1863], Fantin-Latour to JW, February 7, 1863, July 19, 1863, *GUW* 8044, 8043, 8031–32, 1078, 1077, 1082.

46  Heijbrock and MacDonald, *Whistler and Holland*, 49–53, 81–83; JW to Henri Fantin-Latour [August 16, 1863], JW to John O'Leary [August 18 or 25, 1863], *GUW* 8032, 9333.

47  JW to Henri Fantin-Latour, [July 6/10, 1863], [August 16, 1863] *GUW* 8043, 8032; Du Maurier, *Young du Maurier*, 213; YMSM 45–46.

48  JW to George Whistler, October 7, 1863, *GUW* 6677; Grischka Petri, *Arrangement in Business: The Art Markets and the Career of James McNeill Whistler* (Hildesheim, 2011), 50–55.

6 : HOMAGE TO WHISTLER

1  Alice Gilmore Holt, "The Documentation for the Contribution of Three Mid-Nineteenth-Century Exhibitions to the Popularization of Japanese Art," in Mosche Barasch and Lucy Freeman Sandler, eds., *Art the Ape of Nature: Studies in Honor of H. W. Janson* (New York, 1981), 641–44; Ayako Ono, *Japonisme in Britain: Whistler, Menpes, Henry, Hornel, and Nineteenth-Century Japan* (London, 2003), 5–15, 28–29, 41–54; Stephen Calloway, ed., *The House of Liberty: Masters of Style and Decoration* (London, 1992), 20–25.

2  Jacques Dufwa, *Winds from the East: A Study in the Art of Manet, Degas, Monet and Whistler, 1856–86* (Stockholm, 1981), 155–78; D. G. Rossetti to J. A. Rose, February 24, 1864, JW to Henri Fantin-Latour, April [1864], [May 1864], *GUW* 12292, 8038–39; Douglas Druick and Michael Hoog, *Fantin-Latour* (Ottawa, 1983), 54–57.

3  Toshio Watanabe, "Eishi Prints in Whistler's Studio? Eighteenth-Century Japanese Prints in the West Before 1870," *BM*, 128 (December 1986), 874–80; Michael Fried, *Manet's Modernism, or, The Face of Painting in the 1860s* (Chicago, 1996), 224–32; Linda Merrill, "Whistler and the 'Lange Lijzen,'" *BM*, 136 (October 1994), 683–90.

4  Caroline Dakers, *The Holland Park Circle: Artists and Victorian Society* (New Haven and London, 1999), 107–08; David B. Elliott, *A Pre-Raphaelite Marriage: The Lives and Works of Marie Spartali Stillman and William James Stillman* (London, 2006), 24–29; Anna Whistler to J. H. Gamble, February 10–11, 1864, JW to Henri Fantin-Latour, January 4–February 3, 1864, *GUW* 6522, 8036.

5  Ono, *Japonisme in Britain*, 62–64, 65; Aileen Tsui, "Whistler's *la Princesse du pays de la porcelaine*: Painting Re-Oriented," *Nineteenth-Century Art Worldwide*, 9 (Autumn 2010),

1–27   <www.19thc-artworldwide.org>; Marie (Spartali) Stillman to Rose, January 24 [1907], Walter S. Brewster Collection, AIC. For an interesting perspective on Whistler's use of models at this time, see Susan A. Waller, *The Invention of the Model: Artists and Models in Paris, 1830–1870* (Aldershot, 2006), 249–53.

6   Ono, *Japonisme in Britain*, 55–56, 64–66; Lionel Lambourne, *Japonisme: Cultural Crossings Between Japan and the West* (London, 2005), 34–37; YMSM 56, 60.

7   Robin Spencer, "Whistler's Relations with Britain and the Significance of Industry and Commerce for His Art. Part I," *BM*, 136 (April 1994), 212–24, and "Part II," (October 1994), 664–74; Emma Chambers, *An Indolent and Blundering Art? The Etching Revival and the Redefinition of Etching in England, 1838–1892* (Aldershot, 1999), 131, 136, 138, 142–43; Kathleen Pyne, "Whistler and the Politics of the Urban Picturesque," *American Art*, 8 (Summer/Fall 1994), 60–77; Anna Gruetzner Robins, *A Fragile Modernism: Whistler and His Impressionist Followers* (New Haven and London, 2007), 136–37.

8   YMSM 33, 53–55. For the difficulty of assigning an anti-urban, anti-industrial impulse to the French painters of Whistler's generation, see Robert L. Herbert, *From Millet to Leger: Essays in Social Art History* (New Haven and London, 2002), 1–42, and James H. Rubin, *Impressionism and the Modern Landscape: Productivity, Technology, and Urbanization from Manet to Van Gogh* (Berkeley, Calif., 2008), 121–47.

9   Fried, *Manet's Modernism*, 267–76; Grischka Petri, *Arrangement in Business: The Art Markets and the Career of James McNeill Whistler* (Hildesheim, 2011), 84, 92–105.

10   Robin Spencer, "Whistler's Subject Matter: 'Wapping' 1860–1864," *GBA*, 100 (October 1982), 131–42; JW to Henri Fantin-Latour, [July 6/10, 1863], January 4–February 3, 1864, *GUW* 8043, 8036.

11   F. M. Brown to James Leathart, November 4, 1863, D. G. Rossetti to Leathart, December 9, 1863, W. B. Scott to Leathart, February 25 [1864], April 25, 1864, *GUW* 12431–34; Jeremy Maas, *Gambart: Prince of the Victorian Art World* (London, 1975), 165–66; Petri, *Arrangement in Business*, 76–80.

12   Daphne du Maurier, ed., *The Young George du Maurier: A Selection of His Letters, 1860–67* (Garden City, N.Y., 1952), 218–19, 227; Alphonse Legros Account [August 13, 1864], *GUW* 2505; W. M. Rossetti to Joseph Pennell, November 6, 1906, v.298, PWC.

13   JW to Henri Fantin-Latour, January 4–February 3, 1864, *GUW* 8036; Du Maurier, *Young du Maurier*, 227.

14   "The Relief Fund in Lancashire. A Commendation," *Once a Week*, 7 (July 26, 1862), 140; William Whistler to JW, October 14 [1852], WC.

15   William McNeill Whistler File, Compiled Service Records of Confederate Generals and Staff Officers, War Department Collection of Confederate Records, RG 109 (M331, reel 264), NA; R. E. Lee to M. C. Lee, July 15, 1860, *GUW* 12440. For counterfactual speculation on JW's fate had he fought in the war, see Daniel E. Sutherland, "The Civil War Career of General James Abbott Whistler," in Stephen Berry, ed., *Weirding the War: Stories from the Civil War's Ragged Edges* (Athens, Ga., 2011), 282–98.

16   Georgia Toutziari, "Anna Matilda Whistler's Correspondence – An Annotated Edition" (PhD thesis, Univ. of Glasgow, 2002), 600–09; Anna Whistler to Deborah Haden, August 4, 1863, *GUW* 6521.

17   JW to Henri Fantin-Latour, January 4–February 3, 1864, [Summer 1864 – misdated as September 1865], *GUW* 8036–37. For the complex relationship between mother and son, see Georgia Toutziari, "Ambition, Hopes, and Disappointments: The Relationship of Whistler and His Mother as Seen in Their Correspon-

dence," in Lee Glazer et al., eds., *James McNeill Whistler in Context* (Washington, D.C., 2008), 205–14.

18  JW to Henri Fantin-Latour, January 4– February 3, 1864, C. J. Palmer to M. G. Hill, January 28, 1864, Anna Whistler to J. H. Gamble, February 10–11, 1864, November 5 and 22, 1872, *GUW* 8036, 4406, 6522, 6553.

19  Anna Whistler to J. H. Gamble, February 10–11, 1864, *GUW* 6522; Philip Henderson, *Swinburne: Portrait of a Poet* (New York, 1974), 73; *LW*, I:111–12, 122–24.

20  JW to Henri Fantin-Latour, April [1864], [May 1864], *GUW* 8038–39 Catherine Carter Goebel, "Arrangement in Black and White: The Making of a Whistler Legend" (PhD diss., Northwestern Univ., 1988), 175–83, 711–20.

21  Bridget Alsdorf, *Fellow Men: Fantin-Latour and the Problem of the Group in Nine-teenth-Century French Painting* (Princeton, N.J, 2012), 35–38, 47–51, 53–56; Druick and Hoog, *Fantin-Latour*, 175–77.

22  Charles Baudelaire, *The Painter of Modern Life and Other Essays*, trans. and ed. Jonathan Mayne (2nd edn.; London, 1995), 3, 12–15; Francis Frascina et al., *Modernity and Modernism: French Painting in the Nineteenth Century* (New Haven and London, 1993), 50–58. On JW's multiple identities as bohemian, middle-class gentleman, and dandy, see Andrew Stephenson, "Refashioning Modern Masculinity," in David Peters Corbett and Lara Perry, eds., *English Art 1860–1914: Modern Artists and Identity* (Manchester, 2000), 133–49.

23  JW to Henri Fantin-Latour, May 25 and June 13 [1864], [Summer 1864 – misdated as September 1865], *GUW* 11476, 8037; YMSM 52. It is unclear whether or not JW understood the sexual symbolism of certain flowers in Japanese painting, but see Timon Screech, *Sex and the Floating World: Erotic Images in Japan, 1700–1820* (Honolulu, 1999), 136–46, 149–54.

24  Kathleen Pyne, "On Feminine Phantoms: Mother, Child, and Woman-Child," *AB*, 88 (March 2006), 45–48; *WJ*, 118, 162.

25  Du Maurier, *Young du Maurier*, 235–36; F. T. Palgrave to Lord Houghton, May 13, 1865 (230:28), Houghton Papers, TC; Algernon Swinburne to JW [April 2, 1865], *GUW* 5619; Edmund Gosse and Thomas J. Wise, eds., *The Complete Works of Algernon Charles Swinburne*, 20 vols. (London, 1925–27), I:260–62; Cecil Y. Lang, ed., *The Swinburne Letters*, 6 vols. (New Haven and London, 1959–62), I:118–20, 130.

26  Alsdorf, *Fellow Men*, 68–74, 88–89; Mathilde Arnoux et al., *Correspondance entre Henri Fatin-Latour et Otto Scholderer, 1858–1902* (Paris, 2011), 98–99, 105; Fried, *Manet's Modernism*, 276.

27  William Whistler to R. R. Hemphill, [November 29, 1898], *GUW* 7027.

28  Anna Whistler to M. G. Hill, December 23–24, 1864, October 22, 1865, JW to Henri Fantin-Latour [Summer 1864 – misdated as September 1865], JW to C. A. Howell [May 17/24, 1864], *GUW* 11479, 11965, 8037, 2788.

29  Goebel, "Arrangement in Black and White," 183–97, 721–38; Druick and Hoog, *Fantin-Latour*, 192.

30  Petri, *Arrangement in Business*, 38, 57–61.

31  Robyn Asleson, *Albert Moore* (London, 2000), 87–92, 215 n.46; Walford Graham Robertson, *Life Was Worth Living: The Reminiscences of W. Graham Robertson* (New York, 1931), 57–58, 60; Richard Jenkyns, *Dignity and Decadence: Victorian Art and the Classical Inheritance* (Cambridge, Mass., 1992), 268–76; William E. Fredeman, ed., *The Correspondence of Dante Gabriel Rossetti*, 9 vols. (Cambridge, Eng., 2002–11), IV:197; JW to Henri Fantin-Latour, August 16 [1865], *GUW* 11477. For Moore's influence on JW, see Joyce Hill Stoner, "Textured Surfaces: Technique, Facture, and Friendship in the Work of James McNeill Whistler" (PhD diss., Univ. of Delaware, 1995), 88, 92–111.

32   Jenkyns, *Dignity and Decadence*, 273–75; Asleson, *Albert Moore*, 91–92; YMSM 61; Petri, *Arrangement in Business*, 126–32; JW to Henri Fantin-Latour, August 16 [1865], *GUW* 11477.

33   YMSM 62–63; JW to Henri Fantin-Latour, August 16 [1865], *GUW* 11477.

34   JW to Henri Fantin-Latour, August 16 [1865], Anna Whistler to M. G. Hill, October 22, 1865, JW to Lucas Ionides, October 20, 1865, October 26, 1865, Anna to JW, November 25 [1865], *GUW* 11477, 11965, 11310–11, 6526.

35   Gustave Courbet to JW, February 14, 1877, *GUW* 695; Petra ten-Doesschate Chu, ed. and trans., *Letters of Gustave Courbet* (Chicago, 1992), 268–69; Sarah Faunce and Linda Nochlin, *Courbet Reconsidered* (Brooklyn, N.Y., 1988), 157–61; James H. Rubin, *Courbet* (London, 1997), 198–205.

36   YMSM 64–70; Suzanne Singletary, "Manet and Whistler: Baudelairean *Voyage*," in Therse Dolan, ed., *Perspectives on Manet* (Farnham, 2012), 64; R. Lenora Moffa, "The Paintings of James McNeill Whistler, 1859–1877: A Technique of Mutability" (PhD diss., Emory Univ., 1991), 35, 94–95, 187–91; Sarah Elizabeth Kelly, "Camera's Lens and Mind's Eye: Whistler and the Science of Art" (PhD diss., Columbia Univ., 2010), 71–75.

37   Dominique de Font-Reaulx et al., *Gustave Courbet* (New York, 2008), 332–35; Faunce and Nochlin, *Courbet Reconsidered*, 162–69.

38   Anna Whistler to JW, November 25 [1865], *GUW* 6526.

39   Lang, *Swinburne Letters*, I:144, 152; C. S. Keene to Edwin Edwards, [1865], January 10, 1866, Charles S. Keene Letters, FM.

40   JW's entire Chilean adventure, including much documentation omitted below, is told in Daniel E. Sutherland, "James McNeill Whistler in Chile: Portrait of the Artist as Arms Dealer," *American Nineteenth Century History*, 9 (March 2008), 61–73.

41   Anna Whistler to JW, January 22, 1866, Anna to Deborah Haden, January 24, 1866, JW to J. A. Rose (Last Will and Testament), January 31, 1866, Rose to Joanna Hiffernan, January 31, 1866, JW to Manager, Bank of London, January 31, 1866, JW to Rose, January 31, 1866, *GUW* 6527–28, 11483, 11480, 12125, 12127.

42   C. L. Freer to William Webb, July 1, 1902, JW to George Whistler, October 7, 1863, *GUW* 1529, 6677.

43   Valparaiso Notebook, *GUW* 4335.

44   E. R. Pennell Diaries, June 3, 1900, Joseph and Elizabeth R. Pennell Papers, RHC.

45   JW to J. A. Chapman, June 22, 1874, *GUW* 11251.

46   YMSM 71–76; Katherine Emma Manthorne, *Tropical Renaissance: North American Artists Exploring Latin America, 1839–1879* (Washington, D.C., 1989), 159, 162–67; Allen Staley and Christopher Newall, *Pre-Raphaelite Vision: Truth to Nature* (London, 2004), 212–13, 218, 225.

47   JW to William Boxall, December 24 [1867], A. H. Wake to F. S. Haden, September 23, 1867, *GUW* 498, 12946; Pennell Diaries, June 3, 1903; Benjamin Moran Diaries, November 1, 1866, LC. Paul G. Marks, "James McNeill Whistler's Family Secret: An Arrangement in White and Black," *Southern Quarterly*, 26 (Spring 1988), 67–75, offers a partial explanation for JW's racial attitudes.

48   Valparaiso Notebook, p. 22; H. H. Doty to R. N. Wornum, December 9, 1867, JW to William Boxall, December 24 [1867], *GUW* 12947, 498.

7: TROUBLE IN PARADISE

1   Francis Sheppard, *London 1808–1870: The Infernal Wen* (Berkeley, Calif., 1971), 139–48, 284–86, 294–95; Stephen Halliday, *The Great Stink of London: Sir Joseph Bazalgette and the*

*Cleansing of the Victorian Capital* (Stroud, Eng., 1999), 71–83, 144–72.

2  Sheppard, *London*, 74–81; Joanna Hiffernan to J. A. Rose, May 14, 1866, James Sharpe to JW, June [11], 1866, June 16, 1866, Hiffernan to Sharpe, June 22, 1866, J. E. Coleman to JW, June 16, 1866, *GUW* 11484, 13752, 13754, 13753, 13755.

3  Sarah Faunce and Linda Nochlin, *Courbet Reconsidered* (Brooklyn, N.Y., 1988), 175–78; Dominique de Font-Reaulx et al., *Gustave Courbet* (New York, 2008), 362–65, 378–82; Nicholas Daly, "The Woman in White: Whistler, Hiffernan, Courbet, Du Maurier," *Modernism/Modernity* 12 ( January 2005), 18–22. Thierry Savatier, *L'Origine du Monde: Histoire d'un tableau de Gustave Courbet* (Paris, 2007), which offers the most recent version of that painting's story, doubts that Jo was the model.

4  Virginia Surtees, ed., *Diaries of George Price Boyce* (Norwich, 1980), 45; William E. Fredeman, ed., *The Correspondence of Dante Gabriel Rossetti*, 9 vols. (Cambridge, Eng., 2002–11), III:524; Angela Thirlwell, *William and Lucy: The Other Rossettis* (New Haven and London, 2003), 258.

5  Fredeman, *Correspondence of Rossetti*, III:485; *LW*, I:facing 108; Anna Whistler to J. H. Gamble [August 27, 1867], *GUW* 6535.

6  Deanna Marohm Bendix, *Diabolical Designs: Paintings, Interiors, and Exhibitions by James McNeill Whistler* (Washington, D.C., 1995), 86–94; *LW*, I:137–39.

7  Tom Pocock, *Chelsea Reach: The Brutal Friendship of Whistler and Walter Greaves* (London, 1970), 56–88.

8  *LW*, I:138–39; Roger W. Peattie, "Whistler and W. M. Rossetti: Always on the easiest & pleasantest terms," *JPRS*, 4 n.s. (Fall 1995), 78.

9  Robin Spencer, "Whistler, Manet, and the Tradition of the Avant-Garde," in Ruth E. Fine, ed., *James McNeill Whistler: A Reexamination* (Washington, D.C., 1987), 55, 67 n.32.

10  F. W. J. Hemmings, *Life and Times of Emile Zola* (New York, 1977), 52–55; Douglas Druick and Michael Hoog, *Fantin-Latour* (Ottawa, 1983), 203–14.

11  Henri Fantin-Latour to JW, February 12, 1867, February 21, 1867, JW to Alfred Stevens [February 13/20, 1867], JW to G. A. Lucas [March 23, 1867], *GUW* 1083–84, 8145, 9191; Lillian M. C. Randall, ed., *Diary of George A. Lucas: An American Art Agent in Paris, 1857–1909* (Princeton, N.J., 1979), II:231–37.

12  Catherine Carter Goebel, "The Brush and the Baton: Influences on Whistler's Choice of Musical Terms for his Titles," *WR*, 1 (1999), 27–36; Galina Andreeva and Margaret F. MacDonald, eds., *Whistler and Russia* (Moscow, 2006), 72. Suzanne F. Cooper, "Music, Memory and Loss in Victorian Painting," *Nineteenth-Century Music Review*, vol.2 no.1 (2005), 34–42, discusses additional associations of Whistler's painting with music, although the ultimate guide is Arabella Teniswood-Harvey, "Colour-Music: Musical Modelling in James McNeill Whistler's Art" (PhD thesis, Univ. of Tasmania, 2006).

13  Jacques Barzun, *From Dawn to Decadence: 500 Years of Cultural Life, 1500 to Present* (New York, 2000), 494–97, 637–39.

14  JW to G. A. Lucas [April 6, 1867], *GUW* 9192; Jane Mayo Roos, *Early Impressionism and the French State (1866–1874)* (Cambridge, Eng., 1996), 73–88; Patricia Mainardi, *Art and Politics of the Second Empire: The Universal Expositions of 1855 and 1867* (New Haven and London, 1987), 135–50.

15  Timothy J. Wilcox, "Alphonse Legros: Aspects of His Life and Work" (MPhil thesis, Courtauld Institute, 1981), 28–35, 49–54. Luke Ionides, *Memories* (1925; Ludlow, Eng., 1996), 13, 74–78, thought Legros's retort had less to do with old debts than with the Frenchman's belief that JW had recommended Fantin over him for a lucrative commission.

16  Fredeman, *Correspondence of Rossetti*, III:523–24, 526–31, 536; Daphne du Maurier, *The Young George du Maurier: Letters 1860–1867* (Garden City, N.Y., 1952), 244, 301n; JW to Luke Ionides [April 22, 1867], JW to Henri Fantin-Latour, September 30–November 22, 1868, *GUW* 11312, 11983; Edward Burne-Jones to George Howard [April 1867] J22/27/208, Howard Family Papers, CH; C. S. Keene to Ruth Edwards, October 1, 1868, Charles S. Keene Letters, FM. Legros still nursed his "rancour" and "bitterness" forty years after the incident. See Thomas Armstrong to Joseph Pennell, November 9, 1906, v.278, PWC.

17  Randall, *Diary of Lucas*, II:238–40; F. Seymour Haden, *Paris Jurors: A Letter to Henry Cole, Esq., C.B.* (London, 1867), 3–5, 7–9; Henry Cole Diaries, December 18 and 24, 1866 and April 29, 1867, NAL.

18  William Whistler to Edward Forbes [May 6/8, 1867], JW to R. R. Hemphill, October 12, 1898, *GUW* 6996, 2119; Emma Chambers, *An Indolent and Blundering Art? The Etching Revival and the Redefinition of Etching in England, 1838–1892* (Aldershot, 1999), 25–30, 150–52, 157–62.

19  William Whistler to Deborah Haden, May 3 [1867], JW to William Boxall, December 24 [1867], JW to F. S. Haden [April 26, 1867], *GUW* 6994, 498, 1936.

20  JW to Anna Whistler [April 27/May, 1867], Deborah Haden to JW, April 27 [1867], April 30 [1867], May 3 [1867], JW to Haden [May 1, 1867], William Whistler to Haden, May 3 [1867], Haden to William [May 4/6, 1867], *GUW* 6529, 1915–18, 6994; E. R. Pennell Diaries, September 12, 1906, in Joseph and Elizabeth R. Pennell Papers, RHC.

21  William Whistler to Deborah Haden, May 3 [1867], William to Edward Forbes [May 6/8, 1867], Forbes to William, May 9 [1867], William to JW, May 6 and 10 [1867], *GUW* 6994, 6996, 1435, 6995. Giving the story yet another twist, Haden became known in the 1880s and 1890s for advocating the proper "disposal of the dead." See Francis Seymour Haden, *The Disposal of the Dead: A Plea for Legislation, and a Protest Against Cremation* (London, 1888), and *Earth to Earth: A Plea for a More Rational Observance of . . . Disposal of the Dead* (London, 1893). JW's copies of both pamphlets are in Special Collection, GUL.

22  Haden, *Paris Jurors*, 5–17; Elizabeth Bonython and Anthony Burton, *The Great Exhibitor: The Life and Work of Henry Cole* (London, 2003), 70, 132, 186, 194, 197–98; A. J. Mundella to Henry Cole, August 1, 1867, Henry Cole Collection, NAL.

23  Robert Spence to James Laver, October 4, 1960, October 14, 1960, James Laver Papers, GUL; William Boxall and Louis Huth to Burlington Fine Arts Club, February 22, 1867; F. S. Haden to R. N. Wornum (memorandum), and June 11, 1867, Wornum to JW, June 11, 1867, *GUW* 11957, 12942, 11954; Minutes of General Meetings, March 12, 1867, and June 11, 1867; Burlington Fine Arts Club: Records and Correspondence Relating to James McNeill Whistler's Expulsion from the Club, NAL.

24  Minutes of Meetings, June 19, 1867, Burlington Records; R. N. Wornum to JW, June 13, 1867, JW to Wornum, June 14 [1867], *GUW* 437, 439.

25  George Whistler to JW, June 7 and 19, 1867, *GUW* 6680; Fredeman, *Correspondence of Rossetti*, III:543–44; Peattie, "Whistler and Rossetti," 78–79; Roger W. Peattie, ed., *Selected Letters of William Michael Rossetti* (University Park, Penn., 1990), 174–76; Druick and Hoog, *Fantin-Latour*, 101.

26  JW to W. M. Rossetti, June 26, 1867, JW to Alphonse Legros, [July 1867], *GUW* 9388, 2507.

27  H. H. Doty to R. N. Wornum, December 9, 1867, JW to Henri Fantin-Latour [September 1867], *GUW* 12947, 8045; Fredeman,

*Correspondence of Rossetti*, III:562; Benjamin Moran Diaries, May 15, September 21, and November 9 and 11, 1867, LC. JW asked Hunter Davidson and Henry B. Edenborough, another ex-Confederate naval officer who fought in South America, to refute Doty's claims, but their letters came too late to save him. See *GUW* 1039–40, 804–805.

28 Minutes of Meetings, December 2 and 6, 1867, Burlington Records; JW to W. M. Rossetti, December 11, 1867, R. N. Wornum to Executive Committee, December 13, 1867, List of Members Present, December 13, 1867, JW to William Boxall, December 24 [1867], *GUW* 9389, 12958, 12959, 498.

29 Louis Huth to JW, December 25 [1867], William Boxall to JW, January 4, 1868, JW to W. M. Rossetti, December 16 [1867], Baldwyn Leighton to JW [January 1868], *GUW* 2241, 402, 9390, 318, 2508; Peattie, *Selected letters of William Rossetti*, 188–90; Edwin A. Ward, *Recollections of a Savage* (London, 1923), 262–63.

30 Anna Whistler to J. A. Rose, June 13, 1867, June 14, 1867, Anna to Jane Wann, July 24, 1867, July 27, 1867, Anna to J. H. Gamble [August 27, 1867], Anna to Deborah Haden, December 14 [1867], Anna to George Whistler [July/September 1868], Anna to M. G. Hill, December 14–19, 1868, *GUW* 12214, 12216, 6530–31, 6535, 6541, 6682, 11473; Daria E. Seymour Haden to to W. S. Brewster, April 18, 1947, Walter S. Brewster Collection, AIC.

31 George Whistler to F. S. Haden, February 6 and 18, 1868, George to JW, August 25 and September 6, 1868, JW to George [July/September 1868], *GUW* 6681, 6684, 1085.

32 Catherine Carter Goebel, "Arrangement in Black and White: The Making of a Whistler Legend" (PhD diss., Northwestern Univ., 1988), 197–211, 739–52; [Philip G. Hamerton], "Pictures of the Year: IX," *SR*, 23 (June 1, 1867), 690–91; Philip Hamerton, *Etching and Etchers* (1868; London, 1876), 288–89.

33 Sidney Colvin, "English Painters and Painting in 1867," *FR*, 2 n.s. (October 1867), 473–74; JW to Henri Fantin-Latour [September 1867], *GUW* 8045.

34 Bernard Howells, "The Problem with Colour. Three Theorists: Goethe, Schopenhauer, Chevreul," in Peter Collier and Robert Lethbridge, eds., *Artistic Relations: Literature and the Visual Arts in Nineteenth Century France* (New Haven and London, 1994), 76–79; Henri Fantin-Latour to JW, October [7/14], 1862, *GUW* 1075.

35 R. Lenora Moffa, "The Paintings of James McNeill Whistler, 1859–1877: A Technique of Mutability" (PhD diss., Emory Univ., 1991), 56, 86 n.3, 147–48, 234–38; James A. Harrison, ed., *Complete Works of Edgar Allen Poe*, 17 vols. (New York, 1902), XIV:198–202; JW to Henri Fantin-Latour, September 30–November 22, 1868, *GUW* 11983.

36 Henri Fantin-Latour to JW, October [7/14], 1862, November 10, 1862, *GUW* 1075–76.

37 JW to G. A. Lucas [November 5, 1867], *GUW* 9193.

38 M.341–73; Ayako Ono, *Japonisme in Britain: Whistler, Menpes, Henry, Hornel and Nineteenth-Century Japan* (London, 2003), 28–34, 70–72; Catherine Arbuthnott, "E. W. Godwin as an Antiquary," and Nancy B. Wilkinson, "E. W. Godwin and Japonisme in England," both in Susan Weber Soros, ed., *E. W. Godwin: Aesthetic Movement Architect and Designer* (New Haven and London, 1999), 45–91.

39 YMSM 82–88; Linda Merrill, *The Peacock Room: A Cultural Biography* (New Haven and London, 1998), 77–107.

40 Elizabeth Prettejohn, *Beauty and Art, 1750–2000* (Oxford, 2005), 124–30, 139–40, and Prettejohn, ed., *After the Pre-Raphaelites: Art and Aestheticism in Victorian England* (New Brunswick, N.J., 1999), 1–8.

41 William M. Rossetti and Algernon C. Swinburne, *Notes on the Royal Academy Exhibition, 1868* (London, 1868), 44–45, 50.

42 Anna Whistler to J. H. Gamble, October 30 [1868], November 11 [1868], Anna to M. G. Hill, December 14, 1868, JW to Henri Fantin-Latour, September 30–November 22, 1868, *GUW* 6537–38, 11473, 11983.

43 *LW*, I:148–49; JW to Emilie Jones [February 13, 1869], *GUW* 9169; Druick and Hoog, *Fantin-Latour*, 101–02; Emily Chapman Diary (Extracts), December 25, 1868, February 2 and 22 and April 15, 1869, v.280, WC.

44 Anna Whistler to F. R. Leyland, March 11 [1869], *GUW* 8182. Most interpreters of JW's work believe that he learned nothing from the Six Projects, but that is an overly harsh judgment.

45 "The London Art Season," *Blackwood's Magazine*, 106 (August 1869), 224–25; Anna Whistler to J. H. and Harriet Gamble, May 6, 1869, JW to F. R. Leyland [May/June 1869], *GUW* 6542, 8792.

46 Anna Whistler to J. H. and Harriet Gamble, May 6, 1869, June 9, 1869, *GUW* 6542–43.

47 Philip Henderson, *Swinburne: Portrait of a Poet* (New York, 1974), 29–30, 53–57; Patrick Leary, *The Punch Brotherhood: Table Talk and Print Culture in Mid-Victorian London* (London, 2010), 68–72; Surtees, *Diaries of Boyce*, 26–27; Teddy L. Meyers, ed., *Uncollected Letters of Algernon Charles Swinburne*, 3 vols. (London, 2005), II:121.

48 Bernard Denvir, *A Most Agreeable Society: A Hundred and Twenty-Five Years of the Arts Club* (London, 1989), 8–9, 11–12; Derek Hudson, *Munby, Man of Two Worlds: The Life and Diaries of Arthur F. Munby, 1828–1910* (Boston, 1972), 233–34; C. S. Keene to Edwin Edwards, December 21, 1868, July 23, 1869, Keene Letters; Lang, *Swinburne Letters*, II:20–21; JW to G. T. Oldfield, August 11, 1869, *GUW*

202; Joseph Hone, ed., *J. B. Yeats: Letters to His Son W. B. Yeats and Others, 1869–1922* (New York, 1946), 104–05.

49 F. J. Shields to C. A. Howell, June 14, 1869, Charles Augustus Howell Letters, RHC; Fredeman, *Correspondence of Rossetti*, IV:206; JW to Thomas Winans [September 1869], *GUW* 10632.

50 Chapman Diary, December 24, 1869; John H. B. Latrobe to JW, December 24, 1869, *GUW* 2479.

8 : BUTTERFLY

1 Anna Whistler to J. H. Gamble, September 7–10, 1870, Anna to M. G. Hill, September 8–10, 1870, *GUW* 6545, 7642; Catherine C. Goebel, "Arrangement in Black and White: The Making of a Whistler Legend" (PhD diss., Northwestern Univ., 1988), 234–37, 753–55.

2 *LW*, I:124–26; Robyn Asleson, *Albert Moore* (London, 2000), 86, 214 n.33; JW to G. A. Lucas [January 18, 1873], *GUW* 9182; Patricia de Montfort, " 'The Fiction of My Own Biography': Whistler and *The Gentle Art of Making Enemies*" (PhD thesis, Univ. of St. Andrews, 1994), 229–41; "The Royal Academy Exhibition," [London] *The Times*, April 30, 1870, p. 12.

3 Birth Certificate of Charles James Whistler, June 10, 1870, *GUW* 1953; E. R. Pennell Diaries, August 7, 1903, Joseph and Elizabeth R. Pennell Papers, RHC. Rumors of an earlier child, named John, born to Jo in 1864, cannot be confirmed.

4 *WJ*, 163; C. J. Hanson, "Out of my Memory," p. 2, *GUW* 2246.

5 Alphonse V. Roche, *Alphonse Daudet* (Boston, 1976), 51–54, 70; Alphonse Daudet, *Artist's Wives*, trans. Laura Ensor (New York, 2009), xi–xvi; "Artists' Wives," *Graphic*, 10 (October 31, 1874), 427.

6 Virginia Surtees, ed., *The Diaries of George Price Boyce* (Norwich, 1980), 51; Odette Bormand, ed., *Diary of W. M. Rossetti, 1870–1873* (Oxford, 1977), 19–20; Linda Merrill, *The Peacock Room: A Cultural Biography* (New Haven and London, 1998), 153–54; YMSM 95–97, 106–11.

7 Merrill, *Peacock Room*, 109–45; Anna Whistler to J. H. Gamble, September 7–10, 1870, Anna to M. G. Hill, September 8–10, 1870, Anna to C. J. Palmer, October 29–November 5, 1870, *GUW* 6545, 7642, 11841.

8 YMSM 97.

9 Katharine Lochnan, *The Etchings of James McNeill Whistler* (New Haven and London, 1984), 168–74; G.46–50, 53–55, 62, 70, 76, 78–79, 86, 95, 102; JW to F. S. Ellis [October 1870/March 1871], [March/April 1871] (two letters), *GUW* 13328, 9086–87; Grischka Petri, *Arrangement in Business: The Art Markets and Career of James McNeill Whistler* (Hildesheim, 2011), 239–41.

10 "A Whistle for Whistler," *Punch*, 60 (June 17, 1871), 245. William Rossetti published an appreciative review seven months later in *PMG*. See Martin Hopkinson, "An Early Review of Whistler's 'Thames Set,'" *PQ*, 26 (March 2009), 46–54, and "Another Early Review of Whistler's *Thames Set*," *PQ*, 27 (March 2010), 29–32.

11 Walford Graham Robertson, *Life Was Worth Living: The Reminiscences of W. Graham Robertson* (New York, 1931), 48–49; Anna Whistler to J. H. and Harriet Gamble, September 9–20, 1875, *GUW* 6555.

12 Kate Flint, *The Victorians and the Visual Imagination* (Cambridge, Eng., 2000), 285–305; John Siewert, "Rhetoric and Reputation in Whistler's Nocturnes," in Linda Merrill et al., *After Whistler: The Artist and His Influence on American Painting* (New Haven and London, 2003), 64–73; essays by Siewert and Katharine Lochnan in Lochnan, ed., *Turner, Whistler,*

*Monet: Impressionist Visions* (London, 2004), 15–49, 141–47.

13 Marc Simpson, "Whistler, Modernism, and the Creative Afflatus," in Simpson, ed., *Like Breath on Glass: Whistler, Inness, and the Art of Painting Softly* (Williamstown, Mass., 2008), 37–38; Stephen Hackney, "Colour and Tone in Whistler's 'Nocturnes' and 'Harmonies' 1871–72," *BM*, 136 (October 1994), 695–99; David Peters Corbett, *The World in Paint: Modern Art and Visuality in England, 1848–1914* (University Park, Penn., 2004), 118–23.

14 Tom Pocock, *Chelsea Reach: The Brutal Friendship of Whistler and Walter Greaves* (London, 1970), 84; Robert Slifkin, "James Whistler as the Invisible Man: Anti-Aestheticism and the Artistic Vision," *OAJ*, 29 (2006), 53–54, 74.

15 Lochnan, *Turner, Whistler, Monet*, 148–57; Petri, *Arrangement in Business*, 169–71, 225–29.

16 Martha Tedeschi, "The Face That Launched a Thousand Images: Whistler's *Mother* and Popular Culture," in Margaret F. MacDonald, ed., *Whistler's Mother: An American Icon* (Aldershot, 2003), 34–39, 121–41; Anna Whistler to C. J. Palmer, November 3–4, 1871, *GUW* 10071.

17 MacDonald, "The Painting of Whistler's Mother, in *Whistler's Mother*, 29–58.

18 Jonathan Weinberg, *Ambition and Love in Modern American Art* (New Haven and London, 2001), 3–28; Anna Whistler to C. J. Palmer, November 3–4, 1871, *GUW* 10071. For a reasonable argument that JW never totally abandoned subject matter for pure form, see Elizabeth Broun, "Thoughts That Began with the Gods: The Content of Whistler's Art," *Arts Magazine*, 62 (October 1987), 36–43.

19 JW to Walter Greaves [November 14/December 1871], *GUW* 11496.

20 Merrill, *Peacock Room*, 117–18, 133–36; JW to Frances Leyland [August 27/31, 1871], [January 1/6, 1874], *GUW* 8051, 10867.

21 Mortimer Menpes, *Whistler As I Knew Him* (London, 1904), 60–61; Thomas Leyland to JW, December 9, 1873, *GUW* 2609.

22 JW later made an etching of Frances in her velvet dress, part of a series of etchings done of the Leyland family and the grounds of Speke Hall over the next two years. G.120–23, 130, 135–37, 151–52.

23 YMSM 106, 236. The best analysis of the painting is Susan Grace Galassi, "Whistler and Aesthetic Dress: Mrs. Frances Leyland," in Margaret F. MacDonald et al., *Whistler, Women, and Fashion* (New Haven and London, 2003), 92–115.

24 *LW*, I:155–57; Thomas M. Bayer and John R. Page, *The Development of the Art Market in England: Money as Muse, 1730–1900* (Aldershot, 2011), 99–113, 126–36; Pamela M. Fletcher, "Shopping for Art: The Rise of the Commercial Art Gallery, 1850s–90s," in Fletcher and Anne Helmreich, eds., *The Rise of the Modern Art Market in London, 1850–1939* (Manchester, 2011), 47–64; Tom Taylor, "English Painting in 1862," *FAQ*, 1 (May 1863), 15–18.

25 Goebel, "Arrangement in Black and White," 237–42, 756–62; E. J. Poynter to JW, October 10, 1871, *GUW* 5011; Julie L'Enfant, *William Rossetti's Art Criticism: The Search for Truth in Victorian Art* (Landham, Md., 1999), 101, 129–34, 165–66, 169–81; Philip G. Hamerton, "The Artistic Spirit," *FR*, 1 o.s. (June 1865), 332–43.

26 Henry Cole to JW, March 20, 1872, *GUW* 5518.

27 Henry Cole Diaries, January 31, 1861, March 3 and 27 and April 15, 17 and 22, 1872, NAL; JW to A. S. Cole [March/September 1872], [April 14, 1872], [April 25, 1872], [May 1872], *GUW* 9045, 9021, 9011, 9020.

28 *LW*, I:157–58.

29 Benjamin Moran Diaries, February 20, 1867 and May 3, 1872, LC; Mary Gladstone Diaries, May 3, 1872, in Mary Gladstone Papers,

BL; Veronica Franklin Gould, *G. F. Watts: The Last Great Victorian* (New Haven and London, 2004), 108; Goebel, "Arrangement in Black and White," 242–48, 763–68.

30 Macleod, *Art and the Victorian Middle Class*, 279, 382–83; W. C. Alexander to JW, December 21, 1872, Anna Whistler to J. H. Gamble, November 5 and 22, 1872, Anna to R. A. Alexander, August 26 [1872], *GUW* 138, 6553, 7571.

31 Margaret F. MacDonald, "East and West: Sources and Influences," in MacDonald, *Whistler, Women and Fashion*, 71–75; Arthur Jerome Eddy, *Recollections and Impressions of James A. McNeill Whistler* (Philadelphia, 1903), 232, 235; *LW*, I:172–75.

32 Harry W. Rudman, *Italian Nationalism and English Letters: Figures of the Risorgiments and Victorian Men of Letters* (London, 1940), 97–103, 119–22, 287–96; Anna Whistler to C. J. Palmer, October 26–November 5, 1870, Anna to J. H. Gamble, April 10–20, 1872, JW to Giuseppe Mazzini [January 1870/72], *GUW* 11841, 6549, 4031.

33 YMSM 133–37; *LW*, 170–72; Moncure D. Conway, *Autobiography: Memories and Experiences*, 2 vols. (London, 1904), II:106; Lord Redesdale [Algernon Bertram Freeman-Mitford], *Memories*, 2 vols. (New York, 1916), I:2; Mark Stocker, *Royalist and Realist: The Life and Work of Sir Joseph Edgar Boehm* (New York, 1988), 218.

34 YMSM 125; JW to F. R. Leyland [November 2/9, 1872], *GUW* 8794. *Punch*, 62 (March 2, 1872), 97, had already begun to parody the moonlights.

35 Petra ten-Doesschoate Chu, "The Lu(c)re of London: French Artists' and Art Dealers in the British Capital, 1850–1914," in John House et al., *Monet's London: Artists' Reflections on the Thames* (St. Petersburg, Fla., 2005), 40–48; Pierre Assouline, *Discovering Impressionism: The Life of Durand-Ruel* (New York, 2002),

99–105, 112, 117–18. Ironically, a friend of JW, the American-born painter Louis Remy Mignot, was mistakenly imprisoned in Paris during the war and died of smallpox. Anna led a fundraising campaign to assist his widow. Anna Whistler to C. J. Palmer, October 29–November 5, 1870, PWC.

36  YMSM 98, 122; Petri, *Arrangement in Business*, 123–25.

37  JW to G. A. Lucas [January 18, 1873], *GUW* 9182.

38  Sarah Lawrence Parkerson, "Variations in Gold: The Stylistic Development of the Picture Frames Used by James McNeill Whistler" (PhD thesis, Univ. of Glasgow, 2007), 24–25, 32–33, 80–107, 117–18. Parkerson is the authority on JW's frames, but see, too, Ira M. Horowitz, "Whistler Frames," *AJ*, 39 (Winter 1979–80), 124–31.

39  Douglas Druick and Michel Hoog, *Fantin-Latour* (Ottawa, 1983), 15, 216–17, 256; Robin Spencer, "Whistler, Manet, and the Tradition of the Avant-Garde," in Ruth E. Fine, ed., *James McNeill Whistler: A Reexamination* (Washington, D.C., 1987), 56–58; Mathilde Arnoux, et al., *Correspondance entre Henri Fantin-Latour et Otto Scholderer: 1858–1902* (Paris, 2011), 179–81, 194, 196.

40  Goebel, "Arrangement in Black and White," 252–60, 769–80; "Winter Exhibition of Cabinet Pictures in Oil, Dudley Gallery," *Athenaeum*, No. 2349 (November 2, 1872), 568; "Autumnal Picture Exhibitions – The Dudley Gallery," *Graphic*, 6 (November 2, 1872), 419.

41  Arnoux, *Correspondance Fantin-Latour et Scholderer*, 184–86, 191–93.

42  "An Artistic Duologue," *Punch*, 64 (May 10, 1873), 198; Katherine Price, "Walter Greaves: A Native Artist" (MA thesis, Courtauld Institute, 2000), 41–53; Asleson, *Albert Moore*, 112, 119–21, 130–37.

43  Paula Gillet, *Worlds of Art: Painters in Victorian Society* (New Brunswick, N.J., 1999),

192–96; Betty Eleza, *Frederick Sandys, 1829–1904: A Catalogue Raisonné* (Woodbridge, 2001), 14–15.

44  YMSM 105; JW to Louis Huth [January 31, 1873], JW to A. S. Cole [March 1873], [May 18/20, 1873], JW to Henry Cole, [April 27, 1873], *GUW* 2242, 9022, 641, 7887; Pennell Diaries, March 7, 1904; Edwin A. Ward, *Recollections of a Savage* (London, 1923), 265; Lochnan, *Etchings*, 161–66.

45  Madeleine Fidell Beaufort et al., eds., *The Diaries 1871–1882 of Samuel P. Avery, Art Dealer* (New York, 1979), x–xxxii, 98, 114–15, 160–62, 169–72, 176, 186–88, 220; Randall, *Diary of Lucas*, I:16–20, II:365, 369–70, 372–75; JW to S. P. Avery, March 1 [1873], [July 7, 1873], *GUW* 10629, 10628; Petri, *Arrangement in Business*, 182–84; Nigel Thorp, "Studies in Black and White: Whistler's Photographs in the Glasgow University Library," in Fine, *James McNeill Whistler*, 91–92.

46  Merrill, *Peacock Room*, 135–36; Emily Chapman Diary (Extracts), October 24 and November 7, 1873, v.280, PWC; Surtees, *Diary of Boyce*, 59.

47  Lochnan, *Turner, Whistler, Monet*, 21–22; Theodore Reff, *Degas: The Artist's Mind* (New York, 1976), 15–34; Richard B. Brettell, *Impressionism: Painting Quickly in France, 1860–1890* (New Haven and London, 2000), 126–29; Edward Simmons, *From Seven to Seventy: Memories of a Painter and a Yankee* (New York, 1922), 130.

48  *Athenaeum*, No. 2404 (November 22, 1873), 66, also in *GAME*, 55.

9: PEACOCKS AND NOCTURNES

1  Deanne Marohn Bendix, *Diabolical Designs: Paintings, Interiors, and Exhibitions by James McNeill Whistler* (Washington, D.C., 1995), 205–15; Martha Ward, "Impressionist

Installations and Private Exhibitions," *AB*, 73 (December 1991), 600–06; Robin Spencer, "Whistler's First One-Man," in Gabriel P. Weisberg and Laurinda S. Dixon, eds., *The Documented Image: Visions in Art History* (Syracuse, N.Y., 1987), 30–47; David Park Curry, "Total Control: Whistler at an Exhibition," in Ruth E. Fine, ed., *James McNeill Whistler: A Reexamination* (Washington, D.C., 1987), 67–70, 75.

2  William E. Fredeman, ed., *The Correspondence of Dante Gabriel Rossetti*, 9 vols. (Cambridge, Eng., 2002–11), VI:467, 491; Cecil Y. Lang, *The Swinburne Letters*, 6 vols. (New Haven and London, 1959–62), II:297–98; Thomas Carlyle to Lady Derby, May 18, 1874, Colnaghi Gift/Forster Collection, NAL.

3  Fredeman, *Correspondence of Rossetti*, VI:523; Mathilde Arnoux et al., *Correspondance entre Henri Fantin-latour et Otto Scholderer* (Paris, 2011), 207–08;

4  Catherine Carter Goebel, "Arrangement in Black and White: The Making of a Whistler Legend," (PhD diss., Northwestern Univ., 1988), 269–81, 792–816; Sidney Colvin, "Exhibition of Mr. Whistler's Pictures," *Academy*, 5 (June 13, 1874), 672–73; "Mr. Whistler's Paintings and Drawings," *AJ*, 36 (August 1874), 230.

5  JW to J. A. Chapman, June 22, 1874, *GUW* 11251; YMSM 117, 160.

6  Anna Whistler to J. H. and Harriet Gamble, September 9–20, 1875, Anna to J. H. Gamble, September 20 [1875], Anna to Mary Eastwick, July 19, 1876, *GUW* 6555, 6558, 12635. Anna's house in Hastings still stands, adorned with a "blue plaque."

7  Teddy L. Meyers, ed., *Uncollected Letters of Algernon Charles Swinburne*, 3 vols. (London, 2005), II:121.

8  Margaret F. MacDonald, *Whistler's Mother's Cook Book* (2nd edn.; San Francisco, 1995), 39–42; copies of menus, August–December 1875, *GUW* 6846–65.

9  Madeleine Fidell Beaufort, ed., *The Diaries 1871–1882 of Samuel P. Avery, Art Dealer* (New York, 1979), 344–45; Alan S. Cole Diary, November 16 and December 7, 1875, *GUW* 13132/3432; Henry Cole Diaries, June 21, 1873, NAL; JW to Cyril Flower [September 1874/July 1875], *GUW* 1621; names of the guests on menus in 1876.

10  *LW*, I:182; Alan Cole Diary, March 15, 1873, November 16 and December 2, 7, 19 and 21, 1875 and January 6 and 22 and March 10, 1876; Henry Cole Diaries, June 21, 1873 and January 6, March 14 and 19 and April 3, 1876.

11  Edmund H. Wuerpel, "Whistler – The Man," *AMA*, 27 (May 1934), 252; E. J. Sullivan to D. S. MacColl, December 25, 1921, WC; Hilda Orchardson Gray, *Life of Sir William Quiller Orchardson* (London, 1930), 130; "A Breakfast in Cheyne Walk," *World*, June 19, 1878, p. 14; Lord Redsdale [Algernon Bertram Freeman-Mitford], *Memories*, 2 vols. (New York, 1916), II:647; Thomas Hake and Arthur Compton-Pickett, *Life and Letters of Theodore Watts-Dunton* (London, 1916), I:167; J. Comyns Carr, *Coasting Bohemia* (London, 1914), 89–90.

12  Wuerpel, "Whistler – The Man," 250–52; Harper Pennington, "The Whistler I Knew," *MM* 31 (March 1910), 771; JW to May Morris [August/December 1888], *GUW* 8089; Carr, *Coasting Bohemia*, 96–98. For a rare JW vulgarity, see Edmond et Jules de Goncourt, *Journal: Mémoires de la Vie Litteraire*, 22 vols. (Monaco, 1956), XVIII:187.

13  E. R. Pennell Diaries, November 4, 1903, Joseph and Elizabeth R. Pennell Papers, RHC.

14  Arthur Warren, *London Days: A Book of Reminiscences* (Boston, 1920), 163; "Afternoon in Studios – A Chat with Whistler," *Studio*, 4 (January 1895), 117; John Lloyd Balderston, "The Dusk of the Gods: A Conversation on Art with George Moore," *AM*, 118 (August 1916), 170–71; Wuerpel, Whistler – The Man," 319.

15  E. J. Sullivan to D. S. McColl, December 25, 1921.

16   Edward Simmons, *From Seven to Seventy: Memories of a Painter and a Yankee* (New York, 1922), 130; Bernhard Sickert, *Whistler* (London, 1908), 62–65; Nicolai Cikovsky Jr., "Whistler and America," in Richard Dorment and Margaret F. MacDonald, eds., *James McNeill Whistler* (New York, 1995), 30–31; Henry Russell Wray, "An Afternoon with James McNeill Whistler," *IS*, 56 (August 1915), xl–xli.

17   J. Comyns Carr, *Some Eminent Victorians: Personal Recollections in the World of Art and Letters* (London, 1908), 137; Leslie Ward, *Forty Years of "Spy"* (London, 1915), 298; Anon., "Whistler, Painter and Comedian," *McClure's Magazine*, 7 (September 1896), 377; An Indiscriminate Admirer, "A Gossip at Goupil's. Mr. Whistler on His Work," *ILN*, March 26, 1892, 384.

18   Redesdale, *Memories*, II:646; George H. Boughton, "A Few of the Various Whistlers I Have Known," *IS*, 21 (January 1904), 216; Alan Cole Diary, July 24, 1877 and December 22, 1878.

19   Pennell Diaries, February 10, 1904.

20   JW to F. G. Prange, February 11, 1896, *GUW* 5046; Redesdale, *Memories*, II:649.

21   E. V. Lucas, *Edwin Austin Abbey, Royal Academician: The Record of His Life and Work*, 2 vols. (New York, 1921), I:78–79; Hake and Compton-Ricketts, *Watts-Dunton*, I:168–69; Daphne du Maurier, ed., *The Young George du Maurier: A Selection of his Letters, 1860–67* (Garden City, N.Y., 1952), 118.

22   Hake and Compton-Ricketts, *Watts-Dunton*, I:167–69; Redesdale, *Memories*, II:645–46; Carr, *Some Eminent Victorians*, 137, 139, and *Coasting Bohemia*, 95–96, 98–99.

23   Arthur Livermore to Louise Grave, February 17, 1887, September 10, 1890, November 19, 1892 and March 29, 1893, Arthur Livermore Papers, Massachusetts Historical Society.

24   Carr, *Some Eminent Victorians*, 140–41, 142–43, and *Coasting Bohemia*, 90, 93–94, 99; William Rothenstein, *Men and Memories: A History of the Arts, 1872–1922*, 2 vols. in 1 (New York, 1932), I:101–102.

25   YMSM 145, 170.

26   Lynda Nead, *Victorian Babylon: People, Streets and Images in Nineteenth-Century London* (New Haven and London, 2000), 109–46; Tom Morton, "Urban Pleasures: Whistler at Cremorne" (MA thesis, Courtauld Institute, 2000); Eric Denker, *In Pursuit of the Butterfly: Portraits of James McNeill Whistler* (Washington, D.C., 1995), 103–105.

27   David Peters Corbett, *The World in Paint: Modern Art and Visuality in England, 1848–1914* (University Park, Penn., 2004), 117, 122–23; John Siewert, "Art, Music, and an Aesthetics of Place in Whistler's Nocturne Paintings," in Katharine Lochnan, ed., *Turner, Whistler, Monet: Impressionist Visions* (London, 2004), 143–44; Marc Simpson, "Whistler, Modernism, and the Creative Afflatus," in Simpson, ed., *Like Breath on Glass: Whistler, Inness, and the Art of Painting Softly* (Williamstown, Mass., 2008), 27–28; YMSM 140.

28   JW to A. S. Cole [December 2/19, 1875], *GUW* 7888.

29   JW to A. S. Cole [January 22/27, 1876], *GUW* 7889; Alan Cole Diary, February 21, 24 and 28, 1876; "Royal Albert Hall Theatre," *Daily News*, February 28, 1876, p. 6; C. J. Hanson, "Out of my Memory," p. 2, *GUW* 2246.

30   Linda Merrill, *The Peacock Room: A Cultural Biography* (New Haven and London, 1998), 154–69, 178–84, 189–207, 210–11, 257–58; Susan Weber Soros and Catherine Arbuthnott, *Thomas Jekyll: Architect and Designer, 1827–1881* (New York, 2003), 33, 39–41, 105–106.

31   Merrill, *Peacock Room*, 210–17, 231; Lionel Lambourne, *Japonisme: Cultural Crossings Between Japan and the West* (London, 2005), 92–96; Robin Spencer, *The Aesthetic Movement: Theory and Practice* (London, 1972), 68–76; JW to R. A. Alexander [September/October 1874], *GUW* 7583; M.487–94.

32 JW to Frances Leyland [August 20/31, 1876], *GUW* 8054.

33 "Notes and News," *Academy*, 10 (September 2, 1876), 249, and (September 9, 1876), 275; Merrill, *Peacock Room*, 257–60; Anna Whistler to J. H. Gamble, September 8–9, 1876, JW to Anna, September [1876], *GUW* 6560, 3172.

34 Merrill, *Peacock Room*, 210, 222–23, 227–32. Correspondence between artist and patron is on pp. 385–88. JW's friend Walter Crane engaged in a similar disagreement over a fee a few years later. See his correspondence with Lord Wharncliffe, 1877–82, in Wharncliffe Muniments, SA.

35 Merrill, *Peacock Room*, 238–46; M.581–85; Juliet Kinchin and Paul Stirton, eds., *Is Mr. Ruskin Living Too Long? Selected Writings of E. W. Godwin* (Oxford, 2005), 246. JW kept himself afloat financially during these months by helping to illustrate an exhibition catalogue of Nankin porcelain. Merrill, pp. 171–76; M.592–651.

36 Goebel, "Arrangement in Black and White," 313–14, 317–23, 837–62; Meyers, *Letters of Swinburne*, II:121; Henry Cole Diaries, June 30 and December 17, 1876; Kinchin and Stirton, *Is Ruskin Living Too Long?* 247; Philip Webb to George Howard, June 18, 1877, J22/64/95, Howard Family Papers, CH.

37 Meyers, *Letters of Swinburne*, II:121; Alan Cole Diary, January 12, March 5 and 26–27, and April 3 and 29, 1877.

38 "Obituary: William MacNeill Whistler, M.D.," *British Medical Journal*, No. 2046 (March 10, 1900), 613–14; correspondence and documents related to William's financial problems, Box K, PWC; Helen Whistler to E. R. Pennell, February 5, 1907, v.304, PWC.

39 Anna Whistler to J. H. Gamble, September 8–9, 1876, June 8–12, 1877, *GUW* 6560, 6565.

40 The best works on the Grosvenor Gallery are Christopher Newall, *The Grosvenor Gallery Exhibitions: Change and Continuity in the Victorian Art World* (Cambridge, Eng., 1995), Colleen Denny, *At the Temple of Art: The Grosvenor Gallery, 1877–1890* (Cranbury, N.J., 2000), and Susan P. Casteras and Colleen Denny, eds., *The Grosvenor Gallery: A Palace of Art in Victorian England* (New Haven and London, 1996).

41 Walter Crane to George Howard, February 27, 1876, J22/38, Howard Family Papers; C. E. Hallé, *Notes from a Painter's Life* (London, 1909), 104–06; Pamela Fletcher, "The Grand Tour on Bond Street: Cosmopolitanism and the Commercial Art Gallery in Victorian London," *VCB*, 12 (July 2011), 139–53; Thomas M. Bayer and John R. Page, *The Development of the Art Market in England: Money as Muse, 1730–1900* (Aldershot, 2011), 191–97.

42 Casteras and Denny, *Grosvenor Gallery*, 40–45, 54; Veronica Franklin Gould, *G. F. Watts: The Last Great Victorian* (New Haven and London, 2004), 133–34.

43 Elizabeth Prettejohn, *Art for Art's Sake: Aestheicism in Victorian Painting* (New Haven and London, 2007), 167–69; Alison Adburgham, *Liberty's: A Biography of a Shop* (London, 1975), 15–31; Morna O'Neill, *Walter Crane: The Arts and Crafts, Painting, and Politics, 1875–1890* (New Haven and London, 2010), 19–20.

44 Elizabeth Prettejohn, "Walter Pater and Aesthetic Painting," and Robin Spencer, "Whistler, Swinburne and Art for Art's Sake," in Prettejohn, ed., *After the Pre-Raphaelites: Art and Aestheticism in Victorian England* (New Brunswick, N.J., 1999), 36–58, 59–89; Rachel Teukolsky, *The Literate Eye: Victorian Art Writing and Modernist Aesthetics* (New York, 2009), 100–19; Walter Pater, *The Renaissance: Studies in Art and Poetry* (4th edn.; London, 1893), 155.

45 Charlotte Gere, *Artistic Circles: Design and Decoration in the Aesthetic Movement* (London, 2010), 17, 62–70, 85–89, 102–105; *Punch*, 72 (February 10, 1877), 51, (March 17,

1877), 109. An excellent survey of the movement is Stephen Calloway and Lynn Federle Orr, eds., *The Cult of Beauty: The Aesthetic Movement, 1860–1900* (London, 2011).

46  John Siewert, "Whistler's Decorative Darkness," in Casteras and Denny, *Grosvenor Gallery*, 93–108; Henry Cole Diaries, May 20, 1877; Angela Emanuel, ed., *A Bright Remembrance: The Diaries of Julia Cartwright, 1851–1924* (London, 1989), 90–91.

47  John L. Sweeney, ed., *The Painter's Eye: Notes and Essays on the Pictorial Arts by Henry James* (Cambridge, Mass., 1956), 143; William H. Rossetti, "The Grosvenor Gallery," *Academy*, 11 (May 26, 1877), 467; "The Palace of Art," *Punch*, 72 (July 7, 1877), 305.

48  Alan Cole Diary, May 13 and June 17 and 29, 1877; A. B. Proctor to George Forrest, May 6, 1877, Proctor to Emma Forrest, June 1, 1877, JW to [Miss Bateman], January 7, 1877 [correct month June], *GUW* 12486, 12485, 10034.

49  JW to Frances Leyland [August 20/31, 1876], [May/June 1877], [July 1877/September 1879], *GUW* 8054, 8061–62; *WJ*, 104–05, 108–09, 11; Pennell Diaries, October 26, November 7 and 27 and December 7, 1906.

50  F. R. Leyland to JW, July 6, 1877, July 17, 1877, JW to Leyland [July 7, 1877], *GUW* 2581, 2585, 2582; Alan Cole Diary, July 24, 1877; Henry Cole Diaries, July 30, 1877.

51  Merrill, *Peacock Room*, 228, 269–74, 385–88; F. D. Leyland to JW, April 3, 1877, July 17, 1877, *GUW* 2606–07.

52  Tim Hilton, *John Ruskin: The Later Years* (New Haven and London, 2000), 356–57; Judith Stoddart, *Ruskin's Culture Wars: Fors Clavigera and the Crisis of Victorian Liberalism* (Charlottesville, Va., 1998), 1–22.

53  Tim Hilton, *John Ruskin: The Early Years, 1819–1859* (New Haven and London, 1985), 237–38; Prettejohn, *Art for Art's Sake*, 111–16, 125–26.

54  Boughton, "A Few of the Various Whistlers," 212, 215.

55  Linda Merrill, *A Pot of Paint: Aesthetics on Trial in Whistler vs Ruskin* (Washington, D.C., 1992), 57–67; Alan Robinson, *Imagining London, 1770–1900* (Basingstoke, 2004), 167–69; Goebel, "Arrangement in Black and White," 335–39.

10: TRIALS

1  JW to J. A. Rose, April 9, 1878, *GUW* 10730.

2  Examples of debts in *GUW* 8733–34, 8779–81, 8856, 8874, 8955–58, 8960–61, 11940, 11978, 12153, 12183, 12196–98, 13253–55.

3  *WJ*, 69, 164–65; M.587; G.145; Margaret F. MacDonald, "Maud Franklin and the 'Charming Little Swaggerers,'" in MacDonald et al., *Whistler, Women, and Fashion* (New Haven and London, 2003), 135–42; YMSM 183.

4  Examples of dinner menus in *GUW* 6928–36; George and William Webb to E. W. Godwin, September 17, 1877, *GUW* 6148.

5  Charlotte Gere, *Artistic Circles: Design and Decoration in the Aesthetic Movement* (London, 2010), 56–75, 135–57; Joseph F. Lamb, "Symbols of Success in Suburbia: The Establishment of Artists' Communities in Late Victorian London," in Debra N. Mancoff and D. J. Trela, eds., *Victorian Urban Settings: Essays on the Nineteenth-Century City and Its Contexts* (New York, 1996), 57–73.

6  David Park Curry et al., *Whistler and Godwin* (London, 2001), 9–26; Lionel Lambourne, *The Aesthetic Movement* (London, 1996), 152–71. Dudley Harbron, *The Conscious Stone: The Life of Edward William Godwin* (London, 1949), is the only biography of Godwin, but Susan Weber Soros, ed., *E. W. Godwin: Aesthetic Movement Architect and Designer* (New Haven and London, 1999) offers the best analysis of his work.

7  Soros, *Godwin*, 54–55, 85–86, 165–68, 206–209; Giles Walkley, *Artists' Houses in London, 1764–1914* (Aldershot, 1994), 82–86.

8  YMSM 119, 168; JW to Stephen Tucker [September 3, 1877], JW to J. A. Chapman [November 1877], *GUW* 5865, 9037; YMSM 119, 168, 203.

9  Susan Grace Galassi, "The Artist as Model: Rosa Corder," in MacDonald, *Whistler, Women, and Fashion*, 116–31; Jonathan Shirland, "'Embryonic Phantoms': Materiality, Marginality and Modernity in Whistler's Black Portraits," *AH*, 34 (February 2011), 80–101; Arthur Jerome Eddy, *Recollections and Impressions of James A. McNeill Whistler* (Philadelphia, 1903), 214, 254–59.

10  David Park Curry, *James McNeill Whistler: Uneasy Pieces* (Richmond, Va., 2004), 164–69; Gloria Groom, ed., *Impressionism, Fashion, and Modernity* (Chicago, 2012), 21, 243.

11  Grischka Petri, *Arrangement in Business: The Art Markets and the Career of James McNeill Whistler* (Hildesheim, 2011), 149–51, 230–37; JW to C. A. Howell, October 1877, *GUW* 2857; *LW*, I:214–15; "Notes on Art and Archaeology," *Academy*, 12 (November 17, 1877), 480 (December 15, 1877), 562.

12  Petri, *Arrangement in Business*, 151; *LW*, I:225–28, 256–57. The best biography of Howell is Helen Rossetti Angeli, *Pre-Raphaelite Twilight: The Story of Charles Augustus Howell* (London, 1954).

13  G.108, 158–59, 177 (for people), G.105, 143, 154–57, 161, 164–68, 171–76, 178–88 (for London); "Notes on Art and Archaeology," *Academy*, 13 (January 26, 1878), 85; JW to C. A. Howell, July 29, 1878, *GUW* 2789.

14  Martha Tedeschi, "Whistler and the English Print Market," *PQ*, 14 (March 1997), 16–20; J. Don Vann and Rosemary T. Van Arsdel, eds., *Victorian Periodicals and Victorian Society* (Toronto, 1994), 129–30, 135–42. See Michael Melot, *Impressionist Prints*, trans. Caro-line Beamish (New Haven and London, 1996), for the evolution of lithography in France.

15  *LJW*, I:40–41, 43–47, 50–101; Thomas R. Way, *Memories of James McNeill Whistler, The Artist* (London, 1912), 3–17; John Siewert, "Rhetoric and Reputation in Whistler's Nocturnes," in Linda Merrill et al., *After Whistler: The Artist and His Influence on American Painting* (New Haven and London, 2003), 69–72.

16  *LJW*, I:43–46; Thomas Hake and Arthur Compton-Rickett, *Life and Letters of Theodore Watts-Dunton*, 2 vols. (London, 1916), I:169–70; Way, *Memories of Whistler*, 17–20.

17  Louis Gonse to JW, February 7, 1878, June 12, 1878, JW to Gonse [June 13/20, 1878], *GUW* 1650–52,

18  "Gaiety," *Daily News*, December 13, 1877, p. 3; "The Grasshopper," *PMG*, December 14, 1877, pp. 11–12; JW to John Hollingshead, October 27 [1877], JW to W. T. Watts-Dunton, [January 12, 1878] *GUW* 9156, 9575; Alan S. Cole Diary, January 7, 20, and 21, 1878, *GUW* 13132/3432. William Theodore Watts changed his name to Watts-Dunton in the 1890s, but for the sake of consistency, he is referred to as Watts-Dunton throughout.

19  Jehu Junior, "Men of the Day – No. CLXX. Mr. James Abbott M'Neill Whistler," *Vanity Fair*, 21 (January 12, 1878), pp. 24–25; William E. Fredeman, ed., *The Correspondence of Dante Gabriel Rossetti*, 9 vols. (Cambridge, Eng., 2002–11), VIII:131, 133.

20  Edmund Yates, *Recollections and Experiences* (London, 1884), 91, 95–96, 104, 118, 396–425, 454–56, 463; Joel H. Wiener, "Edmund Yates: The Gossip as Editor," in Wiener, ed., *Innovators and Preachers: The Role of the Editor in Victorian England* (Westport, Conn., 1985), 259–74.

21  Patricia de Montfort, "'Atlas' and the Butterfly: James McNeill Whistler, Edmund Yates and the *World*," in Laurel Brake and Julie F. Codell, eds., *Encounters in the Victorian Press:*

Editors, Authors, Readers (Houndmills, Eng., 2005), 161–74; "Celebrities at Home. No. XCII: Mr. James Whistler at Cheyne Walk," *World*, May 22, 1878, pp. 4–5. Also in *GAME*, 126–28.

22 Catherine Carter Goebel, "Arrangement in Black and White: The Making of a Whistler Legend" (PhD diss., Northwestern Univ., 1988), 349–51, 363–65, 895–97, 910–11; Lynda Nead, *Victorian Babylon: People, Streets and Images in Nineteenth-Century London* (New Haven and London, 2000), 5, 19, 29, 53–54.

23 The details of this complex chain of events is in correspondence of JW with the Webbs, Godwin, Benjamin E. Nightingale, George J. Vulliamy, James Hogg, and the Metropolitan Board of Works, September 1877 to September 1878, *GUW*.

24 Deanne Marohn Bendix, *Diabolical Designs: Paintings, Interiors, and Exhibitions by James McNeill Whistler* (Washington, D.C., 1995), 152–61; Walkley, *Artists' Houses*, 85–93; C. S. Keene to Edwin Edwards, August 17, 1878, Charles S. Keene Letters, FM.

25 Laura Beatty, *Lillie Langtry: Manners, Masks and Morals* (London, 1999), 36–42, 58–61, 118–26, 223–25; Walford Graham Robertson, *Life Was Worth Living: The Reminiscences of W. Graham Robertson* (New York, 1931), 69–72.

26 George and William Webb [June 13, 1878], [August 26, 1878], JW to E. W. Godwin, September 11 [1878], Benjamin Verity and Sons to JW, January 3, 1878, *GUW* 8928, 11909, 1748, 5962.

27 Cole Diary, October 16, 1878; Linda Merrill, *A Pot of Paint: Aesthetics on Trial in Whistler vs Ruskin* (Washington, D.C., 1992), 76–77, 95–97, 129–30.

28 Merrill, *Pot of Paint*, 106–22, 124–25; Edward Burne-Jones to George Howard [November 1878], J22/27/124, Howard Family Papers, CH; Mary Lago, ed., *Burne-Jones Talking: His Conversations 1895–1898 Preserved by*

His Studio Assistant, Thomas Rooks (Columbia, Mo., 1981), 69–70.

29 Merrill, *Pot of Paint*, 79–94; W. M. Rossetti to J. A. Rose, November 22 [1878], *GUW* 8786; Julie L'Enfant, *William Rossetti's Art Criticism: The Search for Truth in Victorian Art* (Lanham, Md., 1999), 168, 182–84, 253–54, 298–99, 306–16; Roger W. Peattie, "Whistler and W. M. Rossetti: 'Always on the easiest & pleasantest terms,'" *JPRS*, 4 n.s. (Fall 1995), 85–89.

30 Merrill, *Pot of Paint*, 128–32; W. S. Gilbert Diaries, April 30 and November 21, 24, and 25, 1878, William S. Gilbert Papers, BL.

31 Merrill, *Pot of Paint*, 78–79, 139, 161; JW to J. A. Rose November [20], 1878, *GUW* 5230.

32 Merrill, *Pot of Paint*, 138, 142, 144.

33 Ibid., 97–99, 144–54.

34 Ibid., 154–61.

35 Ibid., 101–06, 147–48, 157, 160, 163–71; Costas Douzinas, "*Whistler v. Ruskin*: Law's Fear of Images," *AH*, 19 (September 1996), 362–64.

36 Merrill, *Pot of Paint*, 171–80, 207–08, 212–14; Edward Burne-Jones to George Howard [November 1878], Howard Papers.

37 Augustus Hare, *Peculiar People: The Story of My Life*, ed. Anita Miller and James Papp (Chicago, 1995), 235; Merrill, *Pot of Paint*, 104–06.

38 Goebel, "Arrangement in Black and White," 450–500, 952–88; *Punch*, 75 (December 7, 1878), 253, 254, 257; [Henry James], "Notes," *Nation*, 27 (December 19, 1878), 385; "Whistler v. Ruskin," *SR*, 46 (November 30, 1878), 687–88.

39 Merrill, *Pot of Paint*, 209–12, 275–78; John Ruskin to William Morris, December 3, 1878, William Morris Correspondence and Papers, Robert Steele Gift, BL.

40 Eric Denker, *In Pursuit of the Butterfly: Portraits of James McNeill Whistler* (Washington, D.C., 1995), 74–79; Merrill, *Pot of Paint*, 278–82; Fredeman, *Correspondence of Rossetti*,

VIII:216, 219, 220; P. P. Marshall to F. M. Brown, December 2, 1878, Box 12, Ford Madox Brown Papers and Correspondence, NAL.

41   Kate Flint, *The Victorians and the Visual Imagination* (Cambridge, Eng., 2000), 167–96; Elizabeth Prettejohn, "Aesthetic Value and the Professionalization of Victorian Art Criticism 1837–78," *Journal of Victorian Culture*, 2 (Spring 1997), 73–74, 81–89; Helene E. Roberts, "Exhibitions and Reviews: The Periodical Press and the Victorian Art System," in Joanne Shattock and Michael Wolff, eds., *The Victorian Periodical Press: Samplings and Soundings* (Leicester, 1982), 79–107; Rachel Teukolsky, *The Literate Eye: Victorian Art Writing and Modernist Aesthetics* (New York, 2009), 3–20, 110–19.

42   JW to A. L. Liberty [November 26/31, 1878] *GUW* 2613.

43   J. A. MacNeill Whistler, *Whistler v. Ruskin: Art & Art Critics* (London, 1878), 5, 7, 12–14.

44   Merrill, *Pot of Paint*, 254–58; quoted are JW to C. A. Howell [January 6, 1879], JW to George Bird [December 31, 1878], *GUW* 2818, 303.

45   Lillian M. C. Randall, ed., *The Diary of George A. Lucas: An American Art Agent in Paris, 1857–1909* (Princeton, N.J., 1979), II:467–68. JW's correspondence with Lucas is *GUW* 9181, 9196–98, 9221.

46   Goebel, "Arrangement in Black and White," 532–54, 989–1005; Merrill, *Pot of Paint*, 260–62; JW to J. W. C. Carr [December 24, 1878/January 1879], Tom Taylor to JW, January 6, 1879, January 9, 1879, JW to Taylor, January 8 [1879], *GUW* 543, 5660, 5663, 5661.

47   Denker, *Pursuit of the Butterfly*, 76–77; Otto Bacher, *With Whistler in Venice* (New York, 1908), 17, 213.

48   JW to Luke Ionides [December 5, 1878], W. Day to JW [January/February 1879], JW to J. A. Rose [January 15, 1879], *GUW* 2366, 8855, 8756.

49   V. Markham Lester, *Victorian Insolvency: Bankruptcy, Imprisonment for Debt, and Company Winding-up in Nineteenth-Century England* (Oxford, 1995), 1–4, 149, 155, 167; JW to J. A. Rose [March 31, 1879], *GUW* 8768.

50   London Bankruptcy Court to [J. A. Rose], May 7, 1879–October 5, 1880, James Waddell to JW, May 9, 1879, William Hazlett to Lewis and Lewis, May 9, 1879, *GUW* 11711, 3592, 8903.

51   John Juxon, *Lewis and Lewis: The Life and Times of a London Solicitor* (New York, 1984), 32, 59–61, 89, 116, 168–71; Yates, *Recollections and Experiences*, 461–62.

52   Juxon, *Lewis and Lewis*, 169–71; Edwin A. Ward, *Recollections of a Savage* (London, 1923), 263–64, 266; E. R. Pennell Diaries, November 1, 1906, Joseph and Elizabeth R. Pennell Papers, RHC; *LW*, I:254–55.

53   JW to F. R. Leyland [May/June 1879], *GUW* 2600; Pennell Diaries, March 14, 1919.

54   JW to G. H. Lewis [May 6/September 1879], *GUW* 10989; *LW*, I:252–54; Pennell Diaries, March 5, 1909.

55   YMSM 208–10; Fredeman, *Correspondence of Rossetti*, 8:335; JW to M. R. Elden [September 13, 1879], JW to James Waddell [September 1879], *GUW* 12815, 6006.

56   *LW*, I:257–60.

11: DEATH AND TRANSFIGURATION

1   Julian Halsby, *Venice: The Artist's Vision: A Guide to British and American Painters* (London, 1990), 40.

2   Hilarie Faberman, "'Best Shop in London': The Fine Art Society and the Victorian Art Scene," in Susan P. Casteras and Colleen Denney, eds., *The Grosvenor Gallery: A Palace of Art in Victorian England* (New Haven and London, 1996), 147–54; Emma Chambers, *An Indolent and Blundering Art? The Etching*

*Revival and the Redefinition of Etching in England, 1838–1892* (Aldershot, 1999), 167–72.

3  JW to M. B. Huish, January 10 [1878], Charnwood Autographs, IV, BL; JW accounts, October 10, 1877, Huish to JW, March 14, 1879, April 7, 1879, April 18, 1879, August 6, 1879, JW to Huish, July 9, 1879, August 13, 1879, JW to E. G. Brown [August 4, 1879], *GUW* 12734, 1098–1100, 1103, 1101, 2988, 1102.

4  William E. Fredeman, ed., *The Correspondence of Dante Gabriel Rossetti*, 9 vols. (Cambridge, Eng., 2002–11), VIII:335; William C. Brownell, "Whistler in Painting and Etching," *Scribner's Magazine*, 18 (August 1879), 481–95; Edward Burne-Jones to George Howard [1879] J22/27/252, Howard Family Papers, CH.

5  Eric Denker, *Whistler and His Circle in Venice* (London, 2003), 12; Margaret F. MacDonald, *Palaces in the Night: Whistler in Venice* (Berkeley, Calif., 2001), 19; JW to Helen Whistler [October/November 1879], *GUW* 6686. MacDonald's book includes JW's most important letters from the city (pp. 141–51).

6  Maud Franklin to G. A. Lucas, October 23, 1879, JW to Deborah Haden [January 1, 1880], JW to Helen Whistler [October/November 1879], JW to Anna Whistler [March/May 1880], *GUW* 9202, 11563, 6686, 13502.

7  JW to Helen Whistler [January/February 1880], *GUW* 6687; E. R. Pennell Diaries, September 25, 1906, Joseph and Elizabeth R. Pennell Papers, RHC.

8  MacDonald, *Palaces in the Night*, 19–22; Denker, *Whistler and His Circle*, 13–14; JW to Deborah Haden [January 1, 1880]; JW to Helen Whistler [October/November 1879] *GUW* 11563, 6686.

9  JW to C. A. Howell, January 26, 1880, JW to Helen Whistler [January/February 1880], [February 20/March 1880], *GUW* 2860, 6687, 6690; "Ididdlia," *World*, December 24, 1879.

10  JW to Helen Whistler [February 20/March 1880], *GUW* 6690; Elizabeth Anne

McCauley et al., *Gondola Days: Isabella Stewart Gardner and the Palazzo Barbaro Circle* (Boston, 2004), 70, 74, 88–89; William H. Gerdts, "The International Milieu," in Warren Adelson et al., *Sargent's Venice* (New Haven and London, 2006), 167–73, 183–89.

11  JW to Deborah Haden [January 1, 1880], *GUW* 11563.

12  Pennell Diaries, September 25, 1906; *WJ*, 164–65; L. V. Fildes, *Luke Fildes, R.A.: A Victorian Painter* (London, 1968), 66.

13  M. B. Huish to JW, January 14, 1880, JW to C. H. Howell, January 26, 1880, JW to Deborah Haden [January 1, 1880], *GUW* 1105, 2860, 11563; Howell to Richard Josey, December 11, 1879, December 30, 1879, Fairfax Murray Papers, UM.

14  JW to M. R. Elden [April 15/30, 1880], JW to C. A. Howell, January 26, 1880, JW to M. B. Huish [January 21/26, 1880], *GUW* 12816, 2860, 2992.

15  MacDonald, *Palaces in the Night*, 64–85. Caroline Arscott, "Stenographic Notation: Whistler's Etchings in Venice," *OAJ*, 29 (2006), 371–93, offers a less orthodox interpretation of the Venice etchings.

16  Alastair Grieve, *Whistler's Venice* (New Haven and London, 2000), 40–42, 64–65, 82–83, 92–94, 108–09, 166–69; G.193, 202, 223, 199, 218, 229. Other of the Venice etchings are G.192–238.

17  Thomas R. Way, *Memories of James McNeill Whistler, The Artist* (London, 1912), 55–56; Jean Sutherland Boogs and Anne Maheux, *Degas Pastels* (New York, 1992), 10–14, 19–35.

18  M.725–828; MacDonald, *Palaces in the Night*, 37–55; Robert H. Getscher, *James Abbott McNeill Whistler: Pastels* (New York, 1991), 20–22; *LW*, I:276–79; JW to M. R. Elden [April 15/30, 1880], *GUW* 12816.

19  JW to Anna Whistler [March/May 1880], *GUW* 13502.

20  Getscher, *Whistler: Pastels*, 22–27, 70–131.

21  *LW*, I:285–87.

22  JW to William Graham [January/October 1880], JW to Helen Whistler [March 22, 1880], JW to M. B. Huish [January 21/26, 1880], JW to C. A. Howell, January 26, 1880, JW to E. G. Brown [January 26/29, 1880], Brown to JW, January 31, 1880, *GUW* 13497, 6688, 2992, 2860, 3600, 1107.

23  "Art Sales," *Academy*, 17 (February 21, 1880), 148–49; M. R. Elden to JW [February 1880], April 12 [1880], JW to Helen Whistler [February 20/March 1880], [March 1880], [March 22, 1880], T. R. Way to JW, February 12, 1880, April 15, 1880, May 1 [1880], JW to Anna Whistler [March/May 1880], *GUW* 1049, 1048, 6690, 6689, 6688, 6080–82, 13502. A copy of the auction catalogue, *Catalogue of the Decorative Porcelain, Cabinet Paintings, and Other Works of Art of J.A.McN. Whistler*, showing the names of purchasers and prices paid, is in the Freer Gallery.

24  JW to Helen Whistler [February 20/March 1880], *GUW* 6690.

25  JW to C. J. Hanson, May 2, 1880, *GUW* 1954.

26  Otto Bacher, *With Whistler in Venice* (New York, 1909), 3–7; Harper Pennington, "The Whistler I Knew," *MM*, 31 (March 1910), 773.

27  Bacher, *With Whistler in Venice*, 10–17, 31, 58–59, 103, 213, and "With Whistler in Venice, 1880–86," *Century*, 73 (December 1906), 207–20; Harper Pennington, "Artist Life in Venice," *Century*, 64 (October 1902), 836–37, and "The Whistler I Knew," 770–71.

28  Bacher, *With Whistler in Venice*, 9–10; Fildes, *Luke Fildes*, 64–66; G. E. Hopkins to H. F. Gutherz, January 8, 1904, Hopkins to Joseph Pennell, January 8, 1904, v.285, PWC; W. Scott, "Reminiscences of Whistler Continued: Some Venice Recollections," *IS*, 21 (December 1903), 97–98.

29  Denker, *Whistler and His Circle*, 36–40; *LW*, I:269–74; Bacher, *With Whistler in Venice*, 19–40, 237–40, 258–61, 280–81; Pennington, "The Whistler I Knew," 770–71.

30  Harry Quilter, "James Abbott M'Neill Whistler: A Memory and a Criticism," *Chambers's Journal*, 6 (6th series), October 3, 1903, 693; Grieve, *Whistler's Venice*, 93–95.

31  E. G. Brown to JW, October 1, 1880, M. B. Huish to JW, October 19, 1880, *GUW* 1109–10.

32  MacDonald, *Palaces in the Night*, 30–33; JW to William and Helen Whistler [October 19/26, 1880], *GUW* 6999.

33  JW to M. B. Huish, October 25, 1880, Huish to JW, October 27 1880, October 29, 1880, November 4, 1880, November 6, 1880, *GUW* 1113–17.

34  MacDonald, *Palaces in the Night*, 33–34, 88–94; Meg Hausberg, "Whistler's Etchings: New Observations," *PQ*, 24 (March 2007), 11–21; Way, *Memories of Whistler*, 41–46.

35  Deanna Marohm Bendix, *Diabolical Designs: Paintings, Interiors, and Exhibitions by James McNeill Whistler* (Washington, D.C., 1995), 217–18; M.836–37; Way, *Memories of Whistler*, 47–48; JW to M. B. Huish [November 28/29, 1880], *GUW* 7974.

36  Maud Franklin to O. H. Bacher [March 21, 1881], *GUW* 11621; Way, *Memories of Whistler*, 52–55; Lynne Bell, "Fact and Fiction: James McNeill Whistler's Critical Reputation in England, 1880–1892" (PhD thesis, Univ. of East Anglia, 1987), 36–74.

37  MacDonald, *Palaces in the Night*, 95–98; Grischka Petri, *Arrangement in Business: The Art Markets and the Career of James McNeill Whistler* (Hildesheim, 2011), 371–73, 402–06.

38  Margaret MacDonald and Joy Newton, eds., "Correspondence Duret – Whistler," *GBA*, 110 (6th series) (November 1987), 150–53; Théodore Duret, "James Whistler," *GBA*, 23

(April 1881), 365–69; JW to Théodore Duret [April 11, 1880], *GUW* 9630.

39   M. B. Huish to JW, December 8, 1880, December 21, 1880, January 26, 1881, JW to Huish, January 27 [1881], *GUW* 1118–19, 1122–23.

40   Bendix, *Diabolical Designs*, 218–20; Sarah Lawrence Parkerson, "Variations in Gold: The Stylistic Development of the Picture Frames Used by James McNeill Whistler" (PhD thesis, Univ. of Glasgow, 2007), 167–74.

41   Maud Franklin to O. H. Bacher [March 21, 1881], *GUW* 11621; Bendix, *Diabolical Designs*, 221–23.

42   Peter Funnell et al., *Millais: Portraits* (Princeton, N.J., 1999), 113–17, 128, 164–65, 167–69, 197–200, 204–07, 209–11.

43   Martha Ward, "Impressionist Installations and Private Exhibitions," *AB*, 73 (December 1991), 604–18; Susan Weber Soros, ed., *E. W. Godwin: Aesthetic Movement Architect and Designer* (New Haven and London, 1999), 169–71.

44   Way, *Memories of Whistler*, 52–55; Mathilde Arnoux et al., *Correspondance entre Henri Fantin-latour et Otto Scholderer, 1858–1902* (Paris, 2011), 358; J. E. Millais to JW, February 17, 1881, JW to Millais [February 18/24, 1881], *GUW* 4078, 9858; Angela Emanuel, ed., *A Bright Remembrance: The Diaries of Julia Cartwright, 1851–1924* (London, 1989), 121; Mortimer Menpes to C. A. Howell [February 1881], Charles F. Murray Collection, RHC.

45   Getscher, *Whistler: Pastels*, 177–89; Pamela Fletcher and Anne Helmreich, "The Periodical and the Arts Market: Investigating the 'Dealer-Critic System' in Victorian England," *VPR*, 41 (Winter 2008), 323–26; Thomas M. Bayer and John R. Page, *The Development of the Art Market in England: Money as Muse, 1730–1900* (Aldershot, 2011), 136–40; Bell, "Fact and Fiction," 75–95; "Whistler's Wenice; or, Pastels by Pastelthwaite," *Punch*, 80 (February 12, 1881), 69. Huish had also become the compiler of the invaluable *The Year's Art*, which he published annually for fifteen years.

46   Bell, "Fact and Fiction," 103–06; Frederick Wedmore, "Mr. Whistler's Theories and Mr. Whistler's Art," *NC*, 30 (August 1879), 334–43, and "Mr. Whistler's Pastels," *Academy*, 19 (February 19, 1881), 142.

47   Maud Franklin to O. H. Bacher [March 21, 1881], JW to Bacher [March 22/25, 1881], *GUW* 11621–22; "Larks with the Critics," Box 201, PWC; MacDonald, *Palaces in the Night*, 101–03; Petri, *Arrangement in Business*, 409–10.

48   JW to Anna Whistler [n.d.], v.19, PWC; *WJ*, 252–52; M.830–32; Pennell Diaries, September 29, 1902 (with marginal notes dated November 14, 1906), March 2, 1904; JW to Drummond and Company [March/June 1881], *GUW* 1011.

49   JW to Mr. Crawshay [February 1, 1881], M. B. Huish to JW, March 8, 1881, March 15, 1881, *GUW* 9030, 1125, 1129.

12: THE BUTTERFLY RAMPANT

1   Thomas R. Way, *Memories of James McNeill Whistler, The Artist* (London, 1912), 42–43; Otto H. Bacher, *With Whistler in Venice* (New York, 1909), 156–57; M.829; *WJ*, 187, 189.

2   *LW*, I:289; *WJ*, 165. Although he did not remain with her, JW apparently escorted Maud to Paris, where he met Renoir for the first time. See Augustin de Butler, "Renoir's Visit to London," *BM*, 155 (May 2013), 327.

3   Giles Walkley, *Artists' Houses in London, 1764–1914* (Aldershot, 1994), 152; Deanna Marohm Bendix, *Diabolical Designs: Paintings, Interiors, and Exhibitions by James McNeill Whistler* (Washington, D.C., 1995), 166–69; correspondence in *GUW* 2384–92, 10877.

4   Richard Ellmann, *Oscar Wilde* (New York, 1988), 128–29.

5   JW to C. W. Dowdeswell [December 1886], *GUW* 860.

6   Emma Chambers, *An Indolent and Blundering Art? The Etching Revival and the Redefinition of Etching in England, 1838–1892* (Aldershot, 1999), 53–62, 174–78; Robert Spence to James Laver, October 14, 1960, James Laver Papers, GUL; Otto H. Bacher, "With Whistler in Venice, 1880–86," *Century*, 73 (December 1906), 215–17.

7   JW to F. S. Haden, [March/May 1881], E. J. Poynter to JW, April 1, 1881, W. T. Watts-Dunton to JW [April 1881], JW to Elizabeth Lewis [May 19/21, 1881], *GUW* 1945, 5012, 6074, 10969; *GAME*, 52–65; James McNeill Whistler, *The Piker Papers: The Printer-Etcher's Society and Mr. Whistler* (London, 1881).

8   George C. Williamson, *Murray Marks and His Friends* (London, 1919), 113–55; *WJ*, 58–70, 130; *LW*, I:296–98; JW to S. W. Paddon [March 22, 1882], *GUW* 8103.

9   Correspondence in *GUW* 4192–93, 150–53, 590. The reunited halves of the cabinet may be seen at the Frederick Leighton House, Holland Park Road, London.

10   S. W. Paddon to JW, March 16, 1882, July 14, 1882, JW to Paddon, March 22, 1882, JW to Mary McNay [August 1882], *GUW* 4365, 9530, 4366, 4242; *LW*, I:309–310; Helen Rossetti Angeli, *Pre-Raphaelite Twilight: The Story of Charles Augustus Howell* (London, 1954), 182–89; James McNeill Whistler, *Correspondence. Paddon Papers. The Owl and the Cabinet* (London, 1882). Copies and drafts of the pamphlet in WC and Box 5 of PWC.

11   Alan S. Cole Diary, May 26 and August 26, 1881, *GUW* 13132/3432; JW to Helen Whistler [September 1881], *GUW* 6694; Laura Beatty, *Lillie Langtry: Manners, Masks and Morals* (London, 1999), 200–01, 223–27; YMSM 227.

12   Virginia Surtees, *The Actress and the Brewer's Wife: Two Victorian Vignettes* (Wilby, Eng., 1997), 105–29; Susan Grace Galassi with Helen M. Burnham, "Lady Henry Bruce Meux and Lady Archibald Campbell," in Margaret F. MacDonald et al., *Whistler, Women and Fashion* (New Haven and London, 2003), 159–61.

13   Lillie Langtry, *The Days I Knew* (London, 1925), 63; Surtees, *Actress and Brewer's Wife*, 124–29; Galassi, "Meux and Campbell," 161–75.

14   YMSM 228–30. Other descriptions of JW's painting techniques and studio habits by the early 1880s are Way, *Memories*, 24–25, 28–30; Mortimer Menpes, *Whistler As I Knew Him* (London, 1904), 69–74; Edmund H. Wuerpel, "Whistler – The Man," *AMA*, 27 (May 1934), 252–53; J. Comyns Carr, *Coasting Bohemia* (London, 1914), 89–90, 92; Joyce H. Townsend, "Whistler's Oil Painting Materials," *BM*, 136 (October 1994), 69–95; David Peters Corbett, *The World in Paint: Modern Art and Visuality in England, 1848–1914* (University Park, Penn., 2004), 118–19; Stephen Hackney et al., *Paint and Purpose: A Study of Technique in British Art* (London, 1999), 86–89. Illustrations of Whistler at work are in Eric Denker, *In Pursuit of the Butterfly: Portraits of James McNeill Whistler* (Washington, D.C. 1995), 106–08, 128–29.

15   Jan Marsh, *Dante Gabriel Rossetti: Painter and Poet* (London, 1999), 507–28; JW to W. M. Rossetti [July 1, 1882], *GUW* 10504.

16   Cole Diary, May 2, 1882; Harper Pennington, "The Whistler I Knew," *MM*, 31 (March 1910), 773; Matthew Sturgis, *Walter Sickert: A Life* (London, 2005), 54–55, 65–67, 91–94, 96–100, 104–05; Menpes, *Whistler*, 15, 89; M.835; Edward Simmons, *From Seven to Seventy: Memories of a Painter and a Yankee* (New York, 1922), 129–32.

17   *LW*, II:10–13, 18–23; Rennell Rodd to Joseph Pennell, June 3, 1907, v.298, PWC; Sturgis, *Walter Sickert*, 100, 109; JW to Lord Wharncliffe, June 30 [1882], JW to T. W. Story [December 1882], *GUW* 7424, 9434.

18   *LW*, II:20–22; Menpes, *Whistler*, 79–83.

19   David Park Curry, *James McNeill Whistler: Uneasy Pieces* (Richmond, Va., 2004),

26–66; Jonathan Shirland, " 'A Singularity of Appearance in a Democracy of Clothes': Whistler, Fancy Dress and the Camping of Artists' Dress in the Late Nineteenth Century," *VCB*, 8 (2007), 15–35; "Thoughts By the Way – II: The Aesthete," *PMG*, 35 (May 3, 1882), 4; Frank Harris, *Contemporary Portraits* (New York, 1920), 69.

20 Oscar Wilde, "The English Renaissance in Art," and "Lecture to Art Students," in *Complete Works of Oscar Wilde*, 12 vols. (New York, 1927), XI: 4, 18–21, 25, 29–30, 36, 103–05.

21 Lord Redesdale [Algernon Bertram Freeman-Mitford], *Memories*, 2 vols. (New York, 1916), I:647; Ellmann, *Oscar Wilde*, 131–32.

22 *Punch*, 79 (October 30, 1880), 194; *Punch*, 80 (January 22, 1881), 26; *Punch*, 80 (February 19, 1881), 81; Ellmann, *Oscar Wilde*, 134–35; Stephen Calloway and Lynn Federle Orr, eds., *The Cult of Beauty: The Aesthetic Movement, 1860–1900* (London, 2011), 212–21.

23 Carolyn Williams, *Gilbert and Sullivan: Gender, Genre, Parody* (New York, 2011), 153–55, 165–66; Jane W. Steadman, *W. S. Gilbert: A Classic Victorian and His Theatre* (Oxford, 1996), 182–85; Carlyle Brahms, *Gilbert and Sullivan: Lost Chords and Discords* (Boston, 1975), 97–109; Gayden Wren, *A Most Ingenious Paradox: The Art of Gilbert and Sullivan* (New York, 2001), 94–120.

24 Katharine Lochnan, *The Etchings of James McNeill Whistler* (New Haven and London, 1984), 222–27; YMSM 204, 246–49; M.855–59; Grischka Petri, *Arrangement in Business: The Art Markets and Career of James McNeill Whistler* (Hildesheim, 2011) 377–79, 386–87, 390–93.

25 Marc Simpson et al., *Uncanny Spectacle: The Public Career of the Young John Singer Sargent* (New Haven and London, 1997), 95–98, 172–76; Warren Adelson, *Sargent's Venice* (New Haven and London, 2006), 24, 27, 183; Richard Ormond and Elaine Kilmurray, *John Singer Sargent: Venetian Figures and Landscapes, 1874–1881* (New Haven and London, 2009), 307–11.

26 Christopher Newall, *The Grosvenor Gallery Exhibitions: Change and Continuity in the Victorian Art World* (Cambridge, Eng., 1995), 136; YMSM 226; Edith E. Marzetti to Pickford Waller, November 4, 1906, v.13, Pickford Waller to E. R. Pennell, November 19, 1906, v.302, PWC; "The Grosvenor Gallery – II," *PMG*, 35 (June 6, 1882), 4; Sturgis, *Walter Sickert*, 105–06.

27 Cole Diary, June 11, 1882; John L. Sweeney, ed., *The Painter's Eye: Notes and Essays on the Pictorial Arts by Henry James* (Cambridge, Mass., 1956), 25–26, 208–10; "The Grosvenor Gallery – II," 4; *Punch*, 82 (May 13, 1882), 225; *Punch*, 82 (May 20, 1882), 240–41.

28 Ellman, *Oscar Wilde*, 154, 156–57, 177, 204–05; Merlin Holland and Rupert Hart-Davis, eds., *The Complete Letters of Oscar Wilde* (New York, 2000), 139, 147–48, 154, 161–62, 171–72, 173–74; JW to Oscar Wilde [February 1882], *GUW* 7054. For Wilde's American tour, see Mary Warner Blanchard, *Oscar Wilde's America: Counterculture in the Gilded Age* (New Haven and London, 1998), and Roy Morris, Jr., *Declaring his Genius: Oscar Wilde in North America* (Cambridge, Mass., 2013).

29 YMSM 240–42; M.848–49; Menpes, *Whistler*, 69–72; Bernhard Sickert, *Whistler* (London, 1908), 69–72; Pennell Diaries, November 14, 1906; Lady Archibald Campbell to E. R. Pennell, December 13, 1906, v.280, PWC; Lady Archibald Campbell, *Rainbow-Music; The Philosophy of Harmony in Colour-Grouping* (London, 1886), 12–15, 26.

30 Pennell Diaries, November 14, 1906.

31 YMSM 240–42; Galassi, "Meux and Campbell," 178–83; Anna Gruetzner Robins, *A Fragile Modernism: Whistler and His Impressionist Followers* (New Haven and London, 2007), 67–93.

32   J. F. Heijbrock and Margaret F. Mac-Donald, *Whistler and Holland* (Amsterdam, 2000), 53–54, 137; M.876–77; JW to T. W. Story [December 1882], M. B. Huish to JW, December 13, 1882, January 11, 1883, January 15, 1883, JW to Huish, January 12 [1883], *GUW* 9434, 1151, 1153, 1155, 1154.

33   Bendix, *Diabolical Designs*, 166–67, 223–27; JW to Bram Stoker [February 10/17, 1883], JW to T. W. Story [February 5, 1883], *GUW* 11260, 9430; *LW*, I:310–11; David Park Curry, "Total Control: Whistler at an Exhibition," in Ruth Fine, ed., *James McNeill Whistler: A Reexamination* (Washington, D.C., 1987), 77–78.

34   Pennell Diaries, April 6, 1906; JW to William Whistler [February 18/23, 1883], *GUW* 11026.

35   Leslie Linder, ed., *The Journal of Beatrix Potter from 1881 to 1897* (London, 1966), 30; Anne Thorold, ed., *The Letters of Lucien to Camille Pissaro, 1883–1903* (Cambridge, Eng., 1993), 8–10; John Rewald, ed., *Camille Pissaro Letters to His Son Lucien*, trans. Lionel Abel (new edn.; Boston, 2002), 22–23, 27.

36   Sarah Lawrence Parkerson, "Variations in Gold: The Stylistic Development of the Picture Frames Used by James McNeill Whistler" (PhD thesis, Univ. of Glasgow, 2007), 174–77; Bendix, *Diabolical Designs*, 227–28, 230; *Punch*, 88 (January 10, 1885), 24. For the etchings shown, see G.190–96, 198–211, 214–16, 218–26, 228–30, 232–46.

37   Curry, *Whistler: Uneasy Pieces*, 316–25; Lynne Bell, "Fact and Fiction: James McNeill Whistler's Critical Reputation in England, 1880–1892" (PhD thesis, Univ. of East Anglia, 1987), 138–41; Frederick Wedmore, "Mr. Whistler's Exhibition," *Academy*, 23 (February 24, 1883), 139; "Mr. Whistler's Exhibition," *SR*, 55 (February 24, 1883), 241; *Punch*, 84 (March 3, 1883), 107; *Punch*, 84 (March 24, 1883), 133.

38   JW to T. W. Story [February 5, 1883], [March 1/7, 1883], *GUW* 9430, 8155.

39   Bell, "Fact and Fiction," 116–17; Bendix, *Diabolical Designs*, 230; Petri, *Arrangement in Business*, 411–14.

40   Mary Cassatt to Joseph Pennell, November 25 [1906], v.280, PWC; JW to Louisine Elder, September 21 [1881], *GUW* 11092; Frances Weitzenhoffer, *The Havemeyers: Impressionism Comes to America* (New York, 1986), 20–25; Louisine W. Havemeyer, *Sixteen to Sixty: Memoirs of a Collector* (New York, 1961), 206–10.

41   Nancy M. Mathews, *Mary Cassatt: A Life* (New York, 1994), 168–71; Lois Cassatt to Joseph Pennell, June 10, 1919, v.280, PWC.

42   YMSM 250; Nancy M. Mathews, ed., *Cassatt and Her Circle: Selected Letters* (New York, 1984), 172; Edmond et Jules de Goncourt, *Journal: Mémoires de la Vie Litteraire*, 22 vols. (Monaco: 1956), XX:157; Harper Pennington, "James A. McNeill Whistler," *IQ*, 10 (October 1904), 158; Arthur Jerome Eddy, *Recollections and Impressions of James A. McNeill Whistler* (Philadelphia, 1903), 254–59.

43   Newall, *Grosvenor Gallery Exhibitions*, 136; Petri, *Arrangement in Business*, 444–49; JW to Alfred Chapman [May/June 1883], JW to T. W. Story [March 5, 1883], *GUW* 9034, 5606.

44   Sturgis, *Walter Sickert*, 109–11; Mathews, *Cassatt and Her Circle*, 167–68; Martin Brimmer to Sarah W. Whitman, May 22, 1883, Martin Brimmer Letters, D32, AAA.

45   Mary Ann Stevens and Robert Hoozee, eds., *Impressionism to Symbolism: The Belgian Avant-Garde, 1880–1900* (London, 1994), 25–26, 30–33; Joy Newton, "Whistler and La Société des Vingt," *BM*, 143 (August 2001), 480.

46   *World*, December 26, 1883.

13 : ART IS UPON THE TOWN

1   Edward Simmons, *From Seven to Seventy: Memories of a Painter and a Yankee* (New York, 1922), 162–66. See generally Jonathan Wyville

Thomson, "From Aestheticism to the Modern Movement: Whistler, the Artists Colony of St. Ives and Australia, 1884–1920" (MPhil thesis, Univ. of Hong Kong, 2004).

2  Mortimer Menpes, *Whistler As I Knew Him* (London, 1904), 135–38. See Nina Lubbren, *Rural Artists' Colonies in Europe, 1870–1910* (New Brunswick, N.J., 2001), for interesting parallels to how JW dressed, worked, and interacted with the local population.

3  JW to E. G. Brown, January 4 [1884], *GUW* 3063; YMSM 262–88; M.915–20; Anna Gruetzner Robins, *A Fragile Modernism: Whistler and his Impressionist Followers* (New Haven and London, 2007), 9–29.

4  JW to J. A. Chapman, January 15 [1884], *GUW* 9038; Matthew Sturgis, *Walter Sickert: A Life* (London, 2005), 114–15; Menpes, *Whistler*, 138–39, 143–44.

5  JW to E. W. Godwin [January 30, 1884], Helen Whistler [January 1884], *GUW* 1754, 8164.

6  Joy Newton, "Whistler and La Sociétié des Vingt," *BM*, 143 (August 2001), 480–83; W. C. Alexander to JW, January 5, 1884, *GUW* 7579.

7  Algernon Graves to JW, March 17, 1881, June 10, 1882, March 7, 1884, *GUW* 1802, 1807, 1810.

8  Coutts Lindsay to JW, April 18, 1884, JW to Lindsay [April 20, 1884], JW to T. W. Story [May 20/25, 1884], *GUW* 1867–68, 9451.

9  Grischka Petri, *Arrangement in Business: The Markets and Career of James McNeill Whistler* (Hildesheim, 2011), 382, 396, 414–15.

10  Greg Smith, "An Art Suited to the 'English Middle Classes'?: The Watercolour Societies in the Victorian Period," in Paul Barlow and Colin Trodd, eds., *Governing Cultures: Art Institutions in Victorian London* (Aldershot, 2000), 114–27; Christopher Newall, *Victorian Watercolours* (London, 1987), 11, 31, 103, 106, 119–20; Petri, *Arrangement in Business*, 393–96.

11  Kenneth John Myers, *Mr. Whistler's Gallery: Picture of an 1884 Exhibition* (Washington, D.C., 2003), 13–22; JW to E. R. Pennell [January 2, 1902], *GUW* 7745.

12  Myers, *Mr. Whistler's Gallery*, x, 22–24; *GAME*, 115–16.

13  Robins, *Fragile Modernism*, 70–72, 124–32; M.895–907, 926–36.

14  M.907, 934–35; Robins, *Fragile Modernism*, 80–81; Frederick Wedmore, "Mr. Whistler's Arrangement in Flesh Colour and Gray," *Academy*, 25 (May 24, 1884), 374.

15  Lynne Bell, "Fact and Fiction: James McNeill Whistler's Critical Reception in England, 1880–1892" (PhD thesis, Univ. of East Anglia, 1987) 149–78; Menpes, *Whistler*, 117–18, 123; Merlin Holland and Rupert Hart-Davis, eds., *The Complete Letters of Oscar Wilde* (New York, 2000), 225; JW to Oscar Wilde, May 29, 1884, *GUW* 13179.

16  Stanhope Forbes to mother [July 1884], Stanhope Alexander Forbes Papers, TGA; Menpes, *Whistler*, 118–20; JW to C. W. Dowdeswell [May 22/24, 1884], [June 1884], June 29, 1884, JW to Earl of Dunraven [June 20/21, 1884], Dunraven to JW [June 28, 1884], J. E. Boehm to JW, June 30 [1884], Wickham Flower to JW, August 15 [1884], JW to Flower [August 16/25, 1884], *GUW* 8613, 8637, 8601, 9075, 975, 327, 1431–32.

17  Newton, "Whistler and La Vingt," 483; JW to T. W. Story [May 20/25, 1884], *GUW* 9451; Petri, *Arrangement in Business*, 428; Menpes, *Whistler*, 121–23.

18  Malcolm Goldstein, *Landscape with Figures: A History of Art Dealing in the United States* (New York, 2000), 47–63, 77–78; Cynthia Saltzman, *Old Masters, New World: America's Raid on Europe's Great Pictures* (New York, 2008), 1–7.

19  JW to G. A. Lucas, [May 17/30, 1884], JW account with Wunderlich Gallery, June 23 [1884], E. G. Kennedy to JW [January 1884],

GUW 9203, 13334, 7152; Petri, *Arrangement in Business*, 464–70, 560–66.

20 Louise Hall Tharp, *Mrs. Jack: A Biography of Isabella Stewart Gardner* (Boston, 1965), 62–63, 122–23; Dianne Sachko Macleod, *Enchanted Lives, Enchanted Objects: American Women Collectors and the Making of Culture, 1800–1940* (Berkeley, Calif., 2008), 87–91; Deborah Davis, *Strapless: John Singer Sargent and the Fall of Madame X* (New York, 2003), 128, 170–86; JW to I. S. Gardner [June 9/12, 1884], *GUW* 9113. For JW's relationship with Gardner, see Linda J. Docherty, "Creative Connection: James McNeill Whistler and Isabella Stewart Gardner," in Lee Glazer et al., eds., *James McNeill Whistler in Context* (Washington, D.C., 2008), 183–203.

21 *LW*, I:313–15; G. R. Halkett to Dear Sir, October 3, 1884, William Hole to Dear Sir, October 6, 1884, JW to Henry Graves, October 10 [1884], *GUW* 11748–49, 10918.

22 Algernon Graves to JW, October 11, 1884, October 14, 1884, October 16, 1884, November 17, 1884, *GUW* 1813, 1815–16, 1818.

23 JW to W. B. Pearsall [November/ December 1884], JW to Henry Graves [June/ November 1884], *GUW* 8106, 10929; *LW*, II:35–36.

24 Jacques-Emile Blanche, *Portraits of a Lifetime: The Late Victorian Era. The Edwardian Pageant, 1870–1914*, trans. Walter Clement (London, 1937), 61–63; YMSM 315.

25 L. V. Fildes, *Luke Fildes, R.A.: A Victorian Painter* (London, 1968), 168–69; *LW*, I:156–60; G. A. Boughton to A. L. Baldry, August 20, 1903, A. L. Baldry Correspondence, NAL; Harper Pennington, "The Whistler I Knew," *MM*, 31 (March 1910), 773.

26 Albert Ludovici, *An Artist's Life in London and Paris, 1870–1925* (London, 1926), 71–77; T. E. Roberts to JW, November 24, 1884, *GUW* 5268; Julie F. Codell, "Artists' Professional Societies: Production, Consumption, and Aes-

thetics," in Brian Allen, ed., *Towards a Modern Art World* (New Haven and London, 1995), 169–87. For the complete story of the Society of British Artists, see Anne Koval, "The 'Artists' Have Come Out and the 'British' Remain: The Whistler Faction at the Society of British Artists," in Elizabeth Prettejohn, ed., *After the Pre-Raphaelites: Art and Aestheticism in Victorian England* (Manchester, 1999), 90–111.

27 Patricia de Montfort, "James McNeill Whistler: The Ten O'Clock Lecture" (MLitt thesis, Univ. of St. Andrews, 1990), 1–16; Alan S. Cole Diary, March 26 and October 19–November 19, 1884, *GUW* 13132/3432; Walford Graham Robertson, *Life Was Worth Living: The Reminiscences of W. Graham Robertson* (New York, 1931), 130, 136–38; Robert H. Sherard, *Oscar Wilde: The Story of An Unhappy Friendship* (London, 1905), 89.

28 Helen Lenoir to Archibald Forbes, January 8, 1885, JW to T. W. Story [February 10/17, 1885], *GUW* 924, 8147; H. D. Carte to Joseph Pennell, September 24, 1906, v.280, PWC.

29 Cole Diary, October 31 and December 7 and 19, 1884, February 8, 14, and 20, 1885; Sturgis, *Walter Sickert*, 118–19; JW to A. S. Cole [February 1/20, 1885], *GUW* 9032; H. D. Carte to Joseph Pennell, September 24, 1906, v.280, PWC.

30 Montfort, "Ten O'Clock Lecture," 18–23; JW to Helen Lenoir [February 1885], James Willing Jr. to R. D. Carte, February 23, 1885, T. R. Way to Carte, February 4, 1885, *GUW* 11174, 7064, 6084.

31 Montfort, "Ten O'Clock Lecture," 109–10; JW to W. T. Watts-Dunton [January 17, 1885], JW to A. S. Cole [February 1/20, 1885], *GUW* 9548, 9032; Seating Plan of Prince's Hall [February 1885] P625, WC.

32 "Mr. Whistler's 'Ten O'Clock,'" *Daily Telegraph*, February 21, 1885; Mortimer Menpes to JW [February 21/28, 1885], *GUW* 4033; James

McNeill Whistler, *Mr. Whistler's "Ten O'Clock"* (London, 1888), 7.

33 Whistler, *Ten O'Clock*, 7–9; Montfort, "Ten O'Clock Lecture," 24–25.

34 Montfort, "Ten O'Clock Lecture," 45–46, 56–71; Whistler, *Ten O'Clock*, 10–13, 17–20, 26–28.

35 Oscar Wilde, *Complete Works of Oscar Wilde* (New York, 1927), XI:93–107; Walter Pater, *The Renaissance: Studies in Art and Poetry* (4th edn.; London, 1893), 2–3; Frederick Wedmore, "Mr. Whistler's Theories and Mr. Whistler's Art," *NC*, 30 (August 1879), 335.

36 Montfort, "Ten O'Clock Lecture," 72–93; Whistler, *Ten O'Clock*, 14–17.

37 Whistler, *Ten O'Clock*, 15, 18.

38 Ibid., 22–29.

39 "Mr. Whistler's Ten O'Clock," *St. James Gazette*, February 21, 1885. For a broad-ranging discussion of the "Ten O'Clock," see David Park Curry, *James McNeill Whistler: Uneasy Pieces* (Richmond, Va., 2004), 262–315.

40 E. G. Brown to JW [February 20/28, 1885], Philip Currie to JW [February 21, 1885], F. M. Du Quaire to JW, February 21 [1885], Albert Ludovici to JW [February 22, 1885], A. S. Cole to JW, February 21, 1885, *GUW* 1177, 766, 977, 2655, 642.

41 Oscar Wilde, "The Relation of Dress to Art. A Note in Black and White on Mr. Whistler's Lecture," *PMG*, February 28, 1885, p. 4; A. S. Cole to JW, February 21, 1885, Violet Fane to JW, February 22, 1885, *GUW* 642, 1071.

42 Oscar Wilde, "Mr. Whistler's Ten O'Clock," *PMG*, February 21, 1885, pp. 1–2.

43 Montfort, "Ten O'Clock Lecture," 94–98; Michele Mendelssohn, *Henry James, Oscar Wilde and Aesthetic Culture* (Edinburgh, 2007), 95–102; Donald Kuspit, *The Critic as Artist: The Intentionality of Art* (Ann Arbor, Mich., 1984), 83–93, 95–107, 109–25.

44 JW to Oscar Wilde [February 24/28, 1885], *GUW* 7058; *GAME*, 162–63; Ellmann, *Oscar Wilde*, 273–74.

45 Helen Lenoir to JW, February 26, 1885, *GUW* 925; *LW*, II:43–44.

46 Agreement between JW and Luigi Fabbrucci, October 11, 1884, JW to C. W. Dowdeswell [December 1884], *GUW* 1070, 8602; Giles Walkley, *Artists' Houses in London, 1764–1914* (Aldershot, 1994), 156; Bendix, *Diabolical Designs*, 177, 178–80.

47 JW to T. R. Way [November 8, 1885], *GUW* 10503; Bendix, *Diabolical Designs*, 177–78, 180.

48 A. I. Ritchie, "Cheyne Walk, Chelsea," *AJ*, 44 (November 1882), 339–41; Katharine S. Macquoid, "Old Battersea Bridge," *AJ*, 43 (February 1881), 33–36; Aaron Watson, "The Lower Thames," *MA*, 6 (October 1883), 485–92; John M. Picker, *Victorian Soundscapes* (Oxford, 2003), 11–13, 42–57; JW to Arthur Locker [November 1885], *GUW* 9211.

49 A. Ludovici, "The Whistlerian Dynasty at Suffolk Street," *AJ*, 68 (July 1906), 195; [William E. Henley], "Current Art – IV," *MA*, 8 (September 1885), 467–70.

50 *LW*, II:57–59; Council Minutes, May 7 and 20 and June 19, 1885, Royal Society of British Artists Archives, AAD; Sturgis, *Sickert*, 118–19; Robins, *Fragile Modernism*, 48–50.

51 P. P. Marshall to F. M. Brown, September 20, 1885, Ford Madox Brown Papers and Correspondence, NAL; YMSM 253, 264, 336; M.1002–07, 1059–95.

52 Ronald G. Pisano, *William Merritt Chase, 1849–1916* (Seattle, Wash., 1983), 13, 77–80; Barbara Dayer Gallati, *William Merritt Chase* (New York, 1995), 25–26, 32–34, 45, 49–51, 80, 96–100, 116; William M. Chase, "The Two Whistlers: Recollections of a Summer with the Great Etcher," *Century*, 80 (June 1910), 219–24.

53 W. M. Chase to wife, July 5, 1885, August 8, 1885, William Merritt Chase Papers, AAA; Menpes, *Whistler*, 144–51; Keith L. Bryant, *William Merritt Chase: A Genteel Bohemian* (Columbia, Mo., 1991), 98–100, 224–25; Chase,

"Two Whistlers," 224–26; W. M. Chase to JW, September 3, 1885, *GUW* 593; *GAME*, 184–85.

54   For sales, see *GUW* 867, 1178–79, 7154, 8606, 8616, 8689, 12994.

55   Sturgis, *Sickert*, 126–27.

56   YMSM 324–35; M.1024–43; Blanche, *Portraits of a Lifetime*, 51–57.

57   Council Minutes, October 5, 12, 19, and 26 and November 12 and 28, 1885; Sturgis, *Sickert*, 133–34; "Mr. Whistler's New Arrangements," *PMG*, December 8, 1885, p. 4; J. E. Boehm to JW, December 10, 1885, *GUW* 3367.

58   M.1074; *GAME*, 193–95; Alison Smith, "The 'British Matron' and the Body Beautiful: The Nude Debate of 1885," in Prettejohn, *After the Pre-Raphaelites*, 217–39; Ronald Pearsall, *The Worm in the Bud: The World of Victorian Sexuality* (London, 1969), 296–306.

59   Alison Smith, *The Victorian Nude: Sexuality, Morality and Art* (Manchester, 1996), 227–34; "Mr. Whistler's New Arrangements," p. 4; "Occasional Notes," *PMG*, December 10, 1885.

14: EXPLANATIONS AND EXPECTATIONS

1   *GAME*, 118–23.

2   Margaret F. MacDonald, *Palaces in the Night: Whistler in Venice* (Berkeley, Calif., 2001), 120–27; JW to C. W. Dowdeswell [February 1886] (three letters), Messrs. Dowdeswell to JW, February 16, 1886, *GUW* 8600, 8609, 8611, 859; Grischka Petri, *Arrangement in Business: The Art Markets and Career of James McNeill Whistler* (Hildesheim, 2011), 423–25; *GAME*, 76–77.

3   Deanna Marohm Bendix, *Diabolical Designs: Paintings, Interiors, and Exhibitions by James McNeill Whistler* (Washington, D.C., 1995), 236–39; JW to Walter Dowdeswell [April 1/20, 1886], *GUW* 8640.

4   Lynne Bell, "Fact and Fiction: James McNeill Whistler's Critical Reputation in England, 1880–1892" (PhD thesis, Univ. of East Anglia, 1987), 187–98, 214–15; Claude C. Abbott, ed., *The Correspondence of Gerald Manley Hopkins and Richard Watson Dixon* (Oxford, 1955), 131, 135.

5   Petri, *Arrangement in Business*, 417–23; Messrs. Dowdeswell to JW, July 3, 1886, JW to C. W. Dowdeswell [May 1/15, 1886], July 27 [1886], *GUW* 865, 8642, 8638.

6   Messrs. Dowdeswell to JW, February 16, 1866, *GUW* 859; K. Theodore Hoppen, *The Mid-Victorian Generation, 1846–1886* (Oxford, 1998), 78–81, 83–84, 276–79, 283–84, 649–51, 686–89; George S. Reaney, "Outcast London," *FR*, 46 (December 1886), 695.

7   "The London Riots," *Sunday Times*, February 14, 1886, p. 6; Leslie Linder, ed., *Journal of Beatrix Potter from 1881 to 1897* (London, 1966), 172–77; JW to Elisabeth Lewis [February 1886/November 1887], *GUW* 2521.

8   A. Ludovici, "A Whistlerian Dynasty at Suffolk Street," *AJ*, 68 (July 1906), 194; Wyke Bayliss to Walter Dowdeswell, September 19, 1886, JW to Albert Ludovici [March 24, 1886], [April 1/7, 1886] (two letters), *GUW* 263, 8077, 8080–81; George Percy Jacomb-Hood, *With Brush and Pencil* (London, 1925), 32.

9   JW to M. C. Salaman [April 26, 1886], *GUW* 10887; Salaman to Marion Spielmann, August 13, 1886, SP/1/81, RA; "Society of British Artists," *Sunday Times*, June 6, 1886, p. 7; "Mr. Whistler," *Critic*, 5 n.s. (June 12, 1886), 297; "Current Art Criticism," *SR*, 62 (July 3, 1886), 21. The *Court and Society* articles and correspondence are in *GUW* 11351–65.

10   JW to M. C. Salaman [July 31, 1886], JW to W. A. Ingram [September 17, 1886], JW to Walter Dowdeswell [June 19, 1886], JW to Richard Whiteing [August 11/31, 1886], *GUW* 10888, 10832, 8594, 7042; Albert Ludovici, *An Artist's Life in London and Paris, 1870–1925* (London, 1926), 87–88; "Lord Colin Campbell in the Divorce Court," *Sunday Times*, July 4,

1886, p. 7; "The Campbell Divorce Case," *Sunday Times*, November 28, 1886, p. 5; YMSM 354.

11   JW to I. S. Gardner [October 29/30, 1886], [October 30 1886], [October 30/31, 1886], JW to T. W. Story [October 1886], *GUW* 9110, 9117, 9116, 9454; M.1081, 1116; YMSM 263.

12   Dudley Harbron, *The Conscious Stone: The Life of Edward William Godwin* (London, 1949), 183–85; Susan Weber Soros, ed., *E. W. Godwin: Aesthetic Movement Architect and Designer* (New Haven and London, 1999), 38–39; JW to J. E. Boehm [December 10/15, 1886], *GUW* 497.

13   Harbron, *Conscious Stone*, 167–76, 185; Soros, *Godwin*, 35–38, 331–36; Gertrude Atherton, *Adventures of a Novelist* (New York, 1932), 178–79.

14   Soros, *Godwin*, 32–33; Margaret F. MacDonald, *Beatrice Whistler: Artist and Designer* (Glasgow, 1997), 6–13; JW to Beatrice Godwin [October/November 1886], *GUW* 6575; E. R. Pennell Diaries, November 27, 1903, Joseph and Elizabeth R. Pennell Papers, RHC.

15   JW to Albert Ludovici [November/December 1886], JW to H. H. Cauty [November/December 1886], *GUW* 8064, 7881; M.1122–26.

16   Bendix, *Diabolical Designs*, 241–43; Stanhope Forbes to Elizabeth Armstrong, November 23 [1886], December 7 and 8, 1886, Stanhope Alexander Forbes Papers, TGA; *GAME*, 187–91.

17   Arthur Warren, *London Days: A Book of Reminiscences* (Boston, 1920), 162–63; Sidney Starr, "Personal Recollections of Whistler," *AM*, 101 (April 1908), 533–34; "A Game of Whistler," *Punch*, 91 (December 4, 1886), 274; Stanley Weintraub, ed., *Bernard Shaw on the London Art Scene, 1885–1950* (University Park, Penn., 1989), 29–30, 133–34; Stanhope Forbes to Elizabeth Armstrong, November 23 [1886], Forbes Papers; Anna Gruetzner Robins, *A Fragile Modernism:*

*Whistler and his Impressionist Followers* (New Haven and London, 2007), 72–80.

18   Bell, "Fact and Fiction," 275–78; "The Society of British Artists," *The Times*, April 20, 1886, p. 5; "The Suffering of a Suffolk Streeter," *Fun*, December 8, 1886, p. 239; Pamela Fletcher, *Narrating Modernity: The British Problem Picture, 1895–1914* (Aldershot, 2003), 14–17, 46–47, 54–57; Robins, *Fragile Modernism*, 31, 95–121; Kenneth McConkey, *The New English: A History of the New English Art Club* (London, 2006), 29–42.

19   Council Minutes, December 13, 17, 21, and 29, 1886 and January 7, 1887, Royal Society of British Artists Archives, AAD; JW to H. H. Cauty [December 9, 1886], Lewis and Lewis to JW, December 20, 1886, *GUW* 5269, 2531.

20   H. B., "London Letter," *Critic*, 7 n.s. (January 8, 1887), 17; T. C. Gotch to Joseph Pennell, November 22, 1906, v.283, W. A. Ingram to Pennell, October 1, 1906, v.289, PWC; JW to Ingram [January 27, 1887], *GUW* 10833; Jacomb-Hood, *With Brush and Pencil*, 29; Council Minutes, January 7, 14, and 24, and February 21, 1887.

21   Correspondence in *GUW* 1836–37, 1844–47, 2210–19, 2126–27, 4993; M.1130–32. A photograph of the memorial (PH10) is in WC.

22   Council Minutes, July 18 and August 15, 1887; General Meeting Minutes, August 10 and September 5, 1887, R.S.B.A. Archives; M.1121, 1133–36.

23   G.301–12; *Manchester Guardian*, September 26, 1887. JW added four views to this "Jubilee" set not done at the naval review, including Westminster Abbey, Windsor Castle, and his home in Chelsea: G.296, 313–15. See also Martin Hopkinson, "Whistler's Sandwich Etchings," *PQ*, 18 (December 2001), 436–43.

24   Petri, *Arrangement in Business*, 568–74.

25   Anne Helmreich, "The Art Dealer and Taste: the Case of David Croal Thomson and the Goupil Gallery, 1885–1897," *VCB*, 6 (Winter

2005), 31–49; *LJW*, II:42–44; Martha Tedeschi and Britt Salvesen, *Songs on Stone: James McNeill Whistler and the Art of Lithography* (Chicago, 1998), 14, 32, 34, 40, 47–48.

26  Correspondence in *GUW* 1964, 7155, 7157, 7159; Joy S. Kasson, *Buffalo Bill's Wild West: Celebrity, Memory, and Popular History* (New York, 2000), 176–83. The London shopfronts and street scenes, made between 1886 and 1888, are G.252–57, 263–70, 272–74, 276–92, 297–300, 316–17, 327–29, 355–61, 379–84; the Wild West etchings are G.293–95.

27  Ralph Thomas, *A Catalogue of the Etchings and Dry-Points of James Abbott MacNeil Whistler* (London, 1874); Frederick Wedmore to JW, July 10, 1886, W. Craibe Angus and Sons to JW, August 18, 1887, C. J. Hanson to Angus, December 16, 1887, *GUW* 6290, 172, 1959; Frederick Wedmore, *Whistler's Etchings: A Study and a Catalogue* (London, 1886). JW owned two copies of Wedmore's catalogue, one being a presentation copy by the author. See Special Collections, GUL.

28  David Park Curry, *James McNeill Whistler: Uneasy Pieces* (Richmond, Va., 2004), 148–49; Helen D'Oyly Carte to Elizabeth Pennell, August 13, 1907, v.280, PWC; R. D. Carte to JW, March 20, 1888, Helen to JW, June 25, 1888, WC.

29  G.338–46; JW to T. W. Story [September 14/18, 1887], *GUW* 5608; Martin Hopkinson, "Whistler's Brussels Etchings," *PQ*, 18 (December 2001), 458–60.

30  Joy Newton, "Whistler and La Société des Vingt," *BM*, 143 (August 2001), 485–86. For JW's reception in Germany, see Grischka Petri, "Whistler and German Histories of Modern Painting: Another Case of *Art and Art Critics*," in Lee Glazer et al., eds., *James McNeill Whistler in Context* (Washington, D.C., 2008), 117–39.

31  Correspondence in *GUW* 2028–40. A rare copy of the 1885 pamphlet is in the Brewster Collection, AIC.

32  Richard Kendall, ed., *Monet by Himself: Paintings, Drawings, Pastels, Letters* (London, 1989), 124; JW to Scoones [July 1888], *GUW* 9417. For the connections between JW and Monet, see Katharine Lochnan, "Whistler and Monet: Impressionism in Britain," in Glazer, *Whistler in Context*, 45–64.

33  Gordon Millan, *A Throw of the Dice: The Life of Stéphane Mallarmé* (New York, 1994), 263; Luce Abeles, "Mallarmé, Whistler and Monet," in Katharine Lochnan, ed., *Turner, Whistler, Monet: Impressionist Visions* (London, 2004), 163–65; Carl Paul Barbier, ed., *Correspondance Mallarmé–Whistler: Histoire de la Grande Amitié de Leurs Dernières Années* (Paris, 1964), 5–15.

34  "Mr. Whistler's Ten O'Clock," *SR*, 65 (May 26, 1888), p. 621; "Mr. Whistler's 'Ten O'Clock,'" *Daily News*, May 12, 1888, p. 4; JW to Stéphane Mallarmé, May 10, 1888, Collection litteraire Jacques Doucet, BSG (copy courtesy Nigel Thorp); Barbier, *Mallarmé–Whistler*, 16–28, 297–300. A copy of the French pamphlet, *Le "Ten O'Clock" de M. Whistler* (Paris, 1888), inscribed to his son with butterfly signature, is in the Brewster Collection.

35  Rikky Rooksby, *A. C. Swinburne: A Poet's Life* (Aldershot, Eng., 1997), 235–37; T. A. Guthrie Diaries, July 5, 1885, Thomas A. Guthrie Papers, BL.

36  Algernon Charles Swinburne, "Mr. Whistler's Lecture on Art," *FR*, 49 n.s. (June 1888), 745–51. Swinburne's remarks also sparked a negative assessment of JW's lecture in the *Westminster Review*, 130 (July 1888), 202–09.

37  Edmund Gosse, *The Life of Algernon Swinburne* (New York, 1917), 270–73; JW to W. T. Watts-Dunton [June 6/10, 1888], *GUW* 11127; Philip Henderson, *Swinburne: Portrait of a Poet* (New York, 1974), 252–54, 273–75.

38  JW to Stéphane Mallarmé [June 6, 1888], JW to A. C. Swinburne [June 6, 1888] (two letters), *GUW* 11120, 5628, 9459; *World*, June 6, 1888, p. 17; *GAME*, 259–62.

39  *LW*, II:45–46; Rooksby, *Swinburne*, 271–72; Pennell Diaries, September 18, 1906; unpublished poem in Swinburne's hand, No. 5097, p. 14, Ashley Collection, BL.

40  Théodore Duret, "Whistler and His Work," *Arts and Letters*, 1 (February 1888), 215–16; Joy Newton and Margaret F. Mac-Donald, "Whistler: Search for a European Reputation," *Zeitschrift für Kunstgeschichte*, 41 (1978), 156–57; Frederic V. Grunfield, *Rodin: A Biography* (New York, 1987), 134–42, 215–17; Ruth Butler, *Rodin: The Shape of Genius* (New Haven and London, 1993), 164–67; JW to Paul Durand-Ruel, May 8, 1888, JW to Auguste Rodin [June 1885], *GUW* 978, 9413.

41  Michael Marlais, *Conservative Echoes in Fin-de-Siècle Parisian Art Criticism* (University Park. Penn., 1992), 30–39; James Kearns, *Symbolist Landscapes: The Place of Painting in the Poetry and Criticism of Mallarmé and His Circle* (London, 1989), 74–81, 88–89, 98–101, 130–35, 164–67.

42  Reinhard Kuhn, *The Return to Reality: A Study of Francis Viele-Griffin* (Geneve, 1962), 17–23; Barbier, *Mallarmé–Whistler*, 18–28; Joy Newton, "Whistler's French Critics," in Glazer, *Whistler in Context*, 81–93.

43  Joris-Karl Huysmans, "Wistler," translated in Robin Spencer, ed., *Whistler: A Retrospective* (New York, 1989), 257–58; Rosalind H. Williams, *Dream Worlds: Mass Consumption in Late Nineteenth-Century France* (Berkeley, Calif., 1982), 125–33; Hilary Taylor, *James McNeill Whistler* (New York, 1978), 139–46; Brian K. Banks, *The Image of Huysmans* (New York, 1990), 92–97, 103–07.

44  Joy Newton, ed., *La Chauve-Souris et la Papillon: Correspondance Montesquiou–Whistler* (Glasgow, 1990), 2–3, 39–49; Edgar Munhall, *Whistler and Montesquiou: The Butterfly and the Bat* (New York, 1995), 58–60, 62.

45  William C. Carter, *Marcel Proust: A Life* (New Haven and London, 2000), 144–49, 186, 362–64, 376–77; Eric Karpeles, *Paintings in Proust: A Visual Companion to* In Search of Lost Time (London, 2008), 107, 146–47, 198–99, 274–75, 304–05.

46  Council Minutes, July 1887–April 1888, Rough Minutes Book, July 1887–April 1888, R.S.B.A. Archives; JW to Caroline Creyke, November 1 [1887], Creyke Collection, BL; Jacomb-Hood, *With Brush and Pencil*, 34–35; W. A. Ingram to Joseph Pennell, October 1, 1906, v.289, PWC.

47  Resolution [May 1888], General Meeting Minutes, May 7, 1888; C. J. to H. H. Cauty, May 6, 1888, Whistler Correspondence, R.S.B.A. Archives; JW to Alfred Stevens, May 7, 1888, *GUW* 9423.

48  General Meetings Minutes, May 12, 1888, Council Meeting Minutes, May 16, 1888; C. J. Hanson to H. H. Cauty, June 18, 1888, Whistler Correspondence; Peter Macnab to JW, May 17, 1888, *GUW* 3731; S. C. Hauxhurst to Joseph Pennell, December 20, 1923, Box 230, G. A. Holmes to Joseph and E. R. Pennell, November 13, 1906, v.284, PWC; "The Rise and Fall of the Whistler Dynasty: An Interview with ex-President Whistler," *PMG*, June 11, 1888, pp. 1–2; Menpes, *Whistler*, 109–11.

49  General Meeting Minutes, May 12, 1888, July 2, 1888; Council Minutes, May 16, 1888; JW to H. H. Cauty, July 2, 1888, *GUW* 3477; W. A. Ingram to Joseph Pennell, October 1, 1906, v.289, PWC.

50  Julie F. Codell, "Marion Harry Spielmann and the Role of the Press in the Professionalization of Artists," *VPR*, 22 (Spring 1989), 7–15; *GAME*, 196–98.

51  "Rise and Fall of Whistler Dynasty," 1–2, also in *GAME*, 248–50; "Mr. Whistler and the Society of British Artists," *PMG* (August 1, 1888), p. 13; Council Minutes, May 28, June 11, June 22, 1888; Lewis and Lewis to JW, June 21, 1888, June 26, 1888, GUW 2537–38.

15: GAMES AND HONORS, VARIOUS

1  Promissory lease, November 14, 1881, 4/145–1988, E. W. Godwin Papers and Correspondence, AAD; Giles Walkley, *Artists' Houses in London, 1764–1914* (Aldershot, 1994), 152–54; Susan Weber Soros, ed., *E. W. Godwin: Aesthetic Movement Architect and Designer* (New Haven and London, 1999), 171–73; JW to Alfred Stevens, May 7, 1888, *GUW* 9423.

2  Roger Brown, *William Stott of Oldham, 1857–1900: "A Comet Rushing to the Sun"* (London, 2003), 9, 33–35, 38–40, 98–99; Margaret F. MacDonald, "Maud Franklin," in Ruth E. Fine, ed., *James McNeill Whistler: A Reexamination* (Washington, D.C., 1987), 24–25.

3  Notes of Conversation with R. Birnie Philip, [1930], James Laver Papers, GUL; *WJ*, 119; E. R. Pennell Diaries, November 16, 1908, Joseph and Elizabeth R. Pennell Papers, RHC; Lillian M. C. Randall, ed., *The Diary of George A. Lucas: An American Art Agent in Paris, 1857–1909*, 2 vols. (Princeton, N.J., 1979), II:662–75; Edwin A. Ward, *Recollections of a Savage* (London, 1923), 258–59.

4  JW to C. J. Hanson [June 14, 1888], John Morley to JW [June 28, 1888], Wickham Flower to JW, July 14, 1888, poem dated July 11, 1888, *GUW* 8008, 4384, 1433, 6839.

5  *The Times*, August 14, 1888, p. 1; "The Marriage of Mr. Whistler and Mrs. Godwin," *PMG*, August 11, 1888, p. 8; JW to William Whistler [August 9, 1888], Deborah Haden to JW, November 18, 1888, *GUW* 7004, 1922.

6  "Marriage of Mr. Whistler and Mrs. Godwin," 8; *LW*, II:75–76; *WJ*, 166–67; Randall, *Diary of Lucas*, II:675.

7  W. B. Scoones to JW, July 24, 1888, lists of silver, *GUW* 5396, 12726–28, 12723.

8  Edgar Munhall, *Whistler and Montesquiou: The Butterfly and the Bat* (New York, 1995), 62; *LW*, II:77; JW to Helen Whistler [September 22, 1888], *GUW* 6713.

9  M.1176–88; G.387–99, 402–03, 405–34; JW to C. J. Hanson, October, 1888, [October 25, 1888] (two letters), *GUW* 8016, 8842; *PMG*, October 30, 1888.

10  JW to C. J. Hanson, October 25, 1888, JW to W. A. Ingram, November 18, 1888, *GUW* 8016, 3507; *St. James Gazette*, November 26, 1888; *World*, November 28, 1888; "The Society of British Artists and Their Signboard," *Athenaeum*, No. 3209 (April 27, 1889), 543–44.

11  *World*, September 5, 1888, p. 17, also in *GAME*, 229; relevant correspondence is *GUW* 7993, 5347, 5215, 4226.

12  JW to Robert Walker, February 28, 1889, JW to G. H. Lewis [February 28, 1889], Thomas Laurie and Son to A. J. Kirkpatrick, March 2, 1889, *GUW* 3527, 2541, 3529. Accounts and correspondence with dealers are *GUW* 910–11, 1197–99, 1204, 1211, 1213, 1224, 1226, 1825–26, 3514–15, 3661–62, 5401–03, 10926, 11751, 12690, 13028–31.

13  G. P. Jacomb-Hood, *With Brush and Pen* (London, 1925), 34; Mortimer Menpes, *Whistler As I Knew Him* (London, 1904), 151–53.

14  "Mr. Whistler and Mr. Menpes," *PMG*, April 27, 1888, p. 5; JW to Mortimer Menpes [April 1888], W. R. Sickert to JW [May/June 1888], *GUW* 1008, 5430; Anna Gruetzner Robins, *A Fragile Modernism: Whistler and His Impressionist Followers* (New Haven and London, 2007), 95–96, 110–11; Kenneth McConkey, *The New English: A History of the New English Art Club* (London, 2006), 53–54.

15  "The Home of Taste: The Ideas of Mr. Mortimer Menpes on House Decoration," *PMG*, December 13, 1888, p. 5; JW to Mortimer Menpes, Christmas 1888, Hanley Collection, RHC; W. R. Sickert to Beatrice Whistler [December 1888], JW to Menpes [March 28, 1889], JW to Henry Labouchere [March 28, 1889], *GUW* 5435, 4034, 3534; *GAME*, 233–34.

16  Stanhope Forbes to Elizabeth Armstrong [April 12, 1888], Stanhope Alexander Forbes

Papers, TGA; JW to Gentlemen [of the Hogarth Club], [January 4, 1889], J. R. Reid to Committee of the Hogarth Club, January 5, 1889, J. W. Sim to JW, January 9, 1889, *GUW* 13461, 5174, 483; Brown, *William Stott*, 39–40; Press Clipping, v.35, PWC.

17   E. G. Kennedy to JW, March 8, 1889, D. A. Kennedy to JW, March 18, 1889, accounts of sales, *GUW* 7171–72, 7175, 7177–78, 13055–56; Deanna Marohn Bendix, *Diabolical Designs: Paintings, Interiors, and Exhibitions of James McNeill Whistler* (Washington, D.C., 1995), 245–46; Frances Weitzenhoffer, *The Havemeyers: Impressionism Comes to America* (New York, 1986), 54–55; Thomas Lawton and Linda Merrill, *Freer: A Legacy of Art* (Washington, D.C., 1993), 17–18, 42–43.

18   Grischka Petri, *Arrangement in Business: The Art Markets and Career of James McNeill Whistler* (Hildesheim, 2011), 561; banquet subscription lists [April 1889], banquet menu [May 1889], GUW 5636, 5642, 5645; Hilda Orchardson Gray, *Life of William Orchardson* (London, 1930), 149.

19   JW to unknown [May 2, 1889], *GUW* 6802; *Sunday Times*, May 5, 1889, a portion reprinted in *GAME*, 285–86.

20   R. C. Hawkins to JW, April 3, 1889, *GUW* 4408; Edward Simmons, *From Seven to Seventy: Memories of a Painter and a Yankee* (New York, 1922), 223–24.

21   Carl Paul Barbier, ed., *Correspondance Mallarmé–Whistler: Histoire de la Grande Amitié de Leurs Dernières Années* (Paris, 1964), 40–44; Joy Newton, ed., *La Chauve-Souris et la Papillon: Correspondance Montesquiou–Whistler* (Glasgow, 1990), 59–62; Munhall, *Whistler and Montesquiou*, 42–45.

22   J. F. Heijbroek and Margaret F. MacDonald, *Whistler and Holland* (Amsterdam, 2000), 29–30, 60–75; C. J. Hanson Diary, August 22, 1889 (H86), WC; G.445–58.

23   JW to M. B. Huish, September 3, 1889,

W. R. Sickert to JW [July 3/10, 1889], *GUW* 8803, 5439.

24   Payments from dealers in *GUW* 913, 1233, 1235, 3555, 6580–83, 7181–84, 8630, 9669, 13080, 13092; Petri, *Arrangement in Business*, 428.

25   Margaret F. MacDonald, *Beatrice Whistler: Artist and Designer* (Glasgow, 1997).

26   Gertrude Atherton, *Adventures of a Novelist* (New York, 1932), 175; Mrs. H. Waldo Warner [Rose Pettigrew], "Memories of Philip Wilson Steer," pp. 7–8, 11–12, D. S. MacColl Papers, GUL, also published in Bruce Laughton, *Philip Wilson Steer, 1860–1942* (Oxford, 1971), 113–21.

27   Pennell Diaries, November 4 and 27, 1903, February 11, 1904, and May 4, 1909; Tom Pocock, *Chelsea Reach: The Brutal Friendship of Whistler and Walter Greaves* (London, 1970), 124–25; Atherton, *Adventures of a Novelist*, 175–78.

28   JW to Beatrice Whistler [June 11, 1891], [June 14, 1891], [June 15, 1891], *GUW* 6591, 6593–94; Atherton, *Adventures of a Novelist*, 175, 180; Pennell Diaries, September 1 and October 15, 1906.

29   "Whistler and His Secretary," *The Times*, November 27, 1923, p. 17; JW to C. J. Hanson, [August 15/20, 1888], *GUW* 8820.

30   See C. J. Hanson Engagement Book, 1888 (H77), and C. J. Hanson Diary, 1889 (H86), WC.

31   Hanson Diary, March 9 and December 11 and 13, 1889; C. J. Hanson to JW, December 15, 1889, *GUW* 1984.

32   JW to Edmund Yates [July/September 1887], *GUW* 7118.

33   Viola Hopkins Winner, *Henry James and the Visual Arts* (Charlottesville, Va., 1970), 45–49; Richard Ellmann, *Oscar Wilde* (New York, 1988), 299–303, 325–26; Michele Mendelssohn, *Henry James, Oscar Wilde and Aesthetic Culture* (Edinburgh, 2007), 146–53; James Run-

ciman to JW, January 1, 1890, January 19, 1890, January 21, 1890, JW to Henry Labouchere [January 2, 1890], *GUW* 5337–39, 5861; *GAME*, 164, 236–38.

34 Merlin Holland and Rupert Hart-Davis, eds., *The Complete Letters of Oscar Wilde* (New York, 2000), 418–20; *GAME*, 239–40.

35 Ronald R. Thomas, "Poison Books and Moving Pictures: Vulgarity in *The Picture of Dorian Gray*," and Nancy Rose Marshall, "James Tissot's 'Coloured Photographs of Vulgar Society,' " both in Susan David Bernstein and Elsie B. Michie, eds., *Victorian Vulgarity: Taste in Verbal and Visual Culture* (Farnham, 2009), 185–200, 207–09; James McNeill Whistler, *Mr. Whistler's "Ten O'Clock"* (London, 1888), 22–23.

36 Ellmann, *Oscar Wilde*, 271, Walford Graham Robertson, *Life Was Worth Living: The Reminiscences of W. Graham Robertson* (New York, 1931), 130; William Rothenstein, *Men and Memories: A History of the Arts, 1872–1922*, 2 vols. in 1 (New York, 1932), I:101–102; Pennell Diaries, November 17, 1903.

37 Ellmann, *Oscar Wilde*, 274–78, 310–13, 325–27; Isobel Murray, ed., *Oscar Wilde* (Oxford, 1989), 223, 232, 245, 247, 252, 591, 595, 600–03; Alison Byerly, *Realism, Representation, and the Art in Nineteenth-Century Literature* (Cambridge, Eng., 1997), 184–95; Mendelssohn, *James, Wilde and Aesthetic Culture,* 153–58.

38 R. A. M. Stevenson to D. S. MacColl, April 5, 1930, McColl Papers.

39 Patricia de Montfort, " 'The Fiction of My Own Biography': Whistler and *The Gentle Art of Making Enemies*" (PhD thesis, Univ. of St. Andrews, 1994), 97–104; clipping dated 1888, Scrapbooks, v.1, p. 5, C. L. Freer Papers, FGA.

40 JW to G. H. Lewis [September 14, 1888], JW to C. J. Hanson September 27/October, 1888], *GUW* 2539, 10081.

41 Hanson Diary, January 13–19 and March 11, 1889; *LW*, II:101, 107; Montfort, "Fiction of My Biography," 97, 123–25.

42 Montfort, "Fiction of My Biography," 123–24, 128–34; Hanson Diary, March 11, 15, 18, 22, and 27, April 20 and 23–24, May 2, 7, 16, and 27–28, June 6, July 1, 18, 22, and 29, and August 19 and 26, 1889; JW to Miss Evans [April 1/4, 1890], JW to Sheridan Ford [August 18, 1889], August 21, 1889, *GUW* 1058, 10997–98.

43 Sheridan Ford, ed., *The Gentle Art of Making Enemies* (New York, 1890), 222–23, 225–26; *WJ*, 215; Montfort, "Fiction of My Biography," 137–39, 144.

44 Montfort, "Fiction of My Biography," 146–50; JW to G. H. Lewis [March 22, 1890], Field and Tuer to Lewis and Lewis, March 25, 1890, JW to J. M. Hamilton, March 28, 1890, Hamilton to JW, March 28, 1890, *GUW* 2553, 2498, 1950–51; Pennell Diaries, April 28, 1905; *WJ*, 214–15, 218–19.

45 Montfort, "Fiction of My Biography," 150–53; JW to Albert Maeterlinck, March 28 [1890], JW to Mlle. Kohler, March 24, 1890, JW to Mme. George Kohler, March 25, 1890, *GUW* 3753, 13811, 13809.

46 Montfort, "Fiction of My Biography," 153–68; G. B. W. Gay to Thorndike Nourse, June 4, 1890, F. A. Stokes and Brother to Lewis and Lewis, April 7, 1890, April 15, 1890, *GUW* 406, 5599, 5602; Barbier, *Mallarmé–Whistler*, 55–61. Ford claimed many years later that he had "stored" a box of the Ghent edition at a London steamship company, but he "never reclaimed them." Sheridan Ford to Don C. Seitz, March 29, 1930, WC.

47 Ford, *Gentle Art*, vii, ix; Montfort, "Fiction of My Biography," 144–45, 170–72, 168–70, 172–74; JW to Miss Evans [April 1/4, 1890], *GUW* 1058.

48 JW to G. H. Lewis [April 5/6, 1890], *GUW* 2544; Patricia de Montfort, "Whistler and Heinemann: Adventures in Publishing in the 1890s," *WR*, 2 (2003), 64–68; Montfort, "Fiction of My Biography," 9–11, 312–41.

49 "Mr. Whistler's New Etchings," *PMG*, March 4, 1890, p. 2; Montfort, "Fiction of My Biography," 9–11.

50 Montfort, "Fiction of My Biography," 175–86. For Heinemann's life, see Frederic Whyte, *William Heinemann: A Memoir* (Garden City, N.Y., 1929), and John St. John, *William Heinemann: A Century of Publishing, 1890–1990* (London, 1990).

51 Montfort, "Fiction of My Biography," 186–93; "Whistler's 'Gentle Art of Making Enemies,'" *Critic*, 16 (June 7, 1890), 289.

52 Montfort, "Fiction of My Biography," 189–93; *New York Tribune*, June 25, 1890, p. 7; "Whistler's Own," *Nation*, 51 (August 7, 1890), 115–16; "Mr. Whistler's Wit," *St. James Gazette*, June 20, 1890; "Mr. Whistler's Writings," *PMG*, June 18, 1890, p. 3.

53 Avis Berman, "Scenes and Portraits: The Lithographs and Whistler's Literary Life," *WR*, 2 (2003), 60; "Mr. Whistler's Gentle Art," *Scots Observer*, July 19, 1890.

54 JW's accounts for February to July 1890 are *GUW* 13002, 13032, 13044, 13047–48, 13057–59, 13064–66, 13093, 13804–06; C. L. Freer Diaries, February 28 and March 4, 1890, Freer Papers; "A Day with Whistler," *Detroit Free Press*, March 3, 1890.

55 Berman, "Scenes and Portraits," 58–59; Martha Tedeschi and Britt Salvesen, *Songs on Stone: James McNeill Whistler and the Art of Lithography* (Chicago, 1998), 47–49; Barbier, *Mallarmé–Whistler*, 70–78; *Whirlwind*, December 27, 1890, p. 195.

56 Beatrice Whistler to E. W. Hopper [September 17/18, 1890], JW to W. G. Robertson [November 16/22, 1890], *GUW* 9565, 9410; YMSM 73, 203, 366, 391. For Howell, see Helen Rossetti Angeli, *Pre-Raphaelite Twilight: The Story of Charles Augustus Howell* (London, 1954), 15–27; Edmund Gosse to Violet Hunt, November 1, 1922, including copy of Howell's death certificate, No.A5081, Ashley Collection, BL.

Howell's dark legacy continued when Arthur Conan Doyle based the character Charles Augustus Milverton, a blackmailer who gets his just deserts, on the Owl in a 1904 Sherlock Holmes story.

57 Adrian Frazier, *George Moore, 1852–1933* (New Haven and London, 2000), 207–08, 211–12, 216–18; *Whirlwind*, September 13, 1890, pp. 179–80; James Runciman to JW, September 7, 1890, *GUW* 5342.

58 Linda Merrill, *The Peacock Room: A Cultural Biography* (New Haven and London, 1998), 302–03; JW to Theodore Child [December 1890], *GUW* 626; Theodore Child, "A Pre-Raphaelite Mansion," *Harper's Monthly*, 82 (December 1890), 82–85.

16: SCOTLAND IS BRAVE, BUT VIVE LA FRANCE!

1 Robert Crawford, "How We Bought the Whistler Carlyle," *Glasgow Evening Star*, March 23, 1905; "Mr. Whistler and the Glasgow Corporation. Fresh Chapter in the Gentle Art of Making Enemies," *PMG*, March 24, 1891, p. 3; Arthur Warren, *London Days: A Book of Reminiscences* (Boston, 1920), 165–67.

2 Roger Bilcliffe, *The Glasgow Boys: The Glasgow School of Painting, 1875–1895* (Philadelphia, 1985), 11–15, 31–39, 288–91; Frances Fowle, *Impressionism and Scotland* (Edinburgh, 2008), 23–31, 55–61.

3 JW to G. H. Lewis [January 29, 1891], JW to Elisabeth Lewis, February 13 [1891], Algernon Graves to JW, May 16, 1891, JW to Aglaia Coronio, April 24, 1891, *GUW* 2550, 10978, 1833, 692.

4 Accounts January to August 1891, Robert Crawford to JW, May 2, 1891, J. C. Bancroft to JW, March 18, 1891, June 8, 1891, July 20, 1891, *GUW* 13007, 13049, 13068–70, 13083–84, 13097, 760, 240–41, 243.

5  Edgar Munhall, *Whistler and Montes-quiou: The Butterfly and the Bat* (New York, 1995), 63–67; Philippe Jullian, *Prince of Aesthetes: Count Robert de Montesquiou, 1855–1921*, trans. John Haylock and Francis Key (New York, 1968), 90–97; Joy Newton, ed., *La Chauve-Souris et la Papillon: Correspondance Montesquiou–Whistler* (Glasgow, 1990), 78–102; Robert Baldick, ed. and trans., *Pages from the Goncourt Journal* (London, 1962), 366.

6  Deborah L. Silverman, *Art Nouveau in Fin-de-Siècle France: Politics, Psychology, and Style* (Berkeley, Calif., 1989), 207–08; Lois Marie Fink, *American Art at the Nineteenth-Century Paris Salons* (Cambridge, Eng., 1990), 122–25; Desmond Flower and Henry Maas, eds., *The Letters of Ernest Dowson* (Rutherford, N.J., 1967), 209.

7  JW to Beatrice Whistler [June 11, 1891], [June 12, 1891], *GUW* 6591–92.

8  Carl Paul Barbier, ed., *Correspondance Mallarmé–Whistler: Histoire de la Grande Amitié de Leurs Dernières Années* (Paris, 1964), 83–95; Newton, *Chauve-Souris*, 103–14; Douglas Druick and Michael Hoog, *Fantin-Latour* (Ottawa, 1983), 15–18, 26–29, 235–39, 259–60, 275–314; JW to Beatrice Whistler [June 15, 1891], *GUW* 6594.

9  JW to Beatrice Whistler, June 14, 1891, [June 15, 1891], *GUW* 6593–94. For Stevens, see William A. Coles, *Alfred Stevens* (Ann Arbor, Mich., 1977), and Saskia de Bodt, *Alfred Stevens: Brussels – Paris, 1823–1906* (Brussels, 2009).

10  Margaret F. MacDonald, *Beatrice Whistler: Artist and Designer* (Glasgow, 1997), 38–39, 41–43.

11  JW to Beatrice Whistler [August 13, 1891], [August 14/17, 1891], [August 15/18, 1891], [August 16/18, 1891], [August 18, 1891], *GUW* 6595, 6598, 6596–97, 6599; Pamela Fletcher, "'To wipe a manly tear': The Aesthetics of Emotion in Victorian Narrative Painting," *VS*, 51 (Spring 2009), 457–69.

12  Barbier, *Mallarmé–Whistler*, 100–01, 198–20; Maurice Joyant to JW, November 11, 1891, Joyant to Stéphane Mallarmé, November 21, 1891, Collection litteraire Jacques Doucet, BSG (copy courtesy Nigel Thorp); Joy Newton and Margaret F. MacDonald, "Whistler: Search for a European Reputation," *Zeitschrift fur Kunstgeschichte*, 41 (1978), 157–59; Margaret F. MacDonald and Joy Newton, eds., "Correspondence Duret–Whistler," *GBA*, 110 (November 1987), 154–55.

13  Margaret F. MacDonald and Joy Newton, "The Selling of Whistler's *Mother*," in MacDonald, ed., *Whistler's Mother: An American Icon* (Aldershot, 2003), 71–78; François Duret-Robert, "The Fluctuating Dollar Prices for Impressionist Paintings," in Barbara Ehrlich White, ed., *Impressionism in Perspective* (Englewood, N.J., 1978), 99; Susan Grant, "Whistler's Mother Was Not Alone: French Government Acquisitions of American Paintings, 1871–1900," *Archives of American Art Journal*, 32, No. 2 (1992), 7–8; Warren, *London Days*, 167.

14  Tom Cross, *Artists and Bohemians: 100 Years with the Chelsea Arts Club* (London, 1992), 8–9, 16–17; Barbier, *Mallarmé–Whistler*, 121–32; Munhall, *Whistler and Montesquiou*, 67–68; Newton, *Chauve-Souris*, 121–34; MacDonald and Newton, "Duret–Whistler," 156–57; G. W. S., "Art Criticism," *New York Tribune*, January 24, 1892, p. 16.

15  JW to Beatrice Whistler [January 19, 1892], [January 24, 1892], GUW 6607, 6606. For other changes that had overtaken the Quarter, see F. Berkeley Smith, *The Real Latin Quarter* (New York, 1901) of which JW owned a copy.

16  McDonald and Newton, "Selling Whistler's *Mother*," 78; Barbier, *Mallarmé–Whistler*, 134–51; JW to Beatrice Whistler [February 1, 1892], A. J. F. Ribot to JW, February 3, 1892, *GUW* 6610, 11036.

17  JW to Beatrice Whistler [February 1, 1892], JW to Duke of Marlborough [January

25/31, 1892], JW to William Whistler [February 1/14, 1892], *GUW* 6610, 13544, 7006.

18  James McNeill Whistler, *Whistler v. Ruskin: Art & Art Critics* (London, 1878), 8–9; Edward Simmons, *From Seven to Seventy: Memories of a Painter and a Yankee* (New York, 1922), 171.

19  *LW*, II:94; Crawford, "How We Bought the Whistler Carlyle"; E. R. Pennell Journals, November 28, 1920, Box 351, PWC.

20  *LW*, II:119–20; D. C. Thomson to JW, December 18, 1891, December 21, 1891, J. C. Bancroft to JW, December 8, 1891, December 17, 1891, JW to Bancroft [December 15/16, 1891], *GUW* 5679–80, 245–46, 7604; "Art Notes," *PMG*, July 22, 1891, p. 1.

21  JW to D. C. Thomson [April 4, 1892], Stephen Richard to Boussod, Valadon et Cie, March 9, 1892, JW to Madeline Wyndham [February 25, 1892], JW to J. G. Potter [March 26/30, 1892], *GUW* 8344, 5188, 7343, 1488; Sarah Lawrence Parkerson, "Variations in Gold: The Stylistic Development of the Picture Frames Used by James McNeill Whistler" (PhD thesis, Univ. of Glasgow, 2007), 211–14; Lynne Bell, "Fact and Fiction: James McNeill Whistler's Critical Reputation in England, 1880–1892" (PhD thesis, Univ. of East Anglia, 1987), 293–303; Deanna Marhom Bendix, *Diabolical Designs: Paintings, Interiors, and Exhibitions by James McNeill Whistler* (Washington, D.C., 1995), 249–54.

22  JW to W. T. Watts-Dunton, February 2 [1878], *GUW* 9577.

23  An Indiscriminate Admirer [Malcolm Salaman], "A Gossip at Goupil's. Mr. Whistler on His Work," *ILN*, March 26, 1892, p. 384; James McNeill Whistler, *Nocturnes, Marines, & Chevalet Pieces* (London 1892), 5, 29 (reprinted in *GAME*, 293–331).

24  JW to D. C. Thomson [February 20, 1892], Thomson to JW, February 27, 1892, March 12, 1892, *GUW* 8219, 5690, 5703.

25  Bell, "Fact and Fiction," 304–23; *LW*, II:121–22; *Punch*, 102 (April 9, 1892), 171; D. C. Thomson to JW, March 23, 1892, March 28, 1892, JW to Thomson [March 29, 1892], [April 1, 1892], *GUW* 5706, 5709, 8355, 8339; JW to C. H. Shannon [March 1892], Ricketts and Shannon Papers, BL; Sydney Cockerell Diaries, April 5, 1892, Cockerell Papers, BL.

26  "Mr. Whistler's Pictures," *SR*, 71 (March 26, 1892), 357; Indiscriminate Admirer, "A Gossip at Goupil's," 384; *Punch*, 102 (April 9, 1892), 180, (April 16, 1892), 181; Walter Sickert, "Whistler To-Day," *FR*, 57 n.s. (April 1892), 543–47; George Moore in *Speaker*, 5 (March 26, 1892), 374–76, (April 2, 1892), 406–07, and (April 9, 1892), 436–37; D. C. Thomson to Beatrice Whistler, March 19, 1892, *GUW* 5705.

27  James Darrach to William Whistler, January 1, 1883, *GUW* 13171; *LW*, II:1–2, 6; John L. Waltman, "The Early London Journals of Elizabeth Robins Pennell" (PhD diss., Univ. of Texas, 1976), 3–26, 33, 57, 65–69, 120, 317, 387–88; Joseph Pennell, *The Adventures of an Illustrator* (Boston, 1925), 153–60.

28  E. R. Pennell, *Life and Letters of Joseph Pennell*, 2 vols. (Boston, 1929), I:200–201, 221–23; Anna Gruetzner Robins, ed., *Walter Sickert: The Complete Writings on Art* (Oxford, 2003), 71–72, 83–84, 89–90.

29  Meaghan Clarke, *Critical Voices: Women and Art Criticism in Britain, 1880–1905* (Aldershot, 2005), 125, 127–45; Peter G. Meyer, ed., *Brushes with History: Writing on Art from The Nation, 1865–2001* (New York, 2001), 48–56; N. N., "Mr. Whistler's Triumph," *Nation*, 54 (September 14, 1892), 280–81.

30  JW to D. C. Thomson [March 29, 1892], [May 6, 1892], JW to Helen Whistler [August 1/5, 1892], *GUW* 8355, 8200, 6717; John Milner, *The Studios of Paris: The Capital of Art in the Late Nineteenth Century* (New Haven and London, 1988), 214–16.

31  Grischka Petri, *Arrangement in Business: The Art Markets and Career of James McNeill Whistler* (Hildesheim, 2011), 575; John Rewald, ed., *Camille Pissarro Letters to His Son Lucien*, trans. Lionel Abel (1943; Boston, 2002), 195, 198–99, 208.

32  Sarah Elizabeth Kelly, "Camera's Lens and Mind's Eye: Whistler and the Science of Art" (PhD diss., Columbia Univ., 2010), 46–48; D. C. Thomson to JW, March 8, 1892, JW to D.C. Thomson [April 1, 1892], *GUW* 5699, 8339.

33  JW to D. C. Thomson [April 4, 1892], Thomson to JW, April 5, 1892, April 7, 1892, April 12, 1892, *GUW* 8344, 5715, 5717, 5721.

34  Dennis Denisoff, "Photography, Whistler's Portraits, and the Public Image of the Artist," *JPRS*, 17 n.s. (Fall 2008), 77–94; T. R. Way to JW, April 9, 1892, *GUW* 6095. For the relationship between photographers and painters at this time, see Anthony J. Hamber, *"A Higher Branch of the Art": Photographing the Fine Arts in England, 1839–1880* (Amsterdam, 1996); Jennifer Green-Lewis, *Framing the Victorians: Photography and the Culture of Realism* (Ithaca, N.Y., 1996); Heather McPherson, *The Modern Portrait in Nineteenth-Century France* (Cambridge, Eng., 2001).

35  JW to D. C. Thomson, July 4 [1893], *GUW* 8243.

36  Valerie Meux to JW, January 13, 1892, May 16, 1892, December 2, 1892, *GUW* 4071, 4074–75.

37  JW to D. C. Thomson [April 13, 1892], Thomson to JW, April 22, 1892, May 10, 1892, Duke of Marlborough to JW, April 19, 1892, Lady Marlborough to JW [April/June 1892], Thomson to Beatrice Whistler, November 17, 1892, *GUW* 8340, 5727, 5737, 8319, 4021, 5758; M.1337.

38  D. C. Thomson to JW, March 23, 1892, JW to Thomson, [March 29, 1892], Julia de Kay Revillon to JW [March 23, 1892], *GUW* 5706, 5710, 5176.

39  JW to Helen Whistler [July 1892], JW to Alexander Reid [August 2, 1892], Valerie Meux to JW, January 13, 1892, JW to Stephen Richard [January 1, 1892], *GUW* 6716, 5136, 4071, 2906.

40  Linda Merrill, *The Peacock Room: A Cultural Biography* (New Haven and London, 1999), 296–97, 304–07; Beatrice Whistler to Alexander Reid [May 1, 1892], Beatrice to E. G. Kennedy, May 1, 1892, *GUW* 11635, 9677.

41  Merrill, *Peacock Room*, 306; JW to D. C. Thomson [May 29, 1892], Thomson to JW, May 25, 1892, May 31, 1892, Alexander Reid to JW, June 16, 1892, Beatrice Whistler to Reid [May 30, 1892], JW to Reid [June 26, 1892], *GUW* 8201, 5741, 5743, 5133, 3207, 3206.

42  JW to D. C. Thomson, [March 29, 1892], [May 11 [1892], [July 5, 1892], Thomson to JW, July 12, 1892, JW to I. S. Gardner [November 1892] [December 1892], (two letters), Gardner to JW [November/December 1892], *GUW* 8355, 8204, 8333, 5753, 9105, 9107, 9109, 1641; YMSM 46, 64.

43  William R. Sieger, "Whistler and John Chandler Bancroft," *BM*, 136 (October 1994), 675–82.

44  Ronald Pickvance, *A Man of Influence: Alex Reid, 1854–1928* (Edinburgh, 1967); Frances Fowle, "Alexander Reid in Context: Collecting and Dealing in Scotland, 1880–1925" (PhD thesis, Univ. of Edinburgh, 1994); R. Macaulay Stevenson to D. S. MacColl, April 5, 1930, D. S. MacColl Papers, GUL; Alexander Reid to JW, August 4, 1892, August 17, 1892, January 3, 1893, JW to Reid [August 14, 1892], August 19, 1892, *GUW* 5137, 5140, 5149, 3223, 3217; YMSM 181, 242.

45  JW to William Whistler [April 14, 1892], D. C. Thomson to JW, May 31, 1892, June 2, 1892, Sidney Starr to JW, September 2, 1892, JW to Starr, September 26, 1892, JW to Samuel Untermyer [September 3, 1892], JW to Thomson [June 6, 1892], [July 5, 1892], *GUW* 7007, 5743, 5747, 5565, 11613, 5886, 8337, 8333.

46  JW to Sidney Starr [October 18/22, 1892], [November 3, 1892], JW to [George] Webb, November 8, 1892, Beatrice Whistler to D. C. Thomson [November 15, 1892], JW to Thomson [November 25, 1892], *GUW* 11615, 11614, 6171, 8329, 8326.

47  JW to John Cavafy [March 31, 1889], JW to E. G. Kennedy, December 19, 1892, *GUW* 552, 9828.

48  Patricia de Montfort, "'The Fiction of My Own Biography': Whistler and *The Gentle Art of Making Enemies*" (PhD thesis, Univ. of St. Andrews, 1994), 201–02, 312–41; JW to D. C. Thomson [April 22, 1892], *GUW* 8348; *GAME*, 287–334.

17: A NEW LIFE, NEW MARKETS, NEW FRIENDS

1  Arthur Jerome Eddy, *Recollections and Impressions of James A. McNeill Whistler* (Philadelphia, 1903), 228–31; JW to Beatrice Whistler [January 27, 1892], *GUW* 6603.

2  "Afternoons in Studios – A Chat with Mr. Whistler," *Studio*, 4 (January 1895), 116; *LW*, II:138–39.

3  JW to Sidney Starr, September 26, 1892, *GUW* 11613.

4  JW to C. J. Hanson, August 30 [1891], [January/February 1892], June 9, 1892, Hanson to JW, November 25, 1892, *GUW* 7840, 1996, 8012, 1999; Helen Whistler to E. R. Pennell, December 15, 1906, Box 272, PWC; enrollment and fees for Charles James W. Hanson, October 8, 1891, Evening Class Winter Session 1891–92, 55/124, KCL. JW would later assist McEvoy's artist son, Arthur Ambrose McEvoy, seven years Charlie's junior.

5  *Calendar of King's College, London for 1892–93* (London, 1892), 508, 521; JW to C. J. Hanson, March 10, 1892, [August 10, 1992], September 27 [1892], C. J. Hanson to JW,

September 12, 1892, *GUW* 8804, 1993, 1997, 1995.

6  C. J. Hanson to JW, November 25, 1892, *GUW* 1999.

7  JW to William Whistler [October 20/30, 1893], *GUW* 7011.

8  Correspondence with dealers in *GUW* 1246, 1251–52, 1254, 2709–11, 2664, 2675, 3238, 5758, 5772, 5778, 7196, 9687, 10063.

9  Pamela Fletcher and Anne Helmreich, "The Periodical and the Art Market: Investigating the 'Dealer-Critic System,' in Victorian England," *VPR*, 41 (Winter 2008), 326–33; "Exhibitions and Notes," *AJ*, 55 (February 1893), 62, and (July 1893), 222–23; "Design and the Art of Mr. Whistler," *AJ*, 55 (May 1893), 134–35; JW to D. C. Thomson [December 16, 1892], *GUW* 8328; Patricia de Montfort, "Negotiating a Reputation: J. M. Whistler, D. G. Rossetti, and the Art Market 1860–1900," in Pamela Fletcher and Anne Helmreich, eds., *The Rise of the Modern Art Market in London, 1850–1939* (Manchester, 2011), 257–59, 263–68.

10  D. S. MacColl, "Mr. Whistler's Paintings in Oil," *AJ*, 55 (March 1893), 88–93; E. J. Sullivan to D. S. MacColl, December 25, 1921 (S264), WC; MacColl to Elizabeth MacColl, May 12, 1893 (M118), D. S. MacColl Papers, GUL.

11  *LW*, II:95–99; Joseph Pennell, *The Adventures of an Illustrator* (Boston, 1925), 237–42; Joseph M. Flora, *William Ernest Henley* (New York, 1970), 55–68, 130–31.

12  J. W. G. White to JW, February 8, 1893, JW to White [February 9/20, 1893], *GUW* 7033–34; *Gants de suede* and *The Long Gallery, Louvre*, in *Studio*, 3 (April 1894), facing pp. 20, 190; Will Rothenstein, "Paris Notes," *Studio*, 1 (May 1893), 80; A. Besnard, "The Exhibition of the Royal Academy and Other Galleries (Second Letter), *Studio*, 1 (June 1893), 114.

13  Peter Macnab to JW, January 27, 1893, D. C. Thomson to JW, March 21, 1893, E. G.

Kennedy to JW, April 12, 1893, November 20, 1893, *GUW* 3737, 5771, 7214, 7224; Grischka Petri, *Arrangement in Business: The Art Markets and Career of James McNeill Whistler* (Hildesheim, 2011), 525.

14  JW to Helen Whistler [January 28–29, 1893], *GUW* 11653; YMSM 63; M. B. Huish, "Whence Comes This Great Multitude of Painters?" *NC*, 32 (November 1892), 720–32.

15  Mrs. H. Waldo Warner (Rose Pettigrew), "Memories of Philip Wilson Steer," p. 7 (P64), MacColl Papers; Edmund H. Wuerpel, "Whistler – The Man [Pt.2]," *AMA*, 27 (June 1934), 316–17. Warner's memoir is also in Bruce Laughton, *Philip Wilson Steer, 1860–1942* (Oxford, 1971), 113–21.

16  Leon Edel, ed., *Henry James Letters*, 4 vols. (Cambridge, Mass., 1974–84), II:167–68, III:435–36, IV:199; Leon Edel and Lyall H. Powers, eds., *The Complete Notebooks of Henry James* (New York, 1987), 140–42, 541–43; Robert L. Gale, *A Henry James Encyclopedia* (Westport, Conn., 1989), 261, 721.

17  Warner, "Memories of Steer," p. 7; Wuerpel, "Whistler – The Man," 316, 319.

18  Jane F. Fulcher, ed., *Debussy and His World* (Princeton, N.J., 2001), 144–45, 151–59, 255–61. See generally, Nelson Blaine Kauffman, "The Aesthetic of the Veil: Conceptual Correspondences in the Nocturnes of Whistler and Debussy" (PhD diss., Ohio Univ., 1975), and Peter Dayan, *Art as Music, Music as Poetry, Poetry as Art, from Whistler to Stravinsky and Beyond* (Farnham, 2011).

19  Carl Paul Barbier, ed., *Correspondance Mallarmé–Whistler: Histoire de la Grande Amitié de Leurs Dernières Années* (Paris, 1964), 152–200; Rosemary Lloyd, *Mallarmé: The Poet and His Circle* (Ithaca, N.Y., 1999), 112–14, 139–43, 150–51; JW to William Heinemann [February 16–17/23–24, 1892], [February 21, 1892], [June 23, 1892], *GUW* 10785, 8466, 8025.

20  C. W. McIlvaine to JW, October 5, 1892, October 31, 1892, *GUW* 4348–49; Barbier, *Mallarmé–Whistler*, 201–11.

21  Rosemary Lloyd, "Mallarmé and the Visual Arts," in Lloyd Austin, ed., *Poetic Principles and Practice: Occasional Papers on Baudelaire, Mallarmé and Valéry* (Cambridge, Eng., 1987), 130–32; *LJW*, I:204–09.

22  Petri, *Arrangement in Business*, 574–77; Nicholas Smale, "Whistler and Transfer Lithography," *Tamarind Papers*, 7 (Fall 1984), 72.

23  *LJW*, I:229–34; G.430, 437–38, 443–44, 473–74, 477, 480; JW to August Delâtre [September 1892], Frank Short to JW, September 18, 1892, *GUW* 11191, 5418.

24  D. C. Thomson to Beatrice Whistler, December 7, 1893, JW to E. G. Kennedy [December 10, 1893], *GUW* 5794, 9712.

25  T. R. Way to JW, November 14, 1893, December 5, 1893, JW to André Marty, December 6, 1893, *GUW* 6102, 6107, 4243; *LJW*, I:236–39, II:68–76.

26  YMSM 434–35; Warner, "Memories of Steer," p. 8; *LJW*, I:185–96; M.1273–74, 1280–90, 1297–1305; Laughton, *Philip Wilson Steer*, 6–7, 17, 21, 29–30, 32, 40–45, 117–21; Alison Smith *Exposed: The Victorian Nude* (New York, 2002), 170–71, 252–53, 262; Matthew Sturgis, *Walter Sickert: A Life* (London, 2005), 133–34; Anna Gruetzner Robins, *A Fragile Modernism: Whistler and His Impressionist Followers* (New Haven and London, 2007), 136–39.

27  *LJW*, I:107–10, 158–61, 172–93, 196–99, 234–52, 350–53, 437–39; M.1204–25, 1231–35, 1273–1313, 1346; Sarah Elizabeth Kelly, "Camera's Lens and Mind's Eye: Whistler and the Science of Art" (PhD diss., Columbia Univ., 2010), 179–80, 184–212.

28  Petri, *Arrangement in Business*, 478–84; Smith, *Exposed*, 262; *LJW*, I:143–45; Martha Tedeschi, "Whistler and the English Print Market," *PQ*, 14 (March 1997), 40–41.

29  *LJW*, II:8–10, 46, 52–59, 66–67, 78, 81;

Thomas R. Way, "Mr. Whistler as a Lithographer," *Studio*, 30 (November 1903), 10–11, 16.

30   *LJW*, II:60–68, 72–74, 84.

31   Ibid., II:74, 81; W. Rothenstein and Thomas R. Way, "Some Remarks on Artistic Lithography," *Studio*, 3 (April 1894), 16–20.

32   YMSM 402; John James Cowan, *From 1846 to 1932* (Edinburgh, 1933), 156, 168–73.

33   D. C. Thomson to JW, November 21, 1893, William Eden to JW, January 5, 1894, JW to Eden [January 6, 1894], *GUW* 5792, 1033, 13318; YMSM 408.

34   O. D. Grover to JW, September 18, 1892, JW to H. C. Ives, October 20, 1892, Beatrice Whistler to E. G. Kennedy [October 22/November 1892], Howard Mansfield to JW, January 10, 1893, D. C. Thomson to Beatrice, January 11, 1893, C. M. Kurtz to Kennedy, October 4, 1893, *GUW* 603, 9694, 9703, 4000, 5765, 605.

35   David Sweetman, *Toulouse-Lautrec and the Fin de Siècle* (London, 1999), 102–10, 129–50, 278–79; Robert L. Herbert, *From Millet to Leger: Essays in Social Art History* (New Haven and London, 2002), 99–104.

36   Richard Sonn, "Marginality and Transgression: Anarchy's Subversive Allure," in Gabriel P. Weisberg, ed., *Montmartre and the Making of Mass Culture* (New Brunswick, N.J., 2001), 120–41; Jerrold Seigel, *Bohemian Paris: Culture, Politics, and the Boundaries of Bourgeois Life, 1830–1930* (New York, 1986), 215–24, 231–41, 337–38.

37   JW to D. C. Thomson, [Septmber 1/8, 1893], *GUW* 8250; YMSM 410–15; M.1350, 1363–69; *LJW*, I:210–19; Thomas R. Way, *Memories of James McNeill Whistler, The Artist* (London, 1912), 90–91; An Indiscriminate Admirer, "A Gossip at Goupil's: Mr. Whistler on His Work," *ILN*, March 26, 1893, p. 384. See also Kelly Roark, "Color and Artistic identity: Whistler, van Gogh and Yellow" (MA diss., Institute of Chicago, 2006).

38   Robyn Asleson, *Albert Moore* (London, 2000), 122–23, 146–50, 162, 183–84, 195–96, 204–05; Walford Graham Robertson, *Life Was Worth Living: The Reminiscences of W. Graham Robertson* (New York, 1931), 58–62, 275.

39   Harrison S. Morris, *Confessions in Art* (New York, 1930), 17–18, 45–46; YMSM 52, 115, 242; JW to A. H. Studd, January 21, 1894, Studd to JW, January 27, 1894, *GUW* 2671, 5610.

40   YMSM 33–34; JW to J. G. Potter [January/February 1894], [February 21, 1894], D. C. Thomson to JW, March 17, 1894, JW to Julia de Kay Revillon, February 23/24, 1894 (quoted), *GUW* 13346, 5010, 5804, 2679.

18: LITIGATION AND THE LAMP

1   Beatrice Whistler to Helen Whistler [February 22, 1894], *GUW* 6725; Spielmann's article appeared in the *National Observer*, April 28, 1894 and a series of six letters between the critic and the artist appeared in the issues of May 5 (p. 637), May 12 (p. 664), May 19 (p. 19), May 26 (p. 46), June 2 (p. 72), June 9 (p. 97).

2   Leonée Ormond, *George du Maurier* (London, 1969), 431–59; Alison Winter, *Mesmerized: Powers of Mind in Victorian Britain* (Chicago, 1998), 322–28, 338–41; J. B. Gilder and J. L. Gilder, eds., *Trilbyana: The Rise and Progress of a Popular Novel* (New York, 1895).

3   George du Maurier, "Trilby," *Harper's Monthly*, 88 (March 1894), 575, 577–79; Ormond, *Du Maurier*, 463–66. Nicholas Daly, "The Woman in White: Whistler, Hiffernan, Courbet, Du Maurier," *Modernism/Modernity*, 12 (January 2005), 12–19, suggests that du Maurier also modeled the character of Svengali on JW, with Trilby modeled on Jo Hiffernan.

4   Beatrice Whistler to E. H. Wuerpel [April 1894], JW to George du Maurier [April 4, 1894], *GUW* 12841, 971; "Mr. Whistler on Friendship," *PMG*, May 13, 1894, p. 2; "Mr. Whistler and Mr.

Du Maurier: The 'Punch' Artist's Attitude," *PMG*, May 19, 1894, pp. 1–2.

5  E. J. Poynter to JW, May 23, 1894, May 27, 1894, William Webb to JW, June 22, 1894, *GUW* 5014–15, 6190; Daphne du Maurier, ed., *The Young George du Maurier: A Selection of His Letters, 1860–67* (Garden City, N.Y., 1952), 66–67, 216, 227, 244.

6  "Mr. Whistler on Friendship," 2; JW to George du Maurier [April 4, 1894], Beatrice Whistler to Helen Whistler [April 15/22, 1894], *GUW* 6625.

7  "Mr. Du Maurier and Mr. Whistler," *PMG*, May 25, 1894, p. 3; Archibald Stuart-Wortley to JW, June 11, 1894, JW to G. H. Lewis [May 18, 1894], Lewis to JW, May 21, 1894, William Webb to JW, May 29, 1894, *GUW* 7134, 2561–62, 6179.

8  JW to William Webb [May 20, 1894], [May 24, 1894], Webb to JW, May 29, 1894, Webb to Harper and Brothers, May 29 [1894], JW to William Heinemann [May 30, 1894], Forster, Frere and Company to George and William Webb, June 6, 1894, July 18, 1894, *GUW* 6181, 6178, 6179–80, 8473, 11212–13.

9  JW to William Webb [August 22/25, 1894], [August 27, 1894], October 4 [1894], JW to William Heinemann [November 9, 1894], JW to Joseph Pennell [October 24, 1894], [November 8, 1894], JW to E. R. Pennell [November 5, 1894], *GUW* 6199–6200, 6208, 9861, 7791, 77998, 7797.

10  *LJW*, II:96–97; JW to E. G. Kennedy [July 22, 1894], JW Accounts, July 29–October 11, 1894, *GUW* 9718, 13061; Edgar Munhall, *Whistler and Montesquiou: The Butterfly and the Bat* (New York, 1995), 86–94; YMSM 411, 412, 420, 425–26.

11  A. J. Eddy to JW, September 15 [1894], November 20, 1894, A. A. Pope to JW, September 21, 1894, November 27, 1894, *GUW* 1015, 1018, 4988, 5000.

12  JW to H. B. Huish [August 14, 1894], JW to D. C. Thomson, August 30, 1894, JW to E. G. Kennedy, September 22, 1894, JW to T. R. Way, September 25, 1894, *GUW* 1277, 8311, 9720, 3387; Martha Tedeschi, "Whistler and the English Print Market," *PQ*, 14 (March 1997), 37–41.

13  *Speaker*, October 27, 1894; J. C. Bancroft to George du Maurier, August 29, 1894, January 22, 1895, *GUW* 11555, 11557.

14  JW to William Whistler [November 15, 1894], [November 20, 1894], JW to J. J. Cowan [February 1895], *GUW* 7015, 13499, 708; Linda Merrill, *With Kindest Regards: The Correspondence of Charles Lang Freer and James McNeill Whistler, 1890–1903* (Washington, D.C., 1995), 92–103.

15  Alexander Varias, *Paris and the Anarchists: Aesthetes and Subversives During the Fin de Siècle* (New York, 1996), 123–62; Richard Thomson, *The Troubled Republic: Visual Culture and Social Debate in France, 1889–1900* (New Haven and London, 2004), 106–15; Beatrice Whistler to E. G. Kennedy [March 1894], JW to Otto Goldschmidt [February 20, 1894], *GUW* 9697, 7968; *LJW*, I:259–63.

16  John Stokes, *In the Nineties* (Chicago, 1989).

17  Alan Robinson, *Symbol to Vortex: Poetry, Painting, and Ideas, 1885–1914* (New York, 1985), 40–43; Karl Beckson and John M. Munro, eds., *Arthur Symons: Selected Letters, 1880–1935* (Iowa City, 1989), 67, 79, 103, 184; Karl Beckson, ed., *The Memoirs of Arthur Symons: Life and Art in the 1890s* (University Park, Penn., 1977), 49–54, 121–48, 174–75.

18  Jonathan Ribner, "The Poetics of Pollution," in Katharine Lochnan, ed., *Turner, Whistler, Monet: Impressionist Visions* (London, 2004), 51–63; Robert L. Peters, "Whistler and the English Poets of the 1890's," *Modern Language Quarterly*, 18 (March 1957), 251–61; Nicholas Freeman, *Conceiving the City: London, Literature, and Art 1870–1914* (Oxford, 2007), 91–95, 103–13, 118–27.

19   JW to William Heinemann [March 1/7, 1894], *GUW* 9853; JW to Charles Ricketts, February 28, 1894, Ricketts and Shannon Papers, BL.

20   Stephen Calloway, *Aubrey Beardsley* (New York, 1998), 54, 58–60, 65–70; Chris Snodgrass, *Aubrey Beardsley: Dandy of the Grotesque* (New York, 1995), 65–67, 81, 93–94, 97–98, 114–15, 217–18.

21   Karl Benson, *London in the 1890s: A Cultural History* (New York, 1992), 242–55; Linda Dowling, "Letterpress and Picture in the Literary Periodicals of the 1890s," *Yearbook of English Studies*, 16 (1986), 117–31; Patricia de Montfort, "'The Fiction of My Own Biography': Whistler and *The Gentle Art of Making Enemies*" (PhD thesis, Univ. of St. Andrews, 1994), 210–26; *Punch*, 108 (February 2, 1895), 58, (March 9, 1895), 118.

22   Snodgrass, *Aubrey Beardsley*, 54–65, 115, 119–24; Desmond Flower and Henry Maas, eds., *The Letters of Ernest Dowson* (Rutherford, N.J., 1967), 345.

23   Calloway, *Aubrey Beardsley*, 70–83; Snodgrass, *Aubrey Beardsley*, 54–65, 115, 119–28.

24   YMSM 428–39; Matthew Sturgis, *Walter Sickert: A Life* (London, 2005), 221–22, 224–25.

25   William Heinemann to JW, January 31, 1895, JW to J. J. Cowan [February 1895], JW to Heinemann [February/March 1895], E. G. Kennedy to JW, March 8, 1895, *GUW* 2087, 708, 8478, 7248.

26   Timothy Eden, *The Tribulations of a Baronet* (London, 1933), 44–78.

27   JW to Beatrice Whistler [March 3, 1895], JW to H. J. C. Cust, February 28 [1895], *GUW* 6626, 4396.

28   Adrian Frazier, *George Moore, 1852–1933* (New Haven and London, 2000), 253–55; JW to P. M. Gay [March 5, 1895], George Moore to JW, March 11, 1895, *GUW* 8095, 4179, the latter also printed in *PMG*, March 12, 1895.

29   *PMG*, March 26, 1895, March 29, 1895; *Westminster Gazette*, March 29, 1895; JW to William Webb [March 24/31, 1895], JW to Jonathan Sturges [March 14, 1895], *GUW* 6243, 9901.

30   JW to J. J. Cowan [March 28, 1895], *GUW* 710.

31   Walter G. Forsyth and Joseph L. Harrison, *Guide to the Study of James Abbott McNeill Whistler*, State Library Bulletin, Bibliography No.1 (Albany, N.Y., 1895); "Mr. Alma Tadema on Art Training," *The Times*, July 26, 1895, p. 8; "L'Influence du Jaune dans les Arts," *PMG*, August 9, 1895, p. 2; JW to Melville Dewey [May/June 1895], JW to Jospeh Pennell [August 8, 1895], *GUW* 838, 7849.

32   Arthur Warren, *London Days: A Book of Reminiscences* (Boston, 1920), 167–69; YMSM 396; JW to Beatrice Whistler [November 3, 1895], *GUW* 6632.

33   JW to William Webb [March 24/31, 1895], JW to Herbert Vivian [April 6, 1895], [April 9, 1895], JW to William Heinemann [April 17, 1895], JW to J. S. Campbell [August 8/15, 1895], *GUW* 6226, 9494–95, 10792, 519.

34   M.693; JW to D. C. Thomson [April 10/21, 1895], Thomson to JW, April 24, 1895, April 27, 1895, Beatrice Whistler to Thomson [April 25, 1895], *GUW* 11531, 5817, 5819, 8286.

35   JW to E. G. Kennedy [July 1/8, 1895], [July 12, 1895], Beatrice Whistler to A. H. Studd [July 2/5, 1895], *GUW* 7254, 9732, 3177.

36   Beatrice Whistler to A. H. Studd [July 15/30, 1895], [September 1/7, 1895], JW to William Whistler [August 29, 1895], JW to J. S. Campbell [September 19, 1895], JW to D. C. Thomson [September 17, 1895], *GUW* 3178–79, 7018, 520, 8370. See generally, Ted Ward, *Portrait in Grey: James McNeill Whistler in Lyme Regis* (Sherborne, 1976).

37   JW to Jonathan Sturges [October 8, 1895], [November 20, 1895], JW to Beatrice Whistler [November 8, 1895], [November 11, 1895], [November 21, 1895], *GUW* 9896–97, 6634, 6636, 6640; *LJW*, I:364–405; YMSM 442–50; M.1442–50.

38 JW to Helen Whistler [October 13, 1895], JW to C. J. Hanson, November 22, 1895, *GUW* 6734, 8013.

39 Tom Pocock, *Chelsea Reach: The Brutal Friendship of Whistler and Walter Greaves* (London, 1970), 124–30; JW to D. C. Thomson, October 24, 1895, Beatrice Whistler to JW [October 26, 1895], JW to Beatrice [October 27/30, 1895] *GUW* 8379, 6628–29.

40 YMSM 449, 450.

41 JW to Beatrice Whistler [November 7, 1895], [November 10, 1895], [November 18, 1895] (two letters), [November 19, 1895] (two letters), [November 28, 1895], *GUW* 6633, 6635, 6639, 6641–43, 6649.

42 JW to Beatrice Whistler [November 18, 1895], *GUW* 6639.

43 JW to Beatrice Whistler [November 19, 1895], *GUW* 6643.

44 William Whistler to C. J. Hanson, December 20 [1895], JW to William [December 23, 1895], *GUW* 7020–21.

45 JW to E. G. Brown [September 19, 1895], JW to T. R. Way [September 25, 1895], M. B. Huish to JW, October 10, 1895, October 26, 1895, *GUW* 3625, 3401, 1297, 1301.

46 *LJW*, II:147–48, 190–93; JW to M. B. Huish [November 20, 1895], *GUW* 1314.

47 E. G. Brown to JW, December 23, 1895, January 7 [1896], *GUW* 1333, 1289; *LJW*, II:150–51, 157–59, 167–77; R.A.M.S., "Whistler," *PMG*, December 11, 1895.

48 [David C. Thomson], "British Art at the Beginning of 1896," *AJ*, 58 (January 1896), 25–27, and "Mr. Whistler's Lithographs," *AJ*, 58 (January 1896), 27; Frederick Wedmore, "The Revival of Lithography," *AJ*, 58 (January 1896), 11–14, and "The Revival of Lithography–II," *AJ*, 58 (February 1896), 41–44; T. R. Way, "Mr. Whistler's Lithographs," *Studio*, 6 (January 1896), 219–27; D. C. Thomson to JW, November 2, 1895, *GUW* 5827.

19: I JOURNEY BY MYSELF

1 JW to E. G. Kennedy, February 2, 1896, *GUW* 9736.

2 Memorandum of Agreement of February 24, 1896, JW to E. G. Kennedy February 2, 1896, *GUW* 7422; Albert Ludovici, *An Artist's Life in London and Paris, 1870–1925* (London, 1926), 93–99.

3 *LJW*, I:439–59.

4 Ibid., I:409–75.

5 E. G. Kennedy to JW, January 23, 1894, February 20, 1894, May 20, 1894, December 14, 1894, March 27, 1896, April 3, 1896, *GUW* 7227, 7231, 7233, 7244, 7276–77.

6 E. G. Kennedy to JW, February 18, 1896, February 28, 1896, March 6, 1896, JW to Kennedy [February 22, 1896], [March 14, 1896], *GUW* 7263, 7267, 7269, 9737–38; YMSM 441.

7 JW to E. G. Kennedy, February 2, 1896, [February 22, 1896], [March 14, 1896], [March 28, 1896], [April 3, 1896], [April 8/25, 1896], Kennedy to JW, March 24, 1896, *GUW* 9736–9739, 9742, 9745, 7275.

8 JW to Deborah Haden [March/April 1896], JW to E. G. Kennedy [March 1, 1896], [March 25, 1896], *GUW* 1929, 9741, 9724; Kennedy comment written on letter of [March 25, 1896].

9 Ludovici, *An Artist's Life*, 99–100; JW to E. G. Kennedy [March 25, 1896], [April 8/25, 1896], *GUW* 9724, 9745.

10 G. P. Jacomb-Hood, *With Brush and Pencil* (London, 1925), 46–47; Beatrice Whistler to JW [November 20, 1895], *GUW* 6645.

11 JW to R. D. Carte [May 15/20, 1896], JW to Deborah Haden [June 7/14, 1896], [April 10/30, 1897], *GUW* 11178, 11235, 13493; Jacomb-Hood, *With Brush and Pencil*, 46–47.

12 Ludovici, *An Artist's Life*, 99–100; JW to R. B. Philip [December 15, 1896], JW to Deborah Haden [June 7/14, 1896], *GUW* 11235, 4690; JW Last Will and Testament, November

27, 1896, Box K, f.2, PWC. The garnets went finally to the Hunterian Museum and Art Gallery.

13 JW to Helen Whistler [August/September 1896], William Webb to R. B. Philip, May 14, 1896, Philip to JW, May 26, 1896, JW to Elisabeth Lewis [July 10/12, 1896], *GUW* 6735, 6230, 4665, 10981.

14 JW to Marion Peck, May 12 [1896], JW to E. G. Kennedy [July 24, 1896], *GUW* 9359, 9758; YMSM 420, 439.

15 YMSM 421; Linda Merrill, ed., *With Kindest Regards: The Correspondence of Charles Lang Freer and James McNeill Whistler, 1890–1903* (Washington, D.C., 1995), 113–18. Monica Kjellman-Chapin, "Anxious (Dis)Figuration: Ingres in Whistler's *Little Blue Girl*," *AH*, 27 (February 2004), 34–61, offers a complex explanation for JW's failure to complete Freer's nude, but it applies more to the artist's other nude studies of the 1890s.

16 JW to Ethel Whibley and R. B. Philip [July 14, 1896], E. G. Kennedy to JW, September 24, 1896, notes in JW sketchbook [July 14, 1896], *GUW* 6314, 7282, 13347.

17 M.1398; Merrill, *With Kindest Regards*, 105–07, 113–15.

18 YMSM 440, 462.

19 *LJW*, I:423–29, II:150; Joseph Pennell, "'Evelyne,'" *AJ*, 58 (March 1896), 89; YMSM 463–71, 475–77.

20 William Whistler to Deborah Haden, November 26, 1896, v.9, PWC.

21 Alfred Gilbert to JW, [May 1] 1896, January 21, 1898, *GUW* 1662–63; JW Last Will and Testament, PWC; Jason Edwards, *Alfred Gilbert's Asetheticism: Gilbert Amongst Whistler, Wilde, Leighton, Pater and Burne-Jones* (Aldershot, 2006), 24–25, 32–36.

22 *LW*, II:187–88; Thomas R. Way, *Memories of James McNeill Whistler, The Artist* (London, 1912), 143–44; JW to Joseph Pennell [March 7, 1897], *GUW* 7852; YMSM 472.

23 E. G. Kennedy memorandum, May 23, 1897; JW to Elisabeth Lewis [July 10/12, 1896] 9768, 10981.

24 Frederick Keppel, "One Day with Whistler," *Reader*, 3 (January 1904), 121, 150–51; JW to Frederick Keppel, June 7, 1896, JW to E. G. Kennedy [June 7/14, 1896] with Kennedy memorandum of September 1903 attached, *GUW* 9177, 9752. For Keppel's attempt to bring JW to task, see Keppel, *The Gentle Art of Resenting Injuries* (New York, 1904), 10–16.

25 Thomas R. Way, *Mr. Whistler's Lithographs: The Catalogue* (London, 1896); *LJW*, II:9, 23–27, 154, 164–67, 177–89; Way, *Memories of Whistler*, 131–41; William Rothenstein, *Men and Memories: A History of the Arts, 1872–1922*, 2 vols. in 1 (New York, 1932), I:131.

26 H. S. Coppee to JW, October 18, 1894, G. D. Ruggles to JW, April 26, 1895, J. W. W. Ravueil to JW, October 25, 1895, D. C. Thomson to JW [November 18, 1895], JW to Thomson [November 17, 1895], *GUW* 686, 5336, 5877, 5828, 8386.

27 Deborah Haden to E. R. Pennell, August 6, 1903, PWC; Frederick Wedmore, *Memories* (London, 1912), 187–88; Rothenstein, *Men and Memories*, I:306–307; YMSM 24, 36; JW to E. G. Kennedy [April 10, 1897], *GUW* 9762. JW reacted less placidly when he learned a few months later that a nephew had sold *The White Girl* for only $6,500, less than half of what the artist thought it worth. See JW to T. D. Whistler, October 1897, *GUW* 2678.

28 Rothenstein, *Men and Manners*, I:266–71; JW–Rothenstein correspondence in *GUW* 10954–59.

29 Matthew Sturgis, *Walter Sickert: A Life* (London, 2005), 237–42; Sickert to C. L. Freer, January 22, 1905, Box 21, Charles Lang Freer Papers, FGA; JW to R. B. Philip [October 12, 1896], [November 24, 1896], JW to Sickert [November 20/24, 1896], *GUW* 4681, 4683, 5445.

30   JW to A. H. Studd [January 3/10, 1897], JW to R. B. Philip [January 22, 1897], [February 10, 1897], *GUW* 3156, 4700, 4703.

31   JW to R. B. Philip [January 13, 1897], [January 14, 1897], [January 16, 1897], [January 28, 1897], *GUW* 4696–98, 4701; YMSM 475–77; M.1500–03.

32   JW to R. B. Philip [January 16, 1897], [January 28, 1897], [February 10, 1897], *GUW* 4698, 4701, 4703.

33   D. C. T., "New Pictures by Mr. Whistler," *AJ*, 59 (January 1897), 10–13; Elizabeth R. Pennell, "The Master of the Lithograph – J. McNeill Whistler," *Scribner's Magazine*, 21 n.s. (February 1897), 277–89; JW to Henry James [February 22, 1897], James to JW, February 25, 1897, *GUW* 2405, 2404.

34   Jonathan Schneer, *London 1900: The Imperial Metropolis* (New Haven and London, 1999), 3–14; JW to E. R. Pennell [April 16, 1900], *GUW* 7697.

35   Martin Hopkinson, "Whistler's 'Company of the Butterfly,'" *BM*, 136 (October 1994), 700–704.

36   Sturgis, *Walter Sickert*, 244–49; *LW*, II:186–92; "Mr. Whistler as a Witness," *Critic*, 30 (May 22, 1897), p. 2; "A Day With Mr. Whistler," *Daily Mail*, April 6, 1897; "Passing Events," *AJ*, 59 (June 1897), 191; JW to R. B. Philip, April 6, 1897, JW to Deborah Haden [April 10/30, 1897], *GUW* 4705, 13493.

37   JW to William Heinemann [April/May 1897], *GUW* 8579.

38   Eric Denker, *In Pursuit of the Butterfly: Portraits of James McNeill Whistler* (Washington, D.C., 1995), 138–42; Sarah Lees et al., *Giovanni Boldini in Impressionist Paris* (New Haven and London, 2009), 192–94, 198–99. JW was displeased when Boldini later reproduced his "scraps of a drypoint" for sale. See JW to William Heinemann [February 1/8, 1898], *GUW* 8490.

39   JW to R. B. Philip [June 6, 1897], E. G. Kennedy memoranda, June 7, 1897, [June 18, 1897], *GUW* 4706, 9769, 9848.

40   JW to R. B. Philip [June 14, 1897], *GUW* 4707; M.1506–07; *Daily Chronicle*, June 18, 1897.

41   JW to Ethel Whibley [July 8, 1897], JW to R. B. Philip [June 24, 1897], *GUW* 6316, 4711; *WJ*, 15; M.1508.

42   G. W. Vanderbilt to JW, May 18, 1897, December 31, 1897, *GUW* 5914, 5917; YMSM 481, 515.

43   Merrill, *With Kindest Regards*, 119–20; Thomas Lawton and Linda Merrill, *Freer: A Legacy of Art* (Washington, D.C., 1993), 46–48; JW to R. B. Philip [July 26, 1897], accounts May–August 1897, *GUW* 4712, 13034, 7288–89; YMSM 388; D. C. Thomson, "The American Tax on Art," *AJ*, 59 (October 1897), 318.

44   JW to William Heinemann [December 16/23, 1897], JW to Deborah Haden [January 5, 1898], *GUW* 8488, 3284; *Punch*, 113 (December 11, 1897), 267.

45   N. John Hall, *Max Beerbohm: A Kind of Life* (New Haven and London, 2002), 49–52, 60–65; Max Beerbohm, "Papillon Range," *SR*, 84 (November 20, 1897), 546–47.

46   J. McNeill Whistler, "An Acknowledgment," *SR*, 84 (November 27, 1897), 592; Rupert Hart-Davis, ed., *Max Beerbohm's Letters to Reggie Turner* (Philadelphia, 1965), 125.

20: PRESIDENT AND MASTER, REDUX

1   JW to William Heinemann [January 31, 1898], *GUW* 10803.

2   Philip Athill, "The International Society of Painters, Sculptors and Gravers," *BM*, 127 (January 1985), 23; Minutes of 1st and 4th–10th Council Meetings, December 23, 1897, February 16–April 9, 1898, Business Papers and Press Cuttings Relating to the International Society of Sculptors, Painters and Gravers, TGA;

Francis Howard to JW [February 22, 1898], JW to Howard, February 24, 1898, *GUW* 2287, 2283; J. G. Paul Delaney, *Charles Ricketts: A Biography* (Oxford, 1990), 40–41, 52–55; Charles H. Shannon Diaries, February 7, 24–25, and 27, 1898, Ricketts and Shannon Papers, BL.

3 John Lavery, *The Life of a Painter* (London, 1940), 108–10, 115–16; Minutes of 2nd, 4th, and 10th–12th Council Meetings, February 7 and 16 and April 9–25, 1898; Albert Ludovici, *An Artist's Life in London and Paris, 1870–1925* (London, 1926), 117–39.

4 Ludovici, *An Artist's Life*, 119; JW to Francis Howard [April 10, 1898], *GUW* 2294; Joy Newton and Margaret F. MacDonald, "Whistler, Rodin, and the 'International,'" *GBA*, 103 (March 1984), 120.

5 "The International Exhibition. Interview with Mr. Whistler," *PMG*, April 26, 1898.

6 Minutes of 13th Council Meeting, May 4, 1898.

7 JW to F. A. Maxse, May 29, 1898, *GUW* 2934; Athill, "The International Society," 25–26; G. Sauter, "The International Society of Painters, Sculptors and Gravers," *Studio*, 14 (July 1898), 109–20.

8 YMSM 500; JW to R. B. Philip [July 15 and 16, 1898], *GUW* 4735.

9 Edith Shaw, "Four Years with Whistler," *Apollo*, 87 (March 1968), 198–201; YMSM 504, 541.

10 M.1209, 1214, 1279, 1379, 1386, 1388, 1498, 1526–30, 1604, 1610, 1624, 1628; Shaw, "Fours Years with Whistler," 200.

11 Carl Paul Barbier, ed., *Correspondance Mallarmé–Whistler: Histoire de la Grande Amitié de Leurs Dernières Années* (Paris, 1964), 288–89; E. R. Pennell Diaries, September 25, 1898, Joseph and Elizabeth R. Pennell Papers, RHC; M.1546a.

12 JW to William Heinemann [November 4, 1898], JW to Elisabeth Lewis [November 4, 1898], *GUW* 9149, 10985; James McNeill Whistler, *Eden versus Whistler: The Baronet & the Butterfly. A Valentine with a Verdict* (Paris, 1899); "Reviews of Recent Publications," *IS*, 7 (July–October 1899), 208.

13 The most complete telling of this story is Robyn Asleson, "The Idol and His Apprentices: Whistler and the Académie Carmen of Paris," in Linda Merrill, et al., *After Whistler: The Artist and His Influence on American Painting* (New Haven and London, 2003), 74–85, but see also Nigel Thorp, "Whistler and his Students at the Académie Carmen," *Journal of the Scottish Society for Art*, 4 (1999), 42–47.

14 Isa Urguhart Glenn, "'Cousin Butterfly': Whistler and a Child," *Century*, 106 (June 1923), 193; R. B. Farley to Celia Beaux, November 1, 1898, Celia Beaux Papers, AAA; *LW*, II:230. Other accounts of the memorable first day are in Mary Augusta Mullikin, "Reminiscences of the Whistler Academy," *Studio*, 34 (April 1905), 237, and Earl S. Crawford, "The Gentler Side of Mr. Whistler," *Reader*, 2 (September 1903), 387–88.

15 Crawford, "Gentler Side," 387; *LW*, II:229–35, 240–44.

16 Louise W. Jackson, "Mr. Whistler as a Teacher," *Brush and Pencil*, 6 (June 1900), 141–43; Mullikin, "Reminiscences," 237.

17 *WJ*, 35.

18 Michael Holroyd, *Augustus John* (New York, 1996), 70–74; Cecily Langdale and David Fraser Jenkins, *Gwen John: An Interior Life* (New York, 1985), 20–24; Mary Taubman, *Gwen John: The Artist and Her Work* (Ithaca, N.Y., 1985), 15–16, 23–24; Augustus John, *Chiaroscuro: Fragments of Autobiography* (New York, 1952), 48–49, 66–67.

19 Suzanne Rodriguez, *Wild at Heart: A Life [of Natalie Clifford Barney]* (New York, 2002), 42–44, 78–79, 292–93; Diana Souhami, *Wild Girls: Paris, Sappho and Art: The Lives and Loves of Natalie Barney and Romaine Brooks* (New York, 2004), 28–34.

20  Rodriguez, *Wild at Heart*, 74–76, 79–80, 83–87; Jean Chalon, *Portrait of a Seductress: The World of Natalie Barney*, trans. Carol Banks (New York, 1979), 18–21, 23–25, 39.

21  Maria Torrilhon Buel, "A Visit to Whistler," *Century*, 86 (September 1913), 694–96; Henry Russell Wray, "An Afternoon with James McNeill Whistler," *IS*, 56 (August 1915), xl–xlii; Minutes of 15th–26th Council Meetings, December 16, 1898–April 25, 1899; F. A. Maxse to Lavery, March 20 [1899], John Lavery Papers, TGA.

22  Minutes of 14th and 24th–28th Council Meetings, July 15, 1898 and April 11–May 3, 1899; Lavery, *Life of a Painter*, 112–14.

23  International Society of Sculptors, Painters and Gravers, *Catalogue of the Exhibition 1899* (London, 1899), 4, 5–28; Ludovici, *An Artist's Life*, 134–36; Karl Beckson, ed., *The Memoirs of Arthur Symons: Life and Art in the 1890s* (University Park, Penn., 1977), 174–75; J. Stanley Little, "The International Exhibition at Knightsbridge," *IS*, 8 (August 1899), 109–22.

24  Lavery, *Life of a Painter*, 115; JW to John Lavery, [June 26, 1899], *GUW* 9967; Minutes of 29th–39th Council Meetings, May 25–August 8, 1899; International Society of Sculptors, Painters and Gravers, *Rules* (London, 1899), copy in Box 201, PWC. For material related to the St. Paul's crusade, see Slade School of Fine Art Collection, TGA.

25  JW to E. G. Kennedy [July 30, 1899], JW to Albert Ludovici [September/October 1899], *GUW* 9793, 8083; YMSM 516–24; M.1514–17.

26  JW to R. B. Philip, [October 24, 1899], [October 30, 1899], [November 14, 1899], [November 17–18, 1899], *GUW* 4753, 4755, 4759–60.

27  Frederic V. Grunfeld, *Rodin: A Biography* (New York, 1987), 395. On Whistler's financial investments, see an exchange of letters with his London bank, Drummond and Company,

from earlier in the year, an example being *GUW* 11075, and JW to William Heinemann [April/May 1899], [August 10/12, 1899], *GUW* 8580, 11282.

28  JW to R. B. Philip [December 5, 1899], JW to Théodore Duret, December 7 [1899], *GUW* 4762, 9660; M.1600.

29  William Webb to JW, July 20, 1899, JW to Inez Bate [September 9, 1899], [September 25, 1899], [October 9, 1899], *GUW* 19, 26, 29, 37.

30  Asleson, "The Idol and His Apprentices," 79–81; E. R. Pennell Journal, June 5, 1920, Box 351, PWC; *WJ*, 71. For the opportunities afforded women artists at this time, see Gabriel P. Weisberg and Jane R. Becker, eds., *Overcoming All Obstacles: The Women of the Académie Julian* (New Brunswick, N.J., 1999); Tamar Garb, *Sisters of the Brush: Women's Artistic Culture in Late Nineteenth-Century Paris* (New Haven and London, 1994); Charlotte Yeldham, *Women Artists in Nineteenth-Century France and England*, 2 vols. (New York, 1984); Jude Burkhauser, ed., *"Glasgow Girls": Women in Art and Design, 1880–1920* (Edinburgh, 1990); Clarissa Campbell Orr, ed., *Women in the Victorian Art World* (Manchester, 1995).

31  JW to Carmen Rossi [July 9, 1900], JW to Inez Bate [February 3, 1900], JW to William Webb [April/June 1900], *GUW* 10742, 48, 6259.

32  JW to Théodore Duret [February 27, 1900], JW to Helen Whistler [February 28/March 2, 1900], [March 6, 1900], [March 7/9, 1900], R. R. Hemphill to JW, May 10, 1900, *GUW* 9662, 6737–38, 6740, 2120; "Obituary: William MacNeill Whistler, M.D.," *British Medical Journal*, No.2046 (March 10, 1900), 613–14; "William M'Neill Whistler, M.D.," *Confederate Veteran*, 8 (June 1900), 282–83.

33  Minutes of 40th Council Meeting, November 21, 1899; *WJ*, 196.

34  "A Day with Whistler," *Detroit Free Press*, March 30, 1899; Wray, "Afternoon with

Whistler," xlii; Nicolai Cikovosky, "Whistler and America," in Richard Dorment and Margaret F. MacDonald, eds., *James McNeill Whistler* (New York, 1994), 29–38.

35    "A Day with Whistler"; John W. Leonard, ed., *Who's Who in America* (Chicago, 1899), 784; Pennell Diaries, October 11, 1898, July 11, 1900; JW to R. B. Philip [July 5, 1898], *GUW* 4731.

36    *WJ*, 76–77, 193–94; JW to R. B. Philip, [November 5, 1899], E. G. Kennedy to JW, February 27, 1900, JW to William Webb October 1/9, 1898, *GUW* 4757, 7321, 6257.

37    Diane P. Fischer, ed., *Paris 1900: The "American School" at the Universal Exposition* (New Brunswick, N.J., 1999), 1–2, 5–11, 21–25, 119–38, 205; JW to E. G. Kennedy [May 12, 1900], *GUW* 9800; YMSM 378; Andrew Wilton, *The Swagger Portrait: Grand Manner Portraiture in Britain from Van Dyck to Augustus John, 1630–1930* (London, 1992), 17.

38    Robert Rosenblum et al., *1900: Art at the Crossroads* New York, 2000), 28–31, 55–60; E. G. Kennedy to JW, May 23, 1900, *GUW* 7325.

39    Fischer, *Paris 1900*, 8–9, 16–21, 91–94, 153–57, 210 n.133; Rosenblum, *1900*, 29–53, 57, 61, 74; John Rewald, ed., *Camille Pissarro Letters to His Son Lucien*, trans. Lionel Abel (New York, 1943), 339–42.

40    Daniel E. Sutherland, "The Viscous Thought: Henry Adams and the American Character," *Biography*, 12 (Summer 1989), 227–50; Ernest Scheyer, *The Circle of Henry Adams: Art and Artists* (Detroit, 1970), 128, 137–43; J. C. Levenson et al., eds., *The Letters of Henry Adams*, 6 vols. (Cambridge, Mass., 1988), V:126–27, 131–32.

41    Henry Adams, *The Education of Henry Adams* (1918; New York, 1931), 370–71, 385–86.

42    YMSM 537–39; M.1612–20; J. F. Heijbrock and Margaret F. MacDonald, *Whistler and Holland* (Amsterdam, 2000), 127–29.

43    JW to Helen Whistler [November 30, 1900], *GUW* 3305; *WJ*, 198–205.

44    JW to Jonathan Sturges [December 14, 1900], *GUW* 9932; Merlin Holland and Rupert Hart-Davis, eds., *The Complete Letters of Oscar Wilde* (New York, 2000), 1056–57.

21: OFF THE TREADMILL

1    JW to R. B. Philip [January 11, 1901], JW to J. J. Cowan, February 18, 1901, *GUW* 4784, 741. Margaret F. MacInnes, "Whistler's Last Years: Spring 1901 – Algiers and Corsica," *GBA*, 73 (May–June 1969), 323–42, describes the journey and Whistler's work on the trip.

2    M.1635–52; YMSM 543; JW to R. B. Philip [January 11, 1901], *GUW* 4784.

3    JW to William Heinemann, January 27 [1901], JW to R. B. Philip January 27–29 [1901], *GUW* 8537, 4787.

4    JW to John Lavery, February 12 [1901], JW to R. B. Philip [January 30, 1901], *GUW* 9975, 4788.

5    M.1653–97; G.485–90; YMSM 544–46; JW to R. B. Philip, February 25–27 [1901], *GUW* 4793.

6    JW to R. B. Philip [January 30, 1901], [March 20, 1901], *GUW* 4788, 4799; *WJ*, 210.

7    JW to R. B. Philip January 27–29 [1901], February [9], 1901, [February 18, 1901], [March 20, 1901], *GUW*, 4787, 4789–90, 4799.

8    JW to William Heinemann, January 27 [1901], JW to William Webb [February/April 1901], JW to R. B. Philip, February [9] 1901, March 1 [1901], *GUW* 8537, 6264, 4789, 4795.

9    R. B. Philip to JW, January 27, 1901, JW to Inez Addams [March 28, 1901], JW final address to students, March 1901, *GUW* 4786, 70, 5.

10    Inez Addams to JW, April 3, 1901, [April 20/25, 1901], JW to Carmen Rossi [March 28, 1901], *GUW* 223, 11156, 5352; E. R. Pennell Journals, July 25, 1920, Box 351, PWC. Clifford Addams let his lofty status as JW's apprentice

go to his head. See E. R. Pennell Diaries, December 3, 1901, Joseph and Elizabeth R. Pennell Papers, RHC; Bruce St. John, ed., *John Sloan's New York Scene, From the Diaries, Notes and Correspondence, 1906–1913* (New York, 1965), 91, 630.

11  John Leonard, ed., *Who's Who in America, 1901–1902* (New York, 1901), 1220–21; JW to [Editor, *Who's Who in America*], February 1901, JW to Deborah Haden [May 18/23, 1896], *GUW* 3576, 13490; *WJ*, 277–78.

12  *WJ*, 206; JW to R. B. Philip [March 8, 1901], *GUW* 4797.

13  JW to R. B. Philip [March 8, 1901], [March 20, 1901], *GUW* 4797, 4799; *LW*, II:265 and facing page for photograph.

14  *WJ*, 208–09; JW to R. B. Philip [April 6, 1901], JW to C. L. Freer [April 1901], *GUW* 4803, 1521.

15  JW to R. B. Philip April 28 [1901], *GUW* 4805.

16  *WJ*, 208; JW to R. B. Philip [May 2, 1901], May 3 [1901], [May 7–10, 1901], *GUW* 4807–09.

17  *WJ*, 219–20; JW to E. R. Pennell [November 15/30, 1901], *GUW* 7742; JW to Edmund Davis [October 1901], Autograph Collection, Millar Bequest, No.54316, XC, BL.

18  Karl Beckson and John M. Munro, eds., *Arthur Symons: Selected Letters, 1880–1935* (Iowa City, 1989), 207–08.

19  Minutes of 43rd–63rd Executive Council Meetings, January 30–December 5, 1901, Business Papers and Press Cuttings Relating to the International Society of Sculptors, Painters and Gravers, TGA; John Lavery, *The Life of a Painter* (London, 1940), 118–19; International Society of Sculptors, Painters and Gravers, *Catalogue of the Third Exhibition – 1901* (London, 1901), 10.

20  Minutes of 62nd–64th Executive Council Meetings, November 26–December 12, 1901; Oswald Sickert, "The International Society," *IS*, 15 (December 1901), 117–24.

21  J. J. Cowan to JW, June 30, 1901, July 5, 1901, JW to Cowan, July 2–4 [1901], JW to E. G. Kennedy [July/August 1901], *GUW* 745, 748, 746, 9827.

22  JW to Clifford and Inez Addams [August] 27 [1901], JW to Inez Addams, [October 21, 1901], R. B. Philip to JW, November 3, 1901, *GUW* 124, 91, 4822.

23  Pennell Diaries, March 2, 1904; Pennell Journal, April 22, 1922; JW to J. J. Cowan, November 10, 1901, *GUW* 754.

24  *WJ*, 221–28; M.1704–05.

25  Alan Crawford, *C. R. Ashbee: Architect, Designer & Romantic Socialist* (2nd edn.; New Haven and London, 2005), 84, 237–59, 467–70; Fiona McCarthy, *The Simple Life: C. R. Ashbee in the Cotswolds* (Berkeley, Calif., 1981), 41, 105; Charlotte Gere, *Artistic Circles: Design and Decoration in the Aesthetic Movement* (London, 2010), 110–11; JW to William Webb [February/March 1902], *GUW* 6267.

26  C. R. Ashbee Memoir, I:94, II:25–26, Charles Robert Ashbee Collection, NAL.

27  G. W. Vanderbilt to JW, April 10, 1902, R. B. Philip to Inez Addams, April 25, 1902, *GUW* 5927, 4835; YMSM 477; *WJ*, 235; Gabriel Mourney, "Some Paintings and Sculpture at the Paris Salon," *IS*, 17 (September 1902), 194, 196.

28  YMSM 505; Pennell Journal, April 22, 1922; *WJ*, 242–45.

29  JW to William Webb [April 1902], *GUW* 6268.

30  C. L. Freer Diaries, May 5 and June 21–July 31, 1902, draft of JW Last Will and Testament, July 1902 (72b), Charles Lang Freer Papers, FGA; C. L. Freer to William Webb, July 1, 1902, Webb to JW, July 2, 1902, *GUW* 1529, 6269.

31  Ethel Whibley to Frances Philip [July 26/28, 1902], *GUW* 6328; Frances Weitzenhoffer, *The Havemeyers: Impressionism Comes to America* (New York, 1986), 169; Thomas Lawton and Linda Merrill, *Freer: A Legacy of Art* (Washington, D.C., 1993), 46–53.

32   R. B. Philip to Frances Philip, July 8, 1902, Ethel Whibley to Frances [July 26/28, 1902], *GUW* 4838, 6328.

33   *Morning Post*, August 6, 1902. The original article and Whistler's reply are also in Arthur J. Eddy, *Recollections and Impressions of James A. McNeill Whistler* (Philadelphia, 1903), 281–84.

34   Harper Pennington to JW, September 2, 1902, *GUW* 4619.

35   JW to [Dr. J. Coert] [August 1902], *GUW* 7475; *WJ*, 245–47.

36   R. B. Philip to C. L. Freer, September 26, 1902, JW to [Ashbee's foreman], October 6, 1902, *GUW* 13833, 209; *WJ*, 250–51, 257.

37   S. E. Garlant to E. G. Kennedy, September 9, 1902, Harper Pennington to JW, October 1, 1902, *GUW* 9868, 4620; *WJ*, 250–51, 255–56; Harper Pennington, "Artist Life in Venice," *Century*, 64 (October 1902), 835–42.

38   *WJ*, 257–61, 270–71; YMSM 551–53; I. B. Davenport Note [January 1906] Box S, PWC.

39   M. B. Huish to R. B. Philip, November 27, 1902, R. B. Philip to C. L. Freer, December 5, 1902, E. B. Brown to JW, December 24, 1902, *GUW* 1381, 13829, 1387; *WJ*, 268–69.

40   Edgar Munhall, *Whistler and Montesquiou: The Butterfly and the Bat* (New York, 1995), 96–100; Joy Newton, ed., *La Chauve-Souris et la Papillon: Correspondance Montesquiou–Whistler* (Glasgow, 1990), 227–30.

41   *WJ*, 258; *GAME*, 292; JW note for "Memoirs" [1893/94], JW note of [September 3/10, 1896], *GUW* 6829, 13373; Charles Whibley, "The Limits of Biography," *NC*, 41 (March 1897), 428–36.

42   William Heinemann to Joseph Pennell, May 28, 1900, published in *WJ*, 1; Robert Underwood Johnson, *Remembered Yesterdays* (Boston, 1923), 507–08; Pennell to Johnson [December 1, 1897], E. R. Pennell to Johnson, December 21, 1897, *GUW* 8193–94; Pennell Diaries, June 24 and October 20, 1900.

43   W. G. Bowdoin, *James McNeill Whistler:*

*The Man and His Work* (London, 1901); JW to F. H. Allen [February 1893], E. G. Kennedy to JW, November 15, 1901, *GUW* 142, 7335; C. L. Freer to Sheridan Ford, July 13, 1900, July 21, 1900, August 15, 1900, Letterpress Book VI:316–18, 339–40, 413–15, Freer Papers. Ford went on to have a successful journalistic and political career in New York and Michigan before dying in 1922.

44   *WJ*, 257–62; Bernhard Sickert to JW, June 18, 1902, *GUW* 5419. Mrs. Arthur Bell, *James McNeill Whistler* (London, 1904), turned out to be one of the best early works about JW. Bernhard Sickert eventually published an analysis of JW's work in *Whistler* (London, 1903).

45   YMSM 469; *WJ*, 264–67; "Une Derniere Incarnation," *Daily Standard*, November 21, 1902; "Ce Perfide Podsnap," *Daily Standard*, November 22, 1902; James McNeill Whistler, *An Interrupted Correspondence*, proof copies in Box 199, PWC, and W263, WC

46   *WJ*, 261–62.

47   Ibid., 272; Pennell Diaries, December 24, 1902, JW to Robert Dunthorne, December 24, 1902, *GUW* 13040.

22: THE EVENING MIST

1   R. B. Philip to C. L. Freer, January 11, 1903, JW to John Lavery [April 14, 1903], *GUW* 13841, 9986; *WJ*, 272–88; Elbert Hubbard, *Little Journeys to the Homes of Eminent Artists: Whistler* (East Aurora, N.Y., 1902). Hubbard republished the slender volume as a magazine article, to which he added a letter from the artist, in "Whistler," *Idler*, 23 (September 1903), 658–66.

2   JW to Helen Whistler [January 16, 1903], JW to K. E. Johnson, February 1, 1903, G. W. Vanderbilt to JW [May 8, 1903], *GUW* 3313, 9891, 5929; I. B. Davenport Note [1906], Box S, PWC; YMSM 423.

3   Alexander Gardiner, *Canfield: The True*

*Story of the Greatest Gambler* (Garden City, N.Y., 1930), 127, 161, 230.

4  R. B. Philip to C. L. Freer, January 11, 1903, *GUW* 13841; Gardiner, *Canfield*, 4–6, 230–33; clippings from *New York American Journal* and *New York Sun* in C. L. Freer Clippings Book, p. 17, Charles Lang Freer Papers, FGA; *LW*, I:292–93; *WJ*, 235, 242–43, 273–75.

5  Gardiner, *Canfield*, 234–35; *WJ*, 270–71; E. R. Pennell Diaries, December 14, 1902, Joseph and Elizabeth R. Pennell Papers, RHC; Ethel Whibley to E. G. Kennedy [January 1, 1897] with E. G. Kennedy notation of February 1, 1897, *GUW* 9765; Royal Cortissoz to Kennedy, January 21, 1903, Edward G. Kennedy Papers, Box 3, NYPL.

6  Gardiner, *Canfield*, 161, 232–36; *WJ*, 279–80.

7  JW to R. H. Story, February [28], 1903, *GUW* 1683.

8  Edgar Munhall, *Whistler and Montesquiou: The Butterfly and the Bat* (New York, 1995), 48–50, 53, 100–01; Harper Pennington to JW, March 12, 1903, *GUW* 4621; Linda Merrill, ed., *With Kindest Regards: The Correspondence of Charles Lang Freer and James McNeill Whistler, 1890–1903* (Washington, D.C., 1995), 180–88; *New York Sun*, May 9, 1903; *New York Times*, May 10, 1903.

9  Gardiner, *Canfield*, 234–35; Walter Gay, *Memoirs of Walter Gay* (New York, 1930), 46; Walter Gay to Matilda Gay [1903], Walter Gay Papers, AAA; Harper Pennington to JW, March 12, 1903, April 16 [1903], *GUW* 4621–22; "At the New Gallery," *Punch*, 124 (May 6, 1903), 313.

10  Walford Graham Robertson, *Life was Worth Living: The Reminiscences of W. Graham Robertson* (New York, 1931), 200–01.

11  *WJ*, 289–92.

12  Merrill, *With Kindest Regards*, 190–93; C. L. Freer Diaries, June 29–July 17, 1903, Freer Papers.

13  *WJ*, 292–93; JW death certificate, July 20, 1903, *GUW* 6964; Freer Diaries, July 17–22, 1903; Thomas Lawton and Linda Merrill, *Freer: A Legacy of Art* (Washington, D.C., 1993), 53.

14  Louisine W. Havemeyer, *Sixteen to Sixty: Memoirs of a Collector* (New York, 1961), 212–13; A. S. Hartrick, *A Painter's Pilgrimage Through Fifty Years* (Cambridge, Eng., 1939), 193–94; Lillian M. C. Randall, ed., *The Diary of George A. Lucas: An American Art Agent in Paris, 1857–1909* (Princeton, N.J., 1979), II:906, 907, 916, 918, 921–23; Maud Little to G. A. Lucas [November 1, 1902], *GUW* 11330; Pennell Diaries, February 9, 1904. Maud married a second time, around 1911, to another American, Richard H. S. Abbott. She died at Cannes, France, in 1939.

15  *WJ*, 295–98; *LW*, II:302; *PMG*, July 22, 1903; *Daily News*, July 23, 1903; *Daily Chronicle*, July 23, 1903; *Morning Post*, July 23, 1903; Arthur Symons, "The Lesson of Millais," *Savoy*, 6 (October 1896), 57; Pennell Diaries, July 22, 1903, August 7, 1903.

16  Christian Brinton, "Whistler," *Critic* (August 1903), 113; *Boston Evening Transcript*, July 18, 1903; *Westminster Gazette*, July 23, 1903; *Daily Telegraph*, February 2, 1904, in Freer Scrapbooks, III:65.

17  Helen Whistler to E. R. Pennell, August 3, 1903, Box 272, PWC; Arthur Symons, *Studies in Seven Arts* (New York, 1906), 121; N. N. [E. R. Pennell], "Whistler," *Nation*, 77 (August 20, 1903), 149; [Roger Fry], "Mr. Whistler," *Athenaeum*, No. 3952 (July 25, 1903), 133.

18  "Some Newspaper Estimates of Whistler," *Literary Digest*, 27 (August 1, 1903), 132; "The Problem of Whistler's Character," *Speaker* (January 30, 1904), 431–32; Fry, "Mr. Whistler," 133; *New York Herald*, July 19, 1903; "James Whistler," *Manchester Daily Dispatch*, July 20, 1903; C. L. H., "The Two Whistlers," *Academy* (July 25, 1903); Ernest F. Fenollosa, "The Place in History of Mr. Whistler's Art," *Lotus*, Special Issue (December 1903), 17.

19  Harper Pennington to JW, March 12, 1903, *GUW* 4621; "English Beauty Tells of Taming Whistler," *Chicago American*, November 22, 1903; C. A. M., "Mr. Whistler and Women Artists," *Madame* (August 15, 1903), 318.

20  *WJ*, 293, 294, 295; JW to E. G. Kennedy [June 28, 1896] with Kennedy notation of September 6, 1903, *GUW* 9761.

21  Thomas R. Way, *Memories of James McNeill Whistler, The Artist* (London, 1912), 144–45; Way to C. L. Freer, July 29, 1903, August 27, 1903, Freer Papers.

22  William Rothenstein, *Men and Memories: A History of the Arts 1872–1922* (New York, 1932); Mortimer Menpes, *Whistler As I Knew Him* (London, 1904); W. M. Chase to wife, July 19, 1903, July 21, 1903, William M. Chase Papers, AAA; F. Usher De Voll, "William M. Chase: Reminiscences of a Student," p. 5, Chase Papers; William M. Chase, "The Two Whistlers: Recollections of a Summer with the Great Etcher," *Century*, 80 (June 1910), 226.

23  Walter Sickert to C. L. Freer, January 22, 1905, Box 21, Freer Papers; Anna Gruetzner Robins, ed., *Walter Sickert: The Complete Writings on Art* (Oxford, 2000), 177–88, 192–96, 386–88, 510–15, 629.

24  The Editor [Marion H. Spielmann], "James Abbott McNeill Whistler: 1834–1903. The Man and the Artist," *MA*, 2 n.s. (November 1903), 9–16; Max Beerbohm, "Whistler's Writing," *MM*, 20 (September 1904), 728–33.

25  E. Wake Cook, *Anarchism in Art and Chaos in Art Criticism* (London, 1904), 15–16, 49, 79–80.

26  JW to C. J. Hanson [June 19, 1896], [June 24, 1896] (two letters), marriage certificate for C. J. Whistler Hanson and Sarah Ann Murray, June 25, 1896, *GUW* 2018–19, 7991, 2020.

27  Pennell Diaries, August 7, 1903; JW to C. J. Hanson, January 15, 1900, [July 16, 1901], JW to C. J. Singleton [August 8/15, 1902], *GUW* 2022–23, 3568; birth certificate for Joan Eleanor Whistler Hanson, death certificate for C. J. Whistler Hanson, H125–26, WC.

28  Tomb Accounts, September 1909 (G92), Edward Godwin to R. B. Philip, May 21, 1912 (G95), WC. Correspondence among Maud, Ione, and other family members survives in F32–92, WC.

29  Notes by R. B. Philip for letter to newspapers [1908] (P612), A. H. Studd to John Lavery, February 6, 1905 (S261), WC; J. S. Sargent to Joseph Pennell, April 3 [1907], Box 261, PWC; *WJ*, 297, 307–16; Joy Newton and Margaret F. MacDonald, "Rodin: The Whistler Monument," *GBA*, 92 (December 1978), 221–32; Ruth Butler, *Rodin: The Shape of Genius* (New Haven and London, 1993), 394–97.

30  Probate of the Will and Codicil for JW, September 3, 1903, *GUW* 7360; Girschka Petri, *Arrangement in Business: The Art Markets and Career of James McNeill Whistler* (Hildesheim, 2011), 525; Frederick Keppel to E. R. Pennell, November 27, 1903, v.290, PWC.

31  R. B. Philip to C. L. Freer, August 5, 1903, August 19, 1903, Freer to Philip, August [1903], August 20, 1903, Freer Papers.

32  M. G. Duncan to Ethel Whibley, July 19, 1903, WC; Pennell Diaries, July 25 and 28 and August 3 and 7, 1903.

33  Pennell Diaries, July 22; Joseph Pennell to D. C. Thomson, April 11, 1905, Box 266, PWC.

34  C. L. Freer to August Saint-Gaudens, September 17, 1903, agreement between Freer and Saint-Gaudens, February 24, 1906, Freer Papers; Lawton and Merrill, *Freer: A Legacy of Art*, 54–55, 177–201.

35  Pennell Diaries, August 4, 6, and 7, October 8, and November 4, 10, and 23, 1903; Helen Whistler to E. R. Pennell, November 16, 1903, Box 272, Frederick Keppel to Pennell, August 7, 1902, Box 235, Annie Thynne to Pennell, February 20, 1907, v.300, PWC.

36   Pennell Diaries, July 18 and 25, August 11 and 24, October 26, and November 3, 7, and 16, 1903, February 9, August 15, and November 4, 1904, September 12 and 27, October 8 and 15, November 7, and December 16, 1906, and February 12 and August 16, 1907; T. R. Way to Joseph Pennell, November 12, 1903, Box 302, Frederick Keppel to E. R. Pennell, November 27, 1903, v.290, William Heinemann to E. R. Pennell, November 19, 1907, Box 286, PWC.

37   R. B. Philip to A. S. Cole, October 30, 1906, November 7, 1906, WC; Pennell Diaries, August 7 and 21, 1903, July 16, 1906, and May 8, 1907; E. R. Pennell to Joseph Pennell, April 17, 1904, Box 305, Helen Whistler to E. R. Pennell, December 15, 1906, Box 272, PWC.

38   Robert H. Getscher and Paul G. Marks, *James McNeill Whistler and John Singer Sargent: Two Annotated Bibliographies* (New York, 1986), 101–36, 210–24; J. C. Van Dyke to Joseph Pennell, January 2, 1904, Box 270, PWC; G. H. Boughton to A. L. Baldry, August 20, 1903, September 11, 1903, A. L. Baldry Correspondence, NAL.

39   Hartrick, *Painter's Pilgrimage*, 113–14; Judgment in *Philip v. Pennell*, July 24, 1907, Box 362, PWC. Box 362 also contains a full transcript of the trial and correspondence between the Pennells and their solicitor, George H. Radford.

40   Advertising flyer for *Life of Whistler* [c. 1908] v.286, PWC; *LW*, I:xxiii–xvi; Freer to T. R. Way, December 1, 1908, Letterpress Book XXV:485–87, Freer Papers.

41   "Whistler Once More," *New York Tribune*, December 8, 1908; Pennell Diaries, May 28, July 19, and October 20 and 28, 1900, November 7, 1903, and September 25, 1906; Joseph Pennell to M. B. Huish, November 5, 1906, v.285, Pennell to G. H. Radford, March 8, 1904, February 15, 1907, Box 362, PWC.

42   Daniel E. Sutherland, "Getting Right with Whistler: An Artist and His Biographers," in Lee Glazer et al., eds., *James McNeill Whistler in Context* (Washington, D.C., 2008), 169–82; Marie (Spartali) Stillman to J. A. Rose, January 24 [1922], Box 2, Walter S. Brewster Collection, AIC; Alan S. Cole copy of *LW* in NAL; René Gimpel, *Diary of an Art Dealer*, trans. John Rosenberg (London, 1966), 229.

43   R. B. Philip to C. L. Freer, May 24, 1909, January 8, 1913, April 15, 1913, June 21, 1913, July 25, 1913, July 29, 1913, Freer Papers; James Laver, *Whistler* (1930; London, 1951), 7–8; Notes on Conversation with R. Birnie Philip [1930], James Laver Papers, GUL.

44   Pennell Diaries, November 11, 1909.

# Bibliographical Note

•

The length of an already over-long volume prohibits the addition of a full bibliography, which, if done properly, would include some two hundred manuscript collections and over two thousand printed sources. I regret this absence, for my desire is to share every bit of information possible about Whistler and his world. Instead, I must depend on the reference notes for each chapter to substantiate my interpretation of Whistler's life and work, and to suggest additional reading.

I shall here simply emphasize that the core of my research comes from unpublished records, especially the correspondence of Whistler with his family and friends. The principal archives and libraries holding these collections have been mentioned in the acknowledgments and are listed in the abbreviations for my endnotes. Clearly, though, the most important portal for entering Whistler's world is the Glasgow correspondence project (*GUW*). In addition, there are valuable published materials written by Whistler's friends and acquaintances, including articles, pamphlets, reminiscences, and diaries, and the correspondence of such people as the Rossettis, Swinburne, Wilde, Mallarmé, and Montesquiou. A good starting point for understanding the scope of this published material is the still useful, though increasingly dated, Paul H. Getscher and Paul C. Marks, *James McNeill Whistler and John Singer Sargent: Two Annotated Bibliographies* (New York, 1986).

Even a lengthy bibliography could hardly do justice to the incredibly rich and varied modern scholarship on American, British, and European nineteenth-century art, literature, and society that has provided the intellectual context for my work. I am particularly indebted to the many Whistler scholars and biographers who, over the decades, have devoted themselves to understanding the life and work of one of the nineteenth-century's dominant personalities and perhaps its greatest artist. The catalogues raisonnés of his paintings, drawings, etchings, and lithographs illustrate Whistler's very reason for being, and are as necessary as his writings for appreciating the man.

# Index